THE HOLY APOSTLES

DUMBARTON OAKS BYZANTINE SYMPOSIA AND COLLOQUIA

Editorial Board
Dimiter G. Angelov
John Duffy
Ioli Kalavrezou

THE HOLY APOSTLES
A Lost Monument, a Forgotten Project, and the Presentness of the Past

Edited by

MARGARET MULLETT AND ROBERT G. OUSTERHOUT

WITH APPENDIXES PREPARED BY FANI GARGOVA

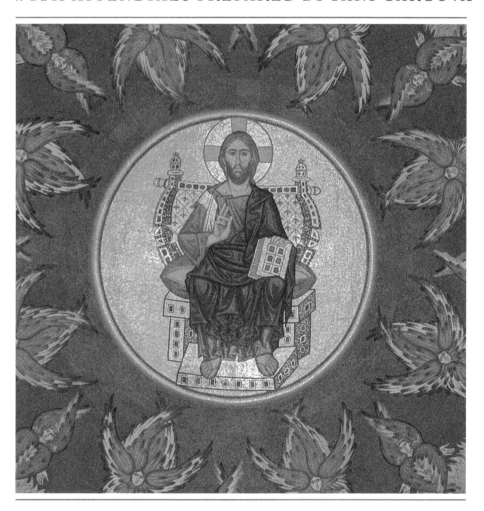

DUMBARTON OAKS RESEARCH LIBRARY AND COLLECTION
WASHINGTON, DC

© 2020 by Dumbarton Oaks Research Library and Collection
Trustees for Harvard University, Washington, DC
All rights reserved
Printed in the United States of America by Sheridan Books, Inc.

www.doaks.org/publications

Design and type composition by Melissa Tandysh

❧

LIBRARY OF CONGRESS CATALOGING-IN-PUBLICATION DATA

Names: Mullett, Margaret, editor. | Ousterhout, Robert G., editor. | Gargova, Fani, 1985– editor. |
 Dumbarton Oaks, host institution.
Title: The Holy Apostles : a lost monument, a forgotten project, and the presentness of the past /
 edited by Margaret Mullett and Robert G. Ousterhout ; with appendixes prepared by Fani Gargova.
Other titles: Dumbarton Oaks Byzantine symposia and colloquia.
Description: Washington, DC : Dumbarton Oaks Research Library and Collection, [2020]
Series: Dumbarton Oaks Byzantine symposia and colloquia | Papers from the Byzantine Studies symposium held
 April 24–26, 2015 at Dumbarton Oaks in Washington, D.C.; Symposiarchs: Margaret Mullett and Robert G. Ousterhout.
Includes bibliographical references and index. | In English; with passages in Greek and Syriac.
Summary: "Founded by Constantine the Great, rebuilt by Justinian, and redecorated in the ninth, tenth, and twelfth centuries,
 the church of the Holy Apostles in Constantinople was the mausoleum of emperors, patriarchs, and saints. It was also a key
 station in the ceremonies of the city, the site of an important school, a major inspiration for apostolic literature, and, briefly,
 the home of the patriarch. Despite its importance, the church no longer exists, replaced by the mosque of Mehmet II after
 the fall of the city to the Ottomans. Today it is remembered primarily from two important middle Byzantine *ekphraseis*,
 which celebrate its beauty and importance, as well as from architectural copies and manuscript illustrations. Scholars have
 long puzzled over its appearance, as well as its importance to the Byzantines. Anxious to reconstruct the building and its
 place in the empire, an early collaborative project of Dumbarton Oaks brought together a philologist, an art historian, and
 an architectural historian in the 1940s and 1950s to reconstruct their own version of the Holy Apostles. Never fully realized,
 their efforts remained unpublished. The essays in this volume reconsider their project from a variety of vantage points, while
 illuminating differences of approach seventy years later, to arrive at a twenty-first century synthesis"—Provided by publisher.

Identifiers: LCCN 2020003448 | ISBN 9780884024644 (cloth)

Subjects: LCSH: Hagioi Apostoloi (Church : Istanbul, Turkey)—Congresses. | Hagioi Apostoloi (Church : Istanbul, Turkey)—
 History—Sources—Congresses. | Dumbarton Oaks—Congresses. | Church buildings—Turkey—Istanbul—Congresses.
 | Church architecture—Turkey—Istanbul—Congresses. | Architectural rendering—Turkey—Istanbul—Case studies—
 Congresses. | Architecture, Byzantine—Turkey—Istanbul—Congresses. | Istanbul (Turkey)—Buildings, structures,
 etc.—Congresses.
Classification: LCC NA5870.H34 H65 2020 | DDC 726.5094961/8—dc23
LC record available at https://lccn.loc.gov/2020003448

CONTENTS

CONCLUSION

Concluding Remarks
ROBERT G. OUSTERHOUT
287

❦

APPENDIXES

Introduction
FANI GARGOVA
293

A The Underwood Drawings
299

B Selected Pages from Albert Mathias Friend, Jr.'s Notebooks
325

C Translation of Constantine the Rhodian's Poem
by Glanville Downey
351

D Paul Underwood,
"The Architecture of Justinian's Church of the Holy Apostles, 1"
369

E Paul Underwood,
"The Architecture of Justinian's Church of the Holy Apostles, 2"
381

F Albert Mathias Friend, Jr., "The Mosaics of Basil I
in the Holy Apostles, Part I"
395

G Albert Mathias Friend, Jr., "The Mosaics of Basil I
in the Holy Apostles, Part II"
407

H Letter from Sirarpie Der Nersessian
to Albert Mathias Friend, Jr., 20 May 1947
419

I Attendance at the 1948 Symposium
421

J Letter from Paul A. Underwood to Father John T. Tavlarides
of St. Sophia Cathedral, Washington, DC, 17 June 1963
427

ACKNOWLEDGMENTS

*T*HIS COLLECTION OF ESSAYS REFLECTS PAPERS GIVEN AT THE 2015 Dumbarton Oaks Spring Symposium as part of a reevaluation of the early collaborative project on the Holy Apostles at the Dumbarton Oaks of the 1950s. At our Dumbarton Oaks we are grateful to James Carder of the Institutional Archives and to the staff of the Image Collections and Fieldwork Archives, particularly Shalimar Fojas White, Fani Gargova, and Rona Razon for their enthusiastic espousal of the project. Fani Gargova with Beatrice Daskas created the accompanying exhibition and booklet. We are also grateful to archivists at Harvard, Princeton, the Smithsonian, Vienna, and the Universities of Indiana and California for their assistance in enabling us to assemble the materials presented in our Appendixes. The symposium was arranged with the advice of the Director and Senior Fellows and as ever depended on the teamwork of Carlos Mendez and Mario Garcia as well as Susannah Italiano and the Byzantine team of Scott Fitzgerald Johnson, Jonathan Shea, and Seh-Hee Koh.

Since the 2015 Symposium, the cast of characters has expanded and contracted, with much revision and rethinking on the part of both editors and contributing authors. Throughout the process, we were (and remain) exceptionally grateful to the keen editing and oversight of Joel Kalvesmaki, the best editor either of us has ever experienced. Without his patience and expertise the final product would have looked very different. We also thank Kathy Sparkes for seeing the volume though production, with her usual flair for design and commitment to the project. Of course, we are also grateful to our numerous authors, who have endured the editing process with such grace. Several of them (including the two editors) have retired while the volume was in process, and their forbearance is much appreciated.

The untimely illness and passing of one of our contributors, Slobodan Ćurčić, left a large and glaring lacuna in the history of the Holy Apostles, one which was ably filled by Nikolaos Karydis, who graciously joined the project at a later date. We also mourn the loss of Ruth Macrides, who died as the volume was moving into production. We hope the final product may stand as a fitting memorial to their lives and careers.

Margaret E. Mullett
Robert G. Ousterhout
Belfast, May 2019

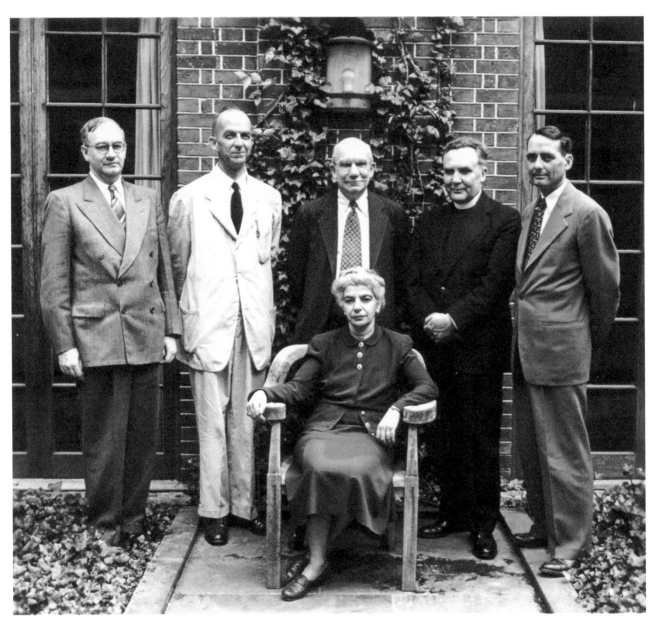

FIG. 1.1. Speakers at the 1948 Symposium. From left to right: Anastos, Downey, Friend, Dvornik, Underwood; seated in front: Der Nersessian. DOA, Byzantine Studies, Symposium 1948, acc. no. AR.PH. Misc.216

INTRODUCTION

Symposium, Project, Monument

MARGARET MULLETT

IN 1940 DUMBARTON OAKS WAS CONVEYED TO HARVARD UNIVERSITY, AND at that time the Blisses founded what they called the Research Institute.[1] A striking feature in the early days was its emphasis on collaborative research projects, which was highly unusual in the humanities until fifty years later. One of these projects, initiated by Albert Mathias Friend, Jr. (fig. 1.2), was an attempt to reconstruct the architecture and mosaics of the second largest church in Constantinople, the Holy Apostles, using the architect's skills of Paul Underwood (fig. 1.3), the philological skills of Glanville Downey (fig. 1.4), and his own skills as an art historian.[2] The project provided an intellectual focus for the Byzantinists at Dumbarton Oaks for the better part of a decade, and had a wide influence on other parts of the research center in its early years, bringing the intimate entwinement of scholars, gardens, and a church in Constantinople. A story is told in two versions: Robin Cormack tells the story that Mrs. Bliss attended the symposium of 1948 on the Holy Apostles and afterward asked for a copy of Underwood's ground plan because she thought it would be a good plan for a garden.[3] A draft plan for the garden exists (fig. 1.5), and was in play at least until 1959.[4] Lawrence Butler has an alternative

1 Mildred and Robert Woods Bliss to the president and fellows of Harvard College, DOA, Blissiana files, Gifts correspondence, 2 July 1940.

2 On Underwood see E. Kitzinger, "Paul Atkins Underwood (1902–1968)," *DOP* 23 (1969): 1–6; on Downey, W. M. Calder III, "Downey, Robert Emory Glanville," *Biographical Dictionary of North American Classicists,* ed. W. W. Briggs, Jr. (Westport, CT, and London, 1994), 141–43; on Friend, M. J. Milliner, "*Primus inter pares*: Albert M. Friend and the Argument of the Princeton University Chapel," *The Princeton University Library Chronicle* 70, no. 3 (2009): 471–517; G. H. Forsyth, "Albert M. Friend Jr 1894–1956," *College Art Journal* 16, no. 4 (1957): 341; "Albert Mathias Friend, Jr. (1894–1956)," *DOP* 12 (1958): ii, 1–2.

3 See Robin Sinclair Cormack, oral history interview by Margaret Mullett, Rona Razon, and Günder Varinlioğlu for ICFA, 18 April 2011, accessed 19 August 2019, http://www.doaks.org/library-archives/dumbarton-oaks-archives/historical-records /oral-history-project/robin-sinclair-cormack: "Mildred Bliss, on the whole, didn't have much interest in the Byzantine center but to their surprise she turned up to one of the symposiums which was never published, which was the reconstruction of the Holy Apostles in Constantinople. And it was noticed, I was told, that Mildred Bliss came to Underwood's reconstruction of the ground plan of the church and at the end asked him if she could have a copy of his plan. He went around to her place a few days later to give her a copy and asked her why she wanted a ground plan of Holy Apostles in Constantinople and the answer she gave was, 'It looks as if it would be a great plan for a garden.'"

4 I should like to thank Gail Griffin who first showed it to me—and for much more—and James Carder for retrieving it for me. Fani Gargova discovered that Mrs. Bliss's request was in 1949, that the drawing was created in 1951—Robert W. Patterson, "Byzantine Garden, Dumbarton Oaks, Washington, DC," 1951, F-2-02, Garden Archives, http://id.lib.harvard.edu/images/8001603067 /catalog—and that the plan was still current in 1959—Ruth Havey, "Sketch Plan for Tennis Court Parterre and Connection with Other Gardens," 1959, T-2-58, Garden Archives, http://id.lib.harvard.edu/images/8001542576/catalog.

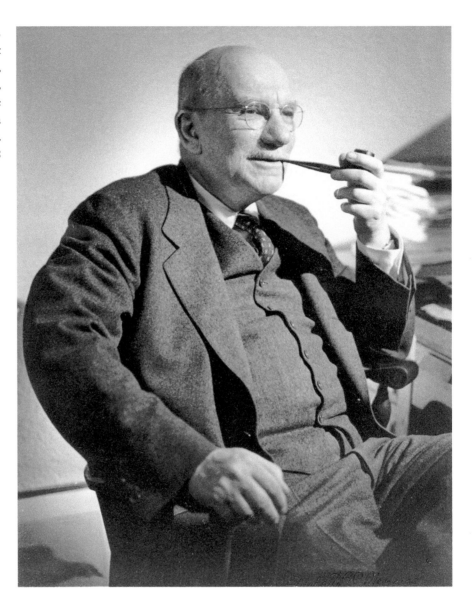

account,[5] which takes the story from Istanbul, once fieldwork became possible again after the war, to California, where Mrs. Bliss had family and charitable interests.[6] Just as the Byzantine

garden was never constructed, so also both the project and the symposium of 1948 remained unpublished (fig. 1.6). The symposium of 2015 and this present volume are an attempt to rectify this deficiency.[7]

I begin on a personal note. I came to the Holy Apostles by two routes. One was via Constantine the Rhodian. While Liz James was preparing her book on the Rhodian, I worked with her in a research center whose members aimed to write a new cultural history of Byzantium by enabling

5 Lawrence Butler, "Report to the Director on Holdings at Dumbarton Oaks of Material Pertaining to the Church of Hagia Sophia in Istanbul," 1985, 12, Curatorial Files, ICFA, "Underwood Drawings. An anecdote: While engaged in excavations around the Fatih Camii in Istanbul looking for traces of the Byzantine church of the Holy Apostles, Paul Underwood received an urgent request from Mrs. Bliss. She needed a plan of the Holy Apostles Church, as she was planning a new garden in California and wanted it laid out in the form of that building. The plans he drew are apparently still somewhere in the Saint Sophia Project Office, Mr. Van Nice believes."

6 It is unknown what that garden might be; Mrs. Bliss had connections to both Casa Dorinda through her mother and Santa Barbara Botanic Gardens both as donor and through

Beatrix Farrand, but there is no clear archival evidence supporting Butler's anecdote.

7 See in particular the Appendixes below, which bring together all the known unpublished pieces, and Fani Gargova's Introduction.

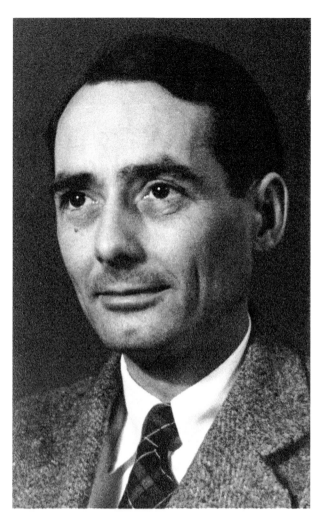

FIG. 1.3. Portrait of Paul Underwood in 1949 (photo courtesy of his daughter, Sarah Underwood)

FIG. 1.4. Portrait of Glanville Downey. "Glanville Downey" (photograph, 22 March 1965), P0046466, http://purl.dlib .indiana.edu/iudl/archives/photos/P0046466 (Photograph Collection, Indiana University Archives, Indiana University, Bloomington)

collaboration among art historians, archae-ologists, and literary scholars.[8] Translating the text of Rhodios weekend after weekend with other literary scholars and art historians made me see how each discipline must help the other. The other route wound through the history of

Dumbarton Oaks. When I was in Vienna before taking up my post at Dumbarton Oaks, I read Kurt Weitzmann's memoirs and was fascinated to learn that his admiration for Friend's tenure as Director of Studies was built on three things: first, his policy of making Dumbarton Oaks researchers Harvard faculty; second, his conduct of symposia; and third, his development of collab-orative projects like the Holy Apostles.[9] Symposia and the relationship with Harvard are still with

8 L. James, ed., *Constantine of Rhodes, On Constantinople and the Church of the Holy Apostles, with a New Edition of the Greek Text by Ioannis Vassis* (Farnham, Surrey, and Burlington, VT, 2012); for the AHRB Centre for Byzantine Cultural History, accessed 7 September 2019, http://www.byzantine-ahrb-centre .ac.uk/index.htm and http://www.sussex.ac.uk/byzantine /research; a new series Studies in Byzantine Cultural History with Routledge will also continue its work.

9 K. Weitzmann, *Sailing with Byzantium from Europe to America: The Memoirs of an Art Historian* (Munich, 1994), 192–203.

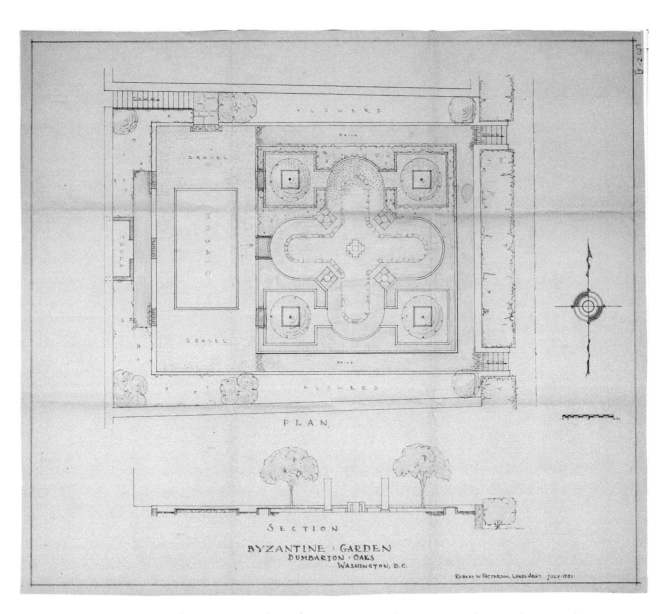

FIG. 1.5. The Byzantine garden. Robert W. Patterson, "Byzantine Garden, Dumbarton Oaks, Washington, DC, " 1951, Garden Archives, F-2-02. Dumbarton Oaks Research Library, Rare Book Collection, Washington, DC, accessed 7 September 2019, http://id.lib.harvard.edu/images /8001603067/catalog.

us, the last not so much; collaboration has become a European mode of research, whereas when I was a young scholar, the reputation of Dumbarton Oaks for collaborative research was enormous.[10]

10 Annual Reports in the 1980s showed a long list of collaborative projects (on texts, demography, numismatics), led by nonresident scholars, which had replaced the golden age of Byzantine fieldwork in the Turkey, Yugoslavia, and Cyprus of the 1960s and early 1970s. On the end of that golden age see G. Constable, "Dumbarton Oaks and Byzantine Field Work," *DOP* 37 (1983):

When I arrived in Dumbarton Oaks in 2009, I came to realize that there is a huge amount of

171–76. So Koehler's Fontes and Research Archive, discussed below by Carder, 17–21, were succeeded by Friend's focused projects, which were, in turn, succeeded by fieldwork initiatives, and then again by a second age of collaborative endeavors. These gave way, in turn, to big institutional projects, like the Typikon Project, the *Oxford Dictionary of Byzantium,* and the Hagiography Database, the last two led by A. P. Kazhdan, together with publication projects of Dumbarton Oaks materials (silver, sculpture, coins, seals, textiles), which are still with us.

SYMPOSIUM ON THE CHURCH OF THE HOLY APOSTLES
IN CONSTANTINOPLE
April 22 - 24, 1948
at Dumbarton Oaks

Under the direction of Miss S. Der Nersessian, Professor of Byzantine Art and
Archaeology, Dumbarton Oaks, Harvard University

Thursday, April 22nd:

A.M. 10:00 - 10:15 Opening remarks by professor A. M. Friend, Jr., Chairman of
 the Board of Scholars, Henry Focillon Visiting Professor
 in Charge of Research, and by Professor Der Nersessian
 10:15 - 10:45 Glanville Downey, Assistant Professor of Byzantine Literature,
 Dumbarton Oaks, Harvard University
 "Constantine of Rhodes, Mesarites and other Literary Texts
 concerning the Holy Apostles"
 11:00 - 12:00 Paul A. Underwood, Assistant Professor of Byzantine Art and
 Archaeology, Dumbarton Oaks, Harvard University
 "The Architecture of Justinian's Church of the Holy
 Apostles": Part I
 12:00 - 12:30 Discussion

P.M. 2:30 - 3:30 Professor Underwood
 "The Architecture of Justinian's Church of the Holy
 Apostles": Part II
 3:45 - 4:45 Professor Downey
 "The Founder of the Pre-Justinian Church of the Holy
 Apostles"
 4:45 - 5:15 Discussion

Friday, April 23rd:

A.M. 10:00 - 11:00 Milton V. Anastos, Assistant Professor of Byzantine Theology,
 Dumbarton Oaks, Harvard University
 "The Imperial Theology of the Sixth Century"
 11:15 - 12:15 Professor Friend
 "The Mosaics of Basil I in the Holy Apostles": Part I
 12:15 - 12:45 Discussion

P.M. 2:30 - 3:30 Professor Friend
 "The Mosaics of Basil I in the Holy Apostles": Part II
 3:45 - 4:45 Professor Der Nersessian
 "The Mosaics of Basil I in the Holy Apostles": Part III
 4:45 - 5:15 Discussion

Saturday, April 24th:

A.M. 10:00 - 11:00 Reverend Francis Dvornik, Visiting Scholar at Dumbarton Oaks
 "The Patriarch Photius, Scholar and Statesman"
 11:15 - 12:15 Professor Der Nersessian
 "Mosaic Decorations of the Ninth Century in Constantinople"
 12:15 - 12:45 Discussion
12:45 - Concluding remarks by Professor Der Nersessian

FIG. I.6. The program of the 1948 Symposium. DOA, Byzantine Studies, Symposium 1948

material surviving, and that not only was the symposium not published as a whole—though some papers were[11]—but this material had not been published either. So we began to plan for an exhibition as well as a symposium.[12]

When Robert Ousterhout and I began to put together our proposal, we realized that not only was this a lost church, but it was also a forgotten project. This is counterintuitive. Bob assured me that all architectural scholars cut their teeth on the problem and certainly after we advertised our plans more and more scholars had come out of the woodwork: Nikolaos Karydis was working on the architecture, Nektarios Zarras on the decorative program, Michael Angold was translating the complete works of Mesarites, Beatrice Daskas was working on Mesarites and the church from the point of view of *ekphrasis*, and Vicky Foskolou from the point of view of narrative.[13] Yet very few people we talked to knew about the project, Friend's ideas, or Underwood's drawings.

So a new collaboration was born among a literary scholar; an architectural historian; and two young researchers trained as art historians, Fani Gargova and Daskas. It was a truly collaborative association, and breakthroughs came from all of us: Ousterhout with the Underwood drawings; Gargova in Princeton and the Friend manuscripts, as well as in Washington with St. Sophia; Daskas in Vienna with the Egon Wellesz correspondence. After we had begun to commission papers, James Carder shared details of the promotions exercise in which the younger researchers were praised for their diligence in the project, and Robert Nelson identified the mysterious "Schwarzenberg" of the Princeton archives (Professor John Martin Schnorrenberg, one of Friend's last pupils) and, in conversation with him, established that Friend was working on the Holy Apostles until the end. My own happiest moment was finding, and recognizing, because of my previous experience, Downey's translation of the Rhodian's poem in the Dumbarton Oaks archives.[14]

11 In no case do we have both symposium paper and published article. Of the 10 papers at the symposium (see the program, fig. 1.6), the 1st, Downey's "Constantine of Rhodes, Mesarites, and Other Literary Texts concerning the Holy Apostles," may be reflected in "Constantine the Rhodian, His Life and Writings," in K. Weitzmann et al., ed., *Late Classical and Mediaeval Studies in Honor of Albert Mathias Friend, Jr.* (Princeton, 1955), 212–21, and in his introduction to "Nikolaos Mesarites: Description of the Church of the Holy Apostles at Constantinople," *TAPS* 47, no. 6 (1 January 1957): 855–924. The second and third, by Paul Underwood, are unpublished but preserved in typescript; see below, Gargova, 293–97 and Appendixes D and E. The 4th paper, Downey's "The Founder of the Pre-Justinian Church of the Holy Apostles," could be reflected in "The Builder of the Original Church of the Apostles at Constantinople: A Contribution to the Criticism of the 'Vita Constantini' attributed to Eusebius," *DOP* 6 (1951): 51–80. Another study by Downey resulted that could not have occurred without the symposium: "The Tombs of the Byzantine Emperors at the Church of the Holy Apostles in Constantinople," *JHS* 79 (1959): 27–51. The 5th paper, by Milton Anastos, "The Imperial Theology of the Sixth Century," could have been worked into "The Immutability of Christ and Justinian's Condemnation of Theodore of Mopsuestia," *DOP* 6 (1951): 123–60. The 6th and 7th papers by Friend were not published but are preserved in manuscript and typescript; see below, Gargova, 293–97 and Appendixes F and G. The 8th paper, by Der Nersessian, has not survived, though it is sought in Armenia and Paris by Fani Gargova. The 9th paper, by Francis Dvornik, "The Patriarch Photius, Scholar and Statesman," was clearly part of his work toward *The Photian Schism: History and Legend* (Cambridge, 1948); he also published during the life of the project "The Patriarch Photius and Iconoclasm," *DOP* 7 (1953): 67–97. The last paper, by Der Nersessian, "Mosaic Decorations of the Ninth Century in Constantinople," preceded her communication, "Le décor des églises du IXᵉ siècle," *Actes du IIᵉ congrès international des études byzantines* (Paris, 1948; published in 1951).

12 For the exhibition in the Orientation Gallery see B. Daskas and F. Gargova, ed., *The Holy Apostles: Visualizing a Lost Monument; The Underwood Drawings from the Image Collections and Fieldwork Archives, Dumbarton Oaks* (Washington, DC, 2015), exhibition brochure and the online exhibition, accessed 7 September 2019, http://www.doaks.org/resources /online-exhibits/holy-apostles.

13 For example, N. Karydis, "The Vaults of St. John the Theologian at Ephesos: Re-visualizing Justinian's Church," *JSAH* 71, no. 4 (2012): 524–51; N. Zarras, "A Gem of Artistic Ekphrasis: Nicholas Mesarites' Description of the Mosaics in the Church of the Holy Apostles at Constantinople," in A. Simpson, ed., *Byzantium, 1180–1204: "The Sad Quarter of a Century"?* (Athens, 2015), 261–82; M. Angold, "Mesarites as a Source, Then and Now," *BMGS* 40 (2016): 55–68 and his translation in the Translated Texts for Byzantinists series (Liverpool, 2017). B. Daskas, "Descrizione della Chiesa dei Santi Apostoli a Costantinopoli: Traduzione, Introduzione, Commento" (PhD diss., Milan, 2010–11); "A Literary Self-Portrait of Nikolaos Mesarites," *BMGS* 40, no. 1 (2016): 151–69; Vicky Foskolou's paper to the Dumbarton Oaks Colloquium on Monumental Painting, 4 November 2016, ended with a discussion of Mesarites' treatment of the Holy Apostles mosaics.

14 G. Downey, "Verses of Constantine of Assicrecy on Rhodes" n.d., DOA, Byzantine Studies, Symposium 1948, Xeroxed and archived also as ICFA, Dumbarton Oaks Research Archive, ca. 1940s, MS.BZ.018. For the 3 different versions of the translation (n.d., November 1945, and April–June 1946), and its annotations by Underwood and Friend, see Gargova, below, 296.

Our collaboration was very different from the first one, as was our symposium.[15] It seemed to us that reexamining the old project gave us a chance not to hash over old conclusions but to arrive at new ones while learning from the perspective of the past. Downey, in a piece published in 1958, talked about "the presentness of the past," and this is at the heart of our volume.[16] We look at how late antiquity engaged with the apostolic age, how middle Byzantines engaged with antiquity, how the Ottomans engaged with the Byzantine past, and how Friend's project engaged with all these.

One question that was not asked at the 1948 symposium was the place held by the Holy Apostles in Byzantine culture as a whole.[17] It could not have been asked then in the same way, because it preceded the great burst of energy in apostolic literature of recent years.[18] And

I am delighted that our volume does address this issue, for this was a crucial way in which Byzantines interacted with their past—the past of Christendom.[19]

Their year was demarcated by feasts and fasts, and one of the major four was the fast and feast of the Apostles (2nd Monday after Pentecost to 29 June, the feastday of Sts. Peter and Paul). In church, their appreciation of other major feasts—the Pentecost, the Ascension, the Dormition—was colored by the participation of the twelve (or eleven) apostles. In the eucharist they were accompanied by the Communion of the Apostles, in travel literature apostles led the way in adventures, and cities and patriarchates based their identity on apostolic foundation. The relations between the churches was couched in personal terms, showing Rome and Constantinople embracing in the persons of Peter and Paul. These past people were present.

We shall see how they become a metaphor for geographical spread, how they are reinterpreted over time for new audiences, and how they offer a particular kind of authority in Byzantium. We should ask also whether this fully accounts for the importance of the building of the early project. Was the church important to Byzantines and later Ottomans because of its connection to the apostolic past, or because of its connection to the past of Constantine and new Constantines? Was it the deadness of the special dead or the living witness of the age of Jesus that ensured that this church was reinvented, or redescribed, in the fourth, the sixth, the ninth, the tenth, the twelfth, and the fifteenth centuries?[20] Was it the imperial significance of the building that ensured its centrality in imperial ceremonial,[21] and why did it appear to lose that significance in the eleventh

15 For the program of the 1948 symposium, 22–24 April, see DOA, Byzantine Studies, Symposium 1948; it is also preserved as MS.BZ.019–03–01–050_002, MS.BZ.019–03–01–050_009, and MS.BZ.019–03–01–050_011, Underwood Papers ICFA, in three identical typed copies. For the list of invitees, Appendix J, see DOA, Byzantine Studies, Symposium 1948, and in one copy with handwritten notes in the Image Collections and Fieldwork Archives, 4 pages, MS.BZ.019–03–01–050_005 to _008, Underwood Papers ICFA. It gives a total of 208 names, most of which were closely connected to Dumbarton Oaks as scholars or benefactors, as well as colleagues interested in the topic from throughout the United States, with Princeton (the home institution of Friend, Downey, and Underwood) preeminent. The list records acceptances by date, and morning/afternoon sessions. The handwritten notes on the last page reveal that a consistent number of more than 66 people were expected to participate at the symposium. The higher number of acceptances for 24 April is due to its being a Saturday and to a two-day meeting of the Trustees. I am grateful to Fani Gargova for the analysis.

16 G. Downey, "The Byzantine Church and the Presentness of the Past," *Theology Today* 15, no. 1 (1958): 84–99.

17 Francis Dvornik was, of course, working at that time toward the book that became *The Idea of Apostolicity in Byzantium and the Legend of the Apostle Andrew*, DOS 4 (Cambridge, MA, 1958) but he did not speak on the subject at the symposium.

18 For a survey see S. F. Johnson, "Christian Apocrypha," in William Johnson and Daniel Richter, ed., *The Oxford Handbook of the Second Sophistic* (New York, 2017). The fundamental contribution of François Bovon is clear; see F. Bovon, "The Synoptic Gospels and the Noncanonical Acts of the Apostles," *HTR* 81 (1988): 19–36; idem, *New Testament Traditions and Apocryphal Narratives,* Princeton Theological Monograph Series 36 (Princeton, 2003); idem, "Canonical and Apocryphal Acts of the Apostles," *JEChrSt* 11 (2003): 165–94; and, with Ann Graham Brock and Christopher R. Matthews, ed., *The Apocryphal Acts of the Apostles: Harvard Divinity School Studies* (Cambridge, MA, 1999).

19 See below Scott Fitzgerald Johnson, 53–66; Demacopoulos, 67–76; see also P. Magdalino, "The Apostolic Tradition in Constantinople," *Scandinavian Journal of Byzantine and Modern Greek Studies* 2 (2016): 115–41.

20 On these rebuilds or reevaluations see below Mark Johnson, 79–98; Karydis, 99–130; Magdalino, 131–42; James, 157–73; Maguire, 193–206; and Ousterhout, 209–34. A. W. Epstein, "The Rebuilding and Redecoration of the Holy Apostles in Constantinople: A Reconsideration," *GRBS* 23 (1982): 79–92.

21 On which see J. M. Featherstone, "All Saints and the Holy Apostles: *De cerimoniis* II, 6–7," Νέα Ῥώμη 7 (2010): 162–74, and Magdalino below, 134–77.

and twelfth centuries, when emperors built new churches—Myrelaion, Mangana, Philanthropos, Pantokrator—to provide a place of burial?[22] Why did it become the patriarchate in the late Byzantine period?[23] And why did it have to be replaced, not repurposed, by the Fatih Camii?

We ask what that building looked like, how it related to other buildings, when it was decorated, and what was the significance of the program. We have specific papers on the Constantinian, Justinianic, and Komnenian phases.[24] But we ask these questions in a different way from our predecessors seventy years ago. They were concerned that reconstructions from the seventeenth century on had concentrated on the intermonumentality of buildings seen as copies of the Holy Apostles and sought to replace that methodology with a rigorous reconstruction on the basis of texts, moderated as a kind of control by their knowledge of other examples of ecclesiastical architecture. And they were very clear that what they were dealing with was a Justinianic church with Constantinian origins and a ninth-century mosaic decoration. Since then there have been developments in the study both of the architecture and of the mosaic decoration which query the latter more fundamentally than the former.[25]

But perhaps more importantly, since 1948 we have learned to treat the texts very differently. We no longer think of ekphrasis as a "literary description of a work of art" as Max Friedländer and Downey did, but as a rhetorical technique designed to bring something (person, place, object, event) vividly before the eyes of the beholder.[26] This did not happen suddenly: the Holy Apostles project was succeeded by the highly positivist work of Cyril Mango, whose *Homilies of Photius* only fueled the reconstruction vogue, before he undercut any conclusions by suggesting that the Byzantines did not look at their built environment at all.[27] But then Henry Maguire opened up the issue with groundbreaking studies of the 1970s, followed by Paul Magdalino and Ruth Macrides, who offered a performative context, and Liz James and Ruth Webb, who began a phenomenological turn that suggested that literary "descriptions" were not primarily concerned with description but with celebration.[28] Once we begin to read texts in this way, whether the Virgin is sitting or standing or

22 On these later buildings, the latter of which were sited very close to the Holy Apostles, see V. Marinis, "Tombs and Burials in the Monastery *tou Libos* in Constantinople," *DOP* 63 (2009): 147–66; P. Gautier, "Le typikon de la Théotokos Kécharitôménè," *REB* 43 (1985): 5–167, trans. R. Jordan in *Byzantine Monastic Foundation Documents*, ed. J. P. Thomas and A. Hero, 5 vols., DOS 35 (Washington, DC, 2000), 2: 664–711, S. Kotzabassi, ed., *The Pantokrator Monastery in Constantinople*, ByzArch 27 (Berlin, 2013).

23 Below, 237–41; 252–54. At the symposium, the paper given by Nevra Necipoğlu also addressed the theme of Gennadios's self-association with the apostle Paul and his panegyric on the Holy Apostles, dated 29 June 1456. For an abstract see page 9 of the symposium program, http://www.doaks.org/research/byzantine/scholarly-activities/the-holy-apostles/holy-apostles -program-and-abstracts.

24 See below Johnson, 79–98; Karydis, 99–130; and Ousterhout, 209–34.

25 Key turning points in architecture are the work of R. Krautheimer, "Zu Konstantins Apostelkirche in Konstantinopel," in *Mullus: Festschrift Theodor Klauser* (Münster, 1964), 224–29, who proposed that Constantine's Apostoleion was a cruciform church (and also a 10th-century reconstruction), and C. Mango, "Constantine's Mausoleum and the Translation of Relics," *BZ* 83 (1990): 51–62, who countered with a circular or octagonal rotunda. As for decoration, the picture was complicated by E. Kitzinger, "Byzantine and Medieval Mosaics after Justinian," *Encyclopedia of World Art* (1965), 10:344, who

proposed a 12th-century decoration phase to match the descriptions of Mesarites. The article of Annabel Wharton Epstein, "Rebuilding and Redecoration," was the first to suggest that the importance of these texts might not lie in their accurate representation of the lost monument.

26 Contrast P. Friedländer, *Johannes von Gaza und Paulus Silentiarius: Kunstbeschreibungen Justinianischer Zeit* (Leipzig and Berlin, 1912) and G. Downey, "Ekphrasis," *Reallexikon für Antike und Christentum* 4 (Stuttgart, 1959), with two recent volumes on ekphrasis: V. Vavřínek, P. Odorico, and V. Drbal, eds., *Ekphrasis: La représentation des monuments dans les litteratures byzantine et byzantino-slaves; Réalités et imaginaires, BSl* 69, no. 3, supplementum (Prague, 2011); P. Odorico and C. Messis, eds., *Villes de toute beauté: L'ekphrasis des cités dans les littératures byzantine et byzantino-slaves; Actes du colloque international, Prague, 25–26 novembre 2011*, Dossiers Byzantins 12 (Paris, 2012); the turning point came with the work of R. Webb, culminating in *Ekphrasis, Imagination, and Persuasion in Ancient Rhetorical Theory and Practice* (Farnham, Surrey, 2009); see also eadem, "The Aesthetics of Sacred Space: Narrative, Metaphor, and Motion in *Ekphraseis* of Church Buildings," *DOP* 53 (1999): 59–74.

27 C. Mango, *The Homilies of Photius,* DOS 3 (Cambridge, MA, 1958); "Antique Statuary and the Byzantine Beholder," *DOP* 17 (1963): 55–75.

28 H. Maguire, "Truth and Convention in Byzantine Descriptions of Works of Art," *DOP* 28 (1974): 111–40; R. Macrides and P. Magdalino, "The Architecture of Ekphrasis: Construction and Context of Paul the Silentiary's Poem on Hagia Sophia," *BMGS* 12 (1988): 47–82; L. James and R. Webb, "'To Understand Ultimate Things and Enter Secret Places': Ekphrasis and Art in Byzantium," *Art History* 14 (1991): 1–17.

how many feasts are mentioned begins to matter very much less than what is expected of the receiver both of the images and the texts.

This volume engages with the two major texts (though Eusebius and Procopius also get their due) and looks at their concerns and those of their writers, receivers, and contemporaries, placing them center stage in a way that Friend would never have allowed Downey to do. But we also must bear in mind that if we say "who cares?" about the issues that possessed the Friend project—and after forty years of revisionism we are very much inclined to do this[29]—then by privileging intertextuality we may be forgetting about intermonumentality. What the church looked like, and what mattered about that to the Byzantines, seem to me to be still valid and important questions. The Friend project chose to work on the Holy Apostles precisely because it did not exist, when in wartime it was impossible to look at monuments that did survive;[30] it is no less important in Byzantium, it seems to me, no less incumbent on us, to try to explain what it looked like and what that meant. And I suggest that "the presentness of the past" has something to do with that as well.

This, I admit, is rather uncomfortable, because what we think about visualization has also changed since the three heroes sat in the upstairs Reading Room and shared their insights, or reported eagerly to each other by letter.[31] How did Byzantines represent their own monuments, and what does this tell us about how they perceived them, how they thought about opticality and hapticality?[32] But it makes sense that if you understand how the Byzantines thought the eye

works and how all the senses were engaged—in listening to a homily in church with light streaming in through windows or censers being swung on ropes, as your nose accommodated the various smells of the city and the building, of incense and your fellow worshipers—then you are better equipped to understand the building.[33] This revised understanding calls for an imaginative reconstruction of a different kind, but still a reconstruction is necessary, or else any of the currently fashionable acoustic and light projects will fail.[34] But we need not assume that we automatically know how and why Byzantines represented their churches: there seems to me a lot of difference between the tone and purpose of the representations in the *Menologion of Basil II*'s Holy Apostles and that of the homilies of James Kokkinobaphos, though that is properly an art historical question.[35] And, finally, it is amazing how tolerant we are of computer reconstructions, where an Underwood drawing might have drawn fire as methodologically naive. Tayfur Öner's amazing reconstructions for Byzantium 1200 are based on the maxim: "thou shalt include all thou knowest; thou shalt not contradict what thou knowest."[36] Is this enough? Has anything really

29 See, for example, James below, 164–65.

30 Friend, in a lecture prepared for the 1947 symposium on Byzantine Art and Scholarship, said of the project (with another on Holy Sion), that they were "started in war time, have to do with churches which were so completely destroyed in the Middle Ages that the first-hand investigation of the sites, impossible under present conditions, would play but a secondary part in their restoration," in "Byzantine Studies at Dumbarton Oaks, Saturday April 26, 1947," notes, photographs, correspondence; 1915–54, Carton 6, Friend Papers; see Gargova, *Holy Apostles: Visualizing a Lost Monument*, 7–8.

31 See below, Nelson, 40–41.

32 R. S. Nelson, "To Say and to See: Ekphrasis and Vision in Byzantium," in R. S. Nelson, ed., *Visuality Before and Beyond the Renaissance* (Cambridge, 2000), 142–68; R. Betancourt, "Why Sight is not Touch: Reconsidering the Tactility of Touch in Byzantium," *DOP* 70 (2016): 51–74; idem, "Tempted to

Touch: Tactility, Ritual, and Mediation in Byzantine Visuality," *Speculum* 91, no. 3 (2016): 660–89.

33 L. James, "Senses and Sensibility in Byzantium," *Art History* 27, no. 4 (2004): 522–37.

34 For acoustic projects see those of Sharon Gerstel with Chris Kyriakakis (USC), "Bodies and Spirits: Soundscapes of Byzantium," and Bissera Pentcheva, "Icons of Sound: Aesthetics and Acoustics of Hagia Sophia, Istanbul," accessed 7 September 2019, http://iconsofsound.stanford.edu; the Onassis Seminar, *Aural Architecture: Music, Acoustics, and Ritual in Byzantium*, accessed 7 September 2019, http://auralarchitecture.stanford.edu/; and the Geballe workshop, *The Material Imagination: Sound, Space, and Human Consciousness*, accessed 7 September 2019, http://soundmaterialimagination.stanford.edu/. Light projects have been less collaborative (though note V. Ivanovici, *Manipulating Theophany: Light and Ritual in North Adriatic Architecture ca. 400–ca. 800* [Berlin and Boston, 2016], part of a Swiss research project [Sncf, 2010–14] conducted by Daniela Mondini) but extremely fashionable; I note only the work of Claire Nesbitt for its emphasis on phenomenology, of Yannis Iliades for its patient measurement, and the long-awaited project of Lioba Theis on architecture.

35 *Menologion of Basil II*, fols. 341r, 353r, 121r; homilies of James of Kokkinobaphos, Vat. gr. 1162, fol. 2; and Paris, B.N. gr. 1208, fol. 2v.

36 For the Byzantium 1200 reconstruction of the Holy Apostles, and the motto, see http://www.byzantium1200.com/apostles.html.

changed? When we read in Nelson's essay about the involvement of successive Dumbarton Oaks Byzantinists in the decoration of a neighborhood church that was only at the time of our symposium expecting its consecration,[37] are we dealing here perhaps with the "pastness of the present"?

Next, I want to return to the 1940s project and ask why the project and symposium were not published. We all had ideas: Ousterhout, for example, suggested that once Underwood got the chance of working on a real building, he lost interest. Weitzmann in 1994 reflected on it as "one of the tragedies of Friend's life, consistent with his character."[38] One thing we can exclude is that the members of the project had second thoughts about the validity of what they were doing.

They worked in a supportive environment at first, with Charles Rufus Morey in 1946 describing the project as "a grand idea,"[39] and Sirarpie Der Nersessian eagerly embracing it in 1947 as a symposium topic that could involve younger scholars in the endeavor.[40] Friend had originally brought the project to Dumbarton Oaks, indeed offering the Board of Scholars a monograph on the subject, but his collaborators caught up quickly and by 16 March 1947 Downey wrote to Erwin Panofsky that he was deeply into the project.[41]

Minutes of the Board of Scholars and Annual Reports show activity in each of the years from 1945 to 1956 and from 1951 to 1952 respectively. On 17 January 1950 Underwood made his first expedition to Constantinople to look at, among other things, the topography of the Holy Apostles.[42]

The proposal of 28 April 1950 to promote Downey and Underwood to Associate Professor depended heavily on Friend's report on their contribution to the project.[43] On 16 February 1952 the Board of Scholars heard for the first time about the projected publication of a three-volume monograph, one volume each on the architecture, the mosaics, and the texts.[44] By then material from the symposium by Downey and Francis Dvornik had appeared or were about to appear in *Dumbarton Oaks Papers,* and the first cracks appear in the collaboration, though this is not apparent in the 30 January 1953 Board of Scholars report on the Holy Apostles project.[45]

On 13 January 1954 Downey writes to Panofsky that his work was begun eight years ago, finished five years ago, and between Underwood's new responsibilities in Istanbul and Friend's slowness, "yours truly was left holding the bag."[46] On 4 February 1954, Downey, now very anxious to see publication, reported to the Board of Scholars on the state of play: Der Nersessian was to bring a report to the next meeting, but Friend suddenly and shockingly "on the advice of his physician" resigned from Dumbarton Oaks.[47] On 3

37 On the commissioning of mosaics for St. Sophia, Washington, DC, in 1964 see below, Nelson, 45–50 and Gargova, 293–97 and Appendix J. The consecration took place on 9–10 May 2015.

38 Weitzmann, *Sailing with Byzantium*, 196.

39 Letter of 14 October 1946 to Friend at the American Embassy in Rome: "Your account of all the doings at the Oaks and your part in them is very exciting and the Holy Apostles job is a grand idea." Notes, photographs, correspondence; 1915–49, carton 6, Friend Papers.

40 Letter from Sirarpie Der Nersessian to Albert Friend, 20 May 1947, p. 1–2, Notes, photographs, correspondence; 1935–55; carton 7, Friend Papers; see below Appendix H, for a transcript. The younger scholars were Underwood and Downey.

41 Glanville Downey to Erwin Panofsky, typed (16 March 1947), Series 1, Subseries 1, Panofsky Papers.

42 Report of the President of Harvard College and Reports of Departments, 1949–50, *Official Register of Harvard University*

51 (1954): 213: "Professor Underwood spent the autumn on topological and archaeological investigations in Istanbul. On his return he worked on reconstructions of the Sacred Palace, particularly of the Daphne Palace of Constantine." Special thanks to Deb Brown for her help with this reference.

43 DOA, Administrative Files, Board of Scholars, Minutes 28 April 1950. Friend as Director both of the project and of Byzantine Studies "can only express the greatest satisfaction concerning Downey's contribution" and says of Underwood that "his is the brilliant reconstruction of the church from the poem of Constantine of Rhodes, which he presented for the first time in two lectures at the Symposium of 1948. These lectures were by common consent considered the best of the gathering." At the Board of Scholars on 6 December 1948 he had reported on the symposium, describing it as "one of the most successful to be had so far."

44 DOA, Administrative Files, Board of Scholars, Minutes 16 February 1952.

45 Downey, "Builder of the Original Church," and Dvornik, "Patriarch Photius and Iconoclasm." DOA, Administrative Files, Board of Scholars, Minutes 30 January 1953, at which Friend claimed that "the greater part of work on the Holy Apostles has been completed. Some drawings are still to be made and the different studies on the texts, the architecture and the mosaics have to be coordinated."

46 Downey to Panofsky, 13 January 1954, Series 1, Subseries 1, Panofsky Papers.

47 DOA, Administrative Files, Board of Scholars, Minutes 4 February 1954 (after dinner at 6, back to the board table at 7:30).

April 1954, at the Board of Scholars, Friend and Underwood agreed to Downey publishing separately, though they did not give up on their own ambitions for publication, though these looked increasingly unlikely.[48] On 6 January 1956 the Publications Committee met with Downey and Underwood, and together they arrived at a two-article solution,[49] but on 23 March Friend died.[50] On 9 April 1956, Downey wrote to Wellesz that he was not sure that he would be able to take Holy Apostles material away from Dumbarton Oaks and place it elsewhere, but on 14 May 1956 the Publications Committee allowed Downey to publish Mesarites elsewhere; Downey told Wellesz three days later that Dumbarton Oaks is interested only in Constantine the Rhodian; he later (January 1958) told Panofsky that he will tell him sometime why Dumbarton Oaks did not want Mesarites.[51] In any case, in 1956 Downey was applying away from Dumbarton Oaks[52] and in January 1957 the Board of Scholars was told

that Downey had prepared Mesarites for the *Transactions of the American Philosophical Society*; a year later they were told it had been published.[53] At the Board of Scholars of 6 February 1959, Ernst Kitzinger replied to a question on the publication of the Holy Apostles by confessing that it was impossible to reconstruct Friend's part, and on 7 October 1961 the Publications Committee allowed Philip Grierson to publish a piece on the tombs in *Dumbarton Oaks Papers*; they had previously thought his work too close to Downey's article on the topic.[54] On 9 May 1962, the Publications Committee decided to make another approach to Downey for the text of Rhodios, and in 1964 Downey left for Indiana University.[55]

The supportive environment was now about to change as well. On 22 September 1968 Underwood died, and a month later the Publications Committee, going through his papers, found an article by him and Downey. They concluded that it was not publishable; "ninety-nine percent fantasy" is how it was phrased.[56] In 1975–76 Slobodan Ćurčić was shown the drawings by then Director of Byzantine Studies, William Loerke, "languishing, rolled up on a musty shelf in one of the rooms containing fieldwork material" relating to Dumbarton Oaks projects.[57] Nearly forty years later Downey's translation

48 DOA, Administrative Files, Board of Scholars, Minutes 3 April 1954: "Messrs Friend and Underwood have indicated that, although they have not given up their intention of completing their parts of the study of the church of the Holy Apostles in Constantinople, they agree to the publication at this time of Mr Downey's work on the literary texts. Mr Downey's material has been brought up to date and is awaiting examination by the readers."

49 DOA, Publications Committee Minutes 1957–71, Publications Committee 6 January 1956. Downey was to republish Constantine the Rhodian with translation and commentary, summarizing his article in the Friend Festschrift and commenting on the poem as a literary work, defining its place in the history of ekphrasis; Underwood was to publish a verbal reconstruction of the main body of the building with a series of drawings. Ideally both were to appear in the same volume of *DOP*, but the second could not appear before the first.

50 "Albert Mathias Friend, Jr., 1894–1956," *DOP* 12 (1958): ii, 1–2.

51 Glanville Downey to Egon Wellesz, typed (9 April 1956), F13.Wellesz.1721 Mus, Österreichische Nationalbibliothek, Musiksammlung, accessed 7 September 2019, http://data.onb.ac.at/mus/MZ00036136; DOA, Publications Committee 14 May 1956: "As for any additional material they might have, they should be informed that they are completely free to do with it as they wish so long as it does not interfere with the material to be made available for Dumbarton Oaks publication." Glanville Downey to Egon Wellesz, 17 May 1956, F13.Wellesz.1721 Mus, Österreichische Nationalbibliothek, Musiksammlung, accessed 7 September 2019, http://data.onb.ac.at/mus/MZ00036136; Glanville Downey to Erwin Panofsky, typed (7 January 1958), Series 1, Subseries 1, Panofsky Papers. Sadly, we have no evidence that he ever did.

52 For example, to the University of Arkansas; see the request for a letter of reference from Dean G. D. Nichols to Erwin

Panofsky (2 October 1956), Series 1, Subseries 1, Panofsky Papers.

53 DOA, Board of Scholars 30 January 1957; DOA, Board of Scholars 24 Jan 1958.

54 DOA, Board of Scholars of 6 February 1959; Publications Committee 7 October 1961; P. Grierson, "The Tombs and Obits of the Byzantine Emperors (337–1042) with an Additional Note by C. Mango and I. Ševčenko," *DOP* 16 (1962): 3–63; Downey, "Tombs" (n. 7 above).

55 DOA, Publications Committee 9 May 1962: "translations would be desirable"; on Downey see the name index term "Downey, Glanville," *AtoM@DO*, 30 April 2015, accessed 28 January 2020, https://web.archive.org/web/20150906134628/http://atom.doaks.org/atom/index.php/downey-glanville; on the thinness of Indiana archival material on Downey see below, Gargova, 295n15.

56 DOA, Publications Committee 2 October 1968: "Mango has seen it and thinks it not publishable. The ideas are too theoretical for us to publish." They considered giving it to Downey to work on, but decided to tell him that they had turned it over to Mrs. Underwood and he could communicate directly with her. The committee comprised Romilly Jenkins, Cyril Mango, Ihor Ševčenko, John Thacher, and Julia Warner.

57 "The Church of the Holy Apostles in Constantinople," Byzantine Studies Scholarly Activities, Dumbarton Oaks Research Library and Collections, accessed 7 September 2019, http://www.doaks.org/research/byzantine/scholarly

of the portion of Rhodios relating to the Holy Apostles was still yellowing in the Dumbarton Oaks archives, and the full translation in various versions was found by Gargova in Princeton.[58] The project went from "a grand idea" to "ninety-nine percent fantasy" in twenty years.

This discussion of publication before any research has been described may appear to be putting the cart before the horse, but I hope it will provide a context for what follows, in which the interplay between the Byzantine centuries and the 1940s and 1950s in Washington is apparent in more than the first two papers: these provide an explicit consideration of the old Dumbarton Oaks project as exemplar both of collaborative research and as applied research by James Carder, institutional archivist of Dumbarton Oaks, and Robert S. Nelson, formerly chair of the Senior Fellows of Dumbarton Oaks.[59]

The two papers which follow concentrate on various aspects of the apostles in Byzantium and also address the iconic work by Dvornik published in 1958 but in progress during the years of the Holy Apostles project.[60] Scott Johnson considers the nature of apostolic literature and its textual, historical, and geographical strands.[61] He notes that the deposition of the relics of Andrew, Luke, and Timothy in the church of the Holy Apostles did not coincide with the mental habit of apostolic geography he analyzes, and he confronts Dvornik directly: the church of the Holy Apostles was not, he argues, the symbol of an apostolic see. George Demacopoulos[62] discusses the concept of "apostolic succession" in Byzantium and notes that patristic authors saw the ancient Jewish priesthood, rather than the

apostles, as models for the clergy, and also were unwilling to link apostolic authority to orthodoxy. What they did connect with the apostles was their faith and their witness to the life of Christ. He views iconoclasm as a crucial turning point after which theologians may have seen apostolic authority to bind and loose sins as a means of wielding political power over emperors and rival sees. But the memory of the apostles in Christian ritual was ever present (during as much as one month in the year of the fast and feast of the apostles, and in regular New Testament readings in the liturgy at other times), and this alone would be enough to explain why successive emperors supported the cult of the apostles in their titular church; for Demacopoulos, the daily aural presence of the apostles supports the church.

The form and meaning of that church is the concern of the next two papers. Mark Johnson[63] sets Constantine's building firmly in the context of imperial mausolea and postulates a domed rotunda, added to by Constantius with a cruciform church and by Theodosios with the north stoa. The apostles, in his view, were given a burial *ad imperatores,* and the point of the building was a place of testimony of the apostles and their companion Constantine to the immortality of Constantine. Nikolaos Karydis[64] looks at the new church of Justinian built after Constantius's cross-shaped church had been razed. He surveys previous reconstruction attempts and treatments from Heinrich Hübsch to Gargova and Daskas, and proposes his own reconstruction on the basis of the accounts of Procopius, Constantine the Rhodian, and Nicholas Mesarites, with reference to St. John of Ephesos and San Marco in Venice. Cautiously he proposes a high central dome with four other pendentive domes; even more cautiously he wonders whether the differences

-activities/the-holy-apostles/holy-apostles-program-and -abstracts.

58 Notes, photographs, correspondence, carton 6, Friend Papers; the translation, entitled "Verses of Constantine of Rhodes, *a secretis,*" is a complete version of June 1946 but split into two sections, housed in two different folders. The first part, lines 1–410, is dated April 46 in typescript with handwritten annotations, marked in ink "revised June 46"; the second, lines 411–981, dated June 46 in typescript with a handwritten note "not revised from this point." A set of notes 1–953 may belong with this version. See Gargova below, 293–97.

59 Below, 17–50.

60 Dvornik, *Idea of Apostolicity.*

61 Below, 53–66.

62 Below, 67–76.

63 Below, 79–98.

64 Below, 99–130. Note that Slobodan Ćurčić had spoken at the symposium, situating the 6th-century architecture of the Holy Apostles within a competitive discourse with Rome over apostolic primacy, suggesting that the subsequent remodeling of the sanctuary of St. Peter's came in response to the reconstruction of St. John at Ephesos and the Holy Apostles in Constantinople. Unfortunately, because of ill health he was unable to contribute to the publication. The editors are grateful to Nikolaos Karydis for ably filling the thematic gap, addressing the 6th-century building directly.

between the accounts may mirror architectural changes between the sixth and tenth, and the tenth and twelfth centuries.

That kind of change is what Paul Magdalino[65] considers in his study of the annexes, neighboring structures, and the neighborhood of the Holy Apostles. He sees the Apostoleion as integral to Constantine's vision of Constantinople, but argues that he was making it up as he went along; the mausoleum and associated palace were perhaps intended to be his tetrarchic retirement home. The building took on new life in the Theodosian period when the neighborhood became fashionable, and in the Macedonian period when the dynasty adopted the complex as its own. Its ceremonial function develops at that period and even into the Komnenian period when there was no more room left for burial, and neighboring foundations like Philanthropos, Kecharitomene, and Pantokrator joined it with imperial functions. Its role in the cult of the apostles was less clear, though neat comparison of the *Typikon of the Great Church* and a passage in the *Anonymous Tarragonensis* suggests that between the mid-tenth century and the late eleventh century it became the venue for a feast on 30 June, for the vigil of which Mesarites' ekphrasis of about 1200 may have been written.

The next four papers are concerned with that text and with the other equally famous ekphrasis of the church in the tenth century by Constantine the Rhodian. Floris Bernard[66] sets Constantine in his literary context, of manuscript J of the Palatine anthology and the epigrammatic features of the ekphrasis; of the mud-slinging of other scholars in the tenth century and his responses; of relations with his patron Constantine Porphyrogennetos and the presence of Leo VI, who had himself written a brief excursus on the Holy Apostles in his homily on the translation of the relics of John Chrysostom; of his response in the ekphrasis to the poems of Paul the Silentiary on Hagia Sophia. Liz James[67] looks at the process of reconstruction from the two ekphraseis by the Dumbarton Oaks project, demonstrates its limitations, and indicates its

influence. Ruth Macrides[68] evokes the particular characteristics of Mesarites' style in the oeuvre as a whole (his account of the coup of John Komnenos, the *epitaphios* for John Mesarites, the letters to the monks of the Euergetis monastery in Constantinople, and accounts of ecclesiastical debates with the Latins) and then in wider developments of the twelfth century; she concludes that we cannot know whether the mosaics he evokes were new compositions of the twelfth century or not, and we should concentrate on determining what spiritual or emotive reaction he aimed to awake in his readers. Henry Maguire,[69] in his reading of the ekphrasis, offers a contribution to this inquiry. He sees the structure of the logos as "a diagram of salvation with the church at its center," sweeping from the wider environment as viewed from the roof of the church (replicated intrepidly by Maguire from the minarets of the Fatih Camii) to the surrounding spaces with their busy everyday life and their undercurrent of fear and violence, to the calm of the church and its mosaics, which resolve problems of the everyday world, and at the very heart a vision of the Pantokrator. He concludes that Mesarites' text must be read as literature, that he described what he saw, and that its main contribution to art history is in its embrace of features of everyday life which can be found both in texts and art of the period.

Maguire's vision from the roofscapes of Constantinople is echoed in Robert Ousterhout's examination of the architectural importance of the Holy Apostles.[70] He rejects any widespread imitation of its characteristic features, but emphasizes instead its contribution to the ideology of imperial burial and its status as urban monument in juxtaposition to other urban imperial monuments of Constantinople—and of the Istanbul which was to succeed it.

Julian Raby[71] takes up the story at just that point and tracks the pragmatic decisions of Mehmed the Conqueror over the decade from 1453 to 1463, offering the city first to the megadoux Loukas Notaras, then changing his mind

65 Below, 131–42.
66 Below, 145–56.
67 Below, 157–73.

68 Below, 175–91.
69 Below, 193–207.
70 Below, 211–236.
71 Below, 247–283.

and executing him, trying again to attract repopulation by installing the new patriarch George Scholarios in the Holy Apostles as the seat of his patriarchate, and finally taking advantage of the move of the patriarch to the Pammakaristos to redevelop the site. Nevra Necipoğlu[72] examines in greater detail the career of patriarch Gennadios, taking into consideration, as well as the internal politics of Mehmed II's court, evolving relations with the papacy, and western powers in response to crusading plans against the Ottomans.

Mehmed's redevelopment to the Fatih Camii, we see, has been hardly less controversial than the Holy Apostles, with its own competing reconstructions, its puzzle about the execution of the architect Sinan, and the uncertainty about its site. Raby concludes that on the basis of non-Ottoman features surviving on the site the new mosque did indeed sit on top of the Holy Apostles and was indeed "an act of enormous symbolic meaning."

Mehmed collected items of imperial symbolic significance, and just as his mosque sat on top of the church of the Holy Apostles, so his tomb sat on top of the mausoleum of Constantine.

In its emphasis on how the apostles, their texts, and their sanctuary were received at different periods of the Byzantine empire and beyond, this volume is very different from the original project's emphasis on architecture of the sixth century, decoration and theology of the ninth century, and what was actually to be seen in the building. It is equally collaborative and interdisciplinary, though in a different way. It privileges text and builds on our increased appreciation and understanding of Byzantine literature; acknowledges what we cannot know, as with the dating of the mosaic program; and shifts attention to cityscape and ceremony. It is unlikely that Friend would have approved of it or that Morey would have described it as a "a grand idea," but through the lens of the Dumbarton Oaks project it is now possible to see how much our view of "the presentness of the past" has changed in the intervening seventy-odd years.

72 Below, 237–246.

Dumbarton Oaks

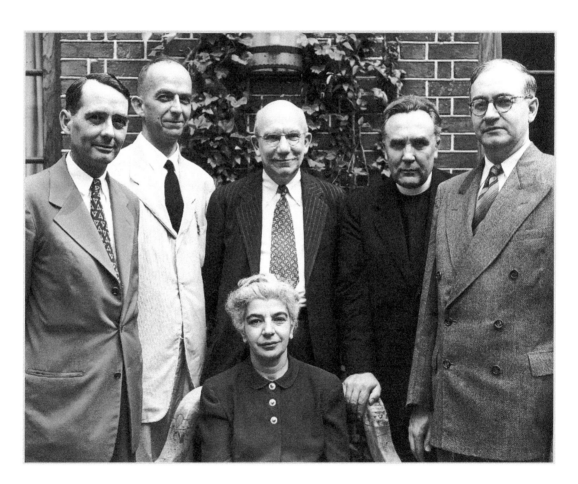

THE 1948 HOLY APOSTLES SYMPOSIUM AND COLLABORATIVE RESEARCH AT DUMBARTON OAKS

JAMES N. CARDER

*T*HE 1948 SYMPOSIUM ON THE CHURCH OF THE HOLY APOSTLES IS TODAY best remembered at Dumbarton Oaks for its pioneering use of a collaborative research methodology, one which allowed the speakers to work together to reconstruct and articulate the importance of the long-destroyed church. The symposium had been in large part engineered and organized, although not presided over, by the medievalist art historian Albert Mathias Friend, Jr., who was Director of Byzantine Studies at Dumbarton Oaks, to use his position's present-day title. The collaborative research methodology, however, had already been established at Dumbarton Oaks by Wilhelm Koehler in 1941, during the institution's first full year of operation. When Friend arrived from Princeton in 1943, he quickly realized that this methodology of joint research could greatly enhance scholarly work on complex topics, especially when the collaborating scholars shared expertise brought together from a wide variety of disciplines. This was especially true for the 1948 symposium, and the situation at Dumbarton Oaks was ideal for such collaboration. All six speakers were in residence, and together they represented a fairly broad swath of Byzantine studies. Glanville Downey was a classicist and historian who could translate and interpret the relevant textual sources. Paul Underwood was both an architect and an architectural historian who could draft plausible plans and elevations of the church. The historians Milton Anastos and Father Francis Dvornik were both specialists in theological history and could provide the imperial and patriarchal contexts for the church. And Sirarpie Der Nersessian and Friend were art historians who could reconstruct the church's mosaic decoration and iconographical meaning. Dealing, as they were, with a building no longer standing, these symposium speakers needed to venture well beyond the traditional research methodologies that applied to their individual disciplines. To do this, they used a potent combination of collateral sources: literary references; analogous monuments; and imperial, patriarchal, and theological practices. And because each speaker had a long-term appointment at Dumbarton Oaks, they could work in concert on the church and continue this work in post-symposium collaboration—a collaboration meant to eventuate in a definitive, multivolume scholarly publication.

To better understand the conditions at Dumbarton Oaks that fostered this collaborative symposium, it is necessary to review briefly how the research institution had evolved during its first decade. Its founders, Mildred and Robert Woods Bliss, had provided little direction when they gifted Dumbarton Oaks to Harvard University in 1940. Their letter to Harvard's president announcing the gift stated rather simply their desire that Dumbarton Oaks "be used for study and research in the Humanities and Fine Arts, with especial emphasis upon Byzantine art and the history and culture of the Eastern Empire in all its aspects." They further expressed their hope that Dumbarton Oaks itself would become a center

of research and a place of residence for scholars, students, and artists.[1] In a 1939 letter to her friend Royall Tyler, Mildred Bliss was better able to articulate the general atmosphere she desired for the institution. She wrote, "I know that what Dumbarton Oaks has to give—the work that it can do—can never be done in a big center—it must be small and quiet and unemphatic: a place for meditation and recueillement."[2] She famously reiterated this sentiment, albeit after the fact, in the 1966 preamble to her last will and testament, where she wrote: "Dumbarton Oaks is conceived in a new pattern, where quality and not number shall determine the choice of its scholars; it is the home of the Humanities, not a mere aggregation of books and objects of art."[3]

In 1941, the Administrative Committee at Dumbarton Oaks appointed Koehler as Senior Fellow in Charge of Research, a position he would hold until 1944. Koehler was a recognized authority on Carolingian manuscript illustration and had come to Harvard University in 1932 as the Kuno Franke Visiting Professor of German Art and Culture. When Harvard's medievalist art historian A. Kingsley Porter died in a drowning accident the following year, Koehler was chosen to replace him. As Senior Fellow in Charge of Research at Dumbarton Oaks, Koehler was tasked with developing the first academic program, a program that, at his instigation, was to be largely based on collaborative research.[4] Koehler's program, in fact, was quite similar to that used by the German Archaeological Institute at its various locations. Young scholars of promise, who typically had already completed their doctoral degrees, were to be awarded

Junior Fellowships for a period of up to three years.[5] During their fellowships, they were to devote half of their time to a collective research project and half of their time to their individual research. The collaborative project involved the gathering of data to demonstrate the formation and development of early Byzantine art. This was done in order to dispel what Koehler called the "arbitrary hypotheses" that he believed plagued Byzantine studies.[6] The focus of the research was to be on early Byzantine monumental structures *in situ,* including "all integral decorative accessories such as sculptures, mosaics, wall paintings, and pavements." To be excluded from this research was what Koehler termed the "'roving' material, consisting of the countless small works of art which, uprooted and homeless for many centuries, constitute the bulk of Byzantine material in our collections."[7] Koehler divided this work into two parts, which quickly came to be known as the "Fontes" and the "Research Archive." Those Junior Fellows who were historians and philologists would work on the "Fontes" and search out primary textual sources for passages relevant to early Byzantine buildings. The Junior Fellows who were archaeologists and art historians would review the existing publications on Byzantine monumental structures and compile critical dossiers. There was no thought of going to study the actual monuments, as this was the height of the Second World War and

1 Mildred and Robert Woods Bliss to the president and fellows of Harvard College, 2 July 1940. DOA, Blissiana Files, Gifts correspondence.

2 Mildred Barnes Bliss to Royall Tyler, 25 September 1939. HUA, Papers of Royall Tyler, HUGFP 38.6, box 6.

3 Preamble of the Last Will and Testament of Mildred B. Bliss, 31 August 1966. DOA, Blissiana Files, Bliss, Mildred Barnes, Last Will and Testament.

4 He detailed this program in his "Proposed Programme for Research at the Dumbarton Oaks Research Library and Collection," *Bulletin of the Fogg Museum of Art* 9, no. 4 (March 1941): 81–84, a special issue of the *Bulletin* devoted entirely to Dumbarton Oaks. See also D. H. Wright, "Wilhelm Koehler and the Original Plan for Research at Dumbarton Oaks," in *Pioneers of Byzantine Studies in America,* ed. J. W. Barker, *ByzF* 27 (Amsterdam, 2002): 134–75.

5 Koehler advocated a fairly constant rotation in the fellowship appointments. "We expect that eventually a certain regularity in the yearly turn-over of older Fellows into suitable positions elsewhere and their replacement by younger scholars will develop, which would provide at the same time for a continuous circulation of new blood." W. Koehler, "The Dumbarton Oaks Program and the Principle of Collaborative Research," *Speculum* 18, no. 1 (January 1943): 118.

6 Koehler, "Proposed Programme," 81.

7 Ibid., 82. Koehler believed that scholars had adequately catalogued the "roving" material. This included the Dumbarton Oaks Census of Early Christian and Byzantine Art in North American Collections, which contained more than 11,000 mounted black-and-white photographic prints of Byzantine small-scale objects. Koehler stressed that "only by relating the 'roving' to the monumental material will it be possible to make progress and to put Byzantine studies on a sound basis. But as the monumental material has never been systematically surveyed and organized, it is suggested that Dumbarton Oaks, which has made in the Census an outstanding contribution to the 'roving' material, should now undertake the study of monumental material."

travel was difficult, at best. The long-term goal of this collective research was to be the publication of an anthology of relevant primary sources and the establishment of a Research Archive for the benefit of future scholars working at Dumbarton Oaks. Koehler articulated his vision for this academic program in a paper titled "The Dumbarton Oaks Program and the Principle of Collaborative Research," which he read at a meeting of the College Art Association and then published in the journal *Speculum*.[8]

In explaining his program of collaborative research, Koehler faulted the typical research institute for exclusively fostering isolated scholarly investigation. In his opinion, this tradition had often failed due to the fact that no one scholar had the training or the resources to successfully investigate the complexities of large research topics. As Koehler put it, "too often the effort on the part of the scholar is out of all proportion to the result." Dumbarton Oaks, in his plan, would firmly depart from this well-established but ill-conceived tradition.[9] The collaborative research of scholars in residence over a considerable period of time would be the "cure" for this "unfortunate situation," to use Koehler's own words. Because, as Koehler stated, "to coordinate the research of a group of scholars who are living in different places [would] be a difficult and strenuous task, requiring much unselfishness, much tact, skill and patience on the part of the scholar who is in charge of the project."[10] By working together at Dumbarton Oaks, scholars could systematically match the

pertinent written sources to the monumental art of all early Byzantine provinces, and from this combined data, stylistic developments and chronologies could be established.[11] To do this, a collaborative team was needed. Koehler summarized the program by stating: "the research program of Dumbarton Oaks implies that the individual efforts of a group of scholars are directed towards a common goal of broad historical scope [which is] the clarification of the origins and of the development of early Byzantine art. That means that to a certain degree the individual scholar yields his independence in favor of collaboration with other scholars.[12] [Moreover,] the close contact between collaborators stimulates the efforts of the individual and provides the basis for constructive criticism on the one hand [and] for reciprocal advice and support on the other."[13]

Koehler's restriction of the initial collaborative research program to the early Byzantine period and to monumental structures and their decorations was done only for reasons of expediency. Koehler envisioned that the program would expand to include the middle and late Byzantine periods as well, and, perhaps more importantly, embrace "church history, economic history, the history of literature, etc." According to Koehler, only at Dumbarton Oaks, where its Fellows were chosen from the many branches of Byzantine studies, could this close collaboration among the various Byzantine disciplines be possible.[14] To illustrate this point, Koehler singled out the topic of the emergence of a new type of church architecture during the sixth century. Koehler believed that the contradictory theories about this Justinianic-period architecture could be settled by a close examination of other churches of the period, especially including their floor and wall decorations, and by a comparison of these buildings with the literary sources. "Only by collecting

8 Koehler, "Dumbarton Oaks Program," 118–23. Previous to this, Koehler had published two descriptions of the academic program at Dumbarton Oaks: Koehler, "Proposed Programme," 81–84, and "Dumbarton Oaks Research Library and Collection in Washington, DC," *College Art Journal* 1, no. 2 (January 1942): 34–36. For the Dumbarton Oaks Census, now housed in the Image Collections and Fieldwork Archives, see the finding aid, "Collection MS.BZ.014, Dumbarton Oaks Byzantine Census Project, ca. 1930s–1980s," *AtoM@DO*, accessed 28 January 2020, https://www.doaks.org/research/library-archives/inventories/ms-bz-014-object-census and the blog post by Jan Zastrow, "1938-2013; 75 Years of the Byzantine Object Census at Dumbarton Oaks," 6 September 2013, accessed 8 September 2019, at http://icfadumbarton oaks.wordpress.com/2013/09/06/1938-2013-75-year-of-the-byzantine-object-census-at-dumbarton-oaks.

9 Koehler, "Dumbarton Oaks Program," 118.

10 Ibid., 122.

11 Ibid., 119.

12 Ibid., 120.

13 Ibid., 121. Interestingly, in this period of the Second World War, Koehler equated the collaborative research model to the model of democracy: the functioning of the individual needed to be channeled to the greater need of society, which was a fundamental principle of democracy. Koehler, "Dumbarton Oaks Program," 122.

14 Ibid., 120.

and coordinating this material," Koehler argued, "will it be possible to elucidate the origins of the Justinianic style and thus lay the foundations for a future history of church architecture."[15] Furthermore, Koehler suggested that scholars engaged in the analysis and interpretation of this material will be led into other fields of Byzantine civilization in order to "correlate its development with the background of institutions, religious thought, liturgy, and social and economic development, and other aspects of eastern history, local and general." "For the interpretation, we will need cooperation between the historian of art, the specialists in social and economic history, the experts in the history of the Church and those interested in Geistesgeschichte and other related fields."[16]

Koehler's collaborative research plan at Dumbarton Oaks was not destined to endure, however. The catalyst for the change was the arrival at Dumbarton Oaks in 1943 of the Princeton University medieval art historian, Albert Mathias Friend, Jr.,[17] known as Bert Friend to his colleagues. Friend was appointed to the Dumbarton Oaks Board of Scholars,[18] and as a board member, he immediately began proposing alterations to the Dumbarton Oaks academic program. Foremost among his proposals was the recommendation that Dumbarton Oaks offer greater support to Byzantinists of recognized standing in the field and, most importantly, facilitate the publication of their research. Friend strongly felt that Dumbarton Oaks would only become a premier Byzantine studies center by making such prestigious appointments, preferably of long-term duration, and by allowing the appointed scholars to engage in research that would lead to groundbreaking symposia and publications. In making these recommendations, Friend was supported by his fellow board member George La Piana, who had been a Senior Research Fellow in residence at Dumbarton Oaks during the 1943–44 academic year. Both men believed that Junior Fellowship appointments should continue at Dumbarton Oaks, primarily in order to insure continuity in the fields of Byzantine studies.[19] However, they argued that Junior Fellowships should typically be limited to one-year terms and that only those who had shown great promise—Milton Anastos, Paul Alexander, and Ernst Kitzinger[20] were held up as examples—should be reappointed at the more senior rank of Senior Scholars.

In a letter written to Paul Sachs, the chairman of the Administrative Committee, Friend outlined his vision for Dumbarton Oaks.[21] With Friend's recommendations in hand, at their meeting of 30 April 1944, the Administrative Committee asserted that Koehler's "Fontes" and "Research Archive" project, although of value, could not be allowed to develop "at a rate which would handicap the whole conception of scholarly

15 Ibid., 82–83.

16 Ibid., 84.

17 Albert Mathias Friend, Jr. (1894–1956) was associated with both Dumbarton Oaks and Princeton University during the period 1943–54. At Princeton, he had been an undergraduate, beginning in 1911, and a graduate student, beginning in 1915, although because of the First World War he did not complete his doctoral work. Beginning in 1921, he was an instructor and, in 1946, a professor, succeeding Charles Rufus Morey as Marquand Professor of Art and Archaeology. At Dumbarton Oaks, he was appointed a member of the Board of Scholars in 1943, became the Resident Scholar in Charge of Research between 1944 and 1946, the Henri Focillon Visiting Scholar in Charge of Research in 1947–48, and the Director of Byzantine Studies between 1948 and 1954. Although Friend retained Princeton faculty status, he devoted much of his time to Dumbarton Oaks, which he helped develop into the premier Byzantine studies center in the United States. He strengthened the institution's ties with Harvard University, attained academic rank for the Senior Scholars while they were employed at Dumbarton Oaks, and he initiated distinguished spring symposia, usually bringing together the best scholars available.

18 The Board of Scholars was first organized on 17 August 1942 with 11 members, of which 7 were from Harvard; its membership was increased as follows, always with a majority of members from Harvard: 20 September 1943 (12 members), 16 May 1949 (13 members), 2 March 1953 (17 members), 1 May 1953 (18 members), and 6 May 1960 (22 members). In 1952, this board was renamed the Board for Scholars in Byzantine Studies. This board was abolished in 1975 and replaced by the Senior Fellows Committee.

19 Friend reiterated this in his letter to Paul J. Sachs of 7 November 1945: "I would keep the system of Junior Fellows much as it is at present but I would reduce the number, as I have had to this year, to three or four. We could then get the best young scholars who would profit by working at a higher level of efficiency than in the past. I don't think there are, at any one time, more than four or five in the country in the Byzantine field who would be worth having, yet in order to get new blood their presence is essential." DOA, Administrative Files, Administrative Committee, 1941–49.

20 Each of these men was appointed as a Fellow in 1945 and as an Assistant Professor in 1946.

21 Albert Mathias Friend, Jr., to Paul J. Sachs, 20 November 1944. DOA, Administrative Files, Administrative Committee, 1941–49.

activities at Dumbarton Oaks."[22] Moreover, they stressed that the continuation of the Research Archive was to be solely the responsibility of the two or three predoctoral Junior Fellows who were to be appointed for one-year fellowships. The Fellows (or Senior Scholars, as they were then called) were to be chosen from among established illustrious academics. These scholars were to have longer-term appointments and were to assist in the preparation of symposia, collaborate on joint publications, as well as pursue independently their own research projects with the expressed goal of publishing their work.[23] These decisions matched Friend's recommendations exactly. When Sachs informed Koehler of this proposed shift in the academic program and offered him the position of Senior Fellow in Charge of the Archives, Koehler replied, "You can count me out completely. I shall not play ball."[24] Koehler immediately relinquished his position as Senior Fellow and withdrew from the Board of Scholars.

As a consequence, the Administrative Committee appointed Friend the Senior Resident Scholar in Charge of Research for the 1944–45 academic year. The position was a long-term appointment, although Friend was to be in residence for approximately half of the academic year—the other half he would spend at Princeton as a faculty member in the Department of Art History and Archaeology. At Dumbarton Oaks, he was tasked with coordinating the scholarly activities of the institution, which now included the organization of the symposia.[25] Also appointed as Resident Scholars for the 1944–45 academic year were two noted Byzantinists, the historian Alexander Vasiliev and the art historian Sirarpie Der Nersessian. Their appointments

came with the understanding that these scholars would assist in the symposia and work independently on their own research projects.

Friend quickly set about implementing the changes he had proposed to the Administrative Committee. He stressed the role of Dumbarton Oaks as the premier publisher of research in Byzantine Studies. He also investigated the possibility that the Senior Scholars would have careers at Dumbarton Oaks with academic ranking at Harvard University. He argued, "No comprehensive or significant program of scholarship can be inaugurated or continued at Dumbarton Oaks until the method of appointments and tenure of the scholars has been put on a more permanent basis."[26] As for the research program, Friend made his ambitions very clear. He stressed that the earlier program of research at Dumbarton Oaks, which had brought about the formation of the Research Archive, "while excellent in itself, was not sufficiently creative to attract and hold for any length of time the more able scholars."[27] He insisted that the main business of these scholars was to engage in important studies of Byzantine civilization.[28] He argued that, for this, collaborative research was essential and noted that this had been and could continue to be well done at Dumbarton Oaks.[29] Indeed, he believed that the peculiar advantage of Dumbarton Oaks was that direct cooperation could be made possible between the various fields.[30] For unlike the traditional university department that was dedicated to a single discipline, Dumbarton Oaks

22 Minutes of the Administrative Committee, 30 April 1944. DOA, Administrative Files, Administrative Committee, 1941–49.

23 Milton Anastos would publish *The Alexandrian Origin of the Christian Topography of Cosmas Indicopleustes* (Cambridge, MA, 1946) and Friend would edit in 1946 the 4th volume of the *Dumbarton Oaks Papers,* which would appear in 1948. This volume had articles by Alexander Vasiliev, Peter Charanis, Milton Anastos, and Monica Wagner, all of whom had appointments at Dumbarton Oaks.

24 Minutes of the Administrative Committee, 30 April 1944.

25 Friend organized and directed the symposia of 1944, "Portraits and Biographies in Byzantine Manuscripts," and 1945, "The Decorations in the Synagogues of Dura-Europos."

26 Friend to Sachs, 7 November 1945.

27 Ibid.

28 In 1945, Friend proposed that Dumbarton Oaks publish a *History of Byzantine Civilization,* which was to be a definitive study and the great contribution of Dumbarton Oaks as a research institution. The text was to be coordinated from the resident Fellows' "many special studies and monographs" and would need to be an ongoing undertaking well into the future. Albert Mathias Friend, Jr., to Paul J. Sachs, 2 November 1946. DOA, Administrative Files, Administrative Committee, 1941–49.

29 Kurt Weitzmann would later restate Friend's achievement: "the integration of research in various aspects of Byzantine culture, including, besides the arts, history—represented by its doyen, A. A. Vasiliev—theology, literature, music, and other fields, [gives] to Dumbarton Oaks the character of a well rounded institute in the Byzantine field." Weitzmann, "Byzantine Art and Scholarship in America," *AJA* 51, no. 4 (October–December 1947): 414.

30 Friend to Sachs, 2 November 1946.

was "an institute where all the various fields of humanities can be studied in relation to one another in a continuing culture. It is a unique entity in the University system of departmental division by subjects."[31] Such interdisciplinary collaboration, Friend believed, would insure that the research program at Dumbarton Oaks would not dissipate into triviality "nor be done in the isolation that stultifies the specialist."[32]

In 1944, as the newly appointed Senior Scholar in Charge of Research, Friend somewhat surprisingly offered the Administrative Committee "the opportunity of publishing his forthcoming book on 'The Mosaics in the Church of Sion in Jerusalem and in the Church of the Holy Apostles in Constantinople.'"[33] Friend, apparently, had been working at Princeton with his students on reconstructions of these lost mosaic programs, and soon after he arrived at Dumbarton Oaks, he realized that the institution provided the opportunity to broaden this study by employing the expertise of the scholars in residence. He articulated this realization in an unpublished paper titled "Byzantine Studies at Dumbarton Oaks."[34] He wrote:

Two projects in cooperative research most recently inaugurated are in architecture. Started in war time, they have to do with churches which were so completely destroyed in the middle ages that the first hand investigation of the sites, impossible under present conditions, would play but a secondary part in their restoration. The churches are famous ones in Jerusalem and Constantinople. The one, the Church of Sion, the mother of all the churches, is the martyrion of the upper chamber of Pentecost. The other is the church of the Holy Apostles where were buried the Byzantine Emperors from Constantine on in order to be near the bodies of the Apostles Andrew, Luke and Timothy. These buildings can be restored only from their copies in architecture, from texts and literary descriptions and from the copies of their famous mosaics preserved in the miniatures of ancient manuscripts. I mention these two projects of research only to illustrate the necessity of a center for scholarly cooperation, such as Dumbarton Oaks. What is required for them is not only a knowledge of Art and Architecture but also expert and critical competence in the fields of history, theology and texts and literature—more than can be demanded of any one man.

The scholar in Art and Architecture in all periods of history has need of cooperation with those competent in other fields but this is particularly true in the Early Christian and Byzantine centuries when the *meaning* of works of art is so central to their artistic significance and when the remains of even the greatest monuments are so fragmentary, so few, and so confusing. Likewise, for similar reasons, the historian, the theologian and the liturgiologist have need of the Arts which can supply them with a synthesis and epitome at once visual and compelling so that the haze of centuries and the prejudices of a different civilization can be swept away by the immediate power of a great work of Art. The effect of Aya Sophia upon all beholders is only the greatest example of the peculiar presence that Byzantine art exerts even down to the smallest ivory or the tiniest enamel.

In essence, Friend was appropriating Koehler's collaborative research model and applying it to a more important topic suitable for a symposium and publication. Friend acknowledged this when he stated that the research methodology behind the Dumbarton Oaks symposium was "in no sense an improvisation but a rational evolution from what had been devised, under varying and difficult circumstances, by my learned predecessors." He further saw that his role in bringing this about was "not so much an innovation as an attempt to bring into focus what was inherent in Dumbarton Oaks."[35] In other

31 Friend to Sachs, 7 November 1945.

32 Ibid.

33 Minutes of the Administrative Committee, 26 November 1944. DOA, Administrative Files, Administrative Committee, 1941–49.

34 A. M. Friend, Jr., "Byzantine Studies at Dumbarton Oaks," unpublished. Read on 26 April 1947 at the Dumbarton Oaks symposium on "Byzantine Art and Scholarship." DOA, Byzantine Studies Files, 1947 Symposium.

35 Friend to Sachs, 2 November 1946.

words, with the symposium, Friend had taken Koehler's research program model and elevated it to a higher plane.

By 1945, all the scholars who would speak at the 1948 symposium were in residence, with the exception of Dvornik.[36] By 1946, all had received academic rankings at Dumbarton Oaks and Harvard University, except Friend, who had academic ranking at Princeton. Der Nersessian, who would be symposiarch, was Professor of Byzantine Art and Archaeology; Downey was Assistant Professor of Byzantine Literature; Underwood was Assistant Professor of Byzantine Architecture and Archaeology; and Anastos was Assistant Professor of Byzantine Theology. Dvornik, who would arrive in the spring term of 1948 as a Senior Scholar, would be named Professor of Byzantine History in 1949.[37] This coterie of distinguished scholars would spend much of their time working together to reconstruct the Holy Apostles church and to contextualize it in the broader history of Byzantine architecture.

Underwood and Downey, in particular, worked closely together on the architectural reconstruction of the Holy Apostles using literary sources and comparative architectural evidence.[38] They began this work during the 1945–46 academic year, and it continued unabated until the May symposium in 1948. Their interest was to articulate the church's plan, elevations, and mosaic programs. To this end, Downey worked on editions of the texts of Nicholas Mesarites and of Constantine the Rhodian, a study made possible by Dumbarton Oaks's acquisition of photographs of the relevant manuscripts. He then turned to the text of the Orations of Themistius to better understand the theory of kingship as it related to the church. The collaborative nature of their work is indicated by the subtitles given to several of Underwood's writings, such as "A Reconstruction of Architecture by Means of Texts" and "A Reconstruction from the Texts Controlled by the Comparison of Parallel Monuments."[39] Friend also assisted by providing Underwood and Downey with photographs of Byzantine manuscripts, mosaics, and wall paintings that might offer evidence for the wall and dome mosaic program of the Holy Apostles church.[40] They were joined in this project by Anastos, who began a study of the theological writings of the emperor Justinian, especially as they related to the Justinianic rebuilding of the church. Tellingly, Friend hoped to be able to devote more time to the study of the mosaics of the church.[41] However, in 1946–47 he was preoccupied with activities for the Princeton University bicentennial celebration. It was not until the early spring of 1948, after the arrival of Dvornik, that he could collaborate on a study of the relationship between the seventh ecumenical council and the theological program of the

36 In Paul Sachs's Report to the President for the academic year 1945–46, he wrote: "The program of research was again carried on under the direction of Albert M. Friend, Jr., Henri Focillon Scholar in Charge of Research. A more unified and satisfactory year of work and one moving definitely in the line of the permanent program of research was made possible by the addition to the staff of the new Fellows with riper scholarly equipment and more mature points of view. In the field of Art and Architecture the work on the restoration of the Church of the Holy Apostles in Constantinople was begun with the purpose of bringing it to a complete publication to include the restored plans, sections, mosaics as well as the editing and translation of all the relevant texts which throw light upon the famous church." P. Sachs, "Dumbarton Oaks," *Official Register of Harvard University: Issue Containing the Report of the President of Harvard College and Reports of Departments for 1945–46* 45, no. 12 (10 May 1948): 285.

37 Although Albert Friend remained Senior Scholar in Charge of Research and was, according to Paul Sachs, in frequent attendance, his attention and energies were temporarily focused elsewhere. This was due to the planning of a multilocation Byzantine Congress to be held in April 1947, in recognition of Princeton's bicentennial celebration. A conference on scholarship and research in the arts was held at Princeton; an exhibition of early Christian and Byzantine art was arranged by the Walters Art Gallery and held at the Baltimore Museum of Art; and the Dumbarton Oaks annual symposium was dedicated to Byzantine art and scholarship to complement the Princeton conference.

38 P. Sachs, "Dumbarton Oaks," *Official Register of Harvard University: Issue Containing the Report of the President of Harvard College and Reports of Departments for 1946–47* 46, no. 30 (1 December 1949): 336.

39 P. Underwood, "Justinian's Church of the Holy Apostles: A Reconstruction of Architecture by Means of Texts" (lecture delivered at Oberlin College, 15–16 October 1948); idem, "The Church of the Holy Apostles and Its Dependencies": A Reconstruction from the Texts Controlled by the Comparison of Parallel Monuments" (draft of publication volume), MS.BZ. 019-03-01-045 to 47, Underwood Papers ICFA.

40 MS.BZ.019-03-01-049, Underwood Papers ICFA.

41 "Minutes of the Meeting of the Board of Scholars of Dumbarton Oaks Held in Cambridge at Shady Hill, November 29, 1947." DOA, Byzantine Studies Files, Board of Scholars, 1943–59.

mosaics of the Holy Apostles church.[42] Sachs summarized this symposium activity with the statement, "these cooperative research activities have resulted in a closer correlation of texts, architecture and decoration than has previously been attained."[43] He later added: "The interplay between the various fields of history, theology and the arts has added greatly to all the individual studies with the saving of time and the gain in scholarly accuracy."[44]

After the symposium, work was to continue on the church of the Holy Apostles in order to bring out a definitive publication in three volumes, to be authored by Friend (mosaics), Underwood (architecture), and Downey (texts), respectively. The symposium papers were to "be revised and cross-referenced when it is finally put together,"[45] but the post-symposium work quickly began to dwindle. With hindsight, it is clear that the project was doomed and would not be realized. Der Nersessian, who had delivered two papers on the mosaics of Emperor Basil I in the Holy Apostles church and on ninth-century mosaic decoration in Constantinople, would not continue as an author in the proposed publication. Friend would be responsible for the mosaics. Friend, however, was notoriously slow in writing for publication[46] and, moreover, his health was beginning to decline. As late as

January 1954, Downey complained to Erwin Panofsky that Downey's "work on the Church of the Apostles begun eight years ago and finished five years ago, is still unpublished, because Bert Friend has never begun his part."[47] At the 30 April 1954 meeting of the Board of Scholars, it was reported, "Messrs. Friend and Underwood have indicated that, although they have not given up their intention of completing their parts of the study of the church of the Holy Apostles in Constantinople, they agree to the publication at this time of Mr. Downey's work on the literary texts. Mr. Downey's material has been brought up to date and is awaiting examination by the readers."[48] However, neither the Downey stand-alone volume nor the Friend and Underwood volumes would be published.

Equally important to the failure of the project, perhaps, was the fact that Underwood turned to new research projects that he was anxious to complete. Although he carried forth his work on the architecture of the Holy Apostles church by adding a study of the colored marbles, he also engaged in a study of the topography of Constantinople, made possible by the war's end and Europe's return to a degree of normalcy. Indeed, Underwood spent the autumn of 1949 making topological and archaeological investigations in Istanbul. After his return, he was consumed with reconstructing the architecture

42 P. Sachs, "Dumbarton Oaks," *Official Register of Harvard University: Issue Containing the Report of the President of Harvard College and Reports of Departments for 1948–49* 49, no. 10 (30 April 1952): 358.

43 P. Sachs, "Dumbarton Oaks," *Official Register of Harvard University: Issue Containing the Report of the President of Harvard College and Reports of Departments for 1947–48* 47, no. 12 (16 May 1950): 325.

44 Sachs, "Dumbarton Oaks" (30 April 1952): 358.

45 Albert Mathias Friend, Jr., to the Dumbarton Oaks Administrative Committee, 30 April 1950. DOA, Administrative Files, Administrative Committee, 1950–59.

46 Friend, himself, acknowledged his tardiness as an author. The minutes of the 6 December 1948 meeting of the Board of Scholars states, "Professor Friend hopes that in the second semester of this year his work on the Church of the Holy Apostles will proceed more rapidly." DOA, Byzantine Studies Files, Board of Scholars, 1943–59. In a letter of recommendation for Downey to the Dumbarton Oaks Administrative Committee dated 30 April 1950, Friend wrote, "His [Downey's] major job during his tenure in Dumbarton Oaks has been the collection, edition and translation of all the surviving texts about the Church of the Holy Apostles in Constantinople. This major work awaits publication until the Director [Albert Mathias Friend] has finished his volume on the Mosaics."

47 Glanville Downey to Erwin Panofsky, 13 January 1954. Panofsky Papers, box 3, reel 2111. In another letter to Panofsky, dated 23 January 1954, in the same collection, Downey wrote: "An effort will be made at the meeting of the D.O. Board of Scholars early next month to clear the way for separate publication of my material on the Church of the Apostles but I do not know how much success this may have. It will be a weary business revising a MS eight years old, but I will not just give up interest in it, as poor Rosalie Green has done in the case of her work on Zion Church, which is a parallel though of even longer standing." For unknown reasons, Dumbarton Oaks did not publish Downey's manuscript on the texts related to the church of the Holy Apostles. In 1957, he published the Nicholas Mesarites material: "Nikolaos Mesarites: Description of the Church of the Holy Apostles at Constantinople, Greek Text Edited with Translation, Commentary, and Introduction," in *TAPS*, n.s. 47, no. 6 (1957): 855–924. On page 855, he wrote: "The present edition was undertaken at Dumbarton Oaks in 1945 as a part of the collaborative monograph on the Church of the Holy Apostles at Constantinople which was planned by Professor A. M. Friend, Jr., Director of Studies at Dumbarton Oaks."

48 Minutes of the Board of Scholars, 30 April 1954. DOA, Byzantine Studies Files, Board of Scholars, 1943–59.

of the Sacred Palace, particularly that of the Daphne Palace of Constantine, work that would lead to his participation in the symposium of 1950, "The Emperor and the Palace," under the direction of André Grabar. In 1951, Underwood would physically leave Dumbarton Oaks when he was appointed field director of the Byzantine Institute in Istanbul, after the death of the Institute's founder and director, Thomas Whittemore. In Istanbul he would work directly on the conservation and restoration of Hagia Sophia and the Kariye Camii and would publish several reports in the *Dumbarton Oaks Papers* on the Institute's work at these sites.

The institution itself was also turning to new initiatives at the end of its first decade of operation. At the early 1949 meeting of the Administrative Committee, Robert Bliss expressed his and Mildred Bliss's "satisfaction and gratitude for the remarkable development that had taken place at Dumbarton Oaks, and for the distinction of the [Holy Apostles] Symposium."[49] But Bliss then turned quickly to the new topic of the Dumbarton Oaks gardens and the Blisses' strong desire that a constructive and scholarly use be made of them, including the establishment of a garden fellowship and an advisory board. Individual research projects and new initiatives were now beginning to supplant the collaborative research model at Dumbarton Oaks. Friend, however, initially remained steadfast. He championed two new projects: Ernst Kitzinger's study of the Byzantine mosaics in Sicily and Otto Demus's study of the Byzantine mosaics in Venice, because they would serve the topic of the 1949 symposium, "The Relations between Byzantium and Its Neighbours," which was under the direction of Robert Blake of Harvard University. Friend would not present a paper at this symposium but gave opening remarks, and the symposium would not be completely a collaborative effort. It did involve all the resident scholarly staff: Vasiliev, Der Nersessian, Grabar, Dvornik, Kitzinger, and Demus, who had been appointed a Visiting Scholar for reasons of the symposium. Blake, however, was not in residence at Dumbarton Oaks and directed preparations from his office in Cambridge. In recognition of this, at its meeting of 11 February 1949, the Administrative Committee decided that it should no longer be the policy of Dumbarton Oaks to invite scholars to join the academic staff purely for the purpose of organizing a symposium.[50]

That the results of the collaborative work on the church of the Holy Apostles went unpublished as a monograph signaled the end of the collaborative research model at Dumbarton Oaks. Friend himself had stated that "all research that is worth while should eventuate in publication. When this is realized by all concerned, the trivial and the isolated types of work which have plagued the humanities are not likely to waste the energies of scholars and the funds of Dumbarton Oaks."[51] And, indeed, unpublished, the results of the scholarship on the church of the Holy Apostles dissipated along with an appreciation for the collaborative research that had brought them about.

49 Minutes of the Administrative Committee, 11 February 1949. DOA, Administrative Files, Administrative Committee, 1941–49.

50 Minutes of the Administrative Committee, 11 February 1949.

51 Friend to Sachs, 7 November 1945.

The Holy Apostles in Constantinople and Washington, DC

The Projects of Albert Mathias Friend, Jr., and Paul Underwood

ROBERT S. NELSON

I N ATTENDANCE AT THE DUMBARTON OAKS SYMPOSIUM ON THE CHURCH of the Holy Apostles in 1948 was Thomas Whittemore (1871–1950), briefly professor of English at Tufts and art history at New York University, Coptic archaeologist, and Russian relief worker, but most famous as the restorer of the mosaics of Hagia Sophia.[1] It was not his first involvement with the new research institute. Whittemore had contributed a paper to the 1946 symposium on Hagia Sophia that Albert Mathias Friend, Jr., the Director of Studies at Dumbarton Oaks, had read in Whittemore's absence. The participants at the earlier symposium were photographed in front of the unique copy of the Imperial Door Mosaic from Hagia Sophia that Whittemore and his staff had created for the most generous patrons of the Byzantine Institute Inc. of America (fig. 3.1), the organization that Whittemore established and which funded his projects.[2] Among its sponsors were Robert and Mildred Bliss, the founders of Dumbarton Oaks. Whittemore had missed the 1946 Symposium, presumably because that year the Byzantine Institute had resumed its work at Hagia Sophia after the war. He came to the symposium on the Holy Apostles two years later not to give a paper but for other pragmatic reasons.

That previous February, he had attended the installation ceremony at a Chicago church for another mosaic copy from Hagia Sophia, the tympanum depiction of John Chrysostom to whom the American church was dedicated. The image defined a small chapel dedicated to the memory of a member of the Crane family, who had long supported the Byzantine Institute.[3] The event was a symptom of a larger problem that Whittemore faced for, like many of his patrons, he was aging, and the number of his private supporters was decreasing. Consequently, on 23 March 1948, he applied for a grant from Dumbarton Oaks to fund his work at Hagia Sophia. His application was granted on 20 April, two days before the Holy Apostles symposium.[4] Later that year, Whittemore produced a joyously optimistic, if not Panglossian, report that appeared in *Renaissance News* in the fall of 1948. The Turkish government had asked the Byzantine Institute to restore the churches of Sergius and Bacchus and the Chora in

1 On Whittemore generally, see R. S. Nelson, *Hagia Sophia, 1850–1950: Holy Wisdom Modern Monument* (Chicago, 2004), 155–86. The list of those attending the symposium is to be found in MS.BYZ.019-03-01-050, Underwood Papers ICFA; and see below Appendix I.

2 Dumbarton Oaks no longer possesses this reproduction of the Imperial Door mosaic. Its whereabouts are not known.

3 Nelson, *Hagia Sophia,* 184–85.

4 MS.BZ.004.01-01-02-104, Byzantine Institute Records ICFA.

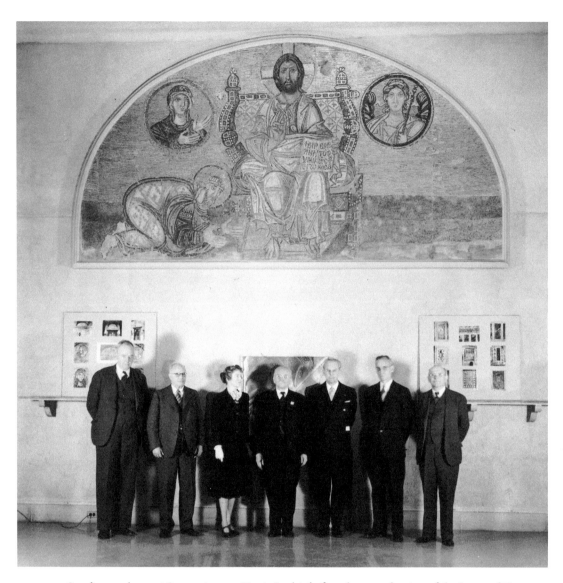

FIG. 3.1. Speakers at the 1946 Symposium on Hagia Sophia before the reproduction of the Imperial Door Mosaic. HUA, Bliss Papers, HUG (FP) 76.4p, series VII, box 9.

Istanbul. Whittemore reported that the Institute was also planning to work on the church of the Pammakaristos, and he continued:

> Just before my departure from America [and thus just after the Symposium] on May 2 to resume my work in Istanbul, I was requested by the Turkish Government in Ankara to assume the task of uncovering and conserving the mosaics of the Church of Saint Irene, just beyond Haghia Sophia toward Seraglio the Great in the sixth century. . . . it is probable that the plaster covering of its walls conceals mosaics. . . . At the present time [June 1948]

> there is also available for archaeological exploration a great area laid off by Henri Prost, official city planner of Istanbul, which he has termed the "Archaeological Park" which includes Seraglio Point and the area bounded by Haghia Sophia, the Hippodrome, the sea and Little Aya Sofya [the church of Sergius and Bacchus] Time is of the essence, for the area cannot be preserved indefinitely, and in the absence of active prosecution of the effort, buildings will again begin to appear. . . . The Institute . . . desires to render all possible service and to share the responsibility and the opportunity with some other

competent institutions by making an affiliated co-sponsorship for excavations during the period from 1948 to 1952.[5]

Except for the cross in the apse, no other mosaics were found at Hagia Eirene, and, unfortunately, neither Dumbarton Oaks nor any other institution took up Whittemore's challenge to excavate the area of the Great Palace that today has become a warren of tourist hotels, restaurants, and rug shops. Whittemore died in June 1950 and the following December, Henri Prost, the Frenchman in charge of the urban plan of Istanbul and someone long sympathetic to Byzantine antiquities, resigned his post.[6] The moment that Whittemore described did indeed pass. As James Carder recounts in his essay, Dumbarton Oaks picked up some of the work of the Byzantine Institute, especially the projects at the Chora and the Pammakaristos, but the new Institute came late to the party, and its commitment to field work in Istanbul would not be as long lasting as Whittemore's.[7]

Instead, in its early years, Dumbarton Oaks focused on other types of projects that this and other papers on the Holy Apostles are exploring. Thomas Whittemore represented an older style of archaeology, one conducted by men—a word deliberately chosen—who had more experience in the field than academic qualifications, who spent their careers excavating or restoring rather than teaching, and pursued fundraising instead of publishing. Knowing the well connected and the wealthy was more important than peer review and tenure. Although still mainly gendered male, the 1948 Symposium was American archaeology of the new school. The subject, the Holy Apostles, was highly academic, for the building was no longer extant, hence a good topic for professors, who

had little or no field experience, and for scholars based in Washington and far removed from the lands of the Byzantine Empire. Their efforts had much in common with the creation of medieval revival architecture and its decoration, a fashion that modernism supplanted and a subject introduced at this end of the article.[8]

In comparison to Whittemore, the six speakers at the 1948 symposium were well credentialed in the academy (see introduction, fig. 1.1).[9] Albert Mathias Friend, Jr., (1894–1956), or Bert as his friends called him, and Sirarpie Der Nersessian (1896–1989) had long taught art history at Princeton and Wellesley, respectively. Der Nersessian was then one of America's most distinguished medievalists, having studied with Gabriel Millet in Paris, as well as a pioneering female scholar and professor.[10] She presided over the 1948 symposium that Friend had organized.[11] Armchair art historians, who had never conducted an excavation or restoration, Der Nersessian and Friend were contemporaries and belonged to a generation younger than Whittemore. Trained as a medievalist, Friend lectured at Princeton on many areas of the history of art, including modern art. One of his most popular courses was Northern Renaissance art. He also gave specialized seminars on medieval art.[12] Father Francis Dvornik (1893–1975) had been a professor of theology at Charles University before World War II. The Dumbarton Oaks Assistant Professors, Glanville Downey (1908–1991), Paul Underwood (1902–1968), and Milton Anastos (1909–1997),

5 T. Whittemore, "Report of the Byzantine Institute," *Renaissance News* 1, no. 3 (1948): 53.

6 On Prost's resignation, see F. C. Bilsel, "Henri Prost's Planning Works in Istanbul (1936–1951): Transforming the Structure of a City through Master Plans and Urban Operations," in *From the Imperial Capital to the Republican Modern City: Henri Prost's Planning of Istanbul (1936–1951)*, ed. F. C. Bilsel and P. Pinon (Istanbul, 2010), 149–50. For Prost's ideas about the area south of the Hippodrome, see P. Pinon, "The Archaeological Park," in ibid., 289–302.

7 G. Constable, "Dumbarton Oaks and Byzantine Field Work," *DOP* 37 (1983): 171–76.

8 On medieval revival architecture and its modernist demise in the years after World War II, see my article "The Byzantine Synagogue of Alfred Alschuler," *Images: A Journal of Jewish Art and Visual Culture* 11, no. 1 (2018): 5–42.

9 The symposium program is in Underwood Papers ICFA, MS.BZ.019-03-01-050. See above fig. 1.6.

10 J. S. Allen, "Sirarpie Der Nersessian (b. 1896): Educator and Scholar in Byzantine and Armenian Art," in *Women as Interpreters of the Visual Arts, 1820–1979*, ed. C. Richter Sherman and A. M. Holcomb (Westport, CT, 1981), 329–56; J. Allen, N. Garsoian, I. Ševčenko, and R. W. Thomson, "Sirarpie Der Nersessian: 1896–1989," *DOP* 43 (1989): viii–xi.

11 DOA, "The 1948 Symposium of the Church of the Holy Apostles," 75th Anniversary blog, 15 June 2017, accessed 21 April 2018, http://www.doaks.org/research/library-archives /dumbarton-oaks-archives/historical-records/75th-anniversary /blog/the-1948-symposium-on-the-church-of-the-holy-apostles.

12 His lecture notes are preserved in the Friend papers at Princeton.

were beginning their research careers, although Underwood was older, having previously worked as an architect and having taught at Cornell before World War II.

The Holy Apostles project provided ample room for the philological, theological, and historical interests of its speakers, but at its core, the topic was art historical and concerned the reconstruction of the architecture and mosaic decoration of the church, the responsibilities of Underwood, Friend, and Der Nersessian. Accordingly, each gave two papers at the symposium. In our reexamination of the Holy Apostles project, others are concerned with the architecture of the church. For my part I will look more closely at the treatment of its decoration and especially the work, or lack thereof, of Friend, the intellectual leader of the project, but also the man primarily responsible for its demise due to his failure to produce his sections of the projected monograph, as James Carder has recounted. Nonetheless, the Holy Apostles project had an unanticipated impact on the decoration of the Greek Orthodox church of St. Sophia in Washington, a matter reserved for the end of this paper.

Bert Friend took all his degrees at Princeton. He graduated with a B.A. in 1915 and remained at Princeton for graduate studies in art history that were interrupted by service in World War I. After the war, he began teaching at Princeton with his master's degree (Princeton 1917) and never completed the PhD. His initial research and teaching concerned early medieval manuscripts, including Carolingian illumination. In 1927 and 1929, his extensively illustrated two-part study of evangelist portraits appeared in *Art Studies,* a journal published by the then principal departments of art history in America, Princeton and Harvard. In these articles, Friend classified the earliest portraits in Greek manuscripts into two types, standing and seated evangelists. He postulated that these types were linked with the major cities of the Hellenistic world, ancient Alexandria and Ephesos, and proposed that other series were associated with Antioch and Rome.[13] Evangelists initially posed, Friend argued, in front of the backdrops of ancient theaters.[14] Collecting sketches of theatrical set designs would become a lifelong interest of his.[15]

The method apparent in these articles differs from that of most historical studies. Instead of working inductively and building an argument from specific examples that leads to an empirically based hypothesis, Friend proceeded deductively, working from the top down not the bottom up. He first asserted that there were two types of portraits, seated and standing, and then associated their origins with two cities. Because standing evangelists were better suited for the narrow columns of papyrus scrolls, they must have originated in Alexandria, since papyrus predominates in Egypt.[16] As poses of seated evangelists resemble figures on "Asiatic" sarcophagi, those representations must have originated in a coastal city of Asia Minor, of which Ephesos is the major example.[17] As in a syllogism, if the premises of the argument are accepted—for example, the two main types of portraits and the principal cities of the ancient world—then the conclusions follow and apply to all examples, in this case, all Greek evangelist portraits. This is the basic difference between deductive and inductive reasoning. The former explains all cases. The latter is an argument of probability, changes with new evidence, and does not pertain to all data.[18] Although most scientific research works back and forth between the deductive and the inductive, or between hypothesis formulation and evidence gathering,[19]

13 A. M. Friend, Jr., "The Portraits of the Evangelists in Greek and Latin Manuscripts, Part I," *Art Studies* 7 (1927): 115–47.

14 A. M. Friend, Jr., "The Portraits of the Evangelists in Greek and Latin Manuscripts, Part II," *Art Studies* 9 (1929): 3–28.

15 Friend donated his collection of 18th-century set designs to the Princeton library, Rare Books and Special Collections, Theatre Collection, Albert Mathias Friend Collection, accessed 5 November 2015, http://princeton-primo.hosted .exlibrisgroup.com/primo_library/libweb/action/dlDisplay .do?institution=PRN&vid=PRINCETON&docId=PRN _VOYAGER2252289.

16 Friend, "Portraits I," 131–32.

17 Ibid., 140–46.

18 On deductive and inductive reasoning, see "Thought," *Encyclopaedia Britannica. Britannica Academic.* Encyclopaedia Britannica Inc., 2015: http://academic.eb.com/EBchecked/ topic/593468/thought, accessed 5 November 2015; and the chapters on these topics by S. A. Sloman and D. A. Lagnado and by J. St. B. T. Evans, respectively, in *The Cambridge Handbook of Thinking and Reasoning* (New York, 2005), ed. K. J. Holyoak and R. G. Morrison, 95–116, 169–84.

19 D. F. Halpern, *Thought and Knowledge: An Introduction to Critical Thinking* (Hillsdale, NJ, 1984), 95–96.

the deductive dominated Friend's work to a greater extent than that of other scholars.

Three years before the appearance of Friend's first article on evangelist portraits, his mentor Charles Rufus Morey published an article in *The Art Bulletin* titled "The Sources of Mediaeval Style." There Morey grappled with the major theories of late antique art promulgated by Josef Strzygowksi, Alois Riegl, and Franz Wickhoff.[20] Morey made a mélange of all three, grafting the formalism of Wickhoff and Riegl onto the regionalism of Strzygowski, while thankfully dropping the latter's racial overtones. The centers of Hellenistic style, Morey declared, were Ephesos and Alexandria. Ephesos inherited the Neo-Attic style, mixing it with the Asiatic to form the abstract component of Byzantine art. By different formal means, artists in Alexandria created the illusionism that Morey regarded as the second source for Byzantine art. Finally, he classified manuscripts according to these two stylistic currents. Once more, the method was deductive or top down.

Other Princeton students and professors subscribed to Morey's theories of medieval art.[21] Friend's notion that Greek evangelist portraits originated in Ephesos and Alexandria followed Morey's paradigm, and both Morey and Friend sought to define the sources of medieval art. After the death of Morey (1955) and Friend (1956), Ernst Kitzinger overturned their theories about the dating and provenance of early Byzantine art. The occasion was Kitzinger's celebrated paper for the 1958 Munich International Congress of Byzantine Studies.[22] Kitzinger was one of the young scholars at Dumbarton Oaks, whose career Friend ironically fostered. In his Munich report, Kitzinger worked inductively and from a broad empirical basis to general conclusions. Even the article's title, "Byzantine Art in the Period between Justinian and Iconoclasm," is more neutral and descriptive than the predictive or deductive genealogy of Morey's *Art Bulletin* article, "The Sources of Mediaeval Style," published a quarter century earlier.

While Friend was constructing ancient prototypes for medieval evangelist portraits in the 1920s, he also designed the iconographic program of Princeton's new University Chapel (fig. 3.2), an experience relevant for the Holy Apostles project. The previous Marquand Chapel, a massive Romanesque revival building, erected in 1882 by Richard Morris Hunt, had burned down in 1920. Ralph Adams Cram, Princeton's Chief Architect, designed the replacement in the Gothic style (fig. 3.2). Friend, then an Assistant Professor of medieval art and Curator of medieval art in the Princeton Museum, devised the subject matter of the chapel's sculpture and stained glass (figs. 3.3, 3.5), and continued working on the program some years after the building's dedication in 1928.[23]

For the principal tympanum of the west façade of this English Gothic church (fig. 3.3), Friend designed a slight variation on the central tympanum of the west façade of Chartres cathedral in France (fig. 3.4).[24] The principle at work here had been standard in medieval revival architecture from the nineteenth century: an appropriate medieval model was identified, copied, and adapted for a modern building. Cram and his firm followed this procedure for his campus architecture. He built in the Gothic style for universities in the northern part of the United States, such as Princeton or West Point, but he

20 On the first two with reference to the third, see J. Elsner, "The Birth of Late Antiquity: Riegl and Strzygowski in 1901," *AH* 25 (2002): 358–79.

21 E.g., Morey's student and later Princeton colleague E. B. Smith, "The Alexandrian Origin of the Chair of Maximianus," *AJA* 21 (1917): 22–37.

22 E. Kitzinger, "Byzantine Art in the Period between Justinian and Iconoclasm," in *Berichte zum XI. Internationalen Byzantinisten-Kongress München 1958* (Munich, 1958), 10, 24, 37–38. The refutation is discreetly buried in the footnotes. For Kitzinger's scholarship more generally, now see *Ernst Kitzinger and the Making of Medieval Art History*, ed. F. Harley-McGowan and H. Maguire (London, 2017).

23 The chapel was officially dedicated on 13 May 1928. Friend was still planning the program of the clerestory windows in 1937. Office of the Dean of Religious Life and the Chapel Records, 1906–81 (AC144), Princeton University Archives, Department of Rare Books and Special Collections, Princeton University Library, box 10. The American journal for the building trades, *Architecture* (58 [1928]: 257–66, 347–54) devoted extensive photographic coverage of the exterior and interior of the new chapel and also published Cram & Ferguson's working drawings for the project: ibid., 371–85.

24 M. J. Milliner, "*Primus inter pares*: Albert M. Friend and the Argument of the Princeton University Chapel," *The Princeton University Library Chronicle* 70, no. 3 (2009): 483.

adopted the Italo-Byzantine style for the campus of Rice University in much warmer Houston.[25]

Friend prepared sketches of the stained glass windows of Princeton Chapel to be sent to the various donors and university authorities, and then worked to satisfy their sometimes conflicting concerns.[26] For the window at the end of the east chapel (fig. 3.5), he prepared a sketch of the

basic components of the large stained-glass window on the lined notebook paper that he used for his class notes (fig. 3.6). The great east window was to have a small rose window at the top of the Resurrection with smaller windows at the sides. Below, in the narrow lancets, would be the Crucifixion with the two thieves on their crosses at the sides, and underneath the Last Supper. He also specified the biblical inscriptions on the window. The actual window departs somewhat from the initial idea (fig. 3.5). The Crucifixion has been moved up into the central rose window;

25 D. Shand-Tucci, *Ralph Adams Cram: Life and Architecture*, vol. 2 (Amherst, MA, 2005): 110–15.

26 Milliner, "*Primus inter pares*," 500–509.

FIG. 3.3. Princeton University Chapel, tympanum, west entrance (photo by author, 2015)

FIG. 3.4. Chartres Cathedral, west façade, central tympanum (photo by author, 2007)

the Last Supper remains at the bottom on the window; and in between stand three figures—in the middle, Jesus crucified with his wounds visible, and Mary and John the Evangelist at the left and right, respectively. Beneath them is the inscription that Friend had originally planned to accompany the Crucifixion: "Greater love hath no man than this, that a man lay down his life for his friends" (John 15:13), a verse that may have

had a special resonance at the time for Friend and other military veterans at the then all male university. The common theme of the windows' iconography and inscriptions is love.[27]

He devised a comprehensive program for all the windows of the chapel. The north windows were devoted to the life of Jesus, the south

27 Milliner, "*Primus inter pares*," 498.

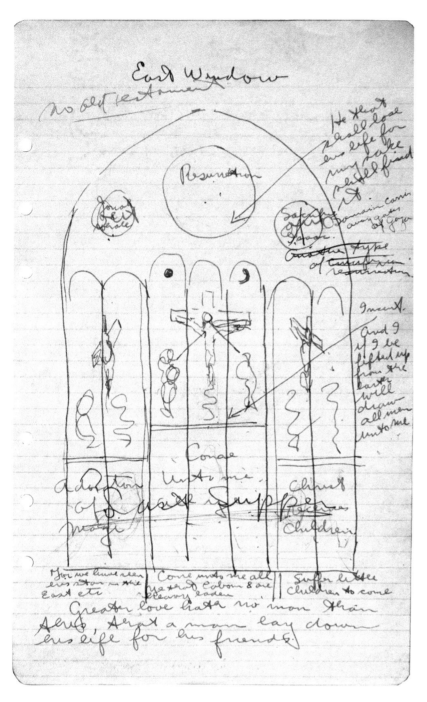

FIG. 3.6.
Albert Mathias Friend, Jr., drawing of east window, Princeton University Chapel. Office of the Dean of Religious Life and the Chapel Records 1906–1981 (ac144), Princeton University Archives, Department of Rare Books and Special Collections, Princeton University Library.

to his teaching, and the four great windows in the north and south transepts and the east and west ends to other topics.[28] Each individual window played its part in the overall scheme. Once more, the chapel demonstrates deductive,

top-down reasoning that befits a unified iconographic program.

Friend also created the Manuscript Room at Princeton, a space consisting of a library and photograph collection for the study of manuscript illumination. It later would be identified with Kurt Weitzmann (1904–1993), who although only ten years younger than Friend outlived him by nearly forty years. Weitzmann

28 A. M. Friend, Jr., "The Sculpture and Glass of the Chapel," *The Princeton Alumni Weekly* (25 May 1928): 991–93.

left Germany for Princeton in 1935 and initially worked on a project that Friend sponsored to publish the manuscripts of the Septuagint. In his memoir, Weitzmann referred to his colleague as his "closest friend in America."[29] Weitzmann's photographs from his expeditions to Mt. Athos became important resources of what was called "the cage," the locked section of photographs of book illumination in the Manuscript Room. Those images would later become important sources for Friend's Holy Apostles reconstruction. As Weitzmann described, he and Friend would work in the Manuscript Room until midnight, then adjourn to Friend's house for drinks and talk a couple of hours more.[30] Weitzmann does not mention when either reported to work the next morning, although Weitzmann at least was renowned for his prodigious work habits as evinced in the scores of articles and books that he published. In contrast, Friend's oeuvre was meager in the extreme. He never published the subsequent study on medieval Greek evangelist portraits announced in his second article in *Art Studies*.[31]

Subsequently, his interests shifted from manuscript illumination to monumental painting in some fashion difficult to detect from his published writings or his other papers archived at Princeton. The new endeavor apparently began about 1940. In 1944, when he proposed to the Administrative Committee of Dumbarton Oaks a book on the church of Sion in Jerusalem and the Holy Apostles, he mentioned that the projects "started in war time" with his Princeton students.[32] The change of direction in Friend's

work was one of medium not method, because he continued to seek lost masterpieces, now great churches of Constantinople and Jerusalem instead of Byzantine evangelist portraits. The Holy Apostles project was one aspect of Friend's broader involvement in reconstructing lost programs. These interests governed his initial plans for the Dumbarton Oaks symposia after his appointment as Senior Resident Scholar in Charge of Research for 1944–45.[33] In the spring of that academic year, he served as symposiarch for "The Decorations in the Synagogues of Dura-Europos." During the three-day event, there were only two speakers, Friend's Princeton colleague Weitzmann and Carl Kraeling, a professor at the Yale Divinity School. Weitzmann gave three lectures, and Kraeling, four. Their focus was the relationship of Jewish and Christian illustration. As would become traditional, the symposiarch gave the concluding remarks.[34]

The next year saw the symposium on Hagia Sophia with Alexander Vasiliev as symposiarch. At the Hagia Sophia Symposium, Friend delivered two papers on "The Mosaics of Basil I in Hagia Sophia," both preserved at Princeton.[35] As usual, neither was published. The first, a review of the literature on the mosaic over the Imperial Door, connected its iconography with mosaics known from texts in the now-destroyed Chrysotriklinos in the Imperial Palace. More original was the second lecture about the mosaics in the central area of the church, "the dome, the pendentives, the tympana, and the great arches."[36] His analysis of the tympana had none of the iconographic or stylistic depth of the later article by Cyril Mango and Ernest Hawkins,[37] but that is historiography by hindsight. His was an initial attempt to treat the program of these

29 K. Weitzmann, *Sailing with Byzantium from Europe to America: The Memoirs of an Art Historian* (Munich, 1994), 107.

30 Weitzmann, *Sailing*, 106.

31 Friend, "Portraits II," 29.

32 See the article of James Carder in this volume, "The 1948 Holy Apostles Symposium and Collaborative Research at Dumbarton Oaks." An example of this student work is an essay among Friend's papers titled "The Mosaic Decoration of the North Transept of the Church of the Holy Apostles, Constantinople," in a folder labeled "Schnorrenberg." Friend Papers, carton 7. This is a paper written in the last seminar that Friend gave just before his death, according to its author, Prof. John Martin Schnorrenberg, Princeton PhD 1964, phone conversation, 13 November 2015. Friend was noticeably ill that semester, and the seminar met only two or three times before it was suspended due to Friend's ill health and subsequent death. Friend was engaged with the Holy Apostles until the end of his life.

33 See Carder, "1948 Holy Apostles Symposium."

34 K. Weitzmann and H. L. Kessler, *The Frescoes of the Dura Synagogue and Christian Art* (Washington, DC, 1990), 3; C. H. Kraeling, *The Synagogue* (repr. New Haven, 1979), 1. I thank James Carder for sending me the program for the 1945 Symposium.

35 Friend Papers, carton 4.

36 "Mosaics of Basil I in Hagia Sophia II," Friend Papers, carton 4.

37 C. Mango and E. J. W. Hawkins, "The Mosaics of St. Sophia at Istanbul: The Church Fathers in the North Tympanum," *DOP* 26 (1972): 1–41.

spaces as a whole, an effort that continues.[38] Friend reconstructed the missing prophets on the north and south tympana by means of the standing prophets in the Vatican manuscript Chigi R. VIII 54.[39] For Friend's symposium lecture, Underwood presumably made the finished drawings of the tympana and the dome, which are among the papers of Paul Underwood at Dumbarton Oaks.[40] Friend understood the general program of the dome, pendentives, and surrounding spaces at Hagia Sophia to have been based upon an earlier monument: "it will become apparent that this scheme was not invented for the Great Church but was adapted for it from an example, now lost to us, which was more beautiful and consistent in its pictorial splendor than Hagia Sophia, because of the ribbing of its dome, could ever be."[41]

The superior model was the Nea Ekklesia in the Imperial Palace.[42] Friend drew a sketch of that church's decorated dome in the same style and on notebook paper similar to that he had used for his sketches of the windows of the Princeton chapel two decades earlier (fig. 3.7). Friend assumed that the tenth homily of Patriarch Photios referred to the Nea church. Some years later, Mango, whom Friend would set to work on these homilies because of their relation to monumental art in Constantinople, changed that interpretation in his translation of the homilies that appeared in 1958 two years after Friend's death. There Mango persuasively argued that the tenth homily referred instead to the

Pharos Chapel in the palace,[43] but in the 1940s, the scholarly world still agreed that the tenth homily concerned the Nea Ekklesia patronized by Emperor Basil I. Its dome with Christ surrounded by angels, Friend thought, was recorded in the upper part of a frontispiece in the homilies of Gregory of Nazianzos in Paris, BnF gr. 510, a manuscript made for Emperor Basil I (fig. 3.8).[44] Indeed, the composition has an enthroned figure of Christ blessing and holding a closed book and seated on a lyre-backed throne of the type found on imperial coins. Cherubim and seraphim curve around the throne, and four archangels holding lances stand guard at the bottom. The medallion framing the enthroned Christ and the partially encircling angelic beings posed against bands of different colors do suggest a domical composition, a conclusion reached by other art historians,[45] but whether the illuminator copied an actual church or only wished to make reference to ecclesiastical decoration cannot be resolved. Friend never gave the matter a second thought, however. He was convinced that the miniatures provided evidence of lost monumental painting. This particular miniature was carefully studied by the Dumbarton Oaks team, for

38 Cyril Mango assembled the evidence for an interpretation in his *Materials for the Study of the Mosaics of St. Sophia at Istanbul* (Washington, DC, 1962) but made only minimal remarks about the general post-Iconoclastic program (p. 98), and Robin Cormack, in his useful general article "Interpreting the Mosaics of S. Sophia at Istanbul," *AH* 4 (1981): 131–49, focused on other issues. Most recently, Natalia B. Teteriatnikov has studied the Justinianic mosaics in her book *Justinianic Mosaics of Hagia Sophia and Their Aftermath* (Washington, DC, 2017).

39 J. Lowden, *Illuminated Prophet Books: A Study of Byzantine Manuscripts of the Major and Minor Prophets* (University Park, PA, 1988), 9–14.

40 Underwood Papers ICFA, MS.BZ.019-03-01-054.

41 "Mosaics of Basil I in Hagia Sophia II," Friend Papers, carton 4.

42 P. Magdalino, "Observations on the Nea Ekklesia of Basil I," *JÖB* 37 (1987): 51–64.

43 C. Mango, *The Homilies of Photius, Patriarch of Constantinople* (Cambridge, MA, 1958), 177–81, and R.J.H. Jenkins and C. A. Mango, "The Date and Significance of the Tenth Homily of Photius," *DOP* 9–10 (1956): 125–40. He does not consider this attribution to be the final word on the matter. See his entry in the *Oxford Dictionary of Byzantium*, online version, accessed 5 November 2015, www.oxfordreference.com/view/10.1093/acref/9780195046526.001.0001/acref-9780195046526-e-3729?rskey=sRET31&result=3.

44 On this miniature see L. Brubaker, *Vision and Meaning in Ninth Century Byzantium: Image as Exegesis in the Homilies of Gregory of Nazianzus* (New York, 1998), 122–23, and for the manuscript's relation with Emperor Basil I, see 147–200, 412–14.

45 A. Grabar, *Byzantine Painting: Historical and Critical Study* (Geneva, 1953), 170–71; K. Weitzmann, *The Miniatures of the Sacra Parallela, Parisinus Graecus 923* (Princeton, NJ, 1979), 147. Both are cited in Brubaker, *Vision*, 283n14. Both Grabar and Weitzmann may have been echoing Friend's ideas, Weitzmann because they spoke often and Grabar because he would have encountered Friend during his visits to Dumbarton Oaks. Those began in 1947, and in 1950, Friend selected Grabar to direct the symposium on "The Emperor and the Palace": H. Maguire, "André Grabar. 1896–1990," *DOP* 45 (1991): xiv. Grabar participated in Friend's symposium on Iconoclasm the following year, as shown in the photograph of its speakers, accessed 5 November 2015, http://www.doaks.org/research/byzantine/scholarly-activities/past/iconoclasm/13995964.jpeg. Grabar is at the left.

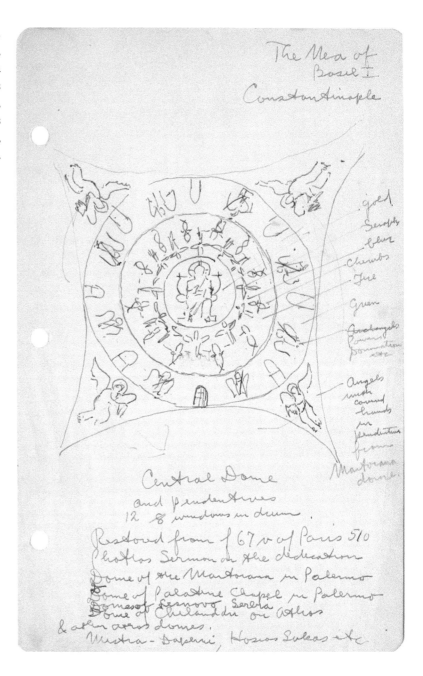

notes survive in Underwood's hand concerning the colors of this miniature.[46]

Prior to the Holy Apostles Symposium in 1948, Friend read a paper at the annual meeting of the College Art Association on 31 January 1947 on the Holy Sion church in Jerusalem, the other part of the double project that he had proposed to the Administrative Committee three years earlier. The handwritten text of the lecture and other documents, preserved in the Princeton archives, anticipate the fate of the Holy Apostles project.[47] The destroyed Sion church was known only from texts, and Friend reconstructed its decorative program by means of illuminated manuscripts, mainly the Rabulla Gospels in this case.

46 Among Underwood's papers, there are notes on several miniatures of Paris, BnF gr. 510, including fol. 67v, in which he describes the colors of the illuminations: Underwood Papers ICFA, MS.BZ.019-03-01-060. The Paris manuscript is now digitized in color, including the page in question: accessed 5 November 2015, http://gallica.bnf.fr/ark:/12148/btv1b84522082/f148.image.

47 Friend Papers, carton 6.

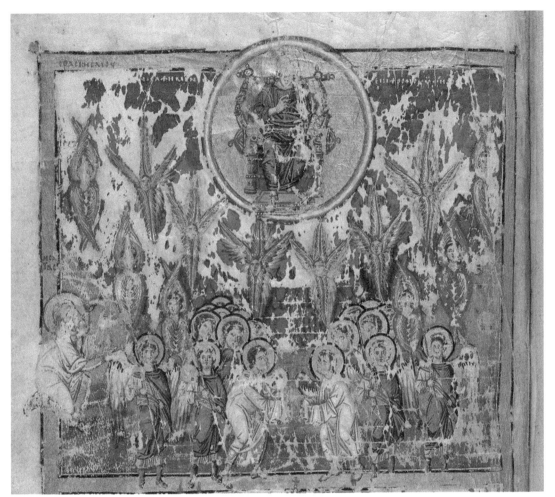

FIG. 3.8.
Vision of Isaiah. Paris,
BnF gr. 510, f. 67v
(image courtesy gallica.
bnf.fr / BnF)

For the Pentecost chamber of the church, how-ever, he used as model the mosaic of the Pentecost over the altar at Hosios Loukas, Greece. At Friend's request, Rosalie Green, a Dumbarton Oaks Junior Fellow and later staff member and Director of the Index of Christian Art in Princeton, compiled and translated the textual sources for the church.[48] The Princeton archives preserves her translations among Friend's papers in a folder labeled "texts for the Sion Church."[49] Green despaired of Friend ever completing his work on the Sion church and was rightly con-cerned about the publication of her translations, and indeed none was published.[50] Also among

the Friend papers is an unidentified translation of Emperor Leo VI's sermon 34 on the church patronized by Stylianus Zaoutzas[51] and two other longer translations without attribution. Of the latter, one is the description by Nicholas Mesarites of the church of the Holy Apostles that Glanville Downey later published and thus must be the work that he prepared for Friend. Downey also feared that his work might never be printed, as James Carder explains in his paper. Next to the Mesarites text is the last translation in a folder, a complete version of Constantine the Rhodian's *ekphrasis* on the Holy Apostles. It also should be credited to Downey. When Liz James was prepar-ing her recent study of Constantine the Rhodian, she searched for Downey's translation but never

48 On Green, see *Dictionary of Art Historians*: https://dictionaryofarthistorians.org/greenr.htm, accessed 5 November 2015.

49 Friend Papers, carton 6.

50 See Carder, "1948 Holy Apostles Symposium," n. 44.

51 Partially translated later in C. Mango, *The Art of the Byzantine Empire, 312–1453: Sources and Documents* (Englewood Cliffs, NJ, 1972), 203–5.

found it, despite appeals to several research libraries, including Princeton's.[52] Librarians are not to be faulted: the text lay among Friend's papers without attribution. Why Downey published his translation of Mesarites but not that of Constantine the Rhodian is not known.

The major endeavor for the group of scholars that Friend assembled in Washington was to reconstruct the Holy Apostles, and the 1948 Symposium was to be one stage toward the completion of their publication. Not all aspects of that work are apparent at this distance, and discerning the working processes of that scholarly enterprise has something in common with the problems that the Dumbarton Oaks team faced in reconstructing the destroyed church of the Holy Apostles. What remains of those preparations, like the sources on the church itself, are texts: the lectures of Underwood and Friend to the 1948 Symposium, a later lecture by Friend at Bryn Mawr College in 1950, a number of notes by Underwood and Friend, and the Downey translations. In the archives at Princeton and Dumbarton Oaks are also what those scholars wished that they had had from the Holy Apostles, namely, numerous visual sources pertaining to the research of Friend and Underwood, drawings by Underwood and Friend, and miscellaneous photographs.

Friend collaborated with Paul Underwood, who made the architectural renderings of the building and ground plans, and with Downey, who controlled the textual sources on the Holy Apostles. Because Friend never relinquished his professorship at Princeton, he commuted to Dumbarton Oaks, and, fortunately for later scholars working on this material, he occasionally corresponded with his associates in Washington. One undated letter from Friend to Underwood, establishes the tenor of their working relationship:

Thank you for sending me the latest in Transfigurations. It came just as I was leaving for Cambridge so I have taken it with me. Here are my immediate reactions:

1. The general layout is very fine, i.e., the placing of the groups, the trees....
2. I am disturbed by the size of the Apostles on Tabor with relation to their size as they go up the Mt and again when they go down. They seem a bit to have swallowed the bottle of Alice had to get bigger and smaller. Perhaps the thing to do is to enlarge the scale of the side groups— you can always put them more behind the rocks; at the same time the central group might be a trifle smaller in scale. If Peter stood up, or James, he would be taller than Christ. Of course they are nearby 15 ft more or less than the Christ, Elijah & Moses but then they would also be foreshortened.
3. I would make the hill in front of the ascending side group go up at a greater slant to the right which will increase the sense that the ground is rising and that ergo they are going up.
4. I think there is a little too much space between X [Christ] and the ascending and descending groups. It breaks up the artistic unity of the whole group.
5. The mountain over X's head at the back of the Dome might have more crags and more interest and perhaps some vegetation at its base.

All these things are details. The main thing is perfectly <u>swell</u>.

 Yours,
 Bert[53]

To summarize what had transpired, Underwood, the junior scholar, had prepared for Friend's approval sketches of the dome of the north arm of the Holy Apostles decorated with the Transfiguration of Jesus. Friend must have received this material in Princeton just before leaving for Cambridge, Massachusetts, perhaps to attend an administrative meeting about Dumbarton Oaks. In Friend's genial response, he referred to *Alice in Wonderland* and ended

52 L. James, ed., *Constantine of Rhodes, On Constantinople and the Church of the Holy Apostles, with a New Edition of the Greek Text by Ioannis Vassis* (Farnham, Surrey, and Burlington, VT, 2012), ix–x. The Dumbarton Oaks archives also has a copy of the Downey translation: Underwood Papers ICFA, MS.BZ.019-03-01-050. See below Appendix C.

53 Underwood Papers ICFA, MS.BZ.019-03-01-053.

with an American colloquialism—"swell"—that has disappeared from today's spoken language. Although polite, Friend was firm about what he wanted in the reconstruction. Amid Underwood's papers, there are several versions of this vault. One corresponds to the version described in the letter (fig. 3.9), because if the figure of Peter at the bottom left stood up, he would indeed be larger than Christ. The basic pictorial model for the composition was the eleventh-century lectionary Mt. Athos Iviron cod. 1, one of the manuscripts that Weitzmann had photographed on his Athos expeditions. Another, Iviron cod. 5, a Gospel book from the thirteenth century, provided the additional scenes of the disciples going to and from the mountain.[54] The Iviron lectionary also served as the basis for their reconstruction of the Anastasis dome in the eastern arm of the Holy Apostles.[55]

For the central dome, Friend reconciled the conflicting accounts of Constantine the Rhodian and Nicholas Mesarites in favor of the latter. The center of the dome, he proposed, had a bust of Christ as Pantokrator, holding the Gospel book with fingers of his left hand spread wide apart, while his right hand made a blessing gesture. Found on coins of Constantine VII (r. 913–959), the gesture also appears in the dome of the church of Daphni that Friend regarded as a direct reflection of the Holy Apostles. The coin iconography indicated that the Holy Apostles had had such domical mosaics from the time of Constantine VII.[56] For the narrative scenes on the side walls of the church, Friend relied upon a variety of illuminated manuscripts, including the aforementioned two manuscripts at Iviron. The typescript of the symposium lectures and another that he gave on the church in 1950 at Bryn Mawr College[57] constitute what can be known of his contribution to the proposed book on the Holy Apostles.

The symposium papers and the Bryn Mawr lecture are similar. The first Dumbarton Oaks paper begins as follows:

The mosaic decoration of the Church of the Holy Apostles, perhaps the richest produced for any church, was certainly the most influential scheme of iconography in the whole realm of Byzantine art. As we shall see, it has left its imprint upon the decoration of other churches in mosaic and in frescoes and the copies of its famous pictures can be found in the precious illuminated manuscripts that were the glory of the imperial scriptorium. The influence of this famous church spread in the course of time to the rock-cut churches of Cappadocia as well as to the cathedrals of Russia, and to the royal foundations of Norman Sicily—nor should we forget, what first is usually mentioned, San Marco in Venice....

I shall be excused, I know, if today I can present only a sketch in its main outlines—if at times there is description instead of conclusive proof. But I am intent to set out before you the unified and single scheme of this great decoration which must have been the product of one extraordinary mind and have been executed—nearly all of it—at one time.[58]

That great intellect he believed was the Patriarch Photios, although he writes that he "cannot prove it."[59]

Proof is an interesting concept for Friend to mention, and I wonder if all in his audience were as quick to excuse him from its rigors, as he hoped. His first sentence states the premise of his deductive argument, namely, that the Holy Apostles was "the most influential scheme of iconography in the whole realm of Byzantine art." If this premise is accepted, then it follows that the evidence of later mosaics and illuminated manuscripts may be used to reconstruct the iconography of the Holy Apostles, precisely because the church had "the most influential scheme of iconography in the whole realm of Byzantine art."

54 Confirmation is provided by Friend's notes in the Underwood Papers ICFA, MS.BZ.019-03-01-066, where he lists these manuscripts as copies of the vault, among other monuments.

55 Ibid.

56 Friend, "The Mosaics of Basil I in the Holy Apostles, Part II, April 23, 1948 Dumbarton Oaks," Friend Papers, carton 4. See below Appendix B.

57 "Holy Apostles Church: Restoration of the Mosaics," 21 February 1950. Friend Papers, carton 5.

58 Friend, "The Mosaics of Basil I in the Holy Apostles, Part I. April 23, 1948 Dumbarton Oaks," Friend Papers, carton 5. See below Appendix F.

59 Ibid.

FIG. 3.9.
Paul A. Underwood,
preliminary drawing of the
Transfiguration from the Holy
Apostles. MS.BZ.019-03-01-057
Underwood Papers ICFA.

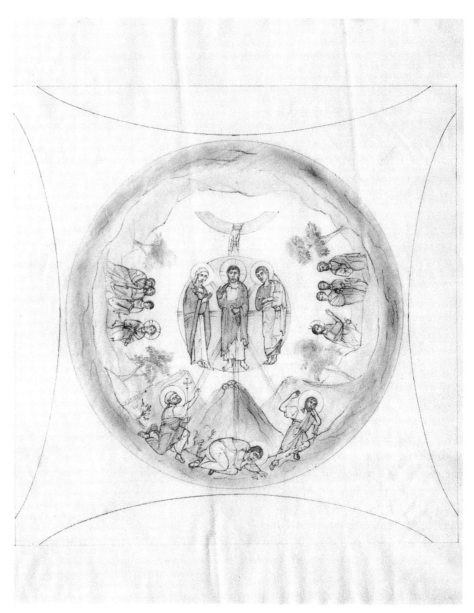

Friend seems never to have wavered from this type of argumentation that may appear circular if one is accustomed to working inductively.

According to his friend and Princeton colleague Kurt Weitzmann, Bert Friend was in ill health during the last three years of his life, that is, from 1953 until his death in 1956 at age sixty-two. The cause was cirrhosis of the liver, which took Weitzmann by surprise.[60] According to the latter, Friend was already "seriously ill" in 1954, when he directed the symposium that

spring on the topic "Byzantine Liturgy and Music" for which he wrote two papers "The Cherubic Hymn in the Art of Ninth Century Constantinople" and "The Chariot of Ezekiel and the Anaphorae."[61] The texts, which survive among Friend's papers in Princeton, are pastiches of his previous symposium papers going back to

60 Weitzmann, *Sailing with Byzantium*, 205; E. T. DeWald, "Obituary," *Speculum* 32 (1957): 641.

61 Weitzmann, *Sailing with Byzantium*, 202; Friend Papers, carton 6. The report of the symposium in the Annual Report suggests that in Friend's absence Weitzmann read the second paper and that the first was not read. See, accessed 8 September 2019, https://www.doaks.org/research/byzantine /scholarly-activities/byzantine-liturgy-and-music/byzantine -liturgy-and-music-program.

the one on Hagia Sophia of 1946. The first lecture begins with the Nea church as described in Photios's sermon. The paper indicates that Friend was not capable of putting together something new by this date, as must have been obvious to his younger collaborators at Dumbarton Oaks. While the paper cannot be defended, it does demonstrate Friend's synthetic approach to art historical monuments. In it he mixes together liturgy and hymnography, to which he adds his old ideas about the imagery in the dome of Hagia Sophia being derived from the Nea church as seen in folio 67v of Paris, B.N. gr. 510. Friend attempted the multidisciplinary scholarship that he sought to foster for the ill-fated Holy Apostles project and among the larger community at Dumbarton Oaks. Building and nurturing that community were the principal duties of his position, and they were needed as much then as now.

Of the many younger scholars invited to Dumbarton Oaks during the years of Friend's tenure, Cyril Mango was among the most promising. In 1951, he arrived to take up a junior fellowship in order to complete his French PhD, and he would remain for a dozen years, before later returning as professor. Incorporated into the informal Holy Apostles group, Mango translated the homilies of Photius in his book of 1958. As noted above, he successfully argued that the tenth homily pertained not to the Nea but to the Pharos Church in the Imperial Palace. Precisely when Mango came to this conclusion is not known, but it may have been close to the time of Friend's symposium lecture, 1 May 1954, for the thesis was presented in an article coauthored with Romilly J. H. Jenkins in *Dumbarton Oaks Papers* of 1956. The authors naturally wrote prior to the time of publication and probably discussed the matter with colleagues at Dumbarton Oaks.[62] By repeating the old identification of the homily in his symposium paper, Friend, who once had been abreast of all developments at the institution, appears ignorant of his colleagues' work.

When interviewed for Dumbarton Oaks's oral history project recently,[63] Mango passed over details of old publications, but he did remember Friend, characterizing him and his work in a way that is relevant for this paper and the Holy Apostles project as a whole. For Mango, Friend was a "fantasist," meaning, as the *OED* puts it, a person who "weaves fantasies."[64] Mango can only be referring to the Holy Apostles project, but how and in what manner is not known. It is safe to assume that the problems Mango saw involved more than the visualization of the destroyed church through the texts and existing works of Byzantine art. Others were routinely employing the approach, including Mango in his next book of 1959.[65] However, in his reconstructions Friend proceeded without necessary caution and evidentiary rigor. Still the clashing perspectives of two men were not simply a matter of Mango's deeper and superior research. Other contributing factors may have been differences in age (Friend b. 1894; Mango b. 1928), background and training (Friend, American born and educated with only rudimentary Greek; Mango born in Istanbul of a Levantine father and Russian mother, educated in England and Paris with a philologist's command of Greek), and accomplishments (Friend with no PhD or book and only a few articles and many abandoned projects; Mango, who by 1954 had already published more articles than Friend did in his entire career).[66]

Nonetheless, these explanations also fail to capture the general phenomenon, for while both men were or would become university professors,

62 Their text provides a clue to the date of its composition, when the authors state that the homily in question had been known to scholarship "for exactly three centuries" and cite a publication of 1655, implying that they were writing in 1955: Jenkins and Mango, "Tenth Homily of Photius," 125–26.

63 See Cyril Mango and Marlia Mundell Mango, oral history interview by Anna Bonnell-Freidin for the DOA, 1 August 2009, accessed 5 November 2015, www.doaks.org/library-archives /dumbarton-oaks-archives/oral-history-project/cyril-mango -and-marlia-mundell-mango.

64 *Oxford English Dictionary*, accessed 5 November 2015.

65 Cyril Mango, *The Brazen House: A Study of the Vestibule of the Imperial Palace of Constantinople* (Copenhagen, 1959).

66 Friend's papers contain limited notes in his handwriting with his Greek translations, so he had some access to the language, but he relied on others for the translations of the major texts about the Holy Apostles and other churches. On Cyril Mango and his background, see D. Barchard, "The Brothers Mango," *Cornucopia* 4, no. 19 (1999): 18–20; and I. Ševčenko, "Preface," in *Aetos: Studies in Honour of Cyril Mango Presented to Him on April 14, 1998*, ed. I. Ševčenko and I. Hutter (Leipzig, 1998), ix–xii. The 11 articles of Cyril Mango through 1954 are listed in the latter Festschrift on p. xiv.

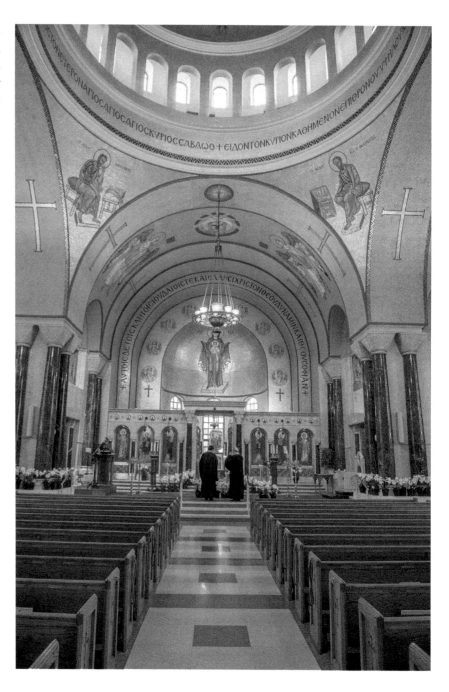

Friend had also been a museum curator and the designer of the iconographic program of the medieval revival chapel at Princeton. What Mango saw as a fantasist might also be interpreted as Friend's wish to create and his admiration for the aesthetic creations of others—hence his collection of theatrical materials that he donated to Princeton and his suggested revisions of Underwood's reconstruction drawings that were aesthetic, not scholarly. Underwood had even more of a creative background, having practiced initially as an architect before taking up art history. Underwood's ability to generate architectural renderings of the church literally held the whole project together and provided the frame into which Friend inserted images mainly taken from illuminated manuscripts. The procedure was similar to what Friend had done when he designed the program of the stained glass and sculpture for the Princeton chapel. There he worked from the building that Ralph Adams Cram had designed and prepared appropriate

imagery for it. Underwood would do the same a few years after Friend's death, as I am about to explain.

Since the medieval revival began to flourish in the eighteenth century, architects, painters, and iconographers had selected the most appropriate medieval models for the project at hand. Thus, it is not surprising that the Princeton-trained architect and architectural historian Paul Underwood responded similarly when approached about the iconographic program for the new Orthodox church of St. Sophia in Washington, DC, whose structure was completed in 1955 (fig. 3.10). I discussed the church and its mosaics briefly in a previous study about the modern reception of the Great Church of Constantinople.[67] For that project, I spoke with the priest Father John Tavlarides and the mosaicist Demetrius Dukas, which was fortunate, because both have since died.[68] Following what Dukas told me in that interview,[69] I wrote that Paul Underwood had advised the church board on the decoration of the church and that Dukas used the resources of Dumbarton Oaks for images. He reported that the iconography of the central dome (fig. 3.11) was based on the vision of Isaiah in a manuscript of the homilies of Gregory of Nazianzos in Paris, BnF gr. 510 (fig. 3.8). Dukas further noted in the interview that after Underwood died, Cyril Mango became the adviser to the church, and after he left for Oxford (to be the Bywater and Sotheby Professor of Byzantine and Modern Greek), Ernst Kitzinger replaced him. The Dumbarton Oaks association, therefore, was strong.

I had not realized then that the initial conceptualization of the project was an outgrowth of Bert Friend's Holy Apostles project. However, when I began preparing my contribution to the second Holy Apostles Symposium, I first encountered Underwood's drawing of the dome of the Nea of Basil I (fig. 3.12) and then Friend's sketch for the same (fig. 3.7). Immediately the relationship to the dome of the Washington church was apparent (fig. 3.11), because Dukas based the dome's monumental Pantokrator on a lyre-backed throne upon the Friend/Underwood reconstruction (fig. 3.12), as much or more than the Paris miniature (fig. 3.8). Surrounding Christ in the modern dome is a resplendent gold ground that comes alive in bright afternoon or morning light. Dukas relied upon the natural lighting of the dome vault to recreate an effect similar to the burnished gold ground of the central medallion in the miniature. Seraphim and cherubim fill the next ring (fig. 3.13). Their upper bodies are set off against a deep blue background, while the tips of their lower wings or feet sink into a ring of red fire. These colors correspond to the Paris miniature. Unlike a Byzantine mosaicist, however, Dukas placed his name beneath the right and thus most important foot of Christ (fig. 3.13), but in a position that is visible not from the main floor but only from the choir loft above.

In preparing for an exhibition to accompany the 2015 Spring Symposium, Fani Gargova discovered an important letter that Paul Underwood wrote on 17 June 1963 to Tavlarides about the decoration of the new church. She also conducted an interview with Underwood's daughter Sarah that has been published online.[70] Both clarify and amplify details of my earlier interview with Dukas. In his letter, Underwood proposed that an international competition be staged to select the artist for the church program. The person chosen, Demetrius Dukas, was already known at Dumbarton Oaks. He had previously corresponded with John Thacher, the Administrative Director of Dumbarton Oaks from 1940 until 1969. Thacher had advised Dukas on his application for a Fulbright fellowship and had encouraged Dukas's growing

67 Nelson, *Hagia Sophia*, 196–97.

68 Father Tavlarides in 2015, obituary in the *Washington Post*, accessed 5 November 2015, www.washingtonpost.com/local/obituaries/john-t-tavlarides-longtime-priest-at-greek-orthodox-cathedral-dies-at-84/2015/09/26/c3b21a66–645e-11e5–8e9e-dce8a2a2a679_story.html, accessed 5 November 2015; Demetrius Dukas in 2011, obituary in the *Baltimore Sun*, accessed 5 November 2015, http://articles.baltimoresun.com/2011-06–24/news/bs-md-ob-demetrius-dukas-20110622_1_byzantine-art-religious-art-iconographer.

69 On 2 November 1999.

70 See below Appendix J. See Sarah Underwood, oral history interview by Alasdair Nicholson and Bailey Trela for the DOA, 23 July 2014, accessed 5 November 2015, www.doaks.org/library-archives/icfa/oral-history-initiative/sarah-underwood.

FIG. 3.11.
Demetrios Dukas,
Dome mosaic
of St. Sophia,
Washington, DC
(photo by author)

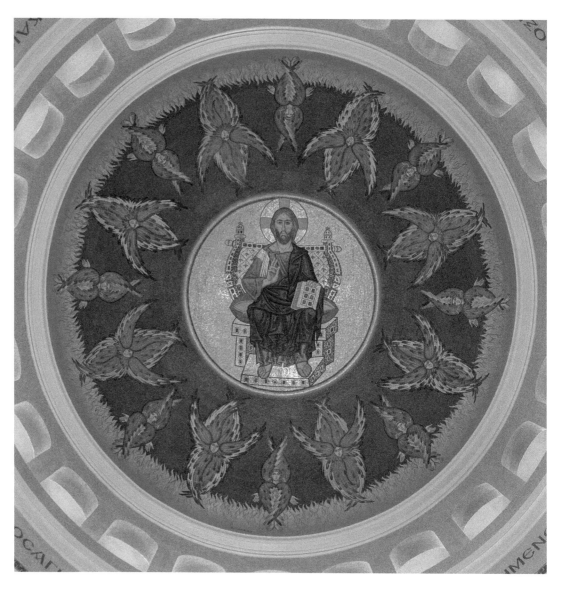

interest in Byzantine painting.[71] In 1954, Thacher offered him employment with the restoration project at the church of the Chora in Istanbul under the auspices of the Byzantine Institute of America. Dumbarton Oaks had assumed control of that Institute upon the death of Thomas Whittemore. Paul Underwood was then directing its projects in Istanbul.

Underwood's letter to Tavlarides follows a prior meeting with a committee directing the decoration of the church. In the letter, Underwood proposed a program "unique" among modern Orthodox churches but one still within the "finest tradition of decoration in Byzantine art." Underwood's solution was a church program made in Constantinople after the end of Iconoclasm. He continued:

> It is a program that may well have been conceived by the great theologian of that period, the Patriarch Photius, probably during his first patriarchal term. We know from textual sources that one of the very first churches to be decorated after Iconoclasm was the Palace church dedicated, in 864 AD, to the Theotokos of the Pharos. For its dedication, Photius delivered a homily that tells a good

71 Correspondence between Demetrius Dukas and John Thacher, MS.BZ.004-01-01-04-125, Byzantine Institute Records ICFA. I thank Fani Gargova for bringing this correspondence to my attention and for her generous aid in this project.

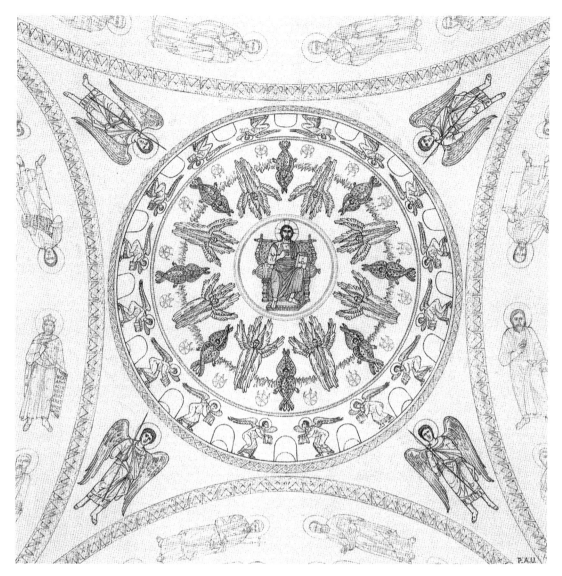

FIG. 3.12.
Paul A. Underwood,
drawing of the dome
mosaics in the Nea
Church. MS.BZ.019-
BF.F.1993.F2814
Underwood Papers
ICFA.

deal about the subjects that were represented in its vaults. It is from this and other texts as well as from some surviving mosaics and paintings, that the program in question can be reconstructed. Much the same scheme of iconography was used also in the great church of Hagia Sophia, in the Chrysotriclinos (the throne room of the Great Palace of the Emperors), and in the church of Kauleas decorated by Leo the Wise towards the end of the 9th century. . . .

The dome is devoted entirely to an arrangement of the celestial hierarchy as revealed to Isaiah (6:1–4) when, in his vision he saw "the Lord sitting upon a throne, high and lifted up, and his train filled the temple.

And above it stood seraphim . . . and one cried unto another and said, Holy, holy, holy is the Lord of Hosts: the whole earth is full of his glory." An excellent painting of this subject, of about the year 880, is among the miniatures of a manuscript in the National Library of Paris (ms. 510) a photograph of which I enclose herewith. I would suggest that this painting be used as the basis for the design of the dome of your church. This can be worked out along the lines of the drawing which I made some years ago to illustrate how the painting may have been based on a great dome decoration in one of the churches of Constantinople. By comparing my drawing with the miniature you will

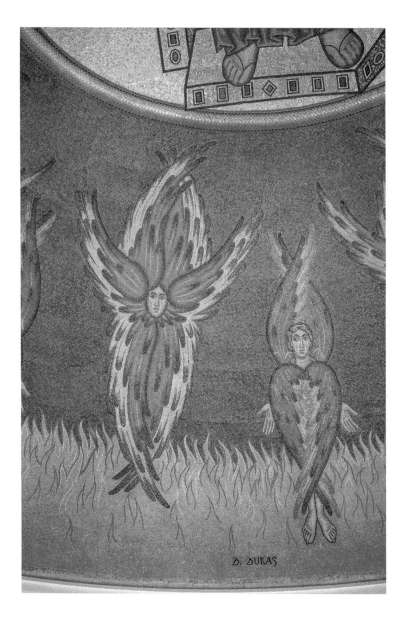

see how well it fits a dome. I can supply later some color notes giving the colors used in the miniature.

The church accepted Underwood's proposal, and according to Father Tavlarides, the Dumbarton Oaks professor visited the church frequently to check on the progress of the work. His daughter supplied a 1966 photograph of her father and Demetrius Dukas on the scaffold beneath the Pantokrator of the dome (fig. 3.14). By this time, the Holy Apostles project was in the past, and Paul Underwood had turned to the restoration of the fourteenth-century mosaics and frescoes in the church of the Chora,

whose publication would be the capstone of his career. However, his letter to Tavlarides also shows that he had not forgotten the Holy Apostles and churches after Iconoclasm. His history lesson reads like a summary of papers at the 1948 Symposium with the addition of Mango's reattribution of Photios's tenth homily. Underwood offered to supply an old drawing to serve as the model for the dome. The precise one chosen is not known, but it presumably was the one that he made for the Nea Ekklesia, for it had been regarded as the source for the Paris miniature. To aid the mosaicist's simulation of ninth-century Byzantine art, Underwood promised the color notes of the Paris manuscript that he

FIG. 3.14.
Paul Underwood
and Demetrios
Dukas beneath dome
mosaic of St. Sophia,
Washington, DC, 1966
(photograph courtesy
of his daughter, Sarah
Underwood)

had prepared for the Holy Apostles investigation. The textual basis for the Paris illustration, verses from Isaiah, would be inscribed around the base of the dome of the Washington church (fig. 3.10).

St. Sophia in Washington and its mosaic program was a medieval revival project in the tradition of the neo-Gothic chapel at Princeton University and the Chicago church that incorporated the copy of the mosaic of St. Chrysostom from Hagia Sophia. All were links in a long chain of similar endeavors stretching back to the eighteenth century but were also contemporary with the building and decoration of two other medieval revival churches in Washington,

the Romanesque/Byzantine National Shrine (Catholic) and the Gothic National Cathedral (Episcopalian), the latter just up the hill from St. Sophia. In part the Friend/Underwood reconstruction of the church of the Holy Apostles was yet another medieval revival project. How comfortably it would have been regarded "within the Byzantine tradition" will never be known with certainty, because the book was not completed and subjected to peer review, but the foregoing has suggested that it may have been more medieval revival than medieval. It was from a period in American architecture and architectural history in which the Gothic revival architect Ralph Adams Cram (1863–1942) participated in the

founding of the Medieval Academy of America,[72] and architects like Paul Underwood, or more to the point the Harvard professor Kenneth John Conant (1895–1984), directed excavations and restorations and published their results, aided especially in Conant's case by his visually appealing architectural renderings.

Conant, born one year after Friend, long outlived him and is best known for his excavation of the several stages of the monastic church at Cluny, France. An excellent draftsman, he was so good at preparing renderings of lost buildings that Cram tried to hire him for his firm.[73] Like the Friend/Underwood Holy Apostles, Conant's reconstructions have also been thought fanciful. As Peter Fergusson has written, "some of Conant's monuments 'existed' largely in beautifully rendered reconstructions whose soaring elevations sprang from little more than foundation walls." Like Friend, Conant was also entranced by one building, Cluny, which he too believed was the greatest of its age,[74] and Conant was fundamentally a medieval revivalist, who saw himself as the heir to Henry Hobson Richardson, the chief American architect of the Romanesque Revival, and others who argued for medieval architecture's relevance to modern life.[75] Moreover, Conant's work, like Friend's, has appeared weak in documentation and "hypothetical in nature."[76]

Friend imposed a certain vision upon the past drawn from restricted visual sources according to prior premises and deductive reasoning. That method, also practiced by others, centered around Charles Rufus Morey of Princeton in the first half of the twentieth century and continued well into the second half of the century in Kurt Weitzmann's reconstructions of lost manuscripts and pictorial cycles.[77] No matter what form it took, the approach preferred the theoretical to the actual, and thus Whittemore's grand project to excavate the Imperial Palace found no backing at Dumbarton Oaks under Friend's leadership, for he had already committed its resources to the Holy Apostles. Conceptually, that project looked back to the earlier decades of the twentieth century and not forward to what Dumbarton Oaks would become in later decades thanks to its remarkable permanent faculty, such as Cyril Mango and Ihor Ševčenko,[78] and to the Directors of Study who succeeded Albert Mathias Friend, Jr.

72 G. R. Coffman, "The Mediaeval Academy of America: Historical Background and Prospect," *Speculum* 1 (1926): 14–15.

73 J. T. Marquardt, *From Martyr to Monument: The Abbey of Cluny as Cultural Patrimony* (Newcastle, UK, 2007), 158.

74 P. J. Fergusson, "Kenneth John Conant (1895–1984)," *Gesta* 24, no. 1 (1985): 88. On Conant's architectural renderings and his drawing style, see Marquardt, *From Martyr to Monument*, 158–63.

75 Marquardt, *From Martyr to Monument*, 163. In the Foreword to his Pelican History of Art volume (*Carolingian and Romanesque Architecture 800–1200* [Baltimore, 1959], xxv), Conant writes that he "is academically the heir of Herbert Langford Warren and his teachers Henry Hobson Richardson and Charles Eliot Norton, the latter an intimate friend of John Ruskin." The less well-known Warren, his primary mentor, was a Harvard professor of architecture and a practicing architect, who, though he worked for Richardson for some years, was "a Goth at heart" or a Gothic Revivalist, according to C. A. Coolidge, "Herbert Langford Warren," *Proceedings of the American Academy of Arts and Sciences* 68 (1933), 690. More generally on Warren, see M. Meister, *Architecture and the Arts and Crafts Movement in Boston: Harvard's H. Langford Warren* (Hanover, NH, 2003).

76 Marquardt, *From Martyr to Monument*, 198–99. Unlike Friend, Conant published the findings of his excavation of

Cluny and wrote the then standard account of earlier medieval architecture: *Carolingian and Romanesque Architecture*.

77 E.g., K. Weitzmann, "A 10th Century Lectionary: A Lost Masterpiece of the Macedonian Renaissance," *RESEE* 9 (1971): 617–40; also K. Weitzmann, *Byzantine Liturgical Psalters and Gospels* (London, 1980), X, 617–40. For a discussion and refutation of Weitzmann's theories of manuscript production, see J. Lowden, "The Transmission of 'Visual Knowledge' through Illuminated Manuscripts: Approaches and Conjectures," in *Literacy, Education, and Manuscript Transmission in Byzantium and Beyond,* ed. C. Holmes and J. Waring, The Medieval Mediterranean (Boston, 2002), 63–69 and M.-L. Dolezal, "Manuscript Studies in the Twentieth Century: Kurt Weitzmann Reconsidered," *BMGS* 22 (1998): 216–63.

78 Mango's contributions to art and architectural history are well known and easily accessible in the digital catalogue of a major library. Ševčenko's art historical publications are less obvious but include his masterly study on the *Menologion of Basil II* ("The Illuminators of the Menologium of Basil II," *DOP* 16 [1962]: 243–76) and its sequel ("On Pantoleon the Painter," in *Festschrift für Otto Demus zum 70. Geburtstag,* ed. H. Hunger und M. Restle [= *JÖB* 21] [Vienna, 1972]: 241–49), as well as his contribution to Underwood's *Kariye Camii* ("Theodore Metochites, the Chora, and the Intellectual Trends of His Time," in *The Kariye Djami,* ed. P. A. Underwood, vol. 4 [Princeton, NJ, 1975], 19–91). While colleagues at Dumbarton Oaks, Mango and Ševčenko coauthored studies of architecture: the especially important "Remains of the Church of St. Polyeuktos at Constantinople," *DOP* 15 (1961): 243–47.

Memory

Apostolic Patterns of Thought, from Early Christianity to Early Byzantium

SCOTT FITZGERALD JOHNSON

In this little book are presented the origins and deeds of certain saintly and most excellent men, along with their genealogies. Also noted in short compass are their honor, their death, and their tomb. All this, even though known to all who look through the extent of the Scriptures, nevertheless will return to memory more easily when read in a brief treatise.[1]

Quorundam sanctorum nobilissimorumque virorum ortus vel gesta cum genealogiis suis in hoc libello indita sunt; dignitas quoque et mors eorum atque sepultura sententiali brevitate notata. Quae, quamvis omnibus nota sint qui per amplitudinem Scripturarum percurrunt, facilius tamen ad memoriam redeunt, dum brevi sermone leguntur.[2]

With these words, the seventh-century bishop Isidore of Seville begins his little book known today as the *De ortu et obitu Patrum* ("On the Origin and Death of the Fathers"). In it he writes mini-obituaries for all of the significant personages in the Bible. He does not follow a liturgical calendar but proceeds in chronological order through the whole of scripture, beginning with Adam and ending with Titus, the disciple of Paul. The work is comprehensive, if brief. As promised in the prologue, he recounts the origin, significance, death, and burial site of each figure (and he includes a number of women, not just men). When he comes to the apostles, he proceeds in their traditional order of precedence, starting with the twelve and then through the second generation. A typical example reads as follows:

Thomas, called *Christi didymus* ("Christ's Twin") [in Greek] and *Christi geminus* ("Christ's Twin") and *similis salvatoris* ("Resembling the Savior") in the Latin language, upon hearing [of the resurrection] was disbelieving, but upon seeing had faith. He preached the gospel to the Parthians, Medes, and Persians, and also to the Hyrcanians and Bactrians, and aiming for the eastern region and entering the homelands of these nations he carried his preaching all the way to the glory of his own martyrdom, for he died having been run through with spears in Calaminia, a city in India, where he was buried in honor.

Thomas, Christi didymus nominatus et iuxta latinam linguam Christi geminus ac similis salvatori; audiendo incredulus, videndo fidelis. Hic evangelium praedicavit Parthis, Medis, et Persis,

1 All translations are my own unless otherwise indicated.

2 Isidore of Seville, *De ortu et obitu Patrum* 1 (ed. Chaparro Gómez 1985, 103).

Hircanisque ac Bactrianis, et destinans orientalem plagam et interna gentium penetrans et praedicationem suam usque ad titulum suae passionis perducens: lanceis enim transfixus occubit in Calaminia Indiae civitate, ubi et sepultus est in honore.[3]

This is a typical mini-biography for Isidore's *libellus*. It is, moreover, very typical of how Isidore regularly breaks his own guidelines offered in the prologue. Notably, almost every detail in this mini-biography does not, in the end, come from scripture itself but is part of a larger Christian mythos surrounding the apostle Thomas. The Greek epithet *Didymus* ("twin"), a literal translation of the Aramaic *Thoma,* is known from the Gospels and Acts, but the suggestion that he was "the Twin" of Christ himself is a later interpretation: the motif shows up in the early third-century Acts of Thomas, for example, where a number of scenes of misidentification add to the intrigue of Thomas's commission to India.[4] His evangelizing of the Persians is an old Syriac tradition but likewise does not appear in the Bible. Indeed, the only narrative lifted from scripture is the poetic doublet *audiendo incredulus, videndo fidelis* from the post-resurrection Upper Room scene in John 20.[5]

What Isidore has done with Thomas, and what he does throughout his *libellus* to both Old and New Testament figures, is to reimagine the history of the apostolic age through the lens of later tradition about the apostles. Often that later tradition is based on a small foothold in the scriptural text, whereby later imaginations gained purchase. Consider a portion of Paul's mini-biography: "Paul, setting out from Jerusalem, went on to Illyricum, Italy, and Spain, and he disclosed the name of Christ among many nations, to whom it had not yet been declared (*[Paulus] incipiens enim ab Hierosolimis usque Illyricum et Italiam Spaniasque processit, ac nomen Christi multarum manifestavit gentium, quibus non fuerat declaratum*).[6] Isidore illustrates here a fundamental tenet of the expansion of the apostolic world in the late antique Christian imagination. In his conclusion to the Epistle to the Romans, Paul writes to the congregation, "When therefore I have completed this and have entrusted to them this fruit, I shall go on by way of you to Spain."[7] Isidore shows us how the smallest foothold of textual support can bear the weight of an entire world. Indeed, in late antiquity Paul was celebrated as a missionary to Spain, as Isidore of Seville knew very well.[8] That visit, only hinted at in Romans and never attested in any contemporary source, nevertheless became foundational for the Spanish church. Isidore makes less out of it here than other authors do, but it remains for him a foregone conclusion that Paul evangelized Spain, as he had Asia, Greece, Illyricum, and Italy before it.

This habit of mind on display in Isidore's *libellus* is deceptively simple. We understand today the influence of authoritative texts in a so-called religion of the book. Each word is scrutinized by believers, for various purposes and with varying results, but the communal act of reverencing a divinely inspired text, even the smallest utterance, is natural and expected. However, certain other thoughts, acts, and habits of mind follow upon this basic principle of reverencing the text that are not nearly so simple. These secondary acts are those of creative imagination,

3 Isidore of Seville, *De ortu et obitu Patrum* 73 (ed. Chaparro Gómez 1985, 209–11).

4 See C. M. Stang, *Our Divine Double* (Cambridge, MA, 2016), 64–106, along with S. F. Johnson, *Literary Territories: Cartographical Thinking in Late Antiquity* (Oxford and New York, 2016), 111–14, on the question of his name. On the *Acts of Thomas* more generally, see A.F.J. Klijn, *The Acts of Thomas,* 2nd ed., Supplements to *NT* (Leiden, 2003); J. N. Bremmer, ed., *The Apocryphal Acts of Thomas,* Studies on Early Christian Apocrypha 6 (Leuven: 2001); and J. F. McGrath, "History and Fiction in the Acts of Thomas: The State of the Question," *Journal for the Study of the Pseudepigrapha* 17 (2008): 297–311.

5 John 20:24–29. This scene inspired a wide range of literary and artistic responses in later centuries: see G. W. Most, *Doubting Thomas* (Cambridge, MA, 2005).

6 Isidore of Seville, *De ortu et obitu Patrum* 68.2 (ed. Chaparro Gómez 1985, 199).

7 Romans 15:28: τοῦτο οὖν ἐπιτελέσας καὶ σφραγισάμενος αὐτοῖς τὸν καρπὸν τοῦτον, ἀπελεύσομαι δι' ὑμῶν εἰς Σπανίαν.

8 On Paul in Spain, see several relevant chapters in A. Puig i Tàrrech, J.M.G. Barclay, and J. Frey, eds., *The Last Years of Paul: Essays from the Tarragona Conference, June 2013,* Wissenschaftliche Untersuchungen zum Neuen Testament 352 (Tübingen, 2015). On the more familiar legend of James the Greater in Spain, see R. Burnet, *Les douze apôtres: Histoire de la réception des figures apostoliques dans le christianisme ancien* (Turnhout, 2014), 333–38; and M. C. Díaz y Díaz, "Die spanische Jakobus-Legende bei Isidor von Sevilla," *HJ* 77 (1958): 467–72.

of confronting the *horror vacui* in the historical narrative, and of fashioning grand cosmologies.[9] The very building blocks of the Christian mind are found in these small cognitive leaps that are so innocuous yet so important.

I have begun this chapter *in medias res* with a Latin author who collected, arranged, and published the legends of the apostles. Isidore provides a litmus test in the seventh century of how firmly the ancient Christian mind was founded on an apostolic inheritance. The cultivated memory of the persons and work of the apostles, I argue below, is one of the most basic assumptions in the thought world of early Byzantine Christianity. In an effort to analyze the cognitive sphere of apostolicity, I place emphasis on the received literature from early Christianity and its deployment within a geographical framework. The organization of received knowledge was an intellectual technology early Byzantines employed to make sense of the world around them. The significance of the apostles for the early Byzantines entailed a mental geography. We have already glimpsed this principle with Isidore, a contemporary Western example, but early Byzantine writers were equally if not more attuned to this habit of writing and thought. The late antique church of the Holy Apostles, with which this chapter concludes, offers a glimpse of how the organization of knowledge was still fluid in early Byzantium. Specific sites of apostolic importance could be interpreted in different ways, and the Church itself, later a centerpiece of apostolic authority for the empire, was for a time a site of multiple expressions of apostolic thinking.

The cognitive operations of the apostolic inheritance in early Byzantium were fundamentally tied to the authority of received texts. These received texts were a stimulus to imagination. It is too often stated in scholarship on Christian apocrypha from the second and third centuries that the great vibrancy of the early Christian imagination was squelched in the fourth century under the totalitarian regime of Constantine and the imperial church. This dictum could not be further from the truth. The establishment of an authoritative canon—a process already in evidence by the late first century in the letter of 2 Peter and in Ignatius of Antioch—seems only to have spurred on new creativity set within that received textual framework.[10]

The canon was, in other words, a "productive" text rather than a smothering or suppressive one. It precipitated an array of new texts, paraphrases, and translations across all manner of genres and languages: novelistic Acts, visionary apocalypses, fictional epistolography, and so on. The new imaginary worlds ended up inspiring texts of their own: not just compendia like Isidore's (though that was a fertile genre), but new narrative texts that took for granted the earlier expansions and incorporated them as history, or a type of canon of their own. One might argue that the famous lists of spurious or banned books that show up from time to time—especially the comprehensive sixth-century Gelasian Decree—signal the continued popularity of apocryphal narrative instead of its real-world suppression. Thus, despite its proscription of books, the Gelasian Decree reads like a library catalogue of literate Christians.[11] These were, to quote a chapter title from Averil Cameron's *Christianity and the Rhetoric of Empire*, "Stories People Want."[12]

The multifarious corpus of Christian apocryphal literature authored, copied, read, and translated during late antiquity and Byzantium constitutes in many ways what could be termed the "dark matter" of the period.[13] This literature

9 I discuss this cognitive trend at greater length in Johnson, *Literary Territories*.

10 I discuss the phenomenon of canon as a creative impetus in S. F. Johnson, "Christian Apocrypha," in *The Oxford Handbook of the Second Sophistic*, ed. W. Johnson and D. Richter (Oxford, 2017), 669–86.

11 The *Gelasian Decree* was not the only such list: others include the *List of the Sixty Books* (7th century), and the *Stichometry of Nicephorus* (4th/9th century). For these texts and others, see E. Hennecke and W. Schneemelcher, eds., *New Testament Apocrypha*, trans. R. M. Wilson, 2 vols., rev. ed. (Louisville, KY, 1991–92 [1989–90]), 34–43.

12 Av. M. Cameron, *Christianity and the Rhetoric of Empire: The Development of Christian Discourse* (Berkeley, 1991), 89–119; and S. F. Johnson, "Apocrypha and the Literary Past in Late Antiquity," in *From Rome to Constantinople: Studies in Honor of Averil Cameron*, ed. H. Amirav and B. ter Haar Romeny (Leuven, 2007), 47–66.

13 This survey of early apocryphal literature is based on Johnson, "Christian Apocrypha." For the themes discussed here, see also S. J. Shoemaker, "Early Christian Apocryphal Literature," in *The Oxford Handbook of Early Christian Studies*, ed. S. Ashbrook Harvey and D. G. Hunter (Oxford, 2008), 521–48; H.-J. Klauck, *The Apocryphal Acts of the*

is "dark matter" first and foremost because it is only rarely included in literary surveys, despite the cultural and religious impact it clearly had. Rampant anonymity and pseudepigraphy among the texts does not help literary historians integrate them into their narratives. Apocryphal literature is also "dark matter" in its sheer bulk. Independent works dealing with the apostles easily number in the hundreds, and many of these involve complex reception histories and manuscript traditions. In terms of languages, Greek and Latin are only the basic starting points; often, the best version of a given text survives today in Syriac, Coptic, Armenian, Georgian, Arabic, or Ethiopic. The requisite skills to do philological justice to Christian apocrypha are rarely, if ever, to be found in a single scholar. The prospect is daunting.

The legends recounted in the Apocryphal Acts concern primarily the careers and deaths of the named apostles from the canonical Gospels. The standard five Acts are (in rough chronological order of authorship) the Acts of John (ca. 150–160), the Acts of Paul (ca. 170–180), the Acts of Peter (ca. 190–200), the Acts of Andrew (ca. 210), and the Acts of Thomas (ca. 220–240). To call these standard, however, is to project an image of inviolate texts confident in their own independence. On the contrary, it is in this literature that the much discussed literary principle of "multiformity" is most clearly on display. Multiformity is the existence of multiple surviving copies of a text that are different enough from one another to be classified as independent works, though related at the level of a shared "myth" or "story" core. There is no single version of the Acts of Peter, for example: multiple similar texts, with varied content, are all classed under this heading by scholars. In late antiquity and Byzantium,

Apocryphal Acts of the Apostles were used as "sites" for writing and rewriting, sites for experimentation and creativity.

Many of the stories contained in these Apocryphal Acts have become part of the collective memory of the early Church: Peter's crucifixion upside down following his *quo vadis?* confrontation with the risen Jesus on the way out of Rome; Paul's description as "small in size, bald-headed, bandy-legged, with large eyebrows, hook-nosed, full of grace"; Paul's baptism of a lion; Thecla on the pyre and her self-baptism in an arena in Antioch; and John's rebuke of the bed-bugs. While these texts are sometimes dismissed as popular or "subliterary" writings, it is precisely their popularity as a historical phenomenon which ensured the longevity of such episodes.

Apocryphal Acts are sometimes said to have enjoyed a readership among early Christian women.[14] This is applied above all to the Acts of Paul and Thecla, which occupies the middle third of the Acts of Paul, though it circulated on its own. Arguments about readership tend to be solipsistic when we have only the work itself to go on. With Thecla, however, there might be enough material evidence in addition to the text to offer a cautious affirmation. Certainly the heroes of the Acts of Paul and Thecla are all women: Thecla, Tryphaena, Falconilla, and a female lion in the arena. Moreover, Thecla's defiant self-baptism—in the face of male oppression, including her abandonment by Paul—was striking enough to ancient readers to elicit reproach by Tertullian as early as 200 CE, shortly after the Acts were written. Despite such censures, Thecla became the preeminent female saint in the early Church. She was titled "protomartyr," paired with the protomartyr Stephen from Acts 7, and received a number of narrative treatments, including multiple extensions to the Acts of Paul and Thecla and a major rewriting of her legend in the fifth-century *Life and Miracles of Thecla*.[15]

Apostles: An Introduction, trans. B. McNeil (Waco, TX, 2008); F. Bovon, "The Synoptic Gospels and the Noncanonical Acts of the Apostles," *HTR* 81 (1988): 19–36; idem, *New Testament Traditions and Apocryphal Narratives,* Princeton Theological Monograph Series 36 (Eugene, OR, 1995); idem, "Canonical and Apocryphal Acts of the Apostles," *JEChrSt* 11 (2003): 165–94; idem, *New Testament and Christian Apocrypha,* ed. G. E. Snyder (Grand Rapids, MI, 2011); idem, "Beyond the Canonical and the Apocryphal Books, the Presence of a Third Category: The Books Useful for the Soul," *HTR* 105 (2012): 125–37; and idem, A. Graham Brock, and C. R. Matthews, eds., *The Apocryphal Acts of the Apostles: Harvard Divinity School Studies* (Cambridge, MA, 1999).

14 On the readership of women among the Apocryphal Acts, see S. J. Davis, *The Cult of Saint Thecla: A Tradition of Women's Piety in Late Antiquity* (Oxford, 2001), and K. Cooper, *The Virgin and the Bride: Idealized Womanhood in Late Antiquity* (Cambridge, MA, 1996).

15 See the edition and translation by G. Dagron, ed., *Vie et Miracles de sainte Thècle: Texte grec, traduction et commentaire,* SubsHag 62 (Brussels, 1978), and the study of S. F. Johnson, *The*

Importantly, this all occurred without the slightest evidence that Thecla was ever a historical person. Her story, however, made a powerful impact throughout the Mediterranean, being translated into every medieval Christian language.

To return to the New Testament, in John 20, following Jesus's resurrection, the disciples have locked themselves in a room "for fear of the Jews"—they have no freedom of movement or expression; they are huddled together and terrified. But after Jesus appears to them in his risen body in that same locked room and breathes on them the Holy Spirit, they are able to move out with confidence into the world and are no longer afraid. For the author of Acts and theologians building upon it, this boldness of movement and expression is connected to Pentecost and the reception of the Holy Spirit: the apostles were the first to receive the fullness of the Trinity and the benefits of Jesus's resurrection. Historically, it means that the church begins to spread outward, and the status of "apostle" as a category becomes entwined with commissioning, movement, and proclamation. To be an apostle meant, theologically, to have a freedom of travel and expression that no one had seen before.

For Eusebius of Caesarea, writing his *Ecclesiastical History* in the 310s–320s, the apostles had inaugurated a new era of redemptive history. From an apocalyptic perspective the apostles were the harbingers of the promised *saeculum,* the final era of God's dealings with mankind. The Constantinian era was alive with millennial expectations—expectations for the fulfillment of the prophetic visions and yearnings of the Old Testament, finally and fully realized in the apostolic mission. The unfolding of the mysteries of creation, sin, and the future of Israel, in the form of the imperial Christian church, was embodied in the apostles themselves, and the frustration of the Old Testament undone by the New sees its fruition in the conversion of the emperor. For Eusebius, as for Byzantine authors later, this connection between the apostolic office and the conversion of the world had special resonance because

of the identification of Constantine's Roman empire with the realm of Christendom. The historical chain of events launched at Pentecost found a real-world teleology in Constantine. The Council of Nicaea in 325 viewed itself as the apex of apostolic teaching, and all subsequent councils, despite elaborations of that *depositum fidei,* framed their theological work, rhetorically, as merely an extension of Nicaea and the apostles. As will be discussed below, the mausoleum of the Holy Apostles described by Eusebius in his *Life of Constantine*—wherein Constantine's sarcophagus was ritually surrounded by symbolic tombs of the twelve apostles—represents less a personal statement of the emperor's faith than a very public and triumphant expression of the cosmic fulfillment of the apostolic mission in the person and office of Constantine himself.[16]

For Eusebius, the history of the Church, from the explosive apostolic age to the tranquility of the Constantinian *saeculum,* was evidenced primarily by a slow and steady increase in ecclesiastical solidity throughout the Mediterranean. Eusebius's very mode of structuring his *Ecclesiastical History* revolves around the patriarchates of pristine, ancient Christianity. These patriarchates—Antioch, Alexandria, Rome, and Jerusalem (Constantinople had not yet been founded)—are the anchors of the Christian world, the bulwarks of an emergent Christian imperial consensus in the 320s. Indeed, time itself, for Eusebius, is measured not by emperors' reigns or by the traditional Seleucid era—even though he was familiar with all of the prevailing modes of timekeeping—but by the succession (the διαδοχή) of bishops in these four illustrious sees, from the time of the apostles up to his present day.

Of the dates of bishops at Jerusalem I have not found any surviving written evidence—the story is that they were quite short lived—but I have received as much as follows from archives, that up to the siege of the Jews in the time of Hadrian [ca. 130 CE] there had been a series of fifteen episcopal successions (ἐπισκόπων διαδοχαί) there. All are said to have been Hebrews in origin, having received

Life and Miracles of Thekla: A Literary Study, Hellenic Studies 13 (Washington, DC, and Cambridge, MA, 2006). English translation of the *Miracles* in A.-M. Talbot and S. F. Johnson, *Miracle Tales from Byzantium,* DOML 12 (Cambridge, MA, 2012).

16 See below and the discussion in Johnson, *Literary Territories,* 107–11.

the knowledge of Christ with all sincerity, so that those with the power to decide such matters deemed them worthy of episcopal service. The whole church in their day comprised believing Hebrews, from the time of the apostles down to the time of the final siege, in which the Jews again fought back against the Romans and were defeated in a not insignificant war. Since this point marked the end of the bishops of the Circumcision, it is necessary here to list them from the first.

Τῶν γε μὴν ἐν Ἱεροσολύμοις ἐπισκόπων τοὺς χρόνους γραφῇ σῳζομένους οὐδαμῶς εὑρών [κομιδῇ γὰρ οὖν βραχυβίους αὐτοὺς λόγος κατέχει γενέσθαι], τοσοῦτον ἐξ ἐγγράφων παρείληφα, ὡς μέχρι τῆς κατὰ Ἀδριανὸν Ἰουδαίων πολιορκίας πεντεκαίδεκα τὸν ἀριθμὸν αὐτόθι γεγόνασιν ἐπισκόπων διαδοχαί, οὓς πάντας Ἑβραίους φασὶν ὄντας ἀνέκαθεν, τὴν γνῶσιν τοῦ Χριστοῦ γνησίως καταδέξασθαι, ὥστ' ἤδη πρὸς τῶν τὰ τοιάδε ἐπικρίνειν δυνατῶν καὶ τῆς τῶν ἐπισκόπων λειτουργίας ἀξίους δοκιμασθῆναι· συνεστάναι γὰρ αὐτοῖς τότε τὴν πᾶσαν ἐκκλησίαν ἐξ Ἑβραίων πιστῶν ἀπὸ τῶν ἀποστόλων καὶ εἰς τὴν τότε διαρκεσάντων πολιορκίαν, καθ' ἣν Ἰουδαῖοι Ῥωμαίων αὖθις ἀποστάντες, οὐ μικροῖς πολέμοις ἥλωσαν. διαλελοιπότων δ' οὖν τηνικαῦτα τῶν ἐκ περιτομῆς ἐπισκόπων, τοὺς ἀπὸ πρώτου νῦν ἀναγκαῖον ἂν εἴη καταλέξαι.[17]

Eusebius does not operate with an abstract notion of universal chronological time. Hadrian's siege and destruction of Jerusalem are dated only by the fifteen successions of bishops of Jerusalem from the apostles to that moment.[18] Thus, in the *Ecclesiastical History* (very differently from his *Chronicle*), the events of the secular world become subservient to the appearance of the incarnate Christ and, especially, to the founding of God's bulwark churches by the apostles. This historiographical artifice, what we might call "apostolic chronology," is employed precisely in order to tell the story of the direct effects of the apostolic mission, which found its resolution in Constantine. History, and time itself, are made to bend to the story of the apostles.

Eusebius's fascination with the apostles as a framing device for his history of the church is taken up with enthusiasm by later historians. Even as John Malalas, writing in the sixth century, structures his chronicle *per annum* from the creation of Adam onward, he diligently includes stories about the activities of the apostles, drawn mostly from the book of Acts and from Eusebius, but also directly from apocryphal literature. Peter's epic battle with Simon Magus is a centerpiece of his apostolic section.[19] Malalas's seamless merging of canonical, historical, and apocryphal evidence into a coherent narrative is not at all unusual. The pattern set by Eusebius has, by Malalas's day, become an ingrained habit of mind for thinking about the apostolic age. Similar patterns of combining apostolic traditions into a historical continuum are employed by historians like George Synkellos in the ninth century, writing in Greek, and Michael the Syrian in the twelfth century, writing in Syriac.[20] These patterns of thought established in late antiquity for dealing with the advent of the apostles into biblical redemptive history became assumed ways of looking at the whole of world history for Byzantine chroniclers.

Probably the most fundamental pattern of thought with regard to the apostolic age was the distribution of the apostles to various parts of the world.[21] This was an extremely common motif in late antiquity and Byzantium, and one that

17 *HE* 4.5.1–4.5.2; G. Bardy and L. Neyrand, eds., *Eusèbe de Césarée: Histoire ecclésiastique*, 3 vols., 2nd ed., SC 31 (Paris, 2003).

18 I analyze this passage in more detail in S. F. Johnson, "Lists, Originality, and Christian Time: Eusebius' Historiography of Succession," in *Historiography and Identity*, vol. 1: *Ancient and Early Christian Narratives of Community*, ed. W. Pohl and V. Wieser, Cultural Encounters in Late Antiquity and the Middle Ages 24 (Turnhout, 2019), 191–217.

19 Malalas 252–256; L. A. Dindorf, ed., *Ioannis Malalae chronographia*, CSHB 15 (Bonn, 1831). See also E. Jeffreys, M. Jeffreys, and R. Scott, *The Chronicle of John Malalas*, ByzAus 4 (Melbourne, 1986), 133–35.

20 On the incorporation of Old Testament pseudepigrapha into Byzantine chronicles, see E. Jeffreys, "Old Testament 'History' and the Byzantine Chronicle," in *The Old Testament in Byzantium*, ed. P. Magdalino and R. S. Nelson (Washington, DC, 2010), 153–74. On the use of apocrypha in Syriac historiography, see M. Debié, "Les apocryphes et l'histoire," in *Sur les pas des Araméens chrétiens: Mélanges en l'honneur d'Alain Desreumaux*, ed. F. Briquel Chatonnet and M. Debié, Cahiers d'études syriaques 1 (Paris, 2010), 63–76.

21 See Johnson, *Literary Territories*, 79–111.

ended up serving as an organizational principle for texts like that of Isidore. One potent example of this motif is the early Christian and late antique lore surrounding the apostle Thomas. As quoted above, Isidore knew that Thomas was the apostle to India. But there were other traditions as well: for example, that he was the apostle to Persia. Isidore knew both traditions—and others, including the rarely cited Hyrcanians and Bactrians—and he simply combined them together. But if one looks closely into the Syriac traditions about Thomas, one finds a rather clearly bifurcated stream: the one tradition of his sojourn and death in India, treated at length by the Acts of Thomas; and a second tradition that associates him with Edessa and the evangelization of Persia. The latter tradition is connected to both the Abgar Legend and the Mandylion lore: Thomas becomes firmly rooted in Syriac tradition from an early point. But the former tradition associating him with India is early too. And this is not "India" as in "Arabia Felix" (or Yemen), which seems to be the dominant tradition surrounding other apostles, for instance, Bartholomew.[22] Instead, this is the real Indian subcontinent, or at least its northern reaches, and the "Thomas Christians" of today, after many vicissitudes of ecclesiastical alignment, are justified in claiming an early tradition for their namesake's inaugural arrival in India.

The opening of the Syriac Acts of Thomas proves to be an important window on an early stage of the motif:

And when all the apostles had been for a time in Jerusalem—Simon Cephas and Andrew, and Jacob [James] and John, and Philip and Bartholomew, and Thomas and Matthew the publican, and Jacob son of Alphaeus, and Simon the Kananite, and Judas the son of Jacob [James]—they divided the countries among them, in order that each one of them might preach in the region which fell to him and in the place to which his Lord sent him. And India fell by lot and division to Judas

Thomas the Apostle. And he was not willing to go.[23]

ܟܕ ܗܘܐ ܕܝܢ ܐܬܐ ܟܠܗܘܢ ܫܠܝܚܐ ܥܕܡܐ ܠܗܘܢ
ܒܐܘܪܫܠܡ ܫܡܥܘܢ ܟܐܦܐ ܘܐܢܕܪܐܘܣ ܘܝܥܩܘܒ
ܘܦܝܠܝܦܘܣ ܘܒܪ ܬܘܠܡܝ ܘܬܐܘܡܐ ܘܡܬܝ
ܡܟܣܐ ܘܝܥܩܘܒ ܒܪ ܚܠܦܝ ܘܫܡܥܘܢ ܩܢܢܝܐ
ܘܝܗܘܕܐ ܒܪ ܝܥܩܘܒ ܦܠܓܘ ܥܠܗܘܢ ܐܬܪܘܬܐ
ܕܢܐܙܠܘܢ. ܐܝܟܢܐ ܕܢܪ ܚܕ ܚܕ ܡܢܗܘܢ. ܢܟܪܙ
ܒܐܬܪܐ ܕܡܛܝܗ ܘܒܐܬܪܐ ܕܫܕܪܗ ܡܪܗ.
ܘܡܛܬ ܗܘܬ ܠܗ ܠܗܢܕܘ ܒܦܠܓܘܬܐ ܠܝܗܘܕܐ
ܬܐܘܡܐ ܫܠܝܚܐ ܘܠܐ ܨ ܒܐ ܗܘܐ ܕܢܐܙܠ.

Thomas's unwillingness is swiftly dealt with: Jesus himself sells Thomas into slavery, whereupon he is taken to India. All along the route he evangelizes and convinces Indian princes and princesses to take up a celibate Christian life. Importantly, as dramatic and long-lasting as the tradition is, there was only limited awareness of Thomas's association with India in the late antique world. Syriac poets like Ephrem and Cyrillona in the fourth century and Jacob of Serugh in the sixth are aware of it, but other contemporaries, such as the Western pilgrim Egeria who visits Thomas's shrine in Edessa in 384, appear completely ignorant of the Indian side of Thomas's legacy.

The apostolic order related here in the Acts of Thomas is standard and follows more or less the New Testament order in naming the twelve. There are four lists of the original twelve apostles in the New Testament, one in each of the Synoptic Gospels—Matthew, Mark, and Luke— and one in the book of Acts, which gives eleven only, since Judas is no longer among them.[24] Each New Testament list differs slightly, but Peter comes first in each list, and Judas Iscariot comes last when he is mentioned at all.[25] After Peter, the two sons of Zebedee, James and John, along with Andrew and Philip are the most prominent members of the twelve and are, narratively speaking, all early disciples of Jesus. They form together with Peter the first five in each of the New Testament

22 Ibid., 133–37.

23 Acts of Thomas 1; W. Wright, ed., [Syriac] Apocryphal Acts of the Apostles, 2 vols. (London, 1871), 146–298.

24 Matt. 10:1–4; Mark 3:16–19; Luke 6:13–16; Acts 1:13.

25 W. Hatch, "The Apostles in the New Testament and in the Ecclesiastical Tradition of Egypt," HTR 21 (1928): 147: "The one occupies the position of honor at the head of the series; the other is named at the end on account of his treachery."

lists. Andrew, on whom see further below, is one of the first disciples called and, in John, is responsible for bringing his brother Peter to Jesus.[26]

This distribution scene from the Acts of Thomas is chronologically the first surviving list of its type, but the most influential is recounted by Eusebius himself. The passage comes at the beginning of Book 3 of his *Ecclesiastical History*, where he begins narrating the new dispensation of the Christian Church discussed above:

> As the holy apostles and disciples of our Savior were scattered over the whole inhabited world, Thomas, tradition maintains, obtained Parthia for his share, Andrew obtained Scythia, John Asia, in which parts he remained and died at Ephesos. Peter seems to have preached to the Jews of the Diaspora in Pontus, Galatia, and Bithynia, Cappadocia, and Asia, and, in the end, he came to Rome where he was crucified head downward, he himself requesting to suffer in this way. What need be said of Paul, who from Jerusalem as far as Illyricum has fulfilled the gospel of Christ and later was martyred in Rome under Nero? This is word for word what Origen reports in volume 3 of his *Commentaries on Genesis*.

> τῶν δὲ ἱερῶν τοῦ σωτῆρος ἡμῶν ἀποστόλων τε καὶ μαθητῶν ἐφ᾽ ἅπασαν κατασπαρέντων τὴν οἰκουμένην, Θωμᾶς μέν, ὡς ἡ παράδοσις περιέχει, τὴν Παρθίαν εἴληχεν, Ἀνδρέας δὲ τὴν Σκυθίαν, Ἰωάννης τὴν Ἀσίαν, πρὸς οὓς καὶ διατρίψας ἐν Ἐφέσῳ τελευτᾷ, Πέτρος δ᾽ ἐν Πόντῳ καὶ Γαλατίᾳ καὶ Βιθυνίᾳ Καππαδοκίᾳ τε καὶ Ἀσίᾳ κεκηρυχέναι τοῖς [ἐκ] διασπορᾶς Ἰουδαίοις ἔοικεν· ὃς καὶ ἐπὶ τέλει ἐν Ῥώμῃ γενόμενος, ἀνεσκολοπίσθη κατὰ κεφαλῆς, οὕτως αὐτὸς ἀξιώσας παθεῖν. τί δεῖ περὶ Παύλου λέγειν, ἀπὸ Ἱερουσαλὴμ μέχρι τοῦ Ἰλλυρικοῦ πεπληρωκότος τὸ εὐαγγέλιον τοῦ Χριστοῦ καὶ ὕστερον ἐν τῇ Ῥώμῃ ἐπὶ Νέρωνος μεμαρτυρηκότος; ταῦτα Ὠριγένει κατὰ λέξιν ἐν τρίτῳ τόμῳ τῶν εἰς τὴν Γένεσιν ἐξηγητικῶν εἴρηται.[27]

The order Eusebius relates here is unusual: Thomas, Andrew, John, Peter, and Paul. He differs starkly from the Acts of Thomas and includes Paul, who was not one of the twelve and called himself the least (or last) of the apostles.[28] One clue to this puzzle might be that Eusebius includes in this list only the five apostles for whom major Apocryphal Acts were written. In the ninth century, Photius knew the Apocryphal Acts associated with these specific five apostles as a single published collection entitled "The Circuits of the Apostles" (αἱ περίοδοι τῶν ἀποστόλων) authored by a Leucus Charinus.[29] Charinus was already known to Clement of Alexandria (ca. 200) as the purported author of the surviving Acts of John, and two centuries later his name was revered among the Manichaeans as the author of their adopted canonical corpus of the same "big five" Apocryphal Acts.[30] Thus, Eusebius's invocation of the "big five" apostles here demonstrates an important intersection of the literary and geographical. We see between the Acts of Thomas and Eusebius's *Ecclesiastical History* two texts in late antiquity trying to claim the historical validity of the apostolic legacy and doing so by incorporating them into much larger world views. While Eusebius's list serves his grander historical argument about the advent of the apostles and the teleology of the Constantinian *saeculum,* it also reveals more than that. The literature itself relating to the apostles, though occasionally deemed spurious or heretical by Eusebius and others, frames the historical vision of the inheritance of the ministry of Jesus, and is, crucially,

26 Matt. 4:18; Mark 1:16; John 1:40.

27 *HE* 3.1 (Bardy and Neyrand, *Eusèbe de Césarée*).

28 1 Cor. 15:9: "For I am the least/last of the apostles, unfit to be called an apostle, because I persecuted the church of God" (Ἐγὼ γάρ εἰμι ὁ ἐλάχιστος τῶν ἀποστόλων ὃς οὐκ εἰμὶ ἱκανὸς καλεῖσθαι ἀπόστολος, διότι ἐδίωξα τὴν ἐκκλησίαν τοῦ θεοῦ).

29 See Photius *Bibliotheca* cod. 114; R. Henry, ed., *Photius: Bibliothèque*, 9 vols. (Paris, 1959), with a discussion at Klauck, *Apocryphal Acts,* 5–6. See also Burnet, *Douze apôtres,* 45–49. Like Eusebius before him, Photius makes a close investigation of the style of these texts in comparison with the Greek of the New Testament: "of the unified and unpretentious language and the innate grace which is on display in the Gospels and apostolic writings, [the Apocryphal Acts] demonstrate not the least trace" (καὶ οὐδὲν τῆς καὶ αὐτοσχεδίου φράσεως καὶ τῆς ἐκεῖθεν ἐμφύτου χάριτος, καθ᾽ ἣν ὁ εὐαγγελικός τε καὶ ἀποστολικὸς διαμεμόρφωται λόγος, οὐδ᾽ ἴχνος ἐμφαίνων).

30 See P.-H. Poirier, "Les *Acts de Thomas* et le manichéisme," *Apocrypha* 9 (1998): 263–87.

linked by Eusebius to the assigned cartographical locations of their dispersion.

The assignment of the apostles to different geographical regions of the known world had a deep cognitive impact on early Byzantine writers. This is, in effect, "Apostolic Geography," a habit of mind in late antiquity that assigned different regions to different saints, based upon assumptions about how the world was arranged spiritually, stemming precisely from the apostolic inheritance.[31] The connection was made more palpable through the recognized association of the twelve apostles with the twelve tribes of Israel. At the end of Acts 1, the disciples cast lots for who will fill the empty place left by Judas Iscariot—the idea that they would soldier on with only eleven apostles was unthinkable. Matthias is chosen by divine guidance to fill the place. This connection between lot casting and the disciples is very naturally carried over into the assignation of regions for their ministries. The model of Joshua casting lots for the twelve tribes of Israel and assigning them to different areas resonates clearly in the New Testament and in second-century literature. The list of nations represented at Pentecost in Acts 2 reinforces this theme. The casting of lots is further related to divination and to what has been called the *sortes apostolorum*—the motif or institution of the assigning of apostles to different parts of the world.[32] This organization of the *oikoumene* becomes even more striking when the patriographical element of early Byzantine saints' Lives is added to the mix. Different cities and regions are literally "owned" by specific saints, and the saints, even posthumously, continue to guide and protect the inhabitants of the cities like provincial governors (surely one of the models lurking in the background).

A number of early Byzantine texts uses the geographical region assigned to the apostles as the primary datum identifying the apostolic legacy. Some of these identifications are made because the apostle was, according to tradition, the first bishop of a given city or region, but just as often it is the site of their martyrdom or burial.[33] Indeed, this habit developed into a technical literature that took on a life of its own: collections of lists of apostles were drawn up in early Byzantium, similar to Isidore's list discussed above but also more spare, offering what could be described as apostolic hand lists.[34] These Greek texts are largely pseudonymous: one is attributed to Epiphanius of Salamis, the great collector of early Christian heresies in the late fourth century. Another is attributed to Dorotheus, bishop of Tyre, reputed to have been martyred under Licinius in the early fourth century. Another is attributed to Hippolytus of Rome from the third century, and another is preserved as part of the *Chronicle* of Pseudo-Symeon the Logothete.[35] These texts reveal interconnections between themselves in both phraseology and organization, but they all circulated independently. Other anonymous texts represent epitomes of these attributed texts, and translations of portions of all of them are found in Latin, Syriac, and other Christian languages (see Table 1).

The Greek manuscript tradition for Pseudo-Epiphanius goes back to the seventh or eighth century (comparably early), that of Pseudo-Dorotheus to the tenth century, and that of

31 See Johnson, *Literary Territories*, 79–111.

32 This motif has been discussed by I. Czachesz, *Commission Narratives: A Comparative Study of the Canonical and Apocryphal Acts* (Leuven, 2007); E. Junod, "Origène, Eusèbe et la tradition sur la répartition des champs de mission des apôtres (Eusèbe, *Histoire ecclésiastique*, III, 1, 1–3)," in *Les Actes apocryphes des apôtres: Christianisme et monde païen*, ed. F. Bovon (Geneva, 1981), 233–48; and J.-D. Kaestli, "Les scènes inventoriés d'attribution des champs de mission et de départ de l'apôtre dans les Actes apocryphes," in *Les Actes apocryphes de apôtres: Christianisme et monde païen*, ed. F. Bovon (Geneva, 1981), 249–64.

33 See now the comprehensive and authoritative study of the elaboration of these legends for the twelve apostles: Burnet, *Douze apôtres*.

34 Burnet, *Douze apôtres*, 55–64, summarizes these lists and gives editions for the many fragments. Burnet emphasizes how the lists promote a coherent discourse about apostolic mission, even where details are lacking: the lists themselves invoke a notional "ordonnabilité" (Burnet, *Douze apôtres*, 55–56).

35 The majority of the texts are edited in T. Schermann, ed., *Prophetarum vitae fabulosae: Indices apostolorum discipulorumque domini, Dorotheo, Epiphanio, Hippolyto aliisque vindicatae* (Leipzig, 1907), but see the collected articles in F. Dolbeau, *Prophètes, apôtres et disciples dans les traditions chrétiennes d'Occident: Vies brèves et listes en latin*, SubsHag 92 (Brussels, 2012), where he adds several minor Latin texts to the group and reorders their overall priority. See also M. Van Esbroeck, "Neuf listes d'apôtres orientales," *Augustinianum* 34 (1994): 109–99, for editions and translations of lists in eastern Christian languages, superseding the limited discussion of such texts in Schermann, *Prophetarum*.

TABLE I. Main Apostolic Dossier Collections from Byzantium

Pseudo-Epiphanius	MSS from 7th/8th century on
Pseudo-Dorotheus	MSS from 10th century on
Pseudo-Hippolytus	MSS from 10th century on
Latin versions	MSS from 8th century on
Syriac versions	2 MSS from 9th century; 1 MS from 13th century
Georgian versions	2 MSS from 10th century
Armenian versions	MSS from 15th century on

Pseudo-Hippolytus also to the tenth century.[36] Excerpted Latin versions are found from the eighth century.[37] Two Syriac versions are preserved in ninth-century manuscripts.[38] Two tenth-century Georgian versions survive, closely related to the Greek tradition, and five Armenian versions, all in later manuscripts, also stem in large part from the Greek.[39] In terms of their redactional history, it is not hard to imagine the Greek texts finding an eager readership in tenth-century Constantinople amid the cultural indexing project initiated under Constantine VII, and many literal parallels can be found in the *Menologion of Basil II* from the eleventh century.

However, it is also clear from the existence of Latin and Syriac versions that core editions of these texts, at the least, were in circulation well before the tenth century, despite the dates of the surviving Greek manuscripts.[40] Given the very early translation of Eusebius into Syriac

(ca. 400), and also into Latin (via Jerome's translations), one can see how a systematization of the material Eusebius provides in the *Ecclesiastical History* would have been deemed valuable.[41] Jerome's own *De viris illustribus,* based in large part on Eusebius, points strongly in that direction: besides its suggestive form as collective biography, phraseology in Jerome matches specific phraseology found in both the Greek and the Latin apostolic catalogues at various points. By extension, Isidore of Seville draws heavily on Jerome in preparing his catalogue of prophets and apostles, completing a chain of influence across the late antique world.[42]

These texts are fascinating for the manner in which they elaborate the posthumous *longue durée* trajectories of the apostles. They often contradict each other and the redactors often, according to their own purposes, draw contemporary attention to, or away from, certain regions. Above all, this technical literature instantiates broader habits of thought and writing in late antiquity and early Byzantium. The tendency to systematize in the tenth century, what some have labeled Byzantine antiquarianism, was not at all new to the period or the culture, but in late antiquity it took different forms than it did later.[43] This is where the

36 Schermann, *Prophetarum.*

37 Ibid.; and Dolbeau, *Prophètes.*

38 Van Esbroeck, "Neuf listes." See also M. Van Esbroeck, "Deux listes d'apôtres conservées en syriaque," in *III Symposium Syriacum, 1980: Les contacts du monde syriaque avec les autres cultures (Goslar 7–11 Septembre 1980)*, ed. R. Lavenant (Rome, 1983), 15–24.

39 Van Esbroeck, "Neuf listes."

40 Ibid., 111, notes the desideratum of working out the genealogy of these texts, which he was not able to fulfill before his untimely death in 2003. Dolbeau, *Prophètes,* has largely achieved this within the Latin tradition. However, the relationship of all the versions to the surviving Greek exemplars has not been satisfactorily explained, an especially difficult task given the numerous versions in Eastern Christian languages published since Shermann, *Prophetarum.* In some cases, as Van Esbroeck notes, it appears that the Eastern versions retain an earlier tradition than either the Latin or Greek, and it may even be the case that the surviving Greek manuscripts (or portions of them) represent retranslations from Syriac or Georgian.

41 Indeed, an apostolic list attributed to Eusebius survives in a Syriac manuscript in the British Library dated to 1203 (Or. 2695): see Van Esbroeck, "Neuf listes." Similar Syriac texts appear elsewhere, e.g., Cambridge BSMS 446, described in J. F. Coakley, *A Catalogue of the Syriac Manuscripts in Cambridge University Library and College Libraries Acquired since 1901* (Cambridge, 2018), 170.

42 On the Latin tradition generally, see Dolbeau, *Prophètes.*

43 See Johnson, *Literary Territories,* 1–16, with special reference to Paolo Odorico, "La cultura della Συλλογή. 1) Il cosiddetto enciclopedismo bizantino. 2) Le tavole del sapere di

geographical perspective becomes especially valuable. As the Roman Empire was still in the process of Christianization, from the fourth to sixth century, ecclesiastical hierarchies across the Mediterranean were looking for historical justification for their existence and especially for their preeminence.[44] In terms of the "Mediterranean Church," a concept that is arguably definitive of late antiquity, the geographical components of apostolic lists gesture towards a shared "global village," whereby the inheritance of the apostolic landscape was intellectually parceled out and mutually agreed upon. As expected, there are numerous minor contradictions in the tradition, but the main lines of the distribution are remarkably stable between texts.

This parceling out for the sake of preeminence and jurisdiction went hand in hand with the reparceling and resystematization of the *oikoumene* as a known world in terms of mental cartography. While many geographical data stayed the same, the apostolic mission brought into relief several areas that had previously been labeled as unknown or even unknowable. This does not require a romantic picture of the apostles as intrepid explorers of the feral wastes surrounding the ancient world, though surely a few were explorers of a type, and later generations certainly took to very unfamiliar roads (such as the Silk Road) in order to spread the gospel in new territories.[45] Rather, the known world as a cognitive landscape changed, and in some cases what was before thought of as unknown or unknowable became newly available to the minds and imaginations of late antique writers. One might say that the process of Christianizing the Greco-Roman *oikoumene*, geographically, supported

and ran in parallel to the historical vision of writers like Eusebius, who saw inaugurated in the era of the apostles a new *saeculum* of freedom of expression and movement. In the words of Psalm 23/24:1, quoted by John Chrysostom in a homily on the apostles, "The earth is the Lord's and the fullness thereof."[46]

However, in order to really cover the *oikoumene*, and to extend its bounds, the twelve apostles were not enough. Thus, the early Byzantine apostolic lists began to incorporate the number 70 (or 72) given to the larger group of disciples mentioned in the Gospels. But a further problem ensued: these seventy are not named individually but only cited as a group, the greater apostolic *collegium*, sent out by Jesus in Luke 10, two by two to preach the arrival of the Kingdom of God, to heal the sick, and to cast out demons. Rather than invent names out of whole cloth, early Byzantine cataloguers used recognized names they had at hand in the New Testament and invented cartographical trajectories for them, sometimes based on bits and pieces from apocryphal literature and from Eusebius. All the individuals, for instance, thanked by Paul in the closing parts of his letters were fair game.[47] Each one of them, in fact, was deployed to serve the canonical number of seventy and fill out the catalogue of the "global village" of apostolic mission. In some cases, specific commissionings by other apostles (or even martyrologies) are recorded as well. A typical example reads like the following, taken from the catalogue of Pseudo-Dorotheus:

> 20. Andronikos, whom the Apostle [Paul] makes mention of in his [Epistle] to the Romans, was bishop of Spain.

Giovanni Damasceno," *BZ* 83 (1990): 1–21. See also C. Rapp, "Byzantine Hagiographers as Antiquarians, Seventh to Tenth Centuries," in *Bosphorus: Essays in Honour of Cyril Mango*, ed. S. Efthymiadis, C. Rapp, and D. Tsougarakis, *ByzF* 21 (Amsterdam, 1995), 31–44.

44 On the formation of the patriarchal "pentarchy," see Dvornik, *Byzantium and the Roman Primacy*, 101–23.

45 A version of these apostolic lists has been found among the Sogdian Christian manuscripts of Turfan, in western China: see N. Sims-Williams, "Traditions Concerning the Fates of the Apostles in Syriac and Sogdian," in *Gnosisforschung und Religionsgeschichte: Festschrift für Kurt Rudolph zum 65. Geburtstag*, ed. H. Preißler and H. Seiwert (Marburg, 1994), 287–95.

46 Dvornik, *Idea of Apostolicity*, 146. The great Syriac poet Ephrem (d. 373) calls the apostles "the twelve husbandmen of the whole world": S. H. Griffith, "The Marks of the 'True Church' according to Ephraem's Hymns Against Heresies," in *After Bardaisan: Studies on Continuity and Change in Syriac Christianity in Honour of Professor Han J.W. Drijvers*, ed. G. J. Reinink and A. C. Klugkist (Leuven, 1999), 129.

47 On the similar process of finding names for "nameless" persons in the New Testament (e.g., the Wise Men), see B. Metzger, *New Testament Studies: Philological, Versional, Patristic* (Leiden, 1980), 23–46. Eusebius, for his part, says no list of the 70 can be found: *HE* 1.12 (Bardy and Neyrand, *Eusèbe de Césarée*).

21. Amplias, whom the same [Apostle Paul] also makes mention of in his [Epistle] to the Romans, was bishop of Odessos.

22. Ourbanos, whom the same [Apostle Paul] also makes mention of in his [Epistle] to the Romans, was bishop of Macedonia.

23. Stachys, whom the same [Apostle Paul] also makes mention of in his [Epistle] to the Romans, the Apostle Andrew sailing across the Black Sea made, in Thracian Argyropolis, bishop of Byzantion.

κ'. Ἀνδρόνικος, οὗ ὁ ἀπόστολος μέμνηται ἐν τῇ πρὸς Ῥωμαίους, ὃς καὶ ἐπίσκοπος Σπανίας ἐγένετο.

κα'. Ἀμπλίας, οὗ καὶ αὐτοῦ μέμνηται ἐν τῇ πρὸς Ῥωμαίους, ὃς καὶ ἐπίσκοπος Ὀδυσσοῦ ἐγένετο.

κβ'. Οὐρβανὸς, οὗ καὶ αὐτοῦ ἐν τῇ πρὸς Ῥωμαίους μέμνηται, ὃς ἐπίσκοπος Μακεδονίας ἐγένετο.

κγ'. Στάχυς, οὗ καὶ αὐτοῦ ἐν τῇ πρὸς Ῥωμαίους μέμνηται, ὃν καὶ Ἀνδρέας ὁ ἀπόστολος τὴν Ποντιδικὴν θάλασσαν διαπλέων ἐν Ἀργυροπόλει τῆς Θράκης ἐπίσκοπον τοῦ Βυζαντίου κατέστησεν.[48]

In addition to the disembodied names from Paul's letters, all of Paul's missionary companions, such as Barnabas, Timothy, and Titus, are given their own specific part of the map and included in the complete collegium of the seventy. Likewise, the two Gospel writers who were not part of the twelve, the evangelists Mark and Luke, have their important roles to play: Mark becomes bishop of Alexandria, and Luke is most often associated with Thebes. This enlarged collegium allowed, in fact, for boutique texts that collected, for example, only the four evangelists and told their brief narratives and gave the locations of their ministry and burial. Other less obvious combinations were made, such as the addressees of Paul's pastoral letters, Timothy and Titus, as a pair. Such boutique mini-catalogues circulated independently, and, unlike in Isidore, they are often not subsumed by other encyclopedic catalogues but rather are

included as individual texts on leaves of the same codex, forming something like a dossier of apostolic archives—which is, in actuality, how they were being treated. From this point of view one begins to see how it might have been possible, first, to select only Andrew, Luke, and Timothy to be interred in the church of the Holy Apostles in Constantinople: perhaps a boutique text was circulating in the fourth century that dealt with precisely those three apostolic personages. It is not out of the question, even if no exemplar survives (see further below). But second, one can see how, after the fact of their deposit, texts could be added to the dossiers—literally stitched into the codices of larger collections—which provided authentication for this mini-collegium's presence in the capital. Mixing and matching biographical notices across catalogues, and even rewriting them for the sake of the new circumstances of their relic deposits, would not have been difficult and, indeed, must have happened frequently.

The Pseudo-Dorotheus passage just quoted includes an etiology for the see of Constantinople. This bishopric obviously has a strong resonance among Byzantinists. Furthermore, in the context of this volume on the church of the Holy Apostles, the apostolic heritage of Constantinople is especially important. The commingling of the apostolic heritage with assertions of imperial power had a long life in Byzantium, and the roots of these ideas go back to the earliest period.

In his 1958 Dumbarton Oaks monograph on *The Idea of Apostolicity in Byzantium and the Legend of the Apostle Andrew,* Father Francis Dvornik dealt with the dating of the legends about Andrew and the apostolic bishopric of Byzantion in a systematic and thorough way, though with some conclusions that, today, seem less convincing.[49] Dvornik dated Pseudo-Epiphanius to the mid-eighth century and Pseudo-Dorotheus to the early or mid-ninth. These dates put the texts rather close to the first surviving manuscripts, which would appear sound. However, Dvornik's reasoning was centered around an arbitrary datum: the fact that the *Chronicon Paschale* from the seventh century does not cite either text was

48 Schermann, *Prophetarum,* 137.

49 Dvornik, *Idea of Apostolicity.* See now the survey of legends and literature surrounding Andrew in Burnet, *Douze apôtres,* 257–303.

proof, for Dvornik, that these two did not exist in his day.[50] This seems, perhaps, to privilege an argument from silence. Elements of these texts, if not the full-blown Andrew legend, were in circulation much earlier, as demonstrated above.[51] There is good reason to assign many apostolic legends, particularly those explaining the origins of specific sees, to a period in which conflict between patriarchates came to the fore. The fourth to fifth century, a period of high theological controversy between bishoprics, is also the age when apostolic legends became prominent and accepted. It is clear that collections of both apostolic apocrypha and bishop lists were in circulation by the fifth century throughout the Mediterranean (and earlier than that in some quarters). Why should the Pseudo-Epiphanius and Pseudo-Dorotheus texts not belong to a more continuous early Christian trend in apostolic literature? The manuscripts of these texts may be medieval, but the thought and mode of organization are apparent earlier. In particular, Dvornik's association of these collections with the Iconophile cause during and after Iconoclasm seems to be overthinking the problem.[52] At the same time, Dvornik is absolutely correct to assert that in the two centuries following the founding of Constantinople, there was precious little attention paid to Andrew in the capital.[53] Surviving texts suggest that no attempt was made in the fourth and fifth centuries to connect the bishopric of Constantinople to the apostle Andrew.

The subsequent work of Glanville Downey, Cyril Mango, Ihor Ševčenko, and most recently Mark Johnson has to a great degree nuanced the problem by focusing on the founding of the church of the Holy Apostles.[54] These scholars

have highlighted the imperial endeavor that, at root, was the church of the Holy Apostles and was not considered at the time to be the symbol of the apostolic see that it came to represent later. Indeed, the tangible association in this complex between apostolic memory and imperial authority is one of its most fascinating aspects.[55] Mehmed the Conqueror's decision to raze the monument and put his own mausoleum on the very spot was not only a replacement of the Byzantine emperor with the conquering sultan, it was an intentional erasure of a key aspect of Byzantine polity, the apostolic legacy as displayed in the imperial office.[56]

The deposition of apostolic relics in the Church in the fourth century—those of Andrew, Timothy, and Luke—would seem to contradict Dvornik's claim that Andrew was not associated with the see of Constantinople. But the addition of these relics to the church of the Holy Apostles does not coincide with the texts discussed above: Andrew's bones may have been in Constantinople, but the apostle Andrew himself, in the minds of these writers, was appointed elsewhere, as Dvornik himself demonstrates. Indeed, writers coming after the deposition of these relics—for example, John Chrysostom and Theodoret of Cyrrhus—almost universally, following early traditions, assign Achaia, sometimes specifically Patras, to the apostle Andrew.[57]

Chrysostom is a particularly interesting case. First, he knows of the relics of Andrew in the mausoleum, which he calls, charmingly, "the vestibule of the fisherman."[58] Second, Chrysostom has a clear predilection for the apostle Timothy, whom he took as his own patron and whom he calls "the second Paul" with reverence.[59] Third, Chrysostom is the first Greek writer to offer a commentary on the book of Acts, recognized in antiquity to have been written by Luke the Physician.[60] So he admires and respects all three

50 Dvornik, *Idea of Apostolicity*, 165–66, 176.

51 Indeed, Dvornik himself argues that the section from Pseudo-Epiphanius that deals, like Isidore, with the patriarchs and prophets of the Old Testament is early and may, in fact, be from Epiphanius himself. Remarkably, he goes even further, suggesting that the patriographical text on which that section of Pseudo-Epiphanius is based was originally an "Aramaic" text from Syria—this has, to my knowledge, no external basis, and rests completely on the supposition of Lipsius-Bonnet that all apostolic literature originated in Syria or Egypt. See Dvornik, *Idea of Apostolicity*, 178.

52 Ibid., 178–80.

53 Ibid., 140.

54 See the survey of scholarly opinions, with bibliography, in M. Johnson, *The Roman Imperial Mausoleum in Late Antiquity* (Cambridge, 2009), 107–11.

55 See Mark Johnson's chapter in the present volume.

56 See Julian Raby's chapter in the present volume.

57 Dvornik, *Idea of Apostolicity*, 146–48.

58 Ibid., 140.

59 Ibid., 144.

60 See A. L. Berry Wylie, "John Chrysostom and His Homilies on the Acts of the Apostles: Reclaiming Ancestral Models for the Christian People" (PhD diss., Princeton Theological Seminary, 1992). On Chrysostom on Paul and Acts, see M. M.

apostolic saints, knows their relics are buried in the church, and points his Constantinopolitan congregation toward them as exemplars of the faith. But he never unduly aligns or confuses their individual *sortes,* their assigned locations of commission and ministry, with the last resting place of their relics. To put it another way, for Chrysostom (even while he was patriarch of Constantinople), relics and their deposition were not the cognitive tools of orientation that were the *sortes apostolorum.*

It is all the more fascinating, therefore, that the bones of Chrysostom himself, after his death in exile, were brought back to Constantinople by Theodosius II and were interred in the church of the Holy Apostles on 27 January 438.[61] His surprising interment alongside the apostolic saints— the first of several Byzantine patriarchs to be interred in the church—was a rehabilitation of his legacy after the death of Eudoxia and a sign of his apostolic authority as bishop. So significant was Chrysostom's unique interment that Dvornik sees in that single act—and not in the deposition of Andrew, Timothy, and Luke, a century earlier— the origins of the apostolic authority of the Constantinopolitan patriarch.[62] Thus, this inaugural act in Constantinople, postdating the construction of the church of the Holy Apostles by a hundred years, was itself the seed of the Andrew legend, rather than the deposition of Andrew's relics in the fourth century. The fifth-century awakening is crucial for understanding the trajectory of the Holy Apostles in subsequent centuries.

On this basis could we suggest that, in the fourth and fifth centuries, relic discovery and deposition does not, in fact, coincide with the mental habit of apostolic geography discussed above? As a general statement that is probably going too far: some places assigned to apostolic personages in this period, even if not mentioned in apostolic lists, certainly became sites of their relics and cult. However, it is clear that there are

two different streams of the cognitive claiming of space: the assigning of apostles to specific places in literature and the physical elaboration of memory via relics and buildings. They overlap and intersect at times, but they are not identical with one another. The widely circulating lists of the seventy apostles represented by Pseudo-Epiphanius and Pseudo-Dorotheus, when given the opportunity to do so, do not connect these two streams of thought. It is only once hagiographical texts like the *Narratio* of Andrew's career and martyrdom become proof texts for calling Constantinople "apostolic"—as in certain laws of Heraclius, and at the Sixth Ecumenical Council in 680—that this connection starts to be made.[63] Unsurprisingly, the *Narratio,* though it circulated independently, is principally known today as an addendum to Pseudo-Dorotheus's catalogue of disciples, following exactly the pattern of textual augmentation, rather than harmonization, described above.

It is helpful to push back against a Byzantine teleology that presumes a linear development of literary embellishment. The example of the church of the Holy Apostles in Constantinople shows that claims to apostolicity in the fourth century were not made in the same way as similar claims in the seventh and later. And even in those later centuries claims about relics were not the only way apostolicity could be explained. The apostolic heritage was being worked out through various means over a long period. Just as occurred in the Apocryphal Acts of the third century, early Byzantine texts filled out the mental world of apostles in an intentional and creative manner, and with equally various expressions.[64] This observation ultimately speaks to underlying processes of textual engagement—the mental hold that canonical scripture held on the thought world of the period—and, at the same time, it shows how new literary and geographical paradigms became frameworks for the working out of theories of *oikoumene,* ecclesiastical authority, and empire itself.

Mitchell, *The Heavenly Trumpet: John Chrysostom and the Art of Pauline Interpretation,* Hermeneutische Untersuchungen zur Theologie 40 (Tübingen, 2000).

61 Dvornik, *Idea of Apostolicity,* 154.

62 Ibid., 155. Chrysostom's interment preceded the parallel act of interring another unlawfully deposed bishop, Flavian of Constantinople—interred by Pulcheria in 451, in the context of the Council of Chalcedon.

63 On Heraclius and "apostolic" Constantinople, see Dvornik, *Idea of Apostolicity,* 162.

64 Once again, Metzger's study of the "nameless" figures of the New Testament is evidence of how creative the process was even at the most basic cognitive level: Metzger, *New Testament Studies,* 23–46.

Apostolic Succession and Byzantine Theology

GEORGE E. DEMACOPOULOS

*T*HIS ESSAY OFFERS AN EXAMINATION OF THE CONCEPT OF APOSTOLIC succession in Byzantine theology in order to understand, more comprehensively, the significance of the Constantinopolitan church of the Holy Apostles. Primarily, it does so by assessing the connection between apostolic authority and orthodoxy, by evaluating the extent to which bishops alone were thought to possess the ability to bind and loose sin, and by examining the ways that the rhetoric of apostolic privilege functioned as a discourse of power and exclusion. Because the broader goal of the symposium and this volume is to understand what the actual church of the Holy Apostles meant for the Byzantines, this essay also considers aspects of cultic devotion to the apostles in Constantinople to illuminate further the ways that the memory of the apostles functioned as a kind of ritualized succession in Byzantine religious life.

From the outset, we must note that "apostolic succession" is largely a modern category, reflecting debates between Catholics and Protestants. As a result, many of the theological assumptions regarding apostolic succession that modern readers might expect to have been central to the precept were, upon closer inspection, rarely discussed in the late ancient or Byzantine church.[1] This is not to say that the basic principles of apostolic succession were unknown, but simply to acknowledge that a genuine "theological defense" of the category seldom appears in Byzantine writing. Thus, this essay argues that even though it was commonplace for Byzantine writers to link their theological positions to that of the apostles, there is little evidence that post-Constantinian authors thought that apostolic succession would, in and of itself, preserve orthodoxy. In fact, Byzantine authors were as likely to undermine (or at the very least nuance) the principles of apostolic succession as they were to endorse them explicitly.

Historical Background

As is generally well known, the idea of apostolic succession stretches back to the second century, when Irenaeus of Lyon advanced it as a principle that preserved authentic Christian teaching against the innovations of heresy. For Irenaeus, the difference between orthodoxy and heresy is a difference between those who adhere to apostolic teaching and those who do not; and the best way to guarantee that a community remains true to apostolic teaching is if its leaders—for Irenaeus this meant bishops—could trace their spiritual pedigree back to an apostle.[2] It is worth noting that Irenaeus's brief comments

1 For example, to my knowledge, no Greek author ever discusses the idea that apostolic grace is delegated from one bishop to another through the rite of ordination. As we will see, Pseudo-Dionysius, who wrote perhaps the most influential book regarding mystical authority of the clergy—*Ecclesiastical Hierarchy*—never directly links the authority of priesthood to the apostles.

2 Irenaeus, *Against Heresies* 3.1–3. For a consideration of the likelihood that Irenaeus's list of successors is purely symbolic and does not constitute an actual historical progression, see J. Behr, *Irenaeus of Lyon: Identifying Christianity* (Oxford, 2015).

leave no conceptual space for the possibility that a bishop who lies within a chain of succession might, himself, fall into theological error.[3]

Not everyone in the early church shared Irenaeus's optimism about the theological safeguards of episcopal succession. The most famous critic was Tertullian who, by the end of his life, believed that bishops who failed to enforce the moral precepts of the faith lost theological insight and also the authority to bind and loose sin.[4] As we will see, similar challenges to the moral and teaching authority of the episcopate would emerge from prominent voices in the Byzantine period, including Gregory of Nazianzos and, especially, Symeon the New Theologian.

Tertullian aside, many early Christian authors shared Irenaeus's view that the correct faith was preserved by a chain of succession stretching to the apostles.[5] The Church historian Eusebius writing in the early fourth century, well reflects this, when he produced lists of episcopal succession in several "apostolically founded" churches, including Rome, Alexandria, Antioch, and Jerusalem.[6] For his part, Gregory the Great (bishop of Rome from 590 to 604) claimed that the bishops of his day held the place of the apostles.[7] And there is little doubt that authority in dogmatic matters rested with the episcopate throughout the Byzantine era—one need look no further than the role that the synod of bishops, especially the ecumenical councils, played in establishing Orthodox teaching. Even the most meddlesome of Byzantine emperors recognized the need to work through the episcopal assembly whenever they sought to set imperial religious policy.

Without question, the most sophisticated—if indirect—theological reflection on the spiritual authority of the episcopate came from Pseudo-Dionysios, who emphasized the role of "hierarchy" (a term he coined) to mediate the knowledge and mysteries of God within a great chain of being that enabled deification and salvation.[8] Two dimensions of Dionysius's thought are especially relevant: first, although his concept of hierarchy is both rich and slippery, for Dionysius, the human hierarch—in other words the bishop—is important because he participates in a process of divinization that brings the mystery of God to every Christian through the sacraments.[9] But, perhaps even more significantly, Dionysius never explicitly links the episcopal hierarch (or even the category of hierarchy) to apostolicity or apostolic succession.[10] In other words, while Dionysius emphasized the importance of the hierarch and bound that importance to the sacraments, he never explicitly spoke of the bishop's sacramental authority as having any connection to the apostles.

What is all the more noteworthy is that when we turn that distinction back upon earlier authors, we notice that all of the pre-Constantinian authors who discuss the authority connected to apostolic succession did so exclusively within the parameters of theological teaching. Put another way, Irenaeus never linked the sacramental role of the clergy to any kind of apostolic pedigree.[11] The

3 Succession for Irenaeus draws from the idea current in Stoic philosophical schools, see A. Brent, "Diogenes Laertius and the Apostolic Succession," *JEH* 44 (1993): 367–89.

4 Tertullian was a hardliner on moral issues and lost faith in the idea of apostolic succession when both Pope Callixtus and the bishop of Carthage readmitted to communion individuals who had committed grievous sins. Specifically, he accused them of readmitting fornicators and murderers to the Church. Tertullian, *De pudicitia* 21.

5 Cyprian of Carthage offers a prime example in that he, like Irenaeus, employs the concept of a succession of bishops from the apostles as the key differentiating factor between orthodoxy and heresy. Cyprian, *Ep.* 69 and 75.

6 Eusebius, *Church History*, book 3.

7 Gregory the Great, *Hom. Evang.*, 26. See Demacopoulos, *Gregory the Great: Ascetic, Pastor, and First Man of Rome* (Notre Dame, 2015), 37.

8 See A. Purpura, *God, Hierarchy, and Power: Orthodox Theologies of Authority from Byzantium* (New York, 2017).

9 In Dionysius, the category of hierarchy often simultaneously refers to both the cosmic hierarchy and the personal hierarch who fills a specific role in mediating between the cosmic and the human. See, especially, his introduction to the *Ecclesiastical Hierarchy*, where he acknowledges this: *EH* 1.2–5.

10 To be sure, one might argue that he does so indirectly by asserting his personal authority through the guise of the pseudonymity of apostolicity, by figuring himself as the disciple of the apostle Paul. In the *Ecclesiastical Hierarchy*, Dionysius does speak of our knowledge of the divine coming to us in the form of the scriptures and those sacred initiators, presumably the apostles, who provided them also conveyed additional information (*EH* 1.4). See C. Stang, *Apophasis and Pseudonymity in Dionysius the Areopagite: "No Longer I"* (Oxford, 2012).

11 On this point, Hippolytus offers an important and complicated early Christian exception in that he linked the grace to teach to the high priesthood. As Brent has shown, however, even though he asserts this claim in the *Apostolic Tradition*, his own activity and the way in which he was subsequently viewed within Rome suggests that the sacramental link was not

same is true of the Pseudo-Clementines, which are a collection of third- and fourth-century apocryphal texts that situate St. Peter in Rome and, in a subset of these texts, connect him to his eventual successors.[12] In the Pseudo-Clementines, even the authority to "bind and loose sin" is understood to concern ruling and interpreting—it is not about the actual forgiveness of sins. In other words, in the pre-Constantinian period those texts that most directly connect the episcopate to an apostolic pedigree do so in order to emphasize the teaching rather than sacramental authority of bishops.[13]

Analyzing this distinction between teaching and sacramental authority of the clergy, it is noteworthy that the same distinction carries forward into the famous fourth-century pastoral treatises. For Athanasius, Ambrose, Gregory of Nazianzos, or John Chrysostom there is no explicit relationship between the precept of apostolic succession and the eucharistic role of the clergy.[14] For these authors, it was the ancient Jewish priesthood, not the apostles, who served as the models for the clergy.[15]

Moreover, whereas Irenaeus simply assumed that a bishop in apostolic succession would preserve theological orthodoxy, by the late fourth century few of the leading voices of the Nicene church would agree. For Athanasius, Gregory of Nazianzos, and Basil of Caesarea, the Arian controversies had made it all too clear that episcopal succession did little, in and of itself, to guarantee that bishops could discern the difference between orthodoxy and heresy. The most explicit—and biting—reflection on this point came from Gregory of Nazianzos, who insisted that it was intense reflection and ascetic detachment, not episcopal election, that guaranteed proper teaching.[16] In one of his most intriguing considerations of this point, he rejected the popular opinion that the apostles had been uneducated fishermen. Instead, the apostles were masters of rhetoric who possessed such eloquence that they were able to convert entire kingdoms. According to Gregory, any bishop who lacked rhetorical competence was unworthy to claim an apostolic pedigree.[17] As far as he was concerned, the world was full of incompetent bishops who were ruining the church.[18]

important. Hippolytus, *Apostolic Tradition* 3.2–4. See Brent, "Diogenes Laertius," 367–89. Brent (pp. 386–88) also quotes the letter known as 1 Clement, which, although it does not employ the terminology for apostolic succession, does speak of the apostles choosing successors so that their "ministry" might be continued.

12 On the lack of sacerdotal concern in the Pseudo-Clementines, see Brent, "Diogenes Laertius," 377–79.

13 Brent, "Diogenes Laertius," 379.

14 John Chrysostom offers a prime example. Although he describes the priesthood as an order superior to that of the angels by virtue of the fact that the priest confers salvation through the sacraments, he never connects the institution of the priesthood to the apostles.

15 The apostles functioned as models for episcopal roles as teachers and spiritual guides. Ambrose, *De officiis* 1.50, models the sacramental role within the Jewish priesthood. Nazianzos, *Oration* 2; Chrysostom, *On the Priesthood*. Chrysostom's *On the Priesthood* does acknowledge the unique authority of Peter and speaks "of his successors" meaning all priests (pp. 53–54 in the trans.). In this passage, it is about caring for the sheep, the teaching and shepherding role. There is no discussion of sacraments in this context. See also Athanasius, *Ad Dracontium*, which differentiates between the bishops who confer salvation through the sacraments and monks who cannot, but makes no connection to the apostles. The connection between apostolic succession and the validity of the sacraments was first made by Augustine of Hippo in the early 5th century. But given that Augustine was not translated into Greek until the 13th century, we should not view him as a likely source for Byzantine theological reflection on this point. With respect to the connection

between apostolic succession and the sacramental authority of the clergy, Augustine argued that so long as the priest or bishop accepted the dogmatic teaching of the faith, his sacraments were assured of the vitality, regardless of the personal character of the priest. On the reception of Augustine in the Christian East, see G. Demacopoulos and A. Papanikolaou, "Augustine in the East," in *Orthodox Readings of Augustine*, ed. G. Demacopoulos and A Papanikolaou (Crestwood, NY, 2008), 11–40.

16 See G. Demacopoulos, "Leadership in the Post-Constantinian Church According to St. Gregory Nazianzen," *Louvain Studies* 30 (2005): 223–39, and *Five Models of Spiritual Direction in the Early Church* (Notre Dame, 2007), 51–81.

17 "If these men were not skilled with words, as you claim, how could they have succeeded in converting kings, cities, and assemblies?" *On Himself and the Bishops*, vv. 237–38. This is not to say that apostolic succession was unrelated to spiritual insight or Orthodox teaching—rather, it is to say that for someone like Gregory of Nazianzos, apostolic succession alone was not enough to guarantee anything. Like many of his contemporaries, Gregory simply took for granted that the episcopate had authority in doctrinal matters. For him, the debate concerned how one knew which type of bishop was to be trusted. See Demacopoulos, "St. Gregory Nazianzen."

18 To be clear, Gregory very much believed that the holy spirit empowered those bishops who had the proper ascetic and moral credentials to fulfill their role as teachers and spiritual leaders. Basil of Caesarea and John Chrysostom similarly understood God to work through those bishops who had proper qualifications.

The Apostles and the Teaching of the True Faith

As John Behr has compellingly argued, the Orthodox confession of faith was intrinsically connected to a belief in the apostolic witness to the life, death, and resurrection of Jesus Christ.[19] When Byzantine theologians linked the apostles collectively or individually to the theological questions of their day, they almost always did so in order to affirm their own confession of apostolic teaching.[20]

There may be no better "collective" confirmation of the centrality of the claim of apostolic faithfulness than the Nicene-Constantinopolitan Creed. While the majority of the creed articulates a series of dogmatic propositions concerning the Trinity and Incarnation, it concludes by affirming that the faith is both "catholic" (i.e., universal) and "apostolic" (i.e., that it is the faith of the apostles). Like previous creedal declarations, this late fourth-century profession of apostolicity functioned in multiple ways. We can assume that the architects of the Constantinopolitan synod believed it to be true—in other words, they believed that their theology was apostolic. But there is also a way to read the assertion of apostolicity as a kind of rhetorical safeguard against the charge of innovation. The doctrine of *homoousios*—that the Father and Son are the same divine essence—has no explicit biblical anchor. And it is for this reason that the advocates of Nicene orthodoxy developed a series of sophisticated arguments to explain why, on the one hand, the biblical texts had not stated more clearly the doctrine of the Trinity but, on the other hand, why their confession of God as Trinity was a true expression of apostolic teaching. We might further understand the subsequent decision to insert the Nicene-Constantinopolitan Creed into the service of the Divine Liturgy in the fifth century to be a ritualized affirmation of this very same claim of apostolic continuity.

There are, of course, other collective affirmations of "apostolicity" as a public, even legal, affirmation of Byzantine orthodoxy, which further confirm that Byzantine theologians, like the Greco-Roman philosophical schools that preceded them, felt the need to demonstrate the continuity of their belief.[21] For example, Justinian's *Novellae* assert the claims of apostolicity when defining imperial religious policy.[22]

In fact, the *Novellae* offer a more explicit connection between orthodoxy, apostolicity, and the episcopate than we typically find in the theological writers of the period. For example, *Novella* 109 defines a heretic as anyone not in communion with the "Catholic and Apostolic Church of God, in which the most holy bishops, the patriarchs of the entire earth, of Italy, of Rome, of this royal city [i.e., Constantinople], of Alexandria, Antioch, and Jerusalem, and all the holy bishops subject to their authority, preach the true faith and ecclesiastic tradition."[23] And while the link between apostolicity and the episcopate is direct in *Novella* 109, the nature of that link is quite vague. Note that there is no notion of succession and there is no explanation for why bishops teach the correct faith.[24] What is more, *Novella* 109 does not explicitly "exclude" anyone from communion in the Church; rather, it prohibits employment in the imperial government for those who refuse to receive the eucharist from

19 See the collective works of J. Behr, but especially, *The Way to Nicaea* (Crestwood, NY, 2001) and *The Nicene Faith* (Crestwood, NY, 2004).

20 To be sure, Byzantine commentators routinely mined the teachings and examples of the apostles to exhort their readers to particular moral or pastoral models. But those discussions looked backward to the historical example of apostolic behavior. Whenever Byzantine commentators sought to bring the example of the apostles into their present circumstance, they typically did so for the promotion of dogmatic reasons. Perhaps one of the most obvious individual cases would be that of Pseudo-Dionysius. As Charlie Stang has argued, both the Areopagite's theological vision and the rhetorical structuring of his corpus is framed by the claim of apostolicity—the claim to be a direct disciple of Paul. Stang, *Apophasis and Pseudonymity*.

21 On the Greco-Roman philosophical schools and their perpetuation of philosophical consistency, see J. Mansfield, "Sources," in *Cambridge History of Hellenistic Philosophy* (Cambridge, 1999), 3–30.

22 In Book I of the *Codex* (1.1.5), Justinian repeats an affirmation of apostolic orthodoxy found from the era of Theodosius. Perhaps the best example of the *Novellae* is to be found in *Novella* 109.

23 *Novella* 109, preface.

24 Dvornik reads this as a deliberate effort to combine the apostolic origin of the church with the Pentarchy. Perhaps this is correct, but it is necessary to clarify that while Justinian is claiming that these cities share the apostolic faith, there is no claim of apostolic succession. F. Dvornik, *Byzantium and the Roman Primacy* (New York, 1964), 76.

bishops who adhere to the catholic and apostolic faith. In other words, the standard for episcopal authority in *Novella* 109 is one of apostolic "faith" not apostolic "succession."

The emphasis on apostolic faith—as opposed to succession—was quite common. In fact, few writers in the post-Constantinian period ever made explicit use of the notion of succession—*diadoche*—as a safeguard to orthodoxy or authority.[25] Neither the Cappadocians, nor Chrysostom, nor Cyril, nor Maximus the Confessor understood the rite of episcopal ordination to be a safeguard against theological error.[26] On this point, one need look no further than the most prolific exegete of the Gospels, John Chrysostom, who never discusses the idea of apostolic succession at any of the key passages where we might expect it. For example, in Chrysostom's commentary on Matthew 10 (where Jesus bids his disciples to go out into the world), there is no reference to bishops or apostolic succession. Similarly, in his analysis of Matthew 28 (the so-called Great Commission), Chrysostom again makes no reference to bishops as modern-day disciples or apostles.[27] Perhaps even most surprising is Chrysostom's analysis of Pentecost in his commentary on the book of Acts. Here we find the single most important biblical warrant for apostolic succession, but Chrysostom's examination does not engage it in any way.[28] In short, although Byzantine law, Byzantine liturgy, and individual Byzantine authors repeatedly defined the Orthodox faith

as apostolic, Byzantine theological reflection prior to the period of Iconoclasm did nothing to develop, or even really affirm, Irenaeus's contention that Orthodox teaching was preserved on the basis of an episcopal succession from the apostles.

As in so many other ways, the era of Iconoclasm altered earlier patterns of theological reflection in the Byzantine Church. Indeed, whereas theologians since the time of Constantine had little reason to defend episcopal authority in broad terms, the controversy prompted the defenders of icons to remind everyone that it was the episcopate—rather than the emperor—that set doctrinal policy.[29] The most outspoken supporters not only employed apostolic succession as a principle empowering the entire episcopate, but they also emphasized the unimpeachable claim to apostolicity possessed by the Church of Rome.[30]

Indeed, Theodore Stoudites offers one of the most explicit arguments for apostolic succession of any Byzantine author and, in doing so, emphasizes the claims of both Roman primacy and the Pentarchy:

> Divine and heavenly questions can only be answered by those to whom the Word of God has said: "whatever is bound on earth is bound in heaven and whatever loosed on earth is loosed in heaven." And who are the men with this authority?—The Apostles and their successors. And who are their successors?— The one who sits upon the throne of Rome is the first, the one who sits upon the throne of Constantinople is second, after them Alexandria, Antioch, and Jerusalem. That is the *Pentarchic* authority [*pentakoryphon kratos*] of the church. To them belong all decisions in divine teaching."[31]

25 With the possible exception of Pseudo-Dionysius—who should be regarded as exceptional for many reasons—none of the great theological writers of the early Byzantine period ever explicitly connected a guarantee of Orthodox teaching to the notion of apostolic succession. Pseudo-Dionysius does not explicitly advance the notion of apostolic succession as a doctrine, but does very much figure his own authority to speak authoritatively about ecclesiastical hierarchy and the authority of the episcopate by virtue of the fact of his own claim to apostolicity via St. Paul.

26 And, frankly, why would they think that succession preserved orthodoxy? The 4th, 5th, and 6th centuries provided countless examples of bishops who stood in a line of succession but were condemned for heresy.

27 He speaks only of the sacrifice of the apostles and their willingness to embrace poverty, which, perhaps, may have been an indirect slight on the bishops of his day, whom he routinely censured for their luxurious appetites.

28 Chrysostom, *Homily 4 on Acts*.

29 Iconophiles draw deeply on apostolic credentials of Rome in the defense of icons and their rejection of imperial intervention. Patriarch Nikephoros, patriarch of Constantinople (806–815), has an *Apology for Sacred Images* at PG 100:597. He stresses the authority of the ecumenical council, in part because of the presence of Rome, a church with apostolic credentials.

30 Since the 6th century, Greek-speaking theologians had generally ignored Roman claims of apostolic purity, but the Iconoclastic controversy had altered the rhetorical calculus and Eastern bishops looking to undermine imperial authority were reawakened to the rhetorical force of apostolic succession.

31 Theodore Stoudites, *Ep.* 129 (PG 99:1417c) also known as the *Ep. to Leo Sacellarius*.

Theodore's argument for episcopal authority relies on two distinct but overlapping assumptions. The first is that the episcopate, especially the five pentarchic sees, possess the authority to bind and loose sin. The second is that the authority to bind and loose sin authorizes the episcopate—and the episcopate alone—to determine dogmatic truth.[32]

Where Theodore's argument is innovative—at least with respect to Byzantine reflection—is in the explicit justification of episcopal authority on the basis of the biblical privilege to bind and loose sin. Both the Pseudo-Clementines and the individual bishops of Rome had made this argument centuries earlier, but this is a rare example of a Byzantine writer adopting the same logic and applying it to the entire episcopate.

Apostolic Succession and the Forgiveness of Sin

The Gospels contain two stories in which Jesus confers upon apostles the authority to bind and loose sin. The most oft-cited appears in Matthew, chapter 16, where Jesus bestows this privilege solely to the apostle Peter and then claims that he will build the church upon the rock of Peter's faith. But a similar episode also appears in the Gospel of John, after Jesus's resurrection in the short period of time between his return to earth and his final ascension into heaven. In the Johannine passage, Jesus blows upon all of the disciples and says "Receive the Holy Spirit. If you forgive any sins of anyone they are forgiven, if you retain the sins of anyone, they are retained."[33]

It has become a scholarly commonplace to note that Byzantine interpreters of Matthew 16 followed Origen of Alexandria in understanding the passage to mean that any bishop who meets the standard of Peter's faith and life is himself a "Peter" before the eyes of God.[34] In other words,

it is not Peter alone who possesses the ability to bind and loose sin, nor is it the exclusive privilege of the bishop of Rome (the supposed heir of Peter's authority), but, instead, the authority to bind and loose belongs to all faithful and morally upstanding bishops. Interestingly, Origen also suggests that those bishops who deny the apostolic faith or fail to act according to it will lose their spiritual knowledge and judicial authority.[35]

As noted, late ancient theologians typically did not connect the clergy's eucharistic or baptismal roles to any kind of specific apostolic authority.[36] When Ambrose, Gregory, and Chrysostom looked for ancient precedents for the sacramental authority of the clergy, they turned to the Jewish priesthood. The one "sacrament" that early Byzantine authors did, occasionally, tie to the apostles and to scripture was the authority to remit sin. For example, John Chrysostom's 86th homily on the Gospel of John connects clerical authority to Jesus's dissemination of the Holy Spirit among the apostles.

There are a few aspects of his commentary that are worthy of our attention. First, Chrysostom, in typical fashion, did not differentiate between the authority of bishops and presbyters—instead he employed the generic term *iereus,* for the clergy as a whole.[37] Second, Chrysostom does not refer to apostolic succession—it is only through the contextual setting of his commentary on this verse of the Gospel of John that helps us to see that the clergy's authority to bind and loose sin derives from the apostles.[38] Third, Chrysostom acknowledges that there are priests who are largely inadequate but argues, nevertheless, that the grace of Christ continues to work through them. In other

32 Any way that you look at it, this is not a particularly compelling argument, even if it is wholly consistent with previous Byzantine theological practice vis-à-vis the authority of the episcopal body to articulate Orthodox teaching. In fact, it is likely that Theodore develops the argument precisely because he has joined forces with the papacy in the fight against imperial Iconoclasm.

33 John 20:22–23.

34 Origen, *Commentary on the Gospel According to Matthew* 12.11 (PG 13). See, for example, J. Meyendorff, *Byzantine Theology* (New York, 1974), 97–99.

35 C. Rapp, *Holy Bishops in Late Antiquity: The Nature of Christian Leadership in an Age of Transition* (Berkeley, 2005), 35–36. Demacopoulos, *Five Models of Spiritual Direction*, 6–7. While Origen effectively follows Tertullian in arguing that bishops can lose their spiritual or judicial authority, he also provided the rationale by which all clerics could share in the spiritual authority bestowed upon Peter and the other disciples.

36 A pre-Constantinian exception is Cyprian of Carthage, who does differentiate authentic baptism from schismatic baptism to apostolic succession. Cyprian, *Ep.* 69 and 74.

37 Chrysostom's *On the Priesthood* similarly employs the generic category *iereus* in his discussion of clerical leadership.

38 One might just as easily conclude that Chrysostom believes the priest to stand in the place of the apostle and, therefore, receives his authority directly from Christ, irrespective of a chain of apostolic succession.

words, Chrysostom believes that the potency of grace works through the priest, regardless of his personal sin.[39]

Of course, any discussion of Byzantine theological reflection connecting the ability to bind and loose sin to the apostles must account for the idiosyncratic ideas of the middle Byzantine Constantinopolitan ascetic Symeon the New Theologian. What is most significant for our purposes is that Symeon offers an alternative vision of Christian leadership, wherein the discipleship and authority of apostolic succession did not pass from bishop to bishop through the rite of ordination but rather from spiritual father to spiritual father through a closed network of enlightened mentorship.[40] In a text now known as *Epistle* 1, Symeon writes:

> Before there were monks, bishops alone used to receive the authority to bind and loose sin, by right of succession [κατὰ διαδοχὴν], as coming from the divine Apostles. But with

the passing of time and with bishops becoming useless, this awe-inspiring function was extended to priests of blameless life and accounted worthy of divine grace. And when these also were infected with disorder, priests and bishops together becoming like the rest of people, and many of them, as is also the case now, falling foul of spirits of deceit and idle chatter, and perishing, then this function was transferred, as I said, to the elect people of Christ, I mean the monks.[41]

While Symeon concedes that even a sinful episcopate can legitimately baptize and commune the faithful, he insists that salvation requires not only Orthodox teaching but also Orthodox living and that instruction in each belongs exclusively to a group of spiritual teachers who follow in a "succession" parallel to but distinctive of the world of corrupt bishops.[42] It is to this parasuccession that Symeon bids his disciples to seek out a counselor to whom they should confess their sins. For only these counselors possess the authority to bind and loose sin.[43]

With Symeon we find the echoes of Tertullian, whose disappointment with the episcopate was made manifest in his privileging of moral—as opposed to institutional—authority. For our purposes, what is perhaps most significant about Symeon is that even though he denies that the bishops and priests of his day possess authentic and dynamic authority, he never abandons the notion that true leadership is linked to the apostles. In other words, a succession of bishops might not guarantee the faith or moral code of the apostles, but that does not mean that the faith and moral code of the apostles is irrelevant. On the contrary, Symeon's radicalized *parousia* is motivated by an alternative vision of apostolic succession that is maintained through a spiritual, rather than an institutional, line of succession.

39 Interestingly, he makes no specific mention of what priestly acts convey this grace (whether it is penance, the eucharist, or perhaps simply the ability to offer spiritual advice). Rather, he only vaguely affirms that grace is operative "through the tongue and hands" of the priest. In many ways, the homily is an encomium for the dignity of the priestly office that we find in his *On the Priesthood* and functions, in this context, as an appeal for consideration of the difficulty of the priestly ministry. Chrysostom, *On the Priesthood*, esp. 3.5. Augustine, in a rather different context, would famously advance the same principle a few decades later.

40 What is, perhaps, so interesting is that Symeon offers us one of the most precise definitions of apostolic succession that exists in middle Byzantine literature. "Our Master and God chose his apostles and disciples, and entrusted and revealed to them all the mysteries of his dispensation which had been hidden for ages and for generations.... Each of the apostles, when he was going to leave the believers and go away to other places, countries and towns, they ordained in their stead bishops and presbyters for them, and left them with teachers and spiritual fathers and leaders. And those in turn, when they were coming to the end of their lives, chose others who were worthy of such a ministry, ordained them and left them in their stead, and thus in succession up to our time such a system and legislation has continued through the action of the Holy Spirit, and is preserved and maintained. In the same way the traditions and teachings from the apostles, which they in turn received from the Master of the universe, our God, have come down to us through them." Symeon, *Ep.* 3.120–23 and 129–40 in H.J.M. Turner, *The Epistles of St. Symeon the New Theologian* (Oxford, 2009). Although I reprint here the translation provided by Turner, note that I list the line numbers that refer to the Greek text (Turner reprints the critical text of Joseph Paramelle), not the facing English, where line numbers do not correspond directly.

41 Symeon, *Ep.* 1.247–53. For a more thorough account of how Symeon believed that bishops eventually lost the authority, see esp. lines 299f.

42 For the viability of the sacraments, all that Symeon seems to demand of morally weak bishops is orthodoxy. See *Ep.* 1.309–19.

43 Symeon, *Ep.* 3.664f.

Apostolic Succession as a Discourse of Power and Exclusion

As we have seen, outside of the Iconoclastic period, there was little effort in the Byzantine Church to advance apostolic succession as an argument for the authority of the entire episcopate. But as early as the fifth century, there was a considerable degree of reflection upon the way that individual apostles, especially Peter, could be marshaled to advance the particular interest of one episcopal see against others.[44] Just as Irenaeus had enlisted the collective authority of the apostles to promote Orthodox teaching against its gnostic opponents, so, too, the bishops of Rome and (eventually) the bishops of Constantinople, Antioch, and Alexandria connected their personal authority to legends linking their episcopal sees to specific apostolic foundations. Indeed, one can identify a Foucaultian-style genealogy of apostolic rhetoric as a discourse of power and exclusion in the Byzantine Church. While space does not permit an exhaustive examination, three points are worth noting.

First, from the fifth century onward, the most significant rhetorical escalations in the claims of Roman privilege—claims that were always dressed in Petrine robes—emerged precisely at those moments when the authority of Roman bishops was most forcefully being challenged either in Rome or abroad.[45] In other words, while it is true that papal claims of theological authority grew over time and that they did so with increasing recourse to a mythology placing St. Peter in Rome, it is not the case that those claims to authority represented actual or actualizable authority in the late ancient church. On the contrary, each rhetorical escalation—including the claims to be Peter's heir, to be the vicar of Christ, or to be sole authority in the Church—emerged precisely at those moments when Roman bishops were suffering their greatest domestic or international humiliations.[46]

For example, when the so-called Robber Synod of 449 advocated a christological position that was deemed heretical by Pope Leo, he responded by asserting his Petrine privilege to dictate theological orthodoxy. Just as Peter had led the apostles and had, alone, been granted the right to bind and loose sin (cf. Mt. 16), so, too, Leo claimed that he alone should be considered the authoritative voice in doctrinal matters. From Leo's rhetorical vantage point, the decision to accept or not accept christological orthodoxy was a decision to respect or not respect St. Peter. And while the Council of Chalcedon in 451 did adopt a christological position more amenable to Leo's taste, the same gathering of bishops repudiated the pontiff's Petrine bluster. In fact, it declared the Church of Constantinople the equal of the Church of Rome.

Second, as Francis Dvornik conclusively demonstrated nearly sixty years ago, the connection between the Andrew legend and the see of Constantinople was especially late in its development.[47] The oldest surviving patriarchal claim to be the heir of Andrew belongs to Patriarch Ignatius, who did so in 861, but it was not until the following century that the Church of Constantinople introduced the connection into the liturgical cycle. Indeed, a tenth-century *Synaxarion* is the oldest evidence we possess that the Church commemorated the Feast of St. Stachys, the legendary disciple of Andrew and supposed first bishop of Byzantium.[48]

Although late in its development, the connection between the apostle Andrew and Constantinople functioned in ways similar to St. Peter and

44 I employ the term "discourse" in the Foucaultian sense to convey more than mere writing or speaking but, rather, the entire knowledge structure that held together and made possible the oral traditions, texts, shrines, icons, and rituals that gave meaning to the continuation of apostolic authority. M. Foucault, *Archeology of Knowledge* (New York, 1982).

45 This is the central thesis of G. Demacopoulos, *The Invention of Peter: Apostolic Discourse and Papal Authority in Late Antiquity* (Philadelphia, 2013).

46 We can similarly understand the development and function of the claim that the patriarch of Constantinople is the "ecumenical" patriarch in much the same way. Demacopoulos, *Invention of Peter,* and "Gregory the Great and the Sixth-Century Dispute over the Ecumenical Title," *TheolSt* 70 (2009): 600–621.

47 Dvornik, *The Idea of Apostolicity in Byzantium and the Legend of Andrew the Apostle* (Cambridge, MA, 1958) and *Byzantium and the Roman Primacy.*

48 *Synaxarium CP,* cols. 177. Dvornik, *Idea of Apostolicity,* 254–55. And while the hymns for Stachys do situate him in Constantinople, it is significant to note that none of the hymns of the *Festal Menaion* mentions anything related to the see of Constantinople for the Feast of St. Andrew.

Rome. This is evident both in terms of the elaboration of the cult for the apostle but also rhetorically, in the way that it combined the claim of apostolicity with the imperial designation of ecumenicity, which we have in the patriarch's title. Not only did this combination function as a rhetorical rejoinder to Rome's Petrine claim (Andrew is, after all, Peter's older brother), but it also provided a basis for Constantinople to assert its own apostolic authority against other would be challengers in the Eastern church.

Third, as much as we might be inclined to see the development of the Petrine and Andrew legends as rhetorical weapons that could be employed against rival bishops, they were primarily developed and asserted against the imperial meddling in ecclesiastical affairs. Indeed, the Roman Church's marshaling of Petrine rhetoric in international disputes was, first and foremost, an effort to ward off imperial interference in the Church. This was as true for Leo and Gelasius in the fifth century as it was for the Orthodox bishops who sought to navigate the iconoclastic controversies. And, as the apologetics of Theodore Stoudites confirm, by the ninth century even the argument for the Pentarchy had begun to reflect characteristics of an apostolic discourse that sought to limit imperial intervention. We should view the development of the Andrew legend in much the same way—in other words, as an effort by the Constantinopolitan Church to provide a biblical justification—however specious—for its control of imperial religious policy.

Cultic Commemoration of the Apostles

As we have seen, Byzantine theological recourse to the idea of apostolic succession was rare even though there was a rich tradition of linking the claim of orthodoxy and the rhetoric of authority to apostolic foundations. What we have not thus far analyzed is the link between the memory of the apostles and Christian ritual, which was actualized in spaces like the church of the Holy Apostles. In order to appreciate the ways in which lived religious experience of Byzantine Christians both reflected and shaped the collective understanding of apostolic significance, we turn now to the liturgical material to appreciate the way that the rhythms of the liturgical year

provided a continuous recollection of the apostles through prayer, hymn, and biblical reading.

Even before the commemoration of 29 June had been established in Constantinople as the Feast for Sts. Peter and Paul and 30 June feasted all of the apostles, the *Kontakia* of Romanos the Melodist offered a hymnographic vehicle for promoting the Apostles as Christian heroes. A fine example is Romanos's *Kontakion* dedicated to Peter's denial of Christ, which was sung in Constantinople from the sixth to the ninth century on Good Friday.[49] The hymn artfully places the entire community alongside its subject, entreating them to see themselves in Peter's sin and redemption.[50] While the text is highly dramatized and makes dozens of intertextual connections between the Hebrew Scriptures and the Peter of the New Testament, it is noteworthy that the action and reflection remain set in the moment of Peter's denial and the spiritual enjoinder is, thus, squarely focused on the recognition of sin and the possibilities of repentance. There are no references to any of the popular apocryphal traditions surrounding Peter's activities, which proposed to chronicle that saint's work after his story ends in the New Testament.

This emphasis on the biblical acts of the apostles is equally clear in Romanos's *Kontakion* for "doubting" Thomas.[51] More than the *Kontakion* for Peter's denial, this hymn offers an asceticizing interconnection between moral behavior and faith. For Romanos, Thomas doubts Christ's resurrection because he lacks the love and humility to believe it. But through divine dispensation, Thomas gains the moral fortitude required for belief. Thus, through the drama of apostolic failing, Romanos encourages Constantinopolitan Christians to see their own lack of faith as a lack of ascetic and moral behavior.

For Romanos, both Peter and Thomas function as guides for redemption, because they were, themselves, men who struggled to believe. Peter and Thomas are like the Christians of

49 The *kontakion* form largely dropped out of style in the Byzantine liturgical tradition with the advent of the canon form and the adoption in Constantinople of liturgical practices from Palestine.

50 *Sancti Romani Melodi Cantica*, 18, ed. P. Maas and C. Trypanis (Oxford, 1963).

51 *Sancti Romani Melodi Cantica*, 30.

Constantinople and, thus, the Christians of Constantinople are to be like them. In a sense, all Christians are encouraged to be the "successors" to the apostles through the apostolic example of repentance after failure. The annual commemoration of Peter's denial and Thomas's doubt, which bookended the resurrectional feast, reinforced for the Constantinopolitan communicants that the saints, especially the apostles, offered models of redemption.

Turning from Romanos's *Kontakion* to the *Typikon of the Great Church*, we see that the ritualized commemoration of the apostles developed a great deal in Constantinople between the sixth and ninth centuries. Most notably, the *Typikon* describes an elaborate series of events for the Feast of Sts. Peter and Paul on 29 June, beginning with a patriarchal procession through the city.[52] Specific readings from 1 and 2 Peter are assigned, as well as hymns emphasizing St. Peter's leadership among the apostles. Whereas the hymns assigned for vespers (evening) service refer only to Peter, the *troparion* hymn assigned to the orthros (morning) service, commemorates both saints Peter and Paul. Especially significant is the fact that this particular hymn provides the lone liturgical recognition in the *Typikon of the Great Church* of the apocryphal traditions placing both St. Peter and St. Paul in Rome.[53] By comparison, it is worth noting that the Feast for St. Andrew the Apostle (30 November) does not make any mention of the saint's supposed affiliation with the see of Constantinople. It does, however, take note of the fact that the relics of St. Andrew (along with those of St. Luke and St. Timothy) reside in the church of the Holy Apostles.[54]

By the eleventh century (if not earlier), monastic *typika* were prescribing a period of fasting in the weeks prior to the Feast of the Apostles.[55] Specifically, the fasting period began

eight days after Pentecost and continued until 29 June. Depending upon the dating of Easter, this fast could last for nearly a month, indicating a significant degree of spiritual preparation for the commemoration of the apostles.

Conclusion

As we have seen, Byzantine theology was rooted in the idea that the Orthodox Christian faith was an apostolic faith, that it reflected the belief and teaching of the men who had walked with Christ. However critical, or even cynical, individual theologians may have been of the episcopate writ large during the Byzantine era, there is little denying that the synod of bishops controlled Orthodox teaching and—with the input of the imperial state—they also controlled the structures of the ecclesiastical institution. Although it was rarely necessary to do so, when Christian leaders felt compelled to justify episcopal authority, they did so on the basis of a chain of succession leading back to the apostles. In most situations, it was open conflict with the imperial government over dogmatic policy that prompted Byzantine theologians to defend episcopal authority on the basis of apostolic succession. This was true of both general arguments—meaning the episcopate as a whole—and for the promotion of individual sees—such as the bishop of Rome or the bishop of Constantinople.

It is important to remember that the apostles, unlike other feasted saints, would have been a perennial element of the Byzantine Christian imagination simply because the stories of the apostles and the writings (of at least some) of the apostles would have been central components of every liturgical service that included a reading from the New Testament. Thus, the simple rhythms of the liturgical life—the constant affirmation of and reflection upon the apostles—helps us to understand the pervasiveness of the apostles in the Byzantine theological imagination. This constant recognition of the apostles also helps to explain why it would make sense that the generations of imperial patrons of the church of the Holy Apostles would have selected this particular group of saints as worthy of imperial support for Christian cultic devotion.

52 *Le Typicon de la Grande Église: Tome 1, Le Cycle des Douze Mois*, ed. J. Mateos, OCA 165 (Rome, 1962), 324–27.

53 *Typicon de la Grande Église*, 1:325.

54 Ibid., 1:117.

55 See, for example, the *Hypotyposis* of Evergetis (an 11th-century monastic foundation *typikon*), lines 508–17, ed. P. Gautier, *Le typikon de la Théotokos Évergétis* (Paris, 1982), 43, trans. and comm. R. H. Jordan and R. Morris, *The Hypotyposis of the Monastery of the Theotokos Evergetis, Constantinople (11th–12th Centuries)* (Farnham, 2012), 173–74.

Foundations

CONSTANTINE'S APOSTOLEION

A Reappraisal

MARK J. JOHNSON

\mathcal{A} FEW YEARS BEFORE HIS LIFE CAME TO AN END ON 22 MAY 337, the Roman emperor Constantine contemplated his eventual death and considered the arrangements he would make for his burial. Having no exact precedent for such a monument—a mausoleum for a Christian emperor—he eventually ordered the construction of a building that would be both a church dedicated to the apostles and his own mausoleum. This was a novel and extraordinary building about which much has been written, but about which numerous questions remain. The efforts of many scholars over several generations to deal with these questions have not created a consensus on countless issues concerning the building. Nevertheless, each scholar who has wrestled with these issues has provided insights, and the present study proposes to add an additional level of understanding upon the foundation built by previous scholars. In particular, it will examine the architectural form of the building, the dating of modifications and additions made to it, and the involvement of Constantine's son, Constantius II, in those changes. It will also consider Constantine's original arrangement of his sarcophagus and other interior furnishings and the meaning of his groundbreaking building.

The Architecture of the Apostoleion

The site chosen was just inside the new western walls of the expanded city, near a city gate and along a street that ran from that gate to the palace area at the other end of the city (fig. 6.1). It stood on the highest hill of the Constantinian city, at or near the location of the present Fatih Camii, which was built on the site in the 1460s.[1] Two important observations about Constantine's choice of site may be made. The first concerns the burial *intra muros*. Under Roman law, burials were to take place outside city walls, not inside them, but exceptions could be made for special individuals such as emperors.[2] During his visits to Rome earlier in his reign, Constantine must have seen the enormous Mausoleum of Augustus standing a few hundred meters inside the Aurelian Walls, and it is likely that he would have known of Trajan's entombment under his column in his magnificent forum. He might also have sought out the burial place of the Flavian emperors on the Quirinal Hill, the Templum Gentis Flaviae.[3] In other words, Constantine's choice of a burial location inside city walls had imperial precedents that

1 For a recent summary of the question of the exact location of the Holy Apostles church see G. Marsili, "L'*Apostoleion* di Costantinopoli: Stato della questione ed analisi delle fonti per alcune reflessioni di carattere topografico ed architettonico," *RSBN*, n.s., 49 (2012): 3–52, esp. 3–23.

2 M. Johnson, *The Roman Imperial Mausoleum in Late Antiquity* (Cambridge, 2009), 25, 187–88.

3 Ibid., 22–26.

FIG. 6.1.

Map of
Constantinople
(drawing by
Mark J. Johnson)

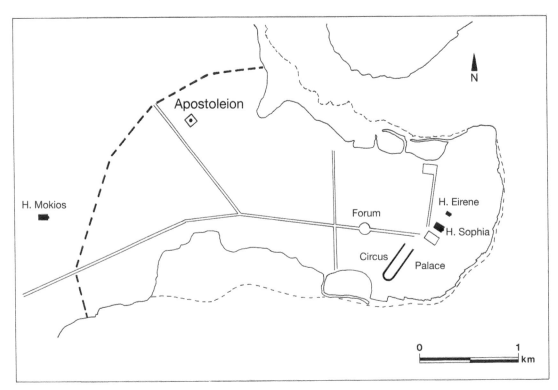

likely provided his inspiration.[4] The other observation about the choice of this site is that, so far as is known, it had no previous Christian associations before Constantine undertook the project. It was not previously connected with martyrs or other saints or their burials, a point that will be discussed later.

The starting place for sorting out the facts of Constantine's original foundation is the description of Eusebius, found in his account of the life of Constantine and written shortly after the emperor's burial in 337 and before Eusebius's own death in 339.[5] Eusebius, who was in Constantinople in July of 336 and likely saw the building either nearing completion or finished, provides the only contemporary account remaining of its architecture, decoration, and interior furnishings.[6] As such, every scholar who has dealt with the Apostoleion has scrutinized

this text, but given its limitations, it has raised as many questions as it has answered.

In Eusebius's account it should be noted that immediately after the topic of the Apostoleion is introduced, there is a lacuna in the text, in which one might suppose additional details about the church were included. Following the lacuna, Eusebius describes the interior:

He (Constantine) himself built up the whole shrine (νεὼν) to an unimaginable height, and made it glint with stones of every kind, facing it from the ground up to the roof. He divided the ceiling with delicate coffers and plated the whole with gold. Up above this, on the roof (δῶμα) itself he provided copper [bronze] instead of [ceramic] tiling to protect the building securely from the rain. Round this too glittered much gold [i.e., the bronze tiles were gilded], so that by reflecting back the rays of the sun it sent dazzling light to those who looked from afar. Trellised relief-work wrought in bronze and gold went right around the building (δωμάτιον).

Such was the eager care the shrine enjoyed as the emperor greatly enriched it. Round it was a spacious court wide open to the fresh

4 As noted by R. Krautheimer, *Three Christian Capitals: Topography and Politics* (Berkeley, 1983), 58.

5 Eusebius, *Vita Constantini*, 4.58–60, ed. F. Winkelmann, *Über das Leben des Kaisers Konstantin*, Eusebius Werke, 1.1, GCS, 2nd ed. (Berlin, 1991), 144–45; Av. Cameron and S. Hall, trans., *Eusebius: Life of Constantine* (Oxford, 1999), 176–77.

6 For his stay in the capital in 336, see T. Barnes, *Constantine and Eusebius* (Cambridge, MA, 1981), 253.

air, and round this quadrangle ran porticoes which faced the middle of the court where the shrine stood, and official houses, washrooms, and lampstores extended along the porticoes, and a great many other buildings suitably furnished for the custodians of the place.[7]

From the information Eusebius provides, we can be certain of the following: at his time there was a single church building, not a church and separate mausoleum. It was a tall structure with an interior decorated of marble revetment from floor to ceiling and covered with a gilded coffered ceiling. The outside roof had gilt bronze tiles, and bronze latticework covered with gold, perhaps in the windows, was visible from the exterior. The main building stood in a rectangular courtyard lined with porticoes on four sides, surrounded by various other buildings in the complex. In what survives of Eusebius's description there is no mention of the plan of the building and no specific dimensions are given. He does not describe a dome, galleries, niches, or other architectural features, and he gives no clue about the material used in the construction of its walls.

A few other fourth-century sources mention the church without providing many additional details. In a speech given in late 355 or early 356, the then Caesar Julian praised Constantius II for having adorned the tomb of Constantine by "lavishing on it splendid decorations."[8] Several sources report the transfer of the relics of St. Timothy, a disciple of Paul, in 356, followed by those of Sts. Andrew and Luke to the church in 357, though other sources place this transfer in 336.[9]

The fifth-century historian Sokrates Scholastikos recounts how, in 359, the church was damaged and threatened to fall. Bishop Makedonios therefore moved the sarcophagus of Constantine to the church of Akakios, provoking a riot between one group of people who did not want it moved, feeling it was a violation of the emperor's tomb, and another group that supported the bishop.[10] The riot left several people dead in the precincts of the church and provoked the ire of Constantius toward the bishop, on account of the bloodshed and because the bishop had dared to remove the remains of his father without consulting him first. Repairs to the building must have taken place immediately, for when Constantius's wife Eusebia died the following year, she was buried in the church, as was Constantius after his death in November of 361, followed by his successor, Jovian, upon his death in 364.[11]

Three other mentions of the church in the late fourth-century sources raise some interesting questions. First, it is reported that the church of the Holy Apostles was dedicated on 9 April, Easter, in 370.[12] About a decade later, Gregory of Nazianzos mentioned the church in a poem in which he notes that it was a large building and cruciform in plan.[13] Finally, in the 380s, John Chrysostom makes it clear in two of his homilies that there were then two separate structures on the site: a church in which were found the relics of the apostles and, located near its vestibule, another structure that housed the remains of the emperors.[14]

Interpreting the Early Sources

With so little information about the architecture of the building included in these accounts, the door has been left wide open for interpretation—and for some misunderstanding. Two

7 *Vita Constantini* 4.58–59, ed. Winkelmann, *Über das Leben*, 144; trans. Cameron and Hall, *Eusebius*, 176; C. Mango, "Constantine's Mausoleum and the Translation of Relics," *BZ* 83 (1990): 51–62; repr. in his *Studies on Constantinople* (Aldershot, 1993), V, with Addendum, on 55.

8 Julian, *Or.,* 1.16, in Julian, *Opera,* ed. and trans. W. C. Wright, Loeb (London and Cambridge, MA, 1913–23), 1:42–43.

9 For the sources on the transfer of these relics see Johnson, *Roman Imperial Mausoleum,* 120 and notes; and R. W. Burgess, "The *Passio s. Artemii,* Philostorgius, and the Dates of the Invention and Translations of the Relics of Sts. Andrew and Luke," *AB* 121 (2003): 5–36.

10 Sokrates, *Historia Ecclesiastica* 2.38, trans. A. Zenos, *A Select Library of Nicene and Post-Nicene Fathers of the Christian Church,* 2nd ser. (New York, 1890), 2:67.

11 For sources, see Johnson, *Roman Imperial Mausoleum,* 208 (Eusebia); 207 (Constantius); 213 (Jovian).

12 Eusebius-Jerome, *Chronicon* a. Abr. 2386, ed. R. Helm, Eusebius Werke, 7, GCS 24 (Leipzig, 1913), 245; *Consularia Constantinopolitana* a. 370, ed. R. Burgess, *The Chronicle of Hydatius and the Consularia Constantinopolitana* (Oxford, 1993), 240; *Chronicon Paschale* a. 370, ed. I. Dindorf, CSHB (Berlin, 1832), 559; trans. M. and M. Whitby, *Chronicon Paschale 284–628 AD* (Liverpool, 1989), 48.

13 Gregory of Nazianzos, *Poemata de se ipso,* 16.59–60 (PG 37:1258).

14 John Chrysostom, *Homilia contra Judeos et Gentiles,* 9 (PG 48:825) and *Homilia in Epist. 2 ad Corinth.,* 26.53 (PG 61:582).

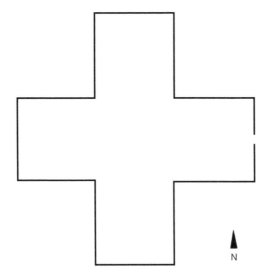

FIG. 6.2. Apostoleion, Constantinople, schematic plan as in ca. 337 according to Richard Krautheimer (drawing by author)

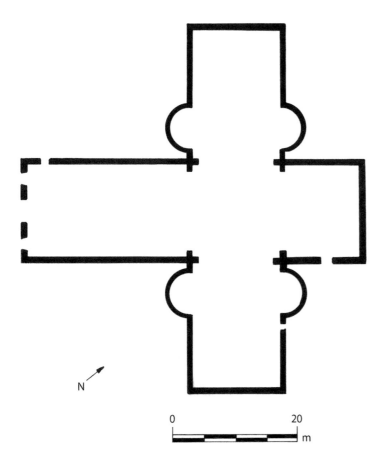

0 20
 m

FIG. 6.3. Basilica Apostolorum, Milan, begun 383, plan (drawing by author)

theories that have had great influence on the study of the Apostoleion merit particular attention.

In his article on Constantine's mausoleum, Richard Krautheimer argued that what Constantine built was a single building, a cruciform church with wooden roofs and perhaps some kind of raised structure over the crossing (fig. 6.2).[15] He based this theory in part on the account of Gregory of Nazianzos but more importantly on the fact that there were several churches constructed in the later part of the fourth century that were copies of the church of the Holy Apostles in Constantinople, such as the Basilica Apostolorum in Milan, begun in 383 (fig. 6.3).[16] He also argued that it was Constantine's son, Constantius II (317–361), who built a separate domed rotunda as a mausoleum next to the church after the patriarch Makedonios had moved the remains of Constantine in 359, with the sarcophagus of Constantine placed there upon its return and the rededication of the complex taking place in 370. His theory was adopted by others, with Rudolf Leeb adding the argument that the cross was an important symbol to Constantine, and a cruciform building would have been recognized as displaying the emperor's passion for it.[17]

In an article published in 1990, Cyril Mango introduced a radically different interpretation of Eusebius's description of the Apostoleion.[18] He argued that rather than building a basilica or a cruciform structure, Constantine had

15 R. Krautheimer, "Zu Konstantins Apostelkirche in Konstantinopel," in *Mullus: Festschrift Theodor Klauser* (Münster, 1964), 224–29; repr. as "On Constantine's Church of the Holy Apostles in Constantinople," in his *Studies in Early Christian, Medieval, and Renaissance Art* (New York, 1969), 27–34; he maintained this interpretation in his *Three Christian Capitals*, 56–64; and in his *Early Christian and Byzantine Architecture*, 4th ed., revised with S. Ćurčić (Harmondsworth, 1986), 69–70.

16 Krautheimer, "Constantine's Church," 28. On cross plan churches in early Christian architecture see M. Johnson, *The Byzantine Churches of Sardinia* (Wiesbaden, 2013), 87–100.

17 R. Leeb, *Konstantin und Christus: Die Verchristlichung der imperialen Repräsentation unter Konstantin dem Großen als Spiegel seiner Kirchenpolitik und seines Selbstverständnisses als christlicher Kaiser*, Arbeiten zur Kirchengeschichte 58 (Berlin, 1992), 93–120. Accepted by P. Speck, "Konstantins Mausoleum: Zur Geschichte der Apostelkirche in Konstantinopel," in his *Varia VII*, Poikila Byzantina 18 (Bonn, 2000), 113–56, esp. 130; and A. Berger, *Konstantinopel: Geschichte, Topographie, Religion* (Stuttgart, 2011), 15–16.

18 Mango, "Constantine's Mausoleum."

FIG. 6.4. Apostoleion, Constantinople, schematic plan as in ca. 337 according to Cyril Mango (drawing by author)

FIG. 6.5. Apostoleion, Constantinople, schematic plan as in ca. 370 (drawing by author)

constructed a rotunda, either circular or octagonal (fig. 6.4). Mango noted that Eusebius had made a point of emphasizing the height of the building rather than its length and had failed to take note of a colonnade. He also noted in passing that such a building would have been similar to other late Roman imperial mausolea, which were all domed rotundas of some sort. Finally, he suggested that the transfer of the relics of the apostles to Constantinople reported as taking place in 356 indicated that the decision had been made by then by Constantius to build a separate church for their relics while keeping the rotunda as mausoleum (fig. 6.5). This new structure, erected next to the rotunda, was the cruciform church mentioned by Gregory of Nazianzos and dedicated in 370.

Since its publication, Mango's interpretation has been widely accepted by various scholars who have written on the Apostoleion.[19] Arne

Effenberger built upon Mango's interpretation by suggesting that the building described by Eusebius can best be understood as the model for the Mausoleum of Constantina, a domed rotunda with a fenestrated drum rising above the central space surrounded by an ambulatory lined with niches, but on a larger scale than its copy in Rome.[20]

The Later Medieval Sources

An important point in understanding the architecture of the original Apostoleion that no one else has discussed is the fact that if Mango and his followers are correct in their assertion that the original building was a rotunda to which was later added a cruciform church, then that means that the original Apostoleion built by

19 Johnson, *Roman Imperial Mausoleum,* 119–29; Marsili, "Apostoleion," 30–32; S. Ćurčić, "From the Temple of the Sun to the Temple of the Lord: Monotheistic Contribution to Architectural Iconography in Late Antiquity," in *Architectural Studies in Memory of Richard Krautheimer,* ed. C. Striker (Mainz, 1996), 55–59; A. M. Vysotsky and F. V. Shelov-Kovediaev, "On the Reconstruction of the First Church of the Holy Apostles in Constantinople According to Contemporary Records," *Acts, XVIIIth International Congress of Byzantine Studies: Selected Papers, Moscow 1991,* vol. 3, *Art History, Architecture, Music,* ed. I. Ševčenko, G. G. Litavrin, and W.

Hanak (Shepherdstown, WV, 1996), 493–501; G. Dagron, *Empereur et prêtre: Étude sur le 'césaropapisme,' byzantin* (Paris, 1996), 151; E. Künzl, *Monumente für die Ewigkeit: Herrschergräber der Antike* (Mainz, 2011), 102–3; C. Barsanti, "Costantinopoli," in *Costantino I. Enciclopedia costantiniana sulla figura e l'immagine dell'imperatore del cosiddetto editto di Milano, 313–2013* (Rome, 2013) 1:471–91, on 483–84.

20 A. Effenberger, "Konstantinsmausoleum, Apostelkirche— und kein Ende?" in *Lithostroton: Studien zur byzantinischen Kunst und Geschichte; Festschrift für Marcell Restle,* ed. B. Borkopp and T. Steppan (Stuttgart, 2000), 67–78; repeated in N. Asutay-Effenberger and A. Effenberger, *Die Porphyrsarkophage der oströmischen Kaiser* (Wiesbaden, 2006), 98–145.

Constantine, stripped of its martyrial function but maintained as imperial mausoleum, survived until the destruction of the whole complex in the 1460s. Therefore, the later sources that discuss what they call the "Mausoleum of Constantine" are, in fact, discussing the original Apostoleion, which had remained intact during the razing of the old cruciform church and its rebuilding under Justinian.

Most important among these later accounts is the description given by Nicholas Mesarites, written in about 1200.[21] In his brief account of the structure, he wrote that, "this church (ναός) was domical and spherical (σφαιροειδὴς καὶ κυκλιὸς), and because of the rather extensive area of the plan, I suppose, it is divided up on all sides by numerous stoaed [sic] angles [or corners] (στωϊκαῖς γωνίαις)." His account confirms that the building was, in fact, a large domed rotunda.

A visitor to Constantinople in the late twelfth century also noted that the building was a rotunda and added that it was built of marble.[22] This could refer to the marble revetment of the interior, but it is also possible that the exterior walls were built of marble, too. If true, it would have been like other imperial mausolea, including those of Augustus, Hadrian, Diocletian, and Galerius that were faced with white stone.[23]

The Apostoleion as a Mausoleum

Even if one sets aside Mesarites' clear description of the building as a domed rotunda, there are other reasons to imagine that the original Apostoleion was indeed something along the lines proposed by Mango. It is important to note that as Constantine was contemplating his final resting place and his architectural setting, he had no precedent to follow in determining what the

mausoleum of a Christian emperor should look like. Nevertheless, his creation did not take place in a vacuum, and he did have several precedents among imperial mausolea in determining what constituted a proper monument for his own imperial burial.

Constantine was certainly aware of the appearance of earlier imperial mausolea and of the fact that since the mid-third century the domed rotunda, whether circular or octagonal, had become the exclusive type employed by his predecessors going back at least to Gallienus.[24] All of these were domed rotundas and most were two-storied buildings with a burial chamber in the lower level. Some were set in the center of open courtyards, a feature Constantine employed in his own monument.[25] Just as all the preceding imperial mausolea from the previous decades had been domed rotundas, it is important to note that all the imperial mausolea that followed would be domed rotundas as well. If Constantine's mausoleum was something other than a domed rotunda, it is very odd that it spawned no copies among the Christian imperial mausolea that followed.

Constantine had actually already built at least one imperial mausoleum before starting the Apostoleion. This was the domed rotunda attached to the east end—that is, the front—of the cemetery church of Sts. Petrus and Marcellinus outside Rome, in which he had buried his mother Helena after her death in about 327 (fig. 6.6).[26] Although he had here followed the practice of using the domed rotunda type, he and his planners had made some significant changes. Unlike the freestanding imperial mausolea of the Tetrarchs, this mausoleum was attached to a church, separated from it by a rectangular vestibule. The church was built in this place because of the presence of tombs of the two titular saints, making a burial in the mausoleum a burial *ad sanctos,* a strong statement of Christian belief.[27] Furthermore, unlike the mausolea of his pagan predecessors, the Mausoleum of Helena had no

21 Nicholas Mesarites, *Description of the Church of the Holy Apostles at Constantinople,* c. 39, ed. A. Heisenberg, *Grabeskirche und Apostelkirche: Zwei Basiliken Konstantins,* vol. 2, *Die Apostelkirche von Konstantinopel* (Leipzig, 1908), 10–96; ed. and trans. G. Downey, "Nikolaos Mesarites, Description of the Church of the Holy Apostles at Constantinople," *TAPS,* n.s., 47, part 6 (1957): 855–924 at 891–92; trans. M. Angold, *Nicholas Mesarites, His Life and Works (in Translation),* TTB 4 (Liverpool, 2017), 83–133, at 125.

22 K. Ciggaar, "Une Description de Constantinople dans le Tarragonensis 55," *REB* 53 (1995): 117–40, on 121.

23 Johnson, *Roman Imperial Mausoleum,* passim.

24 Ibid., 42–57.

25 On the possible symbolism of this arrangement see Ćurčić, "Temple."

26 Johnson, *Roman Imperial Mausoleum,* 110–18.

27 Y. Duval, *Auprès des saints corps et âme: L'inhumation "ad sanctos" dans la chrétienté d'Orient et d'Occident du IIIe au VIIe siècle* (Geneva, 1977).

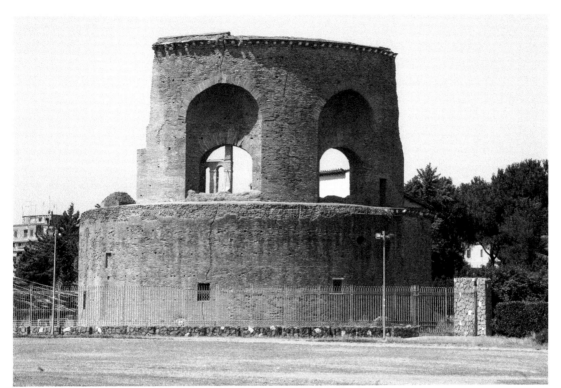

FIG. 6.6.
Mausoleum of
Helena, Rome,
ca. 325, exterior
from northeast
(photo by author)

crypt and possessed a large interior space brightly illuminated by large windows (fig. 6.7). Some have argued that this building was originally constructed for Constantine himself, but no contemporary source makes that claim, and there really is no reason to suppose that Constantine ever desired to be buried at Rome, a city that he avoided most of his life.[28] There is also the enigmatic rotunda of St. George in Thessalonike, the dating and original function of which are uncertain. Some have identified it as a mausoleum built by Galerius, though its lack of a crypt and its large windows make that unlikely; Galerius was buried at Gamzigrad in any case. If built by Galerius, it was more likely to have been a temple. Another proposal is that Constantine built it as his intended mausoleum before he changed ideas and built the Apostoleion, but there really is no evidence to confirm this interpretation.[29]

What Constantine built in Constantinople for his own eventual burial was not exactly like the imperial mausolea of his predecessors, but it now seems evident that he did not completely

FIG. 6.7. Mausoleum of Helena, Rome, ca. 325, plan (drawing by author)

28 Johnson, *Roman Imperial Mausoleum*, 117–18.

29 Ibid., 74–75, with references.

abandon the tradition of imperial mausoleum design they had established. A key to understanding the design of the Apostoleion is found in Eusebius's claim that Constantine started building it as a church to honor the apostles but kept hidden the fact that he intended to be buried in it as well until later.[30] Whether or not Constantine truly held this secret, the important takeaway is that what Constantine started to build was a structure whose design was entirely appropriate for a church, both in architectural form and in size, while also being appropriate architecturally to serve as an imperial mausoleum. For this reason, it can be ruled out that Constantine built a basilica of any type or, for this early period, a cruciform building. He did have two examples of suitable architectural design in his own patronage: the octagonal Great Church of Antioch begun in 327 and the rotunda enclosing the tomb of the savior in Jerusalem. Both may have been still under construction at the time work began on the Apostoleion, but their designs were certainly known by Constantine and his architect in Constantinople.

The church in Antioch is only known through literary accounts, which indicate that it was a double-shell octagon with a tall central core surrounded by an ambulatory and gallery.[31] Eusebius's description of the building is similar to the one he gave of the Apostoleion in a very significant way: there is no mention of length, but he proclaimed that it rose to "an enormous height" while also noting its decoration in bronze and gold.[32]

The Anastasis Rotunda in Jerusalem provides a very significant comparison to the Apostoleion, as both contained tombs and it is generally acknowledged that its design was derived from that of imperial mausolea (fig. 6.8).[33] The tomb of Christ, freed from its surrounding hill, stood near the center of the central space of a rotunda measuring 33.70 meters in diameter, enveloped by an encircling ambulatory, from which three niches opened on the west, north, and south. Separating the spaces are eight piers and twelve columns supporting a gallery and the roof above the central space. Although there has been some question about the date of the rotunda and whether or not it was built before Constantine's death, its primary excavator, Virgilio Corbo, noted that its masonry technique is exactly like that of its neighboring basilica, dedicated in 336, and it seems that the rotunda was part of the original design of the Constantinian project.

How would the original Apostoleion compare to other imperial mausolea? The fact is some of the domed-rotunda, imperial mausolea were relatively small, with the interior diameters of the upper room ranging from about 4 meters at Gamzigrad to 13.35 meters at Split. The largest would have been Maxentius's mausoleum, with a projected interior diameter of about 24 meters for the upper level, which possibly remained unfinished. For the Christian imperial mausoleum, the simple rotunda of Helena's mausoleum measured 20.18 meters in its interior diameter, and the single double-shell design among the mausolea, that of Constantina, has an interior diameter of 22.28 meters including the ambulatory, and a central space only 11.50 meters across.[34] None of these seems a candidate for matching the descriptions noted above of the Apostoleion possessing an "unimaginable height" or a vast size.

Another indication of the size of Constantine's building is found in the fact that by the time of the last burials in the Mausoleum of Constantine in the eleventh century, there were at least twenty-one sarcophagi, some of them almost 4 meters long, in the building and probably more as there are individuals whose burial at the church is recorded but not the specific location of their sarcophagi.[35] Keeping in mind that

30 Eusebius, *Vita Constantini*, 4.60.1, ed. Winkelmann, *Über das Leben*, 144; trans. Cameron and Hall, *Eusebius*, 176.

31 Krautheimer, *Early Christian and Byzantine Architecture*, 75–77; Ćurčić, "Temple," 56, noted that "Constantine's Golden Octagon may have been one of the church buildings whose character and setting resembled the mausoleum of Constantine."

32 Eusebius, *Vita Constantini*, 3.50.2, ed. Winkelmann, *Über das Leben*, 105; trans. Cameron and Hall, *Eusebius*, 141.

33 Krautheimer, *Early Christian and Byzantine Architecture*, 60–64, 74, who links its design with that of imperial mausolea; V. Corbo, *Il Santo Sepolcro a Gerusalemme*, 3 vols. (Jerusalem,

1981–82); J.-M. Spieser, "En suivant Eusèbe au Saint-Sépulcre," *AntTard* 22 (2014): 95–103.

34 On these buildings and all late Roman imperial mausolea see Johnson, *Roman Imperial Mausoleum*.

35 G. Downey, "The Tombs of the Byzantine Emperors at the Church of the Holy Apostles in Constantinople," *JHS* 79 (1959): 27–51, 39–42, counts 21 sarcophagi, but includes only those identified in literary sources with names, leaving out any

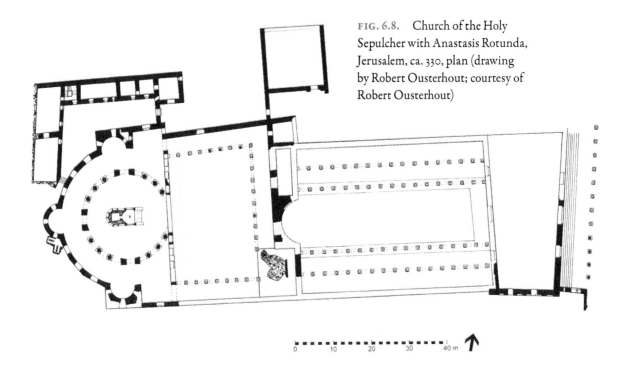

FIG. 6.8. Church of the Holy Sepulcher with Anastasis Rotunda, Jerusalem, ca. 330, plan (drawing by Robert Ousterhout; courtesy of Robert Ousterhout)

the building was also planned as a church and would need to accommodate a congregation, one can imagine that the Apostoleion was much larger than the other imperial mausolea.

The sources that discuss the imperial sarcophagi and their placement in the mausoleum all agree that it was entered from the west and that the one for Constantine was placed opposite the entrance. Mesarites is very specific on the placement of three sarcophagi: Constantine's on the east, opposite the entrance; that of Constantius to the south; and that of Theodosius to the north.[36] His specificity suggests that they were located in niches, which one would expect to find in a fourth-century rotunda. He names others but only gives a slight indication for their placement.[37] Mango, followed by others, imagined that the building was a rotunda with an entrance and seven niches, an arrangement often found in

Roman circular buildings and rooms, whatever their function. He suggested that the three named sarcophagi filled the niches on the main axes of the building with other sarcophagi eventually filling the other niches over the next two centuries.[38] This is not necessarily so. It could be argued that the specificity of the location of three sarcophagi suggests the possibility that the structure had only three large niches, matching the design of the Anastasis Rotunda. As sarcophagi were added they could have simply been placed along the wall.

Two other points are to be made about the possible architectural reconstruction of the Apostoleion. The first concerns a detail from the description of Eusebius. Every scholar who has dealt with the text of Eusebius has struggled with one particular word, δωμάτιον. It can mean little house, little roof, a room, a canopy or ciborium, or an architectural drum, as well as other things, and has been translated as each by scholars trying to understand exactly what Eusebius meant when he used the term. In the passage quoted above, Eusebius noted that the δῶμα was covered with gilt bronze tiles. This word, the root of δωμάτιον, means "house," "room," or "roof." It could be that Eusebius was referring to the church as a "house," but it seems more likely that as he was talking

that may have not been identified. P. Grierson, "The Tombs and Obits of the Byzantine Emperors (337–1042)," *DOP* 16 (1982): 1–63, on 20, counts 20 but omits one whose occupant's name is missing due to a lacuna in the text.

36 Downey, "Nikolaos Mesarites"; see also the discussion in Downey, "Tombs," and Grierson, "Tombs and Obits."

37 Mesarites, *Ekphrasis*, c. 39.3–12, ed. Heisenberg, *Apostelkirche*, 81–85; ed. and trans. Downey, "Nikolaos Mesarites," 891–92; trans. Angold, *Nicholas Mesarites*, 125–26. For the other lists of tombs in the monument, see Downey, "Tombs," and Grierson, "Tombs and Obits."

38 Mango, "Constantine's Mausoleum," 54–55.

FIG. 6.9.
Mausoleum of
Constantina (Santa
Costanza), Rome,
ca. 350, exterior from
northwest (photo
by author)

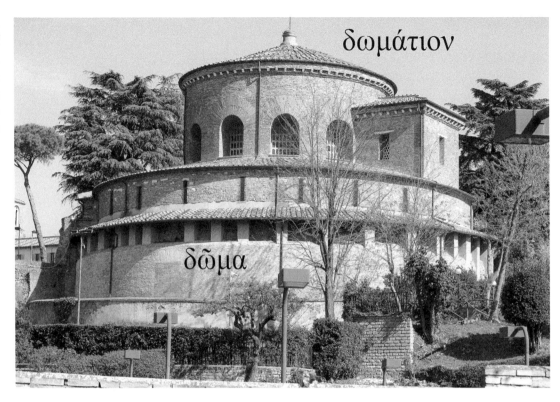

δωμάτιον

δῶμα

about the tiles and how they reflected light, as he was using the word to mean "roof" as translated by Cameron and Stuart. In the very next sentence he stated that "trellised relief-work wrought in bronze and gold went right around the δωμάτιον," the diminutive of δῶμα, which Cameron and Hall have translated as "building," as does Giulia Marsili; in a similar vein, Anatoli Vysotsky and Fedor Shelov-Kovediaev translate it as "temple," arguing that it is used to refer to the whole building. Mango translated it as "room," suggesting that Eusebius had switched his description back to the interior. Effenberger translates it as the "main niche," in which he imagines the sarcophagus of Constantine stood.[39] Krautheimer allowed that it might refer to something in the interior, suggesting a canopy over the sarcophagus, but also noted that if Eusebius was still at this point describing the exterior, then it could be translated as a "tambour" or drum. Rudolf Leeb and Paul Speck also felt that this interpretation was the most likely.[40]

The pattern of Eusebius's description is clear: he begins with noting the height of the interior space and then describes its interior walls and ceiling, going upward from the floor. He then moves to the exterior roof, the δωμάτιον, and then to the courtyard and surrounding buildings, which is to say, from the center to the periphery, as Vysotsky and Shelov-Kovediaev observed.[41] The word δωμάτιον, therefore, most likely describes an exterior feature. Its appearance immediately after the use of the word δῶμα seems to be deliberately relating the two together—the "house" and the "small house" or the "roof" and the "small roof." It should also be noted that the "trellised relief-work wrought in bronze and gold" went "right around" or "encircled" the δωμάτιον, suggesting it was circular in plan.

If one accepts the premise that the Apostoleion of Constantine was indeed a rotunda, and therefore most likely domed, then how does one explain what Eusebius was describing with the word δομάτιον? There is, in fact, a

39 Effenberger, "Konstantinsmausoleum," 71–72.

40 Ibid., 71–72; Krautheimer, *Three Christian Capitals*, 58; Speck, "Mausoleum," 116–17; Leeb, *Konstantin*, 103; Vysotsky and Shelov-Kovediaev, "Reconstruction," 495, translate it as "temple"; Marsili, "Apostoleion," 29, translates it as "structure."

41 Vysotsky and Shelov-Kovediaev, "Reconstruction," 497.

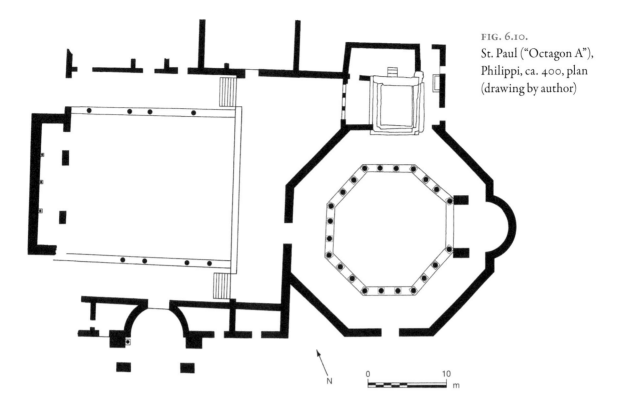

FIG. 6.10.
St. Paul ("Octagon A"),
Philippi, ca. 400, plan
(drawing by author)

fourth-century building that does show what Eusebius was describing—a double-shell rotunda with a central dome and drum raised above the roof of the ambulatory. This is the Mausoleum of Constantina, datable to the period of fifteen to twenty years after the Apostoleion was completed (fig. 6.9). Viewed externally and using Eusebius's terminology, the δῶμα is the lower building or its large roof that is now covered with terracotta instead of its original gilt (probably) bronze tiles. The δωμάτιον—the little house or smaller roof—is formed by the central fenestrated drum and dome, now hidden under a conical roof but originally exposed externally, that rises in the center of the building.

The second point is whether or not this building was circular or octagonal, its designation as a "rotunda" permitting either. One clue may be in Mesarites' description, in which he states that, "because of the rather extensive area of the plan, I suppose, it is divided up on all sides by numerous stoaed [sic] angles [or corners] (στωϊκαῖς γωνίαις)."[42] The word γωνία has usually

been interpreted to mean niche, in this case having a screen of columns or being flanked by columns, or alternatively, as angles in the wall, in which columns are placed in the corners.[43]

Neither interpretation explains why such things would be needed, as Mesarites says, "because of the rather extensive area of the plan." Niches appear in even tiny buildings in late antiquity, as do columns placed in corners of small polygonal structures. Perhaps another interpretation is justified. As the word γωνία means an interior or exterior angle or corner, it should be obvious that corners are not normally found in circular buildings, except in niches, but they are, of course, found in octagonal structures. The word stoa is used to describe anything that consisted essentially of supports bearing a roof.[44] Procopius used it to describe the interior galleries of Hagia Sophia.[45] So, connecting this with Mesarites' observation that the building had an

42 Mesarites, *Ekphrasis*, c. 39.2, ed. Heisenberg, *Apostelkirche*, 82; ed. and trans. Downey, "Nikolaos Mesarites," 891; trans. Angold, *Nicholas Mesarites*, 125. Also discussed by Downey, "On Some Post-Classical Greek Architectural Terms," *TAPA* 77 (1946): 22–34, at 29–30.

43 Asutay-Effenberger and Effenberger, *Porphyrsarkophage*, 115, "niches with columns"; J. Bardill, *Constantine: Divine Emperor of the Christian Golden Age* (Cambridge, 2012), 373, translates it as "niches."

44 Downey, "Terms," 28.

45 Procopius, *De aed.*, 1.1.55, ed. and trans. H. B. Dewing, *Procopius*, vol. 7, *Buildings*, Loeb (London and Cambridge, MA, 1940), 24–25.

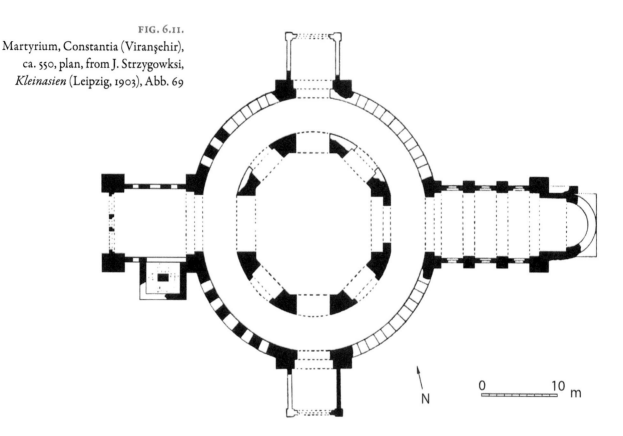

FIG. 6.11.
Martyrium, Constantia (Viranşehir),
ca. 550, plan, from J. Strzygowksi,
Kleinasien (Leipzig, 1903), Abb. 69

0 _____ 10 m

N

extensive area, perhaps the phrase can be taken to refer to colonnades with eight corners forming an interior octagon, as seen in the octagonal church of St. Paul in Philippi, seen here as first built in about 400 (fig. 6.10).[46]

The design of the Apostoleion of Constantine is best understood as a rotunda with a fenestrated drum rising from the center to support a dome. As a large building, it would have most likely possessed an ambulatory, off which opened at least three niches. It could have been circular, like the Anastasis Rotunda, or octagonal, like the Golden Octagon in Antioch, or perhaps it combined an octagonal central core with a circular exterior wall, as was done in the later martyrium church at Constantia (Viranşehir), Turkey (fig. 6.11).[47] Effenberger is probably correct in his assertion that the Mausoleum of Constantina in Rome was a smaller scale copy, or close relative, of this building. Such a structure could be seen as both a church and as a building

that fit the traditional late Roman imperial mausoleum type.

The Interior Furnishings and Their Arrangement

Whatever its exact plan may have been, the Apostoleion was an extraordinary building because of this dual function and because of how Constantine first set up its interior. Eusebius alluded to the dual functions of the building and described the interior arrangements ordered by Constantine to accommodate them:

> All these things the Emperor dedicated to perpetuate for all mankind the memory of our Savior's apostles. But he had another object also in mind when he built, which though secret at first was towards the end surmised by everybody. He had prepared the place there for the time when it would be needed on his decease, intending with supreme eagerness of faith that his own remains should after death partake in the invocation of the apostles, so that even after

46 M. Johnson, *San Vitale in Ravenna and Octagonal Churches in Late Antiquity* (Wiesbaden, 2018), 51–54.

47 Johnson, *San Vitale*, 124–27.

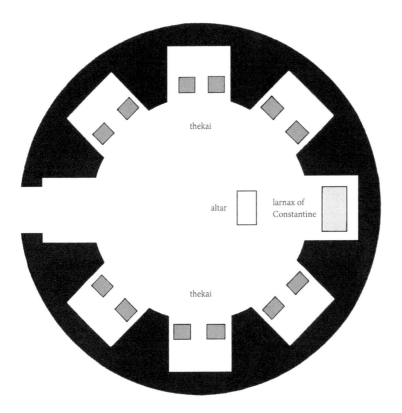

FIG. 6.12.

Apostoleion, Constantinople, hypothetical plan showing location of tombs according to Mango (drawing by author)

his decease he might benefit from the worship which would be conducted there in honor of the apostles. He therefore gave instructions for services to be held there, setting up a central altar. So he erected twelve repositories (θῆκαι) like sacred monuments (στῆλαι) in honor and memory of the company of the apostles and put his own coffin (λάρναξ) in the middle with those of the apostles ranged six on either side. . . . So having planned these things in his mind long in advance he dedicated the shrine to the apostles, in the belief that their memorial would become for him a beneficial aide to his soul.[48]

Constantine's sarcophagus stood near the altar near the center of the building. Nearby and to the sides were the twelve "coffins like sacred stelai (θῆκαι ὡσανεὶ στῆλαι ἱερὰς)," erected as memorials to the twelve apostles. The word θήκη was commonly used at this time to mean "tomb" or "coffin" and is basically interchangeable with

λάρναξ, the word Eusebius used to describe Constantine's sarcophagus.[49]

Mango supposed that the original arrangement of these furnishings was that the sarcophagus of Constantine stood in the main niche opposite the entrance, the altar in front of it, and the twelve θῆκαι in the remaining niches, two in each one (fig. 6.12).[50] Effenberger suggests that the building had fifteen niches plus an entrance and, therefore, a niche was available for each of the θῆκαι.[51] Eusebius stated that the θῆκαι stood like stelai, thereby emphasizing their memorial function. Marsili points out that stelai are usually stone slabs that are often inscribed, suggesting that Eusebius's phrase here might mean that the θῆκαι were inscribed, presumably with the names of the apostles.[52]

48 Vita Constantini 4.60, ed. Winkelmann, Über das Leben, 145; trans. Cameron and Hall, Eusebius, 176–78.

49 Marsili, "Apostoleion," 38; Bardill, Constantine, 368.

50 Mango, "Constantine's Mausoleum," 57–58; followed by Bardill, Constantine, 373.

51 Effenberger, "Konstantinsmausoleum," 71; and Asutay-Effenberger and Effenberger, Porphyrsarkophage, 53.

52 Marsili, "Apostoleion," 38–39; D. Woods, "Libanius, Bermachius, and the Mausoleum of Constantine I," Studies in Latin Literature and Roman History 13 (2006): 428–39, at 435,

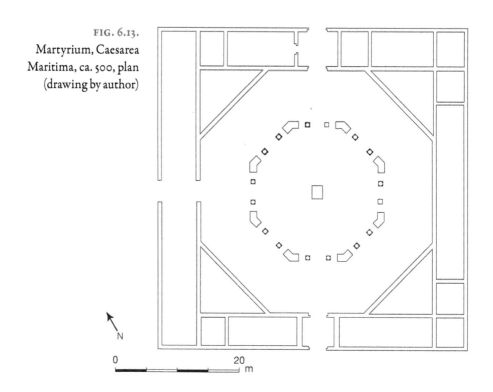

FIG. 6.13.
Martyrium, Caesarea
Maritima, ca. 500, plan
(drawing by author)

0 20
m

N

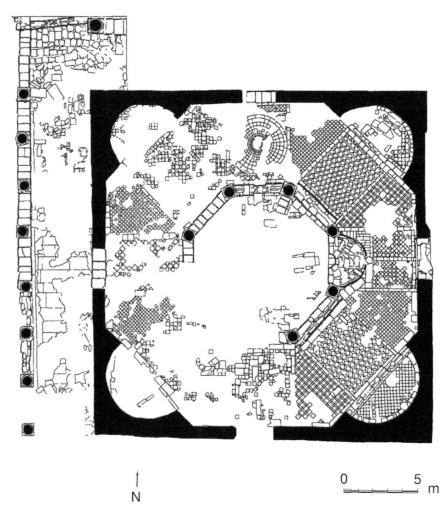

FIG. 6.14.
Martyrium, Gadara,
early sixth century, plan
(drawing by author)

N

0 5
m

Eusebius does not, however, mention niches, and though it is likely that any circular or octagonal building would have had them, it does not necessarily follow that the λάρναξ of Constantine and the twelve θῆκαι must have occupied niches. Eusebius's description allows the possibility of the altar and λάρναξ occupying a position in or near the center of the central space in a rotunda or a double-shell rotunda, similar to what is seen with the aedicula of Christ's tomb in the center of the Anastasis Rotunda.

Eusebius also notes that Constantine had his λάρναξ placed next to the altar of the building. An altar in a church is, of course, expected, but it was not uncommon to find them in tombs as well during this period. Constantine had already furnished one for the mausoleum of his mother in Rome as reported in the *Liber Pontificalis*, and more humble altars are known from other Christian tombs.[53] It was the joining of the monuments of the apostles with his sarcophagus and the altar that made the Apostoleion a new and unique monument—a mausoleum for an emperor that was also a memorial church for the apostles.

Placing the honored tomb at the center of a rotunda near a central altar is found in later buildings that may echo the arrangement in Constantine's Apostoleion. Excavations at the octagonal martyrium at Caesarea Maritima in Palestine, dating to about 500, revealed in the exact center of the building numerous fragments of green *serpentino,* which were identified as the remains of a martyr's shrine (fig. 6.13).[54] From about the same period is another octagonal martyrium at Gadara in Jordan (fig. 6.14). There archaeologists discovered that the whole of the central octagonal space, separated from the ambulatory by parapet walls, functioned as sanctuary. A depression in the center was of the dimensions to accommodate a sarcophagus; to its east were remnants of the altar.[55]

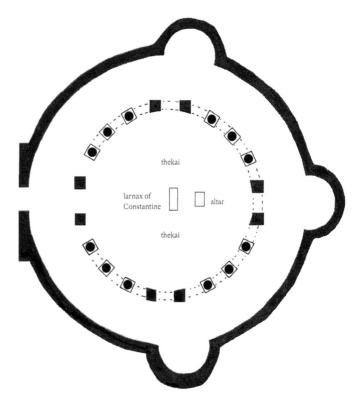

FIG. 6.15. Apostoleion, Constantinople, ca. 337, hypothetical plan (drawing by author)

Using the center of a rotunda as the focal point of an ecclesiastical building was something done in two of Constantine's buildings. The octagon at the west end of the church of the Nativity in Bethlehem surrounded a hole in the floor that had been cut through the ceiling of the grotto, allowing pilgrims to gaze down upon Christ's place of birth.[56] As noted, the tomb of Christ was in the center of the Anastasis Rotunda in the Holy Sepulcher complex in Jerusalem, in what is the most relevant example. Constantine's original Apostoleion may well have been similar in its original design, with his larnax occupying a central position near the altar (fig. 6.15).

Constantius II and the Apostoleion

At some point the θῆκαι were removed from the Apostoleion and the arrangement of the furnishings described by Eusebius was changed. This probably happened under Constantius II when

suggests that a scribe transposed "στῆλαι" and "θῆκαι" and that the original text would have stated that Constantine "erected twelve columns like sacred coffins."

53 *Liber Pontificalis* c. 26, ed. L. Duchesne (Paris, 1886), 1:182; trans. R. Davis, *The Book of Pontiffs (Liber Pontificalis),* rev. ed. (Liverpool, 2000), 23–24. On the use of altars in tombs see Johnson, *Roman Imperial Mausoleum,* 116–17, with references.

54 Johnson, *San Vitale,* 87.

55 Ibid., 92.

56 Krautheimer, *Early Christian and Byzantine Architecture,* 59–60.

he added the cruciform church to the complex, making the new church the monument honoring the apostles and leaving the rotunda to serve as imperial mausoleum. The church was cruciform, as noted by Gregory of Nazianzos, but beyond that one can only speculate as to its details. As with most early Christian churches, it was probably covered with wood roofing. It is likely that the altar stood at the crossing, as was the case in its copies named above, beneath a short, raised tower above the space with windows to bring in light.

This transformation probably did not occur early in Constantius's reign, as he was away from Constantinople. He remained in Antioch until 349, largely occupied with military operations in the east, then headed west in 350 to deal with Magnentius until the usurper's death in 353. This was followed by a period of relative stability, though the emperor remained in the West, residing in Milan until returning to Constantinople in 359. It was during this period of peace that Constantius had the time to think about building projects.[57]

Possible clues as to when the new construction took place are found in Julian's oration delivered in late 355 or early 356, in which Constantius II is praised for his filial piety for having adorned the tomb of his father, as noted above. This might refer to some kind of decoration added to the Apostoleion, or it could suggest further changes were occurring then, such as modifying the interior arrangement or beginning construction on the new cruciform church.

As mentioned above, Krautheimer believed that the arrival of the relics reported by some sources as taking place in 356, and their placement near the tomb of Constantine, upset church authorities, who then moved to separate the remains of Constantine and the relics when an occasion—damage to the church—arose in 359.[58] Other scholars see the reports of the arrival

of the relics in 356 and 357 as evidence that the church had begun and had progressed enough to receive them by that time, assuming that the date of the *translatio* is correct.[59]

Two additional reasons that explain why Constantius would have initiated his project in the 350s have been overlooked. First, this is the same period in which Constantius was also overseeing the construction of tombs for his siblings. Athanasius mentions that Constantius was building the tomb of his brother Constans, who was murdered in 350 and was probably buried at Centcelles in Spain.[60] Kleinbauer has convincingly argued that he was also in this period involved with the construction in Rome of the mausoleum of his sister, Constantina, who died in 354.[61]

The second point, which is significant, is that Constantius, in surveying the original situation in the Apostoleion, must have understood that his father had planned a monument for himself, without concern for his successors.[62] One imagines that following the deaths of his brothers and sister, Constantius was by the mid-350s also considering his own eventual death and burial. This, in and of itself, provided reason enough for him to have initiated changes at the Apostoleion in order to make room for himself in a setting made to his liking and transforming it into a dynastic mausoleum. This meant placing the sarcophagus of his father in the main niche upon its return and installing a sarcophagus for his own eventual use into the south niche. As noted above, Constantius's wife Eusebia died in 360 and was interred in the sarcophagus prepared for her and himself; he followed in November of the following year. Their burials are further evidence that it was not the mausoleum that was under construction at this time, as Krautheimer and others have supposed, but rather it was the cruciform church that would not be completed until 370.

57 As noted by Burgess, "Passio," 30.

58 In contrast, D. Berranger-Auserve, "'À propos du mausolée de Constantin': la réaction des Pères de l'église," in *Le voyage des légendes: Hommage à Pierre Chuvin*, ed. D. Lauritzen and M. Tardieu (Paris, 2013), 57–64, notes that the Church leaders of the fourth and fifth centuries did not object to the imperial cult practices that developed at the tomb of Constantine, arguing that he was seen as an equal to the apostles.

59 Mango, "Constantine's Mausoleum," 59; Marsili, "Apostoleion," 43; Asutay-Effenberger and Effenberger, *Porphyrsarkophage,* 56; Effenberger, "Konstantinsmausoleum," 73–74; Burgess, "Passio," 30.

60 Athanasios, *Historia arianorum ad monachos,* 69 (PG 25:775); Johnson, *Roman Imperial Mausoleum,* 129–39.

61 E. Kleinbauer, "Antioch, Jerusalem, and Rome: The Patronage of Emperor Constantius II and Architectural Innovation," *Gesta* 45 (2006): 126–46, on 136–37.

62 Bardill, *Constantine,* 375, notes that it was not a family tomb.

Constantius opened the door for the Apostoleion complex to become the burial place for all emperors in the East. Jovian was buried there in 364, followed by Valentinian I in 376, who was reburied or whose sarcophagus was moved in 382.[63] The original placement of their sarcophagi is not mentioned in the sources, but could possibly have been in the mausoleum, with one of them occupying the north niche. Jovian's sarcophagus eventually ended up in a small, separate structure known as the "north stoa," about which nothing is known other than its name and a vague location.[64] The location of Valentinian's sarcophagus is not mentioned in the sources, but possibly was in the north stoa by 382 as well.

Theodosius seems to have taken an active interest in the mausoleum, securing for his sarcophagus the honored place in the north niche, possibly removing one belonging to a predecessor and building the north stoa.[65] He also saw to the burials in the monument of Constantia, daughter of Constantius and wife of Gratian, in 383; his own daughter Pulcheria in 385, and his wife Flacilla in 386.[66] He was also probably responsible for the transfer of the remains of Julian to the complex, where they were installed in the north stoa.[67] Early in the fifth century, a second small structure, known as the "south stoa," was built on the south side or to the south of the church and had a cruciform interior arrangement to house the remains of Arcadius, his wife Eudoxia, and their son Theodosius II, all in separate sarcophagi.[68]

Evidently, when Constantius built the new cruciform church next to the rotunda church-mausoleum and separated the functions of the original building into two structures, the θῆκαι of the apostles were not kept. The *Chronicon Paschale* reports that the relics were placed "under the holy altar" of the church, certainly the new cruciform church.[69] Procopius reports at his time that when the church of Constantius was razed to make way for a new church on the site under Justinian, the relics of the apostles were found by accident in an unexpected place.[70] This can perhaps be explained as the result of the altar being moved. In its original setting in the new cruciform church, the altar, with the relics underneath, likely stood at the crossing, as was the case for the altar and related relics at the Basilica Apostolorum in Milan.[71] At some point the altar could have been moved into the eastern arm of the church, leaving the buried relics to be forgotten.

It should be noted that this sequence of construction—a rotunda church that was also a mausoleum built by Constantine, followed by the construction of a cruciform church by Constantius that left the rotunda to serve the sole role of imperial mausoleum—explains the confusion in the sources as to who was the builder of the church of the Holy Apostles.[72] Constantine was the builder of the original church-mausoleum; Constantius is also called the builder because he initiated the construction of a new church on the site and modified the rotunda into a dynastic monument.

The Meaning of the Apostoleion

It is the meaning of the Apostoleion as intended by Constantine that has attracted the most attention of scholars. The key to understanding the meaning of his church-mausoleum is Eusebius's

63 Johnson, *Roman Imperial Mausoleum*, 213 (Jovian) and 216 (Valentinian).

64 On the "stoas" built near the church see Downey, "Tombs," 45–46. Effenberger, "Konstantinsmausoleum," 67, suggests both stoas were built by Constantius II, but there is no evidence for this assertion.

65 As first suggested by Grierson, "Tombs and Obits," 25. On Theodosius's interest in the imperial mausoleum in Constantinople see B. Croke, "Reinventing Constantinople: Theodosius I's Imprint on the Imperial City," *From the Tetrarchs to the Theodosians: Later Roman History and Culture, 284–450 CE*, ed. S. McGill, C. Sogno, and E. Watts, *YCS* 24 (Cambridge, 2010), 241–312, on 252–53.

66 Johnson, *Roman Imperial Mausoleum*, 206 (Constantia), 215 (Pulcheria), and 208 (Flacilla).

67 Croke, "Reinventing Constantinople," 253; on the transfer see M. Johnson, "Observations on the Burial of the Emperor Julian in Constantinople," *Byzantion* 77 (2008): 254–60.

68 Johnson, *Roman Imperial Mausoleum*, 121.

69 *Chronicon Paschale*, a. 356, ed. Dindorf, 542; trans. Whitby and Whitby, 33.

70 Procopius, *De aed.*, 1.4.18–23, ed. and trans. Dewing, *Buildings*, 50–53. Mesarites, *Ekphrasis*, c. 38.5, ed. Heisenberg, *Apostelkirche*, 81, ed. and trans. Downey, "Nikolaos Mesarites," 890–91; trans. Angold, *Nicholas Mesarites*, 124, also states that the relics of the apostles were under the altar of the church.

71 Krautheimer, *Early Christian and Byzantine Architecture*, 81–82.

72 Sources: Johnson, *Roman Imperial Mausoleum*, 119 and 236–37, notes 39–40.

description. In placing his sarcophagus near the altar and in the vicinity of the twelve θῆκαι honoring the apostles, Constantine hoped, as Eusebius recounts, to share in the honor that worshipers would accord the apostles. An overlooked aspect of this veneration is to be found in questioning just how the veneration of emperor and apostles would be linked. If the relics of Sts. Timothy, Andrew, and Luke were not brought to the church until 356–357, long after Constantine's remains had been placed in his sarcophagus near the altar, how would the connection between emperor and apostles have been made in 337? The site was not linked in any fashion with the apostles before the construction of the church, meaning Constantine had not sought out a holy tomb next to which he built his mausoleum. Would it have been enough to simply dedicate the building in the name of the apostles and have twelve monuments or cenotaphs to develop a meaningful connection between the ruler and the apostles?

The church dedications of Constantine fall into three groups: one, those dedicated to martyrs, erected at the sites of their burials, such as St. Peter's and St. Lawrence in Rome and, possibly, St. Mokios in Constantinople; two, memorial churches built at the site of important events in biblical history, such as the church of the Nativity in Bethlehem or that of the Anastasis in Jerusalem; and three, churches that were places of ordinary worship, often cathedrals. These were dedicated not to saints but bore names of their founder or some abstract appellation: St. John in Rome was first known as the "Basilica Constantiniana"; the Golden Octagon in Antioch is referred to in sources most often as simply the "Great Church"; and the first cathedral in Constantinople, Hagia Eirene, was dedicated to Peace. Dedicating a church to a saint or group of saints with no direct connection to their burial was not done under Constantine.[73] Given the fact that the Apostoleion was dedicated, according to Eusebius, to the apostles, could it have served that function without any relics or in a place with no connection to their martyrdom?

For this reason, the other tradition connected with the transfer of relics of Andrew and Luke, which places their arrival in Constantinople on 22 June 336, rings true.[74] In order to be connected to the apostles and truly share in the honor accorded them, Constantine needed to build his tomb next to one of theirs or bring their remains to where he planned to be buried. Instead of a burial *ad sanctos,* Constantine wrought for the apostles a burial *ad imperatores.* Although it became common later, transferring the relics of saints, especially those of the apostles, was an extraordinary action for this period.[75] Only an emperor could make such a thing happen at this time and by so doing, Constantine demonstrates both the imperial power he held and his own particular view about himself and his place in Christianity.

Under Roman law, the dead were to be left undisturbed; violation of tombs was one of the more serious crimes under Roman law.[76] There were, however, some precedents for moving what might be termed the "special dead." Domitian had the remains of his father Vespasian and his brother, Titus, moved from the Mausoleum of Augustus to the Templum Gentis Flaviae in the late first century AD; in the second century, Hadrian was first buried at Puteoli (Pozzuoli), but his remains were later transferred to the mausoleum bearing his name that he had built

73 O. Brandt, "Constantine, the Lateran, and Early Church Building Policy," *ActaIRNorv* 15 (2001): 109–14, especially 111–12.

74 Sources: *Fasti Vindobonenses priores and posteriores,* no. 447, MGH AuctAnt, 9 (1892): 293; *Barbarus Scaligeri,* no. 241, MGH AuctAnt, 9 (1892): 293; *Fasti Berolinenses,* a. 336, now in R. Burgess and J. Dijkstra, "The Berlin 'Chronicle' (P.Berol. inv.13296): A New Edition of the Earliest Extant Late Antique *Consularia,*" *APf* 58 (2012): 273–301, on 278 and 290; Paulinus of Nola, *Poema* XIX, *Carmen XI in S Felicem,* PL 61, 530–31, also attributes transfer of relics to Constantine. That this is the correct dating is argued by Burgess, "Passio," in which he demonstrates that the sources connecting the translation of the relics with Artemios and the date of 360 to be untrustworthy; accepted by Bardill, *Constantine,* 369. Eusebius does not mention the *translatio,* but his *Life of Constantine* was still incomplete at his death. See Barnes, *Constantine,* 265; Cameron and Hall, *Eusebius,* 9. Luke was not, of course, one of the original twelve apostles, but he was one of the evangelists and considered to be one of the "seventy apostles" by writers such as Epiphanius (*Panarion,* 51.11) and would eventually find his name on later lists of the apostles.

75 As noted by Mango, "Constantine's Mausoleum," 51–53.

76 F. De Visscher, *Le Droit des tombeaux romains* (Milan, 1963); M. Kaser, "Zum römischen Grabrecht," *ZSavRom* 59 (1978): 15–92.

in Rome.[77] Constantine could justify the moving of the remains of the two apostles in order to give them a much more honorable burial—while reaping the benefits for himself. Therefore, if this dating is correct, the twelve θῆκαι were not meant to be simple memorials or cenotaphs. It is possible that they were intended to serve as repositories for the twelve apostles, as relics became available.[78] Constantine's own death the following year brought the plan to an end.

Some have seen in Constantine's plan a desire to be seen as a "thirteenth apostle" or even as a Christ-like figure. What probably comes closest to the truth is that Constantine saw the apostles as *comites,* or companions.[79] Earlier in his career, before embracing Christianity, Constantine had issued coins depicting himself together with a divine *comes,* Sol.[80] Constantine must have been cognizant of his own tremendous role in building up the Christian church and could have seen the apostles as his peers in this regard. He could have also viewed them as his peers in having a special relationship with Christ, just as he had earlier in life claimed one with Apollo.[81] Nevertheless, in planning his burial arrangements, Constantine did not envision a memorial monument in which he would be the sole focus of veneration, as had been the case for the Tetrarchic imperial mausolea. If one takes Eusebius at his word, Constantine actually hoped to share in the honor and veneration that would be directed primarily at the apostles.

One final point, which oddly has not received comment, but which throws additional light on Constantine's intent in creating the Apostoleion as he did, is found in the terminology Eusebius employed for designating the building. Everyone has noted that Eusebius calls it a "temple" or "shrine" (ναός), but most have passed over the fact that he may also have called it the "martyrion (μαρτυρίον) in memory of the apostles."[82] Although some scholars have noted the use of the term, none has analyzed its significance, assuming its use simply meant that the building was like other martyria, serving to honor the martyrs to whom it was dedicated.[83]

It is generally accepted that the definition of the word martyrion is a building that was a shrine of a martyr or martyrs, placed on the tomb or place of martyrdom, or a building constructed on one of the holy sites of Palestine. Nevertheless, this is not what Eusebius or any other writer before the late fourth century meant by the word "martyrion," as Robert Ousterhout has pointed out.[84] He noted that the first use of the word to mean martyr's shrine or holy site seems to be in Egeria's late fourth-century account of the Holy Sepulcher complex, and this usage only became standard much later.[85]

Ousterhout notes that the first use of the word martyrion to refer to a venerated Christian site was in Eusebius's *Vita Constantini* in the author's description of the discovery of the tomb of Christ, which he calls "the most holy martyrion of the Savior's resurrection." In this he was using terminology derived from Zephaniah 3:8: "There says the Lord, wait for me at the martyrion on the day of my resurrection" (or, alternatively, "wait until the day of resurrection for a testimony"). Up

77 For the Flavians: Johnson, *Roman Imperial Mausoleum,* 22; for Hadrian, T. Opper, *Hadrian: Empire and Conflict* (Cambridge, MA, 2008), 221.

78 As proposed by Burgess, "Passio," 29; accepted by Bardill, *Constantine,* 329.

79 For Constantine as a 13th apostle see S. Rebenich, "Vom dreizehten Gott zum dreizehten Apostel: Der tote Kaiser in der Spätantike," *Zeitschrift für Antikes Christentum* 4 (2000), 300–324, and M. Wallraff, *Sonnenkönig der Spätantike: Die Religionspolitik Konstantins des Großen* (Freiburg 2013), 149–63; as a *comes,* see Cameron and Hall, *Eusebius,* 339.

80 This gold medallion was issued at Ticinum. See *L'editto di Milano e il tempo della tolleranza, Costantino 313 d.C.,* ed. G. Sena Chiesa (Milan, 2012), 201.

81 Barnes, *Constantine,* 275.

82 Eusebius, *Vita Constantini,* 4.58, ed. Winkelmann, *Über das Leben,* 144, note; trans. Cameron and Hall, *Eusebius,* 176, commentary, 335–36. The passage is found in a supplement to the Geneva edition of 1612 and may be part of the missing text of the lacuna preceding the description of the Apostoleion. The chapter headings, written by Eusebius by an early copyist or editor, also call the building the "Martyrion" of the Apostles; ed. Winkelmann, *Über das Leben* 13; trans. Cameron and Hall, *Eusebius,* 54 and 65.

83 Thus, following the classic definition offered by A. Grabar, *Martyrium: Recherches sur le culte des reliques et l'art chrétien antique,* 2 vols. (Paris, 1943–46), 1:29; Krautheimer, *Early Christian and Byzantine Architecture,* 519. Cameron and Hall, *Eusebius,* 337, equate the use of martyrion here with "mausoleum."

84 R. Ousterhout, "The Temple, the Sepulcher, and the Martyrion of the Savior," *Gesta* 29 (1990): 44–53.

85 Egeria, 30.1, trans. J. Wilkinson, *Egeria's Travels to the Holy Land* (Warminster, 1981), 132.

until this time, the word "martyrion" meant "evidence," "testimony," or "witness." Eusebius used it not in reference to a particular architectural type, but to mean that the empty tomb of Christ was the "witness" of Christ's resurrection.[86]

So, if the passage in question does indeed reflect Eusebius's own terminology, what was his intended meaning in calling the Apostoleion the "Martyrion of the Apostles?" It seems evident that he would have been using the term in a manner similar to how he employed it in his discussion of the Holy Sepulcher complex. The Martyrion of the Apostles was a place of testimony or witness of the apostles and their companion, Constantine. The building was a shrine to the apostles, the tomb of some of them, and perhaps the intended tomb of all of them, as well as the tomb of the emperor. It stood as a witness to the faith of the apostles and of Constantine, as well as to the emperor's view that his status in life and his accomplishments gave him the right to share in the honor accorded the apostles. Additionally, in an era when the immortality of the emperor was a commonly accepted belief, the Apostoleion as an imperial mausoleum, like other imperial mausolea, stood as a witness to Constantine's immortality, only now in the Christian heaven.

86 Ousterhout, "Temple," 51.

JUSTINIAN'S CHURCH OF THE HOLY APOSTLES

A New Reconstruction Proposal

NIKOLAOS KARYDIS

*T*HE SIXTH-CENTURY CHURCH OF THE HOLY APOSTLES AT CON-stantinople may be lost forever, but the interest in its design and history is far from subsiding. Since the rediscovery of two medieval descriptions of the church in the late nineteenth century, several historians of Byzantine architecture have tried to recapture its lost form and study its transformations through time. The strong scholarly interest in this building reflects its historical significance. Occupying a commanding location on the fourth hill of Constantinople, this church was one of the city's major religious landmarks for more than a thousand years. According to most scholars, the history of the monument began with the construction of Constantine's mausoleum in the fourth century. Eusebius's *Life of Constantine* suggests that the imperial tomb inside the mausoleum was surrounded by the repositories of the twelve apostles.[1] But this fusion between the sacred and the profane under the imperial wing was not to last. By the end of the fourth century,[2] the site had changed: it was occupied by a cruciform basilica dedicated to the apostles and a separate mausoleum, which contained the tombs of Constantine and his successors.[3] The middle of the sixth century constitutes a milestone in the development of the complex: between 540 and 550 CE Justinian rebuilt the church and added a new mausoleum to the complex. However, his architects did not alter the overall site plan: funerary monuments and church remained separate. It was largely in this form that the building was to be experienced until the fifteenth century.

Justinian's church exerted a strong influence on the development of ecclesiastical architecture. This was one of the two earliest examples of the cruciform church with plural domes—the church of Saint John in Ephesos being the other contemporary example of this type.[4] These monuments provided the model for later developments. San Marco in Venice and Saint-Front in Périgueux, themselves cruciform domed basilicas, demonstrate the longevity of this type and its influence beyond the borders of Byzantium (fig. 7.1).[5]

1 See P. Grierson, "The Tombs and Obits of the Byzantine Emperors (337–1042)," *DOP* 16 (1962): 3–63, esp. 5.

2 The date of construction of the Mausoleum of Constantine and the first church of the Holy Apostles has been the subject of a long debate that has not yet found a unanimously accepted conclusion. Most authors believe that the first mausoleum was the work of Constantine and that his successor built the first church of the Holy Apostles.

3 For the development of the site in the 4th century see M. Johnson, *The Roman Imperial Mausoleum in Late Antiquity* (New York, 2009), 122.

4 Recent research shows that the early 6th-century phase of St. John's was almost identical to the Apostoleion. See N. Karydis, "The Evolution of the Church of St. John at Ephesos during the Early Byzantine Period," *ÖJh* 84 (2015): 97–128.

5 For the use of the Holy Apostles as a model for the original church of San Marco, see O. Demus, *The Church of San Marco in Venice: History, Architecture, Sculpture* (Washington, DC, 1960), 64. For the 11th-century church of San Marco and its similarities with the church of St. John in Ephesos and Justinian's Apostoleion, see F. Forlati, *La basilica di San Marco attraverso i suoi restauri* (Trieste, 1975), 62, and E. Concina, *Storia dell'architettura di Venezia dal VII al XX secolo* (Milan, 1995), 35–36. For a somewhat

FIG. 7.1.
Basilica of
San Marco,
Venice, view
of the interior
(photo by
author, 2010)

Despite its architectural and historical value, the entire complex was pulled down soon after the Ottoman conquest to clear the ground for the Fatih Camii and its surrounding complex (*külliye*).[6] The first Fatih Camii has not survived, but the little that we know about its form suggests that it was inspired more from the design of Hagia Sophia than that of the Apostoleion.[7] As

a result, the mosque does not seem to have preserved any morphological aspect of the church it replaced. Graphic reconstruction represents the only way to recapture the form of this lost church. Since the late nineteenth century, historians of Byzantine architecture have tried to visualize the monument on the basis of descriptions dating from the sixth to the late twelfth century. The study of affiliated monuments has also provided clues for reconstruction. The church of St. John at Ephesos is one of the most important sources of knowledge in this respect (fig. 7.2). My recent work on this church helps to interpret the descriptions of the Apostoleion in a new light, setting the basis for a new reconstruction of the lost monument. Like previous attempts

dated but interesting examination of the Byzantine origins of the design of Saint-Front de Périgueux, see F. de Verneilh, *L'architecture byzantine en France: Saint-Front de Périgueux et les églises à coupoles de l'Acquitaine* (Paris, 1851), 11–19.

6 The complex of the Holy Apostles was destroyed before it could be visited and described in detail by Renaissance travelers, such as Pierre Gilles, who visited Constantinople in the 1540s. Gilles mentions the destruction of the Holy Apostles and claims that the church was replaced by the Fatih Camii. See P. Gilles (Gyllius), *The Antiquities of Constantinople,* trans. John Ball (London, 1729), 222–23.

7 See G. Necipoğlu, "From Byzantine Constantinople to Ottoman Kostantiniyye: Creation of a Cosmopolitan Capital

and Visual Culture under Sultan Mehmed II," in *From Byzantion to Istanbul: 8000 Years of a Capital,* ed. C. Anadol (Istanbul, 2010): 262–77, esp. 266.

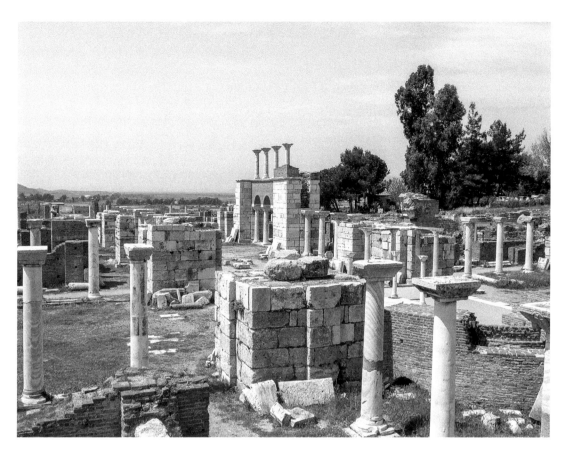

FIG. 7.2.
Church of St. John
in Ephesos, view of
the remains from
the east, looking
northwest (photo
by author, 2007)

to visualize the monument, the present recon-
struction is largely hypothetical. In the absence
of substantial remains of this church, we cannot
recapture its form with certainty. Our objective
is, rather, to construct a plausible model for the
lost church, which will be based on the best pos-
sible interpretation of the limited evidence, pre-
dominantly textual, at our disposal. But before
we move on to analyze previous and current
approaches to reconstruction, a few words are
necessary to describe in more detail the nature of
the evidence on which this paper is based.

Sources of Knowledge: Literary Evidence and Affiliated Monuments

Textual records provide important information
about the form of the sixth-century church. The
earliest description of the building is included
in Procopius's panegyric *On Buildings*.[8] Writing

shortly after the remodeling of the Holy Apostles
by Justinian, Procopius gave an outline of its
plan and vaults, and briefly discussed its previ-
ous, fourth-century phase.[9] However, the study
of this brief and "sketchy" account is not suffi-
cient to envision the building in all its complex-
ity. For this, one needs to turn to two longer and

8 For an English translation of the original Greek text, see
H. B. Dewing, trans., *Procopius*, vol. 7, *On Buildings* (London
and Cambridge, MA, 1940). Procopius's work has been analyzed

from a literary, political, and cultural viewpoint by Av. Cameron,
Procopius and the 6th Century (Berkeley and Los Angeles, CA,
1985), 84–112, and G. Downey, "The Composition of Procopius,
De Aedificiis," *TAPA* 78 (1947): 171–83.

9 The date of Procopius's treatise is controversial. Both M.
Whitby ("Justinian's Bridge over the Sangarius and the Date
of Procopius' de Aedificiis," *JHS* 105 [1985]: 129–48, esp. 141–
47) and Downey ("Composition of De Aedificiis," 181), place
this book at ca. 560. Their attribution is based on Procopius's
reference to the imminent completion of the bridge over the
Sangarius River, which, according to other sources, was begun
only in ca. 560. On the other hand, according to Cameron
(*Procopius*, 9, 85–86), an earlier date, ca. 554/555, "accords far
better, on all grounds, with Procopius' work." According to
F. Montinaro ("Power, Taste, and the Outsider: Procopius and
the Buildings Revisited," in *Shifting Genres in Late Antiquity*,
ed. G. Greatrex and H. Elton [Farnham, 2015], 191–206; "Études
sur l'évergetisme imperial à Byzance" [PhD diss., École Pratique
des Hautes Études-Sorbonne, 2013]), Procopius's work had two
redactions, the first in 550 and the second in 554.

more detailed descriptions written in the middle Byzantine period.

The first of these descriptions is found in the verse *ekphrasis* of the Holy Apostles, which Constantine the Rhodian dedicated to the emperor Constantine VII Porphyrogennetos.[10] Although this was composed approximately four centuries after Justinian's remodeling,[11] the author of the *Ekphrasis* states that he is describing the sixth-century monument. Indeed, his description agrees with Procopius's account. But the approach of Constantine the Rhodian is different: unlike Procopius, he adopts the point of view of the designer and demonstrates an impressive architectural sensibility, providing information rarely found in Byzantine written records.[12] For instance, he describes the number and disposition of columns and piers, and makes detailed references to vaults and their geometry.

Further evidence can be drawn from the lengthy prose description written by Nicholas Mesarites between 1198 and 1203.[13] Remarkably detailed, this document is entirely devoted to the complex of the Holy Apostles. Unlike previous accounts, which view the church as an isolated object, this one examines it in its larger setting, taking into account the mausoleums of Constantine and Justinian. Mesarites' reference to the church itself is also valuable. Although he focuses on mosaic decoration, the author also observes the disposition of columns, the vaults, and even details such as the religious furnishings and paving patterns. If the overall layout Mesarites described is probably that of Justinian's church, the vaults he described are likely to be the result of a subsequent restoration.[14]

Both Constantine the Rhodian and Mesarites pay particular attention to the architecture of the Holy Apostles, and, at first sight, their descriptions appear to be an excellent basis for recapturing aspects of the monument. However, we should note that these accounts also include many poetic elements and are influenced by literary conventions. Their use as basis for a hypothetical reconstruction requires one to distinguish factual information from poetic license. But it is difficult to achieve this: many sections of these descriptions are enigmatic, and they overlook certain aspects of the building, such as the elevations, atrium, narthex, and mausoleums. To fill these lacunae, scholars often turn to other, briefer references in a variety of textual sources, such as visitor accounts, or the *Book of the Ceremonies* of Constantine VII Porphyrogennetos. However, information drawn from these documents is often ambiguous and open to various interpretations. Using the alleged representations of the church of the Holy Apostles in Byzantine illuminated manuscripts has also proven to be problematic due to the lack of precision and "generic" nature of these images, not to mention the difficulty of identifying the church they represent with certainty.[15]

10 Preserved in the Manuscript Athos Lavra 1161 (L. 170, fols. 139r–147r), the *Ekphrasis* of Constantine the Rhodian was first edited by E. Legrand, "Description des oeuvres d'art et de l'église des Saints-Apôtres de Constantinople: Poème en vers iambiques par Constantin le Rhodien," *REG* 9 (1896): 32–65. A complete English translation was recently published by L. James, ed., *Constantine of Rhodes, On Constantinople and the Church of the Holy Apostles, with a New Edition of the Greek Text by Ioannis Vassis* (Farnham, Surrey, and Burlington, VT, 2012), 15–94.

11 James (*Constantine of Rhodes*, 10), discusses the various theories regarding the date of the poem.

12 Constantine the Rhodian (line 538) modestly confesses that he is "a stranger to the deeds of architects." However, his record indicates a rare ability to observe and understand complex forms. See James, *Constantine of Rhodes*, 54–55.

13 The manuscript of this description was discovered in the Ambrosian Library in Milan (Cod. Ambrosianus gr. 350, F 93 sup. and gr. 352, F 96 sup.) in 1898, by August Heisenberg. It was first published in A. Heisenberg, *Grabeskirche und Apostelkirche: Zwei Basiliken Konstantins*, vol. 2, *Die Apostelkirche in Konstantinopel* (Leipzig, 1908), 10–96. For English translation and commentary, see G. Downey, "Nikolaos Mesarites: Description of the Church of the Holy Apostles at Constantinople," *TAPS*, n.s., 47, part 6 (1957): 855–924; M. Angold, *Nicholas Mesarites, His Life and Works (in Translation)*, TTB 4 (Liverpool, 2017), 83–133.

14 Richard Krautheimer raised the possibility that the vaults were modified between ca. 940 and 989, and were therefore different from the Justinianic ones (described by Constantine the Rhodian and Procopius). See R. Krautheimer, "A Note on Justinian's Church of the Holy Apostles in Constantinople," in Krautheimer, *Studies in Early Christian, Medieval, and Renaissance Art* (London, 1971), 270. A. Wharton Epstein, "The Rebuilding and Redecoration of the Holy Apostles in Constantinople: A Reconsideration," *GRBS* 23 (1982): 79–92, esp. 85, has raised justified doubts about the validity of Krautheimer's use of evidence from depictions of the church in illuminated manuscripts to support his theory.

15 According to Krautheimer ("Note on Justinian's Church," 198), four illustrations in illuminated manuscripts are likely to represent the church of the Holy Apostles. Three of these illustrations are included in the *Menologion of Basil II* (Vat.

FIG. 7.3.
Church of St. John in
Ephesos, plan of the
remains (drawing by
C. Vasilikou, 2009)

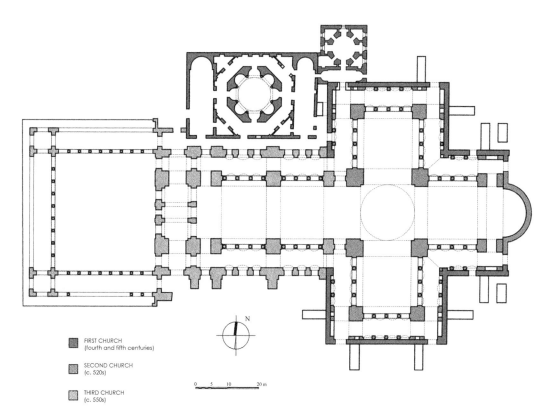

FIRST CHURCH
(fourth and fifth centuries)

SECOND CHURCH
(c. 520s)

THIRD CHURCH
(c. 550s)

0 5 10 20 m

N

Evidence from the written word alone is insufficient to visualize the church. One needs to interpret the descriptions by reference to comparable buildings elsewhere. The closest parallel for Justinian's Apostoleion is the church of St. John at Ephesos. Both monuments were remodeled during the lifetime of Procopius, who claims that they resembled each other very closely.[16] The fact that a similar statement is made in the Patria of Constantinople gives certain credence to Procopius's claim. However, this claim needs to be used with caution.[17] One could argue that Procopius's perception of the resemblance between buildings may be different from the present scholarly understanding of architectural similarities. Indeed, Richard Krautheimer has highlighted differences between buildings that medieval authors considered to be similar.[18] Nevertheless, Procopius's claim is confirmed to a certain extent by recent research in the phases of the church of St. John at Ephesos. Until recently, scholars were confused by the differences between the excavated footprint of the Ephesian monument (fig. 7.3), which had six bays, and the descriptions of the church of the Holy Apostles, which mention only five. But these differences

Gr. 1613, fol. 341r, 353r, 121r) and allegedly represent the 10th-century Apostoleion. A 4th possible representation of the church occurs in the two 12th-century manuscripts of the homilies of James Kokkinobaphos (Vat. Gr. 1162, fol. 2). For further information regarding these representations and the problems of using them as basis for reconstruction, see James, *Constantine of Rhodes*, 190–92.

16 See Procopius, *De aed.*, 5.1.6, ed. and trans. Dewing, *On Buildings*, 316–19. One of the terms that Procopius uses to describe the similarity between St. John at Ephesos and the Holy Apostles at Constantinople is "ἐμφερέστατος," which, according to H. B. Dewing, indicates "close resemblance in all respects." This translation seems to be consistent with another instance of the use of the same term by Procopius in his *History of the Wars*, 1.23.24. In 2009, I had the opportunity to discuss the relevant passages with Dame Averil Cameron, who confirmed that Procopius's statement in *De aed.* (5.1.6) indicates a strong architectural resemblance between the two buildings.

17 See T. Preger, *Scriptores Originum Constantinopolitanarum*, vol. 2 (Leipzig, 1907), 287.

18 See R. Krautheimer, "Introduction to an 'Iconography of Mediaeval Architecture,'" *JWarb* 5 (1942): 1–33, esp. 2–5. Even buildings that belong to the same architectural type can have many differences. In our case, the surviving medieval churches that seem to emulate the cruciform plan and plural domes of Justinian's Apostoleion deviate from each other in substantial ways. See T. Papacostas, "The Medieval Progeny of the Holy Apostles: Trails of Architectural Imitation across the Mediterranean," in *The Byzantine World,* ed. P. Stephenson (London, 2010), 386–405; James, *Constantine of Rhodes*, 192–93.

FIG. 7.4.
Church of St. John in
Ephesos, reconstructed
plan of the first vaulted
church (drawing by
author and and C.
Vasilikou, 2013)

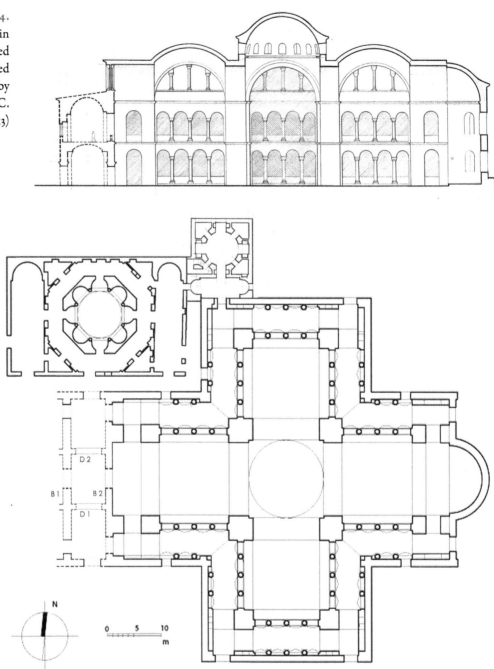

are misleading. My recent reexamination of the architectural history of St. John in Ephesos revealed a previously unknown phase of construction. Survey of the archaeological remains showed that the six-bay church resulted from the modification of an earlier, centralized, five-bay church, which was also domed (fig. 7.4).[19]

This discovery seems to confirm, at least to a certain extent, Procopius's statement regarding the architectural similarity between St. John's and the Apostoleion. Of course, this does not mean that the two buildings were identical.

19 See Karydis, "Church of St. John at Ephesos," 97–128. According to this paper, the transept and east cross arm of the

"current" church of St. John belong to an earlier phase than the nave. This new reading of the phases is different from that published in E. Russo, *Sulla cronologia del S. Giovanni e di altri monumenti paleocristiani di Efeso* (Vienna, 2010), 9–55.

What Procopius's statement suggests is simply that St. John's can be considered a "comparable example," and that the study of this monument can play an important role in the reconstruction of the Holy Apostles. This role has not yet been fully evaluated, and the present article aims to fill this lacuna.

The renewed understanding of the church of St. John at Ephesos, enables us to examine the evidence for Justinian's church of the Holy Apostles in a new light. Detailed observation of the Ephesian church helps to reinterpret the historical descriptions, resolving problems that had puzzled scholars for decades. The study of previous reconstructions is no less important. My understanding of the evidence is indebted to the work of scholars who discovered, translated, and interpreted the written records. Without these efforts, no deduction regarding the form of our monument would be possible. A short account of the literature on which this paper is based can be found in what follows.

Literature Review

The history of the reconstruction of the Holy Apostles begins in 1863, with the work of Heinrich Hübsch, a nineteenth-century architect, whose article "In what style shall we build?" (1828) influenced the transition from neoclassicism to historicism.[20] As a practicing architect who sought to revive aspects of the Romanesque and the Byzantine tradition, Hübsch seems to have been more interested in the church of the Holy Apostles as a precedent for new design than as a missing link in the development of Byzantine architecture. Indeed, his reconstruction drawings provide a palpable image of the lost church, but, alas, lack rigorous substantiation. The only source of evidence available to Hübsch seems to have been the account of Procopius, and many features of his reconstruction (such as the eastern apse or the transept porches) do not agree with the records discovered later in the nineteenth

century. The German architect tried to make up for the shortage of evidence by "borrowing" stylistic elements from the Byzantine monuments of Rome, Ravenna, Venice, and Constantinople. The resulting drawings were stimulating and inventive, but lacked the authenticity required to understand the Constantinopolitan church in depth (fig. 7.5).

The discovery of the accounts of Constantine the Rhodian and Nicholas Mesarites gave a new momentum to the study of the church. However, the potential of these sources was not evaluated immediately. Take Theodore Reinach's work (1896), for instance.[21] Although Reinach was the first to use the account of Constantine the Rhodian, his reconstruction proposal lacks detail and its form can claim only a vague kinship to early Byzantine architecture. Based on a careful linguistic analysis of the same account, Oskar Wulff's reconstruction (1898) is more convincing.[22] Wulff's model has a cruciform plan with five main bays and cross arms of equal length. The central bays are covered by hemispherical domes. The vaults are carried by piers, which alternate with double-storied arcades. The latter consist of four columns each and carry clerestory walls.

Wulff's proposal was to have a major influence on August Heisenberg's reconstruction, published in 1908.[23] Having discovered and analyzed the account of Mesarites, Heisenberg reproduced all the features of Wulff's model, adding to it the *thysiasterion* (sanctuary) and the mausoleums mentioned by the twelfth-century author (fig. 7.6). Still, he disagreed with Wulff about the gallery arcades, which, in his reconstruction, do not carry clerestory walls and appear to be strangely redundant. Heisenberg shows all these elements in a diagrammatic way. A more detailed investigation of this same model was published by the architect Cornelius Gurlitt (1907 and 1912).[24] Reviving the inventive

20 See H. Hübsch, *Die altchristlichen Kirchen* (Karlsruhe, 1862–63), pl. 32. For an analysis of Hübsch's architectural theories, see B. Bergdoll, "Archaeology vs. History: Heinrich Hübsch's Critique of Neoclassicism and the Beginnings of Historicism in German Architectural Theory," *Oxford Art Journal* 5, no. 2 (1983): 3–12.

21 See T. Reinach, "Commentaire archéologique sur le poème de Constantin le Rhodien," *REG* 9 (1896): 66–103, esp. 93–103.
22 See O. Wulff, "Die sieben Wunder von Byzanz und die Apostelkirche nach Konstantinos Rhodios," *BZ* 7 (1898): 316–31.
23 See Heisenberg, *Apostelkirche.*
24 See C. Gurlitt, *Die Baukunst Konstantinopels* (Berlin, 1907), 29, for a description of Justinian's Apostoleion, and

FIG. 7.5.
Church of the Holy Apostles,
Constantinople, reconstructed
plan from H. Hübsch *Die
altchristlichen Kirchen*
(Karlsruhe, 1862–63), pl. 32

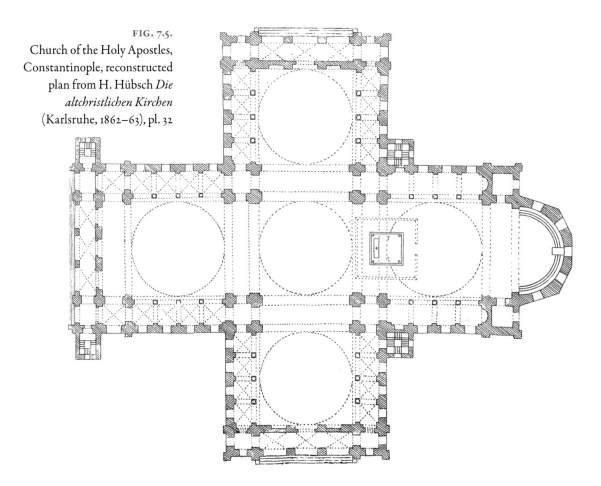

approach to reconstruction championed by Hübsch, Gurlitt was the first to investigate the transformations of the church, from its foundation to Justinian's remodeling. His model of the sixth-century church maintains the lines and structures of Heisenberg's reconstruction, and provides a convincing visualization of the central sanctuary. However, his quatrefoil plan of the Mausoleum of Justinian lacks proof, and his fanciful theory regarding the development of Constantine's mausoleum does not agree with the account of Mesarites, nor indeed with early Byzantine construction principles.

Gurlitt and Heisenberg based their work almost exclusively on textual sources. Two decades later, the discovery and excavation of the remains of St. John at Ephesos by George Soteriou helped to review the descriptions of the Holy Apostles in a new light, providing Soteriou with a new basis

for reconstruction.[25] Published in 1924, his model constitutes a logical compromise between the author's plan of St. John and the historical descriptions of the Apostoleion (fig. 7.7). For instance, the solid, compact piers of the church of St. John are replaced by the composite "fourfold" piers described by Constantine the Rhodian. Also, the number of columns in each screen is reduced to tally with the number given by Mesarites. But the resulting reconstruction does not agree with all the descriptions. For instance, it overlooks Procopius's claim that the west cross arm was longer than the east one. Also, the disconnection between the piers and the aisles seems to be at odds with the relationship between these elements in coeval buildings such as Hagia Sophia and Hagia Eirene at Constantinople. Soteriou's model is quite atypical in this respect.

pl. XL for a tentative graphic reconstruction showing all the phases of the building and the mausolea.

25 See G. A. Soteriou, "Ανασκαφαί του Βυζαντινού Ναού Ιωάννου του Θεολόγου εν Εφέσω," *Αρχ.Δελτ.* 7 (1921–22): 89–226, esp. 205–17.

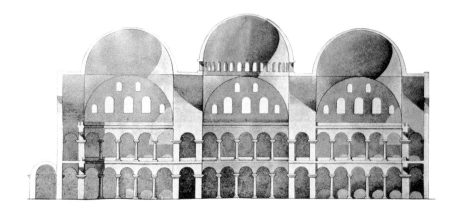

FIG. 7.6.
Church of the Holy
Apostles, reconstructed
plan, from A. Heisenberg,
*Grabeskirche und
Apostelkirche: Zwei
Basiliken Konstantins,*
vol. 2, *Die Apostelkirche von
Konstantinopel* (Leipzig,
1908), fig. 1, pl. 5

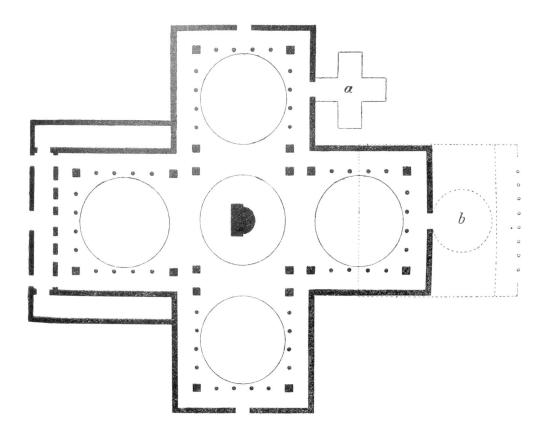

To understand the limitations of Soteriou's reconstruction, one needs to take into account that his excavation of St. John at Ephesos was interrupted under duress in 1922. By this time, the Greek archaeologist had only exposed the transept and east cross arm of the church. It was these parts that he used as a basis for the study of the Holy Apostles. However, when the excavations were resumed by the Austrian Archaeological Institute, St. John's proved to be very different from what Soteriou had expected.[26] The elongated west cross arm of the church included not one but two bays, bringing the total number of bays to six (fig. 7.3). This discovery raised doubts about the alleged similarity between the Holy Apostles with its centralized plan and five bays, and St. John's with its elongated nave and six

26 See H. Hörmann, J. Keil, and G. A. Soteriou, *Die Johanneskirche*, Forschungen in Ephesos 4.3 (Vienna, 1951).

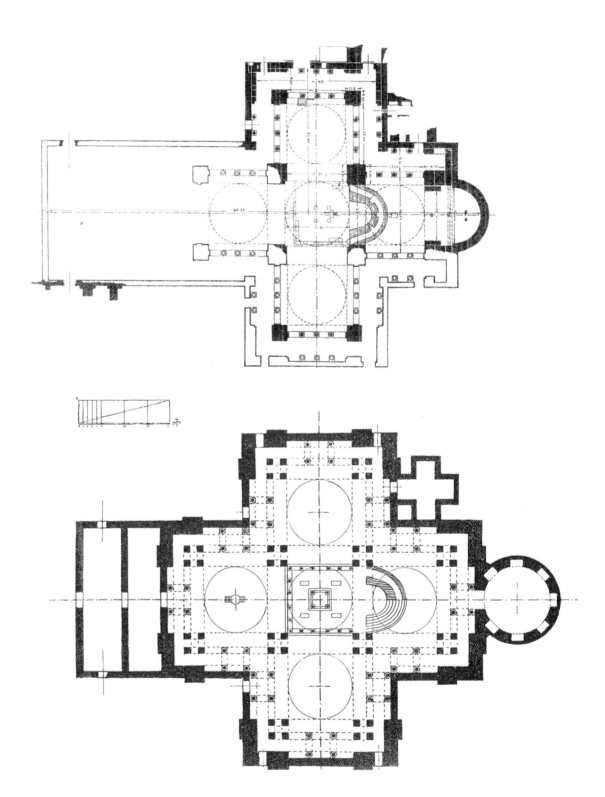

FIG. 7.7. Plans of two monuments investigated by George A. Soteriou in the 1920s. *Above*: survey plan of the church of St. John in Ephesos, carried out during the excavation of 1921–22. *Below*: Reconstructed plan of the church of the Holy Apostles. From G. A. Soteriou, "Ἀνασκαφαί του Βυζαντινού Ναού Ιωάννου του Θεολόγου εν Εφέσω," *Ἀρχ.Δελτ.* 7 (1921–22): 89–226, figs. 7 and 75.

bays. As a result, the latter's value as a basis for reconstructing the Constantinopolitan monument was challenged.

Karl Wulzinger (1932) was the last scholar to use St. John's plan as a model for the reconstruction of the Apostoleion.[27] Trying to follow the definitive, elongated form of the Ephesian church, he ended up contradicting the textual records in his reconstruction. Still, this publication remains interesting because of the author's attempt to establish the dimensions and scale of the monument by reference to the plan of the Fatih Camii. Wulzinger believed that the current mosque was superimposed on the remains of the Holy Apostles, with its dome centered on the crossing of the church. This hypothesis was compromised by an insufficient understanding of the phases of the mosque. However, this approach seems to have influenced later efforts to understand the size of Justinian's Apostoleion and localize its actual site.

The same interest in the scale of the church and its relationship to the mosque also characterize the graphic reconstruction presented by Paul Underwood, Glanville Downey, and Albert Mathias Friend, Jr., in 1948.[28] The methodology of this reconstruction was based on the graphic investigation of the textual evidence, with an emphasis on the description of Constantine the Rhodian. Underwood, the architect of the team, carried out a series of interpretive drawings that sought to "recreate ... the imagery of the poet."[29] Synthesizing these drawings, the team represented the entire complex in plan and the church in cut-away perspective (fig. 7.8). Presented as a direct reflection of the written records, this reconstruction of Justinian's church closely resembled Heisenberg's model. But the new drawings were not only more detailed but also accompanied by a scale rule, which makes this the second attempt to indicate the size of the building. In this instance, the latter was hypothetically established by reference to

Procopius's observation regarding the size of the church of St. Irene. The three authors took into account the sizes of the churches of San Marco and St. John at Ephesos. They also explored the relationship between the Holy Apostles and the Fatih Camii.[30] However, they did not provide conclusive evidence for their hypothesis. The same lack of proof is found in the team's representation of the church of All Saints and the imperial mausoleums. Still, Underwood's plans of the mausoleums seem to be more plausible from a stylistic point of view than those included in Gurlitt's reconstruction.

After the 1950s, interest in reconstruction faded. The publication of the excavations at St. John in Ephesos in 1951 may have played a role in this development. Revealing stark differences between the Ephesian church and the descriptions of the Apostoleion, this deprived scholars from an important architectural parallel, reducing the already slim body of evidence for reconstruction.[31] In the second half of the twentieth century, research in the Holy Apostles tended to focus on the initial stage of the church's history, from its foundation to its reconstruction by Justinian. The date of the first church and its relationship with the Mausoleum of Constantine proved to be controversial. The debate regarding these pre-Justinianic phases is of interest for our study, as it sheds light on Constantine's mausoleum, which was later integrated in Justinian's complex (together with two other, smaller mausoleums).

Research in Constantine's mausoleum has focused on descriptions provided by fourth and fifth-century authors, including Eusebius and Gregory of Nazianzos. In 1951, Downey raised doubts about the authenticity and date of Eusebius's *Life of Constantine,* and attributed both the first church of the Holy Apostles and Constantine's mausoleum to Constantius.[32] This theory was challenged by Philip Grierson, who

27 See K. Wulzinger, "Die Apostelkirche und die Mehmedije zu Konstantinopel," *Byzantion* 7 (1932): 7–39, esp. 25f.

28 This was presented in the Dumbarton Oaks Symposium dedicated to the Holy Apostles in 1948. See B. Daskas and F. Gargova, *The Holy Apostles: Visualizing a Lost Monument; The Underwood Drawings* (Washington, DC, 2015), 7–8.

29 See Daskas and Gargova, *Underwood Drawings,* 11.

30 See below, Appendix E; cf. Daskas and Gargova, *The Underwood Drawings,* 26.

31 James (*Constantine of Rhodes,* 192–93) believes that the use of St. John at Ephesos in the reconstruction of the Holy Apostles is misleading. On the other hand, C. Mango, "Constantine's Mausoleum and the Translation of Relics," *BZ* 83 (1990): 51–62, claimed that "the form of the Holy Apostles can be visualised on the analogy of St. John at Ephesos."

32 See G. Downey, "The Builder of the Original Church of the Apostles at Constantinople: A Contribution to the

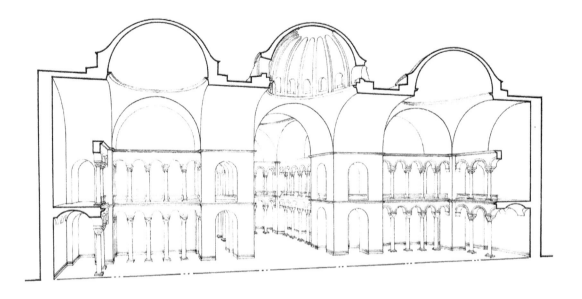

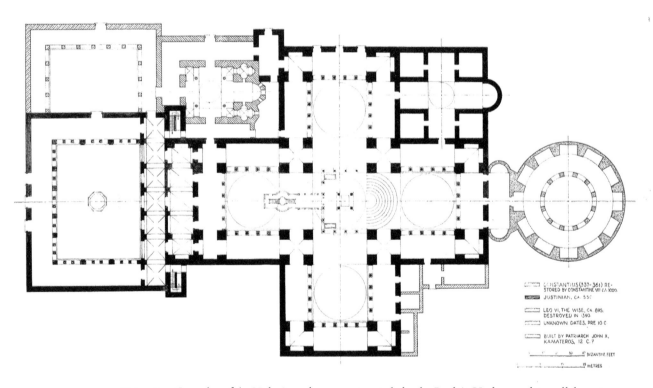

FIG. 7.8. Complex of the Holy Apostles, reconstructed plan by Paul A. Underwood, in collaboration with Albert Mathias Friend, Jr., and Glanville Downey, from B. Daskas and F. Gargova, *The Holy Apostles: Visualizing a Lost Monument; The Underwood Drawings* (Washington, DC, 2015), figs. 8 and 10

maintained that the first mausoleum was built by Constantine on a circular plan.[33] On the other hand, Krautheimer suggested that Constantine's church had a cruciform plan and was intended as the emperor's burial place, until the tomb was moved to the nearby circular mausoleum built by Constantius.[34] However, Mango objected to this reading of the phases and returned to Grierson's theory, suggesting that Constantine built a circular church-mausoleum, and Constantius added the cruciform basilica next to it.[35] This seems to be the most plausible interpretation of the written records. Indeed, this theory was recently adopted by the studies of Gilbert Dagron (2003), Neslihan Asutay-Effenberger (2006), and Mark Johnson (2009), whose work inscribed Constantine's mausoleum in the architectural typology of the late Roman imperial mausoleum.[36]

The debate regarding the mausoleums seems to have overshadowed the discussion about the form of Justinian's church. The latter was recently resumed with the publications of Ken Dark and Ferudun Özgümüş.[37] Their archaeological survey of the Fatih Camii revealed a series of Byzantine fragments incorporated in the substructures of the mosque and its courtyards. Following a careful examination of the written records and a topographical analysis, the two authors attributed these fragments to the church

of the Holy Apostles. According to this theory, elements of the fifteenth-century mosque, such as the lateral staircases and the walls of its cemetery, were built on the foundations of Justinian's Apostoleion. Observing the pattern of these elements, the authors carried out a diagrammatic plan, which shows the outline of the church. Still, they did not examine the degree to which previous reconstructions are consistent with their hypothesis. As a result, the architectural implications of this discovery have not been fully assessed yet.

A New Interpretation

The examination of recent publications shows that the problem of the reconstruction of Justinian's Apostoleion remains unresolved. For all the rigor, aesthetics, and historical value of previous reconstructions, scholars have not yet managed to provide a plausible hypothesis for the overall plan, the disposition of load-bearing elements, and the vaulting pattern. Take the plan of the church, for instance. The identical central bays of previous reconstructions contradict the description of Procopius, who states that the western bay was longer than the others.[38] For Hübsch, Heisenberg, and Wulff, this elongation was obtained by adding a narthex to the west arm of the church.[39] However, as the following section suggests, this would have been more of an "addition" than an "extension," and the elongation obtained would hardly be perceived from the interior of the church. For these reasons, which are explained in more detail in the following section, this interpretation is not entirely convincing. The column layout proposed in previous reconstructions also appears to be problematic: the "double columns" mentioned by Constantine the Rhodian are missing from all reconstructions, and the total number of ninety-six columns that is often shown is very far from Mesarites' count of seventy columns. Moreover, the potential relationship of the church with the fifteenth-century plan of the Fatih Camii has not been fully investigated. The

Criticism of the 'Vita Constantini' Attributed to Eusebius," *DOP* 6 (1951): 53–80.

33 See Grierson, "Tombs and Obits," 5.

34 See R. Krautheimer, "On Constantine's Church of the Apostles in Constantinople," in *Studies in Early Christian Medieval and Renaissance Art* (London, 1971), 27–33. Christina Angelidi (1983) and Rudolf Leeb (1992) adopted Krautheimer's theory. See R. Leeb, *Die Verchristlichung der imperialen Repräsentation unter Konstantin dem Großen als Spiegel seiner Kirchenpolitik und seines Selbstverständnisses als christlicher Kaiser* (Berlin, 1992), and C. Angelidi, "Ἡ περιγραφὴ τῶν Ἁγίων Ἀποστόλων ἀπὸ τὸν Κωνσταντῖνο Ρόδιο. Ἀρχιτεκτονικὴ καὶ συμβολισμός," *Βυζαντινὰ Σύμμεικτα* 5 (1983): 91–125, esp. 113. Angelidi's article includes a reconstructed plan of the Holy Apostles, which closely follows Wulff's late 19th-century model.

35 See Mango, "Constantine's Mausoleum," 51–62.

36 See Johnson, *Roman Imperial Mausoleum*, 125–27, N. Asutay-Effenberger and A. Effenberger, *Die Porphyrsarkophage der oströmischen Kaiser: Versuch einer Bestandserfassung, Zeitbestimmung, und Zuordnung*, Spätantike-frühes Christentum-Byzanz 15 (Wiesbaden, 2006), 129–33, and G. Dagron, *Emperor and Priest: The Imperial Office in Byzantium* (Cambridge, 2003), 135–45.

37 See K. Dark and F. Özgümüş, *Constantinople: Archaeology of a Byzantine Megapolis* (Oxford, 2013), 83–110.

38 See Procopius, *De aed.*, 1.4.13, ed. and trans. Dewing, *On Buildings*, 48–51.

39 See Wulff, "Sieben Wunder," 322; Hübsch, *Altchristlichen Kirchen*, pl. 32; Heisenberg, *Apostelkirche*, 9, 113.

form of the main vaults also remains uncertain: with the exception of Gurlitt, scholars have failed to consider any alternative to the hemispherical dome on pendentives. Finally, previous reconstruction proposals do not discriminate clearly between those hypotheses that are entirely conjectural and those that are reasonably based on the interpretation of written records and similar buildings. As these issues have not yet been fully addressed, our understanding of this major church remains incomplete.

However, significant progress has been carried out since the last reconstruction was presented at Dumbarton Oaks seven decades ago, and it is time to revisit the form of Justinian's church. The starting point of this new reconstruction is the investigation of textual sources. Constantine the Rhodian and Mesarites seem to have an unusual architectural sensitivity and an understanding of construction detail, which distinguishes them from their contemporaries. Their descriptions provide information about the geometry of the Apostoleion, its structure, type of vaults, as well as the number and disposition of its columns and piers. On the other hand, our current approach to the textual sources tends to be more cautious.[40] We are aware that in middle Byzantine descriptions, symbolic and literary considerations often take precedence over the exactness of the recording. In spite of the informative character of our textual sources, it is still necessary to discriminate between their poetic and factual passages. Yet even factual passages are not always exact descriptions but are meant to evoke the overall spirit of the design. In these cases, interpretation can be tricky. Looking at affiliated monuments, such as St. John at Ephesos and San Marco in Venice, can help to penetrate the hidden meaning of these passages. The choice

of the Ephesian church is based on Procopius's statement regarding its strong similarity with the Holy Apostles, as well as recent research in the phases of the Ephesian monument.[41] The choice of San Marco is based on an early twelfth-century source that identifies the Holy Apostles as the model for the Venetian church.[42] Still, it is difficult to identify the specific phase of the basilica of San Marco that used the church of the Holy Apostles as a model, not to mention that it is unlikely that the Venetian monument faithfully reproduced the form of its supposed prototype.[43] Even if there were similarities between the two monuments, these were probably reduced by the transformations of the basilica of San Marco from the ninth to the eleventh century. On the other hand, despite these transformations, John Warren and Rowland Mainstone have suggested that the surviving fabric of the basilica of San Marco incorporates elements of the ninth-century church, and its design is still constrained by it.[44] Furthermore, we cannot overlook the existence of certain analogies between the layout of the present basilica and that of the Holy Apostles as described by Procopius, Constantine the Rhodian, and Mesarites. These analogies include the cruciform configuration of the plan and the use of spherical vaults to cover the main bays. All this suggests that even though the basilica of San Marco is likely to be different in many respects from the Holy Apostles, it can still serve in the interpretation of the historical descriptions of the Constantinopolitan monument.

To conclude, neither the examination of written records alone nor isolated observation of affiliated monuments is sufficient to recapture

40 Analyzing the church descriptions included in the 10th-century *Vita Basilii,* R. Ousterhout, "Reconstructing 9th-Century Constantinople," in *Byzantium in the Ninth Century: Dead or Alive?,* ed. L. Brubaker (Hampshire, 1998), 115–30, showed that this record tends to focus on specific details as representative of the whole. Owing to these characteristics, the use of such texts as an aid to reconstruction may prove to be misleading. James, *Constantine of Rhodes,* 190, reached a similar conclusion. Her investigation of the *Ekphrasis* of Constantine the Rhodian highlights the subjective character of this text, as well as its omissions. For James, these characteristics reduce the value of Byzantine descriptions as accurate records.

41 See Procopius, *De aed.,* 5.1.6, ed. and trans. Dewing, *On Buildings,* 316–19.

42 See Concina, *Venezia,* 33; Papacostas, "Medieval Progeny of the Holy Apostles," 386–89.

43 For the differences between the 9th-century basilica of San Marco and Justinian's church of the Holy Apostles, see Demus, *Church of San Marco,* 64. For the use of the church of the Holy Apostles as the model of the 9th-century basilica of San Marco, see A.H.S. Megaw, "Reflections on the Original Form of St. Mark's in Venice," in *Architectural Studies in Memory of Richard Krautheimer,* ed. C. Striker (Mainz, 1996), 107–10.

44 See J. Warren, "The First Church of San Marco in Venice," *The Antiquaries Journal* 70 (1990): 327–59; R. Mainstone, "The First and Second Churches of San Marco Reconsidered," *The Antiquaries Journal* 71 (1991): 123–37.

the lost form of the Holy Apostles.[45] It is rather the combination of these sources of knowledge that helps us to construct a new model for Justinian's Apostoleion. The reexamination of the descriptions of the church of the Holy Apostles by reference to the two affiliated monuments mentioned above helps to distinguish and interpret those parts of the descriptions that reflect the design of the Constantinopolitan church. This methodology starts from the identification of passages that refer to architectural components and design features. Each of these passages is then interpreted graphically by reference to similar components in affiliated churches. The present comparisons with St. John at Ephesos benefit from information that was not available previously. My recent work on this church has revealed new evidence regarding the building considered by Procopius to be identical to the Holy Apostles.[46] This helps us to examine the descriptions of our building in a new light, resolving some of the inconsistencies observed in previous reconstruction proposals. The following paragraphs provide a step-by-step reconstruction of the different components of the church of the Holy Apostles, starting with its plan.

Shape and General Layout

The literary sources indicate that the church of the Holy Apostles was built on a cruciform plan.[47] Procopius's account adds the following detail: although the north and the south cross arms had a similar length, the western arm was "enough longer than the other [i.e., the eastern cross arm] to make the form of the cross."[48] Previous representations of the church do not seem to take this statement into account. They all show a church built on what we often call a "Greek-cross" plan, that is, a cruciform plan with arms of equal length. Of course, it is likely that the authors of these reconstructions believed that the attachment of a narthex to the west arm made it longer.[49] However, this increase in length would be negligible: a narthex would have to be atypically wide to make a noticeable difference in the overall length. Besides, in most sixth-century churches, the roof of the gallery over the narthex was at a different level than the roof of the main church. It is questionable whether the volume of the narthex and the gallery could be perceived as part of an elongated cross arm. Therefore, the simple addition of a narthex hardly explains Procopius's observation.

The study of affiliated monuments leads to a different interpretation of this passage. Let us start with the church of St. John at Ephesos. Recent research has revealed an intermediate building phase that precedes the definitive Justinianic phase.[50] In this phase, the church had a cruciform plan with five main bays flanked by aisles and galleries (fig. 7.4). Although not all aspects of this plan can be determined, archaeological evidence proves that the single-bay west cross arm was longer than the others. This was probably achieved by extending the space of the central bay by adding a rectangular, subordinate bay to the west. This configuration would make the "entrance" cross arm larger than the others, and this would be noticeable both from the inside and the outside of the building.

If in St. John's our actual understanding of the west bay relies on tentative reconstruction, in San Marco, we observe a similar design in a surviving building (fig. 7.9). Here, too, the west cross arm is noticeably longer than the others.

45 Indeed, as James (*Constantine of Rhodes*, 193) pointed out, "for a medieval church to be described as a 'copy' it needed to share only a very few features of its original, making its use to reconstruct problematic."

46 See Karydis, "Church of St. John at Ephesos," 97–128; N. Karydis, "The Vaults of St. John the Theologian at Ephesos: Visualizing Justinian's Church," *JSAH* 71, no. 4 (2012): 524–51.

47 See Constantine the Rhodian, *Ekphrasis*, line 576; and Mesarites, *Ekphrasis*, c. 13.5, ed. Heisenberg, *Apostelkirche*, 27; ed. and trans. Downey, "Nikolaos Mesarites," 869; trans. Angold, *Nicholas Mesarites* 93.

48 See Procopius, *De aed.*, 1.4.13–14, ed. and trans. Dewing, *On Buildings*, 50–51.

49 The existence of a narthex is attested by the *Book of Ceremonies* of Constantine VII Porphyrogennetos (*De cerimoniis aulae byzantinae,* II, 6, f.181). This states that when the emperors visited the church, they sometimes entered "through the great gate of the atrium into the narthex." Chapter VII of the same book mentions an alternative entrance, "through the gate which leads to the Horologion [i.e., the sundial] of this same church." For a translation of these passages, see J. M. Featherstone, "All Saints and the Holy Apostles: *De Cerimoniis* II, 6–7," *Νέα Ῥώμη* 6 (2009): 235–48, esp. 242–45.

50 See Karydis, "Church of St. John at Ephesos," 120–21, for an attribution of this early building phase of St. John in Ephesos to the 520s, a period when Justinian had already started to play an important political role as principal adviser of his uncle and predecessor, Justin I.

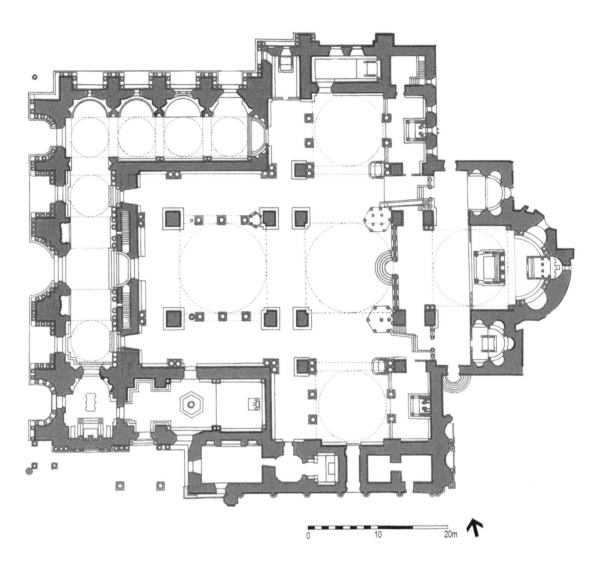

FIG. 7.9.
Plan of the Basilica
of San Marco, Venice
(after plan courtesy of
Thomas E. A. Dale)

Indeed, the western arcades have three columns each, whereas the north and south ones only have two columns each. The integration of cross arms of different length is achieved in two ways. First, the west cross arm is lengthened by adding a barrel-vaulted, rectangular space next to the west bay, connecting the latter with the narthex. But this does not explain the enlargement of the west bay itself, which is sufficient to give its colonnades an extra column. This is achieved with a subtle refinement that is rarely observed: both west bay and crossing are wider than the other peripheral bays. At the transition from wide crossing to narrow bays lies a series of columns set against the central piers. These are strategically located to reduce the width of the north, south, and east bays, making the west one appear more spacious by comparison.

Observing the plans of St. John at Ephesos and San Marco in Venice, we realize that a centralized cruciform church with five bays does not necessarily have cross arms of equal length. In fact, the elongated west cross arm is common in cruciform basilicas built between the fourth and the sixth centuries. The Holy Apostles at Milan, the church of the Prophets, Apostles, and Martyrs at Gerasa, the *Katapoliani* on Paros, and the cruciform basilica on Thasos all include this characteristic.[51] With these examples in mind, we can interpret Procopius's statement as an indication that the Holy Apostles had a cruciform

51 For the churches in Milan and Gerasa, see R. Krautheimer, *Early Christian and Byzantine Architecture* (New Haven and London, 1986), 82 and 158, respectively. For the church on Thasos, see P. Lemerle, "A propos d'une basilique de Thasos et de Saint Jean d'Ephèse," *Byzantion* 23 (1953): 531–43.

plan outline with a slightly elongated entrance cross arm toward the west. As our examination of the basilica of San Marco indicates, it was possible to extend the west arm of the church without giving it a rectangular shape. The elongation of the west arm could be achieved simply by increasing the size of the square western bay. Neither Constantine the Rhodian nor Mesarites contradicts this observation.[52]

Let us now move to the east termination of the building. Most churches of this period had an apsed sanctuary at this point. But the church of the Holy Apostles seems to have been exceptional as far as the location of the sanctuary is concerned. Indeed, Procopius writes that "at the crossing . . . there was set aside a place which may not be entered by those who may not celebrate the mysteries; this, with good reason, they call the sanctuary."[53] Central sanctuaries like this one are rare, but one is encountered at the crossing of the church of St. John at Ephesos.[54] Here, the space of the bema is surrounded by a three-sided colonnade and adjoined by an imposing synthronon, which connects the two east piers of the crossing (fig. 7.7). The account of Mesarites suggests that there was a similar configuration in the Holy Apostles. The "heart" (i.e., the crossing) of the church, Mesarites writes, "encloses within itself . . . the sacred thysiasterion, being semicircular at the east so much of it as lies about the steps of the sacred throne [i.e., the synthronon], but so much of it as lies about the holy table, on the west, being quadrangular."[55] These accounts show clearly that the sanctuary of the Apostoleion and its synthronon lay in the center

of the church.[56] None of them mentions an apse in the east cross arm.[57] The absence of an apse there can be deduced from Mesarites' observation that the central spaces of the church were surrounded by twelve colonnades.[58] This means that there was an aisle colonnade in every side of the perimeter of the church, including the eastern side. Therefore, the "traditional" apse was probably replaced by a straight colonnade. Thus, the eastern extremity of the building would have lost its usual role of terminus to become a vestibule for the Mausoleum of Constantine which, according to Mesarites, lay to the east of the church.[59]

The imperial mausoleums in the complex of the Holy Apostles constitute a vast topic that cannot be fully addressed in this paper. However, some notes regarding the two most important mausoleums are necessary to understand the immediate context of the church and its relationship with earlier structures.

Based on Mesarites' description, most reconstructions of the Holy Apostles show the Mausoleum of Constantine as a domed rotunda attached to the east cross arm of the church.[60] In most models, there is direct access from the church to the tomb. Underwood's reconstruction is the only one that inserts a vestibule between

52 James, *Constantine of Rhodes*, 185, interprets the lines 602–604 of the 10th-century ekphrasis as an implication that the cross arms of the church were of equal length. But, what the passage in question refers to is "a square space." James believes that this passage describes the outline of the entire building. However, it is unlikely that Constantine would ever describe the entire church as "square" in shape. This can only refer to the shape of one of the bays.

53 See Procopius, *De aed.*, 1.4.13, ed. and trans. Dewing, *On Buildings*, 48–49.

54 Cf. Soteriou, "Ἀνασκαφαί," 152–57, figs. 31, 32; M. Büyükkolancı, *Heilige Johannes* (Selcuk, 2000), 58.

55 See Mesarites, *Ekphrasis*, c. 38.1, ed. Heisenberg, *Apostelkirche* 80; ed. and trans. Downey, "Nikolaos Mesarites," 890; trans. Angold, *Nicholas Mesarites* 124.

56 For one of the earliest and most detailed discussions of this central sanctuary, see Heisenberg, *Apostelkirche*, 134.

57 One might argue that the central location of a sanctuary precludes the existence of an apse at the east extremity of the building. However, the church of St. John at Ephesos proves that these elements are not incompatible.

58 See Mesarites, *Ekphrasis*, c. 37.6, ed. Heisenberg, *Apostelkirche* 79; ed. and trans. Downey, "Nikolaos Mesarites," 890; trans. Angold, *Nicholas Mesarites*, 123. The term that Mesarites uses is "twelve stoas." According to Downey ("Nikolaos Mesarites," 869), "the term 'stoa' meant basically any type of structure which contained pillars," but, in the present instance, the word refers to the colonnades which ran around the arms.

59 See Mesarites, *Ekphrasis*, c. 39.1, ed. Heisenberg, *Apostelkirche*, 81–82; ed. and trans. Downey, "Nikolaos Mesarites," 891; trans. Angold, *Nicholas Mesarites*, 125.

60 Indeed, Mesarites, *Ekphrasis*, c. 39.2, ed. Heisenberg, *Apostelkirche*, 82; ed. and trans. Downey, "Nikolaos Mesarites," 891; trans. Angold, *Nicholas Mesarites*, 125, states that the mausoleum, which he calls "church," "is domical, and circular." Its interior "is divided up on all sides by numerous stoaed angles." Most scholars interpret these "stoaed angles" as niches, like the ones found in most imperial mausoleums. For a detailed discussion of this passage and an evaluation of different possible reconstructions of the Mausoleum of Constantine, see R. Egger, "Die Begräbnisstätte des Kaisers Konstantin," *ÖJh* 16 (1913): 212–30.

the rotunda and the church.[61] This hypothesis is corroborated by the literary sources and similar examples in Rome. Indeed, the Mausoleum of Constantina (Sta. Costanza), is attached to the flank of the basilica of St. Agnes. The Mausoleum of Helena is connected with the center of the narthex of the basilica of Marcellinus and Petrus and is coaxial with the church.[62] Both mausoleums are directly attached to churches. The accounts of visitors from the eleventh to the fourteenth century suggest that there was a similar connection between the Mausoleum of Constantine and the church of the Holy Apostles. An eleventh-century visitor noted that the Mausoleum of Constantine lay at the "head of the church, at the east end."[63] Around 1349, Stephen of Novgorod stated that "going straight east through the church from the sanctuary, [one comes to where] stands Emperor Constantine's tomb."[64] There is no mention of an apse or an open space between church and mausoleum. Another description, of approximately 1390, locates the mausoleum "behind the sanctuary" of the church, making the connection between the two appear even more direct.[65] However, the fact that these records do not mention intermediate spaces does not mean that these did not exist. We should also consider the possibility that in the sixth century, the Mausoleum of Constantine was still a freestanding structure inside an atrium, as it was described in Eusebius's fourth-century *Life of Constantine*.[66] The setting

described by this source is reminiscent of the quadriporticus that surrounded the Mausoleum of Maxentius in Rome.[67] Eusebius's description suggests that the original relationship of Constantine's mausoleum to the nearby church was different from that of the Roman mausoleums mentioned above. Did the architects of Justinian alter this relationship by attaching the sixth-century church to the mausoleum? In the absence of sufficient evidence, this question has to remain open. Information about the location of the other mausoleums, including that of Justinian, is also limited. In his brief description of what he calls "the Heroon" of Justinian, Mesarites implies that this building was cruciform and entered from the west cross arm.[68] On the basis of this description, previous reconstructions show the mausoleum attached to the north transept of the Apostoleion.

If the relation of the mausoleums to the church remains unclear, the previous paragraphs shed new light on the layout of Justinian's church. Written records and affiliated buildings seem to indicate that this was a cruciform church with an elongated west cross arm. Still, the passages examined so far tell us little about the articulation of the design and, particularly, the disposition of the main load-bearing elements that supported the vaults. Procopius mentions that the latter were "solidly and safely supported," but does not provide any further information. To understand how these supports looked like, we need to turn to the descriptions of Constantine the Rhodian and Mesarites.

Bays and Piers

All previous reconstructions of the Apostoleion show a cruciform arrangement of five square bays covered by spherical vaults, as confirmed in both middle Byzantine accounts. Mesarites

61 See Daskas and Gargova, *Underwood Drawings*, fig. 9. The narthex shown by Underwood is consistent with similar examples elsewhere (i.e., Sta. Costanza in Rome) as well as with a passage in the *Book of Ceremonies* of Constantine Porphyrogennetos (Book VI, 583), which explains that on the annual feast day of St. Constantine, the emperors entered the Holy Apostles, crossed the main body of the church and were received by the patriarch "inside the gate that leads in" the Mausoleum of Constantine.

62 See Johnson, *Roman Imperial Mausoleum*, 111, 140.

63 See the manuscript Digbeianus lat. 112, f. 17r–28v, published in K. Ciggaar, "Une description de Constantinople traduite par un pèlerin Anglais," *REB* 34 (1976): 211–68.

64 See G. P. Majeska, *Russian Travelers to Constantinople in the Fourteenth and Fifteenth Centuries* (Washington, DC, 1984), 15–47.

65 See Johnson, *Roman Imperial Mausoleum*, 122.

66 See Eusebius, *Vita Constantini*, 4.58–60. This passage is discussed in Mango, "Constantine's Mausoleum," 55. On the basis of this account, Asutay-Effenberger and Effenberger

(*Porphyrsarkophage*, 129–33) suggest that Constantine's mausoleum was originally a free-standing, circular structure.

67 See Johnson, *Roman Imperial Mausoleum*, 87.

68 See Mesarites, *Ekphrasis*, c. 40, ed. Heisenberg, *Apostelkirche*, 85–87; ed. and trans. Downey, "Nikolaos Mesarites," 892–93; trans. Angold, *Nicholas Mesarites*, 127–28. This passage is discussed in Grierson, "Tombs and Obits," 6, and G. Downey, "The Tombs of the Byzantine Emperors at the Church of the Holy Apostles in Constantinople," *JHS* 79 (1959): 27–51, esp. 44.

states that the church was "raised on five stoas," which formed a cruciform pattern. Constantine the Rhodian writes that the additive reproduction of the central bay toward the four cardinal points generated a cruciform structure consisting of five parts.[69] For all the poetic character and lack of detail of these documents, their authors clearly explain the modular character of the building. Their observations match what we know about sixth-century vaulted churches. Similar modular plans are observed in affiliated monuments, such as St. John at Ephesos and San Marco. They are also encountered in early Byzantine domed churches in the Aegean coastlands, Constantinople, and, particularly, west Asia Minor.[70]

Compartmentalization of the church interior into bays was directly related with the choice of vaulted ceilings consisting of multiple domes. Indeed, as Krautheimer has observed, domes "are geared to cover a rectangular bay."[71] The presence of multiple domes in the Holy Apostles is attested by Procopius, who calls them "spheroidal" or "spherical" vaults, and Constantine, who uses the term "spheres."[72] Such spherical vaults are usually supported on broad arches resting on bulky piers at the corner of each bay. These piers interrupt the continuity of colonnades, dividing the interior into bays. The autonomy of the bays depends on pier design. Large, compact piers disrupt the continuity of a basilican plan. Projecting into the nave, they encapsulate spaces that can be seen as subordinate bays in their own right. These

lateral enlargements of the central space subvert the concept of the basilica as an elongated, directional hall. Indeed, envisioning the interior of the church of St. John at Ephesos, Krautheimer remarks that "the overall impression is of individual spatial units clearly segregated from each other" and that "the bays, cut off from each other by the . . . strong projecting piers, seem to stand side by side."

On the other hand, in San Marco, the pier design reduces the compartmentalization of the interior space. Here, the main piers are not solid but dissolve into a cluster of supports. Passages penetrate the piers, making their inner chambers parts of the aisles and galleries that flank the central bays. As a result, the piers are much less intrusive and do not disrupt spatial continuity. Such composite piers are not limited to eleventh-century Venice. The piers of Hagia Sophia and Hagia Eirene at Constantinople indicate that this pier design was known in the capital during Justinian's period. Indeed, Constantine the Rhodian suggests that this design was employed in the piers of the Holy Apostles as well. According to his account, the piers at the four corners of the crossing were "four-legged and quadripartite in composition."[73] This description strongly resembles the central, quadripartite piers at the crossing of San Marco.

It seems, therefore, that like the crossing of San Marco, that of the Holy Apostles had four composite piers in its corners: each pier consisted of four smaller supports and was penetrated by passages. Describing this configuration, Constantine the Rhodian states that there were sixteen supports in total. Now, the interpretation of this number has proven to be particularly challenging. To understand this number, it is important to note that it refers only to the piers in the four corners of the crossing.[74] Constantine never

69 See Constantine the Rhodian, *Ekphrasis*, line 575, discussed in James, *Constantine of Rhodes*, 58.

70 Two characteristic examples of this development are the so-called Building D at Sardis, and the church of St. John at Philadelphia. The interiors of the so-called Basilica B at Philippi and Hagia Eirene at Constantinople were also articulated in 2 domed bays, even though these churches belong to a different type from the buildings mentioned above. For further information regarding this architectural development, see H. Buchwald, "Western Asia Minor as a Generator of Architectural Forms in the Byzantine Period: Provincial Back-Wash or Dynamic Center of Production," *JÖB* 34 (1984): 200–234, and N. Karydis, *Early Byzantine Vaulted Construction in Churches of the Western Coastal Plains and River Valleys of Asia Minor* (Oxford, 2011).

71 See Krautheimer, *Early Christian and Byzantine Architecture*, 238.

72 These terms may describe either full hemispherical domes on pendentives or shallow domes, cospherical with the pendentives (pendentive domes).

73 See Constantine the Rhodian, *Ekphrasis*, lines 564–606, ed. James, *Constantine of Rhodes*, 56–61.

74 Constantine the Rhodian, *Ekphrasis*, lines 591–604, ed. James, *Constantine of Rhodes*, 58–61, states that the architect "set up in four groups four foundations, four in number, equal to the towering piers, using everywhere the measure of four, so that sixteen well-arranged towering piers, four-sided and four-fold in composition all formed the same number of vaults [i.e., barrel vaults supporting the domes]." Thus "a cubical shape was traced." The reference of this passage to 16 towering piers lends itself to misinterpretation. For instance,

mentions the piers at the extremities of the cross arms, even though their presence is implied in his text.[75] The latter would have been necessary to support the spherical vaults over the cross arms, and there is no reason to think that they were different from the central ones. The silence of our records regarding these piers may indicate that they were concealed by the screens of the aisles and the galleries, which now come to our attention.

Arcades and Clerestory Walls

The juxtaposition of massive masonry piers and colonnades consisting of slender columns is one of the hallmarks of vaulted church architecture in the times of Justinian. Both piers and columns played an important role. The former supported the soaring vaulted canopies, which covered the central bays. The colonnades supported the gallery floors and the clerestory walls, and separated the central bays from the more intimate area of the aisles and galleries. Colonnades functioned as "internal elevations," adorned with sophisticated sculptural elements, such as capitals and bases, as well as with the same polychromous marble revetment as the piers. The great prominence of these colonnades in the Holy Apostles is reflected in the middle Byzantine accounts of the monument. Both of them devote extended and detailed

passages to them, and help us complete the visualization of the church in both plan and section.

According to Constantine the Rhodian, next to the central bays lay a series of spaces vaguely designated as "another internal structure," which "ran around the whole church in a circuit."[76] This has been plausibly interpreted as a circuit of aisles and galleries, and this is how scholars have visualized it so far. Most models show a "ring" of arcades that connect the piers, enveloping the central space. Reminiscent of the layout of a centralized building, this exact configuration is not found in any affiliated monument. In St. John at Ephesos, the closest example to this description, there is no arcade connecting north and south aisles in the west and east extremities of the building. Yet Constantine's addendum to the previous passage seems unequivocal: the architect of the Holy Apostles "joined together the arcades from the right and the second aisle, in a circuit to run around the whole church." Mesarites confirms this, stating that the aisles consisted of twelve "stoas" (i.e., porticoes). This indicates that there was an inward-oriented portico in each side of the perimeter (including the east termination of the building). If these accounts imply that aisles and galleries ran without interruption along the perimeter of the north, south, and east cross arms, it is not certain that the same configuration was found in the west arm of the cross: there, a connection of the lateral aisles would have been provided by the narthex, which could have been included in Mesarites' count as one of the twelve "stoas."

According to most reconstructions published so far, these twelve "stoas" were screened by double-storied arcades with four columns each. This means that there would be forty-eight columns on each level (evenly distributed to the four arms of the cross) and a total number of ninety-six columns. These figures agree with the column numbers given by Constantine the Rhodian.[77] Still, they do not correspond entirely

Reinach ("Commentaire archéologique," 96) believed that this is the total number of piers in the peripheral bays. But the reference to one cubical shape (i.e., a shape with a square plan) makes the attribution of this passage to the cross arms unlikely. Soteriou ("Ἀνασκαφαί," 210) misread this as a reference to the total number of piers, and claimed that the figure given by Constantine is mistaken. Angelidi ("Ἡ περιγραφὴ," 110), was the first to notice that the passage refers only to the crossing and to interpret the number correctly as the total number of piers in the crossing. However, James, *Constantine of Rhodes*, 185, recently suggested that the passage refers to the entire building. Nonetheless, Angelidi's remains the most reliable interpretation of this passage.

75 Indeed, in his first reference to piers (line 564), Constantine the Rhodian addresses only those supports that "bear . . . the central dome and the supporting arches." The second relevant passage (lines 589–604) refers only to those piers that enclose the space with a "cubical shape"—a term that the author uses earlier in his description of the crossing. According to the author, this area had "sixteen well-arranged piers, four-legged and quadripartite." Finally, the 3rd passage (lines 605–607) simply mentions that the piers at the gallery level "were placed above those set below." None of these passages discusses the peripheral piers. Angelidi ("Ἡ περιγραφή," 110) came to a similar conclusion.

76 See Constantine the Rhodian, *Ekphrasis*, lines 705–710, ed. James, *Constantine of Rhodes*, 66–67.

77 Constantine the Rhodian, *Ekphrasis*, lines 715–725, ed. James, *Constantine of Rhodes*, 66–69, states that there were 12 columns in the ground floor of each cross arm, and that "all those columns drawn up below number forty plus eight supporting the roof of the colonnade. And in those above, you

to those mentioned by Mesarites. The latter states that the church had twelve double-storied colonnades and *approximately* seventy columns in total, a number that, according to him, had a symbolic significance.[78] This figure is far from what is shown in most reconstructions. Soteriou published the only reconstruction that matches the figures proposed by both accounts. This shows forty-eight columns on the ground floor, evenly distributed in the cross arms. Emulating the aisles of St. John at Ephesos, those in Soteriou's reconstruction are defined by double rows of columns, including pairs of columns that stand against the external wall. As in Ephesos, the columns against the wall occur only at the level of the aisles. This would bring the total number of columns to seventy-two (forty-eight on the ground floor and only half, i.e., twenty-four on the galleries). This configuration shows that it is possible to reconcile both Constantine's number of forty-eight columns on the ground floor and Mesarites' estimate of a total number of approximately seventy columns. Providing a plausible interpretation of the written records and based on a scheme observed in an affiliated monument, the column layout in Soteriou's proposal needs to be taken into account in the reconstruction of the aisles and the galleries of the Apostoleion.

The above column layout needs to be combined with our hypothesis regarding the elongated west cross arm. It is very likely that the aisles and galleries of the north, south, and east cross arms were equipped with screens of two columns each. The elongated, west cross arm would probably have required one more column in each screen. This allocation of columns is identical to the column layout of San Marco in Venice, where the entrance bay is flanked by colonnades with three columns each (fig. 7.9). This reconstruction

agrees with both middle Byzantine accounts, as well as with Procopius's reference to an elongated west cross arm.

It is unfortunate that the above records fail to provide any information about clerestory windows or the area between the roof of the galleries and the intrados of the broad arches supporting the dome. Visualizing this area is essential to figuring out how the interior of the Holy Apostles was lit. So far, two different reconstruction theories have been proposed for this part of the structure. Heisenberg and Underwood's team claimed that the gallery colonnades were only used to screen off the areas of the galleries and did not support any clerestory wall. This aspect of their reconstructions was inspired from the galleries of monuments such as San Marco in Venice and Hagia Eirene in Constantinople (fig. 7.10). In these buildings, the galleries are covered by the broad arches that support the domes. These arches extend from the sides of the central bays to the perimeter of the building, where the perforated clerestory walls lie. The latter are independent from the gallery colonnades, which are sometimes omitted in the present condition of the monuments. This is how Heisenberg and Underwood envisioned the galleries of the Holy Apostles (figs. 7.6 and 7.8).[79] However, this seems to contradict Mesarites' statement, according to which the double-storied colonnades appeared to support the entire structure.[80] Mesarites' observation is hardly compatible with a scheme in which the gallery colonnades do not hold any superior structure. Instead, it implies that there was some kind of collection between the colonnades and the vaults.

Wulff's reconstruction proposal seems to be the only one to show a connection between gallery colonnades and vaults: here, the gallery colonnades are surmounted by clerestory walls, which reach the intrados of the broad arches.[81] According to this scenario, these arches do not cover the entire gallery (a separate roof plays

would find with good reason rose-coloured columns in the same numerical measure."

78 Mesarites, *Ekphrasis*, c. 37.6, ed. Heisenberg, *Apostelkirche*, 79; ed. and trans. Downey, "Nikolaos Mesarites," 890; trans. Angold, *Nicholas Mesarites*, 123, writes: "for the stoas [i.e., colonnades] which support the whole church are twelve in number, and the columns which support these colonnades are close to seventy, a detail arranged by the architect not without purpose, I think, but in order that this might be indeed a living Church of Christ, supported by colonnades and columns equal in number to the disciples of Christ."

79 Cf. Heisenberg, *Apostelkirche*, pl. V, and Daskas and Gargova, *Underwood Drawings*, fig. 10.

80 See Mesarites, *Ekphrasis*, c. 37.6, ed. Heisenberg, *Apostelkirche*, 79; ed. and trans. Downey, "Nikolaos Mesarites," 890; trans. Angold, *Nicholas Mesarites*, 123.

81 See Wulff, "Sieben Wunder," 323.

FIG. 7.10.
Church of
Hagia Eirene,
Constantinople,
view of the interior
from the sanctuary,
looking west (photo
by E. Rizos, 2010)

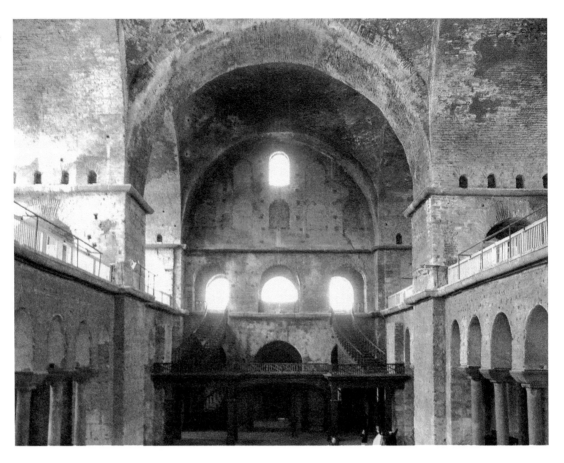

this role). This reconstruction of the colonnades agrees with Mesarites' account and resembles the configuration of the galleries and clerestory walls in the church of St. John in Ephesos (fig. 7.11).

Let us now focus on the clerestory walls above the gallery roof of the Holy Apostles. Owing to the lack of evidence, it is impossible to establish the form of the windows at this part. These may have resembled the arched windows currently found in the clerestory walls of Hagia Sophia or Hagia Eirene.[82] However, we should also consider the possibility that these were big "thermal" windows. Indeed, mullions that belonged to the "thermal" windows were found in St. John at Ephesos.[83] Given the similarity between the

St. John and the Apostoleion, it is possible that the latter also had similar windows in its clerestory walls (fig. 7.12).

The overall configuration discussed above explains the emphasis that Constantine the Rhodian puts on the crossing and his reluctance to mention the piers and arches of the peripheral bays of the church. Colonnades and clerestory walls would have concealed these elements. The only piers and arches that revealed their entire bulk to the visitor must have been the ones at the crossing. The central piers would have been visible from two sides, and the arches they carried were the only ones not to be filled with colonnades. These four quadripartite piers and the massive open arches they supported (mentioned by Constantine in lines 595–600) would have stood out, making the central sanctuary the climax of the monument's interior space.

82 It is worth noting that, according to Rowland Mainstone, *Hagia Sophia: Architecture, Structure, and Liturgy of Justinian's Great Church* (London, 1988), 275, the original tympana of Hagia Sophia had mullioned windows, similar to that currently at the west elevation of the building.

83 For a reconstruction of the church of St. John in Ephesos with "thermal" windows, see A. Thiel, *Die Johanneskirche in Ephesos* (Wiesbaden, 2005), 42–48. Previous reconstructions

of the monument showed its tympanum walls pierced with rows of arched windows.

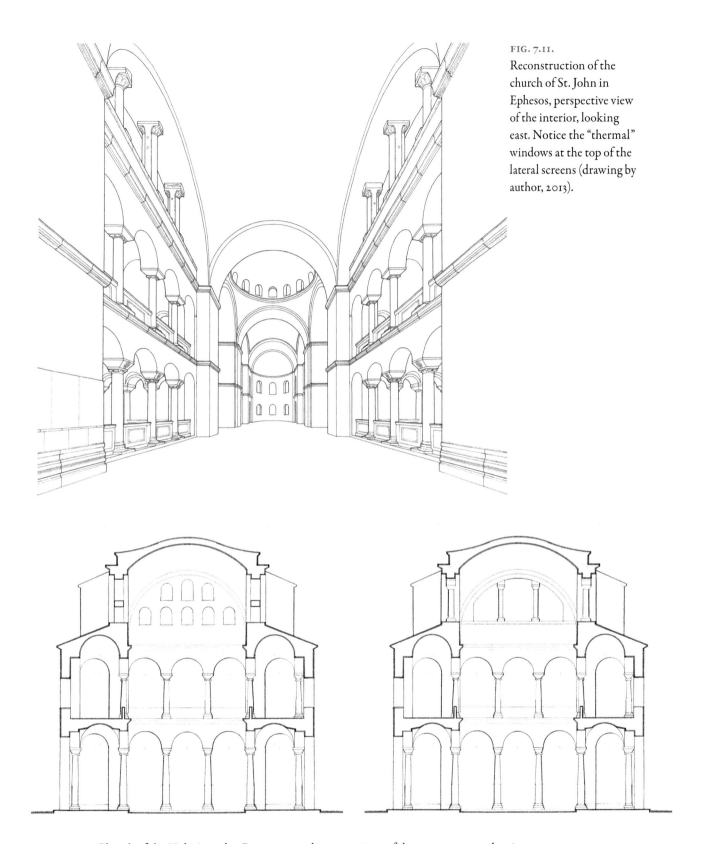

FIG. 7.11.
Reconstruction of the church of St. John in Ephesos, perspective view of the interior, looking east. Notice the "thermal" windows at the top of the lateral screens (drawing by author, 2013).

FIG. 7.12. Church of the Holy Apostles. Reconstructed cross-sections of the east cross arm, showing two alternative clerestory walls. The left version displays a window pattern similar to that of Hagia Eirene in Constantinople. The right version explores the possibility of "thermal," mullioned windows similar to those of Hagia Sophia in Constantinople and St. John at Ephesos (drawing by author, 2016).

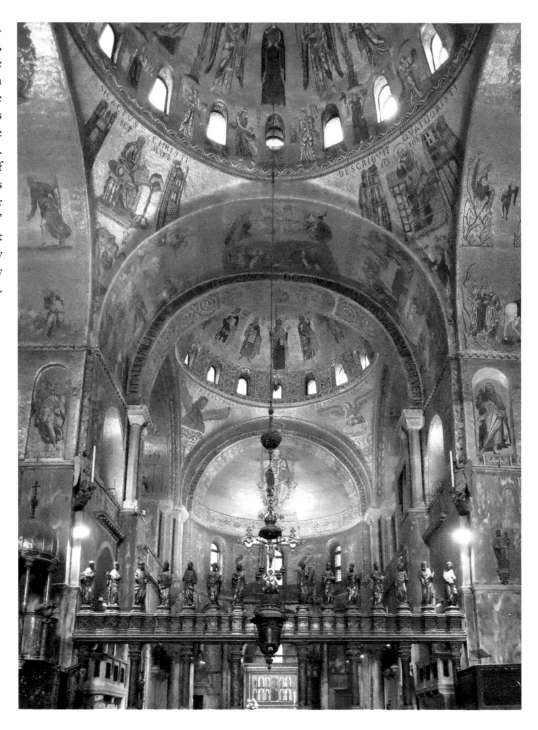

FIG. 7.13.
Basilica of San Marco,
Venice. View of the
east cross arm from
the crossing. Notice
the paired columns
framing the passage
to the east cross arm.
The description of
Constantine of Rhodes
indicates that similar
"double columns"
were used in the east
cross arm of the Holy
Apostles (photo by
author, 2010).

Before completing our survey of the church's columns, it is worth noting that there remains one aspect of Constantine's description that has not yet found a convincing interpretation. Beginning with his detailed description of "the marvelous columns and their nature and colour," Constantine refers to two sets of "double columns" made of polychromous marble, positioned "in the light-bearing east, one on the right side, the other . . . on the left side."[84] Soteriou claimed that these columns belonged to the colonnades of the east extremity of the building and were, therefore, similar to the columns in all other

84 See Constantine the Rhodian, *Ekphrasis*, lines 686–703, ed. James, *Constantine of Rhodes*, 64–67.

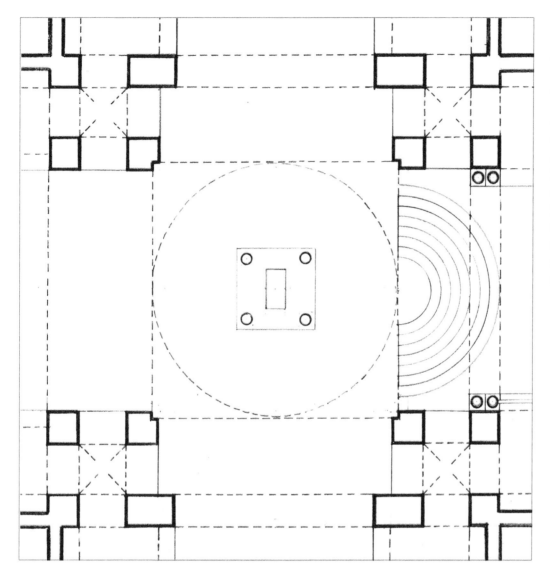

FIG. 7.14.
Church of the Holy
Apostles. Preliminary,
reconstructed plan of the
crossing. Notice the four
"quadripartite" piers and
the layout of the sanctuary,
which includes a ciborium
and a synthronon. It is
likely that the space of the
sanctuary was surrounded
by some form of barrier,
such as a colonnade or
a parapet wall, which
restricted access to it
(drawing by author, 2016).

cross arm.[85] But this interpretation does not take into account Constantine's special emphasis on these columns and their separate treatment in his text, not to mention the author's implication that such double columns were used only at the east end of the church.[86] Taking into account these considerations, Heisenberg claimed that the double columns were independent of the colonnades.[87] However, like Underwood four decades later, Heisenberg does not seem to

have managed to establish the exact position of these elements.

A careful observation of San Marco helps to resolve this problem. Indeed, double columns constitute one of the most prominent aspects of the design of this monument (fig. 7.13). These pairs of columns are set against the central piers, close to the north, south, and eastern peripheral bays (see fig. 7.9). Now, the role of the north and south double columns is to "mask" the transition from the crossing to the slightly narrower lateral bays. As we have seen, a similar difference in width between the crossing and three of the peripheral bays must have also existed in the Holy Apostles. The transition from the crossing to the narrower bays could have been achieved

85 See Soteriou, "Ἀνασκαφαί," 212.

86 See Constantine the Rhodian, *Ekphrasis*, line 700. For a discussion of this passage see James, *Constantine of Rhodes*, 124n205.

87 See Heisenberg, *Apostelkirche*, 130–31.

either by a wall projection from the main body of the piers or, rather more elegantly, by setting pairs of columns like the ones of San Marco against the piers themselves. Constantine the Rhodian implies that the double columns were positioned in the east cross arm. This indication and our observation of similar elements in San Marco seem to suggest that the double columns of the Holy Apostles were set against the two eastern piers of the crossing to provide a harmonious transition from the central to the narrower eastern bay. Located just behind the synthronon described by Mesarites, these columns must have enhanced the view toward the crossing, reinforcing its role as the "heart" of the building (fig. 7.14). The emphasis on this space was enhanced by the articulation of the vaulted roof, which is examined in the following paragraphs.

Vaults

From the form of the piers to the shape of the bays, most of the features we have examined so far were geared to support the central vaults. Written records suggest that these were "spherical," and there is a tendency to visualize them as hemispherical domes on pendentives [i.e., spherical triangles], like the original domes of San Marco.[88] However, a reinterpretation of the written records by reference to comparable monuments elsewhere suggests that the vaulted pattern of the Constantinopolitan monument may have been more varied than we thought.

Let us start the examination of the spherical vaults from their base. Both Procopius and Constantine the Rhodian suggest that each vault was supported on four broad arches that sprang from the piers.[89] According to the same sources, these arches were bound together with pendentives that ensured the transition from the square plan of the bay to the circular springing of the dome.[90] There is nothing problematic here: the two authors are clearly describing the base of a typical domed compound, such as the ones observed in several vaulted churches from Constantinople to Venice. If the descriptions of the lower levels of the vaults are clear, the descriptions of the domes themselves are not entirely consistent and require detailed examination.

Procopius starts his description by stating that the great dome over the crossing "resembled that of the church of [Hagia] Sophia [at Constantinople]."[91] The sixth-century author refers to the first, short-lived dome of Hagia Sophia, which collapsed in 558.[92] This early dome had a shallower profile than the current one. With its crown 6.5 meters lower, the original dome must have had a radius of curvature similar to that of the pendentives themselves. Yet, the first dome of Hagia Sophia was not exactly a pendentive dome: pendentives and the central dome were separated by a cornice and a series of windows at the base of the dome. According to Procopius, the church of the Holy Apostles also had a similar fenestrated dome base, which he calls "kykloteres" (i.e., circular form). But this feature was encountered only in the central dome, distinguishing it from the peripheral domes. On the basis of this description, one could visualize the central dome of the Apostoleion as a shallow dome with its base

88 Cf. Wulff, "Sieben Wunder," 323, and Heisenberg, *Apostelkirche*, pl. V. Gurlitt (*Baukunst Konstantinopels*, pl. 8p) envisioned only the central vault as a dome on pendentives and reconstructed the peripheral vaults as pendentive domes (i.e., shallow domes on pendentives, where the crown of the dome is cospherical with the pendentives).

89 After his description of the piers, Constantine the Rhodian refers to the broad arches as "vaults of circular composition." See Constantine the Rhodian, *Ekphrasis*, lines 577 and 622, ed. James, *Constantine of Rhodes*, 58–59, 60–61. See also Procopius, *De aed.*, 1.4.14, ed. and trans. Dewing, *On Buildings*, 50–51.

90 The reference to the pendentives is slightly obscure. Procopius (*De aed.*, 1.4.15, ed. and trans. Dewing, *On Buildings*, 50–51) refers indirectly to pendentives by stating that the arches were "bound together." Constantine (lines 623–624) mentions that the broad arches were connected with intermediary, circular structures that he calls "σφενδόνας"—i.e., "slings." Now, this is a very good description of a pendentive. James's (*Constantine of Rhodes*, 61) recent translation of the term "σφενδόνη" as "arch" may need to be reconsidered.

91 Procopius, *De aed.*, 1.4.14, ed. and trans. Dewing, *On Buildings*, 50–51.

92 J.A.S. Evans, "The Dates of the Anecdota and the De Aedificiis," *Classical Philology* 64, no. 1 (1969): 29, claims that Procopius's description of Hagia Sophia cannot postdate the collapse of the first dome of the "Great Church" in 558. R. Taylor, "A Literary and Structural Analysis of the First Dome on Justinian's Hagia Sophia, Constantinople," *JSAH* 55, no. 1 (1996): 66–78, agrees with this and states that "there is no question that the dome Procopius described was the first one."

perforated with windows, and the dome over the cross arms as pendentive domes.[93]

Four centuries later, Constantine the Rhodian also observes the difference between the central dome and the peripheral ones.[94] But this is the only similarity with Procopius's account. Constantine does not describe the central dome as a shallow spherical vault (similar to the first dome of Hagia Sophia), but as "a sphere cut in half." This clearly refers to a hemispherical dome on pendentives as opposed to a pendentive dome. According to Constantine, the central, full dome was connected with "a composition of spherical forms." By that he probably means a series of spherical vaults over the cross arms. The fact that these are not "spheres cut in half" may suggest that these "spherical forms" were not complete hemispheres but shallower pendentive domes. Indeed, later in his text, Constantine states that the ceiling included "four equal spheres" as well as a central sphere, which "was arranged by the craftsman so as to be preeminent and lord of all."[95] This statement seems to confirm the reconstruction according to which the hemispherical profile was limited to the "prominent" central dome, which stood amid shallower vaults.

Writing more than two centuries later, Mesarites seems to confirm Constantine's claim that the central dome was hemispherical and distinctively elevated in relation to the other domes.[96] However, this late account suggests that each of the bays were "brought to completion in the shape of a perfect hemisphere." Following this statement, which seems to indicate a series of full hemispherical domes, Mesarites goes on to describe the central dome in more detail. In this passage, he mentions a series of lines that connected the top of the vault with its base. This effect of meridian lines could have been created by a gored domed shell or a dome reinforced by ribs.[97]

We are, therefore, confronted with three different accounts. Procopius seems to be implying that there was a shallow dome with a fenestrated base over the crossing and even shallower pendentive domes over the cross arms. On the other hand, the description of Constantine the Rhodian indicates a full hemispherical dome on pendentives over the crossing and, perhaps, pendentive domes over the cross arms. Finally, Mesarites seems to suggest that all the main bays, including the crossing, were covered by hemispherical domes on pendentives, without clarifying what exactly made the central dome more prominent than the others. It is possible that the differences between these descriptions indicates the transformation of the church from the sixth to the twelfth century, but, unfortunately, the lack of detail of these accounts makes it difficult to draw definitive conclusions.

Almost all the reconstructions of the vaults of the Holy Apostles show a series of hemispherical domes. Consistent with Mesarites' description, this vault pattern is similar to that of San Marco in Venice. In spite of the indirect evidence for pendentive domes in the accounts of Constantine the Rhodian and Procopius, this possibility has not been investigated further. However, my recent reconstruction of the church of St. John at Ephesos suggests that these descriptions need to be reconsidered.[98] Indeed, the investigation of the fragments of the vaults of the Ephesian monument showed that a hemispherical dome on pendentives marked the crossing of the church, and pendentive domes covered the main bays of the cross arms (fig. 7.4). This vault pattern agrees with many aspects of Constantine's description, especially

93 The fact that Procopius compares the central dome of the Apostoleion with the 1st, shallow dome of Hagia Sophia seems to have been overlooked by Epstein, "Rebuilding and Redecoration," 80 and James, *Constantine of Rhodes*, 185. Both authors believe that Procopius describes a vaulted ceiling with five hemispherical domes on pendentives.

94 See Constantine the Rhodian, *Ekphrasis*, lines 577–582, and 625–626. Our current translation is based on that in James (*Constantine of Rhodes*, 61) with some amendments by the author.

95 See Constantine the Rhodian, *Ekphrasis*, line 626, ed. James, *Constantine of Rhodes*, 60–61.

96 According to Mesarites, *Ekphrasis*, c. 13.5–7, ed. Downey, "Nikolaos Mesarites," 869, the central bay "stands up above [the peripheral bays], and … faces toward heaven … it binds the other four [bays] to itself … and stands there as a kind of mediator."

97 For a discussion of Byzantine ribbed domes and further references, see R. Ousterhout, "Building Medieval Constantinople," *Proceedings of the PMR Conference* 19–20 (1996): 35–67, esp. 48 and 66; C. Mango, *Byzantine Architecture* (Milan, 1978), 11; and A. Choisy, *L'art de bâtir chez les Byzantins* (Paris, 1883), 67.

98 See Karydis, "Vaults of St. John," 524–51.

his suggestion regarding the prominence of the central vault. We should, therefore, consider the possibility that at least the peripheral bays of the Holy Apostles were covered with pendentive domes.

The Scale of the Church

If the domed bays of the Holy Apostles were built in a scale similar to that of the greater foundations of Justinian, their serial arrangement must have generated an impressively large space. Depending on its size, this space could have either been overwhelming or given the impression of a lofty, yet protective enclosure. Establishing the exact scale of the Holy Apostles would help to gain a better sense of the impact of the church on the visitor. Unfortunately, information about the size of the building is limited. Our only sources of information are the comparison with similar buildings and the hypothetical evidence derived from the original Fatih Camii.

Procopius states that the dome above the sanctuary of the Holy Apostles was inferior to that of Hagia Sophia in size. This comparison is not helpful, as with its 31-meter diameter, Hagia Sophia's dome would have obviously been unique. Standard monumental construction of this period could attain a scale similar to that of St. John in Ephesos, a building whose central bay measured 14 by 14 meters and the peripheral ones 12.5 by 12.5 meters. The corresponding dimensions in San Marco are 13 by 13 meters and 10.5 by 10.5 meters, respectively. The alleged resemblance between these buildings and the Apostoleion may indicate that the latter had a similar size. But this is an argument from silence. Indeed, one could argue that the special symbolic meaning of the Constantinopolitan building and its location at the imperial capital could have justified a bigger scale than that of its "provincial" counterparts.

Further indications about the size of our church may be drawn from its presumed site, which, according to most authors, corresponds to the actual site of the Fatih Camii.[99] The original

mosque was built by Mehmed II in 1471. Still, its prayer hall and some of its dependencies were rebuilt after an earthquake in the 1770s. Having analyzed these phases, Ken Dark and Ferudun Özgümüş identified a series of pre-Ottoman fragments in the substructures of the mosque and attributed them to the church of the Holy Apostles.[100] Unfortunately, these fragments are insufficient to trace a coherent design layout. However, the analysis of the reconstructed plan of the fifteenth-century mosque of Mehmed II provides valuable indications about the scale of the pre-Ottoman structure on this site.[101]

The original Fatih Camii formed part of a funerary, socioreligious complex that included eight madrasas, arranged in a bilaterally symmetrical layout. Situated at the heart of this complex, the prayer hall had its central space covered by a dome near the entrance and a semidome near the mihrab. A cemetery garden lay to the east of this hall and included the turbe of Sultan Mehmed II and his wife, Gülbahar Hatun, both of which were rebuilt in the eighteenth century.[102] The main entrances to the mosque are quite enigmatic in terms of design.[103] Even though the two lateral stairways align with the entrance portico, they are poorly integrated in the plan. They are asymmetrically bisected by the northwest wall and its minarets, which invade the main landings. It is difficult to justify this slipshod, accidental element in what is otherwise an ordered, symmetrical design. A possible explanation could be that the two staircases were built on foundations of the pre-Ottoman building on this site. Indeed, pre-Ottoman fragments have been identified

99 This theory has been criticized in A. Berger, "Streets and Public Spaces in Constantinople," *DOP* 54 (2000): 161–72, esp. 168–69.

100 See Dark and Özgümüş, *Constantinople*, 93. These fragments are incorporated into the walls of the vast platform on which the central mosque is built. Running, like the walls, in a northwest-southeast direction, these fragments are found at the foot of the walls of the courtyard and the prayer hall, in the base of the window-pierced precinct wall of the mosque's cemetery garden, as well as in the substructures of the northeast staircase. See below, Raby, 258–64.

101 For the reconstruction of the original mosque of Mehmed II, and further references regarding its building history, see G. Necipoğlu, *The Age of Sinan: Architectural Culture in the Ottoman Empire* (London, 2005), 77–103.

102 For a detailed description of the original mosque and its dependencies, see G. Goodwin, *A History of Ottoman Architecture* (London, 1971), 121–31.

103 See Necipoğlu, *Age of Sinan*, 84.

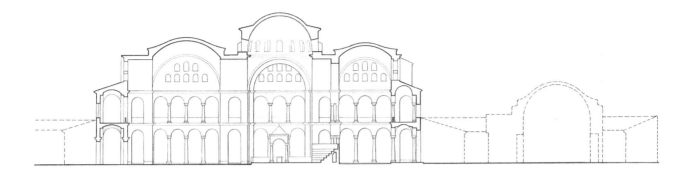

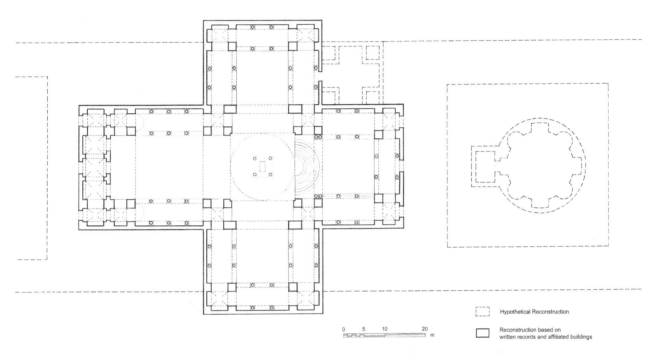

| | Hypothetical Reconstruction |
| | Reconstruction based on written records and affiliated buildings |

0 5 10 20
 m

FIG. 7.15. Complex of the Holy Apostles. Reconstructed Plan and Longitudinal Section showing the sixth-century church (left), the fourth-century Mausoleum of Constantine (right), and the sixth-century Mausoleum of Justinian (upper right corner). The form of the two mausoleums cannot be established with certainty. The hypothetical reconstruction of Constantine's mausoleum is based on the description of the building in Eusebius's *Life of Constantine* (drawing by author, 2016).

in the northeast staircase.[104] This suggests that the Byzantine building on this site had two lateral projections with an approximate width of 30 meters. If this building was the church of the Holy Apostles, then these lateral projections could be interpreted as the extremities of the two transept arms. A width of about 30 meters would place these cross arms between those of San Marco in Venice (about 25 meters) and those of St. John in Ephesos (about 32 meters). However, in the

absence of any conclusive evidence for the identification of this structure as the church of the Holy Apostles, these deductions remain speculative. In spite of the above comparisons and site observations, the question regarding the scale of the Holy Apostles remains open.

Reconstruction

The above discussion completes our exploration of the lost form of Justinian's Apostoleion. The conclusions presented in the previous

104 See Dark and Özgümüş, *Constantinople*, 106–10.

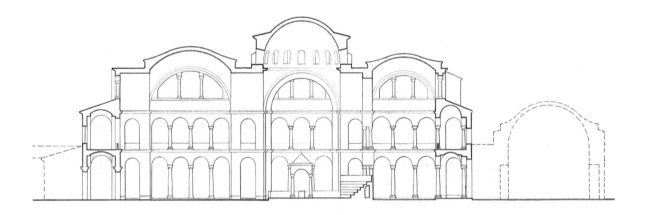

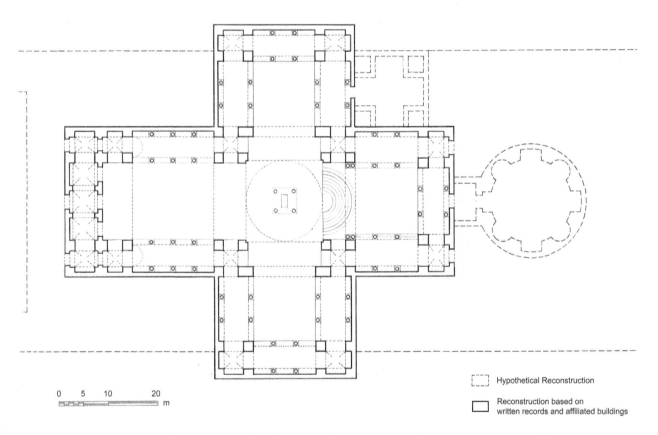

FIG. 7.16. Complex of the Holy Apostles in Constantinople. Alternative Reconstructed Plan and Longitudinal Section. Two alternative themes are explored here: the use of "thermal," mullioned windows in the clerestory walls and the direct connection between the church and the Mausoleum of Constantine (drawing by author, 2016).

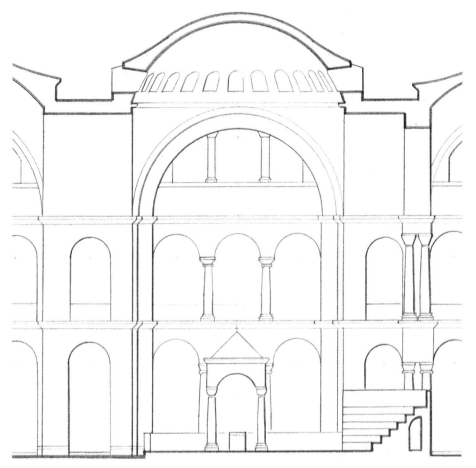

FIG. 7.17.
Church of the Holy
Apostles in Constantinople,
reconstructed section of the
crossing. Based on the account
of Procopius, this alternative
reconstruction explores the
possibility of a central dome
similar to the first dome of
Hagia Sophia (drawing by
author, 2016).

paragraphs are synthesized in the reconstructed plans and sections of the building, shown in figures 7.15–7.17. These tentative reconstruction drawings represent the church and two of its most important dependencies: the mausoleums of Constantine and Justinian. Here, the Mausoleum of Constantine is shown in the middle of a cloister, as Eusebius described it (fig. 7.15). However, this building could have also been connected with the east cross arm of the church (fig. 7.16). Both the plans and the sections of the mausoleums are shown with dashed lines, which indicate the conjectural character of their reconstruction. The concluding paragraphs of this chapter provide an outline of the reconstructed church, with emphasis on those aspects which appear here for the first time.

According to Procopius, the church had a cruciform plan with an elongated west cross arm. This emphasized the axis that connected the entrance and the sanctuary and provided the church with a sense of direction that is missing from previous reconstructions. Preceded by a narthex and an atrium, the core of the church was articulated into five square bays. Unlike previous models, which show five equal bays, our analysis raised the possibility of a larger central bay (15 by 15 meters) connected with somewhat smaller bays (12.5 by 12.5 meters) in the north, south, and eastern cross arms. At the four corners of each bay stood large quadripartite piers. The central piers provided a harmonious transition from the large crossing to the smaller bays. This was achieved through projections from the main body of the piers. In the east cross arm, this projection was probably achieved with the double columns mentioned by Constantine the Rhodian. Included for the first time in a reconstruction of the Holy Apostles, these pairs of columns flank the passage from the east cross arm to the crossing. The latter was occupied by the sanctuary, which included a four-column ciborium with a pyramidal roof and a synthronon that resembled the one of St. John in Ephesos.

Analysis of written records and references to affiliated buildings in Ephesos and Venice provided clues for the appearance of the aisles, the galleries, and their colonnades. As we learn from Constantine the Rhodian and Nicholas Mesarites, these formed a continuous circuit of double-storied porticoes, which surrounded the inner bays. These porticoes had two- and three-column arcades inserted between the piers in both levels. The arcades of the gallery were probably surmounted by clerestory walls, which reached the intrados of the broad arches, giving Mesarites the impression that they supported the entire church. The column layout shown in figure 7.15 is the first one—after that published by Soteriou—to agree with both Constantine the Rhodian and Mesarites regarding the number of columns. This shows that it is possible to respect these indications without departing from the design principles of affiliated buildings.

In spite of the extensive references to vaults in the written records, the vaulted pattern of the Holy Apostles remains unclear. If we can say with certainty that spherical vaults covered the five major bays, it is difficult to establish whether these vaults were hemispherical domes on pendentives or pendentive domes (i.e., shallower domes, cospherical with the pendentives). Having analyzed the descriptions of Constantine the Rhodian and Procopius, and investigated the church of St. John in Ephesos, we suggested that a distinctively elevated dome on pendentives covered the central bay, and pendentive domes covered the peripheral bays. Just how "elevated" the central dome was is difficult to establish. Its profile must have been taller than that of the other domes, but not so tall as to become noticeably different from the first dome of Hagia Sophia,

which had a shallow profile. Figures 7.15 and 7.17 explore the form of the two most likely dome profiles. In all these drawings, the reconstruction of the secondary vaults is based on similar specimens in St. John in Ephesos.

The above hypothetical reconstruction raises the possibility that the church of the Holy Apostles had a hybrid architectural character. Combining a processional axis with encircling corridors, this design represented a rare fusion of the types of the basilica and the centralized church. The interior of the church must have been both compartmentalized and cohesive. The space was articulated in bays covered with distinctive vaults. Cut off from each other by transverse arches and piers, these bays must have maintained some degree of independence. Nonetheless, this remained a unified design. The key of this unity lay in the crossing. Its large size, distinctively elevated dome, and luminous character (thanks to the dome's windows) must have given a special emphasis to the heart of the church. This was not meant to separate this central bay from the neighboring ones but to symbolize its role as the climax of a space that emanates from a center and unfolds in four directions in a fluid movement. This fluidity, combined with the clear hierarchical differentiation between arms and crossing, must have created a complex yet integrative architectural experience. The skillful harmonization of different architectural ideas echoes the multifunctional character of the Holy Apostles. The combination of the roles of church and mausoleum, and the need to accommodate the symbols of religious and political power, inspired the creation of one of the most versatile and sophisticated of early Byzantine churches.

Around and about
the Holy Apostles in Constantinople

PAUL MAGDALINO

I N HIS FUNDAMENTAL ARTICLE ON CONSTANTINE'S MAUSOLEUM, CYRIL
Mango observed, "as often happens in scholarship, the accumulation of bibliography may obscure
instead of illuminating a problem."[1] If this is true of the church of the Holy Apostles and the imperial
burial chambers, over which much more ink has been spilt since Mango wrote, it applies equally to the
surrounding and adjoining buildings, which go almost without comment in the scholarly literature.[2]
My aim in this paper is not to add to the pile of existing bibliography but to start a new pile, to shift the
focus from the church itself to the annexes, the neighboring structures, and the neighborhood in which
the monument was embedded. By looking at the Holy Apostles not as an isolated monument but as the
center of a complex in an urban context, we get a better idea of its significance in the cultural fabric of
Constantine's city.

The Apostoleion was an integral part of Constantine's design for his new capital, and we must
therefore begin by reconsidering its function in the foundation of the city. This, in turn, requires some
brief consideration of the methodological problems involved in trying to determine what Constantine
had in mind, and what relation it bore to later developments. The problems lie not only in the frag-
mentary, mostly late, and sometimes contradictory nature of the evidence, and in the tangled coils of
scholarly conjecture that have been spun from this meager material, but also in the fluid and evolving
nature of the political process in which the foundation of Constantinople was only one, albeit very
momentous, act.

What is not in doubt is that Constantine founded Constantinople in order to mark his victory
over Licinius and the reunification of the Roman Empire under one ruler and one dynasty. Beyond
this, his specific intentions are not clear. He designed his seat of power according to the needs of the
new situation; like his Tetrarchic predecessors and his dynastic successors, he had to work it out as
the situation evolved.[3] He was not working to any preset formula of what constituted a political capi-
tal, a dynastic residence, a state religion, or an imperial burial place; he was in the process of defining
the solutions that suited his purpose, and he was just as liable to reject as he was to adopt or adapt
recent precedents, including those that he himself had set. Thus, we cannot use the examples of the
Tetrarchic residences—Trier, Milan, Nicomedia, and Thessalonike—all of which Constantine had

1 C. Mango, "Constantine's Mausoleum and the Translation of Relics," *BZ* 83 (1990): 51–62, at 54 [reprinted in C. Mango, *Studies on Constantinople* (Aldershot, 1993), no. V].

2 For a sensible and detailed recent survey of the monument, with full bibliography, see J. Bardill, *Constantine: Divine Emperor of the Christian Golden Age* (Cambridge, 2012), 364–95.

3 Recent surveys are legion. In addition to Bardill, *Constantine*, passim, and literature cited, see P. Maraval, *Constantin le Grand: Empereur romain, empereur chrétien (306–337)* (Paris, 2011); M. Wallraff, *Sonnenkönig der Spätantike: Die Religionspolitik Konstantins des Großen* (Freiburg, 2013); D. Potter, *Constantine the Emperor* (Oxford and New York, 2013).

frequented, as a basis for reconstructing his vision for Constantinople. Although he replicated the palace-hippodrome complex that was a standard feature of all these subsidiary capitals, he may well have been inspired by Rome itself, as other features of Constantinople, notably the Capitol and the Senate House, were clearly of Roman inspiration. Yet this does not mean that Constantine's building activity in Constantinople echoed his building activity in Rome, any more than the religious ideology that we read on his Roman triumphal arch, or on his early coinage, can be read as a guide to his cultic intentions for his eponymous city. Equally, no particular one of the imperial mausolea of the Tetrarchs in the Balkans, or either of the famous precedents of Augustus and Hadrian in Rome, or any of the monuments that Constantine may have envisaged for himself and other members of his family before the foundation of Constantinople can be assumed to have determined his final plans for his final resting place.[4]

We should also be careful of reading any particular model, or logic, of urban planning into the sparse evidence for the initial development of Constantinople.[5] The preexistence of Byzantion influenced but did not constrain the urbanization of the huge additional space that Constantine enclosed within his new land walls. The only constraints were the coastline, the steep hills, and the line of the ancient access road that linked Byzantion to its Thracian hinterland, and thus naturally became the Central Avenue (Mese) of the new urban space. The topography did not lend itself to a uniform application of a single Hippodamian grid plan, which can only be faintly discerned in the area between the Mese

and the Golden Horn.[6] Constantinople thus did not follow the pattern of its immediate and neighboring Tetrarchic predecessors, Nicomedia and Thessalonica. But neither did the site favor a close imitation of the layout of Rome, if indeed this was an option that Constantine ever considered.

All this is relevant to the church of the Holy Apostles, because it means that the significance of its siting within the urban space is far from immediately apparent. At first glance, it seems to be situated quite clearly at the outer limits of the new intramural area. But if this was the periphery, where exactly was the city center? Most obviously, perhaps, at the eastern end of the Mese, at the convergence of a large cluster of imposing monuments and colonnaded squares all built by Constantine in the geographical center of the ancient city—the Milion, the Hippodrome, the Palace, the Baths of Zeuxippos, the Royal Courtyard (Basilica), and the Augustaion.[7] How then do we define the Forum of Constantine, the great circular, colonnaded forum that Constantine laid out just outside the old city of Byzantion, with a central porphyry column bearing his own statue?[8] Was this not also the center of Constantine's city? The problem does not end here, for further west along the central avenue stood a tetrapylon that marked an important T-junction, if not a crossroads of *cardo* and *decumanus,* as Cyril Mango has conjectured.[9] Further west still, where the Mese divided, stood an enigmatic monumental ensemble known as the Capitol, which was probably constructed by Constantine, and by analogy with its Roman namesake must have been an urban focus of some symbolic importance.[10] There are also enigmatic references to the city's navel (*omphalos*) between the Mese and the Golden Horn. So it begins to look as if Constantine's city had not

4 For the precedents and options, see in general M. Johnson, *The Roman Imperial Mausoleum in Late Antiquity* (Cambridge, 2009).

5 On the planning and early development of Constantinople, see C. Mango, *Le développement urbain de Constantinople (IVe-VIIe siècles), TM,* Monographies 2 (Paris, 1985; 1990; 2004); S. Bassett, *The Urban Image of Late Antique Constantinople* (Cambridge, 2004); several contributions to *Two Romes: Rome and Constantinople in Late Antiquity,* ed. L. Grig and G. Kelly (Oxford and New York, 2012); R. van Dam, "Constantine's Beautiful City: The Symbolic Value of Constantinople," *AntTard* 22 (2014): 83–94; P. Magdalino, "Le premier urbanisme byzantin," in *Entre deux rives: Villes en Méditerranée au Moyen Âge et à l'Époque moderne,* ed. E. Malamut et al. (Aix en Provence, 2018), 79–93.

6 The most systematic and as yet unsurpassed attempt to reconstruct the street plan of Constantinople is A. Berger, "Regionen und Straßen im frühen Konstantinopel," *IstMitt* 47 (1997): 349–414. See also Magdalino, "Premier urbanisme byzantin."

7 Bassett, *Urban Image,* 22–26.

8 Ibid., 29–31; R. Ousterhout, "The Life and Afterlife of Constantine's Column," *JRA* 27 (2014): 304–26.

9 Mango, *Développement urbain,* 30–31.

10 Ibid., 30; Bassett, *Urban Image,* 31–32; A. Effenberger, "Zur Wiederverwendung der venezianischen Tetrarchengruppen in Konstantinopel," *Millennium* 10 (2013): 215–74, at 220–25, 245–51.

one center but a sequence of several nuclei: to use a linguistic metaphor, the structure of the new city was not syntactic but paratactic, consisting of a series of added-on units along the central axis. Seen in the light of this arrangement, the Holy Apostles appears to be one more unit in the series; it was the city center in the west, where the unconquered sun of the founder finally set below the horizon.

Central or peripheral, the function of the original, Constantinian unit is clear from Eusebius's contemporary and eyewitness description in the *Vita Constantini.* The monument was unequivocally the emperor's mausoleum. It was also a shrine to the apostles, although perhaps more ambiguously so than Eusebius allows, since in a culture saturated with solar symbolism, the position of the emperor's sarcophagus at the center of the twelve apostolic cenotaphs could hardly fail to evoke the image of the unconquered sun among the signs of the zodiac or the months of the year.[11] The combination of functions was original, unique, and ultimately unsustainable, for as we know, they were separated by Constantius II, who provided a different building for the veneration of the apostles. Separately, however, the two functions of apostolic cult and imperial burial had clear precedents, which, interpreted with all due caveats, may help to explain the choice of the site. Constantine's decision to provide his new city with a sanctuary of Christ's apostles cannot have been unrelated to his experience of Rome, where the local church had been founded by the two chief apostles, Peter and Paul, and their sanctuaries, along with other martyr shrines to which Constantine contributed, lay outside the city.[12] As for imperial mausolea, Constantine was spoiled for choice of both remote and recent examples, but the grandest recent precedent was the tomb of the emperor Diocletian at his retirement residence on the Dalmatian coast. What made it grand was not so much the burial chamber as the magnificent residential complex, amounting to a "minuscule city," within which it was inscribed.[13]

It is here that we should pay attention to what Eusebius says about the annexes of the Holy Apostles, which tend to be passed over in discussions of the church. According to the *Vita Constantini,* the church stood at the center of an open courtyard enclosed by four porticoes with flanking outbuildings that comprised βασίλειοι οἶκοι, baths, ἀναλαμπτήρια (whatever they were), and housing for the custodians.[14] If we translate βασίλειοι οἶκοι literally as "royal houses," we can envisage the ensemble as an imperial palace-cum-burial place, just like Diocletian's complex at Split and Galerius's imitation of this at Romuliana/Gamzigrad.[15] We might then speculate that Constantine planned the Apostoleion as his own, Christian or semi-Christian, version of a Tetrarch's retirement home, where he would go and enjoy the view after handing over power to his sons. His intention is difficult to discern, since it was cut short by his death, along with the original, dual function of the central mausoleum-church. It is conceivable that Constantius II, when transforming the mausoleum and the church into separate architectural spaces, converted the adjoining palace for other use, although, as we shall see, we need to balance this possibility against later evidence for an imperial palace in close proximity to the church.

Although Constantine broke with both imperial and apostolic tradition by building his martyrium-mausoleum inside the city walls, he made a concession to precedent by consigning it to the outer zone of the new urban space. Even if the intention was to create a new off-center center, as suggested above, it is hard to avoid the impression that the Apostoleion complex was initially an isolated, self-contained unit, standing in open country, with no connection to the rest of Constantine's city apart from the northern branch of the Mese that passed to the west.

11 Bardill, *Constantine,* 376.

12 Ibid., 249–51. For a more positive assessment of Constantine's role in the building of St. Peter's, see *Old St Peter's, Rome,* ed. R. McKitterick et al. (Cambridge, 2013), esp. the articles by R. Gem and P. Liverani.

13 S. Ćurčić, *Architecture in the Balkans: From Diocletian to Süleyman the Magnificent* (New Haven and London, 2010), 32–38.

14 Eusebius, *Vita Constantini,* 4.59: ed. F. Winkelmann, *Über das Leben des Kaisers Konstantins,* Eusebius Werke, 1.1, GCS, (Berlin, 1975), 144; trans. Cameron and Hall, *Eusebius, Life of Constantine* (Oxford, 1999), 176.

15 Ćurčić, *Architecture in the Balkans,* 38–39.

The presence of washing facilities, attested by Eusebius, might be taken to indicate that the complex was connected to the city's water supply, and the fact that the Fatih Camii now stands practically on top of the line of the main Byzantine aqueduct might suggest that this facility influenced the choice of site. However, the recent and ongoing investigation of the water supply of Constantinople by Jim Crow and others leads to a different conclusion.[16] The long-distance aqueduct, which put an end to the new capital's chronic water shortage by tapping mountain springs deep in the Thracian hinterland, was not completed until the reign of Valens (364–378). Before that Constantinople relied on the old aqueduct of Byzantion, built under Hadrian, which brought water from the lower hills of the Belgrade forest and entered the city at a level some 30 meters lower than the site of the Holy Apostles. Crow thus conjectures that the baths mentioned by Eusebius at the Holy Apostles must have been fed by "wells and rainwater gathered in cisterns."[17] In any case, there is hardly any evidence for further urban development around the church before the long-distance aqueduct was up and running; significantly, the only exception, the great public baths begun by and named after Constantius II, were not completed until long after his reign.[18]

It was under Theodosius I (379–395) and his successors that this part of the city became a high-class residential neighborhood. According to the *Notitia Urbis Constantinopolitanae*, drawn up for Theodosius II in about 425, five empresses and princesses of the Theodosian family possessed houses in the western part of the city.[19] I have argued elsewhere, by combining the information of the *Notitia* with evidence from later sources, that these and other aristocratic mansions of the same period were grouped south and east of the

Holy Apostles (*martyrium Apostolorum*).[20] The fact that the emperor Marcian (450–457) chose to construct his forum and commemorative column in this area attests to the growing importance of the neighborhood in the mid-fifth century.[21] The most important secular structure, after the Baths of Constantius, appears to have been the Palace of Flaccilla (*palatium Flaccillianum*) in the eleventh region, named after Theodosius I's first wife, Flaccilla. It was not only an imperial palace, but it also, according to the *Chronicon Paschale*, housed a set of imperial insignia in 532, which the insurgents in the Nika Riot used to crown the unfortunate Hypatios as emperor.[22] This suggests that it functioned as a regular ceremonial venue. The *Book of Ceremonies* mentions only one such venue in this part of the city: the "God-guarded palace" adjoining the church of the Holy Apostles, where the emperor rested, dined, and changed his vestments on the occasion of his visits to the church.[23] Of course, there are problems in equating the anonymous palace of the tenth-century ceremonial texts with the much earlier Palace of Flaccilla, whose exact location is not known. Yet there is nothing inherently implausible in the idea that Theodosius I or his first wife built this palace in order to serve as a base for the court's devotions at the shrine of the apostles. In any case, it is to these devotions that we must now turn for the next stage of our inquiry.

Procopius does not say whether Justinian's extensive reconstruction of the Holy Apostles affected the adjoining buildings—he does not even mention the emperor's addition of a new mausoleum.[24] Thus, Constantine Porphyrogennetos's

16 J. Crow, J. Bardill, and R. Bayliss, *The Water Supply of Byzantine Constantinople* (London, 2008), ch. 2.

17 Ibid., 13.

18 Ibid., 13, 229.

19 Ed. O. Seeck, *Notitia Dignitatum, accedunt Notitia Urbis Constantinopolitanae et Laterculi Provinciarum* (Berlin, 1876), 229–43, at 237–38; trans. J. Matthews, "The *Notitia Urbis Constantinopolitanae*," in *Two Romes: Rome and Constantinople in Late Antiquity*, ed. L. Grig and G. Kelly (Oxford, 2012), 81–115, at 93–94, with commentary on 108–9.

20 P. Magdalino, "Aristocratic *Oikoi* in the Tenth and Eleventh Regions of Constantinople," in *Byzantine Constantinople: Monuments, Topography, and Everyday Life*, ed. N. Necipoğlu (Leiden, 2001), 53–69 (repr. in P. Magdalino, *Studies on the History and Topography of Medieval Constantinople* [Aldershot, 2007], no. II). See now also D. Angelova, *Sacred Founders: Women, Men, and Gods in the Discourse of Imperial Founding, Rome through Early Byzantium* (Oakland, 2015), 152–59.

21 W. Müller-Wiener, *Bildlexikon zur Topographie Istanbuls* (Tübingen 1977), 14–15; Mango, *Développement urbain*, 46.

22 *Chronicon Paschale*, ed. L. Dindorf (Bonn, 1832), 1:624 with 563–64; trans. M. and M. Whitby, *Chronicon Paschale, 284–628 AD*, TTH 7 (Liverpool, 1989), 53, 122.

23 See below, p. 135 at n. 27.

24 Procopius, *De aed.*, 1.4.9–24, ed. and trans. H. B. Dewing, *Procopius*, vol. 7, *On Buildings* (London and Cambridge, MA, 1940), 48–55. For Justinian's mausoleum, see P. Grierson, "The

Book of Ceremonies, broadly contemporary with the *ekphrasis* by Constantine the Rhodian, is our first port of call after Eusebius for information about the annexes of the church and the imperial tombs.[25] Three chapters in the compilation (I, 10; II, 6–7) describe the procedures for the emperor's visits on designated feast days, all of them in the period after Easter.[26]

Book I, 10 describes the procedure for Easter Monday.[27] The emperor, arriving in procession at the Holy Apostles, sits in the narthex to await the patriarch. After the latter has arrived and their respective corteges have entered the church, emperor and patriarch go in together by the royal doors. The patriarch precedes the emperor into the sanctuary, where the emperor leaves his customary gift on the altar, after which they exit the sanctuary together, and light candles before a series of tombs: those of St. John Chrysostom and St. Gregory the Theologian, then the sarcophagus of Constantine the Great, followed by the tombs of the patriarchs Nikephoros and Methodios, and finally the emperor alone enters and exits "the tombs of the emperors," presumably the Mausoleum of Justinian. They proceed to the women's section (*gynaikites*), where the patriarch takes his leave and returns to the sanctuary to celebrate the liturgy. The emperor passes through the *gynaikites* into the narthex and to the corner of the atrium, where he ascends the "left-hand" spiral staircase into the gallery of the catechumens (*katechoumeneia*). Here he takes his customary place on the right side and remains there throughout the liturgy, except for the moment when he comes to take communion from the patriarch's hands at the *antiminsion* in the center of the gallery. At the end of the liturgy, the emperor "goes by the front gallery and by interior passages to the God-guarded palace, that is the one there" (διὰ τῶν ἔμπροσθεν κατηχουμενείων καὶ διὰ τῶν ἔνδον ἀπέρχεται ἐν τῷ θεοφυλάκτῳ παλατίῳ, ἤγουν τῷ ὄντι ἐκεῖσε). There he rests in his chamber (κοιτῶνι) while two *silentiarioi* go to summon the patriarch. The emperor and patriarch take their seats at table in the dining hall (τρίκλινος), where they are joined for the meal by a group of the emperor's "friends." After the guests and the patriarch leave, the emperor takes a short rest, presumably in his chamber, and changes into his "parade uniform" for the return procession. He goes through the "narthex gallery" (διὰ τῶν κατηχουμενείων τοῦ νάρθηκος) and descends the staircase by which he came up. The court dignitaries are waiting for him at the exit, and they all ride off in procession.

De cerimoniis II, 6, describing the ceremonial for the Feast of Constantine and Helen (21 May), bears the heading, "All that must be observed in keeping with the current celebration of the annual commemoration of the holy and great Constantine and consecration of the holy crosses set up in the New Palace of Bonus."[28] The emperors (in the plural, referring to Constantine VII and his son Romanos II) in fact move into the Palace of Bonus a day or more before the feast, and it is from there that they set off for the Holy Apostles in the morning. Here they change vestments in the narthex before traversing the church to the Mausoleum of Constantine (here called St. Constantine's), where they meet the patriarch. They venerate the tombs of Leo VI, his first wife Theophano, Basil I, and Constantine the Great, in that order. Leaving the patriarch in the church, the emperors return in procession with the senate to the Palace of Bonus by way of the terrace of the church of All Saints. They wait for the patriarch to arrive with the church procession and perform the consecration ritual for the church of St. Constantine. Entering

Tombs and Obits of the Byzantine Emperors (337–342), with an Additional Note by Cyril Mango and Ihor Ševčenko," *DOP* 16 (1962): 3–63, at 29–36.

25 Ed. J. J. Reiske, *Constantini Porphyrogeniti Imperatoris: De cerimoniis aulae byzantinae libri duo*, CSHB 1 (Bonn, 1829), trans. A. Moffatt and M. Tall, 2 vols. (Canberra, 2012) [reproducing the text and following the pagination of Reiske's edition. Book I also ed. and trans. A. Vogt, *Constantin Porphyrogénète: Le Livre des Cérémonies*, 2 vols. (Paris, 1935)].

26 Two chapters are reedited and translated with a topographical commentary by J. M. Featherstone, "All Saints and the Holy Apostles: *De cerimoniis* II, 6–7," *Νέα Ῥώμη* 6 (2010): 162–74. I follow Featherstone's identifications except where otherwise stated. It should be noted that while these chapters of the *Book of Ceremonies* provide fairly complete topographical information, they omit at least one ceremonial occasion, the Feast of the Apostles on 30 June, when the emperor visited the church: see below, n. 36

27 Ed. Reiske, 74–81; ed. Vogt, 1:68–72.

28 Ed. Reiske, 532–35; ed. and trans. Featherstone, "All Saints," 236–39, 241–45.

the church with the patriarch, they bless the apses dedicated to Constantine and Helen, and stand before the cross of Constantine during the Gospel reading and litany. They then go up to the palace (of Bonus), while the patriarch celebrates the liturgy, joining them afterwards for a meal to which selected court dignitaries and bishops are also invited.

The procedure for the Feast of All Saints, described in the next chapter (II, 7),[29] follows a similar pattern, in that it consists of a visit to the main church of the Holy Apostles followed by a consecration ritual and liturgy in the church dedicated to the holy persons whose feast is being celebrated. The emperors arrive at the gate of the Horologion and enter the church by the narthex.[30] They ascend to the galleries and remain there "following the usual procedure" until the patriarch arrives with the church procession and takes up position at the entrance to the sanctuary. The emperors then get dressed up and emerge to be greeted by the court dignitaries; they go down the spiral staircase and exit the narthex. There they are welcomed by reception committees of the circus factions—the Blues, Whites, Greens, and Reds—who present them with wreaths of roses as they process from the terrace through the Horologion and reenter the church by the women's section. They meet the patriarch at the entrance to the sanctuary, where they go in with him to kiss the altar cloth and the Gospel book. All then exit the church, by what route is not specified, and go in procession to the church of All Saints. Here, after the consecration ritual, they enter the sanctuary together "in the usual way" and proceed to bless the chapel of St. Leo on the right. The emperors now take leave of the patriarch, and while he returns to the main sanctuary of All Saints, they go around the wall of the apse to the chapel of St. Theophano, where they change their vestments and sit down until the Gospel reading, for which they stand outside the sanctuary. After the Gospel reading, they return to the chapel and prepare the guest

list for the banquet that will follow the liturgy. They leave the church by way of the narthex of another side chapel, dedicated to St. Hypatios, cross a terrace, and ascend to the galleries of the Holy Apostles by a wooden staircase near the Mausoleum of Constantine. By way of the galleries, they reach "the palaces," where the table has been laid for the banquet, which follows the procedure outlined for Easter Monday.

Comparing these three chapters of the *Book of Ceremonies*, we can see a clear difference between the first one and the last two. Book I, 10, like most chapters in book 1, describes a procedure that had been codified long before the time of Constantine VII, and it probably reproduces a text written, or least revised, in the midninth century. The ritual is confined entirely to the church of the Holy Apostles and those annexes that could be accessed from inside. Book II, chapters 6 and 7, were clearly written by Constantine VII himself, or at his command, and they describe rituals that had been recently created, or more likely modified, to feature neighboring buildings of recent construction: the palace at the cistern of Bonus, built by Romanos I (920–944);[31] the adjoining church of St. Constantine, built by Leo VI's first wife Theophano;[32] and the church of All Saints that Leo had built as a monument to Theophano in his attempt to have her canonized.[33] The history, topography, and dynastic ideology of these buildings have been much discussed, and there is no need to dwell on them here except to reemphasize, with Gilbert Dagron, that these constructions, and their associated rituals, represent a systematic attempt by the Macedonian emperors to extend, develop, and

29 Ed. Reiske, 535–38; ed. and trans. Featherstone, "All Saints," 239–41.

30 Featherstone, "All Saints," 246 and n. 50, takes this to mean the narthex of the church of All Saints, but, along with the previous literature that he cites, I prefer to identify it with the narthex of the main church of the Holy Apostles.

31 John Skylitzes, *Synopsis Historiarum*, ed. H. Thurn, CFHB 5 (1973), 252; Featherstone, "All Saints."

32 G. Majeska, "The Body of St Theophano the Empress and the Convent of St Constantine," *BSl* 38 (1977): 14–21; N. Asutay-Effenberger and A. Effenberger, "Eski Imaret Camii, Bonoszisterne und Konstantinsmauer," *JÖB* 58 (2008): 13–44, esp. 30–32. For a different hypothesis concerning the Palace of Bonus, see A. Berger, "Vom Pantokratorkloster zur Bonoszisterne," in *Byzantina Mediterranea: Festschrift für Johannes Koder zum 65. Geburtstag*, ed. K. Belke et al. (Vienna, 2007), 43–56.

33 G. Downey, "The Church of All Saints (Church of St Theophano) near the Church of the Holy Apostles at Constantinople," *DOP* 9–10 (1956): 301–5; G. Dagron, "Théophanô, les Saints-Apôtres et l'église de Tous-les-Saints," Βυζαντινά Σύμμεικτα 9 (1994): 201–18; Featherstone, "All Saints."

take over the Apostoleion as their own dynastic *lieu de mémoire,* which identified their memory with the cult of Constantine the Great and the cult of royal sainthood. It was part of their wider attempt to whitewash the criminal origins of their dynasty in the murder of Michael III, and it began, appropriately, with Basil I's reopening of the Mausoleum of Constantine for the burial of his son Constantine in 879.[34]

Much less scholarly attention has been paid to the immediate annexes of the church, for most of which the *Book of Ceremonies* is our only source, but which evidently long predated the Macedonian extensions: the atrium (*louter*), the Horologion, and the imperial palace (figs. 8.1 and 8.2). There is no problem with placing the atrium to the west of the narthex, as in all other Byzantine churches, including Hagia Sophia. We shall see that it is described by Mesarites. The Horologion of *De cerimoniis* II, 7 is more problematic. The name, meaning a clock, indicates a sundial court, which should, in principle, have been on the south side of the building.[35] However, it gave access to the women's section (*gynaikites*), which according to *De cerimoniis* I, 10 lay on the north side of the church. Possibly we should envisage a second women's section on the south side directly opposite—could it be that the women occupied both the north and south transepts? As for the imperial palace, the description of the Easter Monday ceremonial is fairly informative but also leaves room for uncertainty. There was a chamber (*koiton*) and a dining hall (*triklinos*), evidently with kitchen facilities, for the banquet that followed the liturgy. We know from another tenth-century witness, Liudprand of Cremona, that the guests included foreign ambassadors, as well as members of the higher clergy; that they sat at a long narrow table, while the servant staff ate in a separate dining room; and that the kitchen facilities were capable of preparing stuffed roast goat.[36] The palace was accessible from inside the church at gallery level. This could mean that it was a detached building, which connected to the church by a kind of bridge, like the one that led from the south gallery of Hagia Sophia to the Great Palace.[37] However, since there is no mention of a ground-floor access, it is more likely that the palace consisted of an upper-level annex, similar to the patriarchal apartments on the south side of Hagia Sophia.[38] In this case, it would have been an integral part of the Justinianic reconstruction of the Holy Apostles, or a later addition. It thus seems, on balance, unlikely that the palace bore any relation to the original *basilikoi oikoi* of Constantine or the Theodosian Palace of Flaccilla. But given the state of our ignorance, we cannot entirely exclude the possibility that Justinian and his architects took the trouble to incorporate the remains of an older building with venerable associations, or, alternatively, to replace a previous palace that had had an indispensable ceremonial role. It is striking that the ceremonial description gives the building the grandiose title of "the Palace protected by God" (θεοφύλακτον παλάτιον). Whatever its origin and layout, the palace clearly had an initial function similar to that of the palace at the Blachernai, built by Anastasios I to accommodate the emperor on his ceremonial visits to the church of the Theotokos.[39] The difference was that the Blachernai Palace developed into a full-scale imperial residence, whereas at the Holy Apostles this role was apparently assumed by the little known Palace of Bonus, which is not attested before or after the mid-tenth century.[40]

34 G. Dagron, *Empereur et prêtre: Étude sur le "césaropapisme" byzantin* (Paris, 1996), 208–14; idem, *Emperor and Priest: The Imperial Office in Byzantium* (Cambridge, 2003), 204–7. On the royal sainthood of the Macedonian dynasty, see also S. Gerstel, "Saint Eudokia and the Imperial Household of Leo VI," *ArtB* 79 (1997): 699–707.

35 Featherstone, "All Saints," 249n50.

36 Liudprand of Cremona, *Legatio,* 19–21: ed. P. Chiesa, *Liudprandi Cremonensis opera omnia,* CC, ContMed 156 (Turnholt 1998), 195–96. The occasion was the Feast of the Apostles (30 June), which is not mentioned in the *Book of Ceremonies,* but which presumably followed the ritual for Easter Monday. See above at n. 27.

37 C. Mango, *The Brazen House* (Copenhagen, 1959), 87–91.

38 As suggested by Featherstone, "All Saints," 248 n57.

39 For the beginnings of the Blachernai Palace, see C. Mango, "The Origins of the Blachernae Shrine at Constantinople," in *Acta XIII Congressus Internationalis Archaeologiae Christianae, Split-Poreč, September 9–October 1 1994,* ed. N. Cambi and E. Marin, Studi di antichità cristiana 54 (Vatican City, 1998), 2:61–76, at 63.

40 The reference, in the *Book of Ceremonies,* to the "new palace, that of Bonus" does not necessarily imply the existence of an older palace of Bonus, but alludes to the building's recent

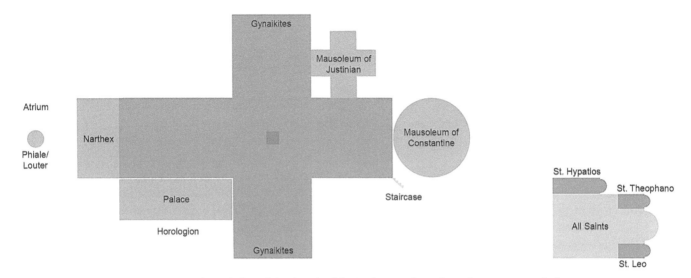

FIG. 8.1. Hypothetical plan of the church of the Holy Apostles, 9th–12th centuries, excluding porticoes (drawing by author)

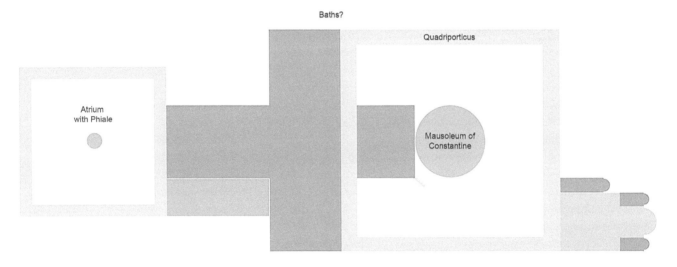

FIG. 8.2. Hypothetical plan of the Holy Apostles with porticoed courtyards, including the outline quadriporticus surrounding the Mausoleum of Constantine (drawing by author)

The two plans (figs. 8.1 and 8.2) are meant to give an approximate idea of the position of the annexes mentioned in the texts relative to each other and to the main church. The scale is entirely conjectural, and so is the position of the church of All Saints. I have followed Featherstone in placing it to the southeast of the Holy Apostles, but it could equally have been to the northeast.

The *Book of Ceremonies* is thus a valuable complement to the description by Constantine the Rhodian, who is no more informative than Procopius about the buildings surrounding the church of the Holy Apostles. In contrast, Nicholas Mesarites does pay careful attention

to the church's topographical and architectural setting.[41] His ekphrasis gives a fascinating insight

construction by Romanos I, which made it the "newest" palace in Constantinople.

41 Nicholas Mesarites, *Description of the Church of the Holy Apostles at Constantinople, c. 39*, ed. and trans. A. Heisenberg, *Grabeskirche und Apostelkirche: Zwei Basiliken Konstantins*, vol. 2, *Die Apostelkirche von Konstantinopel* (Leipzig, 1908), 10–96; ed. and trans. G. Downey, "Nikolaos Mesarites: Description of the Church of the Holy Apostles at Constantinople," *TAPS*, n.s., 47, part 6 (1957): 855–924,

into the way the precinct had evolved by the end of the twelfth century. He describes it in two long passages, one preceding and one following his description of the main church. The first passage effects a transition between the view of the landscape from the church's galleries and the description of the mosaic decoration in the interior. Mesarites begins by evoking the winter and summer baths, which he vaguely locates as being "round about" (περικύκλῳ).[42] He then moves on to describe the "open museums of learning" (ἠνεωγμένα λόγων μωσεῖα), as he refers to the school that occupies the courtyard to the east of the church, extending as far as the church of All Saints. He gives a lively depiction of elementary classes in grammar, music, and arithmetic, specifically mentioning that the grammar students "pace up and down the enclosure of the stoa," and that the music lessons are held "towards the west."[43] More advanced learning takes place in the atrium, which Mesarites describes at the end of the ekphrasis.[44] He first introduces it as a space that is used for the beginning and ending of a liturgical procession throughout the city during the vigil of a feast, which, as we shall see, must be that of the apostles on 30 June. Mesarites evokes the festive scene in the atrium on this occasion, when the porphyry basin at the center is filled with bread and wine for people to enjoy. But he does not want to leave it there, and he asks his audience to bear with him as he describes what happens to this same space late in the evening: it becomes an open university as these forecourts of the church (τὰ τοῦ νεὼ ταῦτα προαύλια) fill with men of all ages and conditions who come to hold animated discussions on dialectic, medicine, arithmetic, geometry, and musical theory.

Mesarites is describing such a different scene from the *Book of Ceremonies*, let alone Eusebius, that it is easy to get the impression that the surroundings of the church had undergone a radical transformation, if not several transformations, in the course of their long history. However, we should not let the human activity obstruct our understanding of the architectural backdrop, which is not unrecognizable from the past. The church of All Saints to the east and the atrium to the west are familiar from the *Book of Ceremonies*. The presence of baths reminds us of the original Constantinian complex, and so, too, do the porticoed courtyards that accommodate the teaching and learning: the school is not a distinct architectural unit but occupies an existing, multipurpose social space. It may not be unreasonable to see the porticoes of the eastern courtyard as the restored remains of the quadriporticus—at least the northern, eastern, and southern sides—that had framed the original Mausoleum of Constantine.[45] If Mesarites does not mention the imperial palace, this does not mean that it had been demolished: it was simply irrelevant to his description of the church's interior, and in evoking the exterior, he was concerned only with those structures and spaces that were detached from the central building.

Let us now move away from the complex itself and return to the question with which we began: was the Holy Apostles central or peripheral to the city of Constantine? Both Constantine the Rhodian and Nicholas Mesarites have no doubt: the church occupies a central, commanding position atop the fourth of Constantinople's seven hills.[46] Mesarites insists that although it may not be the navel of the city, it is nevertheless close to the heart. However, neither author tries to

at 897–919 (text), 861–97 (translation); a new translation by Michael Angold has appeared since the present paper was written: M. Angold, *Nicholas Mesarites: His Life and Works (in Translation)*, TTB 4 (Liverpool, 2017), 83–133.

42 Mesarites, *Ekphrasis*, c. 6, ed. Heisenberg, *Apostelkirche*, 16–17; ed. and trans. Downey, "Nikolaos Mesarites," 864–65, 898; trans. Angold, *Nicholas Mesarites*, 86–87.

43 Mesarites, *Ekphrasis*, cc. 7–11, ed. Heisenberg, *Apostelkirche*, 17–22; ed. and trans. Downey, "Nikolaos Mesarites," 865–67, 898–900; trans. Angold, *Nicholas Mesarites*, 87–90.

44 Mesarites, *Ekphrasis*, cc. 41–42, ed. Heisenberg, *Apostelkirche*, 87–94; ed. and trans. Downey, "Nikolaos Mesarites," 894–96, 916–17; trans. Angold, *Nicholas Mesarites*, 128–31.

45 It is also possible that the north and south *stoai*, which housed the tombs of four 4th and 5th-century emperors, were sections of the original Constantinian quadriporticus: *De cerimoniis*, II, 42, ed. Reiske, 646–47; cf. Grierson, "Tombs and Obits," 36–38. I am grateful to the anonymous reader for this suggestion.

46 Constantine the Rhodian, *Ekphrasis*, ed. I. Vassis; trans. V. Dimitropoulou, L. James, and R. Jordan, in L. James, ed., *Constantine of Rhodes, On Constantinople and the Church of the Holy Apostles, with a New Edition of the Greek Text by Ioannis Vassis* (Farnham, Surrey, and Burlington, VT, 2012), 49–51; Mesarites, *Ekphrasis*, cc. 1–2, ed. Heisenberg, *Apostelkirche*, 10–11; ed. and trans. Downey, "Nikolaos Mesarites," 861–62, 897; trans. Angold, *Nicholas Mesarites*, 83–84.

pretend that the Holy Apostles lies at the center of the built-up urban area—in fact, the panorama that Mesarites describes is overwhelmingly rural—and both are thinking in terms of an urban space defined by the wall of Theodosius II. Within the city of Constantine, as we have seen, the Holy Apostles was decidedly off-center, which was due to the functions it combined. It represented the partial urbanization of two types of monument that were traditionally extramural: the apostolic *martyrium*, and the imperial retirement villa-cum-burial complex. Of course, Constantine and Constantius II may well have conceived of the complex as a center of these specific functions in the urban environment. In this sense it is worth reflecting on how these functions evolved after the rebuilding by Justinian. To what extent did the sanctuary of the apostles remain central to imperial commemoration and apostolic devotion in medieval Constantinople?

The Holy Apostles clearly went from strength to strength as an imperial *lieu de mémoire* and an imperial necropolis, through the steady accretion of imperial tombs, the addition of Justinian's mausoleum, and the more or less explicit canonization of several imperial figures, which in material terms meant the consecration of Constantine's mausoleum as a chapel, and the construction of two new churches in the vicinity: the church of St. Constantine at the cistern of Bonus, and the church of All Saints/St Theophano in close proximity to Constantine's mausoleum. Even after the mausolea of Constantine and Justinian became too full to accommodate more sarcophagi after the burial of Constantine VIII in 1028,[47] the neighborhood attracted further imperial burials in the Komnenian family monasteries of Christ Philanthropos, the Theotokos Kecharitomene, and Christ Pantokrator, which lay north and east of the Holy Apostles.[48] Indeed, John II designated his funerary chapel of St. Michael at the

Pantokrator as a *heroon,* which was deliberately reminiscent of the ancient imperial mausolea just up the hill.[49]

In contrast to this continuous and proliferating tradition of imperial commemoration, the apostles' church did not show a corresponding development as a center of the apostolic tradition.[50] While it remained a venue for liturgical veneration of the twelve as a group, it was not prominent in the cults of individual apostles, whose individual churches were not established nearby. The main churches with apostolic dedications were mostly to be found in the eastern part of the city. By 438, and possibly much earlier, the apostle Thomas acquired a church on the Marmara coast near the harbor of Julian.[51] Following Justinian's rebuilding of Hagia Sophia, a remarkable cluster of four churches dedicated to the chief apostles appeared in the vicinity of the Great Church: St. Paul at the Orphanage;[52] St. James at the Chalkoprateia;[53] St. John at the Diippion, near the entrance to the Hippodrome;[54] and the chapel of St. Peter annexed to Hagia Sophia.[55] These churches became the main liturgical venues for the feasts of the apostles in question, and the tenth-century *Typikon of the Great Church* indicates that the Feast of All the Apostles on 30 June was celebrated at the Orphanage church of St. Paul.[56]

However, this apparent marginalization of the Holy Apostles was not to last, if indeed it was ever the full reality. For 30 June, as for other feasts, there is evidence to show that the *Typikon* and *Synaxarion* of the Great Church cannot

47 Grierson, "Tombs and Obits," 21–22, 29.

48 R. Janin, *La géographie ecclésiastique de l'empire byzantin,* vol. 1, *Le siège de Constantinople et le patriarcat œcuménique,* pt. 3, *Les églises et les monastères,* 2nd ed. (Paris, 1969), 189–91, 515–23, 525–27; cf. V. Stanković and A. Berger, "The Komnenoi and Constantinople before the Building of the Pantokrator Complex," in *The Pantokrator Monastery in Constantinople,* ed. S. Kotzabassi, ByzArch 27 (Boston and Berlin, 2013), 3–32, esp. 25–27; P. Magdalino, "The Pantokrator Monastery in Its Urban Setting," in *Pantokrator Monastery,* 33–55.

49 Ibid., 43, 46.

50 See also P. Magdalino, "The Apostolic Tradition in Constantinople," *Scandinavian Journal of Byzantine and Modern Greek Studies* 2 (2016): 115–41.

51 Janin, *Églises et monastères,* 248–50.

52 Ibid., 393, 399–400.

53 Ibid., 253–55.

54 Ibid., 264–67; cf. P. Magdalino, "The Byzantine Antecedents of the Round Church at Preslav," *Problemi na izkustvoto* 45 (2012): 3–5, at 3–4.

55 Janin, *Églises et monastères,* 398–99; cf. P. Magdalino, "Le culte de saint Nicolas à Constantinople," in *En Orient et en Occident: le culte de saint Nicolas en Europe, X^e-XXI^e siècle,* ed. V. Gazeau, C. Guyon, and C. Vincent (Paris, 2015), 41–55, at 51.

56 J. Mateos, *Le typicon de la Grande Église* (Rome, 1962), 1:324.

always be taken as the last word, and that the liturgical road map of medieval Constantinople is not fully represented in the ceremonial handbooks of the age of Constantine Porphyrogennetos. Even the *Book of Ceremonies* does not reflect the importance of the apostles' feast in the calendar of the imperial court: it mentions no imperial visit to the church on that occasion, yet, as we have seen, Liudprand of Cremona shows us Nikephoros II Phokas dining in the adjacent palace on 30 June 968.[57] It is hard to believe that this was a recent innovation. However, the popular and ecclesiastical celebration of the feast does seem to undergo a ritual evolution in the eleventh and twelfth centuries from the procedure outlined in the tenth-century *Typikon*. The Latin description of Constantinople by the *Anonymus Tarragonensis*, datable to the late eleventh century, records that every year on the Feast of the Apostles, the head of St. Paul was taken out of its repository in the chapel of the Great Palace and carried in public procession to the church of the Holy Apostles, where all the people of the city assembled and the patriarch celebrated the liturgy.[58] The *Anonymus Tarragonensis* is generally a reliable witness, and in this case his information fits perfectly with the festivities evoked by Mesarites in his ekphrasis of the Holy Apostles; in fact, it makes sense of the allusions in the ekphrasis that the editors of the text, August Heisenberg and Glanville Downey, misunderstood. Here is the relevant passage:

> So come with me now and let us go to the forecourt where you may behold the festivity on the eve of the festival. Behold the great Paul who comes *like a kind of sun year after year to dwell in the present church* (ὥς τινα ἥλιον ἐξ ἔτους εἰς ἔτος ἐν τῷ παρόντι ναῷ ἐμφιλοχωροῦντα) and illuminates in every way those who approach him. Look at this luminous evening ritual of the fore-feast, how all these people of the Lord who bear the name

of Christ, of all races and ages and ranks, go before you bearing candles and escorting the procession, each according to his rank, and occupation, progressing all around the imperial city with the great Paul, as if "from Jerusalem to Illyricum" (Rom. 15, 19), with spiritual hymns and incense, to return full circle again to this apostolic church.[59]

Heisenberg and Downey, not unreasonably, took the reference to be to an image of St. Paul that was kept permanently at the church of the Holy Apostles, and their translations reflect this assumption, which the latest translator, Michael Angold, has not challenged, despite being aware of the procession with the head relic.[60] Yet the key verb, ἐμφιλοχωρέω, can refer not only to a continuous state of dwelling but also to a finite, repeated action, and this is surely the point of the comparison with the annual cycle of the sun. Thus, Mesarites associates the festive throng in the atrium of the church with a regular yearly visit by St. Paul in person; he also ends his discourse with an encomium of the patriarch who has come to celebrate the eucharistic liturgy. We can safely conclude that Mesarites is alluding to the ritual described by the *Anonymus Tarragonensis*, and we can regard it as likely that he composed and delivered the ekphrasis in fairly close connection to the celebrations of 30 June, perhaps during the vigil of the feast. At least, this is the sense of immediate occasion that he wishes to convey. At the same time, we should note that the celebrations, as he describes them, are more elaborate than they appear in the earlier Latin description by the *Anonymus*. According to the latter, they take place on 30 June and consist essentially of a procession going from the Great Palace to the church. According to Mesarites, the relic's annual visit to the Holy Apostles starts on the vigil of the feast, that is, on 29 June (which

57 See above, n. 36.

58 K. Ciggaar, "Une description de Constantinople dans le Tarragonensis 55," *REB* 53 (1995): 117–40, at 121: *a presbyteris cum summo honore cantantibus, defertur comitante populorum caterva ad ecclesiam Apostolorum, in qua eo die fit maximus concursus populi tocius civitatis, patriarcha ibi celebrante sacra missarum sollempni.*

59 Mesarites, *Ekphrasis*, cc. 41.1–3, ed. Heisenberg, *Apostelkirche*, 287–88, ed. and trans. Downey, "Nikolaos Mesarites," 916; trans. Angold, *Nicholas Mesarites*, 128: my translation and italics.

60 Heisenberg, *Apostelkirche*, 87–88, "der wie eine Sonne jahraus jahrein in dieser Kirche hier verweilt"; Downey, "Nikolaos Mesarites," 893, "who dwells in this shrine year in, year out, like a kind of sun"; Angold, *Nicholas Mesarites*, 128, "who dwells year after year in this church." Angold comments (n. 95), "This presumably refers to an icon of the saint."

happens to be the Feast of Sts. Peter and Paul), and its arrival is the starting point for another procession that takes it all around the city. Whether this represents a twelfth-century elaboration of the ritual, or whether the anonymous Latin author has simplified his description of the procedure for the sake of his readers, is not clear.

The presence in the Great Palace of a relic claiming to be the head of St. Paul is attested by other pilgrim literature of the eleventh and twelfth centuries.[61] How and when it got there, after Pope Gregory I in 594 had famously turned down an imperial request to have this very relic sent from Rome,[62] is another story that we cannot even begin to construct. We can only guess that the ritual of its public circulation in Constantinople must have been instituted at some point between the mid-tenth century (approximate date of the *Typikon of the Great Church*) and the late eleventh (estimated date of the *Anonymus Tarragonensis*). At this point

some emperor agreed to release the relic from the palace for public procession on 30 June, and some patriarch decided that the procession should not go the short distance to the church of St. Paul at the Orphanage, but should take the long route to the church of the Holy Apostles, there, eventually, to embark on a further tour of the city. Perhaps future research should start with the reforming patriarch Alexios Stoudites (1025–1043)[63] and the emperor Constantine VIII (1025–1028), for it was the latter, according to the hearsay that reached Mesarites, who rebuilt the mausoleum of Constantine.[64] In default of real evidence, this seems as appropriate a moment as any for the Holy Apostles to have received a ceremonial upgrade. It would have been fitting for the last emperor who was buried in the Apostoleion to have enhanced its role as a center of apostolic devotion.

61 K. N. Ciggaar, "Une description de Constantinople traduite par un pèlerin anglais," *REB* 34 (1976): 211–68, at 245; Anthony of Novgorod, *Kniga Palomnik*, trans. B. de Khitrowo, *Itinéraires russes en Orient* (Geneva, 1889; repr. Osnabrück, 1966), 98.

62 St. Gregory the Great, *Registrum Epistularum Libri I–VII*, IV. 30: ed. D. Norberg, CC Series Latina 140 (Turnhout, 1982), 248–50. The letter is addressed to Constantina, wife of the emperor Maurice, who wanted the relic for the imperial chapel.

63 On whom see V. Stanković, "The Alexios Stoudites' Patriarchate (1025–1043): A Developmental Stage in Patriarchal Power," *ZRVI* 39 (2001–2): 69–89; F. Lauritzen, "Against the Enemies of Tradition: Alexios Studites and the *Synodikon of Orthodoxy*," in *Orthodoxy and Heresy in Byzantium: The Definition and the Notion of Orthodoxy and Some Other Studies on the Heresies and the Non-Christian Religions,* ed. A. Rigo and P. Ermilov, Quaderni di Nea Rhome (Rome, 2010), 41–48.

64 Mesarites, *Ekphrasis,* c. 39.12, ed. Heisenberg, *Apostelkirche,* 85; ed. and trans. Downey, "Nikolaos Mesarites," 892, 915; trans. Angold, *Nicholas Mesarites,* 126.

Ekphraseis

CONSTANTINE THE RHODIAN'S *EKPHRASIS* IN ITS CONTEMPORARY MILIEU

FLORIS BERNARD

*G*LANVILLE DOWNEY'S CONTRIBUTION TO THE 1948 DUMBARTON OAKS Holy Apostles symposium eventually resulted in a paper in a Festschrift for Albert Mathias Friend, Jr., published in 1955. The subject of this paper was "Constantine the Rhodian: His Life and Writings," and its intention was to understand Constantine's *Ekphrasis* of Constantinople and the church of the Holy Apostles better against the background of the poet's career.[1]

In the meantime, scholarship has progressed considerably. We now have an excellent edition of and commentary on the *Ekphrasis*, by Ioannis Vassis and Liz James,[2] and we have a fuller picture of tenth-century philology and literary production. This enables us to bring together some pieces of knowledge about Constantine and his contemporaries that hitherto have not been related to each other.

I do not intend here to sketch a biography of Constantine the Rhodian. Rather, in light of the issues that came up at our symposium, I will attempt to elucidate the place of the *Ekphrasis* in Constantine's spectrum of activities as a philologist, as a member of the contemporary intellectual field, and as a poet wishing to meet the demands and tastes of his patrons. Constantine's poem, an oddity at first sight, might then be better understood against the background of contemporary literary, cultural, and political concerns.

The dating of the *Ekphrasis* is a crucial point which perhaps should be brought up first. There are several problems with the chronology and structure of the poem (which is transmitted in only one, late, manuscript).[3] While one passage addresses Constantine VII Porphyrogennetos as member of a tetrad of rulers (lines 22–26), which would fit the period of the power-sharing with the Lekapenoi from 930 to 944, many other indications seem to imply the poem was written in 913–919, when the very young Constantine VII was sole emperor. Moreover, the poem as a whole displays some structural problems: a description of Hagia Sophia is announced but never materializes, and the poem breaks off abruptly in the middle of the description of the mosaics of the Holy Apostles. It is almost certain that there were successive generative phases, as Vassis calls it;[4] in other words, different occasions that

1 G. Downey, "Constantine the Rhodian: His Life and Writings," in *Late Classical and Mediaeval Studies in Honor of Albert Mathias Friend, Jr.*, ed. K. Weitzmann (Princeton, 1955), 212–21.

2 L. James, ed., *Constantine of Rhodes, On Constantinople and the Church of the Holy Apostles, with a New Edition of the Greek Text by Ioannis Vassis* (Farnham, Surrey, and Burlington, VT, 2012). Whenever I quote Constantine the Rhodian's *Ekphrasis* in this article, I use this volume for the Greek text (edited by Ioannis Vassis) and for the translation (made by Vassiliki Dimitropoulou, Liz James, and Robert Jordan).

3 For the question, with bibliography, see James, *Constantine of Rhodes*, at 4–11, 131–44. For the earlier dating, see M. Lauxtermann, "Constantine's City: Constantine the Rhodian and the Beauty of Constantinople," in *Wonderful Things: Byzantium through Its Art; Papers from the 42nd Spring Symposium of Byzantine Studies, London, 20–22 March 2009*, ed. A. Eastmond and L. James (Farnham and Burlington, VT, 2013), 295–308, at 299–300.

4 In James, *Constantine of Rhodes*, at 7.

gave rise to different versions of the poem, with updates made by the poet or a later redactor. In any event, one important redaction, which seems to have included both (a version of) the ekphrasis of the city and (a version of) the ekphrasis of the church, was written at the request of, or tailored to the tastes and wishes of, the emperor Constantine VII Porphyrogennetos, in the beginning of his reign that he shared with his regents (930–944), or some decades earlier, during the first phase of his reign (913–919). The latter hypothesis, most recently convincingly defended by Marc Lauxtermann,[5] who refined earlier arguments by Paul Speck,[6] can perhaps be confirmed by the observations given in the rest of this paper.

Constantine the Philologist

The basic facts of Constantine's biography can be summed up briefly. Constantine repeatedly emphasizes his Rhodian origins.[7] The *Ekphrasis* often takes the perspective of the first-time visitor, who is well placed to be impressed by the beauty of the city and who explores it by doing the typical "tourist things."[8] Furthermore, historical sources mention Constantine's involvement in a rather sordid affair in 908. As the secretary of Samonas, a courtier who felt that he was falling out of favor, Constantine drafted a false libel against the emperor Leo the Wise. The plan backfired, but if Constantine was ever punished, this was not reported in the historiographical record. The rest of Constantine's career can be traced almost exclusively through his own philological and poetical achievements. Of these, it may actually be the *Anthologia Palatina* that was to have the most long-lasting influence. I will briefly zoom in on this, in order to elucidate the place of Constantine's philological work within his overall profile as a tenth-century intellectual.

The *Anthologia Palatina* is our single most important source for the Greek epigram, be it from the archaic, classical, Hellenistic, imperial, or early Byzantine period. The *Anthologia Palatina* came at the end of a long tradition of collecting and anthologizing inscriptions and literary epigrams.[9] The last phase of collecting and arranging epigrams took place in the early tenth century, on the initiative of the *protopapas* Constantine Kephalas.[10] This extensive anthology of Kephalas served as the exemplar for a copy, made some time after 944, when Kephalas had already died. This copy is the manuscript we call the *Anthologia Palatina*. Several scribes worked on this manuscript, but it has long been recognized that scribe J was the most important of them.[11] Scribe J divided the work among other copyists and also copied a considerable part himself. After that, he went through the whole anthology, providing lemmata and annotations in the margin. He also added on his own initiative a supplement of epigrams, many of them contemporary, including a few poems by Constantine the Rhodian. We now call this supplement book 15. Constantine's own poems (15.15–17) are epigrams on a cross he dedicated to the Holy Virgin in Lindos, on Rhodes. Constantine takes care to give a detailed identification of himself, adding that he was a servant of the emperor Leo VI, now honoring the young emperor Constantine VII Porphyrogennetos; the poet also stresses his provenance from Rhodes.

Alan Cameron proposed to identify this scribe J with none other than Constantine the Rhodian himself,[12] an identification that has been contested by some scholars[13] but supported

5 Lauxtermann, "Constantine's City," 299–300.

6 P. Speck, "Konstantinos von Rhodos: Zweck und Datum der Ekphrasis der sieben Wunder von Konstantinopel und der Apostelkirche," *Poikila byzantina* 11 (1991): 249–68.

7 N. Koutrakou, "Οἰκουμενικό πνεύμα καὶ τοπικὴ συνείδηση στη μεσοβυζαντινή περίοδο. Τὸ παράδειγμα τοῦ Κωνσταντίνου Ροδίου," in *Ρόδος, 2400 χρονια. Η πόλη της Ρόδου από την ιδρυσή της μέχρι την κατάληψή της από τους Τούρκους (1523), Πρακτικά Διεθνούς Επιστημονικού Συνεδρίου*, vol. 2 (Athens, 2000), 485–92.

8 Lauxtermann, "Constantine's City," 304–5.

9 For the *Anthologia Palatina* in its Byzantine context: Al. Cameron, *The Greek Anthology from Meleager to Planudes* (Oxford, 1993), and M. Lauxtermann, *Byzantine Poetry from Pisides to Geometres: Texts and Contexts* (Vienna, 2003), 114–23.

10 M. Lauxtermann, "The Anthology of Cephalas," in *Byzantinische Sprachkunst: Studien zur byzantinischen Literatur gewidmet Wolfram Hörandner zum 65. Geburtstag*, ed. M. Hinterberger and E. Schiffer (Berlin and New York, 2007), 194–208.

11 A precise list of scribe J's contributions to the *Anthologia Palatina* can be found in K. Preisendanz, *Anthologia palatina: Codex palatinus et codex parisinus phototypice editi* (Lugduni Batavorum, 1911), lxxv–cix.

12 Cameron, *Greek Anthology*, 300–307.

13 P. Orsini, "Lo scriba J dell'*Antologia Palatina* e Costantino Rodio," *BollGrott* 54 (2000): 425–35.

by others.[14] Cameron argued that scribe J can only have transcribed and annotated the poems of Constantine the Rhodian (and contemporaries) in the way he did if he was Constantine himself. This paper will add some further arguments that reinforce this hypothesis.

Many of the comments left by scribe J/Constantine the Rhodian in the margins of the epigrams indicate that he had a keen interest in architecture, in buildings, and the meaning of their sites—an interest that of course underlies his entire ekphrasis.[15] His marginal annotations in the *Anthologia Palatina* about the exact places where inscriptions are to be found are much more precise than those of the other lemmatists. Constantine cannot have retrieved this information from an earlier source. Most probably, he had been to these places himself and observed the inscriptions *in situ*.[16]

In one scholium to an epigram on the temple of Artemis in Ephesos, he notes that this temple excelled all sights; but now it is the most deserted and ill-starred of all, thanks to the grace of Christ and John the Theologian (referring to the famous church of St. John in Ephesos).[17] Also in the *Ekphrasis*, Constantine shows his fascination for this temple when he describes the gate of the Senate in Constantinople that was taken from it (lines 125–129). Constantine remarks that it was built in the dark times of idolatry, emphatically a remnant of the past; nevertheless, he then proceeds to describe the sculptures of the gate representing the gigantomachy.

This mixture of deep interest in, and rejection of, ancient art, runs through Constantine's *Ekphrasis* and his philological work alike. In some annotations to the *Anthologia Palatina*, Constantine censured the excesses of pagan culture. To an epigram of Roufinos, a poet probably from the first century CE, playfully describing a contest of the most beautiful buttocks, he notes: "This is shameless, rotten, and full of indecency."[18] The very nature of the ancient epigrams studied

by Constantine and his milieu was bound to give rise to suspicions.[19] Arethas, a slightly older contemporary of Constantine, of whom some epigrams are also included in the *Anthologia Palatina*, was twice indicted for impiety because of his interest in classical authors. Arethas, in turn, had attacked Leo Choirosphaktes for his devotion to pagan philosophy.[20]

But in the margin of some epigrams, scribe J/Constantine also added annotations (not extraordinary for Byzantine manuscripts) such as "beautiful" or "take note of this." Clearly, he admired the literary quality of the epigrams but was eager to show his disapproval of their content when it happened to run counter to current moral standards. He displays a similarly ambivalent stance in his *Ekphrasis*: he is fascinated by the aesthetic beauty of ancient art, which he documents in detail, but at the same time he firmly and explicitly disapproves of its significance.[21] This helps us to understand the situation of Constantine and other early tenth-century epigrammatists. On the one hand, they were under the spell of a classicizing vogue, even to the extent that they again began to write erotic epigrams, while on the other hand they always had to be alert for a readership that took fault with their interest in pagan literature and art.[22]

The most incisive commentary of scribe J/Constantine is directed against a certain Kometas. In some epigrams in the *Anthologia Palatina*, Kometas, a ninth-century teacher at the school of Magnaura, takes pride in his careful edition of Homeric texts. In the margins next to one poem, Constantine added the following one-verse quip: "Kometas, how insupportable all your verses are!"[23] showing his predilections for puns (κόμητα–δυσκόμιστα).

His comment on another poem of Kometas is a more elaborate verse invective:[24]

14 Lauxtermann, "Anthology of Cephalas," n. 5.

15 For affinities between *Anthologia Palatina* and the *Ekphrasis*, see also James, *Constantine of Rhodes*, 150.

16 Cameron, *Greek Anthology*, at 152–56.

17 Fol. 366 (ad *AP* 11.58). Cameron, *Greek Anthology*, 150–56.

18 Fol. 93 (ad *AP* 5.35). See Cameron, *Greek Anthology*, 80.

19 Cameron, *Greek Anthology*, 157.

20 P. Karlin-Hayter, "Arethas, Choirosphactes, and the Saracen Vizir," *Byzantion* 35 (1965), 455–81.

21 Perhaps most evident in the above-mentioned description of the bronze gates of the Senate (lines 125–152).

22 On this short-lived classicizing vogue in the Byzantine epigram, see Lauxtermann, *Byzantine Poetry*, 142–47.

23 Fol. 693: Κομήτα ταῦτα δυσκόμιστα παντ᾽ ἔπη.

24 Translation from Lauxtermann, *Byzantine Poetry*, 109. See also Cameron, *Greek Anthology*, 309–10.

Kometas, you were another Thersites. So, how did you dare to impersonate Achilles, you wretch? To hell with these products of an unpoetical mind! Off to the gallows, off to the pillory with these verses full of the rottenness of dung!

Constantine's invective did not so much find fault with Kometas's editorial activities, as with the poor quality of his epigrams and his false pretense. Constantine attacks the rival philologist on a personal level: criticizing his technical skill with aggressive wit, and even stooping to the use of scatological abuse. All the while, the invective is versified, itself a testimony to the critic's metrical skills and acumen. It seems that a select group of skilled readers and poets used the marginal space of manuscripts to settle scores with each other. We will come back to this point.

The *Ekphrasis* may reflect Constantine's activity as a philologist of epigrams. He displays a keen interest in the genre of the epigram throughout the poem. When describing the column of Constantine the Great, he also transcribes the epigram on its base, integrating it entirely into his own poem (lines 71–74).[25] Furthermore, the description of mosaic scenes at the end of the ekphrasis can be interpreted as a cycle of epigrams. Constantine describes a cycle of dominical feasts depicted on the mosaic scenes of the church. Cycles of biblical scenes were quite frequently composed in this period, accompanying complete iconographical programs, without it being clear whether they were intended for a specific church.[26]

Some *topoi* used in the poem are clearly epigrammatic conceits. In lines 227–240, Constantine describes the equestrian statue of Theodosius I in terms that are reminiscent of correspondent epigrams in the *Anthologia Palatina*: an observer gazing at the statue may be convinced that the horse will come alive and start to run, or to neigh (see, for example, *AP* 9.777). His interest in describing statues, so evident in the *Ekphrasis,*

may have been informed by his work as the editor of the *Anthologia,* where he provided ample space to ekphraseis of statues (notably the poem of Christodoros on the Baths of Zeuxippos in book 2).[27] All this suggests that in the *Ekphrasis,* an epigrammatist is at work, who, if he is not identical with such an important philological figure as scribe J, at least displays the same attitudes.

Constantine the Polemicist

It has often been remarked that Constantine had a talent for verbal abuse, a taste for polemic. This reputation is especially based on a series of vitriolic invective poems, still only to be found in print in an old edition by Pietro Matranga.[28] Together with the episode involving Samonas, Downey notes that these remarkable poems show that Constantine "must have been gaining a reputation as a satiric poet,"[29] but he also considers the possibility that Constantine might have written them at the behest of someone else. Downey clearly felt uneasy by the thought that the poet of the *Ekphrasis* should have written such base and slanderous libels.

The first poem in the Matranga edition is an aggressive attack on Leo Choirosphaktes. This important figure in Byzantine intellectual history was a diplomat, courtier, poet, and letter writer, and almost an exact contemporary of Constantine.[30] The name of Leo is not only apparent from the title in the manuscript that transmits the invectives, but is also alluded to in Constantine's lampoon. The poem has nothing of a dignified dispute between poets. Rather, it is an unrestrained invective, bringing up social stigmata and accusations of crimes and deviant

25 On this epigram, see also Lauxtermann, "Constantine's City," 302–3.

26 About cycles of epigrams, see in general Lauxtermann, *Byzantine Poetry,* 76–81. For a 10th-century example, see W. Hörandner, "Ein Zyklus von Epigrammen zu Darstellungen von Herrenfesten und Wunderszenen," *DOP* 46 (1992): 107–15.

27 For this suggestion, see James, *Constantine of Rhodes,* 111.

28 Constantine the Rhodian, "Poems Against Leo Choirosphaktes and Theodore Paphlagon," in *Anecdota graeca,* ed. P. Matranga, vol. 2 (Rome, 1850), 624–32. Translations of these poems in this article are mine.

29 Downey, "Life and Works," 213.

30 On Leo, see P. Magdalino, "In Search of the Byzantine Courtier: Leo Choirosphaktes and Constantine Manasses," in *Byzantine Court Culture from 829 to 1204,* ed. H. Maguire (Washington, DC, 1997), 141–65; Leo Magistros Choirosphaktes, *Chiliostichos theologia,* ed. I. Vassis (Berlin, 2002), xii–xli; G. Kolias, *Léon Choerosphactès, magistre, proconsul, et patrice: Biographie, correspondance (texte et traduction)* (Athens, 1939).

sexual behavior, expressed in long compound neologisms. It is important for the present purpose that the insults also portray Leo as a base and swindling scribbler. Leo contrives false and deleterious libels (line 12: ὀλεθροβιβλοφαλσογραμματοφθόρε), writes barbarisms and solecisms (line 13: σολοικοβαττοβαρβαροσκυτογράφε), et cetera.

The following poems are addressed to a certain "Theodore, eunuch and Paphlagonian," who may either be identified by a tutor of the young Constantine VII,[31] or with Theodore Mystikos.[32] As Charis Messis has shown, Constantine makes use of classical prejudices against Paphlagonians and eunuchs alike, both of which are also associated with each other.[33] In the first poem against Theodore, Constantine censures his claim to have the authority to write and to speak. Constantine adopts a haughty tone, seeking to defend his superiority. Theodore is just some scum who should not aspire to membership of the elite. Constantine remarks in typical fashion:[34]

> Do not write pig-like words in vain,
> but, descending from pigs, rather learn to grunt.

As in the poem against Leo, Constantine refers to "words" that Theodore had written, and which had apparently damaged Constantine's reputation. Comparisons to pigs in particular were a popular device to use in order to defame inane scribblers and expose their supposed stupidity.[35] Hence, although the insults are of a personal, moral, social, and sexual nature, this polemic is part of a struggle between authors, or intellectuals.

The series of poems that comes next in Matranga's edition is an acerbic exchange of poetic invectives between Constantine and Theodore Paphlagon, not unlike other poetic exchanges in Byzantium.[36] The occasion that led to this fierce poetic battle is at length described in the lemma in the manuscript, which certainly deserves some attention:[37]

> Verses of Constantine of Rhodes, in invective iambs against Theodore Paphlagon, the eunuch, also called Brephos (Baby). The verses found their occasion in the following cause. Constantine had written in some book containing works of ancient philosophers the following iambic quip.

Right below this heading, we read the epigram in question, in which Constantine derides contemporary scholars, arguing that in his time there is no wise man (*sophos*) to be found. Immediately after this epigram, we read one of Theodore Paphlagon, who apparently felt personally attacked, and who riposted that the only stupid one was Constantine himself. This unleashed Constantine's wrath, and a vehement exchange of insults follows, totaling eleven poems. In fact, there are nine poems in which the poets take turns pulverizing each other, with two "proems" of Constantine preceding the exchanges.

The lemma quoted above indicates that Constantine had annotated a manuscript containing texts of ancient authors and had added to this manuscript a poem attacking his contemporary colleagues. If this sounds strange, we just have to think of the polemical poem of scribe J against Kometas in the margin of *Anthologia Palatina*,

31 Theophanes Continuatus, *Chronicle,* ed. J. M. Featherstone and J. Signes-Codoñer, *Chronographiae quae Theophanis Continuati nomine fertur Libri I–IV* (Berlin, 2015), 390, 393. For this identification, see P. Magdalino, "Paphlagonians in Byzantine High Society," in *Η βυζαντινή Μικρά Ασία (6ος-12ος αι.),* ed. S. Lambakis (Athens, 1998), 141–50, at 144.

32 Ch. Messis, "Régions, politique et rhétorique dans la première moitié du 10ᵉ siècle: Le cas des Paphlagoniens," *REB* 73 (2015): 99–122, at 109–10.

33 Messis, "Régions, politique et rhétorique," 108–12.

34 Constantine the Rhodian, *Poem* 2, ed. Matranga, lines 36–37: καὶ μὴ λόγους μάταζε χοιρώδεις γράφων, // ἀλλ' ὡς συὸς γέννημα, γρυλλίζειν μάθε.

35 A fine example is Christopher Mitylenaios, poem 84 in M. De Groote, ed., *Christophori Mitylenaii Versuum variorum collectio Cryptensis* (Turnhout, 2012). There was also an association of Paphlagonia with pigs; see Messis, "Régions, politique et rhétorique," 106.

36 See E. van Opstall, "The Pleasure of Mudslinging: An Invective Dialogue in Verse from 10th-century Byzantium," *BZ* 108 (2016): 771–96, where a forthcoming article is announced that will deal in more depth with Constantine the Rhodian. I thank Emilie van Opstall for sharing her work with me before publication.

37 See Constantine the Rhodian, *Poems,* ed. Matranga, 627: Κωνσταντίνου Ῥοδίου ἐν σκωπτικοῖς ἰάμβοις εἰς Θεόδωρον Εὐνοῦχον Παφλαγόνα, τὸν ἐπονομαζόμενον Βρέφος, λαβόντες ἀρχὴν ἀπὸ ταύτης αἰτίας· γράψαντος γὰρ Κωνσταντίνου ἔν τινι βίβλῳ περιεχούσῃ βίβλους τῶν παλαιῶν φιλοσόφων, γνώμην τοιαύτην δι' ἰάμβων ἔχουσαν.

which likewise attacked rival scholars in a philological context. As such, this lemma adds another aspect that scribe J of *Anthologia Palatina* and Constantine the Rhodian have in common.

There are more contemporary examples that testify to this practice of attacking rivals through poetic marginalia. In a tenth-century manuscript with Neoplatonic texts, for example, we find punning epigrams attacking eunuchs.[38] Editing and annotating are acts played out in the lively intellectual arena of tenth-century authors and critics. These scholars used marginal poetry to defend their work and attack that of rivals.

It cannot be possible that Constantine wrote these poems at the behest of someone else, as Downey suggested. Not only do the lemmata mention his full name repeatedly, but also Theodore's poems at one point address a "Rhodian."[39] And more generally, polemicizing, even in such an aggressive register, was part and parcel of the job of being a scholar, or rather, an "intellectual"—someone studying, teaching, and writing on an independent basis and constantly struggling with his peers. This may gain even more significance if Theodore was indeed the tutor of the emperor Constantine, a position Constantine the Rhodian also coveted implicitly in his *Ekphrasis,* as we will see.

Constantine's attack is, on the one hand, directed against Theodore the poet: he is inept at writing verses and does not know anything about the ancient authors. Theodore's ineptitude only proves his point that there were no *sophoi* in these times. But this intellectual invective is mingled with personal abuse, aimed at Theodore's Paphlagonian provenance and his status of an eunuch. The intellectual and personal strands of abuse are fused when Constantine remarks that Theodore is too effeminate to write "manly" dactylic hexameters (lines 34–35). Theodore's vituperations as well ultimately wind down to the accusation that Constantine suffers from "rusticity" and that he is a "bad fabricant of iambs."[40]

Thus, Constantine's acerbic exchanges with contemporary peers turn chiefly around the question of who could rightly claim to be *sophos* (the word with which the exchange with Theodore started). It is in the field of *sophia* that Constantine aspires to prove that he is the prominent scholar, critic, and poet, while the others, Leo and Theodore, are just some inane impostors. All this is expressed in verse, frequently in the margin of the very books they were copying and compiling (as was the case in the *Anthologia Palatina,* as well).

Constantine the Imperial Preceptor

The social context of Constantine's *Ekphrasis* seems at first sight to be radically different than those of the vituperative poems. This is a poem addressed to the emperor, not to rival intellectuals. Yet, it can be argued that also in this poem, similar concerns are present, albeit more indirectly. At the same time, the poem reflects the ideologies and interests at the court of the (young) emperor Constantine VII Porphyrogennetos.[41]

For a Byzantine poem, the *Ekphrasis* is remarkably self-reflective about its motivations and purposes, especially in its numerous dedicatory, preambulatory, and transitional passages. It is left ambiguous whether the initiative for the poem came from the emperor or from the poet. On the one hand, we find the following phrases: "you told me to write this down" (line 8), "I undertook to write this because my most wise lord exhorted me" (lines 276–277), "as I take my starting from your noble commands" (line 301), and elsewhere Constantine attributes the writing of his poem to an "order" (line 387: κελεύεις). All this refers to what we would readily call a "commission."

On the other hand, there are indications that the poem was intended as a gift coming from the author. In the very beginning, the poet states that he presents the poem as "a splendid and pleasing gift" (line 3: δῶρον εὐαγὲς φίλον), and that he has "come unbidden" (line 12: αὐτόκλητος

38 L. G. Westerink, *The Greek Commentaries on Plato's Phaedo* (Amsterdam, 1976), 30–31. See also Cameron, *Greek Anthology,* 307.

39 See line 131 for the (derogative?) term ῥόδαξ, "Rhodian."

40 Line 129: ἀγροικία and line 130: κακόν σε τῶν ἰάμβων ἐργάτην.

41 For literature at the court of Constantine VII, see A. Kazhdan, *A History of Byzantine Literature (850–1000),* ed. C. Angelidi (Athens, 2006), 133–84 and 158–61, on Constantine the Rhodian specifically. See also below for other (critical) views.

ἥκω σοι φέρων), offering the poem to honor the emperor (using a popular Euripidean quote). In the exordium to the Holy Apostles part of the poem, the verb used for the presentation of the poem is "to give" (line 427: δῶκεν).

Furthermore, there is an oblique request for imperial largesse at the end of the prologue of the *Ekphrasis* (lines 17–18):

ὅλως γὰρ αὐτὸς συμπαθὴς ἄναξ πέλεις
ὑπέρμαχός τε τῶν καμνόντων ἐν πόνοις.

for you yourself are wholly a compassionate
 lord
and a champion of those wearied from their
 labors.

Who else should be wearied from labors than the poet himself, especially since he has just described how diligently and completely he has laid down an ekphrasis in verse?

All these indications leave a confused image that cannot be explained away by pointing to the different redactions of the poem. Concurring with Liz James,[42] I think it is probable that in this case (as in others)[43] the distinction between a "commissioned" and an "independently written" poem, which we are often inclined to see when we talk about patronage of poetry, is a futile one. Poets, dependent on the existing courtly, bureaucratic, or ecclesiastical hierarchies, responded to the logic of patronage and wrote according to the wishes and tastes of their patrons. It is also highly unlikely that emperors (not even Constantine VII)[44] concocted a precise cultural program on their own and imposed this on their poets. Rather, the poets themselves generated

interest in a specific topic but ascribed this interest to their imperial patron, who as a result is represented as a lover of learning.

Hence the discourse of the gift is very convenient, because it obscures a direct request for remuneration and at the same time invites reciprocation. Instead of supposing a payment of any kind, poets pleasing their imperial patrons rather hoped that in some short- or long-term future they would benefit from various favors, such as protection, promotions, private audiences, and the like. Especially in didactic poetry, poets added statements that the patron (mostly an imperial one) had exhorted them to write, reinforcing the impression that the emperor was eager for knowledge and a champion of learning.

Such a strategy is very much in evidence in the *Ekphrasis,* which is in essence also a didactic poem. But it takes on a particular form, inspired, as I shall argue, by the connection that the young emperor desired to maintain to his father Leo VI the Wise, and by the general interest in describing buildings during the reigns of both Leo VI and Constantine VII. If written in 913–919, the emperor was only a child. This seems on the one hand hard to reconcile with exhortations coming from the emperor, but as we have seen, the picture is more complex. When Constantine the Rhodian describes the emperor's yearning for wisdom, he is rather setting a program than reflecting reality.

Crucial for the understanding of this program is the conclusion to the long transitional passage which links the description of the city of Constantinople to the church of the Holy Apostles (lines 411–419):[45]

πρώτιστος ἦλθον εἰς φράσιν κλεινοῦ δόμου
τοῦ τῶν μαθητῶν καὶ σοφῶν διδασκάλων,
ὅπως δι' αὐτῶν τὴν πυρίπνοον χάριν
τοῦ πνεύματος λάβοιμι τοῦ σοφῶς γράφειν
λέγειν σαφῶς τε τὴν ὑπέρτιμον θέσιν
τοῦ τῇδε ναοῦ τῶν σοφῶν Ἀποστόλων
τῷ καλλινίκῳ καὶ σοφῷ μου δεσπότῃ
Κωνσταντίνῳ, Λέοντος υἱῷ πανσόφου.

42 James, *Constantine of Rhodes,* 140–41.

43 F. Bernard, "Gifts of Words: The Discourse of Gift-giving in Eleventh-Century Byzantine Poetry," in *Poetry and Its Contexts in Eleventh-Century Byzantium,* ed. F. Bernard and K. Demoen (Farnham and Burlington, VT, 2012), 37–51; and idem, "Greet Me with Words: Gifts and Intellectual Friendships in Eleventh-Century Byzantium," in *Geschenke erhalten die Freundschaft: Gabentausch und Netzwerkpflege im europäischen Mittelalter; Akten des internationalen Kolloquiums Münster, 19.–20. November 2009,* ed. M. Grünbart (Münster, 2011), 1–11.

44 See I. Ševčenko, "Re-reading Constantine Porphyrogenitus," in *Byzantine Diplomacy: Papers from the Twenty-Fourth Spring Symposium of Byzantine Studies, Cambridge, March 1990,* ed. J. Shepard and S. Franklin (Aldershot, 1992), 167–95.

45 James, *Constantine of Rhodes,* 46–47.

so I have come, the very first to describe the
famed house
of the disciples and wise teachers,
so that through them I might receive
the fiery grace of the Spirit to write wisely
and to express clearly the greatly honored
setting
here of the church of the wise Apostles
for my gloriously triumphant and wise lord,
Constantine, the son of Leo the most wise.

The word sophos appears five times in this short passage. The apostles are sophoi, sophos is what the poet hopes to be, sophos is the emperor, and sophos (even *pansophos*) is the emperor's father. Thus, the quality of sophia is represented as a chain interconnecting the four actors.

This passage is mirrored by another one in which the poet states that he began to write his *Ekphrasis* because the emperor "exhorted" him to do so (lines 276–279); his eagerness for learning led to the "noble commands" (line 301) directing the poet. The emperor is even portrayed as offshoot of the Muses, and therefore yearns (line 313: ποθεῖς) to hear Constantine's metrical tunes. Here, as well, the quality of sophia is attributed to the emperor Constantine, but it is again his father Leo who is represented as "most wise" (line 279: πανσόφως). Also, the final dedication to the ekphrasis of the church proper begins with the word sophos (line 423: σοφῷ βασιλεῖ δεσπότῃ Κωνσταντίνῳ; "for the wise emperor lord Constantine").

The prefix παν- used for Leo's wisdom in both extended passages (see also line 278: Λέοντος τοῦ πάνυ) is probably more than just a superlative: Leo is the eponymous wise emperor. Leo VI, as is well known, was already during his lifetime celebrated as a "wise" (sophos) emperor, and Byzantines habitually referred to him with this epithet.[46] "Wise" is not the only, and perhaps not the best, translation for the Greek sophos: it

refers in contexts like these primarily to a keen interest in learning and classical education—and was therefore not unequivocally positive.

The poet repeatedly emphasizes the fact that Constantine is a son of his father and explicitly states that Constantine had inherited noble features from him (lines 395–398). Constantine the Rhodian also mentions in crucial places of the poem (lines 2 and 428) that he himself had been a servant of Leo. The attachment to Leo that both poet and emperor wanted to maintain is rooted in the precarious dynastic situation. As is well known, Constantine's claim to the throne was called into question because of the tetragamy issue (the fourth marriage of Leo, which was considered uncanonical).[47] In these first unstable years of Constantine's reign (if we accept the poem's dating to 913–919), any poet would be eager to help legitimize the dynastic succession from Leo VI to Constantine VII. Constantine the Rhodian had done exactly this in one of his epigrams (*AP* 15.15.4–7). The quality of sophia is instrumental in this: the more Constantine is sophos, the more he can lay claim on the uninterrupted line that binds him to his eponymously wise father.

The message of the *Ekphrasis* is clear: the emperor can capitalize on his sophia if he eagerly inclines his ear to the poem, and if he exhorts poets to write ekphraseis like these. Hence, sophia is the prime imperial virtue reflected in the *Ekphrasis,* and also the virtue responsible for inspiring it.

Leo the Wise himself had included a brief description of the church of the Holy Apostles in his homily on the Translation of the Relics of John Chrysostom.[48] This is all the more remarkable since the description, short as it may be, occurs in a text that, from a generic and rhetorical point of view, did not call for such an reciprocation. The passage is one of the many indications of an intensive interest in the description and interpretation of significant buildings (and especially the "imperial" church of the Holy Apostles). It was an important element in the imperial intellectual program that dominated culture under Leo the

46 For an excellent discussion of Leo's reputation as sophos (with previous bibliography), and a thorough analysis of what it exactly meant, see S. Tougher, *The Reign of Leo VI (886–912): Politics and People* (Leiden and New York, 1997), 110–32; and, more concisely, S. Tougher, "The Wisdom of Leo VI," in *New Constantines: The Rhythm of Imperial Renewal in Byzantium, 4th–13th centuries; Papers from the Twenty-Sixth Spring Symposium of Byzantine Studies, St Andrews, March 1992,* ed. P. Magdalino (Aldershot, 1994), 171–79.

47 See Tougher, *Reign of Leo*, 152–63.

48 Leo the Wise, *Leonis VI Sapientis Imperatoris Byzantini Homiliae,* ed. T. Antonopoulou (Turnhout, 2008), homily 41.

Wise and Constantine VII.[49] Their entourage (men like Constantine the Rhodian and Leo Choirosphaktes) eagerly picked up on this desire. Constantine's assertion that he was the first to do so (line 411: πρώτιστος ἤλθον), implies that he was earlier than Leo Choirosphaktes (and other lesser known rivals).

Descriptions of buildings (especially in verse) have always been an important service that the literary elite could offer to emperors, and now the time was even more rife. Constantine's archrival Leo Choirosphaktes was equally eager to deliver on the promise to describe and explain architecture. For the emperor Leo, Choirosphaktes had written a poem on a bath house. As Paul Magdalino notes, the emperor Leo's wisdom is stressed again and again in this poem.[50] Moreover, the poet states that the emperor has cast away mendacious words, and now only listens to professional explanation, which refers to Leo's poem itself (lines 67–68).

Leo Choirosphaktes also wrote a very similar poem for Leo's son Constantine. This poem in anacreontics describes, extolls, and explains the thermal springs at Pythia, in Bithynia.[51] Throughout Leo's poem, the emperor Constantine (presumably also at an early stage of his reign) is cast as a pupil eager to gain knowledge. Leo states from the beginning that the initiative to learn about the thermal waters came from the emperor. The link with the wise emperor Leo VI is also here emphasized, as Constantine is called "offshoot of a most wise man" (line 59: πανσόφου γέννημα).

At the end of the poem, Leo expresses his wish that the emperor may protect those who have suffered from slander and distress. Leo adds that Constantine may give the beauty of his father to be enjoyed by his subjects. He also entreats the emperor that he allow the poet to see the emperor's face; in other words, to have a private audience. This was, of course, a powerful asset in the world of Byzantine courtly patronage.

As in Constantine's poem, the admiration for the subject of the poem is in a certain way imposed upon the emperor and makes him appear as yearning for wisdom and displaying the virtue of sophia, inherited from his father. And likewise, this yearning should lead the emperor to materially support the very poets who can provide this knowledge.

In his *Thousand-Line Theology* (*Chiliostichos Theologia*), a didactic poem on the nature of the divine and on mystical experience, Leo Choirosphaktes frequently lashes out against people who profess false words. These imaginary adversaries are equated with poets or with eloquent authors (e.g., lines 524–527). The imperial addressee (very probably also the young Constantine) is repeatedly warned not to pay heed to them: he should only listen to Leo's own words, which are, in contrast, repeatedly called "wise." Here is just one example (lines 592–593):[52]

μὴ μυθοτερπεῖς θαυμάσῃς βδελυγμίας,
τὸ ῥυθμικὸν δέδεξο μὴ σοφοῦ δίχα.

Do not marvel at filthiness relishing in myths, but accept these rhythms that are not without wisdom.

If seen against the background of contemporary competition between poets, these combative remarks seem to gain contemporary importance rather than being generic references to pagan authors.[53] Leo may have had rivals such as Constantine the Rhodian in mind, who likewise advertised their ability to compress knowledge in agreeable verse.

In light of all this, it will not suffice just to state that Constantine "had a taste for

49 For some critical reconsiderations of the intellectual program of Constantine VII Porphyrogennetos, see Ševčenko, "Re-reading Constantine Porphyrogenitus," and P. Magdalino, "Knowledge in Authority and Authorised History: The Imperial Intellectual Programme of Leo VI and Constantine VII," in *Authority in Byzantium*, ed. P. Armstrong (Farnham and Burlington, VT, 2013), 187–209.

50 P. Magdalino, "The Bath of Leo the Wise and the 'Macedonian Renaissance' Revisited: Topography, Iconography, Ceremonial, Ideology," *DOP* 42 (1988): 97–118, at 103.

51 C. Gallavotti, "Planudea (X)," *BollClass* 3 (1990): 78–103. See now also G. R. Giardina, *Leone Magistro e la Bisanzio del IX secolo: Le Anacreontee e il carme Sulle Terme Pitiche* (Catania, 2012).

52 Leon Choirosphaktes, *Chiliostichos theologia*, ed I. Vassis, 114.

53 Similar references to rival authors are also abundant in Leo's poem on the baths of Leo the Wise.

polemic." Leo's and Constantine's animosities against each other (with perhaps also Theodore Paphlagon involved as a tutor to the emperor) should be interpreted as a contest to get the attention and the patronage of the new emperor Constantine VII. The interest in buildings—that is, in describing, admiring, and understanding buildings (often accompanied by an interest in ancient art and in astrology)—dominated didactic poetry addressed to the emperor. The virtue of sophia was projected by poets upon their patron and represented as a hereditary quality. This way, the poets helped the young Constantine to assert his paternal lineage and to cement his contested dynastic position.[54]

Constantine the poet

The paper of Liz James in this volume makes clear how Constantine's poem should be read as a literary construction and not as just a faithful textual reflection of a material construction. Furthermore, in the past few decades and years much attention has gone to ekphrasis as a literary technique or genre that aims to bring a work of art to the eyes of the reader in a way that is vivid and convincing, but not necessarily realistic according to our scientific standards.[55] Constantine's poem itself can be regarded as a classical example, all the more so since it announces from the outset that it will offer a description, using generic labels that neatly match our modern terminology (the word φράσις appears at lines 7, 11, and 412, and the verb ἐκφράζειν at line 388). Ruth Webb has highlighted Constantine's poem as a fitting piece in the tradition of Byzantine architectural ekphraseis.[56] The present paper takes these studies as a starting point to give a few more observations on the status of the poem as a literary construct, a textual work of art, shaped by poetic craft.

Constantine leaves many indications about the poetical aesthetics after which he strives. He does so right at the start of his poem. In the prologue, he announces that his composition consists of "the swiftest lines of iambs" (line 5: εὐδρομώτατος, literally "extremely well-running"). In the transitional passage, the conceit of footraces, traveling, and running is very much present. He announces that "I shall set off now on my way rejoicing, traversing eloquently the road of iambs."[57] And toward the end of his long exordium, he writes: "I go towards this swift race of speech (. . .), running round on the nimble feet of iambs."[58] His iambs have "tunes" (line 313: νόμους) and "many beats" (line 390 πολυκρότων).

As Lauxtermann observed,[59] we should see these statements in light of the rhetorical principle of "velocity," which for many Byzantines was a quality connected to dodecasyllables (or "iambs," as they continued to call them). The word krotos, literally "sound" or "clapping" (of hands), can in this context refer to the regular alternation of consonants and vowels. Velocity refers to swiftness of sound, and to a regular rhythm created by semantic and grammatical units (kola) that were equal to each other and that were not too short to be brusque, nor too long to become burdensome to the listener. The images of running reinforce this impression of unhindered, smooth speech.

This principle of "velocity" is also applied by Constantine in practice. It is clear, on the one hand, that Constantine's versification technique leaves much to be desired. In order to obtain the right number of syllables and to meet the complex demands of prosody and rhythmical pattern alike, his word order, syntax, and style are often convoluted, pleonastic, and obscure. One of the most visible consequences of this is the frequent use of redundant particles. Furthermore, as Vassis's metrical analysis of the poem shows,[60] Constantine's handling of prosody was not impeccable. In matters of vowel quantity, he frequently deviates from the standard that most "learned" poets had set for themselves.

54 See also Magdalino, "Imperial Intellectual Programme."

55 See the seminal study by L. James and R. Webb, "'To understand ultimate things and enter secret places': Ekphrasis and Art in Byzantium," AH 14 (1991): 1–17.

56 R. Webb, "The Aesthetics of Sacred Space: Narrative, Metaphor, and Motion in 'Ekphraseis' of Church Buildings," DOP 53 (1999): 59–74.

57 Lines 316–317: ἄπειμι λοιπὸν τὴν ὁδὸν κεχαρμένος // τὴν τῶν ἰάμβων εὐφυῶς ἀνατρέχων.

58 Lines 404–407: εἰμι πρὸς αὐτὸν τοῦ λόγου ταχὺν δρόμον // (. . .) // κούφοις ἰάμβων τοῖς ποσὶ<ν> περιτρέχων.

59 M. Lauxtermann, "The Velocity of Pure Iambs: Byzantine Observations on the Metre and Rhythm of the Dodecasyllable," JÖB 48 (1998): 9–33, at 26.

60 James, Constantine of Rhodes, 11–12.

On the other hand, there is one remarkable exception to this apparent lack of technical metrical skill. Constantine never allows a hiatus to creep in.[61] That is, never are two vowels in a sequence of two words allowed to clash with each other. Thanks to this avoidance of hiatus, vowels and consonants alternate without disagreeable clashes, so that the reader gets the impression that the verse "runs" swiftly, in an uninterrupted, regular flow. So, for all Constantine's poetical defects, he seemed, both in theory and in practice, to attach much importance to the principle of "velocity." His verse craft is rather geared toward this ideal of agreeable rhythm than to impeccable prosody.

Constantine's poem is also a literary construction in the sense that it is firmly placed within a literary tradition, with its own rules and exigencies. It clearly inscribes itself in the ancient and Byzantine rhetorical technique of how to describe buildings. To take one salient element, as Webb has shown, Constantine's poem is structured around the technique of periegesis, in which the author acts as a guide, taking the reader/viewer around the building.[62]

When looking for more specific models, we inevitably have to turn to Paul the Silentiary's description of the Hagia Sophia.[63] Constantine was in any case very familiar with Paul's poetry (and other Justinianic poetry), having copied it into the *Anthologia Palatina*.[64] As Ruth Macrides and Magdalino noted, Constantine's poem "was clearly inspired by sixth-century traditions of architectural ekphrasis."[65]

This remark can be substantiated. The structuring of the material, to begin with, is remarkably similar. Surprisingly, both poets start the description of the church proper with a sort of preamble in which the experience of the church's wonders is compared with the admiration someone feels when contemplating the starry heaven (Constantine 506–533; Paul 286–295). The

description of the church itself follows the same pattern. The architect devised the ground plan (Constantine 548–588; Paul 354–410) with attention first to the geometrical figures that were at the base of it, then the system of supports (piers and columns), and finally the dome that capped it. Subsequently, both poets describe at length the system of piers that create vaults and apses all around the church (Constantine 589–635; Paul 444–616). Then the focus of the poet shifts to the marbles that adorn the church (Constantine 636–685; Paul 617–646), and subsequently to the decorative sculpting (Constantine 725–741; Paul 647–667). Finally, they describe the mosaics, with first an account of the materials and their qualities, and then a description of the mosaic images (Constantine from 742; Paul 668–754).

One might even consider the idea that the many dedications and prologues in Constantine's *Ekphrasis* find their roots in the similarly interspersed structure of Paul's poem. Repeated prologues and exordia were present in Paul's *Ekphrasis* for a totally different reason (announcing successive stages in the procession-like recitation of the poem), but they may have inspired Constantine's many introductory and transitional passages, which in this perspective need not to be explained from a complex genesis of the present text (even if, admittedly, some problems remain).

The description of the marbles on the wall of the church (lines 636–685) is perhaps the passage where Constantine comes the closest to his model, as also noted in James's commentary.[66] The wave patterns, translucency, as well as the exact colors of the marbles, are evocatively described in both poems, and linked to names of places famous for their quarries. Even the phraseology in Constantine's poem echoes his sixth-century model. As in Paul, the Nile is said to "send" marbles to Constantinople (lines 666–667); as in Paul, the Proconnesian marbles are "spread out" on the floor (compare Constantine line 671: ἔστρωσαν with Paul line 664 στορέσασα). The specific features that Constantine ascribes to the marbles (in which he is more concise than Paul) are probably more inspired by his literary than "real" material models. When

61 James, *Constantine of Rhodes*, 12.

62 Webb, "Aesthetics of Sacred Space."

63 Paul the Silentiary, *Descriptio Sanctae Sophiae, Descriptio Ambonis*, ed. C. De Stefani (Berlin and New York, 2011).

64 See also James, *Constantine of Rhodes*, 121.

65 R. Macrides and P. Magdalino, "The Architecture of Ekphrasis: Construction and Context of Paul the Silentiary's Poem on Hagia Sophia," *BMGS* 12 (1988): 47–82, at 80.

66 James, *Constantine of Rhodes*, 121.

marble from the Pyrenees (an intensely dark stone) is black to the point that it "glimmers" in Paul (lines 637–639), it is reduced to a "gleaming slab" in Constantine (line 660: πλακὸς ἠγλαϊσμένης), which in a way imitates Paul, but perhaps misses the point.

The passage on the marbles is an excellent case for gauging the literary constructedness of Constantine's (and Paul's) poem. As Cyril Mango notes, Paul's passage evokes regions famous for their quarries in antiquity, while for the Byzantines, these regions were rather part of a literary legacy.[67] On the other hand, it has recently been shown that Paul's minute description of the colors and features of Hagia Sophia's marbles quite exactly match the real material marbles still found there.[68]

The inapposite nature of place names applies even more to Constantine. Most of the places and regions mentioned by Constantine had long been lost to the empire. Even the famous quarries of Proconnesus, mentioned by Constantine, had probably ceased to be operative.[69] The insistence on the exotic place names harks back to an idea of an empire encompassing the entire area known as the ancient world, rather than to the historical reality of the medieval empire.

Constantine seems to be fully aware of this when he mentions in relation to Carthage that this city was "talked of from ancient times" (line 663: τῆς πάλαι θρυλλουμένης). The marbles, closely connected to their place names, are thus a kind of *spolia,* emphasizing the dominance of Constantinople (and one of its core churches) over a vast empire it no longer really controlled, and conjuring up for the ninth-century reader a historical era of past glory.

Constantine's marbles, one could conclude, are part of a literary world, rather than a real material world. But, just like Paul's marbles, they are no fantasy, either: as James's commentary indicates, the colors and features mostly tally with historical reality. A rhetorical or literary shaping of subject matter is not the same as "fiction," and we should not be led into a too easy dichotomy between "true" and "false" when evaluating the relationship between text and reality.

As we have seen, the church of the Holy Apostles is for Constantine (and his audience) a canvas on which he projects expressions of knowledge, imperial ideas, and poetic tradition. He worked in a context of rivaling experts, who attacked each other's authority while reading, transcribing, commenting, and writing (not shunning personal abuse in the process). This combative erudition stems from an eagerness to catch the attention of a young emperor legitimizing his bid for the throne by connecting himself to the sophia for which his father was so famous. Taking us around the city and the church, the poet strives for knowledgeable admiration, not exact description. Constantine's poem may continue to be of importance to us; if not for reconstructing lost churches, then for reconstructing the place of buildings in the Byzantine mind.

67 C. A. Mango, *The Art of the Byzantine Empire, 312–1453: Sources and Documents* (Englewood Cliffs, NJ, 1972), 87.

68 N. Schibille, *Hagia Sophia and the Byzantine Aesthetic Experience* (Farnham and Burlington, VT, 2014), 97–109 and appendix.

69 N. Asgari, "Roman and Early Byzantine Marble Quarries of Proconnesus," in *Proceedings of the Xth International Congress of Classical Archeology,* ed. E. Akurgal (Ankara, 1978), 467–80. See also J.-P. Sodini, "Marble and Stoneworking in Byzantium, 7th to 15th Centuries," in *The Economic History of Byzantium: From the Seventh Through the Fifteenth Century,* ed. A. Laiou (Washington, DC, 2002), 129–46.

CREATING THE MOSAICS
OF THE HOLY APOSTLES

LIZ JAMES

*A*LTHOUGH IT WAS NEVER PUBLISHED, THE DUMBARTON OAKS Holy Apostles project has been significantly, albeit implicitly, influential in the ways in which Byzantine and medieval mosaics have been studied. Two of the most dominant scholars associated with Byzantine mosaic studies, Otto Demus and Ernst Kitzinger, were both associated with the Dumbarton Oaks work on mosaics. Demus's work at San Marco in Venice and Kitzinger's studies of the mosaics of Norman Sicily were supported with Dumbarton Oaks money and backed by Albert Matthias Friend, Jr., whose inspiration the Holy Apostles project had been.[1] That their works were essentially style-based analyses, concentrating on what the mosaics looked like and the artistic influences apparent in them, above all their relationships with the mosaics of Constantinople, shares much—surely not accidentally—with the ways in which the church of the Holy Apostles and its mosaic program were reconstructed. Further, as I will argue below, Demus's development of the "classical system of Middle Byzantine church decoration," published in 1949, shared many conceptual ideas with Friend's reconstruction of the mosaic programme of the Apostoleion. These ways of understanding mosaics, and the questions that these scholars regarded as important in the study of Byzantine mosaics, continue to influence the ways in which medieval mosaics are analyzed. This chapter engages with the Dumbarton Oaks project, most specifically its recreation of the mosaics of the church.[2] It discusses what the project reveals about Byzantine historiography and why the methodological problems that the project raised still affect the way that decisions about the date and meaning of works of art are made today.

What the church of the Holy Apostles looked like and what its mosaics looked like have been perhaps the central areas of debate around the monument. Destroyed in the 1460s after the sack of Constantinople, yet living on in a handful of textual accounts, the building has been a focus for scholarly imaginations and reconstructions.

Only three Byzantine authors provide descriptions of the church and its mosaics. The shortest is that of Procopius who, in the *Buildings,* in the midst of his account of Justinian's church building in Constantinople, devoted a short section to the Holy Apostles, relating something of its architectural form and the relics contained within, but making no mention of the mosaics. The Holy Apostles occupied lines 437–981 of Constantine the Rhodian's tenth-century poem, the mosaics taking up

❧ My thanks to Michelle O'Malley and Claire Langhamer for their advice and insights.

1 See K. Weitzmann, *Sailing with Byzantium from Europe to America: The Memoirs of an Art Historian* (Munich, 1994), 198. In this context, Anthony Cutler's remarks on the scholarly interests at Dumbarton Oaks in the 1970s are interesting: Oral history interview by Gudrun Bühl and Alice-Mary Talbot, 14 August 2009, accessed 1 May 2018, www.doaks.org/research/library-archives/dumbarton-oaks-archives/historical-records/oral-history-project/anthony-cutler.

2 I shall concentrate on the mosaics rather than the building in which they are located, though the form of that building has itself been a central point in discussion, and many of the points I raise here are as relevant to the church itself.

lines 735–981. Finally, Nicholas Mesarites, in his twelfth-century prose description of the church, made the mosaics central to his account.[3] Other known textual sources that mention the Holy Apostles are Theophanes, who simply comments that Justin II "adorned" the church, and the *Life of Basil,* which noted that Basil I "reinforced" it by "buttressing it up all around and by having its ruined parts rebuilt."[4] The *Patria* claims that Basil removed mosaic and marbles from the Holy Apostles to use in his own foundation of the Nea Church, while his son, Leo VI, used the Holy Apostles as a store for mosaic tesserae.[5] Finally, a homily most probably written by Leo VI describes mosaic scenes in the Holy Apostles.[6]

Of these, the accounts of Constantine and Mesarites have been those most used by scholars to understand what might have been in the church. However, the two authors vary considerably in their descriptions: how their differences can be reconciled has formed the basis of debate and discussion around the church's mosaics, and the ways in which this has been answered says much about changing trends in scholarship.

Constantine describes eleven narrative Gospel scenes and the presence of images of Christ, the Mother of God and the apostles. Mesarites recounts nineteen scenes, as well as the image of Christ Pantokrator and one of the Communion of the Apostles. There are seven Gospel scenes in common (the Annunciation, Nativity, Baptism, Transfiguration, the Raising of Lazaros, the Betrayal, and the Crucifixion). Constantine describes four images that Mesarites does not: the Magi, the Presentation in the Temple, the Raising of the Widow's Son, and the Entry into Jerusalem. Mesarites has nine that Constantine does not mention (in the order in which Mesarites presents them, Christ Walking on Water, the Women at the Tomb, Christ appearing to the Women, the Priests with Pilate and the soldiers, the Disciples going to Galilee, Thomas and the Apostles, Doubting Thomas, the Sea of Tiberias, the Draft of Fishes), as well as several scenes from the Acts of the Apostles (Pentecost, and the missions of Matthew, Luke, Simon, Bartholomew, and Mark).[7] But the majority of the events that Mesarites has that Constantine does not are post-Crucifixion, and Constantine's poem actually terminates abruptly in the middle of a description of the Crucifixion, and may well have gone on to include later events.

It is clear that neither account covers every event from Christ's life that could have been depicted: neither mentions an Anastasis, for example. And the differences between the two accounts in terms of both the scenes described and the ways in which they were explained has led to debates about whether the two authors were portraying the same mosaics. Throughout the early twentieth century, recognizing the importance of the monument and wishing to pin it down on its proper place in the taxonomy of Byzantine art, a huge amount of scholarly debate revolved around the dating of the mosaics of the Holy Apostles— in particular, which ones could be ascribed to Justinian's sixth-century church, which to Basil I's reconstructions, and which to the presumed (because of the differences) renovations which took place at some point between when Constantine and Mesarites wrote. So, for example, August Heisenberg argued strongly for a sixth-century

3 Procopius, *De aed.,* 1.4.9–24; Constantine the Rhodian: L. James, ed., *Constantine of Rhodes, On Constantinople and the Church of the Holy Apostles, with a New Edition of the Greek Text by Ioannis Vassis* (Farnham, Surrey, and Burlington, VT, 2012); Nicholas Mesarites, *Description of the Church of the Holy Apostles at Constantinople*, ed. and trans. A. Heisenberg, *Grabeskirche und Apostelkirche: Zwei Basiliken Konstantins*, vol. 2, *Die Apostelkirche von Konstantinopel* (Leipzig, 1908), 10–96; ed. and trans. G. Downey, "Nikolaos Mesarites, Description of the Church of the Holy Apostles at Constantinople," *TAPS*, n.s., 47, part 6 (1957): 859–918; trans. M. Angold, *Nicholas Mesarites, His Life and Works (in Translation)*, TTB 4 (Liverpool, 2017), 83–133. Of the 43 chapters 24 discuss the mosaics. For a full account of the church see R. Janin, *La géographie ecclésiastique de l'empire byzantin,* vol. 1, *Le siège de Constantinople et le patriarcat œcuménique,* pt. 3, *Les églises et les monastères,* 2nd ed. (Paris, 1969), 46–55.

4 Theophanes, *Chronographia*, AM 6058 (565 AD), ed. C. de Boor (Leipzig, 1883–85), 242; trans. C. Mango and R. Scott, *The Chronicle of Theophanes the Confessor: Byzantine and Near Eastern History AD 284–813* (Oxford, 1997), 355; *Life of Basil,* 80: *Vita Basilii: Chronographiae quae Theophanis Continuati nomine fertur liber quo Vita Basilii imperatoris amplectitur,* ed. and trans. I. Ševčenko, CFHB 42 (Berlin, 2011), 266–67.

5 *Patria*, Book 4, 32 (Basil I), and 3, 209 (Leo VI), trans. A. Berger, *Accounts of Medieval Constantinople: The* Patria (Washington, DC, 2013), 278–79; and 222–23.

6 L. James and I. Gavril, "A Homily with a Description of the Church of the Holy Apostles," *Byzantion* 83 (2013): 149–60.

7 It is worth noting that Mesarites' text has also been transmitted in an incomplete form, with the beginnings and ends of some chapters missing; possibly he, too, described additional scenes.

date for the mosaics of the church and interpreted Mesarites' descriptions in terms of sixth-century iconography. He argued that Mesarites' description of the Raising of Lazaros was a perfect match for the depiction of the scene in the sixth-century Rossano Gospels; he also dismissed Constantine's account of the dead Christ at the Crucifixion as part of that author's unreliability.[8] Martin, however, saw Constantine's dead Christ as a ninth-century iconographic detail and the image in the Holy Apostles as the model for the artist of the ninth-century manuscript of homilies of Gregory of Nazianzos, Paris BnF gr. 510.[9] Yet another scholar, Salač, suggested that Constantine's brief description of the Raising of Lazaros was close to depictions on fourth-century sarcophagi.[10] He made the case that it was possible that Constantine's Lazaros scene was not the same as Mesarites' scene, suggesting a period of alteration to the mosaics between the two authors.[11] Wulff, who agreed with Heisenberg's dating of the mosaics to the sixth century, nevertheless, in contrast, preferred to see the image of Christ in the main dome, which he interpreted as a Pantokrator, as dating to after Iconoclasm. Malickij, who believed in a twelfth-century mosaic campaign, raised the question of whether the image was a Pantokrator or whether Constantine's account was of an Ascension, as was the case at San Marco and in the Kokkinobaphos manuscripts.[12] If so, did Mesarites' Pantokrator then replace Constantine's Ascension at some point between the two descriptions, perhaps as a twelfth-century work of art?[13] Much effort also went into deciding where in the church individual mosaics were located. Théodore Reinach, for one, suggested that the mosaics were positioned in the other domes, the pendentives, and the walls.[14] Heisenberg's detailed plan, based on Mesarites, located, for example, the scene of Christ walking on water in the north arm of the church where Constantine had situated the scene of the Widow's Son, making the case that the one replaced the other.[15]

These issues of date and influence seem to have been key in much early twentieth-century Byzantine scholarship, a need perhaps to set firm foundations for the discipline (if such it was), but also born from art history's own belief in the authority of connoisseurship and the expert's "eye" as the right and proper way to study art. In what they tried to do with nonexistent works of art, art historians working on Byzantine material were in many ways using Giovanni Morelli's dictums and emulating scholarship above all in Renaissance art, with its emphasis on hands and artists.[16] In many ways, the Dumbarton Oaks Holy Apostles project and the 1948 Symposium were the culmination of this scholarship, a bid to bring together debates, and definitively reconstruct and conceptualize the church and its mosaics. Many key scholars of the discipline were involved with it, either directly or tangentially, and it was a project that, in many ways, both shaped and was shaped by the methods and interests of those Byzantinists who defined the discipline and whose influences are only slowly being disentangled.

8 Heisenberg, *Apostelkirche*, 241–47 (Lazarus), 186–96 (Crucifixion); A. Heisenberg, "Die alten Mosaiken der Apostelkirche und der Hagia Sophia," in *Xenia: Homage international à l'Université Nationale de Grèce* (n.p., 1912), 121–60.

9 J. R. Martin, "The Dead Christ on the Cross in Byzantine Art," in *Late Classical and Medieval Studies in Honor of Albert Mathias Friend, Jr.*, ed. K. Weitzmann (Princeton, 1955), 189–96, 191.

10 A. Salač, "Quelques epigrammes de l'Anthologie Palatine et l'iconographie byzantine," *BSl* 12 (1951): 1–28, at 22.

11 For the 6th century, Heisenberg, *Apostelkirche*, 2, and O. Wulff, "Die sieben Wunder von Byzanz und die Apostelkirche nach Konstantinos Rhodios," *BZ* 7 (1898): 316–31, at 329–31; for the 12th century, N. Bees, "Kunstgeschichtliche Untersuchungen über die Eulalios-Frage und den Mosaikschmuck der Apostelkirche zu Konstantinopel," *Repertorium für Kunstwissenschaft* 39 and 40 (Berlin, 1917): 1–62, at 23–26, uses Constantine's text to discuss which mosaics Constantine described and the restorations of Basil I. Also see N. Malickij, "Remarques sur la date des mosaïques de l'église des Saints-Apôtres à Constantinople décrites par Mésaritès," *Byzantion* 3 (1926): 123–51.

12 Wulff, "Sieben Wunder"; Malickij, "Remarques sur la date," 130.

13 As Bees, "Kunstgeschichtliche Untersuchungen," and Malickij, "Remarques sur la date," thought.

14 T. Reinach, "Commentaire archéologique sur le poème de Constantin le Rhodien," *REG* 9 (1896): 66–103, at 68–69.

15 Heisenberg, *Apostelkirche*, 2:141 (plan of mosaics in the church) and 239–40.

16 Giovanni Morelli's *Die Werke italienischer Meister* was published in 1880; the earliest publications of the influential Renaissance connoisseur Bernard Berenson belong to the mid-1890s. Also see J. Elsner, "Significant Details: Systems, Certainties, and the Art-Historian as Detective," *Antiquity* 64 (1990): 950–52.

Reconstructing the Mosaics of the Holy Apostles

The material preserved in the Dumbarton Oaks Holy Apostles collection suggests that the members of the Holy Apostles project had a clear sense of what they thought the Apostoleion building looked like. The several-hundred-page typescript by Paul Underwood, who took the lead on restoring the architecture of the church, posits a meticulous recreation of the building based on a detailed extraction of data from primary sources. It is likely that this represents the first part of Underwood's proposed book on the church. The title of his manuscript sums up Underwood's approach to the material: "The Church of the Holy Apostles and its Dependencies: A Reconstruction from the Texts Controlled by the Comparison of Parallel Monuments." This same methodology based on texts and comparative examples is also apparent in the title of a surviving lecture, "Justinian's Church of the Holy Apostles: A Reconstruction of Architecture by Means of Texts."[17] The titles and the contents of both pieces of writing underline Underwood's firm belief that both later monuments and descriptive Greek texts offered enough evidence to allow scholars to unravel from them the features that properly belonged to the Apostoleion.

It was on this basis that Underwood used the churches of St. John at Ephesos and San Marco in Venice as his fundamental models for reconstructing the architecture of the Holy Apostles, accepting the claims of Procopius for St. John and of twelfth-century Venetian sources for San Marco that both were built to the model of the Constantinopolitan church.[18] His architectural plans and drawings re-creating the Holy Apostles show the particular importance of San Marco. In his lecture "Justinian's Church of the Holy Apostles," Underwood replicated the ground plan of San Marco next to his own conception of the plan for the Holy Apostles, inviting his audience to see their "essential identity."[19] But since this identity was based on his a priori decision that San Marco was the model, the similarities between the two plans are unsurprising.

His analyses were allied with close readings of the written texts and their descriptions of the church, largely the poem of Constantine the Rhodian and Nicholas Mesarites' account of the Holy Apostles and its environs, though Procopius's account of the church in the *Buildings* and its appearance in the *Book of Ceremonies* were also useful sources of information. Underwood paid great attention to deriving plausible architectural reconstructions from the convoluted terminology about the architecture employed by his authors. Constantine's description of the architects "having marked out the linear form of a cube" was turned into a three-dimensional geometric rendering on which the four arms of the cross-shaped church depended.[20] This interpretation placed a considerable belief in Constantine's command of geometry, over which there has been considerable scholarly debate.[21] In this part of the work, Underwood may well have received assistance from Glanville Downey, who had previously published some important papers on classical and postclassical Greek architectural terms, and who was responsible for the translation of Constantine's poem used by the project team.[22]

Underwood's work on the architecture survives in drafts as well as in full and lengthy typescripts, suggesting that he had almost completed

17 The lectures are filed at Dumbarton Oaks under MS.BZ. 019-03-01, folders 45, 46, and 47. See below Appendixes D and E. The typescript entitled "Justinian's Church of the Holy Apostles: A Reconstruction of Architecture by Means of Texts" is 29 pages long; the references to slides suggest that this was the script of a lecture probably delivered at Oberlin College, perhaps a close relative of the one entitled "The Architecture of Justinian's Church of the Holy Apostles" delivered at the Dumbarton Oaks Symposium. I have not devoted as much time to Underwood as his work deserves: it needs to be the subject of a paper in its own right.

18 For discussions of the problems presented by St. John and San Marco, see James, *Constantine of Rhodes*, chap. 6, esp. 192–94.

19 Underwood, "Justinian's Church of the Holy Apostles," 20.

20 See Appendix A, 1–4 below in this volume, for illustration.

21 Constantine the Rhodian, line 552, ed. James, *Constantine of Rhodes*, 56–57. For Underwood's reconstruction work see the discussion of F. Gargova, "Developing a Cruciform Building from a Cube," in B. Daskas and F. Gargova, *The Holy Apostles: Visualizing a Lost Monument; The Underwood Drawings* (Washington, DC, 2015), 10–13. For Constantine as a geometer see James, *Constantine of Rhodes*, 147–48.

22 See, for example, G. Downey, "The Architectural Significance of the Use of the Words *Stoa* and *Basilike* in Classical Literature," *AJA* 41 (1937): 194–211, and Downey, "On some Post-Classical Greek Architectural Terms," *TAPA* 77 (1946): 22–34.

his part of the project. In contrast, the contribution of Albert Matthias Friend, Jr., who had responsibility for the reconstruction of the mosaics, was less far advanced. Friend's work survives as a stack of handwritten notes, drawings, and sketches.[23] There is nothing approaching the detail and volume of Underwood's typescripts, and it seems clear that this second part of the Holy Apostles project became bogged down. This appears to have been true of Friend's output more widely. In his memoirs, Kurt Weitzmann, who had considerable respect and admiration for Friend, noted that Friend was a perfectionist and that this inhibited his ability to publish his work throughout his career.[24] Friend's notes are almost all workings and reworkings of the same set of points and discussions. They are, more or less, a compilation of as much Byzantine theology as might underlie narrative scenes from Christ's life, and of as many parallel examples in art of those scenes as were known in the 1940s and 1950s. The text of Friend's two lectures given at the Dumbarton Oaks Symposium, "The Mosaics of Basil I in the Holy Apostles Parts 1 and 2," survive in typescript, as does a twenty-one-page lecture entitled "The Holy Apostles Church: Restoration of the Mosaics," written to be delivered at Bryn Mawr College in 1950. These three lectures are the most coherent sketch of Friend's grand narrative of the mosaics, the Bryn Mawr piece in many ways a synthesis of the longer Symposium lectures.[25]

Both the lectures and the mass of notes make it apparent that Friend's concerns were exactly those of the day: dating the mosaics; establishing their appearance and sequence; and explaining their theological significance. The Bryn Mawr lecture reflects his conviction that the mosaics were ninth century, dating in fact from the second patriarchate of Photios, 878–886, who had laid out the scheme. His notes indicate that, like Underwood with the architecture, Friend was determined to reconstruct the mosaics through the analysis of texts and parallel monuments. In Friend's mind, the mosaics of the Holy Apostles were enormously influential, as befitted the images in one of the most significant of all Byzantine churches. He went so far as to make the argument, in both the Dumbarton Oaks and the Bryn Mawr lectures alike, that the decoration was "perhaps the richest produced for any church and was certainly the most influential scheme of iconography in the whole realm of Byzantine art," even though he had little hard evidence for what that iconography had been.[26] In a similar vein, the Bryn Mawr lecture asserted that "although our church was long since totally destroyed, we possess for the restoration of its decoration such a plethora of riches that it is embarrassing to have to choose among them."[27] For Friend, as the lectures show and as his notes imply, traces of the mosaics could be seen in almost every surviving post-Iconoclastic representation of scenes of the Life of Christ and scenes of the Missions of the Apostles. They were

23 The Dumbarton Oaks Friend material is filed in Underwood Papers ICFA as series III, subsection 2, carton 6, folders 63–73, esp. MS.BZ.019–03–02–063, 065, 066, 067, 068, 070, and MS.BZ.019–03–01–054, see below, Appendix B.

24 Weitzmann, *Sailing with Byzantium*, 107 (on Friend as a person), 158–60 (on Friend's "tragic flaw" and why he published so little though he was an inspiring teacher), 196 ("It is one of the tragedies of Friend's life, consistent with his character, that, though well-progressed, nothing came of this [Holy Apostles] project"). Cyril Mango went further and described Friend as a "fantasist": Cyril Mango and Marlia Mundell Mango, oral history interview by Anna Bonnell-Freidin for DOA, 1 August 2009, accessed 1 May 2018, http://www.doaks.org/research/library-archives/dumbarton-oaks-archives/historical-records/oral-history-project/cyril-mango-and-marlia-mundell-mango.

25 The Symposium lectures, with a date of 23 April 1948, are entitled "The Mosaics of Basil I in the Holy Apostles Part 1" and "The Mosaics of Basil I in the Holy Apostles Part 2," and are in Friend Papers, Notebooks, notes, papers, course materials, photographs; 1934–51, carton 4; (handwritten

versions) and Notebooks and notecards, PULC; 1916–50, carton 5 (typed lectures 1948); see below, Gargova, 293–97, and Appendixes F and G: The Bryn Mawr lecture is in MS.BZ.019-03-02-072. The typescript indicates that the Bryn Mawr lecture was illustrated with 41 slides and written to be delivered in 1 hour and 15 minutes; if so, it would have taken its audience very briskly through the material. On Friend's lectures at the Symposium see Weitzmann, *Sailing with Byzantium*, 198. Sirarpie Der Nersessian delivered a 3rd lecture on the mosaics, "The Mosaics of Basil I in the Holy Apostles, Part 3," and also lectured on "Mosaic Decorations of the Ninth Century in Constantinople." Presumably her article "Le décor des églises du IX^e siècle," published in *Actes du VI^e Congrès International d'Études Byzantines* (Paris, 1951), 315–20, and most probably delivered at that conference in 1948, was related to the Dumbarton Oaks paper, but I have found no other published trace of her ideas.

26 Friend, "Mosaics of Basil, 1," Appendix F, 396; "Holy Apostles Church," 3.

27 Friend, "Holy Apostles Church," 4.

copied in manuscripts as varied as the Khludov Psalter (Moscow, Hist. Mus. MS. D.129) and the Paris homilies of Gregory of Nazianzos (the Paris Gregory: Paris, BnF gr. 510), and hints could be found in the twelfth-century mosaics of Italy, especially those in San Marco, Venice, and in the church at Cefalù and in the Cappella Palatina in Sicily.[28] Friend's notes and the lectures suggest that he spent a great deal of time working out who copied what from the Holy Apostles. So, for example, "The best copy of the Pantokrator of the Holy Apostles is in the dome of Daphni" and the "whole central dome of the Holy Apostles has been copied in the apse of the Cathedral of Cefalù," while the scene of the Pentecost (described by Mesarites but not by Constantine) was copied at Hosios Loukas, San Marco, the Cappella Palatina, the Abbey of Sta. Maria at Grottaferrata, and in the Paris Gregory.[29]

Friend's sketches for the appearance of the Holy Apostles mosaics are essentially derived from the very monuments that he believed took the Apostoleion as a model: inscriptions on his mosaics, for example, are reconstructed on the basis of surviving mosaic inscriptions—he turned to Hagia Sophia in Kiev for the Communion of the Apostles.[30] The elegant surviving drawings in the archives (as opposed to the sketches in Friend's notes) were almost certainly Underwood's work, as letters between the two men suggest.[31] These drawings are a fascinating pastiche of Byzantine art between the ninth and twelfth centuries, a perfect "guess the original" test, and an interesting historiographic comment on what elements of Byzantine art were well known in the 1940s and 1950s. For example, the dome of the Holy Apostles with the Pantokrator (see below Appendix A.13) appears as a composite of the mosaic at Daphni (the Pantokrator himself) surrounded by the Mother of God and attendant archangels from Cefalù. This is no surprise in terms of Friend's conclusions about the influences of the mosaics on later art. Nor is it surprising how many similarities are apparent with the mosaics of San Marco.

In the Dumbarton Oaks lectures, in particular, the accounts of the mosaics given by Constantine the Rhodian and Nicholas Mesarites served as a starting point. So, Lecture One opened with Mesarites on the Pentecost, accompanied by an image of the western dome of San Marco in Venice, which Friend clearly must have gone on to compare with Mesarites' description, concluding "We cannot be far wrong then if we take this mosaic of St. Mark's as a copy of the West dome of the Church of the Holy Apostles in Constantinople."[32] Equally breathtakingly, the lack of material in Constantine and Mesarites did not prevent Friend (like others before him) from positing and reconstructing several scenes that neither Constantine nor Mesarites mentioned but that he deduced must have been there, because these scenes were so much a part of middle Byzantine church decoration. Theory became reality as Friend recreated them, located them in the church and explored their influences. One such was Malickij's Ascension, hypothesized as present in the Holy Apostles, but not mentioned by any Byzantine source. It, according to Friend, was copied at Hagia Sophia in Thessalonike, at San Marco, and in the manuscript Dionysiou 740, and therefore could be reconstructed in the Apostoleion.[33] Similarly, he believed that a scene of the Anastasis must have been present in the Holy Apostles and came up with a list of artistic descendants of this image, as well as sketches recording what it must have looked like. He asserted that the best copy of these putative mosaics survived in the frontispiece of Iviron 1, an eleventh-century lectionary from the Iviron Monastery on Mt. Athos, believed to have been made in Constantinople. Friend made the connection between the mosaics of the Holy Apostles and the lectionary because, on the basis of a comparison between the reconstructed image of the Transfiguration based on Mesarites' account, he considered that this manuscript had the best copy of that mosaic, and that if Iviron 1 copied the Transfiguration of the Holy Apostles then it "most likely" also copied the

28 Weitzmann, *Sailing with Byzantium*, 195–96, records helping Friend with these manuscript parallels, and specifically in obtaining copies of the relevant images.

29 Friend, "Holy Apostles Church," 19.

30 Friend, "Mosaics of Basil, 2," Appendix G, 412.

31 See F. Gargova, "The Holy Apostles Project at Dumbarton Oaks," in Daskas and Gargova, *Underwood Drawings*, 9.

32 Friend, "Mosaics of Basil, 1," Appendix F, 395.

33 Friend, "Mosaics of Basil, 2," Appendix G, 407–8; "Holy Apostles Church," 16–18.

Anastasis.[34] Friend then located the Anastasis in the east dome, a curious choice of location, since no images of the Anastasis survive from the domes of any churches, but one which was a direct consequence of his interpretation of the meaning of the (reconstructed) iconographic program of the mosaics. Because of the lack of any direct visual comparators (and I accept that that does not prove that there were never any Anastaseis located in domes), Friend and Underwood had to be particularly creative in their use of visual material. The sketch of the scene in the dome of the Holy Apostles (Appendix A.18 and A.19) shows Christ filling the center of the dome and standing perched precariously on a rocky outcrop, his feet on a limp Hades, his hands outspread; below him, Adam and Eve raise their hands, and figures of the virtuous dead standing in their sarcophagi curve around the base of the dome. The construction echoes that of the domes of San Marco with their recurring use of a central Christ and attendant figures, though in San Marco, the Anastasis is on the west vault.

One of the reasons that Friend was so confident that scenes such as the Anastasis and Ascension must have been present in the Holy Apostles was that he had a coherent belief as to what the mosaic program must have been about, and it is clear that this informed his dating and reconstruction of the mosaics of the church. In his view, the mosaics were a visual refutation of Iconoclast beliefs created by the patriarch Photios. They "were the pictorial creed of Orthodoxy made visible by art, the answer once and for all to those iconoclasts, ancient and modern who insist that such a thing ought not to be and cannot be done."[35]

It was on the basis of this conviction that he configured the mosaics of the domes as the Transfiguration in the north, the Anastasis in the east, the Ascension in the south, Pentecost in the west, and the Pantokrator in the central dome. This arrangement, he argued, served to refute the 754 Iconoclast Council of Hiereia, specifically its use of the supposed letter of Eusebius

to Constantia with its sustained criticism of the use of icons with their "dead and lifeless colours" to portray the divinity of Christ.[36] The letter singled out four events in Christ's life—the Transfiguration, the Anastasis, the Ascension, and Christ with his Father in Majesty—that for Eusebius proved that Christ could not be depicted in images. This was because in all four cases, the visible appearance of his unportrayable divine nature concealed his human nature. Consequently, according to Friend, when the Iconophile patriarch Photios placed these four scenes triumphantly in the domes of the Holy Apostles, he was making a display of Iconophile triumph over Iconoclast belief. Furthermore, the Pentecost mosaic, which had been described, though not located, by Mesarites, was placed by Friend in the west dome and interpreted as a protoecumenical council held by the twelve apostles. He went on to suggest that the part of the Seventh Ecumenical Council held in the Holy Apostles had taken place under this very dome.[37] In appearance, Friend conjectured that the Pentecostal apostolic council of the Holy Apostles echoed the (now lost) image of Pentecost in Hagia Sophia, an image below which the Eighth Ecumenical Council of Photios had been held.[38] The use of the same iconography by Photios in the Holy Apostles in this particular dome would hence have reminded Byzantine viewers of both the Seventh and Eighth Ecumenical Councils and of the Triumph of Orthodoxy.

Problems in Reconstructions

How far Friend, Underwood, and the others involved in the project believed that they had recreated the actuality of the Holy Apostles and how far they recognized their work as hypothesis is a line that perhaps became blurred as the project went on. It is clear that Friend's reconstructions of the mosaics of the Holy Apostles lacked an element of rigor: as Ernst Gombrich pointed out, assertions cannot be built on

34 Friend, "Mosaics of Basil, I," Appendix F, 405; "Holy Apostles Church," 16.

35 Friend, "Mosaics of Basil, I," Appendix F, 396; "Holy Apostles Church," 3.

36 Friend, "Holy Apostles Church," 10.

37 Ibid., 8 and 9.

38 For this lost mosaic see C. Mango, *Materials for the Study of the Mosaics of St. Sophia at Istanbul* (Washington, DC, 1962), 35–37.

hypotheses.[39] To suggest that the "best copy" of the Pantokrator of the Apostoleion was in Daphni is a total fiction: we have no means of knowing. But Friend's methodologies for those reconstructions, right back to his positing of Photios as patron of the mosaics, relied very heavily on an acceptance that lost art could be regained through a reconstruction from texts and the comparison of parallel works of art, something at the time perceived as a wholly legitimate scholarly practice. As Kurt Weitzmann wrote, looking back at the Dumbarton Oaks Holy Apostles project in his autobiography published in 1994, the detailed descriptions of the Apostoleion "were exact enough to permit the tracing of their iconography as reflected in other works of art, chiefly miniature paintings which were assumed to be based on the lost mosaics."[40] This was something apparent, for example, in John Martin's argument (appropriately published in Weitzmann's Festschrift for Friend) that Constantine's dead Christ was evidence of ninth-century iconography and that it provided the model for the illuminations of the ninth-century homilies of Gregory of Nazianzos in the Bibliothèque Nationale in Paris.[41] These texts were seemingly unproblematic: they told the reader what was there and the scholar's role was to reconstruct that, not to worry about issues of "accuracy," veracity, function, and meaning in Byzantine literary descriptions.

This quest for "lost originals" was something that was to dominate Weitzmann's own scholarship and thus to underpin much of the study of Byzantine art in the 1960s and 1970s. In manuscript studies, in particular, the use of a study of iconography in order to reconstruct the lost models from which surviving miniatures were drawn

has been highly influential.[42] Much emphasis was laid on relating images across manuscripts, a search for the models copied by an artist in producing a set of particular images, the connections, reminiscences, and "influences" that can be detected in the imagery created and, allied to this, a sense that the differences in imagery were the result of poor copying and incompetence.[43] From these tracings of influences and identification of allied details, it then became possible for the art historian to re-create the original (often lost) model that the artist had had before him. In the case of the Holy Apostles, the original lost model is, of course, the church itself, and so its reconstruction, in terms of both architecture and mosaics, must have seemed a genuine and achievable task in the 1940s and 1950s. Some of this relates again to the importance of connoisseurship within art history in this period: the expert eye able to see and explain these details in a way impossible for those without proper training; some came from a desire to set Byzantine art in its proper place in art history, a classicizing bridge from Greece and Rome over the dark ages to the Renaissance.[44] And in part, surely it was also the result of frustration at what has been lost from Byzantium and can only be apprehended through words.

Now there is a tendency to think that such restorations present more problems than they

39 E. Gombrich, *Symbolic Images* (London, 1975), 210: "One methodological rule, at any rate, should stand out in this game of unriddling the mysteries of the past. However daring we may be in our conjectures—and who would want to restrain the bold?—no such conjectures should ever be used as a stepping stone for yet another, still bolder hypothesis. We should always ask the iconologist to return to base from every one of his individual flights, and to tell us whether programmes of the kind he has enjoyed reconstructing can be documented from primary sources or only from the works of his fellow iconologists."

40 Weitzmann, *Sailing with Byzantium*, 195.

41 Martin, "Dead Christ," 189–96, at 191.

42 See the important article by M.-L. Dolezal, "Manuscript Studies in the Twentieth Century: Kurt Weitzmann Reconsidered," *BMGS* 22 (1998): 216–63, which locates this approach within the tradition of New Testament textual studies and the search for the original text of the Gospels, and discusses Weitzmann's approach within the scholarship of his time, including that of Friend.

43 See the critique in J. Lowden, *The Octateuchs: A Study in Byzantine Manuscript Illumination* (University Park, PA, 1992), chaps. 4, 5, 6, and esp. 7. For problems with the concept of "artistic influence" see M. Baxandall, *Patterns of Intention* (New Haven and London, 1985), 58–62. The practice is unfortunately not dead. See N. Zarras, "A Gem of Artistic *Ekphrasis*: Nicholas Mesarites' Description of the Mosaics in the Church of the Holy Apostles at Constantinople," in A. Simpson, ed., *Byzantium, 1180–1204: "The Sad Quarter of a Century"?* (Athens, 2015), 261–79. This article asserts that Mesarites' account is one of clarity and accuracy, and that the post-Resurrection scenes can be reconstructed as dating to ca. 1200 through comparison to a range of scenes surviving in Byzantine wall paintings in what the author calls "provincial" monuments.

44 On the historiography of Byzantine art, see R. S. Cormack, "'New Art History' vs. 'Old History': Writing Art History," *BMGS* 10 (1986): 223–31, and R. S. Nelson, "Living on the Byzantine Borders of Western Art," *Gesta* 35 (1996): 3–11.

solve: how can anyone be certain that the mosaics of the Holy Apostles were as influential as Friend believed; how can we know that the central dome was copied at Cefalù? Further, if the Apostoleion was indeed a model for other churches such as San Marco, what did that mean? Richard Krautheimer had argued in 1942 that precise imitation was not what the medieval world saw as a "copy": a copy was selective and a model could refer to a single element.[45] It is hard to imagine that Friend and Underwood were not familiar with this article, the implication of which was that in the Middle Ages, a "model" did not necessarily inspire a "copy"; it is almost impossible to know now what a medieval author meant when he claimed that *this* was modeled on *that,* for it was the idea of a building rather than its physical reality that mattered.[46]

In this context, it is perhaps unnecessary to rehearse again the debates about the different elements of the "distorting mirror" of Byzantine literature: it is now accepted by many that although a written text can help to reconstruct a work of art, it is necessary to be careful about using that text and to be very aware of the literary strategies that the author may have employed.[47] But it may be worth looking at Constantine's and Mesarites' accounts to consider how much material they might offer for a potential reconstruction: whether it is fair to say that the descriptions that survive to us of the Holy Apostles and its mosaics do not, in fact, give enough information to allow reconstruction of their appearance.

The Transfiguration was a significant scene in Friend's reconstruction for the written descriptions of it formed the basis for his championing

of Iviron 1 as based on the mosaics of the Holy Apostles and hence a major source for their reconstruction. Constantine describes the Transfiguration in these words:

> The sixth, you will see Christ,
> 805 having set foot on that thrice-blessed mountain Tabor
> with the chosen and beloved of his disciples,
> transforming his mortal form,
> 809 and with his face gleaming more than
> 808 the sun's light-bearing radiance,
> 810 and with his white robe shining like light.
> You will see the greatest Moses together with Elijah
> 813 present and standing together with him
> 812 with reverent and pious awe
> and talking together of the image of the Passion,
> which He was to suffer on entering the city,
> while cloudy light casts shadows
> over Him and those to whom he reveals the wonder.
> And you will see God the Father testifying from above
> in a voice that is powerful and strange to mortals,
> 820 that this is his greatly-beloved Son
> dear to Him, even though He bears the nature of mortal men;
> the disciples having heard this voice,
> which came as thunder, fell down astonished,
> stooping forward to the ground and bowing down;
> 825 He raised them, casting out fear
> and putting courage into their hearts,
> saying that no-one should speak now of the wonder
> until after He had risen from the tomb.[48]

45 R. Krautheimer, "Introduction to an 'Iconography of Mediaeval Architecture,'" *JWarb* 5 (1942): 1–33.

46 A. W. Epstein, "The Rebuilding and Redecoration of the Holy Apostles in Constantinople: A Reconsideration," *GRBS* 23 (1982): 79–92, critiquing R. Krautheimer, "A Note on Justinian's Church of the Holy Apostles in Constantinople," originally published in *Mélanges Eugène Tisserant II*, ST 232 (1964): 265–70, and reprinted in R. Krautheimer, *Studies in Early Christian, Medieval, and Renaissance Art* (London and New York, 1969), 97–201.

47 See the transitions between C. Mango, *Byzantine Literature as a Distorting Mirror: An Inaugural Lecture delivered before the University of Oxford on 21 May 1974* (Oxford, 1975); H. Maguire, *Art and Eloquence in Byzantium* (Princeton, 1981); and R. Webb, *Ekphrasis, Imagination, and Persuasion in Ancient Rhetorical Theory and Practice* (Farnham, Surrey, 2009).

48 Ἕκτον πρὸς αὐτὸ τὸ τρισόλβιον τόρος
805 Θαβὼρ κατόψει Χριστὸν ἐμβεβηκότα
 σὺν τοῖς μαθητῶν προκρίτοις τε καὶ φίλοις,
 μορφὴν ἐναλλάξαντα τὴν βροτησίαν
 καὶ μαρμαρυγαῖς ἡλίου σελασφόροις
 λάμποντος αὐτοῦ τοῦ προσώπου βέλτιον

The description tells us that Christ is placed on Mt. Tabor with his chosen disciples, that he is shown in white and like the sun, that Moses and Elijah are next to him, that God the Father is visible and heard testifying from above, that the disciples have fallen down astonished and afraid, and that Christ has raised them up.

The account by Mesarites is considerably longer, one of the longest in the text, taking up a full chapter in fourteen parts.[49] It opens with an invocation that the author's discourse should find favor and not be blinded as the disciples were, for if Peter could barely keep awake and observe and ask to set up tents for Christ, Moses, and Elijah, what then might befall the author? Mesarites invites his audience to see how the disciples have pressed themselves to the ground, falling headlong, and covered their faces. James rises with difficulty on his knee and protects his eyes with his right hand, while John appears to lie there in sleep. Christ is borne in a cloud of light in the air with darkness about him, while Moses and Elijah flank him, Moses holding a book and Elijah dressed in skins. The space above these figures is occupied by the voice with which God bore witness to his son.

How far each account is a "description" of the actual scene on the Holy Apostles and how far it is an interpretation of a well-known Gospel story and easily recognizable image is debatable. Looking at the miniature of Iviron 1, one of

Friend's most important sources for the mosaics of the Holy Apostles, it is easy to quibble with Friend's reading of the miniature as a copy of the mosaic. Christ in Iviron 1 is barely transformed into light: he does not wear white, in fact his robes share the same colors, though reversed, as Moses's garments; James raises himself without the use of his arms and his left hand supports his face; John appears to be performing proskynesis as much as lying in sleep; there is no sign of the voice of God. It is an immediately recognizable representation of the Transfiguration. However, it is impossible to reconstruct whether that means the details that make it look different from, say, the eleventh-century mosaic image of the Transfiguration at Daphni represent a different source for the image, or a different level of invention from the artist, or even the difference in media and scale. There is not enough in Iviron 1 to make it clear that it has to have been modeled on the Holy Apostles, just as there is not enough in the Daphni image to "prove" that it was derived from the Apostoleion. Similarly, the miniatures of the Transfiguration in the Paris Gregory (fol. 75r) and that in the Khludov Psalter (fol. 88v) share both similarities and differences with Iviron 1 and Daphni.[50] The critical difference between all these post-iconoclastic images is regularly said to be in their dissimilarity with the mosaic of the Transfiguration in the apse of St. Catherine's Monastery on Mt. Sinai, dated to the sixth century. As Leslie Brubaker suggested, this may well represent a new ninth-century formula for the Transfiguration, but I would add that it does not automatically follow that the image of the Apostoleion was the model for any of them.[51] Constantine's account, at least, if it is taken literally, could as well describe the St. Catherine's image as that of Iviron 1: it is simply not specific enough to rule anything out.

There is a level here at which all images of the Transfiguration are similar, just as there is one where all accounts of it are generic, where they share as much as they have differences. Both Constantine and Mesarites took the fundamental aspects of the story from the Gospels:

810 ὡς φῶς τε λευκῆς τῆς στολῆς δεδειγμένης
Μωσῆν τε τὸν μέγιστον Ἠλίαν θ᾽ ἅμα
μετ᾽ εὐλαβοῦς τε καὶ σεβάσματος ξένου
καὶ συμπαρόντας καὶ συνεστῶτας θ᾽ ἅμα
καὶ συλλαλοῦντας τοῦ πάθους τὴν εἰκόνα,
815 οὗπερ παθεῖν ἔμελλε εἰσιὼν πόλιν,
φωτὸς νεφώδους συγκατεσκιακότος
αὐτόν τε καὐτούς, οἷς τὸ θαῦμα δεικνύει,
Θεοῦ τε πατρὸς μαρτυροῦντος ὑψόθεν
φωνῇ κραταιᾷ καὶ ξένῃ βροτῶν φύσει,
820 ὡς υἱός ἐστιν ἠγαπημένος λίαν
αὐτοῦ θεουδής, κἂν βροτῶν φύσιν φέρῃ·
ἧσπερ μαθηταὶ βροντηδόν τ᾽ ἀφιγμένης
ἀκουτίσαντες κἀπ<π>εσον τεθηπότες
fol. 146ᵛ εἰς γῆν προνωπεῖς καὶ κάτω νενευκότες,
825 οὓς αὐτὸς ἐξήγειρεν ἐκβαλὼν φόβον
καὶ θάρσος αὐτῶν ἐμβαλὼν τῇ καρδίᾳ
εἰπὼν τὸ θαῦμα μηδαμῶς τὰ νῦν λέγειν,
ἕως ἂν αὐτὸς ἐξαναστῇ τοῦ τάφου.

Text and trans. from James, *Constantine of Rhodes*, 72–75.

49 Mesarites, *Ekphrasis*, c. 16, ed. Heisenberg, *Apostelkirche*, 32–37, ed. and trans. Downey, "Nikolaos Mesarites," 871–73; text at 902–3.

50 L. Brubaker, *Vision and Meaning in Ninth-Century Byzantium* (Cambridge, 1999), 304–5.

51 Ibid., 305.

Christ on Tabor with his chosen disciples, transformed into light and accompanied by Moses and Elijah; the voice of God; the disciples falling to the ground in fear. The rest of the descriptions are as much what the authors did with the familiar story, with what they chose to include or exclude, for the purposes of their own literary endeavors, as they are veracious accounts of what a specific mosaic looked like. In Constantine's case, emphasis lay with Christ's transformation and revelation and on his forthcoming Passion, themes relating both to his divine humanity and to his salvatory mission that appear as significant throughout the whole account of the mosaics in the poem. Mesarites' account placed more weight on the effect of the Transfiguration on the apostles and the significance of certain elements of the scene: why Moses and Elijah appeared with Christ, and the wonders of the light and brilliance. From what the texts tell us, *pace* Friend and Weitzmann, although they provide a general description of who was shown and where, they are not detailed enough to detect what the specific iconography of the scene might have been. Rather, each author took the Gospel story as it was translated into an image at the Holy Apostles, or as they and their audiences might have expected such an image to be depicted, and turned it back again into a story for that audience. In effect, in fact, this was what Friend and Underwood themselves in their turn did with their image of the mosaic of the Holy Apostles. The central medallion of Christ, Moses, and Elijah replicates Iviron 1 rather than the Paris Gregory, with the addition above of a swooping dove; immediately below Christ, Peter, James, and John are shown in their Iviron 1 pose (Appendix A.15, A16, and A.17). Around the rest of the rim are three additional scenes playing out other elements of the story: Christ ascending Tabor with the apostles; Christ reassuring the apostles; Christ instructing them to keep silent—scenes for which no Byzantine parallels survive.

The image of Christ is equally generic. In Constantine's poem, the central dome

> was destined to be the great throne of the Lord,
> A shelter of the exceedingly honoured image

Painted in the middle of the renowned house.[52]

The image itself is described later in the poem: the church is a "heaven-formed dwelling on earth,"

> with Christ depicted as the sun,
> A wonder of wonders beyond words,
> In the middle of the exceedingly-honoured roof itself,
> And furthermore, the undefiled Virgin like the moon
> And, like the stars, the wise Apostles.[53]

It seems likely that this is the same image of Christ in the main central dome of the church, but whether the text should be interpreted to locate the Virgin and apostles in the central dome as well can be debated, and there is certainly nothing to establish the scene (assuming it is one scene) as an Ascension, a scene which would contain all three elements together, simply because that is the case at San Marco in Venice.[54] These could as easily be three separate mosaics, the sun, moon, and stars, located anywhere within the church, or even an alternative scene containing these three elements, as the Koimesis does, for example.

Mesarites' description is also of the image of Christ in the central dome. It says that the "God-Man Christ" is portrayed "leaning and gazing as through from the rim of heaven," shown as far as his navel; his head is the same size as his body; to those who have a clean understanding, his look is gentle and mild; to sinners, the face is wrathful, terrifying, and stern. The right hand blesses, the left holds the Gospel book; Christ wears a robe colored with more blue than gold.[55] The reasons for suggesting that the eleventh-century mosaic of the Pantokrator at Daphni was modeled on this are very obvious, but such apparent

52 Constantine the Rhodian, *Ekphrasis*, lines 626–630, ed. and trans. James, *Constantine of Rhodes*, 60–61.

53 Constantine the Rhodian, *Ekphrasis*, lines 735–741, ed. and trans. James, *Constantine of Rhodes*, 68–69.

54 As suggested by Wulff, "Sieben Wunder"; Heisenberg, *Apostelkirche*, 2:239–41; and Malickij, "Remarques sur la date," 129.

55 Mesarites, *Ekphrasis*, cc. 13.5–9 and 14, ed. Heisenberg, *Apostelkirche*, 28–30; trans. Downey, "Nikolaos Mesarites," 884.

similarities are not proof of either deliberate imitation or of direct copying, nor indeed of any actual resemblance. As with the descriptions of the Transfiguration, the two accounts have been interpreted as portrayals of two different images, and so of two different dates for the mosaics of the Holy Apostles. But it is not necessary to assume that Mesarites' Christ is not the same as Constantine's: there is simply not enough to go on. Again, in contrast to scholarship of the 1940s, some scholars now would tend to argue that, like the Transfiguration, each author describes the image of Christ as he does for his own purposes within his particular text.

Intrinsic in the reconstructions of scholars from Heisenberg to Friend was the ongoing debate about the relationship between the mosaics described by Constantine and those described by Mesarites. Did the two authors describe the same set of mosaics (and if so, what date were those mosaics?) or had they changed (and if so, how many times?) in the two centuries or so between the texts? Coupled with this were largely unarticulated ideas about which of the two was the more "reliable" writer. However, that the differences between the two authors are less meaningful than has been appreciated is perhaps a point made by the ninth-century homily of Leo VI, a work that predates Constantine's poem.[56] It describes mosaic scenes in the Holy Apostles that are found in both Constantine and Mesarites (the image of Christ in the central dome), or in Mesarites but not in Constantine (Pentecost), and it also describes a scene not mentioned by either (the ranks of angels). This makes it very apparent that Byzantine authors could and did pick and choose what they described, and that scholars need to be very careful in interpreting divergences in accounts. The homily makes it abundantly clear that the presence of a scene in Mesarites' account but not in Constantine's is no guarantee that that scene did not exist in the church when Constantine wrote. It also means that the discrepancies between the two cannot be used to prove that Mesarites was looking at a later, "vastly richer" set of mosaics.

Dating the Mosaics of the Holy Apostles

Both of these examples highlight a central issue in discussions of the mosaics of the Holy Apostles: their date. The logic of the association made by Friend and others between the Transfiguration of the texts and the many post-iconoclastic examples of art, and the conscious dissociation of the scene from that in St. Catherine's is that the mosaic in the Holy Apostles was ninth century not sixth century. The possible date of the image of Christ in the dome is even more complex because of the different ways in which it has been interpreted (Ascension? Pantokrator?) Some of the earliest discussions of the mosaics located them firmly in the sixth century, part of the original Justinianic decoration. The building described by both Constantine and Mesarites was almost certainly the same one, the church put up by Justinian in the sixth century. It may or may not have contained mosaics. Heisenberg in 1908 pre-Friended Friend by interpreting Constantine's account in terms of the iconography of sixth-century art and he asserted that Constantine and Mesarites described the same set of mosaics.[57]

In contrast to Heisenberg, however, Friend gave short shrift to any idea of sixth-century mosaics. He seems to have taken the view that Constantine and Mesarites described the same mosaics, and he asserted that these mosaics were the creation of Photios as a response to Iconoclasm, with a specific date in the 870s to 880s. The evidence he cited for this was twofold. There was the statement made in the tenth-century *Life of Basil* that Basil I had restored the Holy Apostles: "The emperor also reinforced the famous and most spacious temple of the Divine Apostles, no longer displaying its former pleasing appearance and solid construction, by buttressing it up all around and by having its ruined parts rebuilt; thus did he wipe off the <traces of> old age and the wrinkles left by time and rendered the church beautiful and wrought anew again."[58]

56 James and Gavril, "Description of the Church of the Holy Apostles."

57 Heisenberg, *Apostelkirche,* and Heisenberg, "Alten Mosaiken." Wulff ("Sieben Wunder," 316–31) also dated most of the mosaics to the 6th century, though he argued that the image of Christ in the main dome should be interpreted as a Pantokrator and consequently dated to after Iconoclasm.

58 *Life of Basil,* 80: Ševčenko, *Vita Basilii,* 266–27.

There was also Friend's own uncorroborated belief that the image of the Transfiguration in the Paris Gregory was a copy of the mosaic version in the Holy Apostles. This meant that the mosaics must have predated the manuscript, which was, in his view, definitively dated to 886.[59] His dating was a further and inevitable consequence of his argument that the mosaics were both copied widely in middle Byzantine art (allowing them to be reconstructed), and that they formed a coherent program aimed at the Iconoclasts.

This idea of a full ninth-century mosaic program on the evidence of the *Life of Basil* is a recurrent one.[60] Whether the text supports such a reading is another matter: it is certainly not specific. There is also the reverse story told by the tenth-century *Patria* in which Basil "took the mosaic and the marbles away [from the Holy Apostles] when he built the New Church and the <Church of the Mother of God of the> Forum."[61] These two textual references seem to directly contradict each other, and although it is possible to construct a variety of scenarios that would allow for both events to have taken place, the written sources do not offer any help. All they say is that Basil may or may not have carried out repairs on an unknown scale in the Holy Apostles.

In the 1960s, in part because of the perceived differences between Constantine and Mesarites on the mosaics, Krautheimer (who had been invited to the Dumbarton Oaks Symposium but whose attendance is not recorded) proposed another restoration of the church.[62] He dated it to fewer than a hundred years after Basil's work, at some point between 940 (his dating of Constantine's poem) and 989, an unattested reconstruction in the reign or reigns of any one of six possible emperors, Constantine VII, Romanos I, Romanos II, Nikephoros II Phokas, John Tzimiskes, and Basil II.[63] Krautheimer's

argument was based on a belief that the church of the Holy Apostles was accurately pictured in the *Menologion of Basil II* (Vat. Gr.1613, fols 121r, 341r, 353r), which he saw as dated very precisely to 989.[64] These pictures of the church showed it with fenestrated domes in contrast to Procopius's account, which had described the drums of the domes as unfenestrated, as had Constantine's account, or so Krautheimer claimed, though in fact, Constantine did not mention the windows of the church at any point in his poem. But methodologically, little had changed. As with the arguments of scholars in the 1940s and 1950s, that of Krautheimer also depended on an acceptance that images in manuscripts were accurate portrayals of the buildings or monuments (or, presumably, people) that they purported to show. It is a very similar use of manuscript imagery to that of Friend, who had dated the mosaics to before 886 on the basis of a parallel comparison with the Paris Gregory.[65]

Ernst Kitzinger (who did attend the Dumbarton Oaks Symposium) accepted Krautheimer's arguments about Basil's redecoration of the church but additionally proposed a later also unrecorded redecoration inside the building on the basis that the differences between Constantine's and Mesarites' accounts of the mosaics meant that Mesarites described a "vastly richer" cycle of Christological scenes than Constantine.[66] For Kitzinger, this cycle fitted a tendency toward an increase in narrative scenes that he claimed was apparent in later Byzantine churches, such as Monreale on Sicily. The more detailed cycle at the Holy Apostles indicated that there had been both a restoration and a development of the mosaics of the church, which in turn posited a new wider phase of Byzantine mosaic decoration between the tenth and twelfth centuries, spearheaded by the Holy Apostles. In this model, the "simpler" pre-iconoclastic tendency to single figures and nonnarrative scenes developed after Iconoclasm

59 Brubaker, *Vision and Meaning*, 5–7, dating it to 879–882.

60 For example, in Ibid., 305.

61 *Patria*, book 4, 32.

62 See Appendix I, 423. Underwood Papers ICFA, MS.BZ. 019-03-01-050, "Correspondence and miscellaneous documents pertaining to the 1948 Symposium on The Church of the Holy Apostles in Constantinople," also in DOA, Byzantine Studies, Symposium 1948. On this attendance list is Krautheimer's name but with crosses against his attendance.

63 Krautheimer, "Note on Justinian's Church."

64 S. Der Nersessian, "Remarks on the Date of the Menologium and the Psalter Written for Basil II," *Byzantion* 15 (1940–41): 104–25, made a widely accepted case for the less specific "after 979."

65 See Epstein, "Rebuilding and Redecoration."

66 E. Kitzinger, "Byzantine and Medieval Mosaics after Justinian," *Encyclopaedia of World Art* 10 (London and New York, 1965), 344.

into the very full, complex, and detailed narrative programs in place by the twelfth century. Part of Kitzinger's rationale was that he believed that the mosaics of buildings such as the Cappella Palatina, the Martorana, Cefalù, and Monreale in the Norman Kingdom of Sicily could be used as models for interpreting the lost mosaic cycles of Constantinople, extrapolating from what is visible in Sicily to what must have existed in Byzantium, a strategy remarkably Friend-like in nature.[67] The lost mosaics of the Holy Apostles served to close his circle.

The rationale for both Krautheimer's and Kitzinger's creations of new phases of decoration for the church appears to have been those apparent differences in the accounts of the mosaics of the Holy Apostles as given by Constantine the Rhodian and Nicholas Mesarites. But, as discussed earlier, the texts themselves do not allow these conclusions to be drawn. The accounts of both authors share a level of generality, perhaps derived from their common source, the Gospels; Leo VI's homily reveals the inherent flaw in seeing variances in the texts as indicating modifications on the church wall. In fact, it is possible (if not necessarily desirable) to adduce the presence of mosaics from the sixth, ninth, and twelfth centuries alike. In Constantine's description,

> With gold mingled with glass
> the architect [Isidore or Anthemios] made golden everything in the interior
> as far as the height of the dome-constructed roof
> reaches and as far as the hollows of the vaults,
> and down to the many-coloured marble slabs themselves
> and down to the second cornices,
> depicting contests and images worthy of veneration,
> which teach us the abasement of the Word and His presence among us mortals.
> The first wonder then is Gabriel.[68]

The context and phrasing of that passage suggests that Constantine was implying that mosaic was put into the church by the architect when the church was built in the sixth century. This is perfectly possible: figural mosaic survives from the sixth century covering a wide range of topics—scenes from the life of Christ, scenes of Christ in Majesty, images of the Mother of God.[69] Although this is an argument *ex silentio,* the Holy Apostles would have been remarkable among imperial Byzantine churches if it had had bare walls and vaults.

Some of the mosaics may well have been post-Iconoclastic. There is enough textual evidence to suggest that the ninth century saw a whole cluster of new Constantinopolitan churches, such as the Nea, the Pharos, and the church of Elijah, founded and decorated with mosaic; and Hagia Sophia itself had new mosaics added to it. More specifically with regard to the Holy Apostles, in the scene of the Presentation, Constantine described Symeon as holding the Christ child; in the Crucifixion, he described Christ hanging as a "naked" corpse on the cross.[70] Both iconographic details are known only from post-Iconoclastic works of art. Whether they conclusively prove that these particular mosaics were installed after Iconoclasm is another matter. To date them as post-Iconoclastic relies on a belief that we know of no pre-Iconoclastic images of these events shown in this way because they did not exist, rather than an understanding that we do not know them because they have not survived, and they depend on our accepting that Constantine described what he saw with absolute accuracy,

67 E. Kitzinger, "The Mosaics of the Cappella Palatina in Palermo: An Essay on the Choice and Arrangement of Subjects," *ArtB* 31 (1949): 269–92. Note the date of this article.

68 Lines 742–751; trans. is that of James, *Constantine of Rhodes,* 68–71.

69 For example, in Ravenna at Sant'Apollinare Nuovo, San Vitale, the Eufrasian Basilica in Poreč, St. Catherine's Monastery on Mt. Sinai, and the Cypriot churches of Lythrankomi and Kiti.

70 For Symeon, Constantine the Rhodian, *Ekphrasis,* line 781, ed. and trans. James, *Constantine of Rhodes,* 70–71, and H. Maguire, "The Iconography of Symeon with the Christ-Child in Byzantine Art," *DOP* 34/35 (1980/81): 261–69. For the naked Christ see Constantine the Rhodian, *Ekphrasis,* line 928, ed. and trans. James, *Constantine of Rhodes,* 80–81, and Martin, "Dead Christ." Given where this was published, it is no surprise that Martin appears to believe that the image on fol. 30v of the Paris Gregory and the Crucifixion in San Marco were taken from the mosaics of the Holy Apostles. On the Paris Gregory image and the iconography of the dead Christ see L. Brubaker, "Every Cliché in the Book: The Linguistic Turn and the Text-Image Discourse in Byzantine Manuscripts," in *Art and Text in Byzantine Culture,* ed. L. James (Cambridge, 2007), 67–71.

rather than describing what he expected to see. It is worth recalling here Photios's homily on the image of the Mother of God in Hagia Sophia, in which he described Mary as a standing figure, turning her eyes on her Child, whereas in the mosaic she sits and stares out into the church. These discrepancies have also caused scholars some problems.[71]

Other iconographic elements may hint at twelfth-century mosaics. Henry Maguire has suggested that what Mesarites described in the poses of the Apostles at the Transfiguration is closer in appearance to twelfth-century than sixth-century examples.[72] Another intimation comes in Mesarites' account of the Women at the Tomb. He says: "Our discourse, in looking and gazing round curiously hither and thither has recognised the man who with his own hand has depicted these things, as he may be seen standing upright by the Lord's tomb, like a watchful guard, dressed in the same robe and other garments which he wore... when he was living and painting these things," taken perhaps as implying that the artist (of this scene? of the mosaics? A painter? Or perhaps a writer?) put himself in the picture. An undated marginal note on the thirteenth-century manuscript of Mesarites' text gives a name: "He means Eulalios."[73] An artist named Eulalios was hailed as a great painter in two poems of Theodore Prodromos and in verses by the fourteenth-century author Nikephoros Kallistos, including one which associated him with the "image of Christ in the central dome of the Holy Apostles" (this is the heading to the verses).[74] Whilst it is possible that Eulalios was a famous and well-remembered artist from an earlier period, it has been more widely accepted that he was probably a twelfth-century artist, and this would make him contemporary with Prodromos, if not Mesarites.[75] However, whether Eulalios actually existed at all is a moot point: the reference has been plausibly interpreted as one to the "sweet-speaking" author, Mesarites, himself.[76]

So none of this is conclusive. Nevertheless, taken together, these hints imply that there was no single uniform program or installation of mosaics in the Holy Apostles. Rather, it was a piecemeal process over a long time. This would fit very well with what is known about the installation of mosaics in other major medieval churches. Of all the great medieval monuments with mosaics, none ever had a set of mosaics or indeed a program that remained constant. In Hagia Sophia, Justinian began the mosaicking of the church, but subsequent emperors added to them: the apse; the narthex and southwest vestibule panels; the imperial panels of the north and south galleries; the Deësis in the south gallery; and the assortment of mosaics known from written sources but which survive only in those sources or as shadowy outlines, such as the Pentecost so beloved of Friend or the mosaics of the eastern arch. In many cases with the Hagia Sophia mosaics, if the images themselves did not survive, nothing of them would have

71 Photios, *Homily* 17: 2. B. Laourdas, ed., Φωτίου Ὁμιλίαι (Thessalonike, 1959); C. Mango, trans., *The Homilies of Photius Patriarch of Constantinople* (Washington, DC, 1958), 294. For an attempt to suggest that the mosaic and the homily do not go together, see N. Oikonomides, "Some Remarks on the Apse Mosaics of St. Sophia," *DOP* 39 (1985): 111–15.

72 See H. Maguire, "Truth and Convention in Byzantine Descriptions of Works of Art," *DOP* 28 (1974): 122–25, for the Transfiguration and other possible 12th-century scenes. This conclusion was also reached by Otto Demus for similar reasons: Demus, *Mosaics of San Marco*, 232n5, referring also to Underwood's unpublished work on the Holy Apostles in Dumbarton Oaks. The authors (C. Mango, T. E. Gregory) of *ODB*, 2:940, s.v. "Holy Apostles, Church of the," seem to believe in a 12th-century restoration of the mosaics.

73 Mesarites, *Ekphrasis*, c. 28.23, ed. Heisenberg, *Apostelkirche*, 32–37; trans. Downey, "Nikolaos Mesarites," 871–73. See Maguire, "Truth and Convention," 122–23; C. Mango, *The Art of the Byzantine Empire 312–1453* (Toronto, 1972), 229–33, which collects all the references to Eulalios; O. Demus, "'The Sleepless Watcher': Ein Erklärungsversuch," *JÖB* 28 (1979): 241–45.

74 Eulalios is also mentioned in epigrams by Manganeios Prodromos. For Theodore Prodromos as the author of supplicatory verses to Manuel I Komnenos that mention Eulalios, see A. Maiuri, "Una nuova poesia di Teodoro Prodromo in greco volgare," *BZ* 23 (1914–19): 397–407; for debates over the authorship of this text, see H. Eideneier, *Ptochoprodromus: Einführung, kritische Ausgabe, deutsche Übersetzung, Glossar* (Cologne, 1991), 34–37. My thanks to an anonymous reader for stressing this point. That Eulalios was credited with the central dome in the 14th century may reflect a 12th-century repair to that image or simply a later attribution.

75 S. Kalopissi-Verti, "Painters in Late Byzantine Society: The Evidence of Church Inscriptions," *CahArch* 42 (1994): 139–58, and M. Vassilaki, "From the 'Anonymous' Byzantine Artist to the 'Eponymous' Cretan Painter of the Fifteenth Century," in Το πορτραίτο του καλλιτέχνη στο Βυζάντιο, ed. M. Vassilaki (Heraklion, 1997), 161–209.

76 B. Daskas, "A Literary Self-Portrait of Nikolaos Mesarites," *BMGS* 40, no. 1 (2016): 151–69.

come down in the surviving sources. The apse mosaic is recorded in Photios's homily, but no one appears to have noted the installation of mosaic by Alexander, Romanos and Zoe, and then Constantine Monomachos, or by John II Komnenos. Even the Deësis panel of the south gallery passes by unremarked in written texts.

Additionally, as Hagia Sophia also reveals, mosaics were frequently restored and repaired. This is something rarely mentioned by Byzantine sources. In Rome, however, it is very clear that popes repaired, restored, and added to the mosaics of old St. Peter's on many occasions—and this was often noteworthy—as well as in the other great papal basilicas of San Giovanni in Laterano, San Paolo *fuori le mura,* and Sta. Maria Maggiore, among others. In Venice, the mosaics of San Marco, Friend's and Underwood's first port of call for imagining the Holy Apostles, were hardly a well thought out, coherent, and organized program. They went up over a period of at least five hundred years and have consistently been updated, added to, changed, and repaired.[77] The same cycle of repair, renewal, and restoration is apparent in the expanses of mosaic preserved in the Dome of the Rock in Jerusalem and the Great Mosque of Damascus. In other words, it is very clear that major mosaics underwent consistent regeneration. The Holy Apostles was surely another such case. Though its original mosaics were almost certainly Justinianic, Basil I could well have renewed them, and others may well also have done so, only no one bothered to note it down because it was not worth recording.[78] What both Constantine and Mesarites would have seen was surely a fairly eclectic mixture of mosaics, though it seems unlikely that either cared about this aspect. Moreover, it is more than likely that what Mesarites saw was not exactly the same as what Constantine saw, though it is impossible to be certain about what changed between the two authors' accounts.

Rather, in the texts of both Constantine and Mesarites, one of the key questions to ask is what it was that they wanted their audiences to take away from their accounts of the mosaics, how they chose to bring the mosaics to life to accomplish their goals, and what those differences might tell us about the perceptions of their viewers. In the case of Constantine, his Holy Apostles is a magical building in which the mosaics both demonstrate and prove to their post-Iconoclasm audiences the wonders of the Incarnation of Christ (visible in the Transfiguration, for example, through his transforming of his "mortal form") and of his mission of salvation through his suffering on the cross (foreshadowed throughout Constantine's account of the Transfiguration). Perhaps, then, a key value of Friend's monumental work, though it is unlikely that he would ever have expressed it like this, was in his asking how a ninth-century audience might have understood the mosaics of the Holy Apostles, whatever date they were. In the context of audience perception rather than building reconstruction, my reading of Constantine's text argued that a ninth-century author or audience could have interpreted the mosaics in terms of a statement or statements about Iconophile theology, the nature of Christ, and the depiction of the divine, just as Photios did for his audience in Hagia Sophia and the Pharos, just as Leo VI may have done for his audiences in his sermons on the Kauleas Monastery and the church built by Stylianos Zaoutzas, and just as Constantine the Rhodian did with the Holy Apostles.[79]

The Influences of the Mosaics of the Holy Apostles

Nonetheless, the Holy Apostles project haunts the study of Byzantine and medieval mosaics, present above all in the writings of Demus and Kitzinger, two of the greatest and most significant figures in the study of Byzantine art. In 1948, Demus's publication of *Byzantine Mosaic Decoration* established the "Classical System of Middle Byzantine Church Decoration," the idea that mosaic programs were coordinated and coherent to a standard pattern. This is a concept

77 As the two volumes of O. Demus, *The Mosaics of San Marco in Venice* (Chicago, 1984), make very clear.

78 Justin II, for example, mentioned by Theophanes as having "adorned" both Hagia Sophia and the Holy Apostles: Theophanes, *Chronographia,* AM 6058 (565 AD), ed. de Boor, 242; trans. Mango and Scott, *Chronicle of Theophanes Confessor,* 355. Epstein, "Rebuilding and Decoration," considers that Constantine and Mesarites describe the same mosaics.

79 James, *Constantine of Rhodes,* 211–17.

fundamental to Friend and his reconstruction of the mosaics of the Apostoleion: as I noted above, he could posit the presence of a scene of the Anastasis because he believed that there was a consistent program of Byzantine church decoration. Indeed, Demus himself found the idea of a middle Byzantine program convincing because he felt that Mesarites' account made it appear as if the mosaics were arranged hieratically—and must therefore have been ninth century or later.[80] In 1949, both Demus and Kitzinger came to Dumbarton Oaks to speak about mosaics, a sort of progress report on their research projects in Venice and Sicily. When he finally published the massive undertaking of the San Marco mosaics, Demus used Underwood's typescript (or possibly typescripts) on the architecture of the Apostoleion in formulating his own discussion of the mosaics of San Marco and what San Marco had taken from the Holy Apostles, though he noted that he had been obliged to part company with Friend in Friend's reconstructions.[81] Kitzinger, according to the delegate list, had been present at the 1948 Symposium, and so may well have heard Friend on the theme. His views on the mosaics of the Holy Apostles are widely available because John Beckwith put them into his still-in-print handbook, *Early Christian and Byzantine Art*, where they remain. Krautheimer's, too, remain in circulation via his general handbook, *Early Christian and Byzantine Architecture*.[82] The belief that the mosaics of the Holy Apostles were ninth century is kept alive by the *Oxford Dictionary of Byzantium*, among others.[83] The reverberations of the Holy Apostles project can still be felt well beyond Dumbarton Oaks.

The project too, in the twenty-first century, has the potential to shape and define the building. In terms of the Holy Apostles, what Underwood's and Friend's reconstructions offer is a church that is effectively an appropriation of sixth-century architecture using tenth-century buildings as a model, and a set of mosaics that are a pastiche of what ninth-century mosaics might have looked like, based on tenth- to twelfth-century art. And all of it is founded on the premise that the lost can be re-created from texts and the close study of what are deemed to be parallel monuments. But in a digital age, it becomes even easier for the image to become confused with the reality, for those reconstructions to become actuality simply because they exist on the internet, for a story to be "true" because it is on Wikipedia. Digital media has hijacked and transformed memory.[84] That is one of the reasons that I have labored here to insist that reconstruction should not be confused with reality; lost monuments cannot be regained through "a reconstruction from the texts controlled by the comparison of parallel monuments."

The mosaics are gone. The reconstructions of Underwood and Friend, like Constantine's and Mesarites' texts, give us no idea what the Holy Apostles and its mosaics looked like—though unlike the Byzantine authors, they do show exactly where they got their ideas. Rather, the reconstructions are fascinating documents for the history of Byzantine art history, documents whose influences remain potent ekphraseis in their own right, themselves located in time.

80 O. Demus, *Byzantine Mosaic Decoration* (London, 1948). For Demus, such programs reached their full flowering in the 11th century, but then what of the cycles in 9th-century Constantinople, including that of the Apostoleion?

81 Demus, *Mosaics of San Marco*, 1:364n5, 364–66n7. In his *Byzantine Mosaic Decoration*, 17 and 19, although Demus says that the domes of the Holy Apostles contained mosaics, he does not specify which ones.

82 J. Beckwith, *Early Christian and Byzantine Art* (Harmondsworth, 1970), 222. Beckwith's arguments were also based on Krautheimer's belief that the Holy Apostles was pictured in the *Menologion of Basil II* and the two manuscripts of James Kokkinobaphos. R. Krautheimer, *Early Christian and Byzantine Architecture* (London, 1965), 242.

83 *ODB*, s.v. "Holy Apostles, Church of the."

84 For these as issues see B. Fitzgerald, "Here There Be Monsters," *The Daily News* 14 September 2012, accessed 1 May 2018, https://themorningnews.org/article/here-there-be-monsters, an account of a digital history hoax where an historian at George Mason University, as part of a course entitled "Lying about the Past," got his students to create a hoax, put it online, and the internet got angry because it undermined the assumption that material on the internet is true (or at least is created with the intention of being true). Also see H.-J. Bucher, "Crisis Communication and the Internet: Risk and Trust in a Global Media," *First Monday* 7, no. 4 (1 April, 2002), accessed 1 May 2018, http://firstmonday.org/ojs/index.php/fm/article/view/943/865. My thanks to my colleague James Baker for discussions about these issues. More conventionally, see A. Hoskins, "Archive Me! Media, Memory, Uncertainty," in *Memory in a Mediated World,* ed. A. Hajek (London, 2015), 13–35.

The Logos of Nicholas Mesarites

RUTH MACRIDES

NICHOLAS MESARITES' DESCRIPTION OF THE CHURCH OF THE HOLY Apostles, the work for which he is best known thanks to the English translation by Glanville Downey,[1] is one of the two texts at the center of the Holy Apostles "puzzle." His twelfth-century description and that of Constantine the Rhodian two centuries earlier provide the only surviving evidence for the mosaics of the church. The differences in the *ekphraseis* of the two authors have long been noted, commented on, and tentatively resolved in various ways. The discrepancies in their two works are with respect to the number of scenes described by each author, the specific scenes included by one and not the other, and the details mentioned by one and not the other in scenes common to both.[2] To those art historians who studied the texts it seemed that Mesarites described a "vastly richer" cycle of scenes from the life of Christ, that there was a new phase of mosaic decoration created sometime between the tenth and the twelfth centuries.[3] For some, the mention by Mesarites of the portrait of the artist included in the scene of the Women at the Tomb was a sure indication that this mosaic was from the twelfth century, and that other parts of the mosaic cycle of the church were also from that century.[4] Another view, and one that will be explored here, is that the differences between the descriptions of Constantine the Rhodian and Nicholas Mesarites can be explained by "reference to the literary currents of their respective periods" more than by a change in the mosaics.[5]

The controversy has mainly involved historians of art, while the ekphraseis in question have been studied in isolation from the other writings of the respective authors. Although by the time of the Holy Apostles symposium of 1948, Mesarites' main surviving works had already been published by August Heisenberg—that is, the account of the coup of John Komnenos, the *Ekphrasis* of the Holy Apostles, the *epitaphios* for John Mesarites, the letters to the monks of the Euergetis monastery in

All translations are my own, but in cases where translations of the texts have been published, I have given references to them.

1 G. Downey, "Nikolaos Mesarites: Description of the Church of the Holy Apostles at Constantinople," *TAPS*, n.s. 47, part 6 (1957): 855–924.

2 L. James, ed., *Constantine of Rhodes, On Constantinople and the Church of the Holy Apostles, with a New Edition of the Greek Text by Ioannis Vassis* (Farnham, Surrey, and Burlington, VT, 2012), 186, 204–16.

3 E. Kitzinger, "Byzantine and Medieval Mosaics after Justinian," *Encyclopaedia of World Art* 10 (London and New York, 1965), 344. C. Mango, *The Art of the Byzantine Empire 312–1453: Sources and Documents* (Englewood Cliffs, NJ, 1972), 229–30; *ODB* 2:745 (Eulalios).

4 Nicholas Mesarites, *Description of the Church of the Holy Apostles at Constantinople*, c. 28.23, ed. A. Heisenberg, *Grabeskirche und Apostelkirche: Zwei Basiliken Konstantins,* vol. 2, *Die Apostelkirche von Konstantinopel* (Leipzig, 1908), 63.18–64.3; ed. and trans. G. Downey, "Nikolaos Mesarites," 910 and 884n30. The arguments are summarized by N. Maliskij, "Remarques sur la date des mosaïques de l'église des Saints-Apôtres à Constantinople décrites par Mésaritès," *Byzantion* 3 (1926): 123–51, here at 123–26. For the 12th-century date, see also now N. Zarras, "A Gem of Artistic Ekphrasis: Nicholas Mesarites' Description of the Mosaics in the Church of the Holy Apostles at Constantinople," *Byzantium, 1180–1204: "The Sad Quarter of a Century"?* ed. A. Simpson (Athens, 2015), 261–82.

5 A. W. Epstein, "The Rebuilding and Redecoration of the Holy Apostles in Constantinople: A Reconsideration," *GRBS* 23 (1982): 79–92, here at 89, 84–85.

Constantinople, and accounts of ecclesiastical debates with the Latins[6]—Mesarites was not studied as a writer, for his entire oeuvre, but rather as a producer of information: a purveyor of facts about discussions between the Greeks and Latins on ecclesiastical matters, the iconography of the Holy Apostles, the failed usurpation attempt of 1200, the life and education of John Mesarites, travel conditions and attitudes toward travel in the early thirteenth century,[7] and so on. Since 1948, very little has been said about Mesarites as an author,[8] although much has been said about ekphrasis as a rhetorical tool.[9] Indeed, of the changes that have occurred in scholarly practice since the first symposium on the Holy Apostles, it is the way texts are read and the questions asked of them that are at the forefront. Now

is a good time to have another look at Mesarites as an author, now that more of the written works of Mesarites and his contemporaries have been published, now that knowledge of literary developments in the eleventh and twelfth centuries has advanced. Now, too, Mesarites is receiving a burst of attention from scholars.[10] By looking at Mesarites' writing as a whole, recurring themes and motifs, his interests and emphases, we may come to a better understanding of the *Ekphrasis* of the Holy Apostles, that verbal monument, as he called it,[11] that complemented the physical building and its mosaics.

Nicholas Mesarites' life and work straddle the twelfth and thirteenth centuries, divided into a before and after by the events of 1204.[12] Born in Constantinople in the reign of Manuel I Komnenos in the 1160s, he died sometime in the early decades of the thirteenth century, as a subject of a Laskaris emperor in Asia Minor. The eighth child of his parents, he obtained an education in Constantinople; his father held a high position at court.[13] References in his writings and in the titles to his works help to piece together his career. He mentions that he was a

6 A. Heisenberg, *Nikolaos Mesarites: Die Palastrevolution des Johannes Komnenos*, Programm des k. alten Gymnasiums zu Würzburg (Würzburg, 1907); idem, *Apostelkirche*; idem, "Neue Quellen zur Geschichte des lateinischen Kaisertums und der Kirchenunion. I. Der Epitaphios des Nikolaos Mesarites auf seinen Bruder Johannes," in *Sitzungsberichte der bayerischen Akademie der Wissenschaften* (Munich, 1923) (hereafter Heisenberg, "Epitaphios"); idem, "Neue Quellen zur Geschichte des lateinischen Kaisertums und der Kirche. II. Die Unionsverhandlungen vom 30. August 1206. Patriarchenwahl und Kaiserkrönung in Nikaia 1208," in *Sitzungsberichte der Bayerischen Akademie der Wissenschaften* (Munich, 1923) (hereafter Heisenberg, "Reisebericht"); idem, "Neue Quellen zur Geschichte des lateinischen Kaisertums und der Kirche. III. Der Bericht des Nikolaos Mesarites über die politischen und kirchlichen Ereignisse des Jahres 1214," in *Sitzungsberichte der bayerischen Akademie der Wissenschaften* (Munich, 1923).

7 For a summary of the work that has been done in these various areas, see M. Angold, "Mesarites as a Source: Then and Now," *BMGS* 40, no. 1 (2016): 55–68.

8 The exception is Alexander Kazhdan in his comparison of the accounts of Mesarites and Chrysoberges on the coup of 1200: "Nicephorus Chrysoberges and Nicholas Mesarites: A Comparative Study," in A. Kazhdan and S. Franklin, *Studies on Byzantine Literature of the Eleventh and Twelfth Centuries* (Cambridge, 1984), 224–55. See also T. Baseu-Barabas, "Zwischen Wort und Bild: Nikolaos Mesarites und seine Beschreibung des Mosaikschmucks der Apostelkirche in Konstantinopel (Ende 12. Jh.)" (PhD diss., University of Vienna, 1992), 230. See, now, M. Angold, *Nicholas Mesarites: His Life and Works (in Translation)*, TTB 4 (Liverpool, 2017), 22–30 and *passim*.

9 E.g., H. Maguire, *Art and Eloquence* (Princeton, 1981); L. James and R. Webb, "'To understand ultimate things and enter secret places': Ekphrasis and Art in Byzantium," *Art History* 14 (1991): 1–15; R. Webb, "Ekphrasis Ancient and Modern: the Invention of a Genre," *Word and Image* 15, no. 1 (1999): 7–18; eadem, *Ekphrasis, Imagination, and Persuasion in Ancient Rhetorical Theory and Practice* (Aldershot and Burlington, VT, 2009).

10 The latest publication is an edition of two letters of Mesarites: A. Cataldi Palau, "Nicolas Mésarités: Deux lettres inédites (Milan, Ambrosianus F 96 Sup., FF. 15v–16v)," in *Manuscripta Graeca et Orientalia*, ed. A. Binggeli, A. Boud'hors, and M. Cassin (Leuven, Paris, and Bristol, CT, 2016), 187–232. Michael Angold (*Nicholas Mesarites*) has translated into English all the published works of Mesarites. See also his "Mesarites as a Source." Beatrice Daskas has several studies in preparation. See B. Daskas, "Images de la ville impérial dans les ΕΚΦΡΑΣΤΙΚΑΙ ΔΙΗΓΗΣΕΙΣ de Nicolas Mésarités: Le *Récit sur la révolution de palais*," in *Villes de toute beauté: L'Ekphrasis des Cités dans les littératures byzantines et byzantino-slaves*, ed. P. Odorico and C. Messis (Paris, 2012), 135–48, and eadem, "A Literary Self-Portrait of Nikolaos Mesarites," *BMGS* 40, no. 1 (2016): 151–69.

11 "[This house] which I propose to build with materials from speech and the creations of the mind": Mesarites, *Ekphrasis*, c. 12.4, ed. Heisenberg, *Apostelkirche*, 23.7–9; ed. and trans. Downey, "Nikolaos Mesarites," 867; trans. Angold, *Nicholas Mesarites*, 90. On this passage, see R. Webb, "The Aesthetics of Sacred Space: Narrative, Metaphor, and Motion in *Ekphraseis* of Church Buildings," *DOP* 53 (1999): 59–74, here at 63.

12 In the titles to his works Mesarites specifies the time of composition by reference to "the conquest," "the captivity," "as if the world began again" after this date, as Cataldi Palau, "Deux lettres inédites," 198–99, remarks. For his life and career, see now Angold, *Nicholas Mesarites*, 1–13.

13 Mesarites, "Epitaphios," cc. 6, 8, ed. Heisenberg, "Epitaphios," 20, 22.3–8; trans. Angold, *Nicholas Mesarites*, 144–45, 146–47.

didaskalos teaching in Constantinople before 1204.[14] In 1200 at the time of John Komnenos's coup, he was *skeuophylax*[15] or keeper of the sacred treasury of the Great Palace churches; at the same time he was deacon and *epi ton kriseon,*[16] a judicial position in the hierarchy of the Great Church. In 1208 he is attested as deacon and *referendarios* of the church.[17] By 1211 he was metropolitan of Ephesos and exarch of all Asia,[18] the culmination of his career. The last surviving text associated with him, a synodal act, dates to 1216.[19] He died at some undetermined time after that date.[20] It was not only his life that was divided by the events of 1204, so also was his family; while Nicholas died in Anatolia as a subject of the emperors at Nicaea, his brother John, who had chosen the monastic life after his higher education, died in Latin-held Constantinople in 1207.

If, as is thought, Nicholas himself wrote the titles to his works,[21] we can infer from them that he was interested in providing precise indications of the circumstances in which he wrote.[22] He was likewise interested in letting his readers know about other aspects of his work: the range of his writings. In his epitaphios for his brother John he lists the kinds of texts he produced when he "bore the yoke of the *didaskalos* on his shoulders" and later. He mentions commentaries, imperial encomia, ekphrastic narratives, *ethopoiia,* and letters.[23] Apart from the commentaries, examples of each genre have survived,[24] both as freestanding pieces and combined in larger works. The rhetorical figures in which he had been trained, the *progymnasmata,* he put to use in writing about events, people, places, and things.

Take, for example, his ethopoiia of an astrologer who was disappointed in his desire to become patriarch of Antioch. This text, the most recently published of all his works, was written after the fall of Constantinople, according to the title.[25] It is a character sketch. Character is delineated through words put into the mouth of the astrologer who is an anonymous but, it seems, real person.[26] The situation in which the astrologer finds himself, the vacancy of the see of Antioch which he seeks to fill, is also a real one, arising after the death of Theodore Balsamon.[27]

The astrologer, or *mathematikos,* we learn from the monologue that Mesarites creates, had been mad about astrology from his adolescent years. One day he obtained a horoscope that led him, after much thought, to conclude that he should have a high ecclesiastical position, a see.

14 Mesarites, "Epitaphios," c. 29, ed. Heisenberg, "Epitaphios," 42.17–18; trans. Angold, *Nicholas Mesarites,* 166.

15 Mesarites, *Coup,* c. 2, ed. Heisenberg, *Palastrevolution,* 19.20–22; trans. Angold, *Nicholas Mesarites,* 42.

16 He was *skeuophylax* and *epi ton kriseon* from the reign of Alexios III Angelos (1195–1203), as the title of an unpublished oration for this emperor reveals: Cataldi Palau, "Deux lettres inédites," 190.

17 Heisenberg, "Reisebericht," 35.13–14; trans. Angold, *Nicholas Mesarites,* 223. For this ecclesiastical official who transmits messages from the patriarch to the emperor see J. Darrouzès, *Recherches sur les ΟΦΦΙΚΙΑ de l'Église byzantine* (Paris, 1970), 373–74.

18 A. Pavlov, "Sinodalnaia gramota 113 goda o brake grecheskago imperatora s docheriu armiansago kniazia," *VizVrem* 4 (1897): 160–66, here at 166. For Mesarites as metropolitan and exarch see E. Kurtz, "Tri sinodalnich gramoti metropolita Epheskago Nikolaja Mesarita," *VizVrem* 12 (1906): 99–111, here at 105, 110, 111. For the date see Angold, *Nicholas Mesarites,* 10 and n. 60.

19 Kurtz, "Tri sinodalnich gramoti," 105, 110, 111 (1216). For an account of Mesarites' life and career see also E. Lambriniadis, "Die Brüder Ioannis und Nikolaos Mesaritis: Verteidiger der Orthodoxie in den Unionsverhandlungen von 1204 bis 1214 (im historischen und theologischen Rahmen der Epoche)," *Κληρονομία* 28 (1996): 187–236, here at 198–200.

20 Cataldi Palau, "Deux lettres inédites," 191, suggests a date of ca. 1220.

21 B. Flusin, "Nicolas Mésaritès: Éthopée d'un astrologue qui ne put devenir patriarche," *TM* 14 (2002): 221–42, here at 222 and n. 8.

22 See below. A good example is provided by the title to the unpublished "Fifth Logos Katechetikos" (Ambrosianus F 93 Sup (Gr. 350) fols. 32v, l. 14–35v), in which he states that he read the sermon on Cheese Sunday, six days after his arrival in Ephesos from Nicaea, where he had celebrated the wedding of Constantine Doukas Palaiologos to the daughter of Theodore I Laskaris, Eirene Doukaina, in the kastron of Nicaea, "wearing a *sakkos* and the rest of the episcopal costume." See Cataldi Palau, "Deux lettres inédites," 206–7.

23 Mesarites, "Epitaphios," c. 29, ed. Heisenberg, "Epitaphios," 42.17–21. For a discussion of this passage see Flusin, "Éthopée," 223–24.

24 B. Daskas is preparing an edition of Mesarites' encomium for Alexios III Angelos.

25 Edited by Flusin, "Éthopée," 221–42, 235.1–2.

26 For contemporary events as inspiration and subject matter of *ethopoiiai,* see F. Bernard, *Writing and Reading Byzantine Secular Poetry, 1025–1081* (Oxford, 2014), 224–25 and n. 56.

27 Flusin, "Éthopée," 224 and n. 14. See Angold, *Nicholas Mesarites,* 297–300, for a discussion of the historical context of the piece which he dates to before 1207.

Everything seemed in place. His name was put forward as that of the preferred candidate. The insignia of office were prepared, a black tunic, a head covering (*kalyptra*), a candle as tall as a man, a staff, a mantle with "rivers" or bands, a throne. In preparation for his elevation, the astrologer practiced looking the part; he walked with measured tread, cast ferocious glances about him, and fasted to appear more ascetic. But calumnious envy struck, and he was left with his insignia and accessories, wondering what to do with each of them.

What then will I do with my very long and wide-gaping tunic, carefully dyed a deep black? Shall I tear it and pull it apart? ... Let it be thrown into a dark place in the house because the path of the moon and that of the Sun came to be at the house of Leo when it changed from not being in aspect to the configuration of a priest. The head covering which differs from a modiolos, will it lie neglected and will packs of rats hide in it and a litter of cats? It will serve, then, in place of an urn, coming down to the tendons of the neck, covering and sealing my ears, driving away the projectiles, just like hail, rock-like and in heaps, sent by the fault-finders. The candle made of wax and reed, the reed cut into thin strips and made up to the height of a man, wrapped round with linen and, last, poured over from end to end with wax made liquid by fire, touched, after, by cool air. What shall I do with it? Shall I shatter it, break it into small pieces? On the contrary, in no way. I will put it on flaming soot, on a seething shroud, on kindled ashes. . . . The seat also called *selion*, as it is named in the parlance of the many, shall I dismember and scatter it everywhere completely because it did not give rest to my limbs, nor my kidneys, nor my thighs, nor my calves, nor my ankles, nor my knees, nor my heels, nor the soles of my feet, nor my whole body? But no, let it remain unbroken, not in pieces, for it will serve me conveniently when I pretend to be ill. For I am very good at pretending all kinds of illnesses, constant pain, prominent swellings, watery diarrhoea of the intestines, and I will sit for a considerable time. . . . On this

staff I will lean as if I were wasting away and I will feign gout, not in bed. . . .[28] But the mantle itself will cover me when I am shivering with fever . . .[29] from my head, like fire and water passing through my whole body; but first I will cover up with ink the bands of linen and of purple which were woven around the edge of the. . . .[30]

The enumeration of the disappointed candidate's episcopal insignia—now objects of no significance—his detailed deliberation over their future handling and use, highlights another aspect of Mesarites' writing: the list or catalogue, found elsewhere in his work but here used to comic effect.[31] Mesarites lists not only accessories, but also body parts and illnesses. The lists draw attention to Mesarites' inclusion and description of the concrete, of *realia*. Although the episcopal insignia are well known from other texts and contexts, Mesarites is a unique source for the size of the episcopal candle, its composition, and manner of manufacture.[32] A third characteristic of Mesarites' writing which is exhibited in this piece is the combination of real things with the made up. The description of the insignia takes up a large part of the made-up soliloquy of a real but fraudulent person[33] who plans to use his accessories to fake illness. Finally, the interest in the body, its physiology, in sickness and in health, is another aspect of Mesarites' work to be found in all his texts.

While the ethopoiia is an imagined monologue of a real but anonymous person in a real situation, Mesarites' account of the failed

28 Flusin, "Éthopé," lacuna at 241.139.

29 Ibid., lacuna at 241.140.

30 Ibid., 239.102–241.143; lacuna at 241.143; trans. Angold, *Nicholas Mesarites*, 300–305.

31 Angold's commentary (*Nicholas Mesarites*, 300–305) does not highlight the comical aspect of Mesarites' text but rather concentrates on the historical context of the failed appointment.

32 For a protocol for the promotion of a patriarch that refers to some of the insignia, the throne, the staff, and the mantle with rivers, see Pseudo-Kodinos, c. 10, ed., trans., and comm. R. Macrides, J. Munitiz, and D. Angelov, *Pseudo-Kodinos and the Constantinopolitan Court: Offices and Ceremonies* (Farnham, 2013), 250–61 and notes 744, 751, 767; for the candle, see 443 and n. 31. On the insignia see also Flusin, "Éthopée," 230–31.

33 See ibid., 224 and n. 14.

usurpation attempt of John Komnenos, called "the Fat,"[34] is a real event dated to 1200.[35] At the start of his account, Mesarites informs his audience that every re-creation of an event is an approximation. Like those who try to draw an image, the author of a narrative will fail in his attempt to convey the whole of the prototype, its vividness and detail; rather, he will produce a representation, an outline, something painted with shadows, illusively painted (σκιαγραφία).[36] Thus, illusion was just as much a part of an account of a historical event as it was of an ethopoiia.

In his narrative account of the revolt that took place on 31 July according to the date he gives,[37] it is not, as one would expect, the usurper's actions that dominate the narrative. From the time he gains entry into the Great Palace, John Komnenos is inert, passive, motionless, and speechless. The only signs of life in him are his breath—short—and his sweat—profuse.[38] The point is made extensively and explicitly in a series of alternating active and passive verbs that describe John Komnenos, with the active verbs negative and the passive verbs positive: "being led, not leading, commanded, not commanding, receiving orders, not giving them, ruled, not ruling, mastered, not mastering, held under authority, not exercising authority, enslaved, not enslaving, fulfilling the command of everyone, at everyone's behest."[39] By contrast, it is the narrator, Mesarites, the skeuophylax, who is active. Upon hearing of the break-in at the Great Palace by the usurper's men, he rushes to the Pharos chapel to defend its holy treasure from the insurgents.[40] Mesarites is at the center of attention. He is center stage.

Mesarites literally sets the scene, using the language of theater. John is introduced as an actor, ἄνθρωπον σκηνικόν, from the time he enters the palace, which acts as the stage, σκηνή.[41] Furthermore, Mesarites gives stage directions, annotations, in a series of descriptions that take the reader to different parts of the palace, that is, to different parts of the stage set. Mesarites provides a string of images; the main verb is lacking, creating the effect of annotations for stage sets: "From this time on, the gates of the palace, open and unguarded; the triklinos of Justinian denuded of men; the attack at the Chrysotriklinos; the rush of soldiers here and there at the corners of the palace, cutting down those huddled in fear."[42]

Mesarites provides, in this way, multiple perspectives. When he comes to the figure of John Komnenos, the actor who does not act, Mesarites describes him from an untypical and unlikely perspective, from behind. It is a view unique in Byzantine literature and extremely

34 For John's nickname, "the Fat," see Niketas Choniates in *Nicetae Choniatae Historia*, ed. J.-L. van Dieten (Berlin and New York, 1975), 526.35–36, 527.51, and Oration 10, in J.-L. van Dieten, ed., *Nicetae Choniatae Orationes et Epistulae* (Berlin and New York, 1972), 101.13: τοῦ λεγομένου Παχέος. John Komnenos's corpulence is a feature commented on in all 5 contemporary accounts of the usurpation attempt. See Euthymios Tornikes's oration for Alexios III Angelos: Darrouzès, "Les discours d'Euthyme Tornikès (1200–1205)," at 68.23–24; Nikephoros Chrysoberges: M. Treu, ed., *Nicephori Chrysobergae ad Angelos orationes tres* (Breslau, 1892), oration 1:1–45, here at 1.4.

35 J.-C. Cheynet, *Pouvoir et contestations à Byzance (963–1210)* (Paris, 1990), no. 195, 136–37. For the dating of the coup to the year 1200, see J. Darrouzès, "Le discours d'Euthyme Tornikès (1200–1205)," *REB* 26 (1968): 49–121, here at 51; J.-L. van Dieten, *Niketas Choniates: Erläuterungen zu den Reden und Briefen nebst einer Biographie* (Berlin and New York, 1971), 123–28. For an analysis of the political aspects of the coup, see M. Angold, "The Anatomy of a Failed Coup: The Abortive Uprising of John the Fat (31 July 1200)," in *Byzantium, 1180–1204: "The Sad Quarter of a Century"?* ed. A. Simpson (Athens, 2015), 113–34, and Angold, *Nicholas Mesarites*, 31–42. For a comparison of two of the accounts, see Kazhdan, "Nicephorus Chrysoberges and Nicholas Mesarites," 242–55. See F. Grabler, *Die Kreuzfahrer erobern Konstantinopel* (Graz, Vienna, and Cologne, 1958), 271–316 (German translation); trans. Angold, *Nicholas Mesarites*, 42–74.

36 On *skiagraphia*, see Daskas, "Images de la ville impérial," 137–41.

37 Mesarites, *Coup*, c. 2, ed. Heisenberg, *Palastrevolution*, 20.4; trans. Angold, *Nicholas Mesarites*, 43.

38 Mesarites, *Coup*, c. 7, ed. Heisenberg, *Palastrevolution*, 23.30–32; trans. Angold, *Nicholas Mesarites*, 47.

39 Mesarites, *Coup*, c. 8, ed. Heisenberg, *Palastrevolution*, 24.24–28; trans. Angold, *Nicholas Mesarites*, 48.

40 Mesarites, *Coup*, cc. 11–12, ed. Heisenberg, *Palastrevolution*, 27–29; trans. Angold, *Nicholas Mesarites*, 51–53.

41 Mesarites, *Coup*, c. 8, ed. Heisenberg, *Palastrevolution*, 24.22; trans. Angold, *Nicholas Mesarites*, 48. See Daskas, "Images de la ville impérial," 146–47, on theatricality in Mesarites' text.

42 Mesarites, *Coup*, c. 27, ed. Heisenberg, *Palastrevolution*, 44.18–22; trans. Angold, *Nicholas Mesarites*, 69. For this kind of concise description in an ekphrasis, see R. Webb, "The Model Ekphrasis of Nikolaos the Sophist as Memory Images," in *Theatron: Rhetorische Kultur in Spätantike und Mittlealter*, ed. M. Grünbart (Berlin and New York, 2007), 463–75, here at 468.

rare in Byzantine art.[43] Mesarites, always eager to document the circumstances—the context of his *logos*[44]—explains how he first encountered the usurper:

> Entering by the *triklinos* of Justinian and gazing, I saw the head and the crown and the back of that new emperor—for my entrance to him was from behind which prevented me from seeing his face—coarse black hair, appropriate to his birth, coming down to him from his grandfather, shoulders soft and oversize, his back swollen and fleshy, a useless burden on that imperial throne, a projecting belly and a paunch.[45]

But even here, in his description of his first encounter with the "new emperor," he does not maintain one perspective, that from behind, as he says, but supplements the view from the back with the view from the front. The words προγάστορα and προκοίλιον, "projecting belly" make explicit that other perspective.

The suspense for the reader lies not in what will happen to the usurper but in how events will unfold for the narrator. For, from the beginning, we know what the conclusion will be for John Komnenos the Fat. Mesarites foreshadows the outcome six times in the first pages of his narrative, on each occasion in a different way: "the one seeking to kill was killed"; "he was really going to his death"; "he entered the palace of Hades and Pluto"; "at first cock crow I saw him without breath, without a head, cut up into countless pieces"; "his head hung down, a sign it seemed to me that it would not stay on his shoulders."[46]

While we know what will happen to John Komnenos, the dangers Mesarites faces are still to come. When he arrives at the Pharos church he sees men armed with swords and knives. He addresses them in the only speech of the narrative. The would-be plunderers of the holy treasure are told, "Learn the names of the treasures here and tell the generations following you. The narrative is wholly from my lips." Mesarites proceeds to list and describe the Passion relics of the Pharos, starting with the Crown of Thorns, ten relics in all. Mesarites names them the decalogue.[47] The long account ends with a comparison of the sites of the Holy Land with the Pharos church. "This church is another Sinai, Bethlehem, Jordan, Jerusalem, Nazareth, Bethany, Galilee, Tiberias." He concludes, "Having said these things, I transformed into a calmer and more pious manner their beastly and evil ways."[48]

Mesarites' catalogue of the Passion relics, a piece of *realia* inserted into the narrative,[49] is the only inventory of the relics that exists.[50] It is also a set piece that reads like a sermon about the central position of Constantinople, the new Jerusalem, in the ecumene. A version of the same speech is to be found in another of Mesarites' writings, his funeral oration for his brother John, written several years later, in 1207. In that work Nicholas puts the speech about the relics in his father's mouth, a father trying to persuade his son to stay in Constantinople and not seek to live in Jerusalem. John had run away on a ship en route to the holy city but had been detected and brought back to Constantinople.[51] Thus, in both

43 Kazhdan, "Nikephoros Chrysoberges and Nicholas Mesarites," 251: "Contrary to all the canons of Byzantine iconography, he saw him from behind"; O. Demus, *Byzantine Mosaic Decoration: Aspects of Monumental Art in Byzantium*, 2nd ed. (London, 1953), 8: "Full back views do not occur at all in the classical period of middle Byzantine art; for to the Byzantine beholder such figures would not be 'present' at all."

44 On this aspect of Mesarites' writing, see Flusin, "Éthopée," 222 and n. 8.

45 Mesarites, *Coup*, c. 11, ed. Heisenberg, *Palastrevolution*, 28.3–10; trans. Angold, *Nicholas Mesarites*, 51.

46 Mesarites, *Coup*, cc. 6, 7, 8, 11, ed. Heisenberg, *Palastrevolution*, 23.6–9, 23.32–33, 24.15–17, 25.8–10, 25.12–18, 28.13–17; trans. Angold, *Nicholas Mesarites*, 46, 47, 47–48, 51.

47 Mesarites, *Coup*, cc. 13–14, ed. Heisenberg, *Palastrevolution*, 29–32; trans. Angold, *Nicholas Mesarites*, 53–56.

48 Mesarites, *Coup*, c. 15, ed. Heisenberg, *Palastrevolution*, 15.26–27; trans. Angold, *Nicholas Mesarites*, 151–52.

49 Cataldi Palau, "Deux lettres inédites," 196–97, comments on this characteristic of Mesarites' writing, his insertion of texts into other texts that are on another subject.

50 See the volume dedicated to the relics: J. Durand and B. Flusin, eds., *Byzance et les reliques du Christ* (Paris, 2004). For Mesarites' inventory, see P. Magdalino, "L'église du Phare et les reliques de la Passion à Constantinople (VII^e/VIII^e–XIII^e siècles)," in Durand and Flusin, *Byzance*, 15–30, here at 27–30.

51 Mesarites, "Epitaphios," c. 13, ed. Heisenberg, "Epitaphios," 26.22–28.6, here at 27.22–28.2; trans. Angold, *Nicholas Mesarites*, 151–52.

texts the relics become arguments for the superiority of Constantinople over Jerusalem.

The relics in the treasury of the Pharos are presented in catalogue form, while another "real thing" in Mesarites' narrative is conveyed by a rhetorical figure, an ekphrasis. His description of the Mouchroutas, a building in the Great Palace possibly dating from the reign of Manuel I Komnenos,[52] is the only evidence for its appearance and even its existence. The Mouchroutas, built by a Turkish architect,[53] had a large staircase with multicolored tiles of cruciform shape. The stalactite ceiling was gold. Painted images of Persians in various costumes decorated unspecified surfaces.[54] It was in this building that the usurper was found by the emperor's soldiers. It was from the Mouchroutas that John was dragged, down the stairs, to the triklinos of Justinian where he was killed.

The Persian stage, the work of a hand related on his grandfather's side,[55] had the actor John, crowned but not arrayed imperially, sitting on the ground—a symbol this of the condition that had taken hold of the miserable one and of the unbearableness of the misfortune—drinking much and acting agreeably to the Persians represented in the building and drinking their health.[56]

Just as the catalogue of relics is more than an informative list of the relics kept in the Pharos and is used by Mesarites to express Constantinople's centrality in the ecumene, so, too, the ekphrasis of the Mouchroutas is inserted into the narrative not only for its own sake, because it existed and may have accommodated John in his final moments, but as a means of conveying another level of truth. Mesarites' readers and audience, like his modern readers, could not know whether Mesarites really spoke the words he put in the mouth of the Mesarites of the narrative. Likewise, John Komnenos may not have spent his last moments on the floor of the Mouchroutas. He may have been in an adjacent building when he was dragged to his death. Either way, the stage presents a scene appropriate to this grandson of a Turk. The image of the corpulent crowned John sitting (cross-legged?) and toasting the images of Turks conveyed a poetic justice, a bathos that no words could express.[57]

The various buildings of the palace, the Mouchroutas, the triklinos of Justinian, the Pharos church, and the church of Prophet Elijah, provide different stages for the action. Mesarites changes scene also by taking his audience,

52 P. Magdalino, "Manuel Komnenos and the Great Palace," *BMGS* 4 (1978): 101–14, here at 102–9 (= P. Magdalino, *Tradition and Transformation in Medieval Byzantium* [Aldershot, 1991], study no. V); L.-A. Hunt, "Comnenian Aristocratic Palace Decoration Descriptions and Islamic Connections," in *The Byzantine Aristocracy, IX–XIII Centuries,* ed. M. Angold, BAR International Series 221 (Oxford, 1984), 138–56, here at 141–42; N. Asutay-Effenberger, "'Muchrutas': Der seldschukische Schaupavillon im Großen Palast von Konstantinopel," *Byzantion* 74 (2004): 313–29. See now J. Johns, "A Tale of Two Ceilings: The Cappella Palatina in Palermo and the Mouchroutas in Constantinople," in *Art, Trade, and Culture in the Islamic World and Beyond: From the Fatimids to the Mughals; Studies Presented to Doris Behrens-Abouseif,* ed. A. Ohta, J. M. Rogers, and R. Wade Haddon (London, 2016), 58–73. Johns argues that the building was not a Seljuk pavilion, a conical kiosk, but a rectangular hall with a muqarnas ceiling.

53 See at note 55.

54 Mesarites, *Coup,* c. 27, ed. Heisenberg, *Palastrevolution,* 45.1–5; also translated in Mango, *Art of the Byzantine Empire,* 229; trans. Angold, *Nicholas Mesarites,* 69.

55 John Komnenos was the grandson of the Turk John Axouch who was taken prisoner by the Byzantines in 1097 and became *megas domestikos* at the Byzantine court; his mother was the granddaughter of John II Komnenos. See C. M. Brand, "The Turkish Element in Byzantium, Eleventh–Twelfth Centuries," *DOP* 43 (1989): 1–25, here at 4–8, 19–20, 23–25. I understand this passage to refer to the architect of the building, a Turk like John Komnenos's grandfather, and not to the emperor responsible for the building, John II or Manuel I. Angold, *Nicholas Mesarites,* 69n15, understands Mesarites to be saying that the building was "commissioned" by a relative of John the Fat's grandfather, John Axouch.

56 Mesarites, *Coup,* c. 27, ed. Heisenberg, *Palastrevolution,* 45.10–15; trans. Angold, *Nicholas Mesarites* 70.

57 For an analysis of this passage see A. Walker, "Middle Byzantine Aesthetics of Power and the Incomparability of Islamic Art: The Architectural Ekphraseis of Nikolaos Mesarites," *Muqarnas* 27 (2010): 79–101; eadem, *The Emperor and the World: Exotic Elements and the Imagining of Byzantine Imperial Power, Ninth to Thirteenth Centuries* (New York and Cambridge, 2011), 144–54. Walker interprets the passage as an expression of John's "unfitness for rule through assertion of the superior nature of Byzantine imperial authority and John's inability to fulfil this image" (p. 145). For an analysis of the scene as parody, see H. Maguire, "Parody in Art," in *A Companion to Byzantine Satire,* eds. I. Nilsson and P. Marciniak (Leiden, forthcoming). For identification of the Mouchroutas with Manuel I's hall, the Manouelites, see Johns, "Tale of Two Ceilings," 60, 67. Johns also suggests that the same carvers and painters, an atelier from Fatimid Cairo, decorated the Cappella Palatina and then the Mouchroutas.

readers or listeners, out of the time and space of the narrative and putting them into the present. He breaks up the flow of the narrative by addressing his audience members, confronting them with the act of narrating, reminding them that he is telling them a story: "But let my narrative leap, together with my feet, to the place before the church door and let the things of the south side [of the church] await me"; "Come here all you who today gather to hear my tale (διήγημα). Grant to me your attentive thought and willing ears."[58]

Mesarites' narrative supplies the story line, the account of the event, but it provides, in addition, the physical appearance of the characters, their bearing and their clothing, the sound of their footsteps, voices, breathing; in short, their physical presence. This is theater in the round. By his attention to these physical details, he transports his audience, whether those listening to him or reading him, to the event itself. They inhabit it, its time and place. In describing the initial break-in at Hagia Sophia, Mesarites reports that it was understood by those in the church that the matter at hand was a revolt "from the irregular gait of their feet" and "the speech and utterance of those rushing in."[59]

The voice and the quality of the voice are frequently remarked upon by Mesarites. He begins his account of John Komnenos's usurpation attempt by explaining the reason for his written account: so many people stopped him in the holy precincts, in the streets, squares, boulevards, thoroughfares of the city, asking him to tell them in detail everything about the usurpation from the very beginning, that, in the end, he lost his voice:

From shouting that entire day—the month of July had passed beyond the thirty-first—my larynx got hoarse and my breathing almost ceased and my vocal organs gave up. . . . Since my voice was weakened and my throat was in a bad state, I was eager to transmit what I saw on paper and with ink, so that everything

might be in view, so to speak, and visible for all who ask and hear.[60]

Mesarites comments on the quality of a voice, its roughness in the case of the barbarian he encountered in the palace break-in. He even re-creates the bad syntax and grammar of a German who asks him in a threatening manner, "What hides the awesome chest this treasures?"[61]

How the body functions and the effects on it of certain sounds, sights, and circumstances are key elements in Mesarites' reconstruction of events and the characters involved in them. He recreates all possible dimensions, including psychological states. His audience is informed, "The cry pierced through the auricle of my ear." "The hair of my flesh stood up" (Job 4:15) and my flesh crept."[62] "As he was speaking, dizziness overcame me and trembling took hold of my limbs, and my hands and knees were paralyzed and I perceived that I was practically without breath, when I put it into my mind that the wretches would reach also the church of the Mother of God and plunder the holy things."[63]

In keeping with his interest in the body and also in lists, Mesarites gives a full account of the parts of the body that were hit and wounded in the fighting on 31 July.

I stood against the opponents who were hitting me again with an abundance of stones which crushed the bones of my left hand, the shoulder, the forearm, the radius, and the fingers themselves.[64] One was hit on the ankle joint, another was wounded on the metatarsus, another was maltreated on the scaphoid, another on the cuboid, another received

58 Mesarites, *Coup*, cc. 16, 19, ed. Heisenberg, *Palastrevolution*, 33.11–13, 46.33–35; trans. Angold, *Nicholas Mesarites*, 57, 72.

59 Mesarites, *Coup*, c. 3, ed. Heisenberg, *Palastrevolution*, 20.34–21.3; trans. Angold, *Nicholas Mesarites*, 44.

60 Mesarites, *Coup*, c. 2, ed. Heisenberg, *Palastrevolution*, 19.24–20.14; trans. Angold, *Nicholas Mesarites*, 43.

61 Mesarites, *Coup*, c. 31, ed. Heisenberg, *Palastrevolution*, 48.15–16: "τίνα κρύπτει φοβερωτάτη θήκη τις αὕτη κειμήλια"; Angold's translation (p. 73) does not indicate any irregularity in the Greek.

62 Mesarites, *Coup*, c. 26, ed. Heisenberg, *Palastrevolution*, 44.14–16; trans. Angold, *Nicholas Mesarites*, 69.

63 Mesarites, *Coup*, c. 10, ed. Heisenberg, *Palastrevolution*, 26.25–27; trans. Angold, *Nicholas Mesarites*, 50.

64 Mesarites, *Coup*, c. 18, ed. Heisenberg, *Palastrevolution*, 36.3–4; trans. Angold, *Nicholas Mesarites*, 60.

wounds on the heel, most sustained discomfort and lashes on the fibula.[65]

Mesarites' knowledge of and interest in the body, more specifically, in physiology, how the body functions, plays a prominent part in his two letters to the monks of the Euergetis monastery in Constantinople. In these letters he narrates his travels from Constantinople to Nicaea on two occasions, in 1207 and 1208.[66] It is here that the physical is particularly emphasized in his full and frank description of the discomforts and dangers of travel. Indeed, the letters have been cited as evidence that the Byzantines loathed travel.[67]

Into his narrative of his eventful journeys Mesarites inserts ekphraseis of realia—the construction of a crossbow, of houses at Neakomes—and aspects of the body—the workings of mastication, the effect of smoke on eyes and body.[68] The overall effect is to engage the reader's senses. The discomfort Mesarites feels on his bottom from the donkey ride over uneven terrain is as graphic as the effect of a smoke-filled room on his eyes and whole being:

> Then I was distressed because the great amount of smoke afflicted my eyes. For it was whirling around on itself and rising up with no outlet, pressing closely from all sides because of the dwelling's lack of ventilation. For this reason our nostrils were filled with smoke, our brain was confounded and the triple membranes of our eyes became irritated and began to sting, our senses were impaired and our limbs thrown into confusion.[69]

Mesarites re-creates his traveling companions, his servant and the muleteer, for the benefit of the Euergetis monks. He presents the muleteer in an ethopoiia,[70] giving him a long—the longest "speech" in the letter—and abusive statement in which he admonishes Mesarites for whipping his mule. In an ironic comment on the last warning of the muleteer—"So, spur the mule on gently so that you do not die before your time and are harvested like an unripe olive"—Mesarites expresses amazement at the "old drunk's" knowledge of the scriptures, namely Job 15:32–33.[71] To describe his servant, Mesarites highlights his most important characteristic, his love of food and drink. He treats his readers to an ekphrasis of mastication:

> Also a meal was improvised by that gluttonous single diner, for meat was by his left hand and by his right was barley bread and a knife which cut up into small pieces the meat and the bread and sent the food, easily digested, on to the esophagus. There toiled along in this the incisors and the canines also struck together but also the molars chewed and ground down the food. It is in this way that artificial implements and the tools of the body can act together in their natural functions.[72]

65 Mesarites, *Coup*, c. 18, ed. Heisenberg, *Palastrevolution*, 36.12–15; trans. Angold, *Nicholas Mesarites*, 60. See C. Singer, "Galen's Elementary Course on Bones," *Proceedings of the Royal Society of Medicine* 45, no. 11 (1952): 767–76, here at 775. I thank Petros Bouras-Vallianatos for this reference. Unlike Angold's translation (p. 60), mine makes use of technical medical terms because, in my view, Mesarites was striving for an effect by using this language. See below, 184–85, for discussion of his medical knowledge.

66 A. Heisenberg, "Reisebericht des Nikolaos Mesarites an die Mönche des Euergetisklosters in Konstantinopel," in *Neue Quellen zur Geschichte des lateinischen Kaisertums und der Kirchenunion. II. Die Unionsverhandlungen vom 30. August 1206, Patriarchenwahl und Kaiserkrönung in Nikaia 1208* (Munich, 1923). The text has been translated into French by V. Kravari, "Évocations médiévales," in B. Geyer and J. Lefort, eds., *La Bithynie au Moyen Âge* (Paris, 2003), 84–88; English trans. in R. H. Jordan and R. Morris, *The Hypotyposis of the Monastery of the Theotokos Evergetis, Constantinople (11th–12th centuries)* (Farnham, 2012), Appendix 6, 261–72; trans. Angold, 219–223.

67 C. Galatariotou, "Travel and Perception in Byzantium," *DOP* 47 (1993): 221–41, here at 225–26.

68 Mesarites, "Travel Account," cc. 2, 11, 8, ed. Heisenberg, "Reisebericht," 37.17–31, 45.8–11, 41; trans. Angold, *Nicholas Mesarites*, 225, 233, 229, 228.

69 Mesarites, "Travel Account," c. 7, ed. Heisenberg, "Reisebericht," 40.19–24; trans. Angold, *Nicholas Mesarites*, 228.

70 Mesarites, "Travel Account," c. 9, ed. Heisenberg, "Reisebericht," p. 41–42; trans. Angold, *Nicholas Mesarites*, 229–30. Nicholas invites the recipients of his letter to create their own ethopoiia when he says, "What do you suppose we were saying when...?" (τί οἴεσθαι λέγειν ἡμᾶς ὅτε...;): Mesarites, "Travel Account," c. 6, ed. Heisenberg, "Reisebericht," 40.8; trans. Angold, *Nicholas Mesarites*, 227.

71 Mesarites, "Travel Account," cc. 9–10, ed. Heisenberg, "Reisebericht," 41.31–43.2, here at 42.36–43.2; trans. Angold, *Nicholas Mesarites*, 229–30.

72 Mesarites, "Travel Account," c. 8, ed. Heisenberg, "Reisebericht," 41.11–19; trans. Angold, *Nicholas Mesarites*, 229.

Mesarites, there can be no doubt, takes great pleasure in his verbal reconstructions of states of being, of the body and its functions. It seems that at every opportunity he throws in lists of body parts. As he watches his servant chewing away, he admits to feeling nauseated. "My temples were throbbing constantly, my respiratory tubes were constricted and my breathing was made painful by the fluids streaming though the isthmus-like bones of my nose and sometimes a most unintelligible sound was conducted through my nostrils."[73] Likewise, in another exhibition of anatomical knowledge, Mesarites has the muleteer, in the middle of his harangue, add, "Don't you see how I'm gasping for breath now and my ankles are weighed down and my knees and joints and soles and heels and the very sinews of my calves, and my ankle joints and the whole foot with the fibula?"[74]

All the elements of Mesarites' writing that have been outlined above can be seen in each of his works, whatever its genre. Thus, the author's interjections into his text—his self-presentation—are found not only in the account of the failed coup of John Komnenos, but also and even in Mesarites' epitaphios for his brother John, where Nicholas inserts information about his own education, intellectual qualities, writings, and teaching.[75] Beyond these insertions of a biographical type, Nicholas makes interjections frequently into the text of the epitaphios to lament and express his anguish at the loss of his brother.[76] In short, we are always aware of the narrator Nicholas in this account of his brother's life. The expressions of Nicholas's sorrow also serve to bring his audience into the present time, extracting them from the past being narrated, the time of John's life.[77] In this work, too, Nicholas includes actual and made-up speeches. Thus,

Mesarites reports the speeches of the emperor Manuel I and of the father of the Mesarites brothers, both of which he has (re-)created for the narrative, as is the case in what purports to be the transcript of John's dialogues with the Latins.[78] He conveys not only the words of his brother but also the sound of his voice, so that his audience would have the reality of the living John Mesarites.[79] Interest in the body is likewise evident in Nicholas's description of the effects of John's asceticism on his health, and in the naming of the illness that brought about his death.[80]

Nicholas Mesarites' writing brings people, events, and objects before the eyes of the listener or reader. His delight "in the world, as it is perceived by the senses"[81] can be observed not least in his description of the church of the Holy Apostles. He animates each iconographic scene he describes by his use of rhetorical figures and his reference to anatomy and physiology. The New Testament men and women depicted in the mosaics come to inhabit the same space and live in the same time as Mesarites' audience through his ascription to them of human reactions: the apostles sweat, they feel fear.[82] The apostles at the raising of Lazarus "roll their eyes backwards" and "hold their noses," and "cover their mouths with their mantles" "because of the stench which comes from him."[83]

All the senses are engaged. The physiological effects of sounds, sights, and smells are registered and explained. Before entering the church Mesarites refers to the effect on the heart caused by the striking of the wooden board, the *semantron* that summons the faithful: "The heart,

73 Mesarites, "Travel Account," c. 8, ed. Heisenberg, "Reisebericht," 41.22–26; trans. Angold, *Nicholas Mesarites*, 229.

74 Mesarites, "Travel Account," c. 9, ed. Heisenberg, "Reisebericht," 42.9–12; trans. Angold, *Nicholas Mesarites*, 229–30.

75 Mesarites, "Epitaphios," c. 29, ed. Heisenberg, "Epitaphios," 42.17–21; trans. Angold, *Nicholas Mesarites*, 166.

76 Mesarites, "Epitaphios," cc. 3, 29, 54, 55, ed. Heisenberg, "Epitaphios," 18.18–35, 42.9–31, 70.13–71.20, 71.24–72.4; trans. Angold, *Nicholas Mesarites*, 142–43, 165–66, 191–92, 192.

77 Mesarites, "Epitaphios," cc. 29, 32, 51, ed. Heisenberg, "Epitaphios," 42.6–9, 44.34–45.15, 66.29–30; trans. Angold, *Nicholas Mesarites*, 165, 168, 187.

78 Mesarites, "Epitaphios," cc. 12, 13, 41–49, ed. Heisenberg, "Epitaphios," 25.22–26.5, 27.3–28.6, 52–63; trans. Angold, *Nicholas Mesarites*, 150, 151, 175–84.

79 Mesarites, "Epitaphios," c. 40, ed. Heisenberg, "Epitaphios," 50.31–51.15; trans. Angold, *Nicholas Mesarites*, 174.

80 Mesarites, "Epitaphios," cc. 21, 51, ed. Heisenberg, "Epitaphios," 35.12, 67.14–15; trans. Angold, *Nicholas Mesarites*, 159, 188.

81 Kazhdan, "Nicephorus Chrysoberges and Nicholas Mesarites," 213.

82 Mesarites, *Ekphrasis*, cc. 32.10, 25.15, ed. Heisenberg, *Apostelkirche*, 70.16–17, 51.1–2; ed. and trans. Downey, "Nikolaos Mesarites," 886, 879; trans. Angold, *Nicholas Mesarites*, 118, 107.

83 Mesarites, *Ekphrasis*, c. 26.7, ed. Heisenberg, *Apostelkirche*, 54.18–19; ed. and trans. Downey, "Nikolaos Mesarites," 880; trans. Angold, *Nicholas Mesarites*, 108.

affected by the beating of the wood, feels a happy disturbance and blood comes together from all sides for its nourishment."[84] In his description of the mosaic depicting the Women at the Tomb, he again refers to the circulation of blood, this time to explain the yellowness of the women's faces upon seeing the tomb empty: "Like statues of wood and stone are the women bearing myrrh, and a strong yellow tint descends on the aspect of their faces, the redness of their blood having run to the heart, which was the first organ to suffer the shock, in order to bestow upon it courage and vitality and security by means of its circulation about it."[85]

Mesarites displays medical knowledge in other passages also where he explains that the "white skin" of the Antiochenes is a natural quality, "originating in the nature of the humours" or when he states that Thomas's eyes were "wide open, free from rheum and flux and murky accretion."[86] His explanation of the brain's functions is central to the scene of the Annunciation where he elucidates the process by which speech is perceived and understood: "The word comes to the hearing of the Virgin, and enters through it to the brain; the intelligence which is seated in the brain at once lays hold upon what comes to it, recognizes the matter by its perception, and then communicates to the heart itself what it has understood."[87]

Just as Mesarites reveals cognitive and bodily processes, making the New Testament figures vivid and actual, so too he exposes the processes of writing and the material conditions of his work, transporting his audience out of the past of the stories he has been narrating into the present. After describing the scene of the Baptism, Mesarites exclaims, "But what is happening to me? I have fallen somehow into the depths of the Jordan itself and am at a loss as to where I shall make land. I wish to let go of the stylus and reed pen which has helped me in this crossing of the river; like an oar in some black sea, it has constantly been dipped into this inkstand and withdrawn."[88] In this passage, Mesarites not only calls attention to himself, the author or artist who has created the scenes with words, but also makes explicit reference to the material conditions of his work.[89] Thus, he disrupts and destroys the illusion that he is composing his speech in church as the audience listens. Instead, he has pen and ink in front of him and is evoking the scenes in memory.[90]

The images of the church he seeks to convey derive primarily from his mind. Mesarites says so explicitly at the beginning of the ekphrasis when he states that he has set out to build a monument with the materials of speech and the creations of his mind.[91] The role of imagination in a narrative is laid out by Mesarites also in the prooimion to his account of the failed coup of John Komnenos. There, at the start of his eyewitness account, he informs his audience with respect to how narratives are composed: "In writing a narrative, most people who are deep-thinking and resourceful, combine true events (ταῖς ἀληθείαις) with inventions (ἀναπλάσματα) which are appropriate to their purpose, making use of what is plausible and simulating these with fluency and

84 Mesarites, *Ekphrasis*, c. 2.2, ed. Heisenberg, *Apostelkirche*, 11–12; ed. and trans. Downey, "Nikolaos Mesarites," 862; trans. Angold, *Nicholas Mesarites*, 84.

85 Mesarites, *Ekphrasis*, c. 28.16, ed. Heisenberg, *Apostelkirche*, 62.8–12; ed. and trans. Downey, "Nikolaos Mesarites," 883; trans. Angold, *Nicholas Mesarites*, 113.

86 Mesarites, *Ekphrasis*, c. 20.2 (Antiochenes), 34.5 (Thomas), ed. Heisenberg, *Apostelkirche*, 42.9–10, 74.4–6; ed. and trans. Downey, "Nikolaos Mesarites," 875, 888; trans. Angold, *Nicholas Mesarites*, 101–2, 120.

87 Mesarites, *Ekphrasis*, c. 22.7, ed. Heisenberg, *Apostelkirche*, 46.13–16; ed. and trans. Downey, "Nikolaos Mesarites," 877; trans. Angold, *Nicholas Mesarites*, 104. See the discussion of this passage by R. Betancourt, *Sight, Touch, and Imagination in Byzantium* (Cambridge, 2018), 180–81.

88 Mesarites, *Ekphrasis*, c. 25.1, ed. Heisenberg, *Apostelkirche*, 49.3–6; ed. and trans. Downey, "Nikolaos Mesarites," 878; trans. Angold, *Nicholas Mesarites*, 105.

89 Anna Komnene likewise draws attention to the act of writing but also to the time of writing. She jolts her readers, pulling them out of her narrative into the time and the circumstances of her writing: "In the midst of this story, I am forced to laugh at these men and their senselessness and triviality, rather at their mutual bragging"; "Having reached this point, drawing my pen along at lamp-lighting time, I feel my words to be slipping away as I doze a bit over my writing." *Annae Comnenae Alexias*, ed. D. R. Reinsch and A. Kambylis (Berlin and New York, 2001), 1.15.6 (p. 50) and 13.6.3 (p. 401).

90 R. Webb, "Aesthetics of Sacred Space," 73. See above, 182, note 60, for a similar reference to ink and paper in Mesarites' account of the usurpation attempt of John Komnenos.

91 Mesarites, *Ekphrasis*, c. 12.4, ed. Heisenberg, *Apostelkirche*, 23.7–9; ed. and trans. Downey, "Nikolaos Mesarites," 867; trans. Angold, *Nicholas Mesarites*, 90: ταῖς ἐκ λόγου ὕλαις καὶ τοῖς ἐκ νοὸς τεχνουργήμασιν οἰκονομῆσαι προὐθέμην.

refinements."[92] The material fabric of the church, like the events he has experienced, is a source that combines with his memory and imagination to produce his ekphrastic narratives.

Nicholas Mesarites is not unique as a writer in his self-confident expression of personal experience, in his interest in physical and psychological processes. These are features he shares with his contemporaries Michael and Niketas Choniates, Constantine Stilbes, and John Apokaukos, men who also lived and worked across the 1204 divide, men who on the whole had careers, like Mesarites, in the so-called Patriarchal School, careers that culminated in positions in metropolitan sees.[93] John Apokaukos, in particular, has long since been singled out for his direct delivery to us of the concrete, the facts of daily life as it was lived. From him we learn that the Byzantines wore fur coats, cracked Easter eggs, discussed their kidney stones, and poked fun at themselves as well as others.[94]

Many of the literary features outlined here and, in particular, the first-person interjection of the writer in their text, can be traced back to the eleventh century and observed in the writing of Michael Psellos.[95] It is in the eleventh century, too, that real events and people become the subjects of the progymnasmata/schedographiai.[96] But the author who foreshadowed and perhaps instilled in Mesarites and his contemporaries the literary features discussed here is Eustathios of Thessalonike.[97] In a playful petition to the newly appointed "master of the petitions," who was a member of the Doukas family, Eustathios recounts and re-creates the domestic circumstances in which he learned he had unintentionally snubbed that man's brother. In so doing he displays the "aesthetic of the concrete and the comic,"[98] which is well represented by Mesarites and his contemporaries.

I happened upon the most excellent brother of your great pre-eminence on the road and since I do not have very inquisitive eyes and besides, because I was walking on an unsafe road, I was not able to determine that my happy encounter on the road was, as it seems, the most excellent of men Doukas. I was misled also by the plainness of the procession in front of him. For one person only went before him, and he [Doukas] was at a great distance, so that I thought him to be one of those who just now wears white because of the brightness of the day. So I passed him unremarked, inclining my head slightly as to an unknown [person], acquitting myself of my gesture of greeting as if to a stranger. When I was in my little house a short time after—as you would say—and I was reclining at table, and my hand was dipping into the food and the quails which I bought from you were fluttering down from the table, there the eunuch John sprung up as from ambush and fiercely falling upon me he shouted, "What have you done? Why didn't you address Doukas?" I (by my head and by the salvation of my soul) was immediately struck, as if at a most novel report, and I dropped my hands and was astounded by what I heard.[99]

92 Mesarites, *Coup*, c. 1, ed. Heisenberg, *Palastrevolution*, 19.6–11; trans. Angold, *Nicholas Mesarites*, 42. See A. Kaldellis, "The Emergence of Literary Fiction in Byzantium and the Paradox of Plausibility," in *Medieval Greek Storytelling: Fiction and Narrative in Byzantium*, ed. P. Roilos (Wiesbaden, 2014), 115–29, here at 115–21: "reliable historical records, insofar as they too are narratives, also rely on many of the techniques of discursive representation that are characteristic of fiction" (115).

93 For the "Patriarchal School" see R. Browning, "The Patriarchal School at Constantinople in the Twelfth Century," *Byzantion* 32 (1962): 167–202 and *Byzantion* 33 (1963): 11–40; P. Magdalino, *The Empire of Manuel I Komnenos* (Cambridge, 1993), 325–30; N. Gaul, "Rising Elites and Institutionalization—Ethos/Mores—'Debts' and Drafts: Three Concluding Steps towards Comparing Networks of Learning in Byzantium and the 'Latin' West, c. 1000–1200," in *Networks of Learning: Perspectives on Scholars in Byzantine East and Latin West, c. 1000–1200*, ed. S. Steckel and N. Gaul (Berlin, 2014), 235–80, here at 245–56, and n. 113.

94 P. Magdalino, "The Literary Perception of Everyday Life in Byzantium: Some General Considerations and the Case of John Apokaukos," *BSl* 47 (1987): 28–38 [= Magdalino, *Tradition and Transformation*, study X].

95 S. Papaioannou, *Michael Psellos: Rhetoric and Authorship in Byzantium* (Cambridge, 2013), *passim* and esp. 240–49; R. Macrides, "The Historian in the History," in *ΦΙΛΕΛΛΗΝ: Studies in Honour of Robert Browning*, ed. C. N. Constantinides et al. (Venice, 1996), 205–24.

96 Bernard, *Byzantine Secular Poetry*, 224–25.

97 Magdalino, "Literary Perception of Everyday Life," 34.

98 The expression is Paul Magdalino's in his *L'Orthodoxie des astrologues* (Paris, 2006), 133.

99 J.-P. Migne, PG 136, no. 17, cols. 1272–1273. On Eustathios's life and teaching career see P. Magdalino, "Eustathios and Thessalonica," in *ΦΙΛΕΛΛΗΝ*, 225–38. On Eustathios see E. C. Bourbouhakis, *Not Composed in a Chance Manner: The*

In this passage Eustathios conveys the conditions of his daily life in the context of a humorous petition to the new master of petitions. He makes reference not only to the physical reality of his life but also his perceptions, how his eyes deceived him but also why he was misled, as well as his physical and emotional reaction to his servant's fierce reproach. Similar literary features are exhibited in the work of a practically unknown author of the twelfth century, John Nomikopoulos, for whom only one letter is known to have survived. In his letter, which, according to the title, contains an ekphrasis of an Ethiopian and a horse, John sets the scene by describing his bed-ridden condition at the time of the arrival of his unexpected visitors.

We were in bed the day before yesterday; the sun had descended a little from the middle of the sky and was pursuing the western parts. We were sometimes lying supine, sometimes propped up on the right side and a little later again on the left side, and, in a word, we were rolling over, as the illness dictated. This was so for a short time until someone struck the door unsparingly, using the knocker at the gate. I straightway gathered my wits which were scattered here and there, sprung up from the bed—the noise working this wonder. For I was expecting that the one knocking on the door was a letter bearer, the person conveying your golden little stories. But my supposition was not free from error for, fixing my eyes on the gate, I observed that the expected letter bearer was a horse bearer. I uttered a small cry at the sight, for the half-horse, because of the numerous marks [on him], was misjudged by me to be a cheetah. The rider was for the most part burnt in the face to a nightshade. This, the superficial application of sight gave me to understand. But as I affixed a concentrated look at the two spectacles and the mind accurately copied their forms as they appeared in the inner recesses of the palace by way of the light-emitting windows,

the apparition was comprehended as a real Ethiopian and a horse.[100]

In this humorous composition that conveys the material circumstances in which the author received his correspondent's gift, the author plays on the overturning of his expectations, on the instability of his sensory perceptions. Although he had at first thought that there was a sunburnt man and a cheetah at his gate, when he looked again he realized that there was a real Ethiopian and a distressed horse in front of his house.

In this letter—as in Mesarites' work—the author uses the language of natural philosophy, the theory of optics, to say that his eyes transmitted to his brain the vision of the horse and rider. The occasion for the playful letter is a real gift of a horse, sent by Nomikopoulos's addressee. The author combines a re-creation of the moment, the circumstances in which the gift appeared at his door, with a parodic ekphrasis of the Ethiopian and the horse.[101]

In other twelfth-century texts it is tragic events that are the context for realia. Two examples are preserved in a thirteenth-century manuscript, Marcianus graecus 524. An anonymous author combines event, places, and things that can be documented for the twelfth century with the language of the tragic lament, using the structure of a legal document, the *semeioma*, to tell the story. The author of the poem who presents himself as a member of the church hierarchy, a *protekdikos* or judge, reveals the story of a woman who had committed terrible crimes in oppressive circumstances in twelfth-century Anatolia. The narrator-judge uses the language of ancient Greek tragedy to tell the story. He thus presents a kind of defense of the woman's deeds by transmitting the "facts" of the case in the language of

Epitaphios for Manuel I Komnenos by Eustathios of Thessalonike (Uppsala, 2017), 83–125.

100 A. Karpozilos, "Ἰωάννη Νομικοπούλου ἔκφρασις Αἰθιόπος καὶ ἵππου πάνυ ταλαιπωρημένου," *Δωδώνη* 9 (1980): 285–97, text at 294–96. For Byzantine theories of vision, see Betancourt, *Sight, Touch, and Imagination*, 45–46, 195 and *passim*. Here, the theory that the eyes ("windows") send out rays of light is expressed. See also Magdalino, *Manuel I*, 381: "The physiology and psychology of sight was a topic of considerable interest at Manuel's court." On "Ethiopians" in 12th-century texts, see Karpozilos, "Εκφράσις," 287–92, and idem, "Η θέση των μαύρων στη Βυζαντινή κοινωνία," in *Οι περιθωριακοί στο Βυζάντιο*, ed. Ch. A. Maltezou (Athens, 1993), 67–81.

101 Karpozilos, "Εκφράσις," 292.

ancient tragedy. A tragedy of his own times was made more vivid through the use of the classical tradition.[102]

Constantine Stilbes' verse lament on the Constantinopolitan fire of 1197, preserved in the same manuscript, gives the only known account of this conflagration.[103] The poem describes in iambic trimeter the path of the fire and the buildings it destroyed. By giving an ekphrasis of the fire, the narrator re-creates its destructive powers: "How will I speak out, and with what organs, if fire, taking possession of my inner articulation dries up my mouth and the moisture of my lips, and sucks up every tear from my eyes, so that though I want to cry I cannot weep?"[104] Stilbes claims that words, through the imagination, have the power to affect physical and emotional change. This poem, too, uses the classical tradition, its language and meter, to describe a contemporary event and to elicit emotions through that description.

The interest of twelfth-century authors in conveying physical and emotional states and scenes may have derived from the study of the natural sciences, which was part of philosophical studies, linked to the study of rhetoric.[105] Nicholas relates that the education of his brother John included *physike,* the natural sciences. In his detailed account of John's education, Nicholas lists some of the topics covered in physike, questions that were subject to discussion and debate.[106] Also, in his description of the church of the Holy Apostles he mentions some of the same topics. Indeed, Nicholas's account of his

brother's education reproduces almost verbatim his report of the subjects taught in the school of the Holy Apostles.[107]

The school of the Holy Apostles is known only from Mesarites' ekphrasis of the church.[108] There may be one earlier reference to it in Michael Psellos's "Encomium for His Mother," but if so, it is tangential and allusive. Psellos relates a dream his mother saw in which she found herself in the church of the Holy Apostles, in the presence of a woman and two men. The woman enjoined her to fill her son with knowledge of literature. Psellos states that this dream was decisive to his mother's future support of her son's higher education.[109] It has been suggested that the two men were the hierarchs John Chrysostom and Gregory of Nazianzos, whose relics had been deposited in the Holy Apostles in the tenth century and whose reputation as patrons of education was promoted in the eleventh.[110]

The school at the church of the Holy Apostles is thus not well known or securely established, apart from Nicholas Mesarites' description. He refers to two areas on the outside of the church that were filled with students; he opens and concludes his *Ekphrasis* with accounts of the subjects studied in those spaces. In the area to the east, toward the church of All Saints, young children were taught grammar and arithmetic,[111] while in the forecourt of the church were gathered those

102 R. Macrides, "Poetic Justice in the Patriarchate: Murder and Cannibalism in the Provinces," in *Cupido legum,* ed. L. Burgmann, M. T. Fögen, and A. Schminck (Frankfurt am Main, 1985), 137–68, text at 138–47; repr. in R. J. Macrides, *Kingship and Justice in Byzantium, 11th–15th centuries* (Aldershot and Brookfield, VT, 1999), study XI.

103 J. Diethart and W. Hörandner, eds., *Constantinus Stilbes Poemata* (Munich and Leipzig 2005), 8–51 (text); T. Layman, *"The Incineration of New Babylon": The Fire Poem of Konstantinos Stilbes* (Geneva, 2015), 42–119 (text, translation, and commentary). See also J. Diethart and W. Hörandner, "The Poetical Works of Constantine Stilbes: Some Remarks on His Rhetorical Practice," in *La poesia tardoantica e medievale,* ed. A. M. Taragna (Alessandria, 2004), 215–27.

104 Stilbes, "Fire Poem," ed. Diethart and Hörandner, 24.392–396; trans. Layman, 76.392–78.396.

105 Mesarites, "Epitaphios," c. 18, ed. Heisenberg, "Epitaphios," 32.19–20; trans. Angold, *Nicholas Mesarites,* 156.

106 Mesarites, "Epitaphios," c. 18, ed. Heisenberg, "Epitaphios," 31–32; trans. Angold, *Nicholas Mesarites,* 156.

107 Mesarites, *Ekphrasis,* c. 42.2–7, ed. Heisenberg, *Apostelkirche,* 91–93; ed. and trans. Downey, "Nikolaos Mesarites," 894–95; trans. Angold, *Nicholas Mesarites,* 129.

108 Browning, "Patriarchal School," 167–202, here at 177, suggests that the school at the Holy Apostles was a recent foundation since there is no trace of it earlier in the century. A. P. Kazhdan and A. Wharton Epstein, *Change in Byzantine Culture in the Eleventh and Twelfth Centuries* (Berkeley, Los Angeles, and London, 1985), 125: "one of the best-known institutions in the city." If it is well known, it is only because of Mesarites' account.

109 U. Criscuolo, *Michele Psello Autobiografia: Encomio per la madre* (Naples, 1989), 85–153, here at 5d, p. 96.317–97.338; A. Kaldellis with D. Jenkins and S. Papaioannou, ed. and trans., *Mothers and Sons, Fathers and Daughters* (Notre Dame, 2006), 51–109, here at 61.

110 C. Angelidi, "The Writing of Dreams: A Note on Psellos' Funeral Oration for His Mother," in *Reading Michael Psellos,* ed. C. Barber and D. Jenkins (Leiden and Boston, 2006), 153–66, here at 158.

111 Mesarites, *Ekphrasis,* cc. 8–11, ed. Heisenberg, *Apostelkirche,* 19–22; ed. and trans. Downey, "Nikolaos Mesarites," 866–67; trans. Angold, *Nicholas Mesarites,* 88–90.

who studied at a more advanced level. Discussion and debate were the methods of instruction in the forecourt. The subjects were arithmetic, geometry, and music.[112] The fourth subject, traditionally astronomy, is missing; in its place is medicine.[113] Mesarites states that the "physician" students gathered at the porphyry water trough—the same basin which on the feast day of the apostles was filled with wine, mixed with water and bread.[114] There the students discussed veins, arteries, fevers, pulse beats, the organs, whether the power of sight was directed outward or whether images are received by us, and whether the power of feeling, in all the organs of sense, gets it strength from the brain.[115] Many of these subjects of discussion can be recognized in Mesarites' writings, as well as in the writing of other twelfth-century writers.[116]

The mention of the discussion of medical subjects in Mesarites' *Ekphrasis* of the Holy Apostles is rare evidence for the study of medicine in the city. It is only in the *typikon* for the Pantokrator monastery that one finds reference to a teacher of medicine.[117] Yet medical knowledge may have become widespread in the twelfth-century

curriculum.[118] This possibility is supported by the prominence of medicine in twelfth-century Byzantine culture.[119] Medicine became "fashionable" in the twelfth century; medical knowledge was not confined to doctors but was more generally spread and was related to other cultural interests.[120] Doctors enjoyed a high profile.[121] Mesarites himself mentions doctors on two occasions, in his funeral oration for his brother and in his letter to the monks of the Euergetis monastery. In the former, a family relation, a doctor by the name of Megistos who was "at the top of the medical profession," was instrumental in gaining John a place at court.[122] In his letter to the monks Nicholas mentions an incident that occurred when he was eating a meal with Brachnos, "most esteemed among doctors."[123]

Mesarites' enumeration of the topics discussed in the forecourt of the church suggests not only that medicine was a subject of study but also that it had taken the place of astronomy in the

112 Mesarites, *Ekphrasis*, c. 42.6–9, ed. Heisenberg, *Apostelkirche*, 92–93; ed. and trans. Downey, "Nikolaos Mesarites," 895–96; trans. Angold, *Nicholas Mesarites*, 129.

113 Mesarites, *Ekphrasis*, c. 42.1–5, ed. Heisenberg, *Apostelkirche*, 90–92; ed. and trans. Downey, "Nikolaos Mesarites," 894–95; trans. Angold, *Nicholas Mesarites*, 129.

114 Mesarites, *Ekphrasis*, cc. 42.2, 41.3–4, ed. Heisenberg, *Apostelkirche*, 91–92, 89–90; ed. and trans. Downey, "Nikolaos Mesarites," 894; trans. Angold, *Nicholas Mesarites*, 129, 128.

115 Mesarites, *Ekphrasis*, c. 42.2–5, ed. Heisenberg, *Apostelkirche*, 91–92; ed. and trans. Downey, "Nikolaos Mesarites," 894–95; trans. Angold, *Nicholas Mesarites*, 129. Michael Angold (*Nicholas Mesarites*, 79) has suggested that the people who gathered in the atrium of the church, specifically the students of medicine, were not students of the Holy Apostles but had come from all over the city for the celebration of the feast day mentioned by Mesarites. Yet, he also states (129n77) that "Mesarites spends more time than might be expected on medical studies." He sees the lack of reference, other than Mesarites, to the Holy Apostles as a place of instruction in medicine as a drawback to accepting Mesarites' account.

116 See above, 187, note 100, for Nomikopoulos's comment on the brain's reception of the image sent to it by the eyes.

117 P. Gautier, "Le Typikon du Christ Sauveur Pantocrator," *REB* 32 (1974): 1–145, here at 107.1313–1323. Michael Italikos was teaching medicine before 1133/1138 but it is not known where. Gautier surmises that he may have been teaching privately. His case shows that little is known about the teaching of medicine in Constantinople. See P. Gautier, *Michel Italikos: Lettres et discours* (Paris, 1972), 16–19, 97. See also below, note 130.

118 See D. Stathakopoulos, "The Location of Medical Practice in the Thirteenth-Century Eastern Mediterranean," in *Liquid and Multiple: Individuals and Identities in the Thirteenth-Century Aegean*, ed. G. Saint-Guillain and D. Stathakopoulos (Paris, 2012), 135–54, here at 137–45, and D. Stathakopoulos, "On whose Authority? Regulating Medical Practice in the Twelfth and Early Thirteenth Centuries," in *Authority in Byzantium*, ed. P. Armstrong (Farnham, 2013), 227–38.

119 Magdalino, *Manuel I Komnenos,* 361–65; Kazhdan and Epstein, *Change in Byzantine Culture,* 130. See the discussion of medical language in the writing of George Tornikes in M. Loukaki and C. Jouanno, *Discours annuels en l'honneur du patriarche George Xiphilin* (Paris, 2005), 185; I. Grigoriadis, *Linguistic and Literary Studies in the Epitome Historion of John Zonaras* (Thessalonike, 1998), 100–102.

120 Magdalino, *Manuel I Komnenos,* 361–65. In addition to the other indications of Mesarites' medical knowledge there is now his description, using medical terms, of his illness in two letters written to an unknown addressee "two years after the conquest." He seems to have suffered from a severe chronic skin disease. See Cataldi Palau, "Deux lettres inédites," 224, 225; for discussion see Angold, *Nicholas Mesarites,* 312; trans. 315.

121 E. Trapp, "Die Stellung der Ärzte in der Gesellschaft der Palaiologenzeit," *BSl* 33 (1972): 230–34; A. Kazhdan, "The Image of the Medical Doctor in Byzantine Literature of the Tenth to Twelfth Centuries," *DOP* 38 (1984): 43–51.

122 Mesarites, "Epitaphios," c. 24, ed. Heisenberg, "Epitaphios," 37.19–38.24; trans. Angold, *Nicholas Mesarites,* 161. Megistos may be the addressee of an unpublished letter to a "doctor of the emperor who was a relation." See Flusin, "Éthopée," 233.

123 Mesarites, "Reisebericht," 44.5–10; trans. Angold, *Nicholas Mesarites,* 232. See also Mesarites' unpublished letter addressed to an unnamed doctor, an "imperial *oikeios* by marriage," whom Mesarites describes as "closely related" to him (Ambr. F 96 Sup. [Gr. 352], fol. 33v): Cataldi Palau, "Deux lettres inédites," 215.

curriculum[124] and was taught along with arithmetic, geometry, and music.[125] This suggestion is strengthened by the twelfth-century canonical commentaries of John Zonaras and Theodore Balsamon, which show that the ban on astrology had been extended to the study of astronomy.[126] A further indication of the status of astrology in the twelfth century is the multiplication of satires in that century that portray misguided astrologers.[127] Mesarites' ethopoiia for the astrologer who was eager to acquire a patriarchal see is one of them.[128]

The inclusion of medical topics in the curriculum of higher education at the Holy Apostles but also possibly in other schools in twelfth-century Constantinople may provide a clue to understanding Mesarites' particular interest in the processes of the body and the mind. It may, further, help to explain the same interests in the writing of his contemporaries. However, not all twelfth-century writers showed a similar inclination. Alexander Kazhdan has already shown that Nikephoros Chrysoberges, who wrote one of the four surviving accounts of the usurpation attempt of John Komnenos the Fat was a very different writer from Mesarites.[129] Likewise, Michael Italikos, who taught medicine, as well as rhetoric and philosophy, gives no indication in his writing of his medical knowledge.[130] However, another innovative aspect of twelfth-century writing, the emphasis on the everyday, can be related confidently to a development in

education, that is, the use of contemporary events as subjects of rhetorical exercises.[131]

Mesarites' reference to physiology and to places, events and artifacts of daily life, are traits found in all his writings, including his ekphrasis of the church of the Holy Apostles. In his description of the church, as in his other works, Mesarites made vivid whomever and whatever he described and narrated. The author who depicted John Komnenos sitting on the floor of the Mouchroutas, flicking the sweat from his forehead with the crook of his finger, also described Christ Pantokrator leaning out at the summit of the dome of the Holy Apostles "like an earnest and vehement lover."[132]

A parallel development was under way in pictorial representation in Mesarites' time—the preference for the depiction of "realistic" details, an increased reference to everyday objects. Maria Parani has argued that these depictions were intended to "facilitate spiritual and emotive response to the images."[133] This feature in Mesarites' description—the inclusion of realia, not only the Egyptian carpets and woven cloths in the scene of the Communion of the Apostles,[134] but also references to emotional and physical states of being—has led scholars to date at least some of the mosaics of the Holy Apostles to the twelfth century.[135] For many, the inclusion of the artist's portrait in the scene of the Women

124 John Mesarites had, however, studied astronomy in Constantinople at an unknown school. See Mesarites, "Epitaphios," c. 15, ed. Heisenberg, "Epitaphios," 28–29; trans. Angold, *Nicholas Mesarites*, 153.

125 See above at 188, notes 111, 113.

126 G. A. Rhalles and M. Potles, Σύνταγμα τῶν θείων καί ἱερῶν κανόνων, 6 vols. (Athens, 1852–59; repr. 1966), 3:204–6; 4:511–19; Magdalino, *L'Orthodoxie des astrologues*,128–29, 133–37.

127 P. Magdalino, "Debunking Astrology in Twelfth-Century Constantinople," in *"Pour une poétique de Byzance": Hommage à Vassilis Katsaros*, ed. S. Efthymiadis et al. (Paris, 2015), 165–75. See also idem, *L'Orthodoxie des astrologues,* 135: "the best representatives of Byzantine literature in 1204 were opposed to astrology."

128 Magdalino, "Debunking Astrology," 168–69.

129 Kazhdan, "Nicephorus Chrysoberges and Nicholas Mesarites," 244–55.

130 Gautier, *Michel Italikos,* 16–21, 97. See also above, note 117.

131 Bernard, *Byzantine Secular Poetry*, 224–29. Michael Angold suggests that it is the new schedography that is responsible for the vividness in Mesarites' writing. See Angold, "Mesarites as a Source," 62–63.

132 Mesarites, Coup, c. 28, ed. Heisenberg, *Palastrevolution* 45.10–17; trans. Angold, *Nicholas Mesarites*, 70; Mesarites, *Ekphrasis*, c. 14.1–2, ed. Heisenberg, *Apostelkirche*, 29.10–12; ed. and trans. Downey, "Nikolaos Mesarites," 884; trans. Angold, *Nicholas Mesarites*, 94.

133 For a definitive discussion of this phenomenon see M. G. Parani, *Reconstructing the Reality of Images: Byzantine Material Culture and Religious Iconography (11th–15th Centuries)* (Leiden and Boston, 2013).

134 Mesarites, *Ekphrasis*, c. 15.4, ed. Heisenberg, *Apostelkirche*, 31.9–11; ed. and trans. Downey, "Nikolaos Mesarites," 871; trans. Angold, *Nicholas Mesarites*, 95.

135 See R. Cormack, "Living Painting," in *Rhetoric in Byzantium*, ed. E. Jeffreys (Aldershot and Burlington, VT, 2003), 235–46, here at 237–38. Cormack cites Belting on the "new features of Comnenian art": new narrative interest, new visual technique of communicating emotion, new subjects, features equally recognizable in literature of the period. Cormack warns against seeing a link between art of the 12th century and rhetoric.

at the Tomb, "the man who depicted these things with his own hand . . . standing upright at the tomb of the Lord,"[136] provides incontrovertible evidence for the twelfth-century date of at least some of the mosaics Mesarites describes.[137] Thanks to a marginal note that was barely legible even in Heisenberg's time, the "artist" was identified as Eulalios, and thus a twelfth-century date was assigned to this scene and others.[138] Yet, now that the existence of a painter called Eulalios has been called into question,[139] the case for a twelfth-century date is much weaker.

Mesarites is so very concrete in his writing, in all genres, on all subjects, having as his starting point a real situation, event, object, and highlighting the material, the circumstances, physical and emotional, that it is difficult not to take what we see boldly foregrounded as the very thing Mesarites wanted to convey: the number and names of the relics in the Pharos, the appearance of the Mouchroutas, the dangers and discomforts of travel, the mosaics of the Holy Apostles. While these are "finds" for students of Byzantium, they are, even so, only surface finds. We should not content ourselves with collecting and cataloguing them. Rather, we should ask what Mesarites was attempting to express with his description of the church of the Holy Apostles, a monument so very well known to his contemporaries. Was he not trying to elicit spiritual and emotive responses to the mosaic images, like the man who depicted the scenes with his own hand? Was he not creating a representation of a representation?

The solution to the Holy Apostles "puzzle," then, lies in the way Mesarites wrote. We will never be able to state definitively that the mosaics Mesarites describes and celebrates were new additions to the decorative scheme, later than those of Constantine the Rhodian's *Ekphrasis*, or the same as his but described in the style of the twelfth-century literary developments. In the end, we must accept Mesarites' description of his *Ekphrasis* as a monument made of words, *his* creation. We have, after all, his word for it.

136 Mesarites, *Ekphrasis*, c. 28.23, ed. Heisenberg, *Apostelkirche*, 63.19–64.1; ed. and trans. Downey, "Nikolaos Mesarites," 884; trans. Angold, *Nicholas Mesarites*, 114.

137 See above, notes 3 and 4.

138 Artists began to sign their works in the 12th century and thus became prominent then. However, there are no known self-portraits of Byzantine artists, apart from the one under discussion here. See S. Kalopissi-Verti, "Painters' Portraits in Byzantine Art," Δελτ.Χριστ.Ἀρχ.Ετ. 17 (1994), *In Memory of Doula Mouriki*, 129–42, esp. 136, 138; Parani, *Reconstructing the Reality of Images*, 279. If there was an artist called Eulalios, his would be a unique case for Byzantium. It was not until Jan van Eyck (1390–1441) and Caravaggio (1571–1610) that the artist included a depiction of himself in his own work.

139 B. Daskas, "Literary Self-Portrait," 151–69.

INSIDE AND OUTSIDE THE HOLY APOSTLES WITH NICHOLAS MESARITES

HENRY MAGUIRE

*A*T THE TURN OF THE TWELFTH AND THE THIRTEENTH CENTURIES, Nicholas Mesarites wrote his long *ekphrasis* of the Holy Apostles.[1] It presents us with a remarkably detailed account of the church, the buildings surrounding it, and its internal decoration of mosaics. The following paper, however, will not debate the vexed reconstruction of the architecture and decoration of the Holy Apostles, which was to a large extent the project of the Dumbarton Oaks symposium of the 1940s. Rather, it will look at the text itself as a literary construct informed by contemporary visual culture. The primary concern will be to describe the ekphrasis as an artifact in its own right, and as a product of the intellectual and artistic environment of its time and place. For the argument of this paper it makes little difference when the mosaics that Mesarites described were made, whether in the sixth, the tenth, or the twelfth century, or, indeed, at a variety of dates.[2] Nevertheless, an ekphrasis is a visual as well as a verbal exercise; for this reason, any discussion of it has to take account of the visual as well as the literary climate at the time of its composition. Accordingly, this essay falls into two parts. The first considers the structure of the text itself, the second considers how that structure relates to contemporary developments in Byzantine art.

Before we turn to analysis of the text, a few words are necessary about its present form and its reconstruction. The text is contained in several folios of one manuscript, which was probably written in the thirteenth century.[3] The folios were subsequently broken up and rebound, in an incorrect order, in two separate manuscripts, both of which are in the Ambrosian Library of Milan. The conclusion of the *Ekphrasis* has been preserved, but the beginning of the text, together with its original title and introduction, is lost. Since several of the folios are divided at mid-sentence, it is possible to assemble the

For her insightful comments I am grateful to Beatrice Daskas, with whom I discussed the topic of this paper on several occasions. For assistance in gaining access to the minarets of the Fatih Camii, I am indebted to Engin Akyürek. Since the original submission of this paper in 2015 there has been a spate of publications on Mesarites' *Ekphrasis* of the Holy Apostles, including the following: M. Angold, "Mesarites as a Source: Then and Now," *BMGS* 40, no. 1 (2016), 56–68; idem, *Nicholas Mesarites: His Life and Works (in Translation)*, TTB 4 (Liverpool, 2017), 75–133; B. Daskas, "A Literary Self-Portrait of Nikolaos Mesarites," *BMGS* 40, no. 1 (2016), 151–69; eadem, "Nikolaos Mesarites, Description of the Church of the Holy Apostles at Constantinople: New Critical Perspectives," *Parekbolai* 6 (2016), 79–102; and N. Zarras, "A Gem of Artistic Ekphrasis: Nicholas Mesarites' Description of the Mosaics in the Church of the Holy Apostles at Constantinople," in A. Simpson, ed., *Byzantium 1180–1204: "The Sad Quarter of a Century"?* (Athens, 2015), 261–79. Given the date of its submission, my paper is intended to be a complement to these publications rather than a response.

1 A. Heisenberg, *Grabeskirche und Apostelkirche: Zwei Basiliken Konstantins*, vol. 2, *Die Apostelkirche von Konstantinopel* (Leipzig, 1908), 10–96; translation by G. Downey, "Nikolaos Mesarites: Description of the Church of the Holy Apostles at Constantinople," *TAPS*, n.s., 47, part 6 (1957), 855–924. A recent translation by Michael Angold is included in his *Nicholas Mesarites*, 83–133.

2 On the question of the dating of the mosaics, see, in addition to the papers in this volume, A. W. Epstein, "The Rebuilding and Redecoration of the Holy Apostles in Constantinople: A Reconsideration," *GRBS* 23, no. 1 (1982): 79–92, and, recently, Zarras, "Gem of Artistic Ekphrasis," 261–79.

3 Downey, "Nikolaos Mesarites," 860–61.

folios into five main groups. August Heisenberg, in his 1908 edition of the *Ekphrasis*, arranged the five groups in the following sequence. The first group opens with a description of the surroundings of the church, including the baths and the school, before proceeding to an invocation of the apostles, and then ending with descriptions of the mosaics of the Pantokrator in the central dome and the Communion of the Apostles at the east of the building.[4] The next three groups are entirely devoted to descriptions of the internal mosaics.[5] The fifth group begins with the closing part of the description of the internal mosaics, then goes again outside the main church to the mausolea and the atrium with its college of higher learning, finally reaching a conclusion with an encomium of the patriarch, John X Kamateros.[6]

This seems by far the most likely sequence, as to arrange the groups in any other order would entail breaking up the description of internal mosaics with the insertion of accounts of the surroundings outside the church, which, as we shall discover, are very different in character from the passages that deal with sacred subjects. Also, since the first of Heisenberg's groups contains the invocation to the apostles, it is logical to place it at the beginning. The main conclusion to be drawn from this reconstruction of the original *Ekphrasis* is that it was structured as a sandwich, in which the description of the church and its sacred mosaics was framed at the beginning and the end by descriptions of its secular surroundings, such as the baths, the school, and the college. But, as will be shown, Mesarites' account is not a simple itinerary into the church and out again; it is a kind of diagram of salvation, with the church at its center.

In some respects, the *Ekphrasis* of the Holy Apostles by Mesarites can be compared with the tenth-century description by Constantine the Rhodian,[7] but in other respects it differs in revealing ways. Like Mesarites, Constantine the Rhodian structures his *Ekphrasis* around a contrast of the sacred and the nonsacred, but in the case of the tenth-century writer the contrast was between the church and secular monuments and sculptures, rather than with the day-to-day activities described by Mesarites. Before he proceeds to describe the church itself with its mosaics, Constantine begins his poem with an extended account of the columns and pagan statuary in the city, including the porphyry column of Constantine, the column of Justinian with its imperial statue, the column of Theodosius with the nearby statue of the emperor, the column of Arcadius, and the column at the Philadelphion.[8] He also describes the senate house, with the vivid mythological sculptures of the gigantomachy on its doors,[9] the statue of Athena of the Lindians,[10] and the Anemodoulion, or weather vane, with its sculptures of naked erotes.[11]

Mesarites, on the other hand, does not describe the profane world outside the church with reference to ancient monuments and sculptures, but rather with reference to the contemporary daily life that took place around the church, both in its outbuildings and beyond. Alexander Kazhdan first drew attention to this aspect of his art.[12] Although Mesarites does not describe pagan monuments specifically, there is a change in his language when he is presenting the secular subjects. In the secular contexts he uses many allusions to and quotations from classical authors, not only Homer, but also Hesiod, Themistius, and especially Libanius, who is very extensively quoted—plagiarized one would say,

4 Mesarites, *Ekphrasis*, cc. 1.1–15.6, ed. Heisenberg, *Apostelkirche*, 1–32; ed. and trans. Downey, "Nikolaos Mesarites," 861–71; trans. Angold, *Nicholas Mesarites*, 89–95.

5 Mesarites, *Ekphrasis*, cc. 16.1–17.2; 18.1–18.13; and 19.1–23.2, ed. Heisenberg, *Apostelkirche*, 32–38, 38–41, 41–48; ed. and trans. Downey, "Nikolaos Mesarites," 871–74, 874–75, 875–78; trans. Angold, *Nicholas Mesarites*, 96–99, 99–101, 101–5.

6 Mesarites, *Ekphrasis*, cc. 24.1–43.10, ed. Heisenberg, *Apostelkirche*, 48–96; ed. and trans. Downey, "Nikolaos Mesarites," 878–96; trans. Angold, *Nicholas Mesarites*, 105–33; see Heisenberg, *Apostelkirche*, 4–9.

7 Constantine the Rhodian, *Ekphrasis*, ed. L. James, *Constantine of Rhodes, On Constantinople and the Church of the Holy Apostles, with a New Edition of the Greek Text by Ioannis Vassis* (Farnham, Surrey, and Burlington, VT, 2012).

8 Constantine the Rhodian, *Ekphrasis*, lines 19–89, ed. James, *Constantine of Rhodes*, 19–25.

9 Constantine the Rhodian, *Ekphrasis*, lines 90–152, ed. James, *Constantine of Rhodes*, 25–29.

10 Constantine the Rhodian, *Ekphrasis*, lines 153–162, ed. James, *Constantine of Rhodes*, 29–30.

11 Constantine the Rhodian, *Ekphrasis*, lines 178–201, ed. James, *Constantine of Rhodes*, 31–33.

12 A. Kazhdan, *Studies on Byzantine Literature of the Eleventh and Twelfth Centuries* (Cambridge, 1984), 236–55.

were Mesarites not a Byzantine author.[13] As we shall see, his plagiarisms are artful and have a definite literary purpose.

Another characteristic of the passages that describe secular activities is the underlying current of fear, conflict, danger, and violence that runs beneath the descriptions. To take an example, at the opening of the *Ekphrasis* Mesarites gives us a description of the gardens around the church, which begins in a charming way—there are tall trees with rich fruit, balsam and lilies, fresh clover and hyacinth, the rose and the oleander, and everything of sweet aroma. This is more lovely, he says, than the garden of Laertes, described in the *Odyssey*.[14] Borrowing from Libanius's description of Daphne near Antioch, Mesarites describes the choruses of musical birds, the moderate breezes, and the sweet scents of spices.[15] But then, all of a sudden, a more anxious note appears, as Mesarites, abandoning his model Libanius, turns to the food supply. For people who live near the church, he says, "the wheat alone which grows in the land about their houses is sufficient for their nourishment, and they need have no care for invasions of barbarians, for the mighty waves of the sea, for the dangers from pirates, for the laborious drawing up of ships on the shore, for the troublesome handling of the grain by shippers, or for any of the other things which the mischievous minds of sailors can devise."[16]

Following on his account of the land lying around the church, Mesarites describes the fine prospect to be obtained by anyone who climbs up to the upper galleries and the roof of the building. Here also, the delights of the view are tempered with foreboding. From the church, he says, again quoting from Libanius, "one can see the sea, which lies there tranquilly and on its back bears freight-ships before a fair breeze, a sweet sight to all men and a source of rejoicing and pleasure."[17] But then comes a darker tone, for Mesarites says of the spectator: "neither is he frightened by the floods which the sea is wont to spew up, now here, now there, because he stands at a fitting distance from it, nor does he hear the groans of the sailors or the cries of drowning men."[18] Turning to the land side, Mesarites claims that the viewer can see the grounds of the Philopation, which he calls "the open country which [the spectator] sees beyond the walls," adding the explanation that it "has been given its present name because men love to visit it." But in this direction also there is the introduction of a potential threat. Here, says Mesarites, the emperor marshals his troops before he goes to march against the enemy for the safety of his people.[19]

A similar mixture of sweetness and conflict permeates the descriptions of the college outside the Holy Apostles, discussed by Paul Magdalino in this volume. At the beginning of the *Ekphrasis*, Mesarites describes the school for younger pupils,

13 Hesiod is cited in Mesarites, *Ekphrasis*, cc. 7.5 and 11.2; Themistius in c. 8.4; ed. Heisenberg, *Apostelkirche*, 18, 22, 20; ed. and trans. Downey, "Nikolaos Mesarites," 865–66, 867, 866; trans. Angold, *Nicholas Mesarites*, 88, 89, 88. The numerous citations from Libanius are collected in Downey, "Nikolaos Mesarites," 862, n. 1 to chapter 3. On imitation in Byzantine literature, see A. Rhoby and E. Schiffer, ed., *Imitatio, Aemulatio, Variatio* (Vienna, 2010).

14 Mesarites, *Ekphrasis*, cc. 3.3–5, ed. Heisenberg, *Apostelkirche*, 12–13; ed. and trans. Downey, "Nikolaos Mesarites," 863, 897; trans. Angold, *Nicholas Mesarites*, 84–85. Cf. *Odyssey*, 24.336.

15 Mesarites, *Ekphrasis*, c. 3.6, ed. Heisenberg, *Apostelkirche*, 13; ed. and trans. Downey, "Nikolaos Mesarites," 863, 897–98; trans. Angold, *Nicholas Mesarites*, 85. Libanius, *Oratio* XI (*Antiochikos*), 236.

16 Τοῖς μὲν γὰρ ἄλλοις, ὅσοις ὁ νεὼς οὗτος ἀφεστηκώς ἐστι, μήκοθεν ἔστιν ἰδεῖν καὶ τὸν σῖτον εἰσκομιζόμενον, τοῖς δ᾽ ἔγγιστα τούτου μόνος ὁ ἐκ τοῦ τῶν δωμάτων περιχώρου οἶδεν ἀρκεῖν πρὸς διατροφήν, καὶ οὔτ᾽ ἐθνῶν τούτοις μέλει ἐπιδρομή, οὐ τρικυμίαι θαλάσσης, οὐ κίνδυνοι πειρατῶν, οὐ πλοίων ἀπαγωγαί, οὐ μετακομιδὴ θαλαττεμπόρων περίεργος, οὐκ ἄλλο οὐδὲν τῶν ὅσα πράττειν οἶδε κακόσχολος γνώμη ναυτῶν. Mesarites, *Ekphrasis*, c. 4.2, ed. Heisenberg, *Apostelkirche*, 14; ed. and trans. Downey,

"Nikolaos Mesarites," 863, 898; trans. Angold, *Nicholas Mesarites*, 85–86. In this essay I am giving an emended version of Downey's translation of the text, which he originally prepared for the Holy Apostles project at Dumbarton Oaks.

17 ἔστι γὰρ ἐκεῖθεν ἰδεῖν θάλασσάν τε γαληνιῶσαν αὐτὴν καὶ πρὸς νῶτα ταύτης φερομένην ὁλκάδα δι᾽ οὐρίου τοῦ πνεύματος, ἡδὺ δὲ τοῦτο τοῖς ἅπασι θέαμα καὶ θυμηδία καὶ τερπωλή. Mesarites, *Ekphrasis*, c. 5.1, ed. Heisenberg, *Apostelkirche*, 14; ed. and trans. Downey, "Nikolaos Mesarites," 864, 898; trans. Angold, *Nicholas Mesarites*, 86; Libanius, *Oratio* XI (*Antiochikos*), 37.

18 Καὶ οὔτε πρὸς τὰς ἐπικλύσεις, ὁπόσας περ ἄλλοτε ἄλλως οἶδεν ἀπερεύγεσθαι θάλασσα, σεσόβηταί ποτε τῷ διεστάναι ταύτης συμμέτρως, οὔτε τὰς τῶν ναυτῶν οἰμωγὰς ἐπαΐει καὶ τῶν καταποντιζομένων τοὺς κωκυτούς. Mesarites, *Ekphrasis*, c. 5.2, ed. Heisenberg, *Apostelkirche*, 14–15; ed. and trans. Downey, "Nikolaos Mesarites," 864, 898; trans. Angold, *Nicholas Mesarites*, 86; Libanius, *Oratio* XI (*Antiochikos*), 37.

19 ὅσην δὲ καὶ ἡλίκην ὁρᾷ πρὸ τῶν τειχῶν ἄνετον ἤπειρον, τὴν ὡς ἄν τις εἴποι ἐκ τοῦ προσφιλῶς πατεῖσθαι προσωνυμουμένην. Mesarites, *Ekphrasis*, cc. 5.3–5, ed. Heisenberg, *Apostelkirche*, 15; ed. and trans. Downey, "Nikolaos Mesarites," 864, 898; trans. Angold, *Nicholas Mesarites*, 86.

which takes place in a courtyard to the east of the church, where we find grammarians, rhetoricians, and brutal masters who, in words borrowed from Themistius, "spend their whole lives chopping up words and squeezing them and shaving little words, who beat little boys and because of this power make themselves high and mighty and are filled with pride."[20] We are also shown the abusive mathematicians who spend their time "cutting into the children's shoulders unmercifully with whips of bulls' sinews.... They always look upon their pupils with a wild and angry and bitter eye; and all those who are under them are dejected and tremble and are fearful."[21]

At the end of the *Ekphrasis*, after the description of the church and its mosaics, Mesarites returns to the college, this time describing the more advanced studies that take place in the atrium, namely rhetoric, including the various figures and styles of speech, dialectic, medicine, higher mathematics, geometry, and harmonics.[22] But the atmosphere is not much better here than in the lower school described at the beginning. Mesarites gives a particularly vivid characterization of the academic disputes:

not a little disturbance and confusion is raised from the mingled cries, as now one thing, now another, is put forward for examination by the learners or by the teachers, and some of them strive to support their own

views, while others maintain that the truth is not of such a fashion, so that there are times when they fall into difficulty in the solution of the problem, and use harsh words to one another, and allusions to ignorance and lack of philosophical and physical learning stream from their mouths, and they blow and belch them at one another.[23]

At the core of the *Ekphrasis* is the description of the Holy Apostles itself, its architecture and above all its mosaics, which are framed by these unruly secular scenes and activities. The passages on the mosaics are not lacking in drama, but they are presented in a language cleansed of classical quotations, with the exception of some from Homer. On the other hand, it is in the descriptions of the mosaics that we find citations of the Church Fathers, including John Chrysostom and Gregory of Nazianzos. Mesarites himself refers to this change of language, when he asks the apostle James to: "cut out with the sword of the spirit the heavy and earthy quality of my ekphrasis, which draws it down to earth and causes it to creep along the ground, and does not permit the buoyancy and refinement of the discourse to rise toward heaven."[24] And here it may be observed that, whereas the borrowings from classical authors are silent, Mesarites references the Christian writers by name.[25] If a Byzantine writer borrows from a

20 ὄψει δ᾿ ἂν καὶ ἑτέρους... διὰ βίου παντὸς συγκοπὰς ὀνομάτων ἐμμελετῶντας καὶ ἀποθλίψεις καὶ ῥημάτια ἄττα ἀποσμιλεύοντας, οἳ καὶ μειράκια τυμπανίζουσι κἀπὶ ταύτῃ τῇ ἐξουσίᾳ ὡς ὑψηλούς τινας ἐξαίρουσιν ἑαυτοὺς φρονηματισμοῦ ἐμπιπλάμενοι. Mesarites, *Ekphrasis*, cc. 8.1–4, ed. Heisenberg, *Apostelkirche*, 20; ed. and trans. Downey, "Nikolaos Mesarites," 864, 899; trans. Angold, *Nicholas Mesarites*, 88. Cf. Themistius, *Oratio XXI*, ed. W. Dindorf (Leipzig, 1832), 305, 20–25. On Thermistius and Mesarites see I. Giarenis, "Προσλήψεις τῆς ἀρχαιότητας στὸ ἔργο τοῦ Νικολάου Μεσαρίτη," in G. Xanthaki-Karamanou, ed., *The Reception of Antiquity with Emphasis on the Palaeologan Era* (Athens, 2014), 79–106, at 85.

21 ἔστι γὰρ ἰδεῖν τοὺς πλείστους αὐτῶν καὶ βοείοις νεύροις ὠμοῖς κατακόπτοντας ἀνηλεῶς τὰ παιδάρια.... διὸ καὶ πρὸς τοὺς μαθητευομένους συνεχῶς ἐνορῶσιν ἀπηγριωμένον ὀργίλον τὲ καὶ δριμύ. Πάντες οὖν οἱ ὑπ᾿αὐτοὺς κατηφεῖς, τρομαλέοι τὲ καὶ περίφοβοι. Mesarites, *Ekphrasis*, cc. 10.2–3, ed. Heisenberg, *Apostelkirche* 21; ed. and trans. Downey, "Nikolaos Mesarites," 866, 899; trans. Angold, *Nicholas Mesarites*, 89.

22 Mesarites, *Ekphrasis*, cc. 42.1–43.3, ed. Heisenberg, *Apostelkirche*, 90–95; ed. and trans. Downey, "Nikolaos Mesarites," 894–96, 916–17; trans. Angold, *Nicholas Mesarites*, 129–32.

23 Καὶ τάραχος οὐκ ὀλίγος καὶ θόρυβος ἐκ συμμιγοῦς βοῆς ἐπεγείρεται, ἄλλου ἄλλο τι τῶν μαθητιώντων ἢ καὶ τῶν διδασκόντων προθεμένου ἐπὶ συζήτησιν καὶ τῶν μὲν τὴν οἰκείαν ἐπαγωνιζομένων δόξαν συστῆσαι, τῶν δὲ μὴ οὕτως ἔχειν διισχυριζομένων τὸ ἀληθές, ὡς καὶ εἰς ἀπορίαν ἐστιν ὅτε τῆς τοῦ ζητουμένου λύσεως ἐμπίπτειν αὐτοὺς καὶ κατ᾿ἀλλήλων τραχυτέροις χρῆσθαι τοῖς ῥήμασι καὶ τὸ ἀμαθὲς καὶ ἀφιλόσοφόν τε καὶ ἀφυσίκευτον κατὰ ῥοῦν ἐκ τοῦ στόματος αὐτῶν κατ᾿ἀλλήλων πρὸς ἀλλήλους ἀποφυσᾶσθαι καὶ ἀπερεύγεσθαι. Mesarites, *Ekphrasis*, c. 43.1, ed. Heisenberg, *Apostelkirche*, 94; ed. and trans. Downey, "Nikolaos Mesarites," 896, 917; trans. Angold, *Nicholas Mesarites*, 131–32.

24 Σὺ δὲ τὸ τοῦ ἐμοῦ λόγου παχύτερόν τε καὶ γεωδέστερον, τὸ καὶ τοῦτον καθέλκον πρὸς γήν, τὴν χαμαιπῆ δηλαδὴ τοῦ λόγου πλοκήν, καὶ οἷον πρὸς οὐρανοὺς τὸ τῆς ἐκφράσεως μετέωρόν τὲ καὶ κομψὸν ἀναπτῆναι μὴ συγχωροῦν, τῇ τοῦ πνεύματος μαχαίρᾳ περιελών.... Mesarites, *Ekphrasis*, c. 12.16, ed. Heisenberg, *Apostelkirche*, 25–26; ed. and trans. Downey, "Nikolaos Mesarites," 868, 900; trans. Angold, *Nicholas Mesarites*, 92.

25 See Mesarites, *Ekphrasis*, cc. 15.4: "according to him of the golden tongue" and 32.3: "according to Gregory, great among the theologians"; ed. Heisenberg, *Apostelkirche*, 31, 69; ed. and trans. Downey, "Nikolaos Mesarites," 871, 886, 902, 912; trans. Angold, *Nicholas Mesarites*, 95, 117.

Christian author, the source can be cited, but the pagans are best left unacknowledged.

Mesarites' juxtaposition of the church and its surroundings is not a simple contrast of the mundane and the spiritual, for he unites the two into one vision in a sophisticated way. The structure of his ekphrasis can be described as horizontal. In this respect, it can be opposed to earlier accounts of church buildings, which had interpreted the church in abstract, Neoplatonic terms as a closed, vertical hierarchy from earth to heaven, often invoking the mysticism of light. In this earlier model of church description, the colored marbles of the floor and walls represented terrestrial creation, while the shining mosaics above represented heaven.[26] We may take as an example the ekphrasis of the church of the Stoudios monastery in Constantinople by the tenth-century poet John Geometres.[27] Geometres proceeds from the polychromy of the marble pavement and columns, with their glistening brightness and flashes of color, up to the one great light of the golden semidome above, with its sacred images. He declares that even while earth and heaven are separated by variety below and by unity above, nevertheless they are linked by the hierarchy of lights that they share.[28] An epigram on the church of the Kyros monastery by the same poet, in an apparent reference to its marbles, speaks of them as "the foremost [spoils] from the chambers of the earth," and compares the building to a "well-wrought ladder from earth to the orbit of heaven."[29]

The tenth-century ekphrasis of the Holy Apostles by Constantine the Rhodian is also imbued with a light mysticism in which gleaming marbles below and mosaics above reflect each other. The poet declares that the architects:

Constructed with utter thoroughness
the whole star-shining house of the wise apostles,
cladding and fitting it together beautifully
with limitless quantities of many-colored marbles
and the brilliance of marvelous metals [that is, mosaics]. . . .
With gold mingled with glass
the architect made golden everything in the interior
as far as the height of the dome-constructed roof
reaches, and as far as the hollows of the vaults,
and down to the many-colored marble slabs themselves.[30]

Constantine the Rhodian provides a long catalogue of the different marbles to be seen in the church, which he describes as "fiery beacons of precious stones . . . from almost the whole of the inhabited world,"[31] and he also devotes a passage to the colorful columns, which not only resemble the numberless flowers of the meadows but also the multitudes of shining stars.[32] These descriptions were inspired by the sixth-century ekphraseis of the marbles in Hagia Sophia in Constantinople by Paul the Silentiary.[33]

Some of these colorful marbles may still survive in the courtyard of the Ottoman Fatih

26 H. Maguire, *Nectar and Illusion: Nature in Byzantine Art and Literature* (New York, 2012), 124–30.

27 *Carmina* 96; ed. J. A. Cramer, *Anecdota graeca e codd. manuscriptis bibliothecae regiae parisiensis* (Oxford, 1841), 4:306–7. For an art historical discussion of the text together with an English translation, see W. T. Woodfin, "A *Majestas Domini* in Middle-Byzantine Constantinople," *CahArch* 51 (2003–4): 45–53.

28 Ed. Cramer, *Anecdota graeca*, 4:306, line 30–307, line 30.

29 τῶν χθονίων πρῶτα φέρων θαλάμων
. . . . γῆθεν
ἄντυγος οὐρανίης εὐεργὴν κλίμακα.
Carmina, 91; ed. Cramer, *Anecdota graeca*, 4:305, lines 9–12.

30 ὅλον διαμπὰξ συγκατήρτισεν δόμον
τὸν ἀστρολαμπῆ τῶν σοφῶν Ἀποστόλων,
. . .
ὕλαις ἀπείροις μαρμάρων πολυχρόων
καὶ λαμπρότησι τῶν μετάλλων τῶν ξένων
ἐπενδύσας τε καὶ καλῶς συναρμόσας,
. . . .
Χρυσῷ δὲ μίγδην ὑέλῳ πεφυκότι
ἅπαν κατεχρύσωσε τοὔνδοθεν μέρος,
ὅσον τ᾽ἐν ὕψει σφαιροσυνθέτου στέγης
χ᾽ὅσον λαγόσιν ἀψίδων ὑπερφέρει,
καὶ μέχρις αὐτῶν μαρμάρων πολυχρόων.
Constantine the Rhodian, *Ekphrasis*, lines 638–643, 742–746, ed. and trans. in James, *Constantine of Rhodes*, 62, 68.

31 Ταῖς ἐκ λίθων τε μαργάρων φρυκτωρίαις
τῶν ἐξ ὅλης σχεδόν γε τῆς οἰκουμένης.
Constantine the Rhodian, *Ekphrasis*, lines 646–647, ed. and trans. in James, *Constantine of Rhodes*, 62.

32 Constantine the Rhodian, *Ekphrasis*, lines 686–703, ed. and trans. James, *Constantine of Rhodes*, 64–66.

33 *Descriptio S. Sophiae*, lines 286–295, 618; *Descriptio ambonis*, lines 224–39; ed. P. Friedländer, *Johannes von Gaza und Paulus Silentiarius* (Leipzig and Berlin, 1912), 235–245. I am indebted to Floris Bernard for this observation.

FIG. 12.1.

Fatih Camii,
Istanbul, columns
from the Holy
Apostles in the
courtyard (photo
by author)

FIG. 12.2. Fatih Camii, Istanbul, column from the
Holy Apostles in the courtyard (photo by author)

Camii, which replaced the church of the Holy
Apostles. Here we find columns carved in rose
and gray-colored granite, as well as in green verde
antique (figs. 12.1 and 12.2). The famous frontis-
piece miniatures of the two copies of the homi-
lies of James of Kokkinobaphos in Paris and in
the Vatican also evoke the polychrome richness
of these columns and revetments in their original
setting, whether or not these paintings actually
depict the Holy Apostles.[34]

In contrast to the church descriptions by
John Geometres and Constantine the Rhodian,
the ekphrasis by Mesarites contains much less
emphasis on the metaphysics of light. Mesarites
does at one point describe the colored marbles,
but in a very brief and much more muted way. He
compares the sawn revetments to woven cloths
rather than to the brilliance of stars.[35] Mesarites
also replaces the vertical hierarchy of John
Geometres, which ascended from earthly marbles
below to heavenly mosaics above, with a horizon-
tal, centripetal structure that employs an ancient

34 Paris, B.N., MS. gr. 1208, fol. 3v.; Vatican, Biblioteca vati-
cana, MS. gr. 1162, fol. 2v. Color illustrations in A. Cutler and
J.-M. Spieser, *Byzance médiévale, 700–1204* (Paris, 1996), pls.
292–93.

35 Mesarites, *Ekphrasis*, c. 37.3, ed. Heisenberg, *Apostelkirche*,
79; ed. and trans. Downey, "Nikolaos Mesarites," 890, 914;
trans. Angold, *Nicholas Mesarites*, 123.

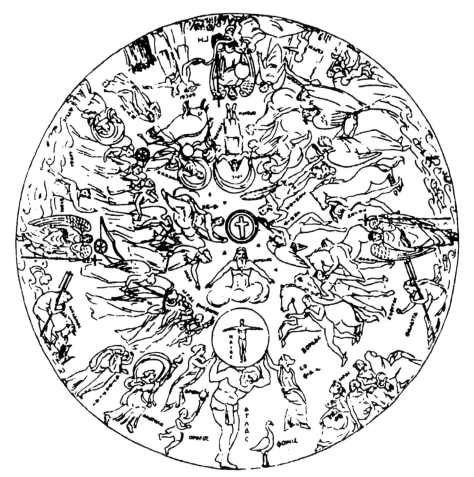

FIG. 12.3.
Reconstruction drawing
of the painting in a
bathhouse described
by John of Gaza, after
G. Krahmer, "De tabula
mundi ab Joanne Gazaeo
descripta" (PhD diss.,
University of Halle, 1920)

symbolism of the cross. In this model, Christ is at the center of the cross and its four arms represent the cardinal directions of the physical world. Mesarites states this idea explicitly, saying that the four projecting arms of the cross face to the east, west, north, and south, respectively, while the central unit faces toward heaven; in his words, the center of the cross "calls on the heavenly God-Man to descend to it and through it, as though from heaven, and in his portrayed form to gaze down upon all of the sons of men, who by his command dwell upon the earth."[36]

This cosmic symbolism of the cross occurs in earlier descriptions of works of art, such as John of Gaza's early sixth-century ekphrasis of a painting of the universe in a bathhouse in Gaza.[37] According to John's description, the painting contained at its center a golden cross, which was surrounded by personifications of various elements of the cosmos, such as earth, ocean, the winds, and the seasons. John of Gaza described the significance of the central cross as follows: "Four extremities grew [out of it], because the primeval age was east, west, south and north, having accomplished the holding together of the world from these four."[38] The painting seen by John of Gaza has long since disappeared, but an imaginative reconstruction of it was provided by Gerhard Krahmer in 1920 (fig. 12.3).[39]

36 Τὸν οὐράνιον οἶμαι πρὸς ἑαυτὴν ἐκκαλουμένη καταβῆναι θεάνθρωπον καὶ δι᾽αὐτῆς ὡς ἐξ οὐρανοῦ καὶ αὖθις εἰκονικῶς ἐπιβλέπειν ἐπὶ πάντας τοὺς τῶν ἀνθρώπων υἱούς, τοὺς μὲν τὴν γῆν οἰκεῖν παρ᾽αὐτοῦ κελευσθέντας. Mesarites, *Ekphrasis*, c. 13.5, ed. Heisenberg, *Apostelkirche*, 27; ed. and trans. Downey, "Nikolaos Mesarites," 869, 901; trans. Angold, *Nicholas Mesarites*, 93.

37 Ed. Friedländer, *Johannes von Gaza und Paulus Silentiarius*, 135–224.

38 Part I, lines 35–37; ed. Friedländer, *Johannes von Gaza und Paulus Silentiarius*, 137.

39 G. Krahmer, "De tabula mundi ab Joanne Gazaeo descripta" (PhD diss., University of Halle, 1920). See also C. Cupane, "Il Κοσμικὸς Πίναξ di Giovanni di Gaza: Una proposta di ricostruzione," *JÖB* 28 (1979): 195–207; R. Talgam,

FIG. 12.4.

View of the Golden
Horn from the
southwest minaret
of the Fatih Camii
(photo by author, 2016)

An earlier description of the Holy Apostles by Leo VI also made use of the cosmic symbolism of the cross.[40] In the *ekphrasis* of the building that Leo inserted into a homily on the translation of John Chrysostom, the emperor referred to the cruciform shape of the church immediately after his description of the mosaic of the Mission of the Apostles. Leo says that: "the whole church [of the Apostles] is made by the craftsman in the form of a cross with infinite beauty and magnitude encompassing the limits [that is, of creation]."[41]

Mesarites embodies this idea of the cross gathering together the cardinal limits of the physical world in his account of the vistas to

be obtained from the galleries and parapets of the church, which, as we saw, come before the main description of the church and its mosaics. Mesarites described the views from the church looking in at least three, if not four, directions. Here the question arises of whether Mesarites could really have seen for himself the prospects that he described, or whether he merely imagined them—or simply copied them from Libanius's description of Antioch without checking the external reality of Constantinople. Of course, it is no longer possible to ascend to the top of the Holy Apostles to verify the views that Mesarites claims could be seen, but it is still possible to climb to the balconies midway up the minarets of its replacement, the Fatih Camii, which should be at approximately the same height as the parapets of the former Byzantine church. Mesarites says that from the upper galleries one could see both the northern and the southern seas, which must be the Golden Horn and the Sea of Marmara. Both of these bodies of water are indeed visible from the lower balcony of the minaret, as can be seen in figure 12.4, showing

"Johannes of Gaza's Tabula Mundi Revisited," in *Between Judaism and Christianity: Art Historical Essays in Honor of Elisheva (Elisabeth) Revel-Neher*, ed. K. Kogman-Appel and M. Meyer (Leiden, 2009), 91–120.

40 L. James and I. Gavril, "A Description of the Church of the Holy Apostles in Constantinople," *Byzantion* 83 (2013): 149–60.

41 Ὁ ναὸς ὅλος, τοῦ σταυροῦ τῷ τύπῳ ἀπείρῳ κάλλει καὶ μεγέθει τῷ τεχνίτῃ δημιουργούμενος καὶ τὰ πέρατα οἰκειούμενος. James and Gavril, " Description of the Church," 152.

FIG. 12.5.
View of the Sea of
Marmara from the
southwest minaret of
the Fatih Camii (photo
by author, 2016)

the view of the of the Golden Horn, and fig-ure 12.5, showing the view of the Sea of Marmara, the latter still bearing the freight ships described in the *Ekphrasis*.

As was remarked earlier, after describing the seas the *Ekphrasis* turns to the view from the parapets of the open grounds of the Philopation to the west; here, too, it can be confirmed that the upper slopes of this area can still be glimpsed from the balcony of the minaret, appearing through modern construction beyond the line of the land walls (fig. 12.6). So Mesarites described what he himself could have observed—the vis-ible limits of the cross projected by the church plan. And we find that the passages borrowed from Libanius described what actually was to be seen—the quotation was not a lie.

As Mesarites' vision converges from the worldly exterior to the central image of the incarnate Christ inside the church, the secular vignettes outside the building find their coun-terparts in the sacred figures and narrative of the mosaics. At the conclusion of his vivid account of the school, just before he describes the church

itself, Mesarites makes an elegant transition from the one realm, of the mundane, to the other, of the spiritual, when he compares the chattering children in the school to singing birds, and then passes to the responses within the church, which he compares to the song of angels. He says:

> And the seats are full of the children, and the benches, and there is a twittering of chil-dren round about the church as though they were some kind of musical birds, and the church within echoes with them, not with a distorted echo, as in the mountains, but a kind of melodious sweet echo, as though one heard angels sing.[42]

42 Καὶ πλήθουσι μὲν τῶν παίδων οἱ σκίμποδες, πλήθουσι δ᾽ ἀναβάθραι, καὶ περιλαλεῖται μὲν τὰ κύκλωθεν τοῦ νεὼ ὡς ὑπό τινων μουσικῶν ὀρνίθων τῶν παίδων, ἀντηχεῖ δὲ τούτοις ἔνδο-θεν ὁ νεὼς οὐκ ἠχώ τινα ὄρειον οὐδὲ ἄπηχον, ἀλλ᾽ ἐμμελῆ τινα καὶ ἡδίστην καὶ οἵαν ἄν τις ἀγγέλων ἀνυμνούντων ἐπακροάσαιτο. Mesarites, *Ekphrasis*, c. 11.3, ed. Heisenberg, *Apostelkirche*, 22; ed. and trans. Downey, "Nikolaos Mesarites," 867, 900; trans. Angold, *Nicholas Mesarites*, 90.

FIG. 12.6.
View toward the
land walls and the
Philopation from the
southwest minaret of
the Fatih Camii (photo
by author, 2016)

The description of the mosaics inside the church illustrates this theme, as their imagery echoes and resolves the conflicts and anxieties adumbrated in the preceding paragraphs, so that order replaces disorder. We have seen, for example, that outside the church Mesarites dwelt upon the dangers of the sea, with its groaning sailors and drowning men; inside he finds the depictions of Christ calming the waves, walking on water, and rescuing Peter from drowning,[43] a scene that he compares to the salvation of Adam from Hades.[44] The instability of the food supply, threatened by pirates and by barbarian invasions, is counteracted by the reassurance of the Miraculous Draft of fishes, the last mosaic that Mesarites describes.[45] The brutal schoolmasters

and bad-tempered academics of the school outside the church are contrasted with the divinely inspired reason of the apostles, as they teach "the various pagan nations to whom they were sent out."[46] In the mosaic of Matthew with the Syrians, for example, Mesarites says, in his words, that "the expression of Matthew's face is thoughtful, as he seeks to convince with written proofs and with reasonable arguments those who oppose his gospel."[47] In the invocation to the apostles that opens his description of the mosaics, Mesarites specifically calls upon St. Thomas to help him banish the trickery of the rhetoricians, whose procedures he has just scornfully described. He prays as follows: "Thomas, banish to perdition that doubt which possesses my soul through the

43 Mesarites, *Ekphrasis*, cc. 25.1–18, ed. Heisenberg, *Apostelkirche*, 49–52; ed. and trans. Downey, "Nikolaos Mesarites," 878–79, 906–7; trans. Angold, *Nicholas Mesarites*, 105–7.

44 Mesarites, *Ekphrasis*, c. 25.18, ed. Heisenberg, *Apostelkirche*, 52; ed. and trans. Downey, "Nikolaos Mesarites," 879, 907; trans. Angold, *Nicholas Mesarites*, 107.

45 Mesarites, *Ekphrasis*, cc. 36.1–5, ed. Heisenberg, *Apostel-kirche*, 77–78; ed. and trans. Downey, "Nikolaos Mesarites," 889, 914; trans. Angold, *Nicholas Mesarites*, 122–23.

46 Πρὸς ἅπερ ἔθνη καὶ ἀπεστάλησαν. Mesarites, *Ekphrasis*, c. 22.1, ed. Heisenberg, *Apostelkirche*, 45; ed. and trans. Downey, "Nikolaos Mesarites," 877, 905; trans. Angold, *Nicholas Mesarites*, 103.

47 Ἔμφροντι τῷ Ματθαίῳ τὸ τοῦ προσώπου κατάστημα, ἐξετάζειν σκεπτομένῳ ἐκ γραφικῶν ἀποδείξεων κἀκ λογισμῶν εἰκότων τοὺς τῷ εὐαγγελικῷ αὐτοῦ συγγράμματι ἀντιλέγοντας. Mesarites, *Ekphrasis*, c. 19.2, ed. Heisenberg, *Apostelkirche*, 41; ed. and trans. Downey, "Nikolaos Mesarites," 875, 905; trans. Angold, *Nicholas Mesarites*, 101.

wiles of Satan," and then he adds, using a tag from Homer, "banish with it those who say one thing with their tongues and hide something else in their minds."[48] Earlier, in his description of the school, Mesarites had used the same quotation to characterize the teaching of the rhetoricians, saying: "Still others, those who have reached the higher and more complete stages, weave webs of phrases and transform the written sense into riddles, saying one thing with their tongues, but hiding something else in their minds."[49]

In summary, the description of the Holy Apostles by Mesarites converges toward the center, following the cardinal directions of the cross. It draws inward by stages, from the outer limits of the view to be obtained from its parapets, with its delights and potential horrors, to the immediate surrounds of the church, with their vignettes of everyday life, to the church itself with the mosaics of the Gospel, which resolve the conflicts of the exterior, and finally to the vision of the incarnate Christ himself in the very center, gazing down on earth from his dome. Through this centripetal structure, Mesarites skillfully integrates the inside and outside environments of the Holy Apostles into a unified exegesis of the church and its setting.

Up to this point we have been considering Mesarites' description of the Holy Apostles as a work of literature. But the question remains of the relevance of developments in twelfth-century Byzantine art to our understanding of the *Ekphrasis*. Since the monument itself no longer survives, attempts to reconstruct the building and its mosaics with reference to the text are likely to be speculative. But the *Ekphrasis* can be related to Byzantine art in a more general way, as evidence for trends in Byzantine culture that affected both literature and art at the moment of

its composition. Mesarites' concern to relate the everyday existence of his own time to the timeless narrative of the Gospel scenes in the mosaics can be associated with a new and associated phenomenon in late twelfth-century Byzantine art. At this time artists became increasingly interested in incorporating realistic details of daily life into the closed circle of traditional sacred iconography. This interest expressed itself in two ways: first, in the occasional incorporation of the physical realia of contemporary life into sacred scenes; and second, an enhanced interest in the expression of psychological and physical states such as anxiety and suffering.

Maria Parani has drawn attention to several instances of the inclusion of everyday items into New Testament scenes during the second half of the twelfth century and has related this phenomenon to developments in Byzantine literature.[50] For example, in the frescoes of the church of St. Panteleimon at Nerezi, which date to 1164, the women who attend the Birth of the Virgin carry two vessels that are clearly intended to illustrate specific types of contemporary housewares. The woman standing behind the bed carries a tall cylindrical container, the distinctive shape of which is matched by contemporary glass bottles.[51] The spherical vessel carried by the woman on her right reproduces, I believe, the shape and color of a bronze bowl with a hemispherical lid, similar to one preserved in the Byzantine and Christian Museum of Athens.[52]

Another example cited by Parani is the remarkable collection of paraphernalia hanging from the belt of the old shepherd in the Nativity fresco in the church of St. George at Kurbinovo, which dates to 1192 (fig. 12.7).[53] His equipment includes a sheathed knife, an ellipsoidal flint-striker, and even a comb. We can add to these items the circular stockade of thorn bushes that encloses the sheep—a feature still to be seen in some mountainous areas of the Balkans

48 Θωμᾶ, τὸν τὴν ἐμὴν ψυχὴν κατέχοντα δισταγμὸν ἐξ ἐπιβουλῆς τοῦ . . . σατὰν . . . ἐς κόρακας ἐξαπόστειλον, ἀλλὰ καὶ τοὺς ἄλλα μὲν λαλοῦντας ἐν γλώσσησιν, ἄλλα δ᾽ ἐνὶ φρεσὶ κεύθοντας. Mesarites, *Ekphrasis*, c. 12.13, ed. Heisenberg, *Apostelkirche*, 25; ed. and trans. Downey, "Nikolaos Mesarites," 868, 900; trans. Angold, *Nicholas Mesarites*, 91. Cf. *Iliad*, 9.313.

49 Ἕτεροι οἱ καὶ πρὸς τὰ μείζω καὶ τελεώτερα πεφθακότες πλοκὰς συνείρουσι νοημάτων καὶ τὸν τῶν γεγραμμένων νοῦν ἐς τὸ γρῖφον μετασκευάζουσιν, ἄλλα μὲν λαλοῦντες γλώσσησιν, ἄλλα δὲ κεύθοντες ἐν φρεσίν. Mesarites, *Ekphrasis*, c. 8.3, ed. Heisenberg, *Apostelkirche*, 20; ed. and trans. Downey, "Nikolaos Mesarites," 866, 899; trans. Angold, *Nicholas Mesarites*, 88.

50 M. G. Parani, *Reconstructing the Reality of Images: Byzantine Material Culture and Religious Iconography (11th–15th Centuries)* (Leiden, 2003), 213, 226, 251–53.

51 Parani, *Reconstructing the Reality of Images*, 226, pls. 233, 235.

52 Demetra Papanikola-Bakirtzis, ed., *Καθημερινή ζωή στο Βυζάντιο* [exh. cat., White Tower] (Thessalonike, 2001), 222–23, no. 257.

53 Parani, *Reconstructing the Reality of Images*, 213, pl. 214.

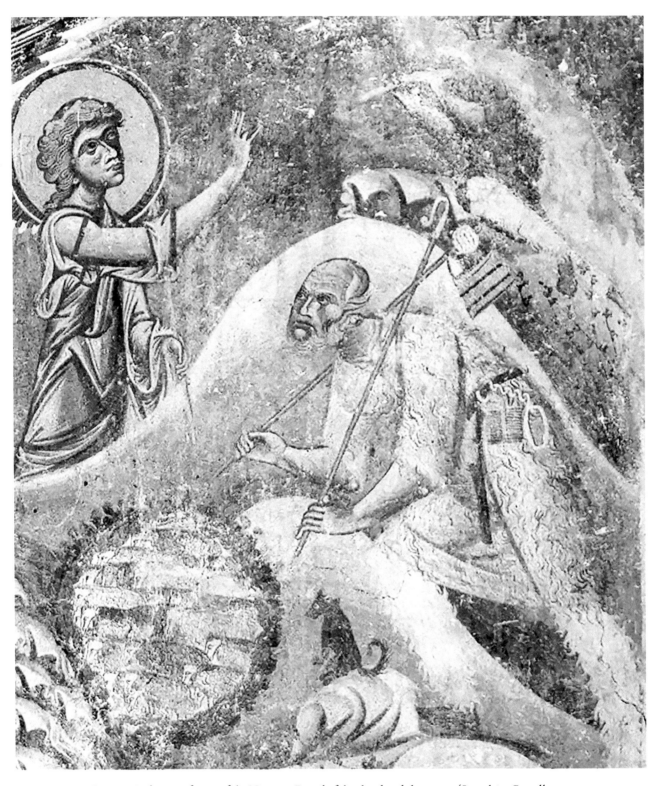

FIG. 12.7. St. George, Kurbinovo, fresco of the Nativity. Detail of shepherd and sheep pen (Josephine Powell Photograph, courtesy of Special Collections, Fine Arts Library, Harvard University)

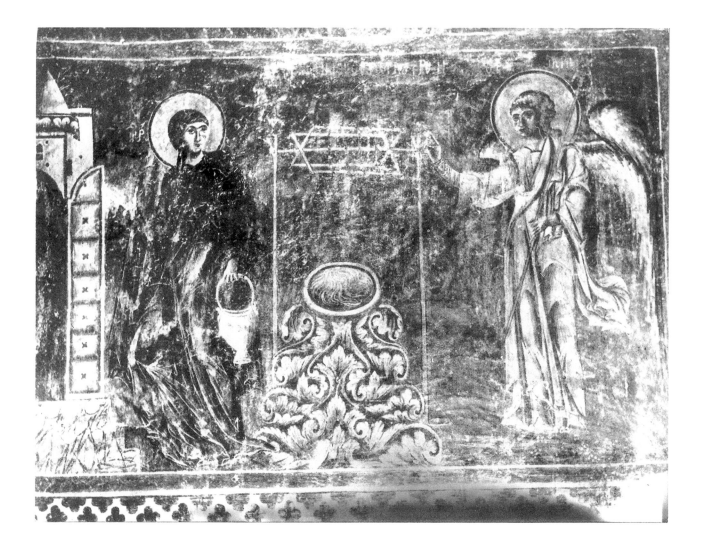

today. But this circular pen is a very rare, if not unique, feature of Byzantine iconography. These details almost seem to forecast the realism of fourteenth-century Italian paintings, such as the landscape of Good Government in the City Hall of Siena by Ambrogio Lorenzetti.[54]

Also dating to the late twelfth century is the distinctive portrayal of the well in the fresco of the Annunciation by the Well in the Hagioi Anargyroi at Kastoria (fig. 12.8). Here we find the realistic detail of an ancient foliate Corinthian capital turned upside down and reused as the wellhead. We are also shown the delicate wooden mechanism for raising the water.[55] A sixth-century

capital that was converted into a water basin survives in the Museum of Byzantine Culture at Thessalonike.[56]

Such small observations of the apparatus of ordinary existence, which enliven Byzantine religious painting of the late twelfth century, find their counterpart in the detailed descriptions of the daily life of Constantinople that frame Mesarites' *Ekphrasis* of the Holy Apostles. At one point in his *Ekphrasis* Mesarites offers a kind of apology for the intrusion of elements of physical experience into sacred painting. This occurs in his description of the mosaic of the Nativity, where he states that Mary "lies on a straw mattress . . . showing the face of a woman who has just been in pain—even though she escaped the

FIG. 12.8.
Hagioi Anargyroi,
Kastoria, fresco.
The Annunciation
by the Well (photo
by Lykides).

54 E. Carli, *Sienese Painting* (London, 1956), pls. 72–83

55 S. Pelekanidis, *Kastoria* (Thessalonike, 1953), 1: pl. 15a; S. Pelekanidis and M. Chatzidakis, *Kastoria* (Athens, 1985), 22–49, fig. 14 on p. 34.

56 Papanikola-Bakitrzis, ed., Καθημερινή ζωή στο Βυζάντιο, 216, no. 247.

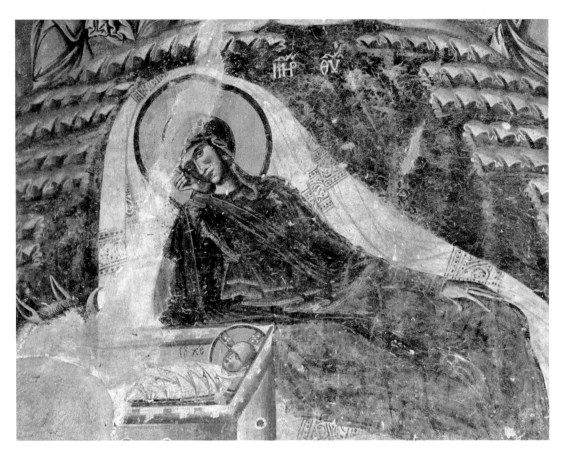

FIG. 12.9. Hosios David, Thessalonike, fresco of the Nativity. Detail of the Virgin (photo by Miodrag Marković).

pangs of labor."[57] In saying that Mary "escaped the pangs of labor," Mesarites reiterates the teaching of the Church that the Virgin's parturition was miraculous and without pain.[58] Of all women, only she escaped the curse of Eve: "In pain thou shalt bring forth children."[59] Accordingly, to my knowledge, Byzantine painting never showed suffering on the facial features of the Virgin in Nativity scenes, except in one instance, namely the late twelfth-century fresco of the Nativity in the church of Hosios David in Thessalonike (fig. 12.9). Here the face of the Virgin exhibits drawn features with a deeply arched brow line that clearly portray suffering.[60] It is Mesarites who provides a justification for this exception, saying that the expression of the Virgin was made to look pained in the mosaic: "in order that the dispensation of the incarnation might not be looked upon with suspicion, as fantasy."[61] It is not clear whether the mosaic that Mesarites was looking at resembled the painting at Hosios David, or whether he read his characterization of the Virgin's expression into the image, which may have been some distance away from him when he looked at it. Whatever the case, both the fresco and the text exhibit a new

57 ἀνακειμένην ἐπὶ στοιβάδος ... ὠδινησάσης ἀρτίως ὑποδεικνύουσαν πρόσωπον, κἂν καὶ τὰς ὠδῖνας διέφυγεν. Mesarites, *Ekphrasis*, c. 23.1, ed. Heisenberg, *Apostelkirche*, 47; ed. and trans. Downey, "Nikolaos Mesarites," 877, 906; trans. Angold, *Nicholas Mesarites*, 104–5.

58 H. Maguire, "'Pangs of Labor without Pain': Observations on the Iconography of the Nativity in Byzantium," in *Byzantine Religious Culture: Studies in Honor of Alice-Mary Talbot,* ed. D. Sullivan, E. Fisher, and S. Papaioannou (Leiden, 2012), 205–13.

59 Genesis 3:17.

60 E. N. Tsigaridas, Οἱ τοιχογραφίες τῆς μονῆς Λατόμου Θεσσαλονίκης (Thessalonike, 1986), pl. 7.

61 ἵνα μὴ φαντασία ἡ οἰκονομία ὑποπτευθῇ. Mesarites, *Ekphrasis*, c. 23.1, ed. Heisenberg, *Apostelkirche*, 47; ed. and trans. Downey, "Nikolaos Mesarites," 877–78, 906; trans. Angold, *Nicholas Mesarites*, 104–5.

interest on the part of late twelfth-century writers and artists in introducing mundane human experience into the sacred narrative, even at the expense of doctrinal orthodoxy.

In conclusion, three main points may be drawn from the discussion presented here. First, the *Ekphrasis* of the Holy Apostles by Mesarites has to be assessed in light of both the visual and the literary culture of its time. A full understanding of the text cannot be achieved by considering only its literary context. Second, there is meaningful connection between description and reality; we are not dealing with an unalloyed work of the imagination. However artful his composition and his prose, Mesarites both described what he saw at the Holy Apostles and reacted to the artistic trends of his own time. Third, the chief relevance of the *Ekphrasis* to the history of Byzantine culture lies in its new embrace of everyday life, a phenomenon that took place in both art and literature during the twelfth century, and particularly toward its close.

Legacies

THE CHURCH OF THE HOLY APOSTLES AND ITS PLACE IN LATER BYZANTINE ARCHITECTURE

ROBERT G. OUSTERHOUT

*A*S REBUILT BY JUSTINIAN IN THE SIXTH CENTURY, THE CHURCH of the Holy Apostles remained one of the most significant landmarks of Constantinople into the beginning of the Ottoman period.[1] In addition to its description in Procopius's account of Justinian's building program, the church merited not one but two lengthy *ekphraseis*, and it appears three times in the *Menologion* of Basil II—all of which reflects continued Byzantine interest in the church (fig. 13.1).[2] That said, our evidence for post-Justinianic investment in the building itself is vague, at best, as Liz James has emphasized in her paper in this volume. For example, Theophanes commented ambiguously that Justin II had "adorned" the church; the *Vita Basilii* is only slightly more specific about Basil I's interventions: "Likewise the famous great church of the Holy Apostles, which had lost its former beauty and firmness, he [Basil] fortified by the addition of buttresses and the reconstruction of broken parts, and having scraped off the signs of old age and removed the wrinkles, he made it once more beautiful and new."[3] Basil's interest in the church would correspond with the reopening of the Mausoleum of Constantine for imperial burials after a long gap, as well as the symbolic appropriation of the building by the Macedonian dynasty, with constructions "around and about" that Paul Magdalino has discussed in this volume. However, neither Justin II nor Basil is mentioned in the account of Constantine the Rhodian, who gives all credit to Justinian.[4] The latter omission is odd if the Rhodian is writing at the behest of Basil's grandson, Constantine VII. But the text is rife with inexplicable omissions, including the burials in the mausolea.[5] Nicholas Mesarites seems to suggest that Constantine VIII had restored the mausoleum of Constantine; at the very least he was buried there, for he commented as he noted his tomb: "This is the Constantine who built this Church in the form in which it is now

1 A. Heisenberg, *Grabeskirche und Apostelkirche: Zwei Basiliken Konstantins,* vol. 2, *Die Apostelkirche von Konstantinopel* (Leipzig, 1908); G. Downey, "Nikolaos Mesarites: Description of the Church of the Holy Apostles at Constantinople," *TAPS,* n.s., 47, part 6 (1957): 855–924; R. Janin, *La géographie ecclésiastique de l'empire byzantin,* vol. 1, *Le siège de Constantinople et le patriarcat oecuménique,* pt. 3, *Les églises et les monastères* (Paris, 1969), 41–50; W. Müller-Wiener, *Bildlexikon zur Topographie Istanbuls* (Tübingen, 1977), 405–11; R. Krautheimer, *Early Christian and Byzantine Architecture,* 4th rev. ed., with S. Ćurčić (New Haven, 1986), 242–45; most recently, L. James, ed., *Constantine of Rhodes, On Constantinople and the Church of the Holy Apostles, with a New Edition of the Greek Text by Ioannis Vassis* (Farnham, Surrey, and Burlington, VT, 2012).

2 In addition to sources listed in note 1, see Procopius, *De aed.,* 1.4.9–24, ed. and trans. H. B. Dewing, *Procopius,* vol. 7, *On Buildings* (London and Cambridge, MA, 1940), 48–55; *Il Menologio di Basilio II (cod. vaticano greco 1613)* (Turin, 1907), fols. 341r, 353r, 121r.

3 I. Ševčenko, ed. and trans., *Chronographiae quae Theophanis Continuati nomine fertur liber quo Vita Basilii imperatoris amplectitur,* CFHB 42 (Berlin, 2011), 5.80, ll. 1–3; trans. C. Mango, *Art of the Byzantine Empire 312–1453, Sources and Documents* (Toronto, 1972; repr. 1986), 192.

4 Constantine the Rhodian, *Ekphrasis,* lines 494–594, ed. James, *Constantine of Rhodes,* 52–53.

5 Note comments by James, *Constantine of Rhodes,* 202–3.

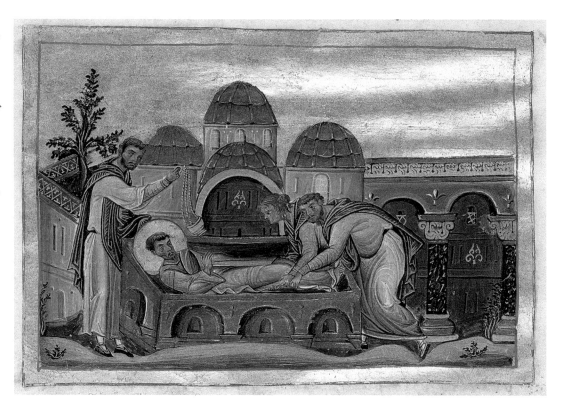

to be seen, as various people have told us."[6] We also have the alleged tenth-century reconstruction proposed by Richard Krautheimer and an alleged mid-twelfth-century redecoration hypothesized by Ernst Kitzinger, both unmentioned in the sources.[7]

The addition of the church of All Saints by Leo VI, originally dedicated to his pious first wife Theophano, also fits within the Macedonian dynasty's appropriation of the Holy Apostles to

symbolic ends, to bolster their dynastic claims.[8] All Saints stood immediately next to the Holy Apostles and was connected to it, as Glanville Downey has demonstrated—although probably somewhere to the east rather than flanking its western arm, as Paul Underwood had reconstructed it (see Appendix A.10). It contained an oratory dedicated to St. Theophano, built by Constantine VII.

In addition to being shored up and beautified and expanded and appropriated, did the Holy Apostles leave an architectural legacy? Or was it, like Hagia Sophia, built to be unique and destined to remain unique? Like the five domed

6 See Paul Magdalino's paper in this volume; Nicholas Mesarites, *Description of the Church of the Holy Apostles at Constantinople*, c. 39, ed. Heisenberg, *Apostelkirche*, 85, ed. and trans. Downey, "Nikolaos Mesarites," 859–918, esp. 892, trans. M. Angold, *Nicholas Mesarites, His Life and Works (in Translation)*, TTB 4 (Liverpool, 2017), 83–133, at 126; see also P. Grierson, "The Tombs and Obits of the Byzantine Emperors (337–1042)," *DOP* 16 (1962): 3–63, esp. 26–29; 58–59.

7 R. Krautheimer, "A Note on Justinian's Church of the Holy Apostles in Constantinople," in *Mélanges Eugène Tisserant* (ST 232 [1964]), 2: 265–70; reprinted in *Studies in Early Christian, Medieval, and Renaissance Art* (New York, 1969), 197–201; criticized by A. W. Epstein, "The Rebuilding and Redecoration of the Holy Apostles in Constantinople: A Reconsideration," *GRBS* 23, no. 1 (2011): 79–92; and James, *Constantine of Rhodes*, 190–94; E. Kitzinger, "Byzantine and Medieval Mosaics after Justinian," *Encyclopedia of World Art* 10 (1965), 344; criticized by James, *Constantine of Rhodes*, 206–7.

8 G. Downey, "The Church of All Saints (Church of St. Theophano near the Church of the Holy Apostles at Constantinople," *DOP* 9/10 (1956): 301–5; P. Magdalino, "The Foundation of the Pantokrator Monastery in Its Urban Setting," in *The Pantokrator Monastery in Constantinople*, ed. S. Kotzabassi, ByzArch 27 (Berlin, 2013), 33–55, esp. 46–47; G. Dagron, "Theophanô, les Saints-Apôtres et l'église de Tous-les-Saints," *Βυζαντινά Σύμμεικτα* 9 (1994): 201–28; S. Gerstel, "Saint Eudokia and the Imperial Household of Leo VI," *ArtB* 79 (1997): 699–707; J. M. Featherstone, "All Saints and the Holy Apostles: *De Cerimoniis* II, 6–7," *Νέα Ρώμη* 6 (2009): 235–248; see also *Patria* 3.209, ed. A. Berger, *Accounts of Medieval Constantinople: The Patria*, DOML 24 (Cambridge, MA, 2013), 222–23.

bays of the Holy Apostles, I divide my paper into five sections, examining the afterlife of the building as an architectural planning concept and as an idea. I begin with its defining features—that is, the dome on pendentives as a modular unit employed in churches with multiple domes. I follow familiar footsteps here—notably Richard Krautheimer, Annabel Wharton Epstein, and more recently Tassos Papacostas and Charles A. Stewart, among many others.[9] First, I address the more or less exacting replications, such as San Marco in Venice, which have been regularly noted by scholars. This leads me to the problem of multiple-domed buildings as they might possibly relate to the design of the Holy Apostles. In a separate section, I examine some intriguing middle Byzantine variants and their possible implications. Then, I turn to the role of the Holy Apostles in later Byzantine imperial burials, specifically in relationship to the most important, the imperial mausoleum at the Pantokrator monastery. Finally, from this analysis, I conclude with some thoughts on how buildings conveyed meaning to a Byzantine audience.

Part 1

There are a few exact replicas, most of them familiar and requiring little explanation. These employ the basic concept of the domed square as a modular unit. What is perhaps noteworthy in these buildings is the similarity is scale. The churches at Ephesos and Venice have domed bays approximately 40 feet square, and this may give some indication of the scale of the original, as Underwood and company had suggested.[10] It is a circular argument, of course, but the texts indicate that the main dome was smaller than that of

Hagia Eirene, which had a diameter of 50 feet, so 40 feet is as good a guess as any.

Procopius describes St. John at Ephesos as "most resembling and in every way rivaling the Temple of the Apostles in Constantinople (fig. 13.2)."[11] It might thus be able to provide us with a good impression of the lost prototype. The difficulty is that St. John is only slightly better preserved than the Holy Apostles. When excavated, it stood to a maximum height of 3 to 4 meters—that is, perhaps one-sixth of its original height.[12] As with the Holy Apostles, we may be making assumptions based on hypothetical reconstructions, including the heavy-handed re-erection on-site (fig. 13.3). An earlier phase has been reconstructed on limited archaeological evidence, but its relationship with the Holy Apostles remains speculative. For Justinian's church, the plan is more or less certain, with six major bays defined by piers or pier clusters at the corners of each. For the elevation, Nikolaos Karydis has had the last word, in his 2011 dissertation and subsequent publications. Although drawing on the work of Andreas Thiel, Karydis bases his reconstruction of the vaulting on the careful autopsy of the surviving masonry fragments (fig. 13.4).[13] As Thiel had suggested on stylistic grounds, he also reconstructs the church with four low pendentive domes and a taller dome on pendentives at the crossing.[14] This gives greater prominence to the crossing dome and creates a more unified interior. Interestingly, Theil's process of visualization compares nicely with Underwood's, as he in effect builds the church from its foundations upward in his drawings.[15] The implications of their studies may be significant for our own investigations. Although the organization of the domes is similar, for

9 Krautheimer, "Note on Justinian's Church"; also Wharton Epstein, "Rebuilding and Redecoration," 79–92; C. A. Stewart, "Domes of Heaven: The Domed Basilicas of Cyprus" (PhD diss., Indiana University, Bloomington, 2008); T. Papacostas, "The Medieval Progeny of the Holy Apostles: Trails of Architectural Imitation across the Mediterranean," in *The Byzantine World,* ed. P. Stephenson (Abingdon, 2010), 386–405.

10 P. Underwood, "The Architecture of Justinian's Church of the Holy Apostles, part 2," Underwood Papers ICFA MS.BZ.019–03–01–050, page 8. See below Appendix E, 381–83. Note also the chapter by Nikolaos Karydis in this volume.

11 Procopius, *De aed.,* 5.1.4–6, ed. and trans. Dewing, *On Buildings,* 316–19.

12 See the critique by Hugh Plommer, "St. John's Church, Ephesus," *AnatSt* 12 (1962): 119–29.

13 Andreas Thiel, *Die Johanneskirche in Ephesos* (Wiesbaden, 2005); Nikolaos Karydis, *Early Byzantine Vaulted Construction in Churches of the Western Coastal Plains and River Valleys of Asia Minor,* BAR International Series 2246 (Oxford, 2011).

14 Karydis, *Vaulted Construction,* plan fig. 7, reconstructed elevation fig. 114; ideas repeated in idem, "The Vaults of St. John the Theologian at Ephesos: Re-Visualizing Justinian's Church," *JSAH* 71, no. 4 (2012): 524–51.

15 Thiel, *Johanneskirche,* pls. 24–25.

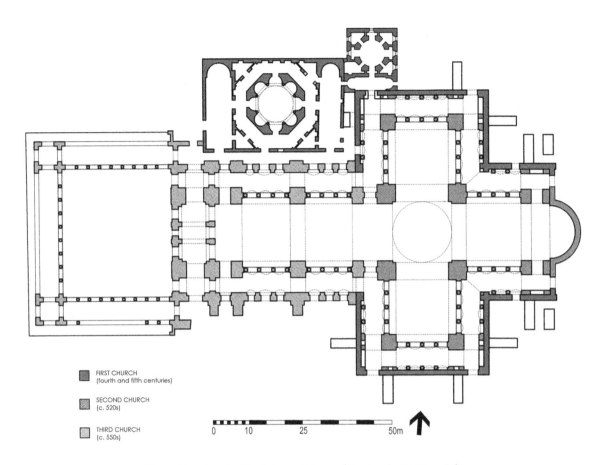

FIRST CHURCH
(fourth and fifth centuries)

SECOND CHURCH
(c. 520s)

THIRD CHURCH
(c. 550s)

0 10 25 50m

FIG. 13.2. Plan of the church of St. John at Ephesos (drawing by N. Karydis)

FIG. 13.3.
View of the church
of St. John at
Ephesos from the
southeast (photo
by author)

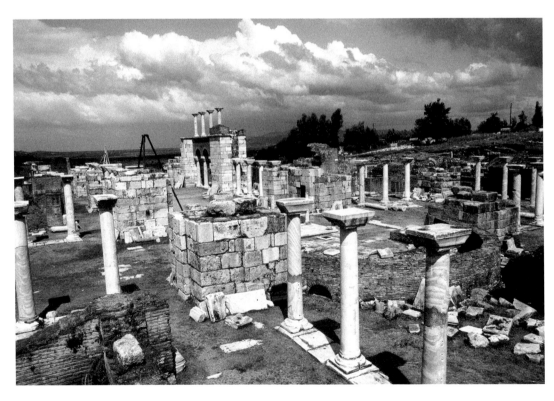

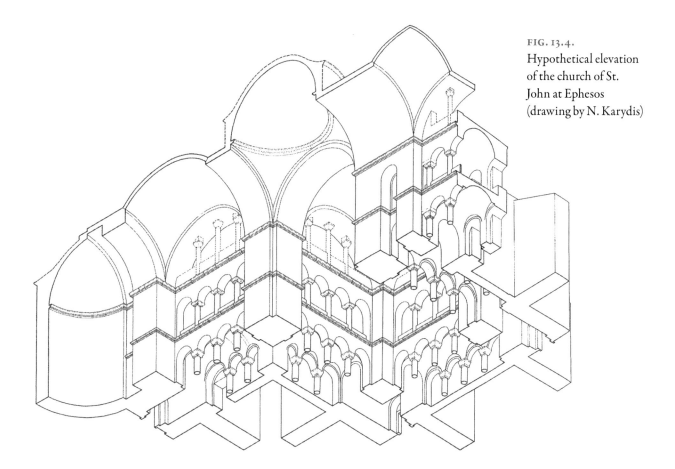

FIG. 13.4.

Hypothetical elevation
of the church of St.
John at Ephesos
(drawing by N. Karydis)

example, with the central dome most prominent, Underwood chose to reconstruct the minor domes as blind domes on pendentives. Would the pendentive domes of St. John have been more appropriate? Also of significance is Karydis's reanalysis of the sixth-century St. John, demonstrating that it was built in two phases.[16] If he is correct, it may have actually preceded the construction of the Holy Apostles as a five-domed church, subsequently expanded into a six-domed church. Could the vaulted church architecture of western Asia Minor have established a model for the innovative monuments in the capital? On this matter, I defer to Karydis, and to his paper in this volume.

From the limited archaeological evidence presented by Ferdinando Forlati, scholars assume that the first church of San Marco in Venice (begun after 829) followed the centralized cruciform model of the Holy Apostles.[17] This was accepted by Otto Demus, although it continues to be debated.[18] The relationship is much clearer in the present building, begun some time in the second half of the eleventh century (fig. 13.5). The interior must give something of the impression of how the Holy Apostles may have appeared, with domes on pendentives, organized in a Greek-cross plan, rising about cluster piers. A monk from San Nicolò di Lido noted in the early twelfth century that the church was "a skillful construction entirely similar to that of the Twelve Apostles in Constantinople."[19] As Demus suggests, the building would have responded to the emerging civic pride within eleventh-century Italy, offering

16 N. Karydis, "The Evolution of the Church of St. John at Ephesos during the Early Byzantine Period," *Jahreshefte des Österreichischen Archäologischen Institutes in Wien* 84 (2016): 97–128.

17 F. Forlati, "Il primo San Marco," *ArtV* 5 (1951): 73–76.

18 O. Demus, *The Church of San Marco in Venice: History, Architecture, Sculpture*, DOS 6 (Washington, DC, 1960), 64–69. See more recently J. Warren, "The First Church of San Marco in Venice," *The Antiquaries Journal* 70, no. 2 (1990): 327–59; and R. Mainstone, "The First and Second Churches of San Marco Reconsidered," *The Antiquaries Journal* 71/1 (1991): 123–37.

19 Demus, *Church of San Marco*, 90.

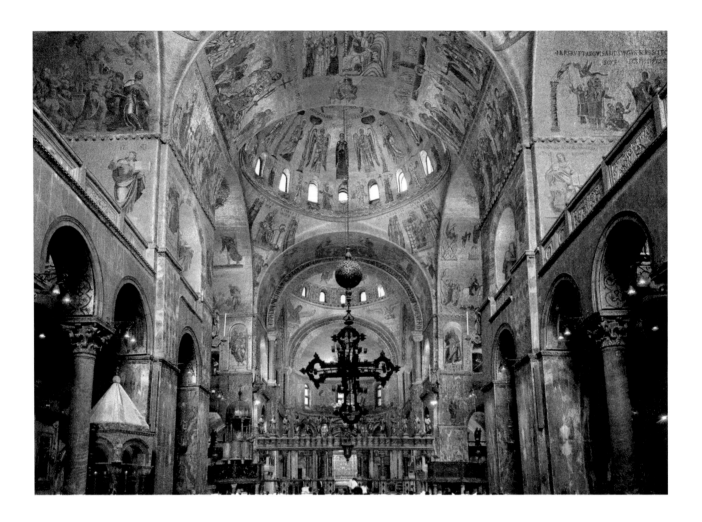

FIG. 13.5.
Interior view,
Basilica of San
Marco, Venice,
looking east (photo
by R. Nelson)

visual competition to Venice's rival Pisa, which was building its new cathedral at the same time.[20] It also provided visual testimony of Venice's cosmopolitan character, its close relations and growing rivalry with Constantinople. In the words of Jonathan Shepard, "the visual vocabulary of Constantinople was simultaneously saluted and subverted."[21]

The presence of at least one Byzantine mason at San Marco seems likely although undocumented. While the bricks are locally produced and laid with thin mortarbeds, a variety of details find good comparison at the mid-eleventh-century St. George of Mangana in Constantinople, such as the detailing of pilasters and niches, the bundled triangular and

semicircular shafts on the piers, and the arched "hearts."[22] Nevertheless, there are discrepancies, most notably the shifted orientation, with the sanctuary in the east bay rather than centrally placed, and the central and western domed bays slightly larger than the others. These changes give greater emphasis to the longitudinal axis, so that the building reads not unlike a Romanesque basilica with a transept.

As is commonly understood, in both San Marco and St. John, the repetition of the design of the Holy Apostles has symbolic resonance. Both buildings were dedicated to evangelists/apostles and contained their relics, and this

20 Ibid.

21 J. Shepard, "Imperial Outliers: Building and Decorative Works in the Borderlands and Beyond," in Stephenson, ed., *Byzantine World*, 372–85, esp. 381.

22 R. Ousterhout, "The Byzantine Heart," *Zograf* 17 (Belgrade, 1989): 36–44; idem, *Master Builders of Byzantium* (Princeton, 1999), 197–98; R. Demangel and E. Mamboury, *Le quartier des Manganes et la première région de Constantinople* (Paris, 1939), 19–37, esp. figs. 21–22; F. Zuliani, "Considerazioni sul lessico architettonico della San Marco contariniana," *ArtV* 29 (1975): 50–59, esp. fig. 6.

intended relationship must have influenced the selection of plan.

Part 2

The multiplication of the dome on pendentives as a modular unit seems to be one of the key developments of Justinianic architecture. Krautheimer saw this as a domed cross, with the central figure amplified by arches on four sides. As he wrote, "It lent itself to easy combinations of large size, and the number and variety of such combinations are surprising. Repeated five times and arranged in a Greek cross pattern, it formed the plan of Justinian's Church of the Holy Apostles."[23] But, as Hans Buchwald has noted, the single example of this in the church architecture of the capital is the Holy Apostles, while there are a variety of near-contemporaneous examples in western Asia Minor.[24] The enigmatic church of St. John at Alaşehir (Philadelphia) has a curious single-aisled plan, with a nave covered by two domes; Building D at Sardis was similar, while two churches at Pammukkale/Hierapolis seem to have employed comparable modular designs (fig. 13.6).[25] Did these (rather than the Holy Apostles) set the pattern for later developments? Indeed, Buchwald once wondered if it was the design of St. John that served as the model for the Holy Apostles, rather than the other way around— a possibility further developed by Karydis.[26] Although the *Patria* is wrong in many other respects, this is what it relates as well.[27]

Tassos Papacostas recently investigated multidomed churches in Cyprus, Italy, and France, in which the domed bay was used as a modular spatial unit—as it was in Justinian's church.[28] With the exception of San Marco and Saint-Front at

FIG. 13.6. Plans of vaulted churches in western Asia Minor: Urban basilica, Hierapolis; St. John, Philadelphia; Building D, Sardis (drawing by author, after N. Karydis)

23 Krautheimer, *Early Christian and Byzantine Architecture*, 242.

24 H. Buchwald, "Western Asia Minor as a Generator of Architectural Forms in the Byzantine Period, Provincial Back-Wash or Dynamic Center of Production," *JÖB* 34 (1984): 199–234, esp. 209–14; reprinted in H. Buchwald, *Form, Style, and Meaning in Byzantine Church Architecture* (Aldershot, 1999).

25 Ibid.; and see Karydis, *Early Byzantine Vaulted Construction*, esp. 8–21.

26 Karydis, "Evolution of the Church."

27 *Patria* 4.32; ed. Berger, *Patria*, 274–75.

28 Papacostas, "Medieval Progeny," 386–405.

Périgueux, however, he could find no clear connection to the Holy Apostles. This point has been reinforced in the recent dissertation of Charles A. Stewart.[29] The multidomed churches of Cyprus belong to the Dark Ages—that is,

29 Stewart, *Domes of Heaven*.

The Church of the Holy Apostles and Its Place in Later Byzantine Architecture 217

after the Arab invasion of 649, when the island was cut off from developments elsewhere. They seem to represent an independent regional phenomenon, beginning with and perhaps following the remodeling of the cathedral of Hagios Epiphanios in Salamis, which was the largest church in the largest city of the island (fig. 13.7). The standard design has three domes above a longitudinal nave, as at Hagios Lazaros in Larnaka and Hagios Barnabas near Salamis. Stewart has speculated that the repetition of three domes may relate to important actions in the liturgy as interpreted by Maximos the Confessor (i.e., First Entrance, Liturgy of the Word, Great Entrance), or perhaps to the Trinity, but it is just as likely that the proportions of the nave required three bays to be fully covered.[30]

The related five-domed churches as at Hagia Paraskevi in Yeroskipou (figs. 13.8–13.9) and Hagioi Barnabas and Hilarion at Peristerona maintain the longitudinal three-domed nave, but with two smaller domes added to the side aisles, although these are visually cut off from the nave and do not mark cross arms or transepts—that is, they are spatially very different from the Holy Apostles, maintaining a longitudinal character.[31] In short, the Cypriot churches represent an independent development. Notably, after the Byzantine reconquest of the island in 965, the multiple-domed format was abandoned in favor of the single-domed church, more in keeping with middle Byzantine standards.[32]

The multidomed churches of Apulia pose similar problems, although they are considerably later in date, with the oldest from the eleventh century.[33] For these, the cathedral of San Sabino at Canosa is perhaps the most important (fig. 13.10). How important it is depends on its date. Although a dedication of 1101 is recorded by inscription, and generally accepted, Annabel Wharton has proposed instead a date in the

second quarter of the eleventh century, based on the use of alternating bands of brick and ashlar in the construction, which finds better comparison before the arrival of the Normans, who took control of Bari in 1071.[34] Moreover, while most of the domed churches in the area have three domes in series—as, for example, the Benedictine church of the Ognissanti in Valenzano, dated 1061, San Sabino, in contrast, has five domes, although they are organized with three above the nave and the additional two above transept arms. Based on the five-domed plan, Wharton attempted to connect the design to the Holy Apostles, thus adding a "political dimension" to the church.[35] Because of her early dating, she argued, it could not have been based on San Marco in Venice, as others had suggested. Moreover, the addition of the curious mausoleum of Bohemond of Antioch, who died in 1111, might suggest the imperial mausolea appended to the Holy Apostles. But Bohemond had only a few years earlier suffered a humiliating defeat when he attacked the army of Alexios Komnenos, so it seems unlikely that he would have been looking to Constantinople for symbolic architectural forms.[36] The architectural reference, if there was one, may have been to Jerusalem instead, to the burials of the Latin kings in the Holy Sepulcher. Moreover, Wharton's dating of the cathedral fails to convince. The plan forms a Latin not a Greek cross and may just as easily be explained as a transept basilica, common to the region, into which modular vaulting has been added—that is, all features may be explained by regional developments.

For Aquitaine, the picture is similar but the monuments are slightly later.[37] Saint-Front at Périgueux (after 1120) is usually included in the group of "copies" of the Holy Apostles (fig. 13.11). However, its design is more likely based on San Marco and not directly upon the Holy Apostles—the connections are with

30 Ibid, 178–83.

31 Ibid.

32 Ibid.; for previous discussions, see A.H.S. Megaw, "Byzantine Architecture and Decoration in Cyprus: Metropolitan or Provincial?" *DOP* 28 (1974): 57–88; S. Ćurčić, *Middle Byzantine Architecture on Cyprus: Provincial or Regional?*, The Bank of Cyprus Cultural Foundation 2 (Nicosia, 2000).

33 Papacostas, "Medieval Progeny," 395–402.

34 A. Wharton Epstein, "The Date and Significance of the Cathedral of Canosa in Apulia, South Italy," *DOP* 37 (1983): 79–90.

35 Ibid., esp. 85.

36 See, among others, J. Shepard, "When Greek Meets Greek: Alexius Comnenus and Bohemond in 1097–98," *BMGS* 12, no. 1 (1988): 185–278.

37 Papacostas, "Medieval Progeny," 389–95.

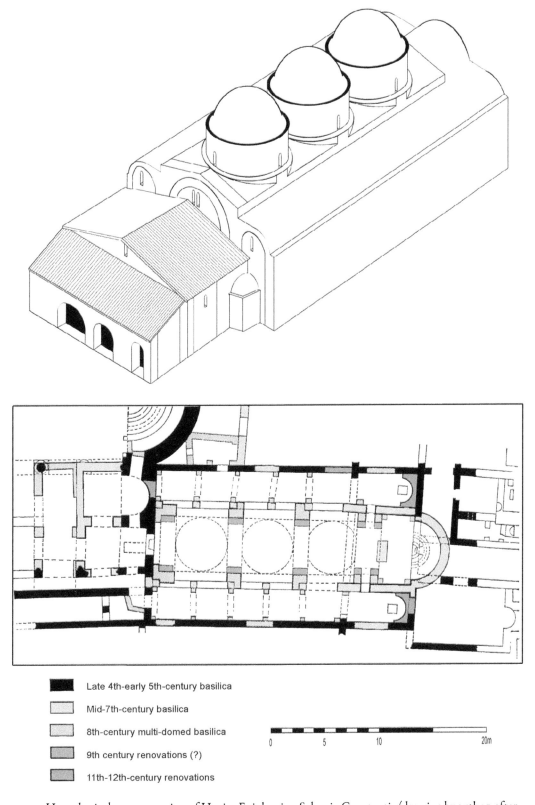

Late 4th-early 5th-century basilica

Mid-7th-century basilica

8th-century multi-domed basilica

9th century renovations (?)

11th-12th-century renovations

0 5 10 20m

FIG. 13.7. Hypothetical reconstruction of Hagios Epiphanios, Salamis-Constantia (drawing by author, after C. A. Stewart)

FIG. 13.8.
View of
Hagia Paraskevi,
Yeroskipou, from
the northeast
(photo by author)

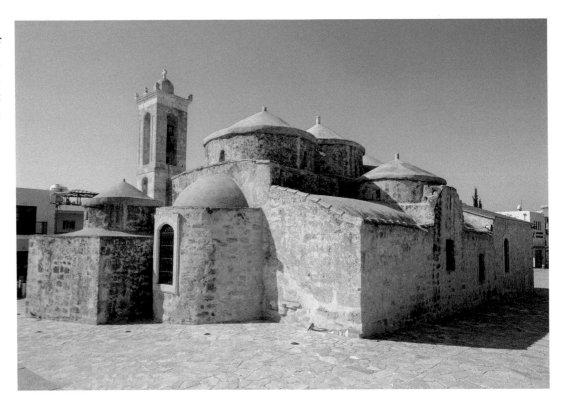

FIG. 13.9.
Plan of Hagia Paraskevi,
Yeroskipou (drawing by author,
after C. A. Stewart)

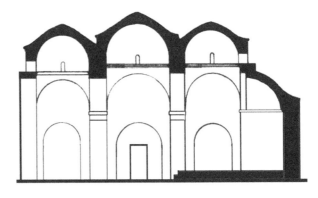

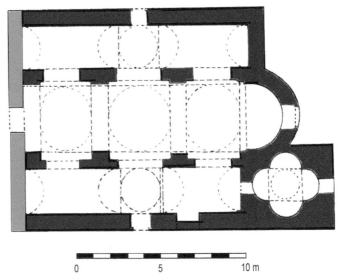

0 5 10 m

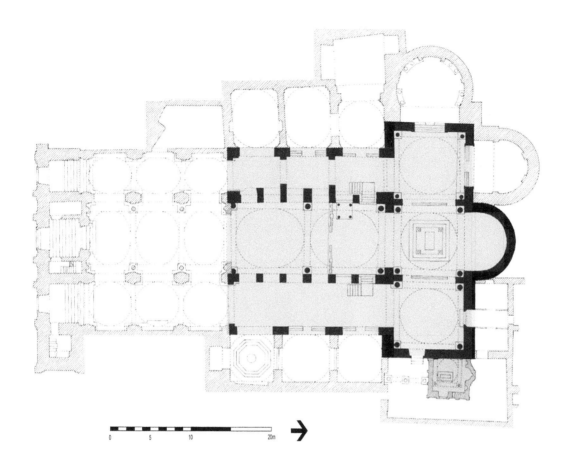

FIG. 13.10.
Plan of San Sabino,
Canosa (drawing
by author, after
P. Belli d'Elia)

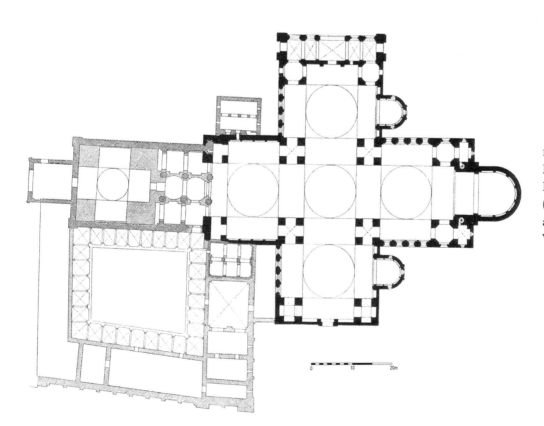

FIG. 13.11.
Plan of Saint-
Front, Périgueux
(drawing by
author, after F. de
Verneilh)

The Church of the Holy Apostles and Its Place in Later Byzantine Architecture 221

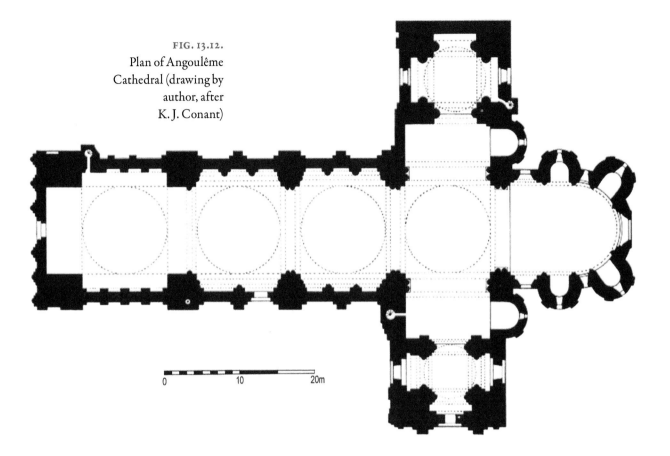

FIG. 13.12.

Plan of Angoulême
Cathedral (drawing by
author, after
K. J. Conant)

0 10 20m

Venice, not Constantinople.[38] Since the mid-nineteenth century, the church has been seen as the centerpiece for "l'architecture byzantine en France," as M. Félix de Verneilh titled his 1851 study, written before the drastic rebuilding of the church by Paul Abadie (1852–95).[39] But it is out of character with the other fifty-nine multidomed Romanesque churches surviving in western France, which have two to five domes arranged in a linear fashion, covering a single-aisled interior, as at Fontevrault (dedicated 1119) or Angoulême (1105–28 and later) (fig. 13.12). Enlart had suggested the twin-domed Saint-Étienne at Cahors as the prototype behind the Aquitaine domed churches, with its "caractère absolument oriental." The church was dedicated in 1119 (although incomplete), and its bishop Géraud III de Cardaillac had traveled to the East

and returned with a relic of the headcloth from Christ's burial.[40] The unusual forms may have been intended to represent the exotic East in a very general way rather than following a specific model. Now much altered, the scale of Cahors is remarkable, with domes close to 50 feet in diameter. There is a sense of spaciousness to the interior that still impresses. While Cahors and the other churches of Aquitaine are perhaps eccentric by French Romanesque standards, as Conant noted long ago, the dome as a structural form has had a much better survival rate than the more standard barrel vault of the region—Conant estimated an 80% survival rate for domes versus a 30% survival rate for barrel vaults in Aquitaine.[41]

The source of the idea of the multidomed longitudinal nave remains unresolved for both Apulia and Aquitaine. Cyprus has been suggested and rejected for both, in part because

38 Demus, *Church of San Marco*, 95–96.

39 M. Félix de Verneilh, *L'architecture byzantine en France: Saint-Front de Périgueux et les églises à coupoles de l'Aquitaine* (Paris, 1851).

40 Papacostas, "Medieval Progeny," 392–93.

41 K. J. Conant, *Carolingian and Romanesque Architecture, 800 to 1200* (New Haven, 1978), 283–91.

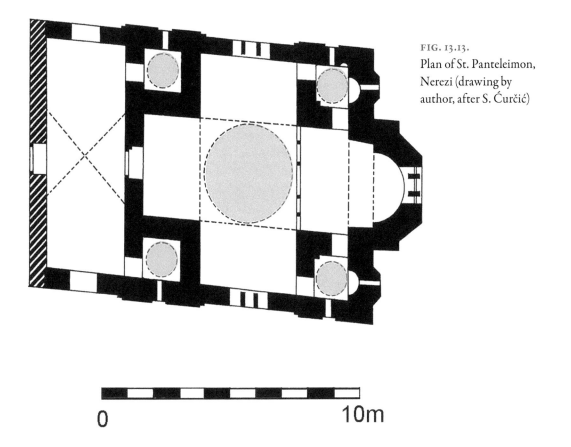

FIG. 13.13.

Plan of St. Panteleimon,
Nerezi (drawing by
author, after S. Ćurčić)

0 10m

of the dramatic differences in scale.[42] By comparison, the churches of Cyprus are small and humble. Nevertheless, in all there is a flavor of the Byzantine, but no more than that—and virtually nothing to suggest a specific prototype.

Part 3

The middle Byzantine variations are perhaps more interesting for the present readership. As Professor Slobodan Ćurčić has taught us, it is more common for middle and late Byzantine five-domed churches to position the minor domes on the diagonals, rather than on the major axes.[43] This is what we find at the Theotokos

tou Libos in Constantinople (907)—if the gallery chapels were indeed domed, as well as at St. Panteleimon at Nerezi (1164) (fig. 13.13) and the Kosmosoteira at Ferai (1152).[44] Moreover, during the middle Byzantine period, at least in areas associated with the capital, the domes marked separate functional spaces on the interior, rather than joining as modular units in a unified interior, as they had at the Holy Apostles. While topped by multiple domes, these churches bear no relationship to the Holy Apostles, either formally or symbolically.

Perhaps most important among the middle Byzantine examples is Hagios Andreas at Peristera, in the hills outside Thessalonike, erected by St. Euthymios the Younger, circa 870–871 (figs. 13.14–13.16).[45] A native of Galatia, the

42 See Papacostas, "Medieval Progeny," 394; and Stewart, *Domes of Heaven*, 16–20; both critically assess the older literature.

43 S. Ćurčić, "Architectural Significance of Subsidiary Chapels in Middle Byzantine Churches," *JSAH* 36 (1977): 94–110, esp. 102–4; for question of the original form of the Theotokos church, see Vasileios Marinis, "The Original Form of the Theotokos *tou Libos* Reconsidered," in *Δασκάλα. Απόδοση*

τιμής στην καθηγήτρια Μαίρη-Παναγιωτίδη Κεσίσογλου, ed. P. Petrides and V. Foskolou (Athens, 2014), 267–303.

44 Ćurčić, "Architectural Significance"; also Ousterhout, *Master Builders*, 119–24.

45 N. K. Moutsopoulos, *Περιστερά, ο ορεινός οικισμός του Χορτιάτη και ο Ναός του Αγίου Ανδρέα* (Thessalonike, 1986);

FIG. 13.14.
View of Hagios
Andreas, Peristera,
seen from the north
(photo by author)

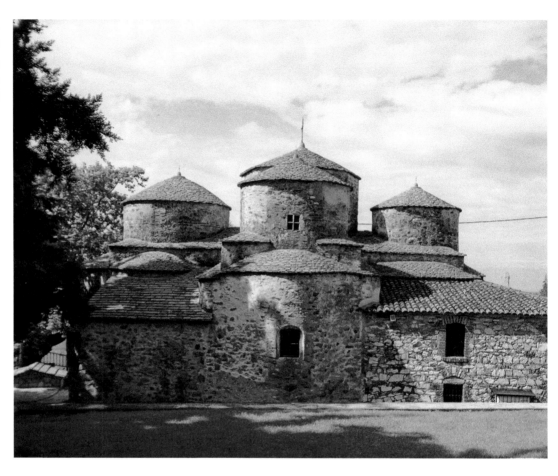

saint had lived an ascetic life on Mt. Olympos and Mt. Athos, and had been a stylite in Thessalonike before settling at Peristera, where he built the church himself with the assistance of a few followers in a site plagued by demons. The saint's *vita* claims that he found an older church dedicated to the first apostle in ruins and set about to rebuild it and to found a monastery. Both the demons and the do-it-yourself nature of the enterprise may explain the crudeness of the construction, which is heavy, rubbly, and without ornament, but its sophisticated plan comes as something of a surprise. A five-domed church, with the domes arranged on a Greek-cross plan, the building originally lacked a narthex. It thus replicated the basic configuration of the Holy Apostles, albeit on a considerably smaller scale—indeed, the entire building would have fit under

the main dome of the Holy Apostles, as Professor Ćurčić has commented.[46] More significant is the elaboration of the five bays: the crossing is a cross-in-square unit with very tiny corner compartments, while the arms of the cross are trefoil. The western bay may have functioned as the narthex, while the eastern triconch is framed by pastophoria, forming a standard middle Byzantine tripartite sanctuary. The lateral triconches may be the "precincts" (τεμένη—perhaps better translated here as "chapels") of the Prodromos and Euthymios the Great, mentioned in the *vita*. Where exactly Euthymios found the plan is anyone's guess, but the dedication to St. Andrew suggests that the Apostoleion might have something to do with it. Here, however, the design is dramatically updated with a standard middle Byzantine cross-in-square unit at its core, framed by elaborated cross arms. Despite the uniqueness

A.-M. Talbot, trans., "Life of Euthymios the Younger," in *Holy Men of Mount Athos*, ed. and trans. A.-M. Talbot and R. Greenfield, DOML 40 (Cambridge, MA, 2016), 84–97.

46 S. Ćurčić, *Architecture in the Balkans from Diocletian to Süleyman the Magnificent, c. 300–1500* (London, 2010), 339–40.

FIG. 13.15.
Interior of Hagios Andreas,
Peristera, looking south
(photo by author)

FIG. 13.16.
Plan of Hagios Andreas,
Peristera (drawing by author,
after N. K. Moutsopoulos)

0 10m

The Church of the Holy Apostles and Its Place in Later Byzantine Architecture 225

of the plan, the claims of the *vita*, and the assertions of Moutsopoulos, there does not appear to be any trace of an older church on the site.[47]

Intriguingly, the church at Peristera appears shortly after the last Iconoclast imperial burials in the Mausoleum of Justinian and immediately before we find renewed interest in the Mausoleum of Constantine by the Macedonian emperors. Basil I buried his son Constantine there in 879.[48] Moreover, Basil I built the Nea Ekklesia inside the Great Palace in Constantinople within the same decade as Euthymios was laboring at Peristera. Now lost, the Nea is described in the *Vita Basilii* as dedicated to Christ, along with Gabriel, Elijah, the Theotokos, and St. Nicholas; "its roof, consisting of five domes, gleams with gold and is resplendent with beautiful images as with stars, while on the outside it is adorned with brass that resembles gold."[49] Like the Holy Apostles, the Nea has been the plaything of modern architects, with very different ideas.[50] Should it be reconstructed following the model of the standard five-domed middle Byzantine church discussed above, or perhaps as a cross-domed church with the domed naos framed by four domed chapels, as it is usually reconstructed? An addition of four subsidiary chapels would certainly account for its five-fold dedication. From the brief description, however, it is clear that the domes were visually prominent on both the exterior and the interior—that is, like the Holy Apostles and like Peristera. I suspect that the five domes covered a five-bayed, cruciform naos, with nondomed chapels set at the corners, as Buchwald once suggested.[51]

The *Patria* claims that Basil took marbles and mosaics from the Holy Apostles to adorn the Nea (as well as the Theotokos of the Forum).[52] Although Liz James has read this as contradicting the *Vita Basilii* on Basil's treatment of the Holy Apostles, we might give the statement a more positive spin—that is, it indicates an intended relationship between the two buildings.[53] Could the reused marbles and mosaics have been the leftovers of Basil's restoration, meaningfully recycled? In any event, considering the Macedonian dynasty's subsequent investment in the Holy Apostles, it would not be surprising to find a reflection of it in Basil's architectural endeavors.

The so-called Ala Kilise in Belisırma (Cappadocia) repeats this plan in rock-cut form, but it is unique within the region (figs. 13.17 and 13.18).[54] A monumental arch opens directly into the naos, which has a Greek-cross plan, with a square central bay and four smaller, rectangular bays projecting from it. All five bays are domed. Four small barrel-vaulted compartments fill the corners. There is no narthex, and the western domed bay may have functioned as the narthex. The eastern domed bay along with the apse behind it formed a large bema, flanked by pastophoria. The plan ultimately finds its model in Justinian's church of the Holy Apostles in Constantinople, although it is closer in form to the middle Byzantine version at Peristera.[55] Unfortunately we do not know the dedication, and the painting, while of high quality, is too damaged to offer any suggestions—the main dome and the apse are completely bare. Whoever the patron was, he or she must have been both well off and well connected. While the carving must have been done by local craftsmen, the spacious feel of the interior is cosmopolitan. The site preserves no significant burials and no trace of a monastery, and I suspect it may have been a parochial church for the village.

The rock-cut chapel connected to the residence at Hallaç near Ortahisar similarly has

47 Moutsopoulos, Περιστερά, passim.

48 See Grierson, "Tombs and Obits," 58–59.

49 *Vita Basilii*, ed. Ševčenko, 272–78; P. Magdalino, "Observations on the Nea Ekklesia of Basil I," *JÖB* 37 (1987): 56–57.

50 R. Ousterhout, "Reconstructing Ninth-Century Constantinople," *Byzantium in the Ninth Century: Dead or Alive?*, ed. L. Brubaker, SPBS 5 (Aldershot, 1998), 115–30; See also K. J. Conant, *A Brief Commentary on Early Medieval Architecture* (Baltimore, 1942), 15.

51 H. Buchwald, "Sardis Church E—A Preliminary Report," *JÖB* 26 (1977): 277–79; reprinted in Buchwald, *Form, Style, and Meaning*.

52 *Patria*, 4.32; ed. Berger, *Patria*, 278–79.

53 James, *Constantine of Rhodes*, 204.

54 V. Kalas, "Middle Byzantine Art and Architecture in Cappadocia: The Ala Kilise in the Peristrema Valley," in *Anathemata Eortika: Studies in Honor of Thomas F. Mathews*, ed. J. Alchermes, H. Evans, and T. Thomas (Mainz, 2009), 181–90.

55 Krautheimer, *Early Christian and Byzantine Architecture*, 371–72; also Moutsopoulos, Περιστερά.

FIG. 13.17.
Interior of the Ala Kilise, Belisırma
(Cappadocia), looking south (photo
by author)

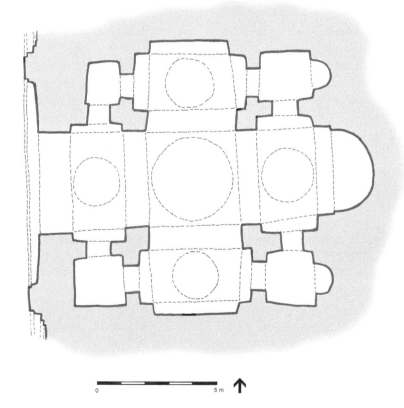

FIG. 13.18.
Plan of the Ala Kilise,
Belisırma (Cappadocia)
(drawing by author, after
V. Kalas)

0 5 m

The Church of the Holy Apostles and Its Place in Later Byzantine Architecture

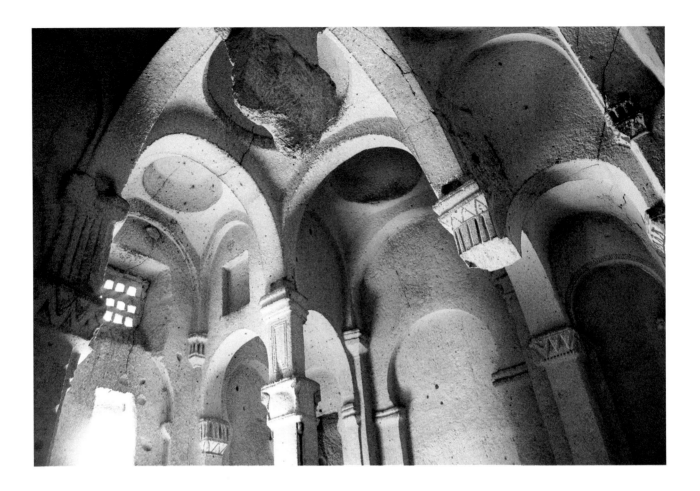

FIG. 13.19.
Interior view of the
church at Hallaç,
near Ortahisar
(Cappadocia),
looking north
(photo by author)

five blind domes above its naos (fig. 13.19).[56] The central dome rises above pendentives and cruciform piers, but the four slightly smaller axial domes spring directly from flat ceilings. The corner bays have either groin vaults or barrel vaults. Within the building, all surfaces are articulated, if not always uniform or structurally logical. The point here, I suspect, was to emphasize the verisimilitude of the rock-cut forms through the multiplication of signifying architectonic details. That is to say, domes signify "real" architecture, and this may explain the often structurally illogical multiplication of domes in Cappadocian cave churches, as at Hallaç. This is often carried to extremes elsewhere: at the Elmalı Kilise in Göreme, for example, all nine bays are domed.[57]

56 L. Rodley, "Hallaç Manastir: A Cave Monastery in Byzantine Cappadocia," *JÖB* 32, no. 5 (1982): 425–34; eadem, *Cave Monasteries of Byzantine Cappadocia* (Cambridge, 1985), 11–26.

57 See my comments in R. Ousterhout, *Visualizing Community: Art, Material Culture, and Settlement in Byzantine Cappadocia*, DOS 46 (Washington, DC, 2017).

In sum, one good dome deserves another. The multiple-domed churches I have discussed here seem to have been built in regional clusters, and in most cases, it is impossible to connect them back to the Holy Apostles, except in the most general terms, and without specific transfer of meaning. The exceptions seem to be apostolic dedications—Ephesos, Venice, Peristera. On the other hand, later Byzantine interest in the Holy Apostles seems to have been more oriented toward the imperial tombs than toward the apostolic relics. With the exception of Venice, none of the copies seems to have had an intended political dimension.

Part 4

Let me now shift gears and attempt a different approach, as I examine the ideological role of the Holy Apostles in later Byzantine architecture and the special meanings it accrued as a place of imperial burial. I take as my starting point the *Typikon* of the Pantokrator monastery, written in

1136, in which John II refers to the imperial burial chapel as the *heroon*.[58] To my knowledge the only other buildings referred to by this antiquated term of which John would have been aware were the mausolea of Constantine and Justinian at the Holy Apostles. I suspect the use of the term was intended to draw a comparison between John's new imperial mausoleum and the older and more famous one nearby.[59] Although the two buildings were completely different in their designs, the connection was ideological, associated with their function as imperial mausolea.

Built between circa 1118 and 1136 by John II and Eirene Komnenos as three large, interconnected churches, the Byzantine form of the Pantokrator is well known (figs. 13.20 and 13.21).[60] The south church was constructed first as the monastic *katholikon* dedicated to Christ Pantokrator. To this the north church was added, dedicated to the Virgin Eleousa; it was open to the laity and served by a lay clergy. The middle church was sandwiched between these two, the mausoleum, called the *heroon*, was dedicated to St. Michael, the site of Komnenian imperial burials (fig. 13.22). In its final form an asymmetrical sprawl of mismatched components, the complex was topped by five domes of different sizes and shapes, with a row of disparate apses along its east façade. Perhaps its only physical similarity with the Holy Apostles is its five domes, but these were constructed sequentially as the complex grew and were not planned from the beginning. For example, as I have discussed elsewhere, the heroon was begun as a single-domed chapel, and the smaller, oblong eastern dome was added only after the western dome was completed.

Can we find more specific links between the two complexes? First, how was the term *heroon* understood, at least as it appears in the Pantokrator *Typikon*? The term is actually first applied to an imperial mausoleum by Cassius Dio (in the third century CE) to refer to the Mausoleum of Augustus, which I view as the ideological prototype of Constantine's mausoleum.[61] Traditionally, the term *heroon* designated the shrine of a hero who has achieved the status of demigod through accomplishments on this earth. Although archaizing, it is used in especial frequency during the middle Byzantine centuries with respect to the mausolea of Justinian and Constantine: by Constantine Porphyrogennetos, in the *Catalogus Sepulchrorum*; by Kedrenos; by Symeon the Logothete; by Niketas Choniates, in the *Vita Ignatii*; as well as in the *Ekphrasis* of Mesarites. And there may be others.[62]

In their earthly roles, these emperors were also known as great warriors. Constantine, like Augustus, had brought peace to the empire by putting down the tyranny of his tetrarchic contemporaries. Justinian, although not a warrior himself, oversaw military campaigns on the European, African, and Asian frontiers, as chronicled by Procopius and commemorated by the triumphal column and statue in the Augousteion. John II Komnenos, like his father Alexios, went to battle for the security of the empire and was fighting against the Seljuks in Asia when his consort Eirene died in 1134—that is, immediately

58 P. Gautier, "Le typikon du Christ Sauveur Pantocrator," *REB* 32 (1974): 1–145, esp. 72–73.

59 As I suggested in R. Ousterhout, "Architecture, Art, and Komnenian Ideology at the Pantokrator Monastery," in *Byzantine Constantinople: Monuments, Topography, and Everyday Life*, ed. N. Necipoğlu (Leiden, 2001), 133–50; see now Magdalino, "Foundation," esp. 43; as well as G. Downey, "The Tombs of the Byzantine Emperors at the Church of the Holy Apostles in Constantinople," *JHS* 79 (1959): 27–51.

60 See most recently Kotzabassi, *Pantokrator Monastery*, with a useful bibliography, 251–54; for a survey of the sources, see Janin, *Églises et monastères*, 515–23; for the building itself, see J. Ebersolt and A. Thiers, *Les églises de Constantinople* (Paris, 1913), 171–207; A. Van Millingen, *Byzantine Churches in Constantinople: Their History and Architecture* (London, 1912), 219–40; both superseded by A.H.S. Megaw, "Notes on the Recent Work of the Byzantine Institute in Istanbul," *DOP* 17 (1963): 333–64. For the *Typikon*, see Gautier, "Typikon"; and English translation by Robert Jordan in *BMFD*, 725–81, with notes and commentary. For the restoration, see R. Ousterhout, Z. Ahunbay, and M. Ahunbay, "Study and Restoration of the Zeyrek Camii in Istanbul: First Report, 1997–98," *DOP* 54 (2000): 265–70; and "Study and Restoration of the Zeyrek Camii in Istanbul: Second Report, 2001–05," *DOP* 63 (2010): 235–56; also M. and Z. Ahunbay, "Restoration Work at the Zeyrek Camii, 1997–1998," in Necipoğlu, *Byzantine Constantinople*, 117–32.

61 Cassius Dio, *Roman History*, 256.33, ed. and trans. E. Gray, 9 vols. (Cambridge, MA, 1914–27), 7:72–73; M. J. Johnson, *The Roman Imperial Mausoleum in Late Antiquity* (Cambridge, 2014), esp. 186, with further references, 250n54.

62 The *Synopsis Chronike* also refers to the stoa of Julian at the Holy Apostles as a heroon; see Johnson, *Roman Imperial Mausoleum*, 186.

FIG. 13.20. View of the church of Christ Pantokrator (Zeyrek Camii, Istanbul), from the east (photo by author)

FIG. 13.21.
Plan of the church of
Christ Pantokrator
(Zeyrek Camii,
Istanbul) (drawing
by author)

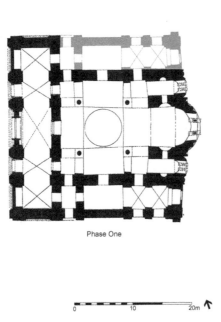

Phase One

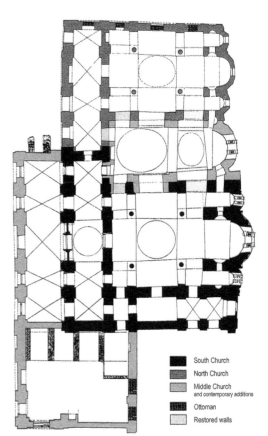

	South Church
	North Church
	Middle Church and contemporary additions
	Ottoman
	Restored walls

0 10 20m

before the *Typikon* was written.[63] A heroon, then, could be understood as a sort of war memorial, commemorating a victorious military leader. In addition to a pious foundation, the Pantokrator could also be viewed as a monument to imperial victory. The anonymous *Enkainia* epigram, discussed by Magdalino, presents the Pantokrator in exactly this way:[64]

105 We are your people, your elected lot.
Break our ungodly enemies with your strength
Who are ever breathing murder against us.
Grant victory to the emperor, who in you alone
Nurtures his hopes of salvation.

Indeed, John was at war with the Seljuks at the time, and current events must have played a role in shaping contemporary views of the undertaking.

A second consideration is the character of the Pantokrator chapel. An important distinction of the *heroa* at the Holy Apostles is that they were fully independent funerary structures attached to the church. The church and its annexes had been last used for imperial burial for Constantine VIII, who was inserted into the Mausoleum of Constantine a century earlier. Subsequent emperors had not devised a strategy for their own burials, beyond the foundation of grand monastic complexes, where communities of monks could commemorate them *in perpetuum*.[65] To my knowledge, the Pantokrator represents the first example that included a separate mausoleum appended to the church, and this marks a significant shift in burial practices. Indeed, the change came about only gradually as the complex grew. Initially the narthex may have been the

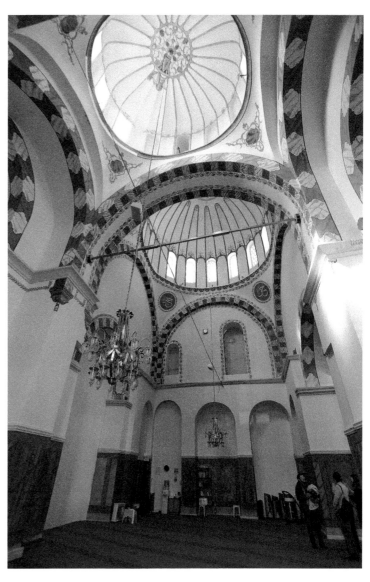

FIG. 13.22. Interior of the chapel of St. Michael at the Pantokrator, looking west (photo by A. Vinogradov)

intended site of the burials, as A. H. S. Megaw had discerned, but as the complex was enlarged, a separate funerary chapel was added—not simply an annexed chapel, but a substantial structure that competed in scale with the churches to either side.[66]

A third consideration, related to this, is the necessity of additional space for the commemorative services at the imperial tombs. At an imperial heroon of old, the ceremony of *consecratio* would

63 M. Loukaki, "Piroska-Eirene's Collaborators in the Foundation of the Pantokrator Monastery: The Testimony of Nikolaos Kataphloron," in Kotzabassi, *Pantokrator Monastery*, 196–97.

64 Magdalino, "Foundation," 45; for the epigram, 49–52.

65 See J. P. Thomas, "In Perpetuum: Social and Political Consequences of Byzantine Patrons' Aspirations for Permanence for their Foundations," in *Stiftungen in Christentum, Judentum und Islam vor der Moderne: Auf der Suche nach ihren Gemeinsamkeiten und Unterschieden in religiösen Grundlagen, praktischen Zwecken und historischen Transformationen*, ed. M. Borgolte (Berlin, 2005), 123–35.

66 Megaw, "Notes on Recent Work," 340–44.

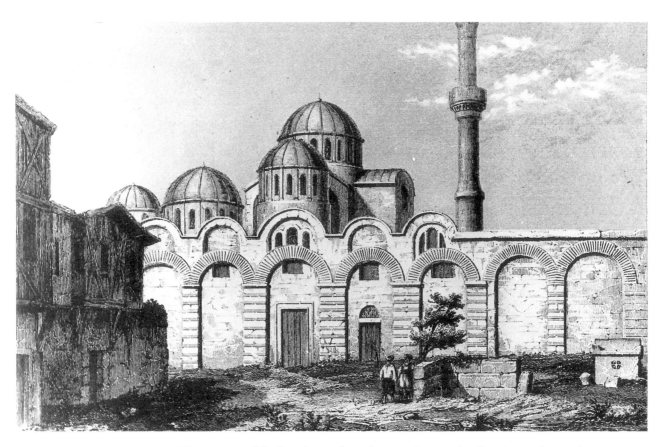

FIG. 13.23. Historic view of the Pantokrator from the west, showing the alleged sarcophagus of St. Eirene (engraving by A. Lenoir)

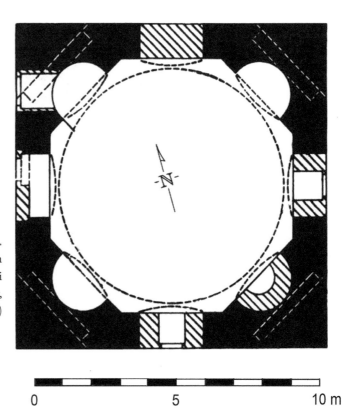

FIG. 13.24.
Plan of the Şeyh
Süleyman Mescidi
(drawing by author,
after C. Gurlitt)

0 5 10 m

have honored the *apotheosis* of the emperor, which in Christian terms became the commemoration of the *dies natales* or the day of death.[67] Constantine the Great was so honored long after his passing by Constantine Porphyrogennetos, as recorded in the *Book of Ceremonies*.[68] Perhaps the *ad hoc* commemorative ceremonies at the Pantokrator, which involved rerouting the procession from the Blachernae, with its *signa* and icons, might be viewed as a reflection of the ceremonies that honored the revered emperors at the Holy Apostles.[69] While other middle and late Byzantine *typika* might specify monastic commemoration of the deceased, there is nothing quite comparable to the ceremonies at the Pantokrator. Moreover, as the *Typikon* indicates again and again, the Pantokrator was an urban monument, provided with its own colonnaded street that linked it to the urban matrix.[70]

Finally, we should consider the concept of the sainted ruler. Constantine was, after all, venerated as St. Constantine, and other emperors, even if not sainted, received similar veneration by visitors to the Holy Apostles. Moreover, as Magdalino has suggested, there may be a reflection at the Pantokrator of the Macedonian emperors' attempts to co-opt the Holy Apostles as a dynastic *lieu de mémoire* by associating their own familial cult with that of Constantine and royal sainthood.[71] The promotion of the sainted Eirene-Piroska at the Pantokrator seems to mirror attempts to sanctify Theophano, wife of Leo VI, at the Holy Apostles. While the promotion of the cult of Eirene probably belongs to the period of her son Manuel I and may postdate the composition of the *Typikon,* this may be the logical consequence of the association between the two complexes.[72]

A side note on this. For centuries a great *verde antico* sarcophagus lay in front of the Pantokrator and was regularly said to be that of St. Eirene (fig. 13.23). It has since been moved to the narthex of Hagia Sophia.[73] Late antique in origin, it could not be that of Eirene, as it would not fit through the door of the church; it must have come from elsewhere. Could it be from the cemetery that developed around the Holy Apostles, and how close to the Pantokrator did it extend? I note the usually overlooked little octagonal Şeyh Süleyman Mescidi to the west of the Pantokrator. Although it is often said to have been the library or dependence of the Pantokrator monastery, it has all the trappings of a late antique mausoleum (fig. 13.24).[74]

Part 5

To conclude, I believe that the *idea* of the Holy Apostles was perhaps more important than its physical form. But its form bore some meaning as well, although perhaps not in the clean architectonic impression given by Underwood's drawings or by the reconstructions of Tayfun Oner—or even by the interior of San Marco.[75] As Magdalino has emphasized in his paper, by the middle Byzantine period, if not earlier, the church of the Holy Apostles was part of a large cluster of buildings. Could one ever have had an uncluttered monumental view? Probably not. Seen from a distance, the domes would have dominated the view, while the lower portions of the complex were likely blocked by ancillary structures—including porticoes, mausolea, the church of All Saints, and perhaps a temenos wall. Indeed, this is the impression the Pantokrator must have given as well. Like the Holy Apostles, five domes rose above the core of the building, likewise perhaps the only part

67 See the discussion by Johnson, *Roman Imperial Mausoleum*, 88–89.

68 *De cer.*, 2.6; ed. A. Moffatt and M. Tall, *Constantine Porphyrogennetos, The Book of Ceremonies* (Canberra, 2012), II.532–35.

69 Gautier, "Typikon," 80–83; N. P. Ševčenko, "Icons and the Liturgy," *DOP* 45 (1991): 45–57; B. V. Pentcheva, *Icons and Power: The Mother of God in Byzantium* (University Park, PA, 2006), 165–87.

70 A point emphasized by Magdalino, "Foundation," esp. 44–46.

71 Ibid., 47.

72 Ibid.

73 G. Moravcsik, *Szént László leánya és a Bizánci Pantokrator Monostor* (Budapest, 1923), 6; J. Deér, *Dynastic Porphyry Tombs of the Norman Period in Sicily* (Cambridge, 1959), 133–34. The first mention of the sarcophagus may be by Richard Pococke, *A Description of the East, and Some Other Countries* (London, 1745), 2:130.

74 Müller-Wiener, *Bildlexikon*, 202–3; T. F. Mathews, *The Byzantine Churches of Istanbul: A Photographic Survey* (University Park, PA, 1976), 315.

75 T. Oner, "Holy Apostles," Byzantium 1200, accessed 20 August 2015, www.byzantium1200.com/apostles.html.

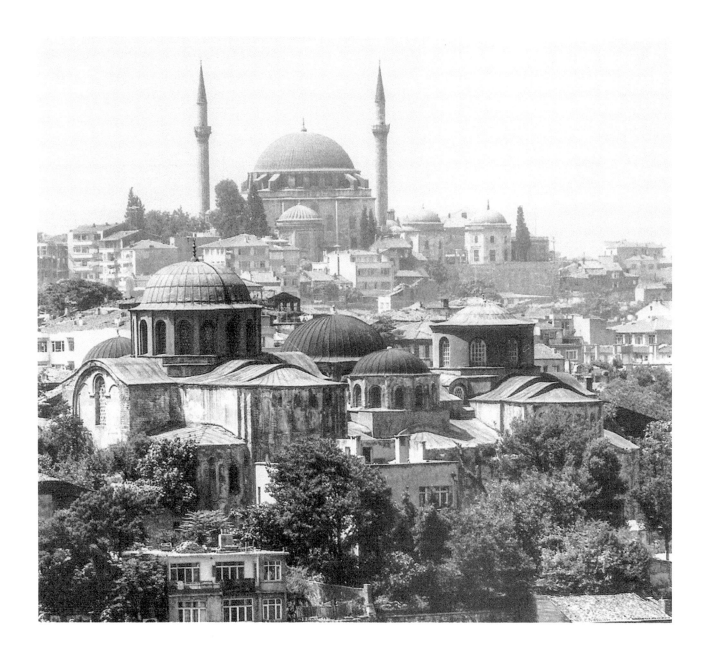

FIG. 13.25.
View of the Zeyrek
Camii complex and
Fatih Camii complex,
seen from the east,
ca. 1970 (T. F.
Mathews, ICFA)

of the church complex visible above the walls of the monastery.

Viewed from the east today, from the Süleymaniye, the dome of the Fatih Camii, preceded by the domed mausoleum of Mehmed II, rises above the multiple domes of the Zeyrek Camii. The two complexes seem to merge visually (fig. 13.25). This must have been the case in the Byzantine period as well, with the five domes of the Holy Apostles on the skyline, preceded by the domes of Constantine's mausoleum and the church of All Saints, cascading toward the domes of the Pantokrator. Of the Komnenian foundations, the Pantokrator lay closest to the Holy Apostles.[76] Perhaps more importantly, no other Komnenian complex connected *visually* to the Apostoleion in such a dramatic fashion. Indeed, the visual relationship of the two emphasized the urban character of the Pantokrator.

The jumble of domes and disparate building components surely meant something to the Byzantine viewer, identifying the site as significant, a place where many things happened. In short, complexity rather than monumentality would have been the dominant visual impression of both buildings, with the exterior view perhaps

76 Magdalino, "Foundation," 43.

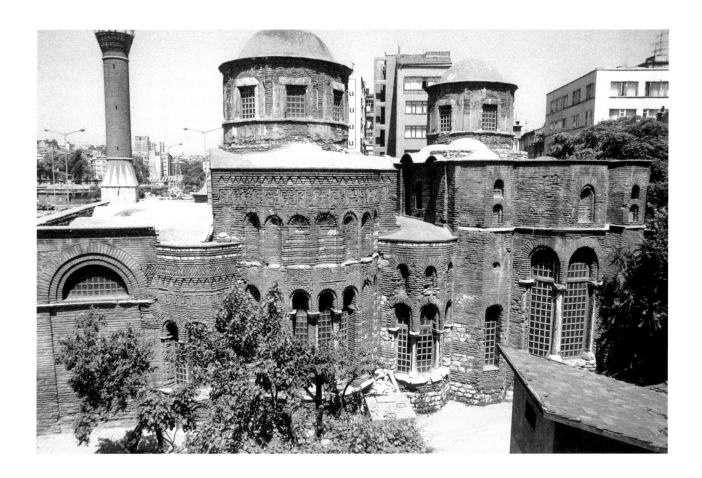

more important than the interior. Indeed, both were urban buildings, bound to the urban matrix by porticoes and processions, visible symbols of imperial presence.

As I have discussed elsewhere, in its final form, the complex design of the Pantokrator complex lay behind the construction of several of the later Byzantine imperial and aristocratic burial churches.[77] Perhaps most important of these was the Monastery *tou Libos*, constructed below the Holy Apostles to the west, joining the ring of Komnenian foundations around it, and consciously following the church cluster plan developed at the Pantokrator, with the south church added to serve as a grand mausoleum for the immediate family of Michael VIII Palaiologos (fig. 13.26).[78] However, it is never

referred to as a *heroon*—and for good reason: no heroes were involved in its construction. The monastery had been refounded by Theodora, the widow of Michael VIII, while the emperor himself had been a usurper to the throne who had died in disgrace as a heretic and was not accorded an Orthodox burial.[79] Their son Andronikos II, who was buried in the church and was Orthodox, was an unqualified disaster on the battlefield.[80] The Monastery *tou Libos* is diminished both in scale and significance.

Instead, if there is a link to follow back to the Holy Apostles, it may be through the piety of the empress. Both manly virtue and

FIG. 13.26.
View of the Monastery of the Theotokos *tou Libos* (Fenari İsa Camii), from the southeast (photo by author)

77 R. Ousterhout, *The Architecture of the Kariye Camii in Istanbul*, DOS 24 (Washington, DC, 1986), 95 and n. 11.

78 V. Marinis, "Tombs and Burials in the Monastery *tou Libos* in Constantinople," *DOP* 63 (2009): 147–66; A.-M. Talbot, "Empress Theodora Palaiologina, Wife of Michael VIII," *DOP* 46 (1992): 295–303; "Lips: Typikon of Theodora Palaiologina for the Convent of Lips in Constantinople," trans. A.-M. Talbot, in *BMFD* 3:1254–86.

79 Talbot, "Empress Theodora," 297; D. Geanakoplos, *Emperor Michael Palaeologus and the West, 1258–1282* (Cambridge, MA, 1959).

80 Pachymeres 6.20–21, *Georges Pachymérès. Relations historiques*, 2 vols. (Paris, 1984), ed. A. Failler, 2:591–99; A. Laiou, *Constantinople and the Latins: The Foreign Policy of Andronicus II, 1282–1328* (Cambridge, MA, 1972), esp. 24–25.

feminine piety are asserted in the *Typikon* of the Kecharitomene monastery, written by John's mother Eirene Doukaina, and the texts related to the Pantokrator follow suit.[81] The *Enkainia* epigram for the Pantokrator includes a prayer for imperial victory, and both Magdalino and I have argued that the *heroon* at the Pantokrator stood as a victory monument.[82] While the Palaiologan period could boast of few such heroes as those buried in the Apostoleion, the memory of past glories persisted. Indeed, it must have been this sort of meaning associated with the Apostoleion that ultimately led Fatih Mehmed to appropriate it to his own ends—and that led to its ultimate destruction.[83]

81 P. Gautier, "Le typikon de la Théotokos Kécharitôménè," *REB* 43 (1985): 5–167, trans. R. Jordan, in *BMFD* 2:664–711.

82 Magdalino, "Foundation," 45.

83 S. Vryonis, "Byzantine Constantinople and Ottoman Istanbul: Evolution in a Millennial Imperial Iconography," in *The Ottoman City and Its Parts: Urban Structure and Social Order*, ed. I. A. Bierman, R. A. Abou-El-Haj, and D. Preziosi (New Rochelle, 1991), 13–52; Ç. Kafescioğlu, *Constantinopolis/ Istanbul: Cultural Encounter, Imperial Vision, and the Construction of the Ottoman Capital* (University Park, PA, 2009), 66–85; and the paper by Julian Raby in this volume.

GENNADIOS SCHOLARIOS AND THE PATRIARCHATE

A Reluctant Patriarch on the "Unhappy Throne"

NEVRA NECIPOĞLU

*T*HE RESTORATION OF THE ORTHODOX PATRIARCHATE BY SULTAN Mehmed II shortly after his conquest of Constantinople was a major landmark in the transition from Byzantine to Ottoman rule. The first patriarch to be appointed by an Ottoman sultan, Gennadios Scholarios acted as the religious leader of the Greek Orthodox community during the turbulent years between 1454 and 1456, based initially at the church of the Holy Apostles, which, due to the conversion of Hagia Sophia into the royal mosque of the city immediately after the conquest, became the new seat of the patriarchate. Less than ten months later, Gennadios, allegedly finding the vicinity of the Holy Apostles uninhabited by Christians and unsafe, and demanding, therefore, to be relocated, moved to the monastery of Pammakaristos, which would serve as the second seat of the patriarchate in Ottoman Istanbul until the conversion of its church into the Fethiye mosque in the late sixteenth century. As for the church of the Holy Apostles, about a decade after its abandonment, Mehmed II ordered it to be demolished and had his New Mosque constructed on its site between 1463 and 1470.

Gennadios Scholarios may be considered among the most important representatives and symbols of the transition from the Byzantine to the Ottoman political order, as a person who had been born circa 1400 a Byzantine subject but died in about 1472 an Ottoman subject, and, like many other Byzantines of his generation, his life also intersected with the Latin world.[1] As is well known, his baptismal name was George, and during 1438–1439 he attended the Council of Ferrara-Florence as the secretary (*grammatikos*) of the emperor John VIII, at which time he supported the Union of the Churches. He knew Latin well and admired Thomas Aquinas; he translated and wrote commentaries on several of his works. In the earlier part of the 1430s, he had even considered moving to Italy, in particular to Rome, but decided to stay in his native city of Constantinople when he was finally able to secure a good position at the Byzantine imperial court. Besides serving as imperial secretary, Scholarios held other official posts, including that of "judge general of the Romans" (*katholikos krites ton Rhomaion*) and court preacher, and also worked as a teacher (*didaskalos*) both in private and public capacities.[2] In about 1444, in large part owing to disillusionment caused by the failure of the crusade of Varna

1 For the most recent monograph on Scholarios, see M.-H. Blanchet, *Georges-Gennadios Scholarios (vers 1400–vers 1472): Un intellectuel orthodoxe face à la disparition de l'Empire byzantin* (Paris, 2008). For other works on him, see also the references cited in note 8, below.

2 Before becoming *grammatikos* (ca. 1436/37), Scholarios had considered moving not only to Italy but also to the Peloponnese and, possibly, to the Genoese-ruled island of Lesbos. See Blanchet, *Scholarios*, 300–310. In the 15th century, *grammatikos* was a prestigious position that included the additional responsibility of acting as the emperor's personal advisor: ibid., 309–10; N. Oikonomidès,

against the Ottomans, he changed his position with regard to the Union of the Churches, and, following the death of his teacher and anti-unionist leader Mark Eugenikos in June 1445, he became the leader of the anti-unionists in Constantinople. Under Scholarios's leadership, the anti-unionist group was transformed within the next two years into a strongly crystallized and well-structured faction bearing institutional traits—that is, the so-called *synaxis,* which has been described as a "parallel Church" in a recent monograph.[3] In 1449/50 Scholarios moved into the Charsianeites monastery of Constantinople, where he took monastic vows and adopted the name Gennadios, henceforth becoming more radical in his resistance to the Union now that he was no longer officially attached to the imperial court.[4] On the day after the fall of Constantinople on 29 May 1453, he was taken captive together with his nephew Theodore Sophianos and carried off to the environs of the Ottoman capital Edirne (Adrianople), where he temporarily remained in the household of his master, an Ottoman military official, until certain Greek advisors at Mehmed II's court recommended him to the sultan, who must have been already contemplating the reestablishment of the Orthodox patriarchate in his newly conquered city, as a candidate for the patriarchal throne. Probably in the early fall of 1453, Scholarios returned to Constantinople in the company of Mehmed II, his new master, who liberated him sometime either prior to or after their arrival in the city, but certainly before 6 January 1454, when Scholarios assumed the patriarchal office as Gennadios II.[5]

It may be pertinent to recall that the patriarchal throne had been practically vacant during the final years of Byzantine rule in Constantinople, given that the unionist patriarch Gregory III Mammas, pressured by anti-unionist opposition, had left the Byzantine capital and taken refuge in Rome in the summer of 1450 or 1451.[6]

Ever since the publication of his complete works in eight volumes between 1928 and 1936,[7] modern literature on George-Gennadios Scholarios has been steadily growing. Particularly from the 1960s onward, he began to attract much greater scholarly attention that led to a proliferation of studies devoted to him, culminating in Marie-Hélène Blanchet's magisterial biography published in 2008.[8] Blanchet's book, to which the present paper is heavily indebted, has done much to challenge various misconceptions regarding Scholarios's controversial career both before and

"La chancellerie impériale de Byzance du 13e au 15e siècle," *REB* 43 (1985): 170–72. For Scholarios's other official functions, see Blanchet, *Scholarios,* 316–21.

3 Ibid., 414–19.

4 Ibid., 424–25. Scholarios had chosen to live in a monastic environment already as a layman, residing in the Pantokrator monastery from an unknown date, possibly prior to the Council of Ferrara-Florence, until his move to the Charsianeites.

5 For an accurate reconstruction of the events between Gennadios's capture and his elevation to the patriarchal throne, with a detailed analysis of the relevant contemporary sources, see Blanchet, *Scholarios,* 68–84. On his liberation, see also M.-H. Blanchet, "L'ambiguïté du statut juridique de Gennadios Scholarios après la chute de Constantinople (1453)," in *Le Patriarcat œcuménique de Constantinople aux XIVᵉ–XVIᵉ siècles: Rupture et continuité* (Paris, 2007), 202–11. The date for Gennadios's assumption of the patriarchal office is based on a

passage in his second pastoral letter of October 1454, quoted below, 244.

6 On controversies regarding the date and circumstances of Gregory Mammas's departure from Constantinople, see Blanchet, *Scholarios,* 428–30.

7 *Œuvres complètes de Gennade Scholarios,* ed. L. Petit, X. A. Sidéridès, and M. Jugie, 8 vols. (Paris, 1928–36) [hereafter, Scholarios, *Œuvres*].

8 See especially J. Gill, *Personalities of the Council of Florence and Other Essays* (Oxford, 1964), 79–94; C. J. G. Turner, "George-Gennadius Scholarius and the Union of Florence," *JTS,* n.s., 18 (1967): 83–103; idem, "The Career of George-Gennadius Scholarius," *Byzantion* 39 (1969): 420–55; idem, "The First Patriarchate of Gennadios II Scholarios as Reflected in a Pastoral Letter," in *From Arabye to Engelond: Medieval Studies in Honour of Mahmoud Manzalaoui on His 75th Birthday,* ed. A. E. C. Canitz and G. R. Wieland (Ottawa, 1999), 25–38; A. Papadakis, "Gennadius II and Mehmet the Conqueror," *Byzantion* 42 (1972): 88–106; S. Vryonis, Jr., "The 'Freedom of Expression' in Fifteenth Century Byzantium," in *La notion de liberté au Moyen Age: Islam, Byzance, Occident,* ed. G. Makdisi (Paris, 1985), 261–73; idem, "The Byzantine Patriarchate and Turkish Islam," *BSl* 57, no. 1 (1996): 82–111; T. Zeses, Γεννάδιος Βʹ Σχολάριος: Βίος, συγγράμματα, διδασκαλία (Thessalonike, 1980; 2nd ed., 1988); A. D. Angelou, "Ὁ Γεννάδιος Σχολάριος καὶ ἡ Ἅλωση," in *Ἡ Ἅλωση τῆς Πόλης,* ed. E. Chrysos (Athens, 1994), 99–132; idem, "'Who am I?' Scholarios' Answers and the Hellenic Identity," in *ΦΙΛΕΛΛΗΝ: Studies in Honour of Robert Browning,* ed. C. N. Constantinides et al. (Venice, 1996), 1–19; E. Zachariadou, "Les notables laïques et le Patriarcat œcuménique après la chute de Constantinople," *Turcica* 30 (1998): 119–33; F. Tinnefeld, "Georgios Gennadios Scholarios," in *La théologie byzantine et sa tradition,* vol. 2, *XIIIᵉ–XIXᵉ s.,* ed. C. G. and V. Conticello (Turnhout, 2002), 477–549; C. Livanos, *Greek Tradition and Latin Influence in the Work of George Scholarios* (Piscataway, NJ, 2006); Blanchet, *Scholarios.*

after 1453, and has shed light on many aspects of his life that had for long remained obscure, enigmatic, or unexplored. For example, Blanchet has forcefully argued that Gennadios Scholarios served as patriarch only once, from 6 January 1454 until January 1456, and not three times as it long used to be held (with a second patriarchate generally ascribed to him during April–May 1463, and a third one during 1464–65).[9]

Nevertheless, despite all that has been written about Gennadios, the exact circumstances under which he was installed as patriarch at the church of the Holy Apostles on 6 January 1454 and why merely six to ten months later the patriarchate was transferred from the Holy Apostles to the Pammakaristos still remain obscure. Other related questions arise as well. What were the physical state and use of the church of the Holy Apostles during the first seven months that transpired between the city's conquest and Gennadios's assumption of the patriarchal office? Was it Gennadios himself who requested the removal of the patriarchate from the Holy Apostles to the Pammakaristos, as sixteenth-century and later sources claim, or was this rather forced upon him by Mehmed II? What became of the Holy Apostles during the years in between its abandonment and its demolition for the construction of the sultan's New Mosque on the same site?

Such questions are unfortunately hard to answer because the available contemporary sources offer either little or no direct evidence. Of the four so-called Greek historians of the Fall, writing in the second half of the fifteenth century, Sphrantzes, Chalkokondyles, and Doukas are completely silent on the reestablishment of the patriarchate, while Kritoboulos of Imbros, in his history dedicated to Mehmed II, provides a relatively detailed account of the patriarchate's restoration, which nonetheless falls short of answering our questions.[10] After relating the discovery of Gennadios as the captive of an Ottoman notable near Adrianople, his first encounter with the sultan, and his return to Constantinople in the fall of 1453, Kritoboulos states that Mehmed II in the end appointed Gennadios patriarch, granting him "together with many other things, the rule of the Church, and the rest of the power and authority, not any less than those which it [the Church] formerly had from the emperors."[11] Yet, concerning the grant of the church of the Holy Apostles and the Pammakaristos to Gennadios as successive patriarchal seats, Kritoboulos disappointingly says nothing explicit but simply notes in general terms that Mehmed II restored the Church to the Christians "together with much property," a statement which certainly includes but is not restricted to the two churches that successively served as patriarchal seats.[12] Like Kritoboulos, the Ottoman chronicler Tursun Beg is another contemporary and a personal witness to Mehmed II's reign, but he passes in total silence the reestablishment of the patriarchate; nor does he ever refer to the church of the Holy Apostles,

9 The argument that Gennadios was patriarch only once, first suggested briefly by Zeses, Γεννάδιος Β΄ Σχολάριος, 194–96, and P. Konortas, "Les rapports juridiques et politiques entre le patriarcat orthodoxe de Constantinople et l'administration ottomane de 1453 à 1600" (PhD diss., Université Paris I, 1985), 443, has gained wide acceptance since its elaboration by M.-H. Blanchet, "Georges Gennadios Scholarios a-t-il été trois fois patriarche de Constantinople?" Byzantion 71 (2001): 60–72; eadem, Scholarios, 212–15, 220–23, 468–69. On Gennadios's disputed second and third patriarchates, with their most frequently cited chronology, see V. Laurent, "Les premiers patriarches de Constantinople sous domination turque (1454–1476)," REB 26 (1968): 243–45, 249–52. It must be noted that the number of times Gennadios served as patriarch is still debated: see D. G. Apostolopoulos and M. Païzi-Apostolopoulou, Οι πράξεις του Πατριαρχείου Κωνσταντινουπόλεως: επιτομή–παράδοση–σχολιασμός. I: 1454–1498 (Athens, 2013), 26–28, 31–32.

10 For a brief analysis of these four historians' narratives of Mehmed II's reign, see D. R. Reinsch, "Mehmed der Eroberer in der Darstellung der zeitgenössischen byzantinischen Geschichtsschreiber," in Sultan Mehmet II.: Eroberer Konstantinopels—Patron der Künste, ed. N. Asutay-Effenberger and U. Rehm (Cologne, Weimar, and Vienna, 2009), 15–30. On Kritoboulos, see also idem, "Kritobulos of Imbros—Learned Historian, Ottoman Raya and Byzantine Patriot," ZRVI 40 (2003): 297–308.

11 D. R. Reinsch, ed., Critobuli Imbriotae Historiae, CFHB 22 (Berlin and New York, 1983), 90–91.

12 Reinsch, ed., Critobuli Imbriotae Historiae, 91. The property restored to the patriarchate would have included some other churches and monasteries in the city, along with their dependencies. Later in his narrative, when relating Mehmed II's plans for the construction of his mosque, Kritoboulos again makes no mention of the Holy Apostles, stating only that the sultan chose for it "the best site in the middle of the city," even though his additional remark that Mehmed intended the mosque to "compete with the largest and finest temples existing in the city" alludes no doubt, besides the Hagia Sophia, to the Holy Apostles. See ibid., 132.

even though he is one of the main sources for the mosque complex built by the sultan on its site.[13]

It is, in fact, not a contemporary source but the sixteenth-century anonymous compilation known as the *Ekthesis Chronike* that provides the first detailed account of the events surrounding the abandonment of the church of the Holy Apostles and the relocation of the patriarchate to the Pammakaristos shortly after Gennadios's installation as patriarch:

> [Mehmed II] also gave him [Gennadios] the famous church of the Holy Apostles for his Patriarchate. While the patriarch was there, a murdered man was found in the middle of the church's courtyard; so the patriarch and his staff began to fear in case they, too, would suffer a similar fate; thus they abandoned that wonderful church. At that time the area around that church had no houses and there were no neighbors in the vicinity.... They left that region and asked for the monastery of Pammakaristos to become the Patriarchate; he granted it in one word. They asked for this church because its neighborhood was inhabited by the Christians who had been brought as *sürgün* from all cities.[14]

According to this passage, then, two interrelated factors—fear induced by a corpse found in the courtyard of the Holy Apostles and the deserted state of the environs of the church—compelled Gennadios to request that the patriarchate be moved from there to the

Pammakaristos, which stood in an area that our source claims already contained a visible Orthodox community in 1454 made up of people who had been forcefully deported (*sergounides*) by Mehmed II to the newly conquered city. Variants of this passage, embellished with additional details, also appear in later sixteenth-century chronicles emanating from a patriarchal milieu.[15] In the chronicle of Pseudo-Sphrantzes (Makarios Melissourgos-Melissenos), for example, an ethno-religious identity is ascribed to the murdered man who thus becomes a Muslim/Turk (*Agarenos*), while the Christian deportees, who are specified as originating from Kaffa, Trebizond, Sinope, and Asprokastron, are no longer mentioned with particular reference to the neighborhood of the Pammakaristos in 1454 but with general reference to the city somewhat later (*met' oligon*), given that none of these places had yet been conquered by the Ottomans in 1454.[16] Studies on the sixteenth-century and later patriarchal chronicles have in fact observed that these sources reflect the biased and distorted views of the Orthodox clergy and should be used with caution for the events of the second half of the fifteenth century, which they present in anachronistic terms according to how they wanted to see the position of the Church rather than how it really was at the time.[17] Thus, even the account found in its purest form in the *Ekthesis Chronike* passage quoted above, dating from the early

13 For Tursun Beg's account, which on the other hand emphasizes the mosque's architectural associations with the Hagia Sophia, see *The History of Mehmed the Conqueror by Tursun Beg*, ed. H. İnalcık and R. Murphey (Minneapolis, 1978), fols. 53r–63v, esp. 56r–60r. On the mosque complex, its representations in Ottoman written sources, and its particular relationship to the Hagia Sophia and the Holy Apostles, see most recently G. Necipoğlu, *The Age of Sinan: Architectural Culture in the Ottoman Empire* (London, 2005), 83–88; Ç. Kafescioğlu, *Constantinopolis/Istanbul: Cultural Encounter, Imperial Vision, and the Construction of the Ottoman Capital* (University Park, PA, 2009), 66–96; and Julian Raby's article in the present volume.

14 S. P. Lampros, ed., *Ecthesis Chronica and Chronicon Athenarum* (London, 1902), 19; M. Philippides, ed. and trans., *Emperors, Patriarchs, and Sultans of Constantinople, 1373–1513: An Anonymous Greek Chronicle of the Sixteenth Century* (Brookline, MA, 1990), 56–57. I offer here a slightly altered version of Philippides' translation.

15 E.g., the so-called *Historia politica* and *Historia patriarchica,* both inserted into the *Turcograecia* of Martin Crusius, the so-called *Chronicon maius* of Pseudo-Sphrantzes (Makarios Melissourgos-Melissenos), etc. On these sources, see E. A. Zachariadou, Δέκα τουρκικὰ ἔγγραφα γιὰ τὴ Μεγάλη Ἐκκλησία (1483–1567) (Athens, 1996), 42–46; P. Schreiner, "Die Epoche Mehmets des Eroberers in zeitgenössischen Quellen aus dem Patriarchat," in *Sultan Mehmet II.,* ed. Asutay-Effenberger and Rehm, 31–40. For a comparison of the quoted passage from the *Ekthesis Chronike* with relevant passages from some of the later chronicles, see M. Philippides and W. K. Hanak, *The Siege and the Fall of Constantinople in 1453: Historiography, Topography, and Military Studies* (Farnham, 2011), 59–64.

16 *Macarie Melissenos, Cronica, 1258–1481,* 3.13, in *Georgios Sphrantzes, Memorii, 1401–1477,* ed. V. Grecu (Bucharest, 1966).

17 B. Braude, "Foundation Myths of the *Millet* System," in *Christians and Jews in the Ottoman Empire: The Functioning of a Plural Society,* ed. B. Braude and B. Lewis, 2 vols. (New York, 1982), 1:74–77; Vryonis, "Byzantine Patriarchate," 85–88; E. A. Zachariadou, "The Great Church in Captivity 1453–1586," in *The Cambridge History of Christianity,* vol. 5, *Eastern Christianity,* ed. M. Angold (Cambridge, 2006), 172.

decades of the sixteenth century, is of questionable reliability.

A crucial matter to consider in this respect is whether the actual request for the patriarchate's removal from the Holy Apostles came from Gennadios himself. Some scholars, elaborating upon the reference to the murdered man in the patriarchal chronicles, have assumed that the corpse was planted in the church's courtyard by a largely Muslim local population that was hostile to Christians and resented the presence of the patriarchal institution in the area.[18] Yet the existence of a sizable Turkish population there in 1454, which is not supported by any other source, cannot be inferred from the passage above or its later variants that only refer to the lack of houses and inhabitants (i.e., Christians) in this region. Therefore, rather than local hostility, what pushed Gennadios and his staff out of the Holy Apostles may well have been a direct interference on the part of Mehmed II, which the sixteenth-century sources, composed in order to praise the sultan's magnanimity toward the patriarchal institution and to emphasize his good relations with Gennadios, were likely to gloss over. It is thus not inconceivable that the murdered man—if indeed he is real and not a fabrication of the later sources—was planted there by the order of the sultan, who must have had second thoughts about his initial grant of the Holy Apostles to the patriarchate. The reasons for Mehmed II's possible change of mind are not difficult to surmise. Standing prominently on top of the city's highest hill, Holy Apostles was the second largest church and second most important religious symbol of the Byzantine Empire after Hagia Sophia. It was also an important political symbol of the city's Byzantine imperial heritage, with its two mausolea housing the remains of Constantine the Great and Justinian I, its founder and rebuilder, respectively, along with the tombs of most other pre-eleventh-century emperors. Mehmed II, extremely concerned right after the conquest of Constantinople about attracting former Byzantine inhabitants to the depopulated city,

and perhaps not sufficiently aware at this time of the symbolic significance of the Holy Apostles, had ceded the church to Gennadios upon reestablishing the patriarchate primarily as a measure to alleviate the population shortage.[19] Several months later, however, he must have come to realize that the church was too weighted in political and religious symbolism and too visible to be allowed to function as the main religious organ of a non-Muslim community within Ottoman Istanbul. By comparison, the church of St. Mary Pammakaristos, located at a distance from the center of the city, was a less important and much less pretentious monument that did not have the symbolic religious or political associations of the Holy Apostles. As such, it was more in line with the modest scale at which Mehmed II presumably intended to maintain the patriarchal institution, which by its very existence would serve his purpose of encouraging Orthodox inhabitants to resettle in the city.

As reasonable as these speculations seem, we cannot entirely discard the possibility that in 1454 Gennadios himself may have requested the patriarchate's transfer to the Pammakaristos. But instead of the reasons given in the *Ekthesis Chronike*, he might have been prompted by other factors to make this request. Could it perhaps not have been that the church of the Holy Apostles was too big or too dilapidated, and thus beyond the means of the patriarchal administration and the Orthodox community to maintain?

18 S. Runciman, *The Great Church in Captivity* (Cambridge, 1968), 184; Blanchet, *Scholarios*, 94. Cf. M. Angold, *The Fall of Constantinople to the Ottomans: Context and Consequences* (London, 2012), 71.

19 This motive is explicitly stated by the patriarchal official Theodore Agallianos in a discourse dated ca. 1463: C. G. Patrineles, ed., Ὁ Θεόδωρος Ἀγαλλιανὸς ταυτιζόμενος πρὸς τὸν Θεοφάνην Μηδείας καὶ οἱ ἀνέκδοτοι λόγοι του (Athens, 1966), 98. The early 16th-century *Ekthesis Chronike* also connects the reestablishment of the patriarchate with Mehmed II's desire to repopulate the city: Lampros, *Ecthesis Chronica*, 18–19; Philippides, *Emperors, Patriarchs, and Sultans*, 56–57. The contemporary chroniclers Kritoboulos, Doukas, Tursun Beg, and Aşıkpaşazade recount the sultan's efforts to repopulate the city but do not suggest a link with the patriarchate's restoration. On the city's repopulation, see H. İnalcık, "The Policy of Mehmed II toward the Greek Population of Istanbul and the Byzantine Buildings of the City," *DOP* 23–24 (1969–1970): 231–49; E. A. Zachariadou, "Constantinople se repeuple," in *1453: Ἡ ἅλωση τῆς Κωνσταντινούπολης καὶ ἡ μετάβαση ἀπὸ τοὺς μεσαιωνικοὺς στοὺς νεώτερους χρόνους*, ed. T. Kiousopoulou (Heraklion, 2005), 47–59; S. Yerasimos, "Les Grecs d'Istanbul après la conquête ottomane: Le repeuplement de la ville et de ses environs (1453–1550)," *Revue des mondes musulmans et de la Méditerranée* 107–110 (2005): 375–99.

Significant in this respect is the Florentine traveler Cristoforo Buondelmonti's description of the Holy Apostles as ruined already in 1422, that is, about thirty years before the fall of Constantinople to the Ottomans.[20] As early as the first half of the thirteenth century, during an earthquake that took place while the city was under Latin rule, the church had suffered such heavy damage that it was spared from collapse through the intervention of the Nicaean emperor John III Vatatzes (r. 1222–54), who donated a large sum of money to the Latins for its restoration.[21] Further repairs in the early Palaiologan period, undertaken with the sponsorship of the emperors Michael VIII (r. 1259–82)[22] and Andronikos II (r. 1282–1328),[23] respectively, suggest that its condition must have continued to deteriorate. Yet, despite such evidence of physical decay, the particular interest these emperors took in the Holy Apostles, combined with Michael VIII's choice of the space in front of it as the site for his column topped by a kneeling bronze statue of himself offering a model of Constantinople to the archangel Michael,[24] indicate that the church maintained its strong symbolic role in the restored Byzantine capital. In the later Palaiologan period, on the other hand, there is evidence of two important synod meetings that were held at the Holy Apostles on the occasion of the election of patriarchs Joseph II (in 1416) and Metrophanes II (in 1440).[25]

Bearing in mind these details regarding the state and role of the Holy Apostles in the late Byzantine period, we must now turn to Gennadios Scholarios's writings postdating 1453, which constitute our chief contemporary literary sources, besides Kritoboulos's history, for the years immediately following the Ottoman conquest, for evidence in support of the speculative arguments offered in the preceding pages or for answers to the questions raised above. Indeed, in the titles of two works by Gennadios, we do find, respectively, a confirmation about the use of the Holy Apostles as the initial seat of the patriarchate (otherwise mentioned only in the later patriarchal chronicles) and a clue that allows us to date the patriarchate's transfer to the Pammakaristos more or less precisely to the early fall of 1454. The first of these works is an undated public prayer, which contains a note at its beginning stating that "he read this prayer to the people during his patriarchate after his [celebration of the] liturgy in the church of the Apostles."[26] The second work is Gennadios's famous "Pastoral Letter on the Fall of Constantinople," the autograph title of which specifies that it was written at the monastery of Pammakaristos. This letter does not bear a date, but since Gennadios seems to refer to it in a subsequent pastoral letter, which is datable on the basis of internal evidence to October 1454, we can be almost sure that the patriarchate had been moved from the Holy Apostles to the Pammakaristos shortly before October 1454, hence in the late summer or early fall of 1454.[27] Yet, apart from these references, no further direct information is to be found among the writings of Gennadios about the two churches with which we are concerned or their neighborhoods.

On the other hand, Gennadios does offer some descriptions of postconquest Constantinople with vague references and allusions to the state of the city's churches and monasteries,

20 *Description des îles de l'Archipel grec par Christophe Buondelmonti*, ed. E. Legrand (Paris, 1897), 88; G. Gerola, "Le vedute di Costantinopoli di Cristoforo Buondelmonti," *SBN* 3 (1931): 276.

21 A.-M. Talbot, "The Restoration of Constantinople under Michael VIII," *DOP* 47 (1993): 248; V. Kidonopoulos, *Bauten in Konstantinopel 1204–1328* (Wiesbaden, 1994), 100, 102; idem, "The Urban Physiognomy of Constantinople from the Latin Conquest through the Palaiologan Era," in *Byzantium: Faith and Power (1261–1557); Perspectives on Late Byzantine Art and Culture*, ed. S. T. Brooks (New York, 2006), 101.

22 Talbot, "Restoration," 254.

23 Kidonopoulos, *Bauten*, 100–102; idem, "Urban Physiognomy," 71; A.-M. Talbot, "Building Activity in Constantinople under Andronikos II: The Role of Women Patrons in the Construction and Restoration of Monasteries," in *Byzantine Constantinople: Monuments, Topography and Everyday Life*, ed. N. Necipoğlu (Leiden, Boston, and Cologne, 2001), 330.

24 On Michael VIII's column and its bronze statue group, commissioned by the emperor in order to commemorate his restoration of the Byzantine capital in 1261, see Talbot, "Restoration," 258–60; G. P. Majeska, *Russian Travelers to Constantinople in the Fourteenth and Fifteenth Centuries* (Washington, DC, 1984), 306.

25 *Les "Mémoires" du Grand Ecclésiarque de l'Église de Constantinople Sylvestre Syropoulos sur le concile de Florence (1438–1439)*, ed. and trans. V. Laurent (Paris, 1971), 102–5, 550–51.

26 Scholarios, *Œuvres*, 4:352; cf. Blanchet, *Scholarios*, 124 and n. 3.

27 Scholarios, *Œuvres*, 4:211, 231; cf. Blanchet, *Scholarios*, 94n50, 496.

which are useful for giving us a firsthand glimpse of the general physical conditions prevailing in the city during his years as patriarch, even if not about the church of the Holy Apostles itself. In his aforementioned "Pastoral Letter on the Fall of Constantinople," Gennadios writes that upon returning from Adrianople/Edirne to Constantinople/Istanbul in the company of Mehmed II (in the late summer or early fall of 1453), he found the city "in greater misfortune" than when he had left it as a captive.[28] He goes on to relate that before being raised to the patriarchal office he was given charge of a monastery that was in a plundered and deserted state, which unfortunately he does not identify. He describes his efforts to rehabilitate this monastery and ransom its monks as follows: "I was ordered to rule a monastery which had been trampled under foot [plundered] and stripped of everything, and I became the liberator of those monks who would be my colleagues, without money."[29] Several scholars have proposed to identify this unnamed monastery as the Charsianeites, where, as stated above, Scholarios had taken monastic vows in 1449/50 and resided until 29 May 1453.[30] However, the harsh words Gennadios uses in the same passage to criticize the hypocrisy and dreadful conduct of the monks whom he helped liberate, which made them seem to him "more painful to stand than the barbarians," make this identification difficult to embrace. Leaving aside, therefore, the question of the monastery's identity, which remains uncertain, we turn to a letter written shortly after the fall of Constantinople

by a Greek official in Edirne, the *archon* Nicholas Isidoros, "judge (*krites*) and *emin*" of the sultan, that provides a precious clue as to how Gennadios was able to accomplish "without money" the task of ransoming this monastery's captive monks in accordance with Mehmed II's command. The letter informs us that Nicholas Isidoros had made a donation to an unidentified monastery and was in return requesting from "the *didaskalos* Scholarios" to be commemorated during its liturgical services.[31] From Isidoros's reference to Scholarios as *didaskalos,* it can be concluded that the letter was almost certainly written in the period before he was ordained patriarch, and the donation in question was, therefore, most likely to have been made to the pillaged and deserted monastery that Gennadios had been ordered to rehabilitate during the final months of 1453. Thus, it was probably with the money donated by Isidoros that Gennadios could ransom the abovementioned monks. Two letters addressed to this rich and influential Greek "judge and *emin*" of the sultan in Edirne reveal that he was in fact very actively involved in ransoming Byzantines—including priests, monks, and laymen—who had fallen captive in Constantinople in 1453.[32] It may also be true, as has often been suggested, that Nicholas Isidoros was one of the Greek notables who had recommended Gennadios to Mehmed II as a candidate for the patriarchal office while he was being held captive near Edirne.[33]

During the interval before his official enthronement as patriarch, Gennadios writes that he had also been required by the sultan to restore certain churches in Constantinople: "And then I was forced to build and to re-erect churches that had been destroyed."[34] It seems

28 Scholarios, *Œuvres*, 4:224.22–24. On Gennadios's use of the word δεσπότης to refer here to Mehmed II, see Blanchet, *Scholarios,* 71–72, n. 21 and 32.

29 Scholarios, *Œuvres*, 4:224.24–26. This is a slightly altered version of the translation in Vryonis, "Byzantine Patriarchate," 110. On this passage see also D. Tsourka-Papasthati, "À propos des privilèges octroyés par Mehmed II au patriarche Gennadios Scholarios: Mythes et réalités," in *Patriarcat œcuménique,* 257; M. Angold, "Memoirs, Confessions, and Apologies: The Last Chapter of Byzantine Autobiography," *BMGS* 37 (2013): 220.

30 For the identification, see Turner, "Career," 439; Zeses, Γεννάδιος Β′ Σχολάριος, 192; Tinnefeld, "Georgios Gennadios Scholarios," 489; Blanchet, *Scholarios,* 72–73, 75. On the Charsianeites monastery founded around the middle of the 14th century by a partisan of the emperor John VI Kantakouzenos, see R. Janin, *La géographie ecclésiastique de l'empire byzantin,* vol. 1, *Le siège de Constantinople et le patriarcat oecuménique,* pt. 3, *Les églises et les monastères,* 2nd ed. (Paris, 1969), 501–2; *BMFD,* 4:1625–66.

31 J. Darrouzès, "Lettres de 1453," *REB* 22 (1964): 101, 123.

32 Darrouzès, "Lettres," 80–81, 99. It may be noted that the first of these two letters gives Isidoros's title as "judge and grand *emin*." For a discussion of these titles and their possible meaning in the Ottoman administration, see T. Ganchou, "Le *prôtogéros* de Constantinople Laskaris Kanabès (1454): À propos d'une institution ottomane méconnue," *REB* 71 (2013): 227–31, 238, 253–56.

33 Laurent, "Premiers patriarches," 244; Zachariadou, "Notables laïques," 121; Blanchet, *Scholarios,* 75; Angold, *Fall of Constantinople,* 70.

34 Scholarios, *Œuvres*, 4:224.35–38; trans. Vryonis, "Byzantine Patriarchate," 110.

clear from all this that in the months leading up to his assumption of the patriarchal office, Gennadios was held responsible by Mehmed II for rebuilding as well as repopulating some of the ruined and deserted churches and monasteries in Constantinople and reestablishing some degree of order for the Orthodox Christians then present in the city. These were the first unofficial measures preceding the rebuilding and reorganization of the Greek Orthodox community around the patriarchate. Yet they were conceived within the framework and as part of Mehmed's overall program to rebuild and repopulate the newly conquered city. Perhaps in a minor way, they also echo the sultan's future order in 1458/59 to his grandees to undertake constructions of public and private buildings in the city at their own expense.[35]

A similar impression of postconquest Constantinople is conveyed by the first Ottoman survey of Istanbul, completed in December 1455.[36] This important document, which was published relatively recently in 2012, registers the buildings and population of Istanbul only two and a half years after its conquest by Mehmed II, while Gennadios Scholarios still served as patriarch at the Pammakaristos monastery. As Tursun Beg recounts in his *History*, the task of conducting the survey was entrusted by the sultan to Cebe (Cübbe) Ali Beg, the then governor of Bursa, and Tursun, who was his relative, personally took part in the survey as the scribe, going around the city quarter by quarter and recording the information.[37] Although one would have hoped to find new evidence relating to the church of the Holy Apostles or to the Pammakaristos in this document, unfortunately no information is available on them. This is presumably because only those buildings that were made state property and allocated to the Ottoman treasury were registered in it, whereas the church and monastery in question must have been allocated to the patriarchate and therefore may be assumed to have escaped being registered. It must also be taken

into account, however, that the survey is not intact in the form it has come down to us, and, although less likely, the two monuments we are concerned with may have been registered in the missing parts of the document.[38]

Nonetheless, the survey of 1455 is still of interest to us, first, because of the general image of ruin and desolation it conveys, which closely corresponds to the impression imparted by Gennadios Scholarios's writings, and second, and even more important, because it reports on the conditions of many specific churches and monasteries within the walled city which, with few exceptions, are registered mostly as unoccupied, ruined, or on the way to ruin.[39] Several of them, on the other hand, are seen to have been converted to nonreligious uses, serving as residences for Muslim or non-Muslim newcomers to the city, even including dervishes, or else being used for commercial or artisanal purposes.[40] Only one unidentified church and a building described as "a large sumptuous house called *drapez* by the Rumîs," no doubt the refectory of a monastery, are recorded as having been converted into quarter mosques (*mescid*), indicating that there was no desire at this time to convert Byzantine churches.[41] Thus we have both entirely original documentary evidence about the state of Constantinople in the initial years following the Ottoman conquest, as well as some pieces of evidence corroborating and confirming what we know from contemporary literary sources: for example, Kritoboulos writes about Mehmed's grant to his grandees of beautiful churches to be

35 Reinsch, ed., *Critobuli Imbriotae Historiae*, 131–32. See Kafescioğlu, *Constantinopolis/Istanbul*, 53–56.

36 H. İnalcık, *The Survey of Istanbul, 1455: The Text, English Translation, Analysis of the Text, Documents* (Istanbul, 2012).

37 Tursun Beg, *History*, ed. İnalcık and Murphey, fols. 55v–56r.

38 The survey consists of two sections, devoted respectively to Galata and Istanbul. The extant parts of the Istanbul section comprise 33 quarters (*mahalles*), while its missing parts include most notably the districts of Perama, Neorion, and Hagia Sophia. See İnalcık, *Survey of Istanbul*, ix, 4–7, 451–55.

39 For a summary table which gives an idea of the large number of unoccupied churches and monasteries within the city, see ibid., 371–74.

40 Ibid., 170, 179, 189, 195, 197, 211 (text); 308, 319, 332, 341, 345, 367 (trans.); etc.

41 These are located, respectively, in the quarters of Ral Karmir and Altı-Mermer (Eksi-Marmara): ibid., 193, 198 (text); 338, 347 (trans.). By the end of Mehmed II's reign, apart from the Hagia Sophia, only four major Byzantine churches within the walled city are known to have been converted for use as Muslim religious or charitable institutions: see Kafescioğlu, *Constantinopolis/Istanbul*, 22.

used as residences;[42] Doukas recounts how the Pantokrator monastery was occupied by fullers and its church used as a workshop by shoemakers, while the monastery of Mangana was taken over by dervishes (*tourkokalogeroi*), and the rest of the abandoned monasteries were inhabited by Turkish families.[43]

In fact, as stated above, one of Mehmed II's main motives for reestablishing the patriarchate was to repopulate Constantinople by way of encouraging the settlement of a considerable number of Greek Orthodox inhabitants.[44] The dramatic dislocation that took place in Constantinople after 1453 and the new patterns of settlement emerging in Mehmed II's Istanbul, for which the Ottoman survey of 1455 provides new documentary evidence, find literary expression in a discourse composed by Theodore Agallianos in 1463. An anti-unionist churchman who had fallen captive in Constantinople in 1453, Agallianos had ended up in Bursa, was ransomed shortly afterward, and went back to Constantinople in 1454 in the company of his longtime friend and associate Gennadios Scholarios, who promoted him to the position of *megas chartophylax* shortly after the restoration of the patriarchate. A decade after his return to Constantinople, Agallianos described it as follows:

> Now the City is no longer [as it used to be]. The traumatic transformation that we have experienced through God's mysterious judgements has produced confusion no less than that of the Tower of Babel. Nobody knows his neighbor. Somebody who once lived in one quarter of the City is now found in another and the same is true of the priests [who no longer know their flock].[45]

During his short tenure as the first Orthodox patriarch under Ottoman rule, Gennadios Scholarios was confronted with numerous challenges and problems. Rebuilding and reorganizing the Orthodox community around the restored patriarchate under the new social and political conditions was not an easy task. In a letter dated 1455 to Maximos Sophianos and the monks of Sinai, Gennadios summarized the novel situation after the fall of Constantinople as follows: "At present Christendom is as it was before Constantine, for now as then we have no empire, no free church, no freedom of speech (*parresia*)."[46] It is clear that Gennadios had no illusions about his or his Orthodox flock's state under Ottoman rule when he wrote this statement in 1455. It was a challenge for the Orthodox people to have to live in the absence of their own empire and their own emperor, but there was a historic precedent for this: namely, the pre-Constantinian church. Gennadios also admitted that he was the head of a church that was captive. For him, the only way of coming to terms with the new political situation was to focus on the defense and preservation of Orthodoxy, as his only remaining element of identity with continuity from his Byzantine past under the new political order. Preservation of Orthodoxy, then, was the main motivation for accepting to live as an Ottoman subject (and thereby the main justification for this choice as well). This was not an idea that was unique to Gennadios or even one that was entirely new in Byzantium. Back in 1387, when Thessalonike capitulated to the Ottomans, the city's archbishop Isidore Glabas had urged the inhabitants to be obedient to their new masters in the interest of keeping Orthodoxy "unstained."[47]

An interesting motif that is found in Gennadios's writings is that of the "reluctant patriarch." In apologetic fashion, Gennadios repeatedly states that he was constrained to

42 Reinsch, ed., *Critobuli Imbriotae Historiae*, 83.

43 V. Grecu, ed., *Ducae Historia Turcobyzantina (1341–1462)* (Bucharest, 1958), 399. Doukas also mentions here the use of lead tiles from abandoned monasteries as building materials for the roof of Mehmed II's first palace (Eski Saray) in the city.

44 See above, 239 and note 19.

45 Patrineles, Θεόδωρος Ἀγαλλιανός, 133; trans. M. Angold, "Theodore Agallianos: The Last Byzantine Autobiography," in *Constantinopla: 550 años de su caída; Constantinopla Bizantina*, ed. E. M. Guirao and M. M. Filactós (Granada, 2006), 42. On his return to the city together with Gennadios, see Patrineles, Θεόδωρος Ἀγαλλιανός, 98. On Agallianos, see also Angold, "Memoirs, Confessions, and Apologies," 222–25. The quoted

passage reflects the consequences of Mehmed II's policy of repeated forced settlements from newly acquired territories, particularly his massive deportations beginning with the campaigns into the Peloponnese in 1458 and including also those following the conquest of Trebizond in 1461.

46 Scholarios, *Œuvres*, 4:203.

47 N. Necipoğlu, *Byzantium between the Ottomans and the Latins: Politics and Society in the Late Empire* (Cambridge, 2009), 53.

become patriarch against his will, trying thereby to justify his assumption of the patriarchate under Ottoman rule. Both in his "Pastoral Letter on the Fall of Constantinople" and his later "Lament," composed in 1460, Gennadios wrote that he was kept on the "unhappy throne" against his will.[48] Regardless of the apologetic nature of these remarks, it is certain that Gennadios wanted to resign already before he had completed one year in patriarchal office. His wish to resign was related to a number of pastoral and administrative problems with which he had not been able to deal successfully, as we understand from the references he makes to his lack of means, pressures, scandals he had to regulate rapidly, rivalries against him, worries he confronted, the solitude he faced, the refugee problem and sufferings of his compatriots whom he could not help, his incorruptibility in handing out ecclesiastical posts (i.e., his resistance to simony), and people, including laymen, monks, even clergy, who passed or threatened to pass over to the impious (i.e., apostasy to Islam).[49] Moreover, he had opponents who were plotting against him and even against his life: "in return for our zeal on their behalf, they pay us back with chicane and deceit, even plotting against this wretched life."[50]

After an initial attempt, two months later, in October 1454, Gennadios repeated his wish to resign. In his second pastoral letter he wrote:

We have written to those who, with God, are able to release us from this burden, saying that we can no longer bear it and that they must consider the others so far as they can, for our work is coming to an end. Two months have passed since we gave them this

day as our limit. But on their advice we are willing to forego the limit; for they say, with reason, that it makes no difference if after two months I did the same, and the common good would be secured. Today is the beginning of the tenth month; and, if not sooner, the day of Epiphany, which last year gave me the rank of Archbishop, shall see us in a private capacity as a humble monk.[51]

But Gennadios ended up serving another year as patriarch, until January 1456.[52] We do not know whether possible tensions with Mehmed II or other Ottoman authorities might have played any role at all in his strong desire to resign. Based on what he has written, his greatest problem and conflicts rather had to do with his fellow Christians in Constantinople. The role played by factional rivalries among the Greek *archontes* at Mehmed II's court on the early evolution of the patriarchate in postconquest Constantinople has been minutely analyzed both by Elizabeth Zachariadou and Blanchet, and we need not go into them.[53]

In conclusion, much of this discussion has clearly led us away from the church of the Holy Apostles, yet it is hoped that the information provided in the course of it helps us understand better the man who spent the initial six to ten months of his relatively short but crucial patriarchate at a time of major transformation from Byzantine to Ottoman rule based at this church, and together with Mehmed II became instrumental in the continuity of an institution that still exists in our day.

48 Scholarios, *Œuvres*, 1:292; 4:225, 229.
49 Ibid., 4:225, 228; see also 3:388.
50 Ibid., 4:228; trans. Turner, "First Patriarchate," 34.
51 Scholarios, *Œuvres*, 4:233; trans. Turner, "First Patriarchate," 35.
52 For this date, see Blanchet, *Scholarios*, 202–4, 468–69.
53 Zachariadou, "Notables laïques," 119–34; Blanchet, *Scholarios*, 224–47.

FROM THE FOUNDER OF CONSTANTINOPLE TO THE FOUNDER OF ISTANBUL

Mehmed the Conqueror, Fatih Camii, and the Church of the Holy Apostles

JULIAN RABY

*T*HE MOSQUE OF MEHMED THE CONQUEROR IS THE FIRST OF THE GREAT imperial mosques founded after Mehmed's conquest of Constantinople in 1453. It is nowadays known as Fatih Camii, a name it acquired in the nineteenth century, but in Mehmed's days it was mostly known as the New Mosque (Cami-i Cedid) or sometimes as the Cami-i Ebu'l Feth. It stands on the top of one of the highest hills in the city and at the center of a vast esplanade ringed by attendant buildings that make it among the most extensive architectural complexes the Ottomans ever constructed. It thus held a preeminent position in physical, architectural, historical, and symbolic terms. Yet Fatih Camii has posed scholars a number of problems over the last century.

Some have largely been resolved, but one still looms large. At the outset, there is an issue that the Fatih Camii of today is not what was built in Mehmed's day. Mehmed's mosque was constructed in the 1460s, whereas the present mosque was largely rebuilt in a new form three hundred years later, following a devastating earthquake on 22 May 1766 (figs. 15.1 and 15.2). What we see now is not the mosque that helped define the aesthetics of Ottoman imperial mosque architecture but—from an age with a "baroque" aesthetic in architecture—a conscious revival of a classical idiom. It did not repeat the asymmetrical dome and single half-dome arrangement of Mehmed's original mosque. It introduced instead a quatrefoil plan used in imperial mosques in the sixteenth and seventeenth centuries. As Ünver Rüstem has described it: "For although the new Fatih Mosque had to look suitably old, it also had to look suitably graceful, a criterion unlikely to be met by emulating the outmoded works of the fifteenth century. This balance of age and elegance was instead sought in the influential sixteenth-century idiom of Sinan, an idiom whose ties with the empire's heyday made it appropriate—if anachronistically so— to Mehmed's memory."[1]

It was in the late 1920s and 1930s that Mehmed Aga-Oglu, drawing on a range of literary descriptions and early Ottoman and European visual depictions, established the outlines of the original

❧ I would like to thank Robert Ousterhout and Margaret Mullett for their many suggestions and their Job-like patience; Ken Dark, Walter Denny, and Robert Ousterhout for generously providing images; and Karl Gelles for his numerous drawings.

1 On the earthquake see D. Mazlum, *1766 Istanbul Depremi. Begeler Işığında Yapı Onarımları*, Istanbul Studies 2 (Istanbul, 2011); on the aesthetics of the Fatih see Ü. Rüstem, "Architecture for a New Age: Imperial Ottoman Mosques in Eighteenth-Century Istanbul" (PhD diss., Harvard University, 2013), 307, and see now idem, *Ottoman Baroque: The Architectural Refashioning of Eighteenth-Century Istanbul* (Princeton, 2019). I am grateful to Ünver Rüstem for sharing a copy of the relevant chapter.

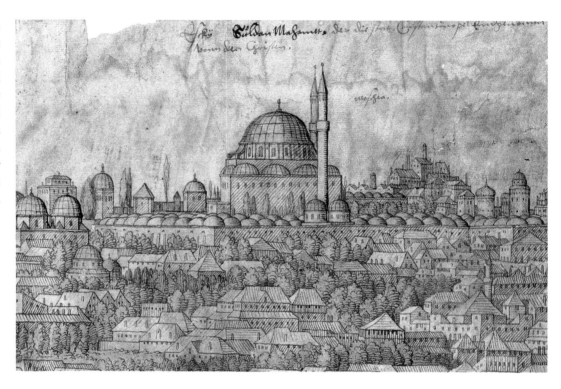

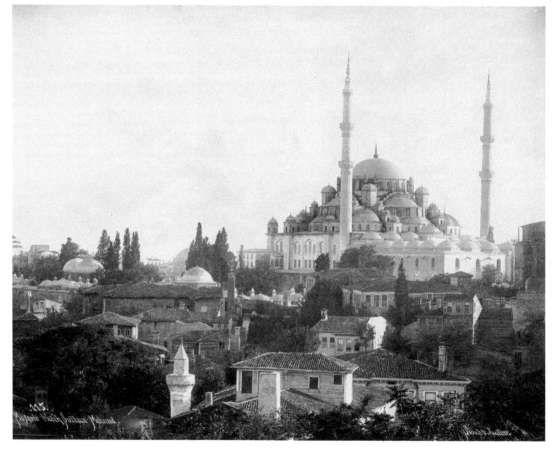

appearance of Mehmed's mosque.[2] His findings gained agreement from several leading experts, though it also drew vituperative criticism from the German orientalist Franz Babinger, whose article Aga-Oglu described as "malicious."[3] Subsequent work has provided more detail, but the picture remains the same: the principal axis of the prayer hall of the original mosque was covered by a full dome on pendentives with a diameter of approximately 26 meters, set almost immediately inside the main, west entrance from the courtyard, followed by a semidome on pendentives on the eastern, mihrab side (figs. 15.3, 15.4, and 15.6).[4] The junction of dome and

semidome was supported by two huge piers, and the domed bay was separated from the side aisles by arcades supported on two porphyry columns. Aga-Oglu, however, overlooked the important fact that, whereas the prayer hall was rebuilt in the eighteenth century, much of the courtyard remained from the original fifteenth-century mosque.

As consensus began emerging on the original form of Fatih Camii, a debate began on its place in the development of Ottoman mosque architecture. Did it mark a new departure in Ottoman architecture, one that reflected the influence of Hagia Sophia, or was it, as Aga-Oglu argued, the logical development of an Ottoman urge—forged over the preceding 120 years—to explore spatial solutions in mosque architecture?[5] Implicit in the debate about the Byzantine influence on Fatih Camii was a controversy on the origin of the architect: was he a Greek Christian or a Muslim convert?[6] A more recent issue has been the suggested influence of Renaissance ideal planning and, indeed, Florentine involvement in the construction of the accompanying madrasas.[7]

There was also disagreement over where the mosque was sited. That it was placed at least in

2 M. Aga-Oglu, "Die Gestalt der alten Mohammedije in Konstantinopel und ihr Baumeister," *Belvedere* 9–10 (1926): 83–94; idem, "The Fatih Mosque at Constantinople," *ArtB* 12 (1930): 179–95; idem, "About One of the 'Two Questions in Moslem Art,'" *AI* 3 (1936): 116–23. For a recent reconstruction of the mosque, see G. Necipoğlu, *The Age of Sinan: Architectural Culture in the Ottoman Empire* (London, 2005), 84–88.

3 F. Babinger, "Zum Sinân-'Problem,'" *Orientalische Literaturzeitung (Monatschrift für die Wissenschaft vom vorderen Orient und seine Beziehungen zum Kulturkreise des Mittelmeers)* 7 (1927): cols. 548–551; Aga-Oglu, "Fatih Mosque," 179n6.

4 The plan of the mosque can be read as comprising twelve squares (four by three), of which the central six opened up into a continuous visual and functional space: E. H. Ayverdi, *Osmanlı Mi'mârîsinde Fâtih Devri 855–886 (1451–1481)*, İstanbul Fetih Cemiyeti İstanbul Enstitüsü 69 (Istanbul 1973), 356–406, and articles cited below, n. 5. On the size of the dome, the account books of the Süleymaniye Mosque record that it measured 32 *zira*, but Ayverdi has argued that the measurement was taken from the inner edge of the console at the skirt of the dome, which would have projected by some 80 cm at both ends of the diameter; he accordingly calculated a dome of 24.26 m plus 1.60 m, totaling just under 26 m: Ayverdi, *Fâtih Devri*, 372; idem, "İlk Fatih Camii hakkında yeni bir vesika," *Vakıflar Dergisi* 6 (1965): 63–68. Aga-Oglu had proposed a most unlikely rendering in which the northern side of the main dome rested on the northern entrance wall. Rudolf Riefstahl and Ekrem Hakkı Ayverdi showed that it must have rested on piers that were part of the main entrance, for which there is a surviving example in the Selimiye mosque in Konya: R. M. Riefstahl, "Selimiyeh in Konya," *ArtB* 12, no. 4 (December 1930): 311–19. The Selimiye allows us to sense how disturbing it is to enter the mosque immediately under the main dome, without the sweeping prospect of a semidome on the entrance side.

Mehmed's mosque is oriented, as we shall see, to the southeast, but I have referred to it, following the convention adopted by Ekrem Hakkı Ayverdi and others, as if it was aligned on the cardinal directions, with the qibla wall, for example, referred to as being on the east. This is for simplicity's sake, and has the advantage that references to east in connection with the Holy Apostles refer, especially in medieval texts, to "liturgical east" rather than the strict geographical direction; cf. the description by Mesarites: *Description of the Church of the Holy Apostles*

at Constantinople, c. 13, ed. A. Heisenberg, *Grabeskirche und Apostelkirche: Zwei Basiliken Konstantins*, vol. 2, *Die Apostelkirche von Konstantinopel* (Leipzig, 1908), 10–96; ed. and trans. G. Downey, "Nikolaos Mesarites: Description of the Church of the Holy Apostles at Constantinople," *TAPS*, n.s., 47, part 6 (1957): 855–924 at 869; trans. M. Angold, *Nicholas Mesarites, His Life and Works (in Translation)*, TTB 4 (Liverpool 2017), 83–133 at 93.

5 Aga-Oglu, "Mohammedije"; idem, "Fatih Mosque," 179; H. B. Kunter and A. S. Ülgen, *Fatih Camii ve Bizans Sarnıcı* (Istanbul 1939); Kunter and Ülgen, "Fatih Camii," *Vakıflar Dergisi* 1 (1938): 91–101; E. H. Ayverdi, "Yine Fatih Cami'i," *Tarih Dergisi* 7 (1954); R. Anhegger, "Beiträge zur frühosmanischen Baugeschichte III: Zum Problem der alten Fatih-Moschee in İstanbul," in *Zeki Velidi Togan Armağanı* (Istanbul 1953); idem, "Eski Fatih Cami'i Meselesi," *Tarih Dergisi* 6 (1954): 145–60.

6 N. N. Martinovitch, "Two Questions in Moslem Art," *JRAS* 2 (April 1935): 285–98; idem, "Christodulos and Riza," *Artibus Asiae* 8 (1945): 265–68; H. Kurdian, "The Builders of the Fātih Mosque: Christodulos or Sinân?" *JRAS* 1 (January 1937): 109–13.

7 M. Restle, "Bauplanung und Baugesinnung unter Mehmet II. Fatih: Filarete in Konstantinopel," *Pantheon* (1981): 361–67; idem, "Die osmanische Architektur unter Mehmet dem Eroberer und die italienische Renaissance," in *Italien und das osmanische Reich*, ed. F. Meier (2010), 15–28.

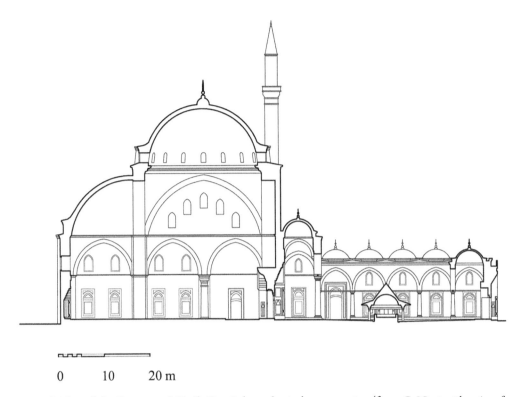

FIG. 15.3. Mehmed the Conqueror's Fatih Camii, hypothetical cross-section (from G. Necipoğlu, *Age of Sinan: Architectural Culture in the Ottoman Empire* [London, 2005], fig. 60. Source: Archnet, Reconstruction Section of the Original Fatih Mosque, accessed 23 October 2019, http://archnet.org/publications/1435).

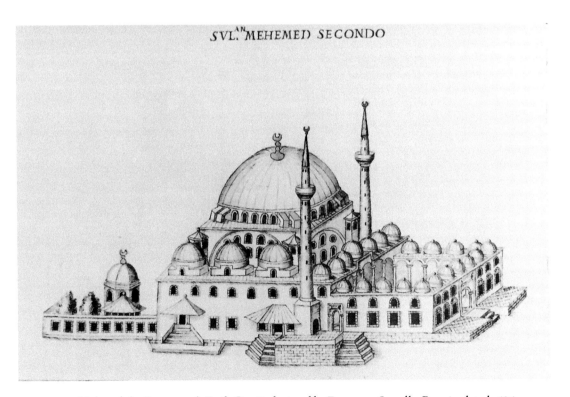

FIG. 15.4. Mehmed the Conqueror's Fatih Camii, depicted by Francesco Scarella, Brescia, dated 1686. Vienna, Österreichische Nationalbibliothek, Cod.8627, fol. 13 (photo by author).

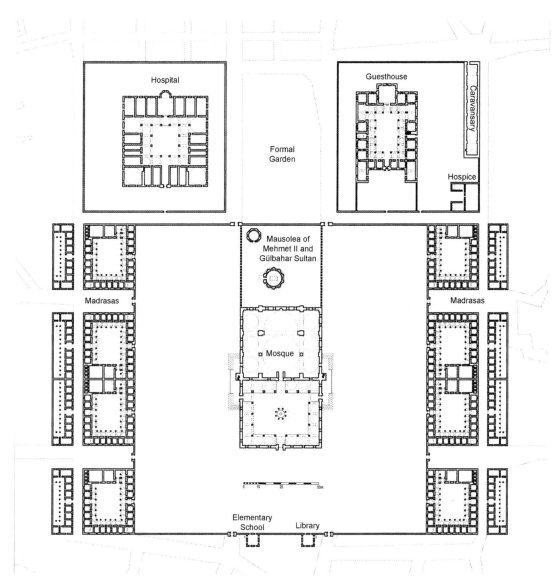

Hospital

Formal
Garden

Guesthouse

Caravansary

Hospice

Mausolea of
Mehmet II and
Gülbahar Sultan

Madrasas

Madrasas

Mosque

0 10 25 50m

Elementary
School

Library

FIG. 15.5
Ground plan
of Mehmed the
Conqueror's original
complex, with its
mosque in the center,
flanking suites of
madrasas on the north
and south, a hospital
on the northeast, and
a *tabhane*, *imaret*,
and caravansary in
the southeast (after
G. Necipoğlu, *Age of
Sinan*, fig. 59)

the general vicinity of the Byzantine church of the Holy Apostles was certain. The problem was whether it was sited near or exactly over the foundations of the church of the Holy Apostles. This was important as the Holy Apostles was, as this volume has emphasized, no ordinary church, but, like Hagia Sophia, (re)built by Justinian in the sixth century and, after Hagia Sophia, the second most important church in the city, for it comprised the imperial necropolis of the emperors of Byzantium, including the *heroon* of Justinian and the mausoleum of the founder of Constantinople, the emperor Constantine.

It is this last issue—the relation of Fatih Camii to the Holy Apostles—that is the focus

of this article and, as I hope to demonstrate, of major significance.

The Site and Its Structures

Let us first familiarize ourselves with the site. The mosque occupied the central axis of a precinct some 320 meters square. This precinct stood on one of the highest hills of the Byzantine and Ottoman city, and rested on a terrace, with land falling steeply away on several sides that necessitated the building of massive vaults. The precinct had enclosure walls east and west, while its north and south sides were flanked by a highly symmetrical arrangement of madrasas (fig. 15.5). On both sides were four principal madrasas, with

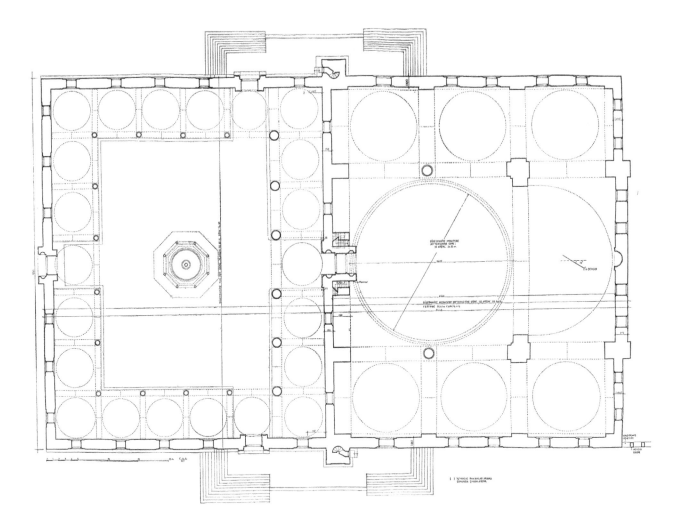

FIG. 15.6.
Ground plan
of Mehmed the
Conqueror's
mosque based on
extant evidence
and hypothetical
projections (from
Ayverdi, *Fâtih
Devri*, fig. 577)

four subsidiary blocks. To the east of the mosque were three enclosures. The central one held the cemetery, with Mehmed's tomb and that of one of his consorts, the mother of his successor Bayezid. The enclosure to its north contained a hospital; that on its south a hospice, soup kitchen, and caravansary.[8]

This complex was unparalleled in size and symmetry. It occupied an area the equivalent of seventeen and a half American football fields. At the time there was nothing quite like it in Europe or the Near East, other than the recently constructed Ospedale Maggiore in Milan. Designed to cater to body and mind and spirit, to the needy, and to the next generation of clerics, it was, in Evliya Çelebi's words, "like a town of lead-covered domes";[9] its "population" was the

equivalent of a small town. In 1490 it had a total of 496 functionaries, and the soup kitchen served daily meals for 1,117, including 794 theological students and an unknown number of needy.[10] The madrasas alone counted some 250 student rooms. This was very different from the domestic scale of the schools and colleges that Nicholas Mesarites described at the Holy Apostles in the early thirteenth century.[11]

8 Necipoğlu, *Age of Sinan*, 82–92.

9 This loose translation is from Evliya Çelebi: J. v. Hammer-[Purgstall], ed., *Narrative of Travels in Europe, Asia, and*

Africa, in the Seventeenth Century by Evliyá Efendi, translated from the Turkish by the Ritter Joseph von Hammer, 3 vols. (London, 1834–50), 1.1:67. Cf. Evliya Çelebi, *Seyâhatnâmesi* (Istanbul, 1314; repr. 1896), 1:140; and O. Ş. Gökyay, ed., *Evliya Çelebi Seyahatnâmesi: Topkapı Sarayı Bağdat 304 Yazmasının Transkripsiyonu, dizini 1 1* (Istanbul, 1996), 58.

10 A. S. Ünver, "Fatih külliyesine ait diğer muhim bir vakfiye," *Vakıflar Dergisi* 1 (1935): 39–45.

11 Mesarites, *Ekphrasis*, cc. 8, 42; ed. Heisenberg, *Apostelkirche* 19–20, 90–94; ed. and trans. Downey, "Nikolaos Mesarites," 865–67; trans. Angold, *Nicholas Mesarites*, 88, 129–31.

In the early eighteenth century the architect was identified by Demetri Cantemir as a Greek by the name of Christodoulos,[12] but from fifteenth-century Ottoman sources, documents, and his own tombstone we know that he was a convert to Islam known as Sinan al-Din Yusuf bin 'Abdullah. He was also known as Atik Sinan, which indicated that he was a manumitted slave.[13] An endowment deed drafted in 1464 refers to him as "the architect" (al-mi'mār) whereas another dated 1468 calls him the "imperial architect" (al-mi'mār al-amīrī). The change probably reflected his increasing status, and he received grants of land from the sultan. All that was to change, however. His tombstone, placed in the grounds of the mosque he founded, confirms a bleak story: he died on 12 September 1471, having been kept in a "dungeon by the sea" (fi'l ghār ... ṭaraf al-baḥār). The tombstone confirms what we know from the late fifteenth-century Anonymous Chronicles: "Thanks to God that you have seen with your own eyes how Sultan Mehmed had Sinan the architect, the builder of the New Mosque, the Eight Madrasas, the Imaret and the Hospital, killed after repeated beatings and so long in prison. I wonder, was his sin so great that he deserved to die in this way?"[14] We well may ask why Atik Sinan was executed.

Mehmed might have been disappointed, as Evliya Çelebi suggests, by the size and appearance of his mosque, but several accounts, including Evliya's, suggest there were errors in the construction of the dome. Evliya Çelebi tells a strange tale of Mehmed being arraigned before the supreme judge of Istanbul for chopping off the hands of his architect. According to this tale, Mehmed peevishly replied, if I may paraphrase: "I cut off his hands because he cut down my columns. Each of these columns was worth the tribute of Rum."[15] Evliya is a notably quixotic source, but there may be a kernel of truth here. The columns were especially valuable as they were porphyry, and the Anonymous Chronicles, which contained the lament about Atik Sinan's death, relate that the columns were cut before being put in place, and that some experts said they had been cut too short, a mistake implicit in the way other Ottoman sources described the columns as "dumpy."[16] The story of the columns suggests Mehmed's disappointment was related to a structural fault, and in the 1670s, the English chaplain to the Levant Company John Covel attests that long before the destructive earthquake of 1766 the dome was in a perilous state: the cupola was "very flat," he said, and lacked cross buttresses: "afterward they [the Ottomans] grew more cunning in building."[17]

The original dome of Justinian's Hagia Sophia (537) had likewise proved structurally faulty and was replaced by a higher dome completed in 562. Mention of Hagia Sophia reminds us that the

12 D. Cantemir, The History of the Growth and Decay of the Othman Empire. Part I: Containing the Growth of the Othman Empire, from the Reign of Othman the Founder, to the Reign of Mahomet IV ... Translated into English, from the Author's Own Manuscript, by N. Tindal, M.A. vicar of Great Waltham in Essex ... (London 1734), 105n17, 109n31, 160n35. See above, note 6 for further references.

13 İ. H. Konyalı, Fatih'in mimarlarından Azadlı Sinan (Sinan-i Atik): Vakfiyeleri, eserleri, hayatı, ve mezarı, İstanbul Fetih Derneği Neşriyatı 4 (Istanbul, 1953).

14 F. Giese, Die altosmanischen anonymen Chroniken = Tawārīḫ-i āl-'Usmān / in Text und Übersetzung herausgegeben von Dr. Friedrich Giese, 2 vols. (Breslau and Leipzig, respectively, 1922–25), 1:99–100, 2:132–33; Konyalı, Azadlı Sinan, 59. It is curious that there is no mention of Sinan or his execution in Aşıkpaşazade's chronicle, as the two men were close acquaintances and Aşıkpaşazade was made the şeyh of Sinan's zaviye, with an interest in perpetuity for his family: Konyalı, Azadlı Sinan, 57. For his tombstone, see also Ayverdi, Fâtih Devri, 439–42.

15 Evliya Çelebi, Seyâḥatnâmesi, 138; idem, Narrative of Travels, 1.1:66–67; Gökyay, Evliya Çelebi Seyahatnâmesi, 58–59; Konyalı, Azadlı Sinan, 65, 73, 85–86. Ayverdi, Fâtih Devri, 364, measured two granite columns excavated during work in the courtyard of the mosque in 1949 and suggested these were the somaki columns mentioned by Hafız Hüseyin Ayvansarâyî, on whom see below, note 119. On the finds of various columns and column fragments, see K. Dark and F. Özgümüş, Constantinople: Archaeology of a Byzantine Megapolis; Final Report on the Istanbul Rescue Archaeology Project 1998–2004 (Oxford, 2013), 89–90.

16 See the Anonymous Chronicles: Giese, Altosmanischen anonymen Chroniken, 1:98, lines 26–29, 2:131; Konyalı, Azadlı Sinan, 58. Giese's translation is tautological. However, if one reads (l. 29) "uzun gerekti" as a parenthetical interjection, the passage makes better sense: "Some masters who have seen them at the present time, say 'They have cut those columns too short.' (They should have been long.)"

17 "Sultan Mahomets Church is very flat cupola, and hath been crakt and falling 2 or 3 times, but hath been patcht and cobbled up again w[i]th Iron." Covel suggests a structural failing: "it hath not those cross buttresses wc h are in ye latter mosques, from whence this decay might happen; afterward they grew more cunning in building." Cambridge University Library, MS. MM.6.52 fol.228.

issue of Hagia Sophia's influence turned into a sometimes toxic debate between Turkish scholars and European or American scholars in the first half of the twentieth century. The views of Mehmed's contemporaries were unequivocal, however, for two expressly referred to the influence of Hagia Sophia. Gian-Maria Angiolello, who was a member of Mehmed's court in the 1470s, described Mehmed's mosque as "a large cube on the likeness of the church of Santa Sofia" (*una gran cuba alla similitudine della Capella di Santa Sofia*).[18] Tursun Beg, another member of Mehmed's court, describes it as based on an old model in a new style. Mehmed, he relates, constructed a "great mosque on the plan of Hagia Sophia" (*Ayasofya kârnâmesi resminde*), which "not only encompassed all the arts of the latter, but in addition attained a fresh new idiom [*nev'-i şîve-i tâze*] and unequalled beauty in accordance with the practices of the moderns [*tasarrûfat-ı müte'akhkhirîn*]."[19] He adds "and in its effulgence its miraculous quality is evident (like the white hand of Moses)" (Qur'an 7:108).

What a Difference a Decade Makes

From almost the moment it was created, then, Fatih Camii has tended to be framed in relation to Hagia Sophia rather than the Holy Apostles, and the latter's apparent lack of architectural imprint on the mosque might suggest it had no other impact. This is not the case, as we will see when we return to questions of the site and symbolism of the Holy Apostles, but let us first

review Mehmed's actions toward the church of the Holy Apostles. In 1454 the twenty-two-year-old Mehmed installed a new patriarch as the head of the Greek orthodox church and community. He had sought out George Scholarios, the monk Gennadios, from among the many prisoners taken in the Fall of Constantinople in the previous year. His choice of Gennadios was doubtless prompted by the fact that he was one of the senior critics of the attempted Union of the Churches, which had had its most public demonstration in the Council of Florence from 1438 to 1439. Gennadios's desire to preserve Greek orthodoxy from assimilation with Latin Catholicism agreed with Mehmed's political and military concerns. In January 1454, when the sultan installed Gennadios as patriarch, he granted him the church of the Holy Apostles to be the seat of the patriarchate.[20] Yet a little less than ten years later, in the early 1460s, the church was demolished and a great mosque built. What a difference a decade made, from the magnanimous grant of the church to its demolition. What prompted such a reversal in the church of the Holy Apostles' fortune?

As the Byzantine emperor had refused to surrender Constantinople to Mehmed, and thereby declined his offer of mercy (*amān*), he had forfeited the rights of the Christian inhabitants to retain their places of worship. The conundrum for later Ottoman jurists was that Christians did retain their churches, with the notable exception of Hagia Sophia.[21] More remarkable still was that Mehmed accorded the new patriarch a church that embodied the imperial legacy of Constantine and his successors. The site comprised a church, a martyrium, and imperial mausolea; in the words of Nicholas Mesarites, it "has been to the Emperors from time immemorial a prized possession, wherefore they chose this

18 G. M. Angiolello, ed., A. Capparozzo, *Di Gio: Maria Angiolello et uno suo manoscritto inedito* (Nozze Lampertico-Balbi) (Vicenza, 1881), 25.

19 Tursun Bey, *Tā'rīh-i Abū'l Fath*, ed. M. Arif (Istanbul, 1912), 63, lines 4–7; ed. A. M. Tulum (Istanbul, 1977), 70; facs. and trans. H. İnalcık and R. Murphey, *The History of Mehmed the Conqueror* (Minneapolis and Chicago 1978), fol. 56a, lines 9–12; Konyalı, *Azadlı Sinan*, 68, 99–100. Translation from G. Necipoğlu, "From Byzantine Constantinople to Ottoman Kostantiniyye: Creation of a Cosmopolitan Capital and Visual Culture under Sultan Mehmed II," in *From Byzantion to Istanbul: 8000 Years of a Capital; Sabancı University Sakıp Sabancı Museum June 5–September 4, 2010* (Istanbul, 2010), 266. For an excellent discussion of how Mehmed's contemporaries and near contemporaries viewed the building, in part depending on their political sympathies, see Ç. Kafescioğlu, *Constantinopolis/Istanbul: Cultural Encounter, Imperial Vision, and the Construction of the Ottoman Capital* (University Park, PA, 2009), 86–91.

20 M.-H. Blanchet, *Georges-Gennadios Scholarios (vers 1400–vers 1472): Un intellectuel orthodoxe face à la disparition de l'Empire Byzantin* (Paris, 2008); S. Runciman, *The Great Church in Captivity: A Study of the Patriarchate of Constantinople from the Eve of the Turkish Conquest to the Greek War of Independence* (London, 1968).

21 H. İnalcık, "The Policy of Mehmed II toward the Greek Population of Istanbul and the Byzantine Buildings of the City," *DOP* 23–24 (1969–70): 229–49.

place for their unbroken sleep and their rest until the time of resurrection."[22]

Mehmed's gift to Gennadios was born of political pragmatism. There is a widespread sense that the Fall of Constantinople was inevitable, and the success of Mehmed and his army inexorable. These assumptions have been fed over time by Byzantine doom-mongering, Ottoman triumphalism, and Turkish national pride.[23] Yet in reality Mehmed's position immediately before the conquest and immediately after the Fall of the city was precarious. There was internecine strife among his viziers that led to the execution of Çandarlı Halil Paşa, who had argued for the siege of Constantinople to be abandoned.[24] The anti-Greek faction in his court seemed to be in the ascendant, but in the immediate wake of the Fall, Mehmed himself expressed a willingness for conciliation, offering to entrust the city and all its welfare to the Byzantine megadoux Loukas Notaras. Mehmed, though, quickly changed his mind, and within less than a month he had Loukas Notaras and two of his family executed.[25] Nonetheless, accommodation with the vanquished was Mehmed's only viable route, for he needed to repopulate the city, and while he demanded his governors send him settlers, few Muslims wished to abandon their homes for the uncertainties of a pillaged city, under the threat of a Latin *revanche*. When persuasion failed, Mehmed adopted carrot and stick: he used forced settlement and, in order to make the city a magnet for orthodox Greeks, selected not a secular leader such as Loukas Notaras, but a religious leader, George Scholarios, Gennadios. When Gennadios was enthroned as patriarch, the sultan played the role of emperor and personally presented him with the symbols of his office, including a pastoral staff and a newly made silver-gilt cross, as well as a robe of cloth-of-gold.[26]

Above all, Gennadios was granted the second church of the city, the Holy Apostles. Reestablishing a patriarchate made perfect political sense; granting the new patriarch a church, a necessity. But granting him the Holy Apostles was a gesture of reconciliation prompted by the reality of Mehmed's position in 1454. To consolidate his victory, he needed to secure the Balkans, command the Aegean, and repopulate the Polis. For the last he needed the cooperation of the Greek community. The Holy Apostles was a price he paid. Mehmed's gesture was highly symbolic, because while he appropriated Hagia Sophia for Islam he reestablished the Holy Apostles for Christ. It was a declaration that the Greeks were to be partners, albeit minority partners, in the new polity he was creating.

Within less than a year, Mehmed regained possession of the Holy Apostles, however, with Gennadios leaving the church in May 1454.[27] Greek sources state that Gennadios abandoned the Holy Apostles of his own accord: he and his brethren were alarmed for their safety when they found the corpse of a slain man in the precinct of the church, and he asked Mehmed's permission to move to the convent of the Pammakaristos.[28] The church was also in dire condition, as Gennadios himself remarked in 1454, confirming Cristoforo Buondelmonti's description of it a few decades earlier as "ecclesia jam derupta."[29] The church,

22 Mesarites, *Ekphrasis*, c. 3, ed. and trans. Downey, "Nikolaos Mesarites," 862.

23 For Byzantine "prophecies" and fatalistic post-eventum interpretations of the Fall of Constantinople, including by Gennadios, see D. M. Nicol, "The Death of Constantine," in *The Immortal Emperor: The Life and Legend of Constantine Palaiologos; Last Emperor of the Romans* (Cambridge and New York, 2002), ch. 5.

24 H. İnalcık, "Mehmed the Conqueror (1432–1481) and His Time," *Speculum* 35 (1960): 412–18.

25 He was executed on either the 3rd or 4th of June. On the Notarades, and Loukas's surviving children, see K-P. Matschke, "The Notaras Family and Its Italian Connections," *DOP* 49 (1995): 59–72.

26 Runciman, *Great Church in Captivity*, 169. The *Historia Politica* in *Historia Politica et Patriarchica Constantinopoleos*, ed. I. Bekker, CSHB (Bonn, 1849), 28, adds that the Holy Apostles was to be his *katoikia/domicilium*.

27 Blanchet, *Scholarios*, esp. 94.

28 Steven Runciman claimed the corpse "had obviously been planted there," and the Greeks were forced out by a tactic of fear-mongering (Runciman, *Great Church in Captivity*, 184). Runciman follows Sphrantzes—Phrantzes, ed. I. Bekker, CSHB (Bonn, 1838), 307—in saying the corpse was that of a Muslim, but the *Historica Politica*, 28, the *Historia Patriarchica*, 81–82, in *Historia Politica et Patriarchica Constantinopoleos*, ed. Bekker, and the *Ekthesis Chronike*, ed. S. P. Lambros, *Ecthesis Chronica and Chronicon Athenarum* (London, 1902), 19, suggest otherwise, as they state that Gennadios and his brethren feared the same would happen to them. Runciman's claim that the area was populated by Turks is not borne out by the Greek accounts, which state that the area was uninhabited.

29 A. A. Vasiliev, "Imperial Porphyry Sarcophagi in Constantinople," *DOP* 4 (1948): 7. The same passage occurs in

for all its symbolic importance, was an impossible practical burden for the patriarch. Preference and perhaps pressure from Turks who resented the sultan's concession to the Greeks worked in tandem to persuade Gennadios to abandon the most potent focus of Byzantine imperial memory still in Greek hands. Gennadios's move to the Pammakaristos ultimately gave Mehmed the opportunity to redevelop the site of the Holy Apostles. He took it over; he did not take it away.

The 1460s were a very different decade for Mehmed from the 1450s. It was in the 1460s that Mehmed began to see the fruits of his strenuous campaigning. He had secured the Balkans, taken the Morea, and extinguished Trebizond. He had moved his capital from Edirne to Istanbul, and he spent several years in Istanbul, free of campaigns. He concentrated much of the empire's military efforts not on land campaigns but in building a massive fleet and confronting the Venetians at sea in a war that would persist for the next sixteen years.

Mehmed suffered from ill health in the mid-1460s, but this gave him an opportunity to oversee the many building projects he had initiated between 1461 and 1463, including the construction of his new palace—the present Topkapı Sarayı—and Fatih Camii. His officers were also building prodigiously, and Mehmed's city was finally becoming populous. From the early 1460s Mehmed put his personal stamp on the city. In 1454, when he granted Gennadios the Holy Apostles, there was a fragility about Mehmed's Istanbul project. Ten years later Mehmed devoted his full energies and resources to realizing his vision. Replacing the Holy Apostles, the symbol of Byzantine imperial longevity, with a mosque was the ultimate fruit of victory.

Ottoman sultans traditionally constructed Friday mosques with the proceeds of the booty from jihad.[30] An imperial Friday mosque was thus a lasting testimony to a sultan's triumph,

and to the triumph of Islam. In one of the versions of Aşıkpaşazâde's chronicle there is a section on the traits of different sultans, in which Mehmed is singled out as having built a mosque complex every time he captured a region from an emperor (*kâfir padişahlarından*).[31] What triumph did Fatih Camii celebrate?

In the immediate aftermath of 1453 Mehmed built a mosque outside the walls of Constantinople at Eyüp, but he did not build a great mosque inside the city. Instead, he converted Hagia Sophia. Construction of Fatih Camii did not begin until February 1463 (Jumada al-Awwal 867), a decade after his conquest of Constantinople and nine years after his construction of the mosque in Eyüp. Work thus began a little over a year after Mehmed had taken the last independent remnant of the Byzantine empire, Trebizond (15 August 1461).[32] The capture of Trebizond played a key part in Mehmed's later propaganda vis-à-vis the West, but it does not feature in references to Fatih Camii. Instead, Aşıkpaşazâde implies that the mosque was connected to the capture of Constantinople, and Evliya Çelebi expressly states so.[33] This is supported by an Arabic inscription that belongs to the original portal of the main entrance to Fatih Camii, and is dated 867–875/1463–70. It trumpets Mehmed's conquest of Constantinople, the peerless city no Muslim had succeeded to take before him, and cited a hadith of the prophet that blessed the leader who captured the city.[34]

31 Ç. N. Atsız, *Osmanlı Tarihleri* 1 (Istanbul, 1949), 233.

32 D. M. Nicol, *The Last Centuries of Byzantium, 1261–1453* (Cambridge and New York, 1993).

33 A conquest that he marked with the building of the eight madrasas, the great mosque, the imaret, and the hospital of Fatih Camii: Atsız, *Osmanlı Tarihleri*, 233.

34 For the Arabic inscription, see Ayverdi, *Fâtih Devri*, 385–87; Kunter and Ülgen, "Fatih Camii," 101; eidem, *Bizans Sarnıcı*, 15. It is translated into English by Kafescioğlu, *Constantinopolis/Istanbul*, 82 and 84. It is discussed by Necipoğlu, "From Constantinople to Kostantiniyye," 266. S. Yerasimos, *Constantinople: Istanbul's Historical Heritage* (Cologne, 2005), 215, suggests that the idea for the building of Fatih Camii began in 1459. He presumably is thinking here of the passage in which Kritoboulos suggests that building of the mosque and of the palace now called Topkapı Sarayı began in 1459. Kritoboulos seems to conflate building work with moving the capital from Edirne to Istanbul, but he may be correct in suggesting that the idea of the mosque complex was formed then: Kritoboulos, *De rebus gestis Mechmetis II inde ab anno 1451 usque ad annum 1467 p.Chr.*, ed. K.W.L. Müller, *FHG* 5.1:127; Kritoboulos, ed., *History of*

a Greek translation of Buondelmonti in a manuscript still in the library of the Topkapı Sarayı: Buondelmonti, ed. Legrand, *Description des Îles de l'Archipel par Christophe Buondelmonti: Version grecque par un anonyme; Publiée d'après le manuscrit du Sérail avec une traduction française et un commentaire par Émile Legrand*, Publications de l'École des Langues Orientales Vivantes, 4th series, 14 (Paris, 1897), 88 and 244.

30 Necipoğlu, *Age of Sinan*, 65–66.

The mosque's triumphalism focused on the city of Constantinople.

Contemporary Ottoman imperial representation thus projected an ideological image of Fatih Camii connected to the conquest of Constantinople, while members of Mehmed's court viewed the mosque architecturally in relation to Hagia Sophia rather than the Holy Apostles. Yet Mehmed was keenly attuned to the resonances of place and past. In building the mosque at Eyüp, he commemorated the spot where a companion of the prophet Muhammad is said to have been martyred. The mosque in Eyüp served to bridge the distance between past and present, to create the link between the prophet Muhammad and the Ottomans. It was only later, from the seventeenth century, that every sultan went there on his accession to the throne to be girded with a sword, but Mehmed initiated imperial visits to the mosque, creating the precedent for the site to become ceremonially and ideologically central to the House of Osman.[35] If the mosque at Eyüp provided a link to the earliest age of Islam, Hagia Sophia was the transcendent vision of Byzantium, the city that Eyüp (Ayyub al-Ansari) and others had failed to take. The conversion of Hagia Sophia into a mosque symbolized the new order: the splendor of the past was appropriated—retained but repurposed. The presence of the past was a constant reminder of Mehmed's achievement in realizing eight hundred years of unfulfilled dreams.

Hagia Sophia's preservation contrasts with the destruction of the Holy Apostles. A key question is whether Mehmed regarded the Holy Apostles as nothing more than a site to be cleared, leaving a space for him to place his mosque on the highest hill of the city. Or did the site resonate for Mehmed as a *lieu de mémoire*? The fact that he had granted it to Gennadios suggests he was mindful of its importance, but critical to any answer is whether Fatih Camii stands on the site of the Holy Apostles or just in its approximate neighborhood. In 2000 Albrecht Berger surmised that "if the mosque had replaced the church exactly, the grave of Sultan Mehmet would have taken the place of Constantine's mausoleum. This would have been an act of enormous symbolic meaning." Berger, however, dismissed the idea "as a modern projection backward in time."[36] Things, though, may not be so simple.

The Location of the Holy Apostles

Some of the most noted scholars of the history of Constantinople have rejected the notion that Fatih Camii was built over the Holy Apostles, voicing three principal objections.[37] Cyril Mango cited a passage in the sixteenth-century *Ekthesis Chronike,* where it is stated "that church [The Holy Apostles] stood in what is now the *imaret* of Sultan Mehmed in the southern part; and there are remains of its buildings standing to this day." Mango understandably took *hemaration* to refer to "l'*imaret*, c'est-à-dire l'hospice de Fatih, à une faible distance au Sud de la mosquée"[38] (cf. fig. 15.5). However, Greek and European sources in the fifteenth and sixteenth centuries frequently called the entire mosque complex "the Imaret." We cannot, therefore, presume the reference in the *Ekthesis Chronike* was precisely to the hospice.[39] Consequently, we should be

Mehmed the Conqueror, by Kritovoulos [Critobule d'Imbros]: Translated from the Greek by Charles T. Riggs (Princeton, 1954), 140, 149, 207; Kritoboulos, ed. V. Grecu, *Din domnia lui Mahomed al II-lea, anii 1451–1467* ([Bucharest], 1963), 237–39.

35 Necipoğlu, "From Constantinople to Kostantiniyye," 266: Mehmed "reconsecrated the city with the memories of a distant Islamic past"; Kafescioğlu, *Constantinopolis/Istanbul,* 67; Cemal Kafadar, "Eyüp'te kılıç kuşanma törenleri," in Tülay Artan, ed., *Eyüp: dün / bugün,* Tarih Vakfı Yurt Yayınları (Istanbul, 1994), 50–61; N. Vatin, "Aux origines du pélerinage à Eyüp des sultans ottomans," *Turcica* 27 (1995): 91–99. For Mehmed's appreciation of Troy when he visited it, see Kritoboulos, ed. Grecu, *Din domnia lui Mahomed,* 297; trans. Riggs, *History of Mehmed the Conqueror,* 181; L. Chalcocondylas, *De origine ac rebus gestis Turcorum,* ed. I Bekker, CSHB 32 (Bonn 1843), 403.

36 A. Berger, "Streets and Public Spaces in Constantinople," *DOP* 54 (2000): 169.

37 The most detailed refutation is the short contribution by Albrecht Berger to a study published by Speck in 2000, A. Berger, "Über die wahrscheinliche Lage der Apostelkirche," *Varia 7, Ποικίλα Βυζαντινὰ* 18 (2000), 157–58.

38 C. A. Mango, *Le Développement urbain de Constantinople (IVᵉ–VIIᵉ siècles),* rev. ed. (Paris, 1990) 27. See Lambros, *Ecthesis Chronica,* 19. Idris Bidlisi, writing in the first decade of the 16th century, also referred to ruins ("the place and a few fallen columns": Kafescioğlu, *Constantinopolis/Istanbul,* 68).

39 The 15th-century Vavassore Map, for example, calls it "Almaratro," the *Historia Patriarchica,* ed. Bekker, 82 line 21, "imaretion." Dorotheos of Monembasia says "the church of the Apostles is now the imaret of Sultan Mehmed." See Caedicius, *Ancien Plan de Constantinople imprimé entre*

cautious in assuming on the basis of this passage alone that the mosque and the church had different locations. Moreover, if the Holy Apostles had been located where Mango proposed, it would have been near to the southeastern corner of the esplanade, and, regardless of the date of the terrace, close to where the land falls steeply away.[40]

Wolfgang Müller-Wiener, by contrast, proposed that the Holy Apostles was located toward the northeastern corner of the enceinte. His argument rested on his identification of a cistern to the geographical northeast of Fatih Camii as the substructure of the church of All Saints.[41] This church, built by Leo VI (r. 886–912), lay, in Glanville Downey's words, "alongside and to the east of the Holy Apostles."[42] As the cistern lies some 175 meters northeast of the mihrab wall of Fatih Camii, Müller-Wiener's identification would mean that the Holy Apostles was situated a long way distant from the mosque.[43] There is no reason to doubt that the cistern structure belonged to a Byzantine church, probably from the Macedonian period, but there is reason to question the identification. As Müller-Wiener's attribution has been accepted by Gilbert Dagron and Albrecht Berger, among others, it merits a short digression.[44]

Müller-Wiener dismissed the possibility that the cistern could have belonged to one of several churches recorded to have been in the area, on the grounds that they lay to the east of the Holy Apostles rather than "southeast" as is the case with the cistern, seemingly ignoring the medieval tendency to refer to the "east" of a church in terms of "liturgical east" rather than accurate geographical bearing, which is how he uses the term "southeast." Müller-Wiener also accepted Downey's detailed argument that the church of All Saints was identical with another of Leo VI's constructions, the church of St. Theophano, which the emperor built in honor of Theophano, the wife he had slighted. In making this argument, Downey contradicted Jean Ebersolt and Raymond Janin, who insisted that the two churches should be distinguished.[45] The topic is complicated by the fact that Leo's son Constantine VII dedicated an oratory to St. Theophano in the Holy Apostles,[46] but the evidence is not as clear cut as Downey asserts and others have accepted.

1566 et 1574 avec notes explicatives (Istanbul, n.d.), 4. See also Angiolello, *Manoscritto inedito*, 16: "e lo Imarato nuovo, il quale è un Tempio che ha fatto edificar il Gran Turco." The *Ekthesis Chronike* may use the word to refer to the mosque itself or to the complex as a whole, when it says the church "stood in what is now the *imaret*" (ἐν ᾧ ἐστι νῦν ἡμαράτιον). The reading is, however, an emendation by the editor Spyridon Lambros of the text in the Dionysiou manuscript. The other known manuscript—in Lincoln College, Oxford—reads "that church which is now the imaret of Sultan Mehmed" (ὃς νῦν ἐστιν), explicitly equating, as does Dorotheos of Monembasia, the Holy Apostles and the "imaret": Lambros, *Ecthesis Chronica*, 19. The compiler of the "Dionysiou tradition" of the *Ekthesis Chronike* was perhaps confused by the term *imaret* here, and, assuming it must refer to the cookhouse rather than the entire complex, added the phrase "in the southern part" in an attempt at clarification. Spandugino identifies the "Great *Imaret*" as the mosque: "Marath grande, cioè della Moschea": K. N. Sathas, *Mnēmeia Hellēnikēs historias: Documents inédits relatifs à l'histoire de la Grèce au moyen âge* (Paris, 1880–90), 9:243. Johannes Leunclavius, however, in *Pandectes* in *Annales Sultanorum Othmanidarum* (Frankfurt, 1588), 339–40, refers to Mehmed building a mosque with an imaret, indicating the confusion that seems to have developed in the course of the 16th century: "deque diruto antiquissimo Christianorum templo, quod ædificatum a Cõstantino magno Sanctorum Apostolorum nomen habebat, cujus ipse loco suam struxit cum imareto messitam, Turcicarum omnium in vrbe primam, & operis magnifici, [p. 340] quemadmodum hodieque conspicitur."

The Ottomans in the 15th and 16th centuries often used the term *imaret* to refer to an entire mosque complex, though this has been superseded in modern usage by the term *külliye*: Necipoğlu, *Age of Sinan*, 71. However, Aşıkpaşazade, in discussing the Fatih complex, clearly uses "imaret" to refer to the soup kitchen, which he distinguishes from the mosque, the madrasas, and the hospital (Atsız, *Osmanlı Tarihleri*, 233), as do account registers for the mosque from 1489 to 1490: Ömer Lûtfi Barkan, "Fatih Câmii ve İmareti Tesislerinin 1489–1490 Yıllarına Ait Muhasebe Bilançoları," *İktisat Fakültesi mecmuası (Revue de la Faculté des sciences économiques de l'Université d'Istanbul)* 23, nos. 1–2 (1962–63): 297–341. For documentation on how the soup kitchen operated, see Ayverdi, *Fâtih Devri*, 400–403.

40 Dark and Özgümüş, *Constantinople*, 86–87, who also discuss other objections.

41 W. Müller-Wiener, "Zur Lage der Allerheiligenkirche in Konstantinopel," in *Lebendige Altertumswissenschaft: Festgabe zur Vollendung des 70. Lebensjahres von Hermann Vetters dargebracht von Freunden, Schülern und Kollegen* (Vienna, 1985), 333–35.

42 G. Downey, "The Church of All Saints (Church of St. Theophano) near the Church of the Holy Apostles at Constantinople," *DOP* 9–10 (1956): esp. 302.

43 Müller-Wiener, "Lage."

44 G. Dagron, "Théophanô, les Saints-Apôtres et l'église de Tous-les-Saints," Βυζαντινά Σύμμεικτα 9 (1994): 201–18.

45 Downey, "All Saints," 301n1.

46 Ibid., 303.

Downey claims that two texts—*The Life of Saint Theophano* by Nikephoros Gregoras, and a passage in the *Patria*—"show that the Church of All Saints and the Church of St. Theophano were the same building."[47] Nikephoros Gregoras was, however, writing some four hundred years after the event, and none of the sources contemporary or closely contemporary with Theophano that mention either the church of St. Theophano or the church of All Saints—the author of an earlier *Life of Saint Theodora*, Constantine VII in *De Cerimoniis*, and Symeon Magister—mentions a change of name. The passage in the *Patria* should be treated with caution, as it is a gloss in a fifteenth-century manuscript.[48] Later sources, too, are largely silent on the subject, Downey himself admits: "The other sources do not hint that the Church of St. Theophano and that of All the Saints are the same."[49] Nikephoros Gregoras's reliability is questionable because in the same passage he stated that Leo had the empress Theophano's body placed in the monastery of St. Constantine she had built, yet, as Downey himself points out and George Majeska has confirmed, this is flatly contradicted by earlier sources.[50]

Nikephoros Gregoras is not, then, an unimpeachable witness in support of the argument that the church of All Saints was the same as the church of St. Theophano, and he might have confused the latter with the oratory of Theophano in the Holy Apostles. Downey's argument seems tenuous. If the church of St. Theophano was distinct from the church of All Saints, the substructure Müller-Wiener describes might have belonged to the church of St. Theophano rather than All Saints. The church of All Saints would have lain elsewhere, and that could, in theory, have been near the present-day Fatih Camii.

Neither of the two arguments against Fatih Camii being built over the Holy Apostles that we have just reviewed is unassailable. A third is that there are no surviving traces of the Holy Apostles in Mehmed's mosque. It is this last claim to which we shall now turn.[51]

The most detailed proposal that Fatih Camii stood on the site of the Holy Apostles was made in the early 1930s by Karl Wulzinger.[52] He attempted to reconstruct the original form of the Fatih Camii, comparing it to the mosque after its rebuilding in the 1760s. He then made the very explicit assumption that Mehmed's architects would have tried to use preexisting foundations rather than build anew. In the second part of his article Wulzinger developed a plan of the Holy Apostles by looking at the "parallel monument" of the church of St. John in Ephesos, which, like the church of the Holy Apostles, had been built by Justinian, in Procopius's words "most resembling and in every way rivalling the Temple of the Apostles in the Royal City."[53] Wulzinger created

47 Downey, "All Saints," 301n2, in fact, cites "Nicephorus Gregoras, Hist. Byz., VI, 9, 1 (v. 1, p. 202, 7–14 Bonn ed.)," but it says nothing about either the church of All Saints or the church of St. Theophano. This is surely an editorial error for a passage in Nikephoros Gregoras's *vita* of St. Theophano: E. Kurtz, "Zwei griechische Texte über die hl. Theophano, die Gemahlin Kaisers Leo VI," in *Zapiski Imperatorskoi Akademii Nauk po Fiziko-Matematicheskomu Otdeleniyu: Mémoires de l'Académie impériale des sciences de St.-Pétersbourg; Série 8, Classe des sciences physiques et mathématiques* 3, no. 2 (St. Petersburg, 1898), 43.

48 Parisinus gr. 1788, one of the topographic recensions of the *Patria*; see *Patria*, 281, ed. T. Preger, *Scr. orig. Const*; Dagron, "Théophanô," 206, esp. n. 18; A. Berger, *Accounts of Medieval Constantinople: The* Patria, DOML 24 (Cambridge, MA, 2013), 222 (Greek) and 223 (English): book 3.209. G. P. Majeska, "The Body of St. Theophano the Empress and the Convent of St. Constantine," *BSl* 38 (1977): 16, on a related passage in *Patria* book 3.212. The copyist of the Paris manuscript may have been subject to a similar misunderstanding as Nikephoros Gregoras, which was understandable after Theophano's remains were removed to her monastery of St. Constantine from the Mausoleum of Constantine, most probably following the latter's sack in 1204: Majeska, "St. Theophano," 16.

49 Downey, "All Saints," 301.

50 Majeska, "St. Theophano," 16; Dagron, "Théophanô," 204–5.

51 Dark and Özgümüş, *Constantinople*, 88, suggest that the entire terrace the Fatih complex rests upon was Byzantine in origin. As a section of the east side of the terrace is cut into by the covered cistern just discussed, they take this as "another Byzantine *Terminus Ante Quem*" (see also p. 89). If the layout of the terrace were indeed Byzantine, it seems reasonable to suppose that the Holy Apostles would have occupied the center, at least the central axis, as does Fatih Camii.

52 K. Wulzinger, "Die Apostelkirche und die Mehmedije zu Konstantinopel," *Byzantion* 7 (1932): 7–39. Wulzinger made, however, several errors, notably on the shape of the courtyard and where he positioned the entrance wall of the mosque.

53 Procopius, *De aed.*, 5.1.6, ed. and trans. H. B. Dewing, *Procopius*, vol. 7, *On Buildings*, 316–19. The *Patria* (book 4.32) make St. John the model for the Holy Apostles: Berger, *Patria*, 274 (Greek), 275 (English). For the church in Ephesos, see G. A. Soteriou, "Ἀνασκαφαί του Βυζαντινού Ναού Ἰωάννου

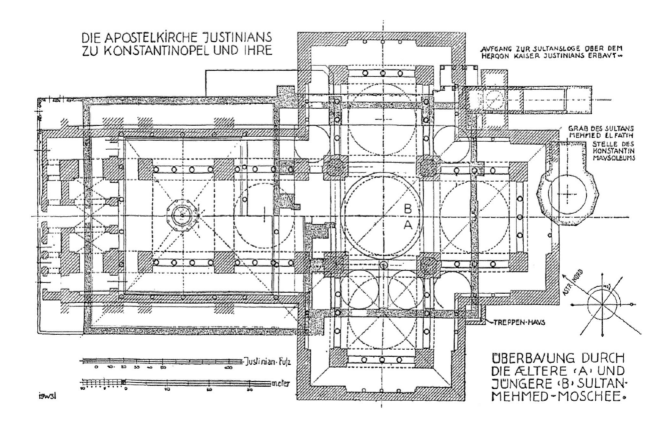

DIE APOSTELKIRCHE JUSTINIANS
ZU KONSTANTINOPEL UND IHRE

AVFGANG ZUR SULTANSLOGE OBER DEM
HEROON KAISER JUSTINIANS ERBAVT→

GRAB DES SULTANS
MEHMED EL FATIH
STELLE DES
KONSTANTIN
MAVSOLEVMS

Justinian·Fuß

meter

isw3l

B
A

·TREPPEN·HAVS

ÜBERBAVUNG DURCH
DIE ÆLTERE ‹A› UND
JÜNGERE ‹B› SULTAN-
MEHMED-MOSCHEE·

FIG. 15.7.
Overlay by Karl
Wulzinger of his
hypothetical ground
plan of Justinian's
Holy Apostles over
his ground plans of
Fatih Camii as built
in the 1460s and
rebuilt in the 1760s
(from Wulzinger,
"Mehmedije," fig. 14)

a ground plan of the Holy Apostles one-third bigger than the church in Ephesos, and then aligned this scaled-up version of the Holy Apostles onto the plans of Fatih Camii—onto the plan of the current mosque built in the 1760s, and onto what he thought was its plan in Mehmed's day, onto actual present and hypothetical past (fig. 15.7). There are problems with Wulzinger's argument, for the domes of the Holy Apostles must have been considerably smaller than he envisioned. And there are certainly difficulties with his proposed reconstruction of Mehmed's mosque. Yet issues with detail need not inevitably invalidate Wulzinger's premise.

Janin dismissed Wulzinger's efforts as "à nôtre avis, un soin inutile," on the straightforward grounds that there are no signs of the church's foundations surviving after its

demolition.[54] Others, too, have shared this concern, and Wulzinger himself conceded that he could see no visible remains.[55] In the sixteenth century, according to the *Ekthesis Chronike* and the *Historia Patriarchica,* remains of the church's buildings were visible,[56] and the question is whether there are any signs of the church today.

Remains of the Church of the Holy Apostles

In 2002 and in expanded form in 2013, Ken Dark and Ferudun Özgümüş drew attention to some distinctive features that antedate Fatih Camii's courtyard, which is a section of the mosque that

του Θεολόγου εν Εφέσω," *Ἀρχ.Δελτ.* 7 (1921–22): 89–226; H. Plommer, "St. John's Church, Ephesus," *AnatSt* 12 (1962): 119–29; N. Karydis, "The Vaults of St. John the Theologian at Ephesos: Visualizing Justinian's Church," *JSAH* 71 (2012): 524–51.

54 R. Janin, *La géographie ecclésiastique de l'empire byzantin, 1: Le siège de Constantinople et le patriarcat oecuménique, 3: Les églises et les monastères* (Paris, 1969), 48.

55 Wulzinger, "Apostelkirche," 27. The *Ekthesis Chronike* states that there were remains of the church's buildings visible in the 16th century: Lambros, *Ecthesis Chronica,* 19. In the 16th century Pierre Gilles (Gyllius) claimed that nothing remained of the Holy Apostles, but he was confused on the site, see Dark and Özgümüş, *Constantinople,* 86.

56 Lambros, *Ecthesis Chronica,* 19. *Historia Patriarchica,* ed. Bekker, 82, lines 21–22.

FIG. 15.8.
Three courses of masonry that predate the ashlar of the courtyard of Fatih Camii, a section which still survives from the fifteenth-century construction of Mehmed the Conqueror. South wall of the courtyard of Fatih Camii (photo by Ken Dark, courtesy of Oxbow Books).

a

b

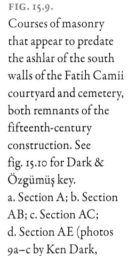

FIG. 15.9.
Courses of masonry that appear to predate the ashlar of the south walls of the Fatih Camii courtyard and cemetery, both remnants of the fifteenth-century construction. See fig. 15.10 for Dark & Özgümüş key.
a. Section A; b. Section AB; c. Section AC; d. Section AE (photos 9a–c by Ken Dark, courtesy of Oxbow Books; photo 9d by Robert Ousterhout).

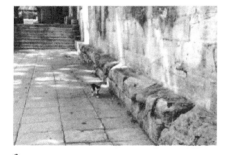

c

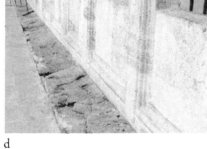

d

survives from the fifteenth century.[57] They were able to record these before the extensive "face-lift" made to the mosque in the early part of this century. The most notable of these features are three courses of very large and heavily eroded ashlar that form the visible base of the south wall of the courtyard of the mosque. The three courses

protrude from the line of the upper Mehmed-period ashlar, and the stones differ in type, size, condition, finish, and mortar from the Mehmed ashlar (figs. 15.8 and 15.9a).[58] The top course has

57 K. Dark and F. Özgümüş, "New Evidence for the Byzantine Church of the Holy Apostles from Fatih Camii, Istanbul," *Oxford Journal of Archaeology* 21, no. 4 (2002); eidem, *Constantinople*, 83–110.

58 On the lower courses being a fossil-free stone different from the fossiliferous limestone ashlar of Mehmed's courtyard walls, see Dark and Özgümüş, *Constantinople*, 92. J. Bardill, *Constantine: Divine Emperor of the Christian Golden Age* (Cambridge and New York, 2012), 390n222, believes these foundation courses belong to the Ottoman mosque and were not a relic from the Holy Apostles, as "it is not uncommon to see projecting courses of rougher stone in the foundations of Ottoman mosques." The wear of these "foundation courses"

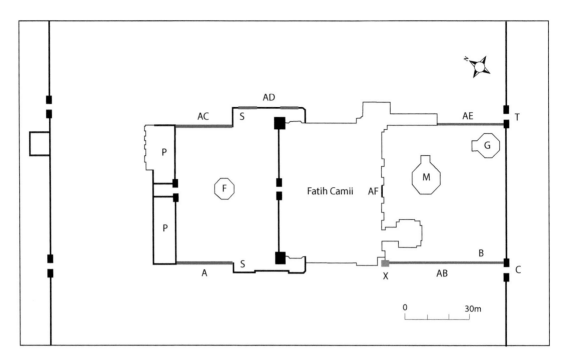

FIG. 15.10.

Plan of Fatih Camii and adjoining cemetery, with the stretches of wall where the earlier "eroded" masonry was observed highlighted here in red (plan by Ken Dark)

holes that suggest they were intended to take ties to connect to a now-missing course above, and in at least one case there is an iron cramp still in one of these holes. This wall aligns with a run of similar masonry east of the steps, and this continues in uninterrupted fashion along the south side of the cemetery courtyard (fig. 15.10).

The main upper part of the south wall of the cemetery is fenestrated with openings that have Bursa-style arches and surrounds sculpted with moldings similar to those around the windows of the main courtyard, and this part of the cemetery wall is undoubtedly fifteenth century. The lower course of this wall is composed of the by now familiar eroded masonry and projects in a very uneven fashion (fig. 15.9b), and some of projecting stones are inexplicably curved. The masonry seems different from the fifteenth-century wall

above, and the two are not bonded. It is difficult to explain if it did not belong to a structure that preceded Mehmed's.[59]

On the north side along part of the main courtyard of the mosque are remains of a similar wall of large worn stones. Only two courses were visible when Dark and Özgümüş were recording, and these courses were noticeably more eroded than those on the south side of

seems unusual, though. However, one must be cautious about the present condition of much of the ashlar, as there has been considerable work in many parts of the exterior, as a glance at the condition of the cemetery wall in the 1930s demonstrates (Kunter and Ülgen, "Fatih Camii," fig. 27; eidem, *Bizans Sarnıcı*, fig. 27). On the differences in the color and nature of the mortar used in the eroded courses and the upper ashlar, see Dark and Özgümüş, *Constantinople*, 106.

59 Dark and Özgümüş, "New Evidence," 401–3, fig. 8. The authors draw attention to a "short stretch of blocking or replacement stonework" (their AB1) that continues the course of huge masonry (AB) and, they say, runs under the eastern perimeter wall of the enceinte just to the north of the Çorbakapısı (marked C on fig. 15.10), a gate acknowledged as one of the most important survivals from Mehmed the Conqueror's complex, and which is bonded into the perimeter wall. This area has been neatened considerably since they published their fieldwork in 2002, but their claim suggests that "feature AB1 must, therefore, precede the construction of the fifteenth-century precinct wall. If feature AB pre-dates feature AB1, it must also date from before the fifteenth century construction of the mosque. If so, it seems likely that the whole of feature A1 pre-dates the construction of the fifteenth-century mosque, as the other evidence implies." In 2013 (p. 109) they withdrew the tentative identification they made in 2002 (p. 403) of an earthwork feature as a buried wall that predated the 15th-century Ottoman perimeter wall just to the east.

the mosque courtyard (fig. 15.9c; AC on fig. 15.10).[60] Today the masonry on the north side has been considerably tidied up.[61] Remains of a similar wall can be found along the north side of the cemetery courtyard. It protrudes several feet from the cemetery wall, and its size and distinct slope make no obvious structural sense for the Ottoman fifteenth-century wall above (fig. 15.9d; AE on fig. 15.10). Two further features observed by Dark and Özgümüş support the idea that the relatively slim Ottoman fenestrated cemetery wall was of a different date from the wide eroded blocks on which it rests. One is that the course of eroded masonry continued below the north-south perimeter wall of the enceinte, near Türbekapısı, which strongly suggests that it predates this perimeter wall, which originated under Mehmed.[62] Unfortunately, the masonry at this juncture has also been recently tidied. The second is that the north cemetery wall is not perfectly aligned with the eroded masonry on which it rests: it is "at a slight northwest to southeast angle" to the line of the eroded blocks on which it rests (fig. 15.9d).[63]

Dark and Özgümüş's plan shows the lines of these prior walls east and west of the current prayer hall (fig. 15.10). They suggest that there was a substantial structure (or aligned structures) here before Mehmed's mosque and raise the possibility that these might be remnants of the Holy Apostles: the lines on the west belonging to the enclosing walls of the nave, and the lines on the east to the courtyard that surrounded the Constantinian mausoleum.[64] The evidence that the mosque sits on top of at least part of an earlier structure seems to me compelling, and there are at least four further architectural features that can be added to Dark's and Özgümüş's observations:

SOCLE. The mosque at one time appeared to rest on a socle, and a drawing made by Francesco Scarella in the 1680s clearly differentiates the stonework of this socle from the ashlar above (fig. 15.4).[65] Evliya Çelebi noted that from the [surrounding] ground level to the floor of the prayer hall there was a height of 4 ells or not quite 3 meters.[66] High socles are not standard in imperial Ottoman mosques of the fifteenth and sixteenth centuries, but they do occur. In the case of the mosque of Mihrimah Sultan in Üsküdar and the Yeni Cami in Eminönü, they were necessitated by the mosques' proximity to the water's edge.[67] This was not the case with the mosque of Sultan Ahmed, the so-called Blue Mosque, which was built over part of the palaces of Rüstem Paşa and of Sokollu Mehmed Paşa, and ultimately of the Byzantine imperial palace just by the Hippodrome. Its high socle may have been a way to build over architectural remains and avoid painstaking removal. There may thus have been a parallel between Fatih Camii and the mosque of Ahmed I, if both used a high socle as a way of dealing with the presence of a substantial Byzantine structure.

STEPS. The socle necessitated comparatively high steps to access the mosque and courtyard from the esplanade, at least on the north and south sides. Each set of steps is divided by a huge platform we shall return to shortly. The platform creates an eastern and western sector of steps, which are each L-shaped. The steps are not only high but enormously wide, some 31 meters on the north side and 35.5 meters on the south side, wider than those of any other imperial mosque from the fourteenth to the sixteenth century (fig. 15.6).[68]

60 Dark and Özgümüş, "New Evidence," 403, fig. 9. See also p. 404, on where the heavily eroded ashlar and the north staircase adjoin.

61 I would like to thank Robert Ousterhout for taking some recent photos for me (December 2016).

62 Dark and Özgümüş, "New Evidence," 405–6, fig. 13.

63 "So that the eastern part of the north cemetery wall is set further back from the outer edge of the underlying block than its western end": Dark and Özgümüş, Constantinople, 110. The precise degree of that misalignment is not recorded, however.

64 Dark and Özgümüş, "New Evidence," 408.

65 F. Babinger, "Francesco Scarella e i suoi disegni di Costantinopoli (circa 1685)," Rivista d'arte 35 (1960): 9, fig. 9.

66 Evliya Çelebi, Seyâhatnâmesi, 138; idem, Narrative of Travels, 1.1:66; Gökyay, Evliya Çelebi Seyahatnâmesi, 57; Aga-Oglu, "Mohammedije," 85; Wulzinger, "Apostelkirche," 21.

67 Respectively, G. Goodwin, A History of Ottoman Architecture (London, 1971), 212–14, fig. 203, and 340, and figs. 338 and 339.

68 There are differing number of treads, ranging from 8 on the northwest stairway to 11 and 12 on the others. By way of comparison, the stairways at the mosque of Ahmed I have 10 to 12 treads, e.g., C. Gurlitt, Die Baukunst Constantinopels, 3 vols. (Berlin, 1907–12), 3: pl. 30d. On the steps incorporating pre-18th-century masonry, see Dark and Özgümüş, Constantinople, 108.

The plan of the current mosque made by Ekrem Hakkı Ayverdi in 1971 reveals that the steps are differently sized and poorly aligned (fig. 15.12).[69] Misalignments affect the sectors on the same side of the mosque, as well as the overall size and placement of the stairways on the north and south sides of the mosque. These differences could be put down to later rebuilding work, but they might have been caused by the presence of an earlier structure that had to be encased by these large stairways, whose lack of symmetry is highly unusual for an imperial mosque.

PLATFORMS ON THE NORTH AND SOUTH STAIRWAYS. In plan, the sectors of the stairways on each flank of the mosque can be read as a unit punctuated by a large square platform, but in reality they are so physically and visually divided that they function as two separate flights of steps, one leading to the prayer hall, the other to the courtyard.[70] Francesco Scarella clearly depicted the way in which these platforms interrupt the steps, and the platforms are still a prominent feature today. There is a symmetry between the platforms on the north and the south sides of the mosque, as they are in a similar position and of similar width and depth. They are well aligned, even if the steps that flank them are not. Each platform provides a support for a minaret, but the platform, at more than 15 meters, is much wider than required for that purpose.[71]

It can be argued that the combined width of the flights of steps and the platform was dictated by the desire to unify three separate features—the side entrances to the prayer hall and to the courtyard, and a base for the minaret. There is an indication, however, that it was also to obscure

some preexisting features, as the platform on the north side of the mosque rested on a couple of courses of the large eroded masonry. Only segments of this wall can be seen, however, as the base of the platform has been largely obscured by a new surround for a tree.[72]

WESTERN PLINTHS. On the outside of the west wall of the courtyard were two huge low plinths, about 11.5 meters deep, flanking the steps that lead from the esplanade into the court. The plinth on the south side still looks very much as it appears in Matrakçi Nasuh's depiction of Istanbul in 1538 and in Scarella's drawing of 1685 (figs. 15.11a and 15.4).[73] The outer faces of this south plinth were once composed of the same type of massive, well-worn masonry that we find in the three courses along the southern wall of the courtyard, but it has recently been refaced. Indeed, the three courses continue without a break, indicating that they were all part of the same phase of construction (fig. 15.11b).[74] The plinth on the north side was rebuilt higher in the eighteenth or nineteenth century to create a *yangın hafuzu*.[75] If we can rely, though, on Francesco Scarella's drawing of 1685, this northern plinth was also built of the massive ashlar, and several courses of the earlier ashlar were visible along the outer north wall of the main courtyard (fig. 15.9c).

Parallels can be found in other Ottoman mosques of the fourteenth to sixteenth century for some of these features;[76] yet when taken

69 Ayverdi, *Fâtih Devri*, fig. 577.

70 To avoid confusion, I have adhered to Dark and Özgümüş's description of the section between the stairs as platforms and the flat areas on the west of the mosque as plinths, even though these might more accurately be described as platforms, and the sections by the stairs as plinths, because they served as supports for the minarets.

71 There was a precedent for a minaret to rest on a separate-looking plinth at the Üç Şerefeli mosque in Edirne built some 25 years earlier by Mehmed's father, but the plinth of the eponymous minaret with the 3 balconies is not of the scale of those at Mehmed's mosque. A similar arrangement to that at Fatih Camii, with stairways into the prayer hall and the courtyard linked by a large plinth, can be found at the Valide Sultan Camii ("Yeni Cami") in Eminönü.

72 Dark and Özgümüş, "New Evidence," 404–5, figs. 10 and 11.

73 W. B. Denny, "A Sixteenth-Century Architectural Plan of Istanbul," *Ars Orientalis* 8 (1970): esp. 61, no. 66, and fig. 12 (where the reference to the catalogue is inadvertently given as no. 45). N. Atasoy, S. A. Kahraman, and R. Deniz, *Swordsman, Historian, Mathematician, Artist, Calligrapher: Matrakçı Nasuh and His Menazilname; Account of the Stages of Sultan Süleyman Khan's Iraqi campaign*, 2 vols. (Istanbul, 2015), 38–47, see fig. on p. 47 for an excellent color detail showing Fatih Camii. For Scarella's drawing from about 1685, see Babinger, "Scarella," 9, fig. 9; Necipoğlu, *Age of Sinan*, 86, fig. 61. On these plinths, and the southern one's relationship to the courtyard wall, see Dark and Özgümüş, *Constantinople*, 106–7, where the upper courses of the southern plinth are said to have been added in the late 20th century. They clearly abut and do not bond with the exterior face of the courtyard wall of the mosque (fig. 17.11b).

74 Ayverdi, *Fâtih Devri*, fig. 582.

75 W. Müller-Wiener, *Bildlexikon zur Topographie Istanbuls* (Tübingen, 1977), 406, fig. 481.

76 Scarella's reliability is open to some question, though. He depicted comparable "plinths" to those on the west of Fatih

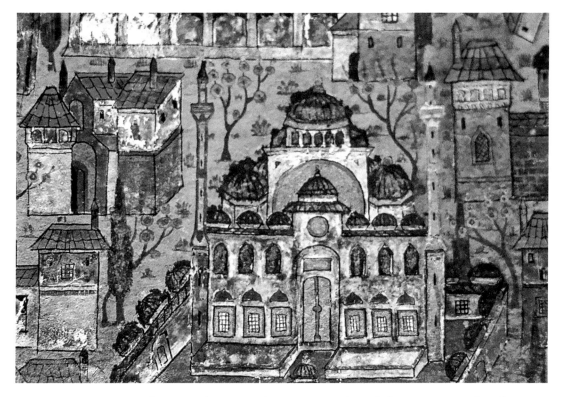

FIG. 15.11A. Fatih Camii from Matrakçı Nasuh's bird's-eye view of Istanbul, *Beyān-I Menāzil-I Sefer-I Irākeyn*, Istanbul University Library, MS Yıldız T5964 (photo by Walter Denny)

FIG. 15.11B. Fatih Camii, the three courses of ashlar running below the south wall of the courtyard of Fatih Camii and the external plinth (photo by Ken Dark)

together, they are most readily explained as features built over the remains of an earlier construction, since incorporation was an easier option than removal. The presence of an earlier building might also explain the discovery, when the paving of the courtyard was lifted in 1953, of a substantial quantity of sculpted marble fragments, which Semavi Eyice attributed "incontestably" to the period of Justinian, concluding that they belonged to the church of the Holy Apostles.[77]

All this suggests a prior building that was monumental in size and substantial in material and construction. The most obvious candidate is the church of the Holy Apostles, and Dark and Özgümüş have compared the construction technique of the eroded masonry courses with masonry in Constantinopolitan buildings of the fifth and sixth centuries.[78]

Skeptics will insist that only excavations or geophysical surveys can resolve the matter for certain. The two excavations to date have not, regrettably, produced the conclusive evidence one would hope. The excavations referred to by Eyice need indicate nothing more than that Mehmed's builders used Byzantine sculpture and other material as an infill, and that material could have come from a nearby building rather than a building on the very spot. Different excavations in 1949 revealed—some 3 meters south of the line of the ablution troughs (fig. 15.12) on the south side of the mosque, and 1.24 meters below the ground level—"three courses of cut-stone foundation."

This foundation wall was 1.33 meters high and was observed running a length of 10.5 meters.[79] The excavator, Nezih Fıratlı, published only a very brief reference to these finds, providing none of the above information. Tantalizingly, though, he said the remains found did not belong to the church of the Holy Apostles as first thought, concluding that this "increases the probability that the Mosque was not built on the site of the Church."[80] He did not give his reasons, and the passage has remained rather mysterious. A letter and accompanying drawings from Fıratlı to Paul Underwood, now held at Dumbarton Oaks, provide some details of the find, but no further explanation of Fıratlı's reasoning (figs. 15.13 and 15.14). The masonry wall evidently belonged to a substantial building aligned almost parallel to the courtyard of Mehmed's mosque.[81]

Camii at the mosque of Selim I and the Süleymaniye, and a high socle at Şehzade Mehmed Camii (Babinger, "Scarella," figs. 11, 12, and 13). He depicted stairs somewhat similar to those at Fatih Camii at Sultan Ahmed Camii (op.cit., fig. 14) though they are not similar to the current stairways. He was accurate, however, in representing the stairways on the north side of Yeni Cami (op.cit., fig. 15).

77 S. Eyice, "Les fragments de la décoration plastique de l'église des Saints-Apôtres," CahArch 8 (1956): esp. 71. For a stamped brick also found in the courtyard of Fatih Camii, see J. Bardill, Brickstamps of Constantinople, 2 vols. (Oxford, 2004), 1:220, cat. no. 3661 1.a; cf. 9, 242, cat. no. 546, 390, cat. no. 1606 1.a. (found near Fatih Camii); Dark and Özgümüş, Constantinople, 88. In 1912 workmen digging a canal "near the mosque of Mohammed the Conqueror" found some "well-preserved capitals with reliefs of Greek crosses" "as well as a number of columns, and parts of the walls of the temple," but there was apparently no proper record of the activities or the finds: Anon., "CONSTANTINOPLE—A Byzantine Temple," AJA 17 (1913): 132.

78 Dark and Özgümüş, "New Evidence," 406.

79 Nezih Fıratlı wrote to Paul Underwood providing some sketch plans (figs. 15.13 and 15.14) and the following brief note on the continuing excavations: "11/1/50 Istanbul

Dear Mr. Underwood: . . . The excavations on the south side of the Fatih Mosque have been carried on; under the exterior stairs of the Mosque were found fragments of foundations adjoining those we had examined previously. I have also marked those new finds in the plan, thinking they might interest you. The technique and mortar of the wall are the same as the foundations we examined." (Byzantine Institute Records, ICFA, MS.004-02-01-243—Excavation plans and drawings for Fatih Camii. I am grateful to Alyson Williams for her assistance). A description of the earlier phase of this excavation has yet to be found. However, it is possible to identify where the excavation referred to in the surviving letter took place (see fig. 15.14).

80 N. Fıratlı, "Excavations and Finds in İstanbul and Its Environment," Istanbul Arkeoloji Müzeleri Yıllığı 4 (1950): 41–42 (Turkish), 61 (English), merely states: "6. While levelling the ground around the Fatih Mosque at Istanbul, remains of foundations were discovered near the north and south walls of the Mosque. It was thought possible that they might belong to the Church of the Holy Apostles, but further investigations proved the contrary, which increases the probability that the Mosque was not built on the site of the Church." Cf. Dark and Özgümüş, Constantinople, 89.

81 Fıratlı's drawing (fig. 15.13) shows that the outer face of the excavated wall lay 3 meters south of the wall of the ablution troughs, which, in its turn, is about 2.25 meters from the south wall of the current mosque. (Note the faucet in the bottom of the cross-sections in fig. 15.14.) The south wall of the current mosque is set back from the line of the outer face of the courtyard, and Ayverdi insisted that in the 15th-century scheme the south wall of Mehmed's original mosque would have aligned with the courtyard, and not been set back as Anhegger (1954) argued. (Ayverdi's argument finds confirmation in the 15th-century ground plan discussed below, see fig. 15.16.) Nevertheless, the southern face of the prayer hall of Mehmed's mosque would still have been about 3.25 meters away from the wall found by Fıratlı. Fıratlı's wall must have belonged either to

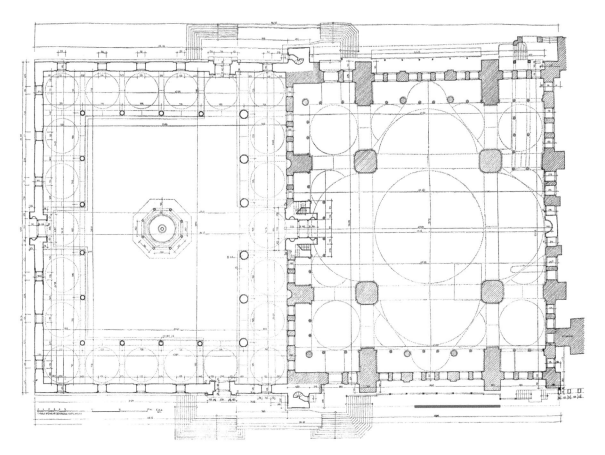

FIG. 15.12. Fatih Camii, as rebuilt in the 1760s (after Ayverdi, *Fâtih Devri*, fig. 578). The red line added here marks the position of the wall excavated 1.24 meters below ground level (Byzantine Institute Records, ICFA, MS.004-02-01-243—Excavation plans and drawings for Fatih Camii).

More revealing has been the GPR (Ground-Penetrating Radar) survey conducted after the major earthquake of 1999. While the survey was intended to ascertain how resilient the mosque might be to further earthquakes, the results of a large number of transects—293 in the mosque itself, and 126 in the courtyard—proved of considerable archaeological importance. They revealed two earlier structures below the prayer hall. One is at a depth of about 1.25 meters below the present floor level and in "approximately the same position as the present mosque."[82] Between this and the present floor level is rubble fill. The second structure lies twice as deep—2.5 meters below the present floor level.[83] Below that the

a very wide foundation for Mehmed's mosque or a Byzantine phase of construction. The excavated wall was found to be at a 1° angle SE to the current mosque wall, which might suggest that it did not belong to an Ottoman construction. However, Ayverdi's plan of the current mosque reveals that the 18th-century prayer hall was angled slightly to the NE compared to the courtyard. (This is most clearly visible in the northwest corner of the prayer hall.) We have also seen how the 15th-century northern wall of the cemetery was at a slight, if unspecified, angle towards SE compared to the earlier eroded wall on which it sat. Without further details it is perhaps unwise to conclude whether the excavated wall was Ottoman or Byzantine in date.

82 Dark and Özgümüş, *Constantinople,* 95.

83 Ö. Yılmaz and M. Eser, "Ground-Penetrating Radar Surveys at the Fatih Mosque and the Church of St. Sophia, Istanbul," *SEG Technical Program Expanded Abstracts 2005*, accessed 11 February 2017, https://library.seg.org/doi/abs/10.1190/1.2147879, 1125–1128. They observed a "sag" "at a location that coincides with the main entrance to the prayer hall. This sag is probably associated with the marble doorstep that has been eroded over a period of nearly three centuries." This confirmed their view that the "archaeological features . . . confined to within a depth interval of 1.25 m from the ground level . . . are most likely related to the debris of the first mosque built on the site which collapsed in the 1766 earthquake."

FIG. 15.13.
Excavations
undertaken by Nezih
Fıratlı in 1949 on
the south side of the
mosque. The upper
part of the drawing
shows the line of
ablution troughs just
above the excavated
area, highlighted in
red on fig. 12.

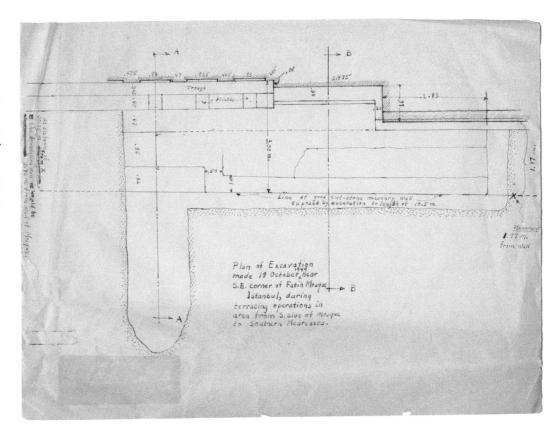

FIG. 15.14.
Section views of the
excavations undertaken by
Nezih Fıratlı in 1949 on the
south side of the mosque.
On the left are the ablution
troughs, indicated by the
tap in the lower of the two
cross-sections, see fig. 15.12.

Figs. 15.13 and 15.14:
Excavation plans and
drawings for Fatih Camii,
Byzantine Institute Records
ICFA, MS.004-02-01-243.

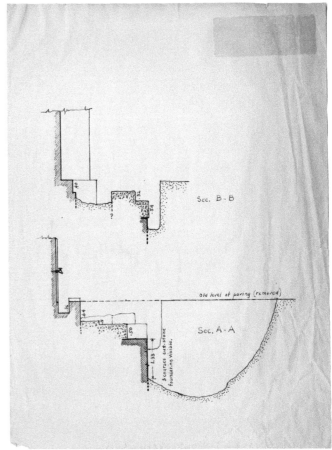

GPR data "are consistent with terrace make-up layers, and show what may be tip-lines."[84]

Öz Yılmaz and Murat Eser, who led the team that conducted the GPR survey, interpreted their results as evidence that the fifteenth-century mosque lies 1.25 meters below the current floor, with the church of the Holy Apostles below that. Dark and Özgümüş, however, observed that the entrance portal to the prayer hall dates from Mehmed's construction and, as the portal "stands above present floor-level," they argue this indicates that "the floor-level in the fifteenth century was closer to that of the current building." Their conclusion is not expressly stated, but the implication is that the structure 1.25 meters below ground is the Justinianic Holy Apostles, and the structure at 2.5 meters, the Constantinian. It will require further investigation to resolve which building should be associated with which archaeological layer, but for our purposes the GPR survey provides strong evidence that there was a Byzantine building on the site that predated Mehmed's mosque. The Holy Apostles is the logical candidate.

The courtyard transects also revealed two phases, which Yılmaz and Eser interpreted as rubble above the terrace. Dark and Özgümüş suggested, "These might be explained if the Byzantine church had first been demolished (to form the lower rubble layer) and then its shell was filled with more rubble to form a level platform for the courtyard."[85] At first glance it might not seem logical that remains of a church were left below the prayer hall but more comprehensively demolished under the courtyard. But there is a possible explanation: the courtyard pavement slopes noticeably toward the central fountain, and the pavement's lowest level is just under 1 meter lower than the floor of the prayer hall.[86] To create this slope in the courtyard, the builders presumably had to dig deeper than in the area of the prayer hall.

The Azimuth of the Qibla

For the physical evidence connected to the mosque, I have relied on the observations of Dark

and Özgümüş. However, their claims have not found wide acceptance. Jonathan Bardill, for example, recently described them as "incredible," arguing, the church of Constantine or Constantius "is most unlikely to have been built by chance on the exact alignment (about 141°) that would later be required for the qibla of the Fatih mosque (and about forty-five other mosques of the Fatih period: Barmore 1985, 87)."[87]

This appears at first sight to be irrefutable, but the issue is not so straightforward. Fatih Camii is not on the same bearing as most of the other mosques built in Istanbul during Mehmed's reign, nor is it on the same bearing as the principal sixteenth-century imperial mosques in Istanbul. If Fatih Camii's azimuth of the *qibla* was atypical, and if the mosque was built over the church of the Holy Apostles, an obvious question is whether its alignment was determined by that of the church. Research is still in progress, but it appears that the Justinianic church may have been aligned to coincide with the position of the sun at noon on the Feast of the Holy Apostles, 30 June 536, the year the empress Theodora laid the first stone. The azimuth then would have been 143.98°E, which is close to the azimuth of the qibla of Fatih Camii, which appears to be 143.25°E. An even closer match, 143.51°E, would have been at noon on 28 June 536, the 28th being the day when the church was consecrated in 550. I would argue that the orientation of Mehmed the Conqueror's original Fatih Camii was atypical, and that this anomaly was caused by the alignment of the Holy Apostles.[88]

84 Dark and Özgümüş, *Constantinople*, 95.

85 Ibid., 95.

86 See the cross-section in Ayverdi, *Fâtih Devri*, fig. 579.

87 Bardill, *Constantine*, 390n222.

88 I owe considerable thanks to Iakovos Potamianos for calculating the sun's position on a variety of years, day, and times. We hope to return to the issue in due course.

It has variously been stated that the azimuth of the *qibla* (Az) of Fatih Camii is correctly aligned to Mecca or to the orientation of 15th- and 16th-century Istanbul mosques (respectively, Fatih Camii, Istanbul, Turkey, Archnet, accessed 3 March 2016, https://archnet.org/sites/1982, and Bardill, *Constantine*, 390n222). In both cases, this means that its alignment was not dictated by the orientation of the Holy Apostles: the mosque was an *ex novo* construction. However, there are not only problems with the claim, but also evidence that the orientation of the Holy Apostles could have been along the same alignment as the current mosque. In other words, the mosque could have been built over the church. First, published readings of Fatih Camii's Az range impossibly from 148°E to 141°E. Ayverdi's figure of 148°E must have been one he took in the middle of the last century without allowing for magnetic

declination, which today is +5° 31' [+5.52°], while readings given by Wulzinger (143.5°E) and Frank Barmore (145°E and 141°E) are derived from maps issued shortly after the end of the First World War (Wulzinger, "Apostelkirche," 11–13, 25; F. E. Barmore, "Turkish Mosque Orientation and the Secular Variation of the Magnetic Declination," *JNES* 44 [1985]: 81–98, and 96–97 for an Appendix on Ayverdi's readings). A reading taken with the internet program Set Compass, developed by the Barcelona Field Studies Centre, yields 143.25°E, which supports Wulzinger's figure. While we clearly need confirmation from on-site readings, Set Compass's general reliability was confirmed by checks made against the known orientation for Hagia Sophia and the mosques of Yavuz Selim, Sultan Bayezid, Şehzade, and the Süleymaniye.

Fatih Camii's Az of 143.25°E was not typical of the 70 mosques built in Istanbul during Mehmed Fatih's reign whose alignment was recorded by Ayverdi (who came to acknowledge magnetic declination), including the Kumrulu mescid (140°E) which was built by Atik Sinan, the architect of Fatih Camii (Ayverdi, *Fâtih Devri*, 439–42, esp. 440). This is puzzling, as one might reasonably expect the same architect to have used the same qibla orientation for two mosques built nearby and in the same decade. Fatih Camii's Az is also some 5 to 6 degrees greater than the azimuths of the imperial mosques of 16th-century Istanbul (cf. Wulzinger loc. cit.; Barmore op. cit.). As the most important mosque of its period, Fatih Camii should have established the norm for mosque orientation in Istanbul. It did not.

An alternative approach is to consider the orientation of Fatih Camii in relation not to Istanbul's mosques but to the city's Byzantine churches. Recent studies have shown that while most churches in the areas of Constantinople and Thessalonike were oriented SE, they were subject to considerable variation due to three principal factors: topographical constraints; preexisting urban and architectural features; and, most interestingly, the freedom to choose an azimuth from a variety of different solar events, such as solstice or equinox, or to the position of the sun at either Terce or noon on the feast day of the church's patron saint. See Y. Iliades, "The Orientation of Byzantine Churches in Eastern Macedonia and Thrace," *Mediterranean Archaeology and Archaeometry* 6, no. 3, special issue (2006): 207–12; I. Liritzis and H. Vassiliou, "Further Solar Alignments of Greek Byzantine Churches," idem, 7–26; Liritzis and Vassiliou, "Does Sunrise Day Correlate with Eastern Orientation of Byzantine Churches on Significant Solar Dates and Saint's Days? A Preliminary Study," *BZ* 99, no. 2 (2006): 523–34; T. G. Dallas, "On the Orientation of Byzantine Churches in Thessalonike," *Mediterranean Archaeology and Archaeometry* 15, no. 3 (2015): 213–24; W. Jabi and I. Potamianos, "Geometry, Light, and Cosmology in the Church of Hagia Sophia," *International Journal of Architectural Computing* 5, no. 2 (2007): 303–19; and N. Schibille, "Astronomical and Optical Principles in the Architecture of Hagia Sophia in Constantinople," *Science in Context* 22 (2009): 27–46.

Regarding topography, the argument has been made that the alignment of the Holy Apostles was influenced by the route of the Byzantine Mese (Dark and Özgümüş, "New Evidence," 407), but the route of this branch of the Mese is highly contested: C. Mango, "The Triumphal Way of Constantinople and the Golden Gate," *DOP* 54 (2000): 173–88; Berger, "Streets and Public Spaces," 161–72; M. Cerasi, "The Urban and Architectural Evolution of the Istanbul Divanyolu: Urban Aesthetics and Ideology in Ottoman Town Building," *Muqarnas* 22 (2005): 189–232, esp. 193 and notes; M. Cerasi,

The Courtyard and the Western Plinths

So far we have seen anomalies in the architecture and construction of Fatih Camii that can be explained if Mehmed's mosque sat right on top of the Holy Apostles. His architect would have found it easier to incorporate some of the features of the Holy Apostles into the mosque than remove them entirely. This point can be underlined by looking again at the unusual plinths outside the western façade of the courtyard.

Mehmed's mosque followed the imperial prerogative of a porticoed courtyard, but it was the first mosque in which the courtyard was almost equivalent in size to the prayer hall of the mosque. Yet it was originally conceived to be even bigger. An architectural plan datable on the basis of its watermark to the second half of the fifteenth century represents, as Gülru Necipoğlu has shown, an earlier concept for Mehmed's mosque (cf. fig. 15.15).[89] Support for this identification can be found by laying this plan over Ayverdi's reconstruction of Mehmed's original mosque (fig. 15.16). The plan indicates enormous steps on the north and south sides, but also

E. Bugatti, and S. D'Agostino, *The Istanbul Divanyolu: A Case Study in Ottoman Urbanity and Architecture,* Istanbul Texte und Studien 3 (Wurzburg, 2004). Astrogeodetic calculations for Justinian's Holy Apostles appear more promising.

The church's first stone was laid in 536, though the day is not recorded. It might have been on the patronal day, the Feast of the Holy Apostles, which is celebrated on 30 June. At noon on 30 June 536 the azimuth of the sun for a building on the exact site of the present Fatih Camii would have been 143.98°E (www.findmyshadow.com/). There is though an even closer bearing. Justinian's Holy Apostles was consecrated on 28 June 550, so it is possible that 28 June was also the day the first stone was laid: Malalas, CSHB, 484; Kedrenos CSHB, 658–59; Zonaras, 14.7; Heisenberg, *Apostelkirche*, 118; Theodore Reinach, "Commentaire archéologique sur le poème de Constantin le Rhodien," *REG* 9, fasc. 33 (1896): 93–94; Bardill, *Brickstamps*, 37. At noon on 28 June 536 the azimuth of the sun for a building on the exact site of the present Fatih Camii would have been 143.51°E.

We now have a possible explanation for Fatih Camii's somewhat anomalous azimuth: it could have been based on the orientation of Justinian's Holy Apostles, which was derived from the position of the sun at noon on the day when the first stone was laid, in the presence, so later Byzantine sources claim, of Empress Theodora (Downey, "Nikolaos Mesarites," 862n8; to which can be added Zonaras, 14.7).

89 G. Necipoğlu, "Plans and Models in 15th- and 16th-Century Ottoman Architectural Practice," *JSAH* 45 (1986): 229–30; eadem, *Age of Sinan,* 84 and fig. 62; Kafescioğlu, *Constantinopolis/Istanbul,* 75, fig. 41.

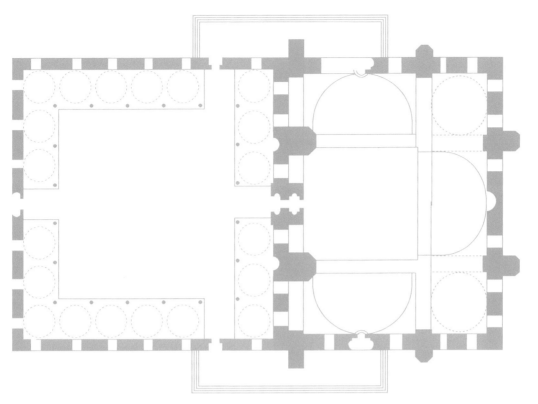

FIG. 15.15.
Ground plan developed from a partial fifteenth-century Ottoman plan for Fatih Camii. It shows three semidomes flanking the central dome, and a courtyard extended one bay further to the west than the mosque Mehmed II actually built (drawing by Karl Gelles after Kafescioğlu, *Constantinopolis/Istanbul*; the original plan is in the Topkapi Museum Archives 9495/8).

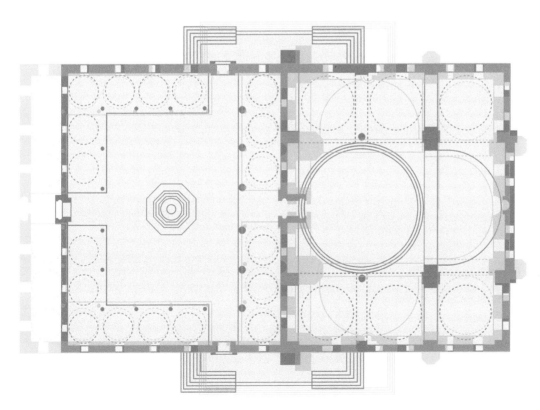

FIG. 15.16.
Unexecuted fifteenth-century concept plan for Fatih Camii, in blue (see fig. 15.15) overlaid onto Ayverdi's proposed ground plan, in gray, of Fatih Camii as built by Mehmed the Conqueror (drawing by Karl Gelles after Ayverdi, *Fâtih Devri*, fig. 577; drawing by Karl Gelles)

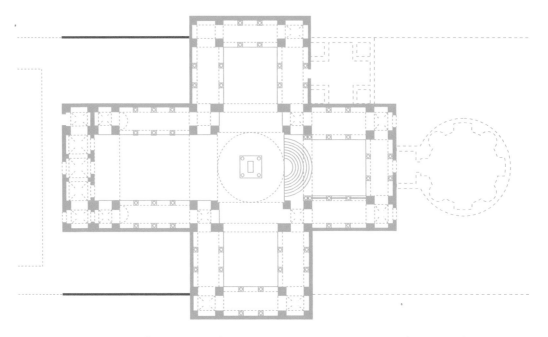

FIG. 15.17A. Plan of Justinian's church of the Holy Apostles following Karydis (this volume). The red lines have been added to indicate the relative position of the basal courses of eroded masonry along the courtyard of Fatih Camii (see figure 15.10).

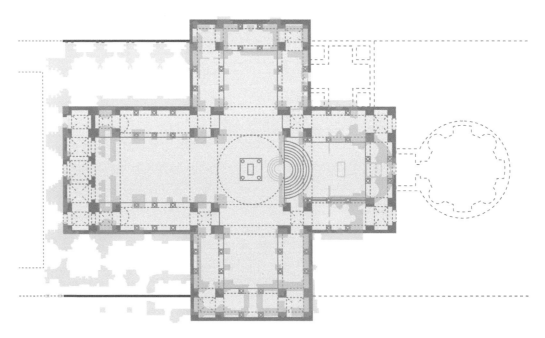

FIG. 15.17B. Plan of the Holy Apostles, in gray (fig.17a), overlaid onto a plan, in blue, of the Basilica of San Marco, Venice (the plans are not to relative scale)

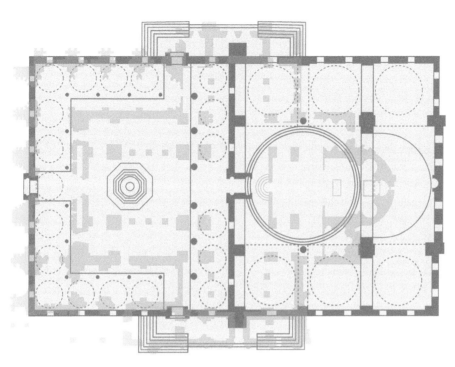

FIG. 15.17C. Plan of the Basilica of San Marco, in blue, overlaid onto Ayverdi's plan, in gray, of Mehmed's Fatih Camii (the plans are not to relative scale)

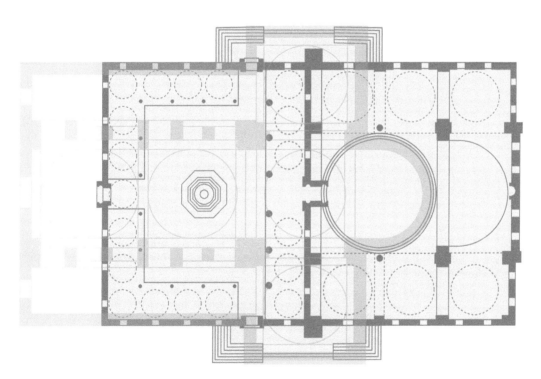

FIG. 15.17D. Plan of San Sabino in Canosa, in blue (after Epstein, "Canosa"), overlaid onto Ayverdi's plan, in gray, of Mehmed's Fatih Camii (the plans are not to relative scale)

Figs. 15.17a, b, c, and d:
Drawings by Karl Gelles

shows the courtyard extending further west than the current courtyard, which is accepted to date from Mehmed's construction. That additional area corresponds to the depth of the two plinths west of the courtyard. These plinths, then, might well cover remnants of the floor and foundations of the propylaeum of the Holy Apostles mentioned in the *Book of Ceremonies*.[90]

This suggests that the size and proportions of Mehmed's courtyard were not prompted solely by an internal evolution in Ottoman architectural aesthetics, but in part by the opportunities and challenges of the plan of the Holy Apostles. The Üç Şerefeli mosque in Edirne, which was built for Mehmed's father, Murad II, and was the immediate predecessor of Fatih Camii, was the first imperial mosque to feature a courtyard integral with the prayer hall; in this case the courtyard was larger than the prayer hall. The normative approach to courtyards that obtained in imperial Ottoman mosques of the sixteenth and seventeenth centuries—with courtyards equivalent in size to the prayer hall—was not a teleological inevitability in the evolution of Ottoman architectural aesthetics. The turning point was the Fatih Camii, where the foundations of the Holy Apostles were a key determinant. They were not, though, the sole determinant, as Mehmed's architects initially planned to incorporate the area of the western platforms into the courtyard but revised the plan once they realized how ungainly the result would be. In modifying the courtyard to its current size, they could make good use of the key foundations of the Holy Apostles and yet produce a courtyard that established a norm.

There is, however, a problem with this argument. The most scrupulous reconstruction of the layout of the church of the Holy Apostles is that by Nikolaos Karydis in this volume (fig. 15.17a).[91]

His work is based on combining a re-reading of the textual accounts of the church of the Holy Apostles with archaeological and architectural data from the church of St. John in Ephesos. In Karydis's plan the four arms are similar in width. This would mean, though, that, if the end of the transept arms of the Holy Apostles coincided with the plinths on the north and south sides of Fatih Camii, the width of the entrance arm of the Holy Apostles would be narrower than the width of Mehmed's courtyard. The western arm of the Holy Apostles was only about 30 meters wide in Karydis's reconstruction.[92] This compares to a width of almost double—58 meters—for the courtyard of Fatih Camii. This can be seen on figure 15.17a, where the position of the outer north and south walls of Mehmed's courtyard are marked in red. Put another way, if the north and south walls of the courtyard of Fatih Camii rested, as we have seen, on the remnants of much earlier walls, it is difficult to reconcile those remains with the dimensions of the entrance arm of the Holy Apostles in Karydis's reconstruction. Is there a solution?

Changes to the Holy Apostles

Karydis's reconstruction is of Justinian's Holy Apostles, including its relationship to the Mausoleum of Constantine, and does not extend to possible later changes. Indeed, the extent and dating of any alterations to Justinian's Holy Apostles have caused disagreement among scholars. The focus, though, has been on putative changes to the church's mosaic cycle and on a major shift in Byzantine aesthetics from an iconic to a more narrative and liturgical iconography, in which changes to the mosaics in the Holy Apostles

90 On the propylaeum, see *De cer.*, II, 13, ed. Reiske, 558; however, J. M. Featherstone, "All Saints and the Holy Apostles: De cerimoniis II, 6–7," *Νέα Ῥώμη* 6 (2009): 246n51, raises the possibility that the propylaeum referred to the Horologion (see his sketch plan). Wulzinger, "Apostelkirche," 34–35, suggested the platforms might be remnants of the double narthex of the Holy Apostles, and provides two possible explanations of why they were not removed. For Scarella's depiction of them, see Babinger, "Scarella," 9, fig. 9; Necipoğlu, *Age of Sinan*, 86, fig. 61.

91 For a convenient assemblage of the five most important interpretations from the late 19th and early 20th century, see

Soteriou, "Ἀνασκαφαί," 204; also Wulzinger, "Apostelkirche."

92 Karydis in part derived this measurement from the dimensions of the north and south staircases of the current Fatih Camii, but he expresses caution: "in the absence of any conclusive evidence for the identification of this structure as the church of the Holy Apostles, these deductions remain speculative." We need to be alert, then, to circular reasoning: Karydis's hypothetical plan of the Holy Apostles may have connections to that of Mehmed's Fatih Camii because he has chosen to adopt a scale for the church based on a key feature of the mosque. On the other hand, a width of 30 meters for the cross arms of the Holy Apostles is between the width of the cross arms of the related churches in Venice and Ephesos, which were some 25 and 32 meters, respectively.

purportedly played a seminal role. Less attention has been paid to changes in the architecture.[93]

Richard Krautheimer posited a major architectural intervention to the superstructure, in particular the domes, in the tenth century, but Annabel Wharton Epstein has called the argument into question.[94] There can be no dispute, however, that a century earlier Basil I (r. 867–886) commissioned repairs of the Holy Apostles, among his construction or repairs of some thirty other monuments in Constantinople. At the Holy Apostles he installed buttresses, reconstructed ruined areas, and "thus he did wipe off the <traces of> old age and the wrinkles left by time and rendered the church beautiful and wrought new again," as his grandson Constantine VII Porphyrogennetos put it.[95] The exact nature and extent of these works is unknown, but there has been surprisingly little attention paid to possible changes in the ground plan of the Holy Apostles, whether under Basil I or later.[96]

We can best determine whether there were changes in the ground plan of the Holy Apostles under the Macedonian dynasty by looking at correlate buildings. The church of St. John in Ephesos was built under Justinian and clearly echoes Procopius's description of the Holy Apostles: a cruciform building with the western arm sufficiently longer than the others to create the form of a cross.[97] Five hundred years later, over the course of the second half of the eleventh century, the church of San Marco in Venice was rebuilt in conscious emulation of the Holy Apostles, and it can be argued that this rebuilding reflected intervening changes to the church in Constantinople.

If we overlay a plan of San Marco on Karydis's plan of Justinian's Holy Apostles, and scale them so that their central axes are of similar length, we can note a major discrepancy (fig. 15.17b). The western arm of San Marco was ringed on three sides by vestibules—a narthex, in this instance usually referred to as the atrium, which embraced the west entrance and ran along the north and south sides of the nave. The result was that the four arms of the church were not of equal width: the western arm was twice the width of the other arms.[98]

If we superimpose a plan of San Marco on that of Fatih Camii and scale the two plans so that the ends of the transept arms of San Marco coincide with the steps of the "north" and "south" staircases of the mosque, the basilica's west arm is almost exactly the same width as the mosque's courtyard (fig. 15.17c). In other words, if the Holy Apostles at one time had a U-shaped narthex proportional to that at San Marco, the stones seen below the Ottoman masonry of the walls of Mehmed's courtyard could be the remnants of the exterior walls of that narthex.

The similarities can hardly be fortuitous and suggest conscious emulation. This, in turn, points to a widening of the western arm of the Holy Apostles. San Marco, though, fails to provide indisputable indication of when that change occurred, as the alterations that created the

93 Dagron, "Théophanó," 218, provides a sketch plan of the complex in the 10th century, which he believes was remodeled after the burial of St. Theophano, but for the main building on the site—the Holy Apostles—he relies on Soteriou's plan of Justinian's church.

94 R. Krautheimer, "A Note on Justinian's Church of the Holy Apostles in Constantinople," in *Mélanges Eugène Tisserant*, ST 232 (1964): 265–70; A. W. Epstein, "The Rebuilding and Redecoration of the Holy Apostles in Constantinople: A Reconsideration," *GRBS* 23 (Spring 1982): 79–82. Epstein, however, verges on the economical when dealing with Krautheimer's argument, especially in relation to the visual evidence of the homilies of James of Kokkinobaphos: these do suggest a change in the domes.

95 *Vita Basilii*, 5.80, in *Theophanes Continuatus*, ed. I. Bekker, CSHB (Bonn, 1838), 323; ed. I. Ševčenko, *Chronographiae quae Theophanis continuati nomine fertur liber quo Vita Basilii Imperatoris amplectitur*, CFHB, Series Berolinensis 42 (Berlin and New York, 2011), 266 (Greek), 267 (English). See also Epstein, "Rebuilding and Decoration," 81, citing C. Mango, *The Art of the Byzantine Empire 312–1453* (Englewood Cliffs, NJ, 1972), 192.

96 Cf. S. Bettini, *L'architettura di San Marco: Origini e significato* (Padua, 1946), 60–61, 67–68, criticized previous reconstructions of the Holy Apostles because they did not take into account a major rebuilding he dates to between 930 and 940. However, he misinterpreted a passage in Theophanes Continuatus that referred to the rebuilding of an apostle church in Hieria (modern Fenerbahçe) as referring to the Holy Apostles: O. Demus, *The Church of San Marco in Venice: History, Architecture, Sculpture* (Washington, DC, 1960), 91n129.

97 Procopius, *De aed.*, 1.4.13, ed. and trans. Dewing, *On Buildings*, 48–51; Heisenberg, *Apostelkirche*, 118–19.

98 Quite apart from the many practical and ceremonial advantages of these galleries, this additional width gave San Marco a more extended and impressive façade. Even without the narthex, the western and eastern arms were somewhat wider than the transept arms.

U-shaped narthex of San Marco are generally dated to the thirteenth century rather than to the rebuilding that began in 1063.[99]

Confirmation that the Holy Apostles was altered comes from another church in Italy that looked to the Constantinopolitan basilica as a model.[100] This is the church of San Sabino in Canosa, which in its original form was a cruciform basilica with five domes. Although it did not have an encircling narthex, its nave was flanked by aisles. These made its western arm approximately twice the width of its transept arms—in other words, the same proportions as San Marco with its U-shaped narthex (fig. 15.17d). According to Annabel Wharton Epstein, San Sabino was built toward the middle of the eleventh century, a decade or more before the Venetians began rebuilding San Marco, and it drew its inspiration directly from the Holy Apostles rather than from Venice, a conclusion supported by Canosa's relationship with Byzantium at the time.[101]

Two five-domed cruciform basilicas were independently constructed in different parts of the Italian peninsula in the eleventh century, and one, if not both, employed a 2:1 ratio between the widths of the nave arm and the other three arms of the cross. This strongly suggests that their common model—the Holy Apostles—had a wider western arm by the mid-eleventh century at the latest. A narthex at the Holy Apostles is referred to on several occasions in the *Book of Ceremonies*. The widening is most easily explained by the addition of galleries on its north and south faces.

All the major attempts to reconstruct the ground plan of Justinian's church—by Hübsch, Reinach, Gurlitt, Heisenberg, Wulff, Soteriou, Bettini, Underwood, and Karydis—include a narthex,[102] but Heisenberg and Bettini are the only scholars to depict it as U-shaped.[103] Heisenberg based his reconstruction on two passages in the *Book of Ceremonies* that describe the emperor's involvement in ceremonies at the Holy Apostles.[104] Neither passage provides

99 On Karydis basing the dimensions of the transept arms of the Holy Apostles in part on the width of the current steps of Fatih Camii, see note 92, above. For a late date for the narthex, see Demus, *Church of San Marco*, 76–77. However, R. Cecchi, M. Baldan, and N. Martinelli, *La Basilica di San Marco: La costruzione bizantina del IX secolo, permanenze e trasformazioni* (Venice, 2003), 80n135, notes that fragments of mosaics of the 11th century were found in 1913–14 near the Porta di Sant'Alipio, indicating that the northwest corner of the narthex dated to the Contarini phase of San Marco. John Warren boldly proposed that San Marco had a U-shaped narthex in the 9th century: J. Warren, "The First Church of San Marco in Venice," *Antiquaries Journal* 70 (1990): esp. 330, 332, 346. His reconstruction of the first church has proved controversial: see R. J. Mainstone, "The First and Second Churches of San Marco Reconsidered," *Antiquaries Journal* 71 (1991): 123–37; and A.H.S. Megaw, "Reflections on the Original Form of St. Mark's in Venice," in *Architectural Studies in Memory of Richard Krautheimer*, ed. C. L. Striker (Mainz, 1996), 107–10. Ferdinando Forlati did not envisage a U-shaped narthex in his analysis of this earliest phase: F. Forlati, *La basilica di San Marco attraverso i suoi restauri* (Trieste, 1975), 47–52. Cecchi et al., *Basilica di San Marco*, 203, 83, notes that the narthex is structurally separate from the Greek cross of the main building, and writes on the narthex not belonging to a single campaign (132–33). John Warren's speculation about the earlier building does not, however, necessarily invalidate his criticisms of the Gothic date commonly accepted for the northern gallery (Warren, "First Church," 332).

100 Saint-Front in Périgueux does not, however, seem to have had a wider entrance nave.

101 A. Wharton Epstein, "The Date and Significance of the Cathedral of Canosa in Apulia, South Italy," *DOP* 37 (1983): 79–90. For a wide-ranging discussion of derivatives of the

Holy Apostles, see T. Papacostas, "The Medieval Progeny of the Holy Apostles: Trails of Architectural Imitation across the Mediterranean," in *The Byzantine World*, ed. P. Stephenson (London, 2010), 386–405.

102 Soteriou, "Ἀνασκαφαί," 204.

103 Heisenberg, *Apostelkirche*, 113, fig. 1. Bettini, *San Marco*, plate VIII.

104 The first passage, *De cer.*, I, 10, ed. Reiske, 76–80, mentions the emperor entering to take his seat in the narthex, but there is nothing to suggest a side gallery. The second passage (II, 6, ed. Reiske, 532; Featherstone, "All Saints," 238 and 242) mentions the emperors entering the narthex from the fountain court and "heading left towards the east of the narthex itself" to take their seats before entering the main church. The contrast is intriguing because the phrase ἐκνεύουσιν ἀριστερὰ πρὸς ἀνατολὴν τοῦ αὐτοῦ νάρθηκος might refer to the northeast side of the narthex or a gallery that extended eastward from the left end of the narthex. Almost the identical directional phrase ἐκνεύουσιν ἀριστερᾷ πρὸς ἀνατολὴν τοῦ αὐτοῦ βήματος occurs 6 lines later: after the emperors have entered the church they head east of the bema to go to the Mausoleum of Constantine. In this case the phrase seems to indicate that they were heading east of the bema rather than to the eastern end of the bema. (Featherstone, "All Saints," 242–43, note 36, offers a different understanding.) Ann Moffatt read the phrase in both cases to mean the equivalent of "on one's left as one is facing east": Constantine Porphyrogennetos, *De cerimoniis*, trans. A. Moffatt, *The Book of Ceremonies*, 2 vols., ByzAus 18 (Canberra, 2012), 2:532–33. This is an attractive suggestion in light of the different dating of our two main passages. As Paul Magdalino has pointed out in this volume, the first passage is thought to belong to a text "written or revised in the mid-ninth century," whereas the second was added perhaps between 956 and 959

incontrovertible evidence of side galleries,[105] although Jean Ebersolt and Janin also believed the narthex enveloped the entire western arm of the Holy Apostles.[106]

Heisenberg included a U-shaped narthex as part of Justinian's original scheme.[107] This error does not mean, though, that the western arm remained the same size as the other arms. While the textual evidence is far from conclusive, the evidence of the correlate buildings suggest that the nave arm of the Holy Apostles was widened by adding galleries or possibly porticoes on the north and south flanks. We might attribute this work to Basil I, given that he made a substantial renovation of the Holy Apostles, and given that he included porticoes along the north and south flanks of his most important ecclesiastical construction, the Nea Ekklesia in the precinct of the Great Palace.[108]

Put briefly, if vestibule galleries were added some time before the middle of the eleventh century to the north and south sides of the western arm of the Holy Apostles, they would have altered the proportions of Justinian's church, provided a model for San Marco and San Sabino, and created a western arm the outer walls of which would have run where today we can see the scarred remains of masonry that lie beneath the ashlar of Fatih's courtyard.

The preceding evidence and arguments suggest, I would contend, that Mehmed's mosque lay over the church of the Holy Apostles and used some of its key foundations. When Hafız Hüseyin al-Ayvansarayî wrote in his *Garden of the Mosques* that "The site of [Fatih Camii] was previously the location of a church. After falling into ruin, it remained unrestored. In that place, the above-mentioned sultan built a blessed mosque with two minarets, each with one balcony," we might take him literally about the location (see below n. 119). At the very least, this meant that Mehmed built his tomb close by the Mausoleum of Constantine. That would have been, in Berger's words, "an act of enormous symbolic meaning." We can, however, be more precise, and the result is arguably even more remarkable.

The Mausoleum of Constantine

Karydis indicates that there were two likely ways in which the Holy Apostles connected with Constantine's mausoleum: either the two were contiguous or there was an intervening hall. Karydis expresses a general preference for the former. If

under Constantine VII and refers to him and his co-emperor Romanos II. Following Moffatt's reading, I would venture to suggest that the use of πρὸς ἀνατολὴν to qualify the word "left" might have been an attempt by Constantine Porphyrogennetos to clarify the unmodified use of the terms left (and right) in earlier texts. See Underwood below, Appendix E, 384–85.

105 Heisenberg, *Apostelkirche*, 135–38, argued that a northern wing made better sense of elements of the ceremonial, as it was unlikely the emperor disrobed in the left-hand end of the narthex, when the "whole court" assembled in the narthex to enter the church. But there are several passages that refer to a curtain, and *De cer.* II, 13, ed. Reiske, 558, describes emperors sitting in the narthex, screened off by young courtiers, so that they could not be so easily seen.

106 J. Ebersolt, *Sanctuaires de Byzance: Recherches sur les anciens trésors des églises de Constantinople* (Paris, 1921), 33; Janin, *Églises et les monastères*, 47. Neither explains their reasoning. Ebersolt cites Heisenberg and the same passages Heisenberg cites, which suggests he may just have been copying. Janin cites another section of the *Book of Ceremonies* (*De cer.* II, 13, ed. Reiske, 558), but it is not clear what he saw there that would indicate a side gallery; in fact, possibly the contrary, as explained here in the previous footnote.

107 If the narthex of Justinian's church had flanking wings, it is surprising Procopius made no mention of the fact. While one should generally be cautious about arguments from silence, in this case the silence can be telling, as Procopius's description of the Holy Apostles is his most detailed architectural description, and in it he emphasized difference and similarity: the western arm, he said, was longer and the four flanking domes the same size as the central dome. A wider western arm would surely have prompted a word of contrast. See Procopius, *De aed.*, 1.4.13–17, ed. and trans. Dewing, *On Buildings*, 48–51; Heisenberg, *Apostelkirche*, 118–119. See G. Downey, "The Builder of the Original Church of the Apostles at Constantinople: A Contribution to the Criticism of the 'Vita Constantini' Attributed to Eusebius," *DOP* 6 (1951): 66, on this being the most architecturally detailed description in Procopius's treatise.

108 *Theophanes Continuatus: Vita Basilii*, ed. Bekker, 28; *Chronographiae*, ed. Ševčenko, 278, 280 (Greek), 279, 281 (English). Chapter 86: "When you leave the temple through the northern door, you enter a long barrel-vaulted portico [περίπατος] whose ceiling is splendidly adorned with encaustic [?] paintings. . . . If, however, you should leave through the southern door facing the sea and wish to process eastwards, you will find another portico [δίαυλον] equal in length and direction to the northern one; it, too, runs as far as the imperial playing field where emperors and scions of the high-born are wont to play ball on horseback. . . . As for the space to the east of the church that is enclosed between the two porticoes [μέσον τῶν δύο περιδρόμων], the emperor turned it into a garden." On the Nea Ekklesia, see P. Magdalino, "Observations on the Nea Ekklesia," *JÖB* 37 (1987): 51–64.

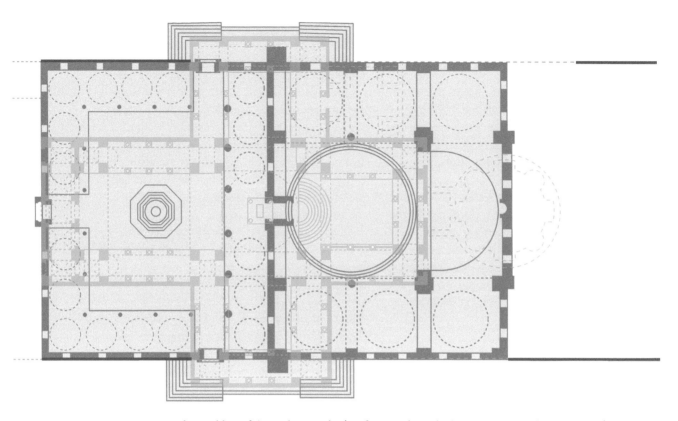

FIG. 15.18. Plan, in blue, of the Holy Apostles (see fig. 15.17a) overlaid onto Ayverdi's plan, in gray, of Fatih Camii as built in the fifteenth century (see fig. 15.6). It shows the transept arms coinciding with the steps. The red lines indicate the remains of earlier masonry (see fig. 15.10). On the east the proposed center point of Constantine's mausoleum lies almost exactly under the mihrab.

we overlay Ayverdi's plan of Mehmed's original mosque over Karydis's plan of the Holy Apostles, there is the major divergence in the width of the entrance arm compared to the width of the mosque's courtyard, a point we have just examined (fig. 15.18). There are, though, impressive points of convergence. If the entrance façade of the Holy Apostles was sited where the west entrance wall of the mosque courtyard stands, the church's transept arms fall in the middle of the mosque's broad external staircases. Their ends correspond almost perfectly in width and depth to the flat landings at the head of those flights of stairs, and are neatly framed by the steps. The termination of the church's transept arms at this point makes sense of Fatih Camii's unusually wide steps and its intervening platforms, for it would have been much easier for Mehmed's builders to sheathe the bulk of the masonry remnants of the church with ashlar than to remove them completely.

The remains of earlier courses of masonry provide clues that Fatih Camii sits astride the remains of the Holy Apostles; the coincidence of the church transept and the mosque's staircases provides strong corroboration. If Karydis's reconstruction accurately depicts the original ground plan of the Holy Apostles, and Ayverdi's the original ground plan of Fatih Camii, the most remarkable discovery is that the mihrab of Mehmed's mosque was positioned over the center of Constantine's tomb (fig. 15.18). (The positioning of the mihrab was not quite as central in the unexecuted plan for Fatih Camii; fig. 15.19)[109]

109 The mihrab would have been almost, but not exactly, over the center of the mausoleum, in the preliminary scheme for Fatih Camii for which a drawing survives (fig. 15.19). The center of the mausoleum was not occupied by the tomb of Constantine I, which was on the eastern side, but by the tomb of Constantine VIII (r. 1025–28): Downey, "Nikolaos Mesarites," 891–92.

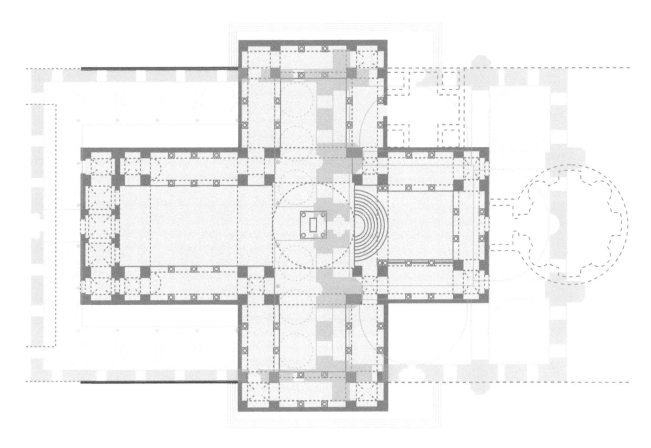

FIG. 15.19. Plan, in blue, of the Ottoman fifteenth-century unexecuted proposal for Fatih Camii (see fig. 15.15) overlaid onto Karydis's plan for the Holy Apostles (see fig. 15.17a), shown here in gray. The church's transept arms coincide with the proposed steps of the mosque. On the east the mihrab lies close to, but not directly over, the center point of Constantine's mausoleum.

In the 1950s Semavi Eyice noted a legend that Mehmed's grave was not in his tomb but in a vault under the mihrab. One could gain access to it by a tunnel from the catalfalque in Mehmed's tomb. Eyice refused to dismiss this legend, because, as he advised, it must have been prompted by some mysterious underground remains.[110] Similar information was given to Dark and Özgümüş about fifteen years ago, with the added details that there is a "Byzantine brick curvilinear structure" under the mihrab, with the sultan's tomb in the center.[111]

Whether there are, indeed, remains of Constantine's tomb under or in the vicinity of the mihrab of Mehmed's mosque can only be established definitively through excavation or a noninvasive geophysical survey. Until then we have to rely on inference, while those who have a taste for it can sprinkle onto reasoning the spice of oral tradition.

The Legacy of the Imperial Mausolea

When Gennadios returned the Holy Apostles to Mehmed, the sultan acquired more than the location and the buildings; he acquired the contents of the imperial tombs. Over the course of almost

110 Eyice, "Saints-Apôtres," 64n2.

111 Dark and Özgümüş, *Constantinople*, 90: "a claim by the staff of the mosque that a Byzantine brick curvilinear structure underlies the *mirhab* [sic] of the mosque. Mosque officials told us that this chamber is accessible by a tunnel from the eighteenth-century mausoleum of Mehmet II, and contains the body of that sultan in a 'pyramid' (a gable-ended sarcophagus?) in the centre of the tomb. The officials also informed us that

the last 'secular' visitor allowed into the chamber was Kemal Attatürk [sic], the founder of the Turkish Republic. Access by our team was impossible."

FIG. 15.20.　Sarcophagus with cover, originally from the Mausoleum of Constantine at the Holy Apostles. Istanbul Archaeological Museums, inv. no. 3145 (photo by author).

seven hundred years the heroa of Constantine and Justinian at the Holy Apostles became the foremost burial places of the Byzantine emperors and their families. Constantine's came to hold twenty sarcophagi, twelve of which were for emperors. Justinian's held twenty-three.[112]

Mehmed gathered in the Topkapı Palace items from these imperial tombs of the Holy Apostles and from the church's Christian relics. The Topkapı Palace became the resting place for an impressive array of monumental stone items taken from four principal sites: the mausolea of the Holy Apostles, the monastery of the Pantokrator (Zeyrek Camii), the Augustaion monument next to Hagia Sophia, and the Hippodrome. This is significant because in the first three cases, at least, there is a known connection with Mehmed II.

The sarcophagi from the Holy Apostles were not removed as building material, as some have suggested: of the ten porphyry sarcophagi known to have been in the imperial necropolis of the Holy Apostles, eight are still extant, and the remaining two can be accounted for (fig. 15.20). Of these ten, four, if not five, were found within the grounds of the Topkapı Palace, and another was for a long time on the site of the former Eski Saray, the first palace that Mehmed built, in the center of the city. That this was a deliberate collection of imperial sarcophagi is supported by the fact that another find in the grounds of the Topkapı Palace, the seven-domed tomb cover of Manuel I Komnenos (1143–80), was taken from the Pantokrator, part of which had become the mausoleum of the Komnenian and Palaiologan dynasties, effectively the successor to the necropolis of the Holy Apostles.[113] Mehmed's New

112　G. Downey, "The Tombs of the Byzantine Emperors at the Church of the Holy Apostles in Constantinople," *JHS* 79 (1959): 27–51; P. Grierson, C. Mango, and I. Ševčenko, "The Tombs and Obits of the Byzantine Emperors (337–1042); With an Additional Note," *DOP* 16 (1962): esp. 21–22, 26–27.

113　C. A. Mango, "Three Imperial Byzantine Sarcophagi Discovered in 1750," *DOP* 16 (1962): 65n2; Vasiliev, "Porphyry Sarcophagi."

Palace contained a trophy ground of spolia: some were there because they were architecturally impressive memorials, many because of their historical and imperial associations.[114]

They were the outdoor equivalent of the Christian religious vestigia Mehmed assembled in the Topkapı Palace.[115] These included the stone on which Christ had allegedly been born, but which was almost certainly the Stone of the Deposition that was in the church of the Pantokrator in about 1453, when it was seen by Francesco Pepino. It forms part of a remarkable list drawn up for Mehmed's son, Sultan Bayezid, of Christian relics that had been assembled in his father's palace.[116] The register, dated 1489, enumerates twenty-one items, nine of which pertained to Christ, two to the Virgin; the others included the bodies, each *tucto integro*, of the prophet Isaiah, one of the Innocents massacred by Herod, St. Euphemia, and Sts. John Chrysostom and Damascus (*lo corpo de sancto Joanne damascheno*), and assorted bodily parts of St. (sic) Lazaros and St. Andrew the Apostle, as well as a fragment of the vest of St. George and the Gospel of St. John written by the hand of St. John Chrysostom, *che fa grandi miraculj*. The royal sarcophagi and the Christian relics bear witness to Mehmed's keen appreciation of imperial propaganda and historical symbolism. It is difficult to believe that he was not fully aware of the significance of burying the church of the Holy Apostles under his mosque, and Constantine's mausoleum under his mihrab.

Ayasofya remained above ground while the Holy Apostles and the mausolea of Constantine and Justinian were flattened and buried.[117] Ayasofya stood as a perpetual memorial to the city's ancient past, source of pride, and source of sadness; the Holy Apostles was subsumed. The symbolism of that act was only as good as people's memories. As a generation grew up who had never seen the church of the Holy Apostles, memory of it faded. Fatih Camii retained its importance as a premier mosque of the city, but time eroded knowledge of Mehmed's physical and symbolic appropriation of a site that for eleven hundred years had demonstrated Byzantine imperial continuity.

Or so it might seem. But Evliya Çelebi can teach us otherwise. Writing some two hundred years after Gennadios finally abandoned the Holy Apostles, he wrote:

> In an ancient age there was an unusual sanctuary of a king by the name of [...] on the site of this gracious mosque; after Ayasofya, there had not been in the land of the Emperor such an artistic building. It was destroyed by a earthquake, and with the felicitous advent of Sultan Mehmed Ghazi, on going down to the depth of the ground of the original building, they razed its name and trace, and the mosque of Mehmed Han was built.[118]

The destruction is portrayed as deliberate, total, triumphant—destruction in "name and trace." Yet even if the name of the Holy Apostles was forgotten and scant physical traces were left, the fact that the mosque was built on the site of a church second only to Ayasofya lingered in the memory. More than three hundred years

114 It included other items such as the Miraculous Toad of Leo the Wise, which was brought from the Apokalipti monastery near the Pantokrator. J. Raby, "Mehmed the Conqueror and the Byzantine Rider of the Augustaion," *Topkapı Sarayı Müzesi. Yıllık* 2 (1987), 141–52; idem, "Mehmed the Conqueror and the Equestrian Statue of the Augustaion," *ICS* 12 (1987): 305–13.

115 Necipoğlu, "From Byzantine Constantinople to Ottoman Kostantiniyye," 268–69.

116 F. Babinger, *Reliquienschacher am Osmanenhof im XV. Jahrhundert: Zugleich ein Beitrag zur Geschichte der osmanischen Goldprägung unter Mehmed II., dem Eroberer* (Munich, 1956), esp. 21. On relics in the Holy Apostles, Ebersolt, *Sanctuaires*, 38–43; Janin, *Églises et les monastères*, 45–46; G. P. Majeska, "Russian Pilgrims in Constantinople," *DOP* 56 (2002): 93–108. The body of St. John Chrysostom was still in the Holy Apostles in 1348 or 1349, where it was seen by Stephen of Novgorod, but was later moved to Hagia Sophia: Heisenberg, *Grabeskirche und Apostelkirche*, 2:134; see Majeska, "Russian Pilgrims," 106, on the date.

117 Justinian's heroon is normally placed in a location that would correspond to the site of the sultan's loggia: Wulzinger suggested this was purposeful (Wulzinger, "Apostelkirche," 38). For a recent discussion of Venetian reactions to the destruction of the Holy Apostles, see J. Israel, "A History Built on Ruins: Venice and the Destruction of the Church of the Holy Apostles in Constantinople," *Future Anterior* 9, no. 1 (Summer 2012): 107–22.

118 Evliya Çelebi, *Seyâhatnâmesi*, 138; Gökyay, *Evliya Çelebi Seyahatnâmesi*, 57. In the 1470s Mu'ali wrote that Mehmed had built his mosque by getting rid of the "mysteries," implying that he had destroyed the Holy Apostles: Kafescioğlu, *Constantinopolis/Istanbul*, 86.

FIG. 15.21. Sultan Süleyman proceeding through the Hippodrome towards Faith Camii in the distance. After Pieter Coecke van Aelst, *Ces moeurs et fachons de faire de Turcz avecq les regions y appertenantes ont este au vif contrefaictez* (Antwerp, 1553). Sheet 35.2 × 87.3 cm, New York, Metropolitan Museum of Art, acc. no. 28.85.7a, b, Harris Brisbane Dick Fund, 1929 (photo from Metropolitan Museum of Art).

after Mehmed constructed Fatih Camii, Hafiz Hüseyin Ayvansarayî summarized the issue we posed at the beginning: "The site [*yeri*] of the abovementioned mosque was previously the location [*mahalli*] of a church."[119]

Conclusion

In 1453 Mehmed's victory realized a dream that the Dar al-Islam had harbored for eight hundred years—the capture of Constantinople. But Mehmed's vision of a triumphant city could barely begin to be realized until a decade later, when he embarked on his major architectural campaign. In 1453, the preservation of Hagia Sophia was testament to continuity, and ceding the Holy Apostles to the patriarch was a symbol of accommodation. In 1462/63, on the other hand, the Holy Apostles was erased to make way for Fatih Camii, which became the most abiding symbol of the new order.

Mehmed the Conqueror defined the city in multiple ways—demographically, spatially, architecturally, ceremonially, ideologically, and, of course, religiously. He ordained the fate of both Hagia Sophia and the Holy Apostles. One he preserved, the other he demolished. If I am correct in suggesting that Mehmed built directly over the Holy Apostles, then the tomb of the founder of the new Constantinople lay near the tomb of the founder of the first Constantinople. If the mihrab of Fatih Camii did indeed stand over the tomb of Constantine, then the mihrab established by the man who conquered Constantinople for Islam stood over the tomb of the man who established Christianity as an imperial religion.[120] One marked the future, the other the past.

Continuity was averred by maintaining the name of the city. In imperial gold coinage minted in Istanbul from Mehmed's day until the fall of the Ottoman Empire four and a half centuries

119 The translation is by H. Crane, *The Garden of the Mosques: Hafiz Hüseyin al-Ayvansarayi's Guide to the Muslim Monuments of Ottoman Istanbul*, Studies in Islamic Art and Architecture 8 (Leiden and Boston, 2014), 11, with the Ottoman words in brackets added from Hafiz Hüseyin Ayvansarâyî, *Hadîkatü'l-Cewâmi'* (Istanbul, 1281; 1864), 8.

120 Cf. Wulzinger, "Apostelkirche," 37. Kafescioğlu, *Constantinopolis/Istanbul*, 66–67, discusses the symbolism of the site and the removal of the sarcophagi, and memorably concludes: "Monumental architecture and symbolic locus simultaneously represented rupture and continuity between two imperial orders."

ز

later, the city was referred to as Kostantiniyye ("Constantinople").[121] The city's popular name, however, was Istanbul, and it is fitting that Mehmed himself is said to have quipped that Istanbul had become İslambûl—"full of Islam"—for he created not only its crowning mosque but an entire educational "city" devoted to the training of a religious and legal class.[122] Mehmed's vision, I suggest, was of a city that contained echoes of Constantinople's past but was, above all, a living witness to Islam.

This vision was perfectly conveyed half a century after his death in the culminating scene from the sequence of seven tapestries Pieter Coecke van Aelst is often assumed to have designed in the 1530s for Süleyman the Magnificent: Süleyman rides past the sphendone of the Hippodrome, past the Serpent Column and the obelisks (fig. 15.21).[123] These items themselves were testimony to Byzantium's appropriation of ancient histories: the Serpent Column, for example, was brought from the Sanctuary of Apollo in Delphi by Constantine in 324 CE.[124]

Süleyman thus rides past mementoes that testify to the Ottoman's *prise de possession*. The Ottomans were not oblivious to these mementoes. Although the significance of the Serpent Column, for example, changed, it retained a symbolic potency, because the Ottomans viewed it as a talisman of Istanbul.[125] Süleyman's grand vizier, Ibrahim Pasha, even added to them after his successful conquest of Buda in 1526, with Renaissance statues of Hercules, and of Diana and Apollo, an echo of which appears in Pieter Coecke's panorama (fig. 15.21).[126] These were new trophies in dialogue with ancient ones, the Renaissance in dialogue with the antique. Ibrahim Pasha's statues did not last much beyond his death about ten years later, whereas the obelisks and Serpent Columns still stand.

Sultan Süleyman is framed against the Hippodrome, against the backdrop to this Theater of Ancient Empire. But his trajectory is clear: his cavalcade heads toward the north, toward the great mosque that sits at the highest point on the horizon. This was the mosque of Süleyman's great-grandfather, Mehmed the Conqueror. This was Fatih Camii. Built over the remains of Byzantium's second greatest church and principal imperial necropolis, Mehmed's mosque was the herald of a new dispensation. The changing fate of the Holy Apostles in the decade 1453 to 1463 reveals, at one end, the pressures of Realpolitik and, at the other, Mehmed's vision for his imperial city—*Islambûl*.

121 Babinger, *Reliquienschacher,* on Mehmed's gold coinage.

122 N. Sakaoğlu, "İstanbul'un adları," in *Dünden bugüne İstanbul ansiklopedisi* (Istanbul, 1993–94).

123 G. Marlier, *La Renaissance Flamande: Pierre Coeck d'Alost* (Brussels, 1966); *Grand Design: Pieter Coecke van Aelst and Renaissance Tapestry,* ed. E. Cleland, M. W. Ainsworth, and I. Buchanan (New York and New Haven, CT, 2014). In a recent study, Annick Born has proposed that they were designed for Charles V: A. Born, "The *Moeurs et façhons de faire de Turcs* Süleyman and Charles V: Iconographic Discourse, Enhancement of Power and Magnificence, or Two Faces of the Same Coin?" in *The Habsburgs and Their Courts in Europe, 1400–1700: Between Cosmopolitanism and Regionalism,* ed. H. Karner, I. Ciulisová, and B. J. García García, PALATIUM e Publication, 2012, accessed 17 May 2018, www.courtresidences.eu, 283–302.

124 In general, S. Guberti Bassett, "The Antiquities in the Hippodrome of Constantinople," *DOP* 45 (1991): 87–96.

125 V. L. Ménage, "The Serpent Column in Ottoman Sources," *AnatSt* 14 (1964): 169–73. P. Stephenson, *The Serpent Column: A Cultural Biography,* Onassis Series in Hellenic Culture (Oxford, 2016).

126 These had originally been commissioned by Matthias Corvinus from the Florentine-trained Giovanni Dalmata: T. Wiegand, "Der Hippodrom von Konstantinopel zur Zeit Suleimans d.Gr," *JDAI* 23 (1908). On Giovanni Dalmata, see J. Röll and I. Duknović, *Giovanni Dalmata,* Römische Studien der Bibliotheca Hertziana 10 (Worms am Rhein, 1994).

Conclusion

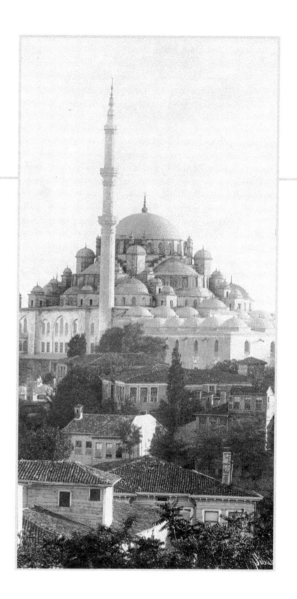

Concluding Remarks

ROBERT G. OUSTERHOUT

OUR COLLEAGUE HENRY MAGUIRE ONCE COMMENTED, "ISTANBUL HAS always been a city of ghosts, ghosts of its past that have lingered and have refused to be eradicated by future ages."[1] The Holy Apostles is one of those ghosts—a shadowy but very persistent one, its reputation enduring long after its mortal remains have vanished. When we began to plan the symposium that led to this volume, a non-Byzantinist friend queried why we would devote an entire conference to a building that no longer exists. "I mean, it's not Hagia Sophia, is it?" she asked. As I attempted to explain—and as the preceding chapters amply demonstrate—the Holy Apostles provides a useful lens through which to view Byzantine culture, not just its art and architecture, but also its literature, theology, imperial ideology, and urbanism, not to mention major turning points in history. The topic also allows us to view our own growth as field of study: the contributors to this volume have taken us from the early days of Dumbarton Oaks in the 1940s into the present, offering a reassessment of how we read and how we see.

In many ways, our own development as scholars may be reflected here as well. We all cut our teeth on the Holy Apostles, so to speak—no matter what our specialty, we all had to come to terms with it, as it loomed large on our scholarly horizon. For example, I first saw Paul Underwood's drawings in a conference presentation given by Prof. Ćurčić almost forty years ago.[2] As a budding architectural historian, my interests at the time were purely positivist: how do we reconstruct it, and how does it fit with the idea of the domed bay as a modular unit? And as students, Mark Johnson and I debated the original form of the Apostoleion: I found Richard Krautheimer's explanation compelling; he didn't.[3] Art historians face similar problems of basic fact. Is the mosaic program sixth, ninth, tenth, or twelfth-century, or a combination of these?[4] Is it, in fact, a program? And does it matter?

While that last sentence might sound flippant, it is worth noting again the remarkably different approaches art historians have employed as they address our two seminal texts on the building, the *ekphraseis* of Constantine the Rhodian and Nicholas Mesarites. While some scholars continue to "see" the mosaics through the lens of the texts,[5] in this volume, art historians Liz James and Henry Maguire chose to focus instead on how modern scholars read texts about art and how Byzantine writers composed them. Maguire demonstrated that the text as a literary construct could lead us horizontally from the dangerous secular world outside to converge centripetally at the sacred center. But if we work with the assumption that the text is more of an evocation than a description, we may be left

1 In H. Maguire and R. Ousterhout, "Introduction: Constantinople; The Fabric of the City," *DOP* 54 (2000): 158.

2 S. Ćurčić, "Architectural Reconsideration of the Nea Ekklesia," *BSCAbstr* 6 (1980): 11.

3 R. Krautheimer, "Zur Konstantins Apostelkirche in Konstantinopel," in *Mullus: Festschrift Theodor Klauser, Jahrbuch für Antike und Christentum,* Ergängszuband 1 (Münster, 1964), 224–29; republished as "On Constantine's Church of the Holy Apostles in Constantinople," in *Studies in Early Christian, Medieval, and Renaissance Art* (New York, 1969), 27–34; but see now M. J. Johnson, *The Roman Imperial Mausoleum in Late Antiquity* (Cambridge, 2009), 119–29; as well as his chapter in the present volume.

4 See in particular the comments by Liz James, in L. James, ed., *Constantine of Rhodes, On Constantinople and the Church of the Holy Apostles, with a New Greek Edition by Ioannis Vassis* (Farnham, Surrey, and Burlington, VT, 2012); and her chapter in the present volume.

5 See most recently, N. Zarras, "A Gem of Artistic Ekphrasis: Nicholas Mesarites' Description of the Mosaics in the Church of the Holy Apostles at Constantinople," in *Byzantium, 1180–1204: "The Sad Quarter of a Century"?* ed. A. Simpson (Athens, 2015), 261–82.

with the quandary of how to justly include major monuments that no longer survive into our art historical or architectural record—a problem with which we still continue to wrestle, as the differing approaches of James and Nikolaos Karydis demonstrate. Nevertheless, our contributors have both broadened our perspective on the building and the society that produced it, while honing in on the elusive heart of our studies, that famous lost building.

Chronologically, our examinations begin with Constantine in the fourth century. Mark Johnson reminds us that the first construction marked a critical turning point as the first Christian imperial mausoleum. The innovative character of Constantine's project is further underscored by Paul Magdalino, who suggests that Constantine, like his Tetrarchic predecessors, was, in effect, making it up as he went along. At the other end of our chronology came Fatih Mehmed in the fifteenth century, as Julian Raby emphasizes the continued symbolic power the building and its site held in the imagination of the conqueror. Thus, within the course of a decade, Mehmed gave the building to the patriarch, then claimed the site for his own ends. Like Hagia Sophia, it was simply too visible, too historical, and too redolent with meaning to ignore. As Nevra Necipoğlu notes, it could represent a major transformation of group identity, from that of a politically defined power base to a religiously defined minority, and back again.

We've had various stops along the way—and well beyond, thanks to Robert Nelson and James Carder, who not only introduced us to the early days of Dumbarton Oaks but also to the afterlife of the project of visualization in the decoration of St. Sophia in Washington, DC, for which Underwood served as advisor. Moreover, with the Appendix to our volume, carefully prepared by Fani Gargova, we are provided with a palpable glimpse into the Dumbarton Oaks project as it developed.[6] We all learned a great deal from their collective efforts. There is still much to be discovered and explored in the archives.

One of the notable absences in the present volume is the symposium paper of the late Slobodan Ćurčić, who had situated Justinian's Holy Apostles within the context of apostolic competition with Rome, suggesting that the remodeling of St. Peter's shrine may have come in response to Justinian's interventions at the Holy Apostles and in Ephesos. His paper, like my own, encouraged us to look beyond the usual suspects—and beyond mere formal analysis—as we attempt to situate the building within the larger context of architectural history. In turn, I explored ways the Holy Apostles and the *idea* of the building might have impacted later architectural developments in Constantinople and elsewhere, viewing in particular the so-called *heroon* at the Komnenian Pantokrator monastery as a victory monument, ideologically and visually connected to the Holy Apostles complex. With the basic premise that one good dome deserves another, I suggested that the urban panorama would have dramatically linked the two complexes visually, as a cascade of domes.

While neither Ćurčić nor I confronted the building directly, this was admirably accomplished by the paper of Karydis, who joined our project when Prof. Ćurčić fell ill. Remarkably, Karydis's methodology does not differ dramatically from that of Underwood, A. M. Friend, and Glanville Downey, although his conclusions rest solidly on an additional seventy-five years of scholarly inquiry, including his own. In Karydis's recent study of the church of St. John at Ephesos, for example, he distinguished two sixth-century building phases, thereby clarifying that building's relationship to the Holy Apostles with data unavailable to the Underwood team. His analysis is nicely complemented by Julian Raby's examination of the first Fatih Camii: following the published observations of Ken Dark and Ferudun Özgümüş,[7] both scholars argue that anomalous foundations at the present mosque are leftovers from the Holy Apostles. As many had suspected, the Fatih Camii sits directly upon the site of the Holy Apostles—it has not *quite* disappeared completely.

6 For the 2015 symposium, Fani Gargova and Beatrice Daskas prepared a booklet, exhibit, and online exhibit of the archival materials; see "The Holy Apostles—Visualizing a Lost Monument," accessed 15 November 2016, www.doaks.org/resources/online-exhibits/holy-apostles.

7 K. Dark and F. Özgümüş, *Constantinople: Archaeology of a Byzantine Megapolis* (Oxford, 2013), 83–110.

The contributors to this volume have taken us outside the building, around and about the neighborhood, as well. Paul Magdalino situates the church within its urban matrix, examining textual evidence—in particular the *Book of Ceremonies* and Mesarites' *Ekphrasis*—for annexes, outbuildings, neighboring palaces, and churches—notably the church of All Saints, which lay to the east of the Holy Apostles, and not where it is represented on Underwood's site plan. In turn, Maguire follows the structure of Nicholas Mesarites' *Ekphrasis,* which leads the reader from the annexes into the church and out again, providing impressions of the lively schoolrooms and the distant vistas from the galleries. But rather than a simple itinerary, as Maguire discerns, Mesarites structures for us a diagram for salvation. Instead of a monument set in splendid isolation, we may now envision the Holy Apostles surrounded by urban clutter, much as Hagia Sophia appeared well into the nineteenth century—and yet within sight of wheat fields.

As several of our speakers have noted, although dedicated to the apostles, with relics introduced at an early date, these seem far less important to the identity of the church than the imperial presence. Perhaps the apostolic remains were more important in the early days of relic gathering, but as the city's collection expanded to some 3,600 documented relics representing at least 476 different saints, these may have faded in significance.[8] Magdalino reminds us that the head of Paul was taken there on June 30—as if the apostolic relics already there were insufficient. The imperial burials seem to have merited more attention in Byzantine times, and I suspect those of Gregory of Nazianzos and John Chrysostom did as well.

And what of the apostles? George Democopoulos's study demystifies apostolic succession: while apostolicity might seem to affirm Orthodoxy, it's not enough to protect us from incompetent bishops or theological error. The emphasis was on apostolic faith, not on succession, and we are left to contemplate contrasting ideals

of apostolicity, episcopal versus monastic. Scott Johnson situated the apostles into a cognitive landscape to represent the Christian *oikoumene*, enhanced by a collegium of invented cartographic trajectories, which clearly resonated with the idea of empire that the church itself projected. The idea of dominion could also be expressed in a multicolored program of marble revetment—a theme that Constantine the Rhodian picked up from Paul the Silentiary's description of the marbles of Hagia Sophia.[9] Interestingly, it was the mission of the apostles, not their relics, that expressed this geographical notion.

The ideas of apostolic church and empire may have come together in the tenth century, as Floris Bernard demonstrates; while we have hagiography written at the behest of the emperor, we also have an architectural *ekphrasis*, which could serve to legitimize the dynastic succession from Leo VI to Constantine VII. Finally, Ruth Macrides dispels the notion that Nicholas Mesarites was nothing more than a purveyor of information, as he provided a nuanced view of the interface between rhetoric and *realia*, to create a "verbal monument." His evident familiarity with both the monument and the curriculum of its schools raises the question, did he teach at one of the schools at the Holy Apostles?

So what have we learned? Byzantine Constantinople was a city of both words and monuments. As an architectural historian, I thought I'd developed a clear picture of the monuments, but the rhetoric enriches them, providing another dimension. I trust with the publication of our collected essays, we should be able to say vice versa. I've often claimed that our image of Constantinople today is based on texts,[10] that the city remains more the realm of the philologist than of the archaeologist. We have learned much about the Byzantine city from text-based scholars, but all too many important studies construct Constantinople as a city of words, not of images. Because, in contrast to other ancient capitals, Istanbul has witnessed virtually no urban archaeology, basic elements of the Byzantine city—the street system, public spaces, and housing—remain all but unknown, as do the meager traces of the Holy Apostles. Apart from

8 See the discussion by J. Wortley, "Iconoclasm and Leipsanoclasm: Leo III, Constantine V, and the Relics," *ByzF* 8 (1982): 254; P. Maraval, *Lieux saints et pèlerinages d'Orient: Histoire et géographie des origines à la conquête arabe* (Paris, 1985), 92–104.

9 *Descriptio S. Sophiae*, lines 286–295.

10 In Maguire and Ousterhout, "Introduction," 157–59.

the largely unidentified archaeological remains, we are left with isolated churches, their contexts long since vanished. At best, they offer a tantalizing evocation of the city's historic greatness. In short, we know Constantinople more as a concept than as a reality.

The studies collected here also bring into the discussion a wealth of other lost monuments that once surrounded the Holy Apostles—its school and outbuildings, the church of All Saints, and the various Komnenian monastic foundations that once ringed it. While almost all have vanished, we may begin to get a sense of its context— physical and social, ideological and historic, and we must remind ourselves that all the major monuments of the Byzantine capital must have been situated in similarly rich and redolent infrastructures. One lost monument notably missing from our discussion is the triumphal column erected by Michael VIII in front of the Holy Apostles, although this has been admirably addressed by Alice-Mary Talbot and more recently by Cecily Hilsdale.[11] Surmounted by a brazen statue of St. Michael with the emperor kneeling at his feet, offering an image of the city to him, the unique monument celebrated Michael's reconquest and restoration of the city, while reviving a form of imperial display unknown in Byzantium for centuries. That Michael should have chosen the Holy Apostles as the venue for his monument suggests both the continued evocative power of the building and Michael's imperial ambitions. For Michael to view himself as a "New Constantine," it made good sense for him to insinuate

himself into a venue so strongly associated with the founder of the city and might even suggest that he had hoped to have his own burial there. Remnants of the imperial monument appear in the view of Constantinople from a fifteenth-century version of Cristoforo Buondelmonti's *Liber insularum archipelagi*, alas missing the archangel and the city, but with the kneeling emperor identified as Constantine.[12] In short, Constantine's mausoleum and his legacy continued to resonate into the last centuries of Byzantium.

One important lesson I have learned from my colleagues is how texts celebrate monuments. We might want them to describe the monuments for us, as a previous generation had wished. But a text is a work of art, just as is a decorated Byzantine church, whether still standing or only imagined. Of course, it is the task of each generation to reimagine the Byzantine world, and this is the lesson we ultimately take away from the Holy Apostles in its 1948 and 2015 iterations, for just as a reconstruction from a text may be controlled by comparison with parallel monuments, so, too, the texts, properly read, can help to bring the ghosts— those morbid archaeological remains—back to life. Which is to say, the collaborative enterprise envisioned by our predecessors at Dumbarton Oaks still has much to teach us. Indeed, as Margaret Mullett noted in the introduction to this volume, our revisiting of the Holy Apostles and its historiography may raise as many questions as it answers, and we hope our efforts will challenge the next generation of scholars. In sum, the legacy of the Holy Apostles and the "presentness of the past" are still very much with us.

11 A.-M. Talbot, "The Restoration of Constantinople under Michael VIII," *DOP* 47 (1993): 243–61; and C. J. Hilsdale, *Byzantine Art and Diplomacy in an Age of Decline* (Cambridge, 2014), esp. 107–16; both with extensive bibliography.

12 Hilsdale, *Byzantine Art*, esp. figs. 2.7–2.8.

APPENDIXES

Materials from The Dumbarton Oaks Holy Apostles Project
and 1948 Symposium

Introduction

FANI GARGOVA

The aim of this section of appendixes is to publish in full the Holy Apostles project materials that were considered finalized, or at least presentable, but never made it to publication. Finalized in this sense were the papers given at the symposium, two by Paul Underwood (Appendixes D, E) and two by Albert Mathias Friend, Jr. (F, G), as well as Glanville Downey's translation of Constantine the Rhodian (C). Other papers were either published in some form or have not survived.[1] We also publish a letter from Sirarpie Der Nersessian (H) on the genesis of the symposium and the attendance list (I).

The appendixes additionally include archival items at the core of the Holy Apostles project: selected pages from Albert Friend's notebooks (B), and the detailed reconstruction drawings of the architecture and mosaic decoration made by Paul Underwood based on Downey's translations (A). The appendixes illustrate the methodology of the project, which began with a textual source (C), moved to detailed analyses (D–G), and resulted in concrete visualizations (A, B). Our selection of individual pages from a total of six notebooks by Albert Friend is in no way representative of the entirety of the development of his understanding of the Holy Apostles church. Those visual examples give an idea of

his approach and working method, which ultimately thwarted him from publishing any of the material.[2] The Underwood drawings exist in several versions and variations. Some are preserved as originals, others only as reproductions. We have selected items from both groups, with the addition of the drawing of the dome of the Nea Ekklesia, the first trial project of 1945 and 1946 and an important step toward the full development of the methodology employed in the Holy Apostles project. The last drawing is also significant not least because it was materialized in the interior decoration of the St. Sophia Cathedral in Washington, DC. The unique proof of Underwood's involvement and of his suggestion that this drawing be used is found in a letter from him to Father John Tavlarides (J).

After the Holy Apostles manuscripts were dismissed by the Publications Committee in 1968 as being unpublishable and "ninety-nine percent fantasy,"[3] the material that remained at

1 For the papers that were published individually, see Mullett, Introduction, 6n11. The papers given by Sirarpie Der Nersessian could not be found in either of the two collections related to her at Dumbarton Oaks. See Sirarpie Der Nersessian Papers and Photographs, DOA, and Sirarpie Der Nersessian Papers and Photographs, 1939–1966, MS.BZ.005, ICFA. Inquiries about the existence of the two papers in the Fonds Sirarpie Der Nersessian in the Matenadaran in Armenia and in Paris are still in progress.

2 See also above, Mullett, 10–11, Carder, 24, and James, 160–61.

3 See the contribution by Margaret Mullett in this volume, 11. The article by Underwood and Downey, which was discussed by the committee in 1968, was given to Irene Underwood and Downey was told to communicate with her about it. The minutes of 25 October 1968 of the Publications Committee are part of the Administrative files, DOA. Sarah Underwood, daughter of Paul Underwood, was asked by ICFA staff whether she has any remaining manuscripts that were connected to her father's work. She found only material connected to his Kariye Camii publications, which she donated to ICFA; see Sarah Underwood, interview by Fani Gargova for ICFA, 19 December 2014, video recording and transcript, accessed 27 August 2019, http://www.doaks.org/library-archives/dumbarton-oaks-archives/historical-records/oral-history-project/sarah-underwood-icfa-interview.

Dumbarton Oaks seems to have been merged with the old Byzantine Institute fieldwork archives, where Slobodan Ćurčić saw it rolled up on a musty shelf in 1975/76.[4] Some content must have been known to William Loerke, then Director of Byzantine Studies, since he gave permission to Otto Demus to look through the items during his tenure as visiting scholar from 1973 to 1978.[5] The combined archives were first inventoried, arranged, and processed in 1981 and 1982. Later in the 1990s to early 2000s the Byzantine Institute collection was reorganized and reprocessed by the staff of the Byzantine Photograph and Fieldwork Archives (now the Image Collections and Fieldwork Archives [ICFA])[6] to fit the research needs of the Byzantine community by reordering according to author's name and represented site, and making the material available through a finding aid.[7] The Holy Apostles material that originally came from Paul Underwood's office was still, since the 1968 merging, subsumed under the large Istanbul corpus of the Byzantine Institute Records, even though their content and context of creation were different. ICFA staff separated a majority of the Paul Underwood records, including the Holy Apostles documents, only in February of 2011, when the finding aid and collection arrangement for the Byzantine Institute Records was revised. It was decided to extract all Underwood papers that were not the result of any Byzantine Institute or Dumbarton Oaks fieldwork projects, and let them create a separate collection. The associated finding aid was published a year later.[8] During processing, additional related records were identified in the holdings of the Dumbarton Oaks Archives (DOA), home to material from previous Directors and Directors of Studies, as well as activities at Dumbarton Oaks such as the symposia. Those related records were assembled and transferred from DOA to ICFA in 2011.[9] This collection, "Paul Underwood Research Papers and Project Materials on the Reconstruction of the Church of the Holy Apostles in Constantinople, ca. 1936–1950s," laid the foundation for the reconstruction of the 1940s Holy Apostles project and the 1948 symposium. Margaret Mullett studied the collection closely in preparation for the 2015 symposium and identified misinterpretations and erroneous information in the available finding aid. Revisions and updates were made in preparation for an exhibition to accompany the 2015 symposium.[10]

4 See the Holy Apostles 2015 symposium abstract by Slobodan Ćurčić, cited by Margaret Mullett above, 11–12.

5 While Demus knew about the Holy Apostles project as early as 1949, he cites only Friend, Underwood, and Downey as having given him advice and help in his *The Church of San Marco in Venice: History, Architecture, Sculpture*, DOS 6 (Washington, DC, 1960), 91–92. Later in "Probleme Byzantinischer Kuppel-Darstellungen," *CahArch* 25 (1976): 105, he cites Friend's Bryn Mawr paper of 1950 "dessen Manuskript sich in Dumbarton Oaks befindet," unmistakably to be identified with Albert Friend, "Draft for a Lecture: 'Holy Apostles Church: Restoration of the Mosaics,'" 21 February 1950, MS.BZ.019-03-02-072, Underwood Papers ICFA. Lastly, in *The Mosaics of San Marco in Venice* (Chicago, 1984) he refers to "P. Underwood's masterly interpretation in a lecture given at Oberlin College (manuscript at Dumbarton Oaks, p.17)," which is most likely Paul Underwood, "Draft: 'Justinian's Church of the Holy Apostles: A Reconstruction of Architecture by Means of Texts,'" MS.BZ.019-03-01-047, Underwood Papers ICFA, of which another draft exists as MS.BZ.019-03-02-063. The occasion was the Oberlin College Symposium on Medieval Architecture, 15–16 October 1948, organized by the Art Department of Oberlin College; most papers were published in the *JSAH* 7, nos. 3–4 (1948); see ibid, p. 37. Demus also saw "another work, possibly intended for publication as a monograph, on the architectural reconstruction of the church by the late Professor P. A. Underwood," which would be one of the drafts cited in footnote 1 above. Therefore, it is clear that Demus got access to and read some of the Holy Apostles material only after Friend's and Underwood's deaths. See also above, James, 173.

6 Byzantine Photograph and Fieldwork Archives was the department's name from 1994 to 2007, when it was expanded to incorporate material relevant to Pre-Columbian and Garden and Landscape studies and renamed Image Collections and Fieldwork Archives (ICFA) in 2007. See Administrative Records of ICFA and Dumbarton Oaks, "Dumbarton Oaks, 2006–2008," *Annual Report* (Washington, DC, 2009), 61.

7 See the "Processing Information" note of the finding aid for Byzantine Institute Records ICFA, accessed 27 August 2019, https://id.lib.harvard.edu/ead/dca00003/catalog.

8 See the "Processing Information" note of the finding aid for Underwood Papers ICFA, accessed 27 August 2019, https://id.lib.harvard.edu/ead/dca00010/catalog.

9 See "Copies of Materials Related to the Dumbarton Oaks Symposium, 'The Church of the Holy Apostles at Constantinople,' 22–24 April 1948," MS.BZ.019-03-01-050, "Notes on the Colored Marbles of the Church of the Holy Apostles in Constantinople, 1948–1949," MS.BZ.019-03-01-061, and "Notes and Draft of 'The History of the Church of the Apostles,'" MS.BZ.019-03-01-062, Underwood Papers ICFA.

10 The exhibition entitled "The Holy Apostles—Visualizing a Lost Monument" was on view in the Orientation Gallery of Dumbarton Oaks from 23 April to 20 July 2015. It was accompanied by an online exhibition at http://www.doaks.

The DOA proved to be a rich source of documents attesting to the Holy Apostles project. It holds a vast body of meeting minutes from the Publications Committee and the Board of Scholars, which helps explain the progress of the project and the planned publications, as well as all of the preserved documents that relate directly to the 1948 symposium.[11] The collections in ICFA and DOA also present a significant lack of evidence: there is hardly anything by Glanville Downey or more than one page of a version of Albert Friend's volume. Papers and contributions by Dvornik, Anastos, or Der Nersessian are completely missing.

Taken together, the rich material of twenty-nine folders and twenty-six oversize drawings of the ICFA Underwood Holy Apostles collection raised more questions than it answered about the nature of the Holy Apostles project. Other archives became indispensable. Some extremely enlightening and relevant correspondence were found in unexpected collections, such as the Egon Wellesz collection in the Austrian National Library in Vienna[12] or the Erwin Panofsky Papers in the Smithsonian Archives of American Art.[13] Those letters offer insight into Downey's struggle to publish his translations of Mesarites and Constantine the Rhodian, which he claims were

finalized by 1949.[14] Documents in other repositories that seemed to be promising—such as the Indiana University Archives[15] or the Harvard University Archives[16]—were surprisingly scarce. The majority of the missing material was found in the Albert Mathias Friend Papers at Princeton University, where he remained full professor during and after his tenure as Director of Studies at Dumbarton Oaks. Friend had preserved his lectures in handwritten and typed final versions.[17] He also kept two fragments of complete versions of Downey's translation of Constantine the Rhodian,[18] copies of which did not exist at

org/resources/online-exhibits/holy-apostles and a booklet: F. Gargova and B. Daskas, *The Holy Apostles: Visualizing a Lost Monument; The Underwood Drawings from the Image Collections and Fieldwork Archives* (Washington, DC, 2015), http://www.doaks.org/resources/online-exhibits/holy-apostles/the-holy-apostles-visualizing-a-lost-monument-booklet.

11 See above Carder, 22–25 and Mullett, 4–7, 10–11.

12 There are three letters from Downey expressing his frustration about whether he can publish his Mesarites translation: Glanville Downey to Egon Wellesz, typed (9 April 1956), http://data.onb.ac.at/mus/MZ00036136; Glanville Downey to Egon Wellesz, 7 May 1956, http://data.onb.ac.at/rec/AL00097634; Glanville Downey to Egon Wellesz, 17 May 1956, http://data.onb.ac.at/mus/MZ00036136, all part of F13.Wellesz.1721 Mus, Musiksammlung, Österreichische Nationalbibliothek.

13 There are 6 letters from both Downey and Panofsky directly discussing the advancement of the project: Glanville Downey to Erwin Panofsky, typed (7 January 1958); Glanville Downey to Erwin Panofsky, typed (23 January 1954); Glanville Downey to Erwin Panofsky, typed (13 January 1954); Glanville Downey to Erwin Panofsky, typed (16 March 1947); Erwin Panofsky to Glanville Downey, typed (12 December 1957); Erwin Panofsky to Glanville Downey, typed (21 March 1947), all part of Series 1, Subseries 1, Panofsky Papers. There are also several more that discuss topics that could be linked to the Holy Apostles.

14 See specifically the letter from Glanville Downey to Erwin Panofsky from 13 January 1954: "My work on the Apostles, begun eight years ago and finished five years ago, is still unpublished, because Bert Friend has never begun his part, and Underwood, after completing a part of his portion, has now gone off to Istanbul. The faithful servant is as usual left holding the bag."

15 Glanville Downey became professor at Indiana University in 1964, where he taught history and classics until his retirement in 1978. See the name index term "Downey, Glanville," *AtoM@ DO*, 30 April 2015, accessed 28 January 2020, https://web.archive.org/web/20150906134628/http://atom.doaks.org/atom/index.php/downey-glanville. The Archives of Indiana University hold only Downey's official faculty file with a few newspaper clippings and Downey's CV as well as 3 official photographs (email from Philip Charles Bantin, 1 October 2014): "Glanville Downey" (photograph, 22 March 1965), P0046466, http://purl.dlib.indiana.edu/iudl/archives/photos/P0046466 (reproduced in this volume as fig. 1.4); "Glanville Downey" (photograph, 1972), P0046464, http://purl.dlib.indiana.edu/iudl/archives/photos/P0046464; "Glanville Downey" (photograph, 1973), P0046465, http://purl.dlib.indiana.edu/iudl/archives/photos/P0046465—all part of the Photograph Collection, Indiana University Archives, Indiana University, Bloomington.

16 Specifically, the Papers of Robert Woods Bliss and Mildred Barnes Bliss, approximately 1860–1969, HUGFP 76, HUA.

17 Albert Friend, "Symposium / The / Church of the Holy Apostles / Constantinople / The Mosaics of Basil I / in / the Holy Apostles / Part II / April 23 / 1948 / Dumbarton Oaks" (handwritten lecture, 1948) and Albert Friend, "Symposium / The / Church of the Holy Apostles / Constantinople / The Mosaics of Basil I / in / the Holy Apostles / Part I / April 23 / 1948 / Dumbarton Oaks" (handwritten lecture, 1948), both in Notebooks, notes, papers, course materials, photographs; 1934–1951, Box 4; Albert Friend, "SYMPOSIUM ON THE CHURCH OF THE HOLY APOSTLES / IN CONSTANTINOPLE / The Mosaics of Basil I in the / Holy Apostles. / Part II / April 23, 1948 / Lecture V" (typed lecture, 1948), and Albert Friend, "SYMPOSIUM ON THE CHURCH OF THE HOLY APOSTLES / IN CONSTANTINOPLE / The Mosaics of Basil I in the / Holy Apostles. / Part I. / April 23, 1948 / Lecture I." (typed lecture, 1948), both in Notebooks and notecards, PULC; 1916–1950, Box 5. All items are part of the Friend Papers.

18 Glanville Downey, "Constantine / Original Version: Not Revised," 3 November 1945; Glanville Downey, "Verses of Constantine of Rhodes, a Secretis," April 1946, both in Notes,

either Dumbarton Oaks or Indiana University, and one early complete version of the translation, which is also available in ICFA.[19] Other visual resources in the collection include photographs from the 1946 Dumbarton Oaks Symposium on Hagia Sophia. Those resources show not only an exhibition of photographs of the building and its mosaics by the Byzantine Institute but also Underwood's drawings, both those of the Hagia Sophia tympanum iconography and those of the ground plan and dome decoration of the Nea Ekklesia.[20] This reflects the project approach of starting with a smaller case study of a lost building before moving to the larger and more complex structure of the Holy Apostles. Lastly, several letters from Sirarpie Der Nersessian[21] and Glanville Downey[22] illuminate the acquisition of microfilm copies of the original Mesarites manuscript and the decision to devote the 1948 symposium to the Holy Apostles.

The Holy Apostles project enjoyed an afterlife in the form of the interior mosaic decoration of St. Sophia Cathedral in Washington, DC. The history of this phase was reconstructed by interviewing individuals and acquiring material from their personal collections. Contact with Father John Tavlarides (1930–2015), presiding priest from 1960 to 2011, was established in July 2014 through the help of Stavros Mamaloukos, who had first acquired the letter transcribed in Appendix I. At a meeting with Father John Tavlarides, Harriett Tavlarides, Peter Koutsandreas, Dennis Menos, and Tony

Diamond on 25 September 2014 at St. Sophia Cathedral, those present confirmed that Paul Underwood was asked to give a talk at the cathedral in 1963 and was subsequently asked by Father Tavlarides to help establish a plan for the interior decoration of the cathedral. Underwood's letter was provided to the competing artists as a guide. Underwood also became an active member of the iconography committee, which included Father Tavlarides, George J. Charles, and Andrew D. Vozeolas. In early 1964 Demetrios Dukas was unanimously selected to execute the mosaics, which he finished only in the late 1980s. At the membership meeting of 13 November 1964, it was agreed that work on the iconography could proceed with a budget of $110,000. Underwood would visit the cathedral daily to monitor progress, and he would occasionally require Demetrios Dukas to make changes in order to improve the appearance of the mosaic.[23] St. Sophia Cathedral was consecrated only on 9 and 10 May 2015 after the interior mosaic decoration was finally finished.[24]

From a personal photo album, Sarah Underwood, daughter of Paul Underwood, provided a copy of a photograph showing Paul Underwood together with the iconographer Demetrios Dukas below Christ in the dome, corroborating the account of Underwood's monitoring Dukas's work.[25] She also told about her father's

photographs, correspondence; 1915–1954, Box 6, Friend Papers. A fragment of the early version of November 1945 is also available at Dumbarton Oaks. It covers verses 425 to 982 and contains notes and corrections in Paul Underwood's handwriting. The copy in the Friend collection in Princeton also contains handwritten notes and corrections by Albert Friend.

19 Glanville Downey, "Verses of Constantine of Assicrecy on Rhodes," n.d., Notes, photographs, correspondence; 1915–1954, Box 6, Friend Papers. See also Downey, "Verses of Constantine of Assicrecy on Rhodes," n.d., Dumbarton Oaks Research Archive, ca. 1940s, MS.BZ.018, ICFA.

20 "Notes, Photographs, Correspondence" 1915–1954, Box 6, Friend Papers.

21 Der Nersessian, letter to Albert Friend, 20 May 1947, p. 1–2, Notes, photographs, correspondence; 1935–1955, Box 7, Friend Papers. See below, Appendix H.

22 Glanville Downey to Albert Friend, 25 July 1947; Glanville Downey to Albert Friend, July 1947; Glanville Downey to Albert Friend, 5 September 1946, all part of Notes, photographs, correspondence; 1935–1955, Box 7, Friend Papers.

23 For the story told from the Dukas end see Nelson, above, 45–48. See also Andrew Vozeolas, "Interior Decoration Program Approved: Iconographer Begins Work," *Saint Sophia Cathedral: Challenge*, 1965. On page 11 the article lists the committee members involved: "We are greatly indebted to the previous committees for their valuable investigations and studies of the various aspects of these projects; to Professor Underwood for his generosity as to time and guidance in making this undertaking possible; to Father Tavlarides as an active member and advisor of the committee; to Mr. Peter Koutsandreas, Vice Chairman; Mr. S. Thomas Stathes, architect and Mrs. Joanna P. Vozeolas, interior designer, committee members, for their professional advice. Last, but certainly not least, to Mr. George J. Charles, President, the members of the Board of Trustees and the General Membership for their interest, assistance and enthusiastic encouragement in realizing this historic milestone in the life of Saint Sophia Community."

24 See "Consecration–Saint Sophia," accessed 27 August 2019, http://www.saintsophiadc.com/about/consecration/.

25 Sarah Underwood first mentioned the specific photo album and photograph in her oral history interview with the Dumbarton Oaks Archives. See Sarah Underwood, oral history interview by Alasdair Nicholson and Bailey Trela for the

enjoyment in contributing to the church community through this activity.[26]

DOA, 23 July 2014, accessed 27 August 2019, https://www
.doaks.org/research/library-archives/dumbarton-oaks-archives
/historical-records/oral-history-project/sarah-underwood. She
allowed ICFA to scan the photograph for study purposes and
to be included in the exhibition "Holy Apostles—Visualizing a
Lost Monument," see *St. Sofia, Washington, with Mosaicist, 1966*,
photograph, 1966, https://www.doaks.org/resources/online
-exhibits/holy-apostles/legacy/paul-a-underwood-and-dukas-at
-saint-sophia-washington-dc-1966.

26 Sarah Underwood, oral history interview by Fani Gargova for ICFA, 19 December 2014, video recording and transcript, accessed 27 August 2019, http://www.doaks.org/library
-archives/dumbarton-oaks-archives/historical-records/oral
-history-project/sarah-underwood-icfa-interview.

While the Holy Apostles Project was never published, it did not remain without influence on scholarship at Dumbarton Oaks and on the mosaic program of St. Sophia. The latter remains its most visible legacy. By publishing a considerable amount of the project material in these appendixes, we hope to contribute to the historiography of the subject, the institution, and the field.[27]

27 Throughout the appendixes the author's original spelling, punctuation, and transliteration are preserved, even where they differ from one author to the other, in order to present the author's original voice. Obvious typographical errors and slips have been silently corrected and changes in spelling conventions within a single text have been normalized.

APPENDIX A

The Underwood Drawings

Paul Underwood had a vital, double role in the Holy Apostles project.[1] Paul Sachs wrote in a letter of November 1946 to James Conant, the President of the Trustees for Harvard University, that the Dumbarton Oaks Administrative Committee unanimously recommended appointing Paul Underwood as Assistant Professor for five years. He explains the Committee's reasoning:

> In dealing with the Civilization of the Byzantine Empire, research in the history of architecture and the decoration of churches must occupy a very central position. It is essential to have at Dumbarton Oaks a scholar who can handle not only the description and texts concerning the buildings but who is also able to make restorations and drawings of the structures and figure decorations on such a professional level that they may be published. It is impossible to hire a mere draughtsman to do this last. It requires a scholar. Paul Underwood has this combination of powers.[2]

Thus, Underwood was responsible for the scholarship concerning the architecture of the Holy Apostles church, planned to be published as a separate volume,[3] and he was also the person who visualized Friend's ideas concerning the iconography of the different scenes within the building, which is evident in the slides that Friend showed during his two presentations (see Appendixes F and G). There are also several letters that exemplify Friend's and Underwood's collaboration. They exchanged descriptions and depictions of manuscripts or other church decorations; Underwood would present a sketch or a more complete drawing, and Friend would give feedback.[4] Sometimes Underwood would also add notes for Friend to the duplications of his sketches and drawings.[5] From this working

1 He maintained an interest in the project during his fieldwork days as head of the Byzantine Institute in Istanbul. In 1949 Nezih Fıratlı with some possible contribution by Paul Underwood carried out limited excavations on the south side of the Fatih Camii. Hand-drawn plans of the site of 18 October 1949 were sent to Paul Underwood on 1 November 1950. While they cannot prove that the foundations of the Holy Apostles church still exist underneath the Fatih Camii, the plans clearly do show remains of walls that do not belong to the Fatih Camii: see "Excavation Plans and Drawings for Fatih Camii," 1949–1950; "Ground Plan Drawing of Fatih Camii," 1949–1950, both part of Byzantine Institute Records ICFA. See above, Raby, 264 and figs. 15.13 and 15.14.

2 Paul Sachs to James Conant, 2 November 1946, Paul J. Sachs Papers (HC3), file 507, ARCH.0000.778, Harvard Art Museum Archives, Harvard University, Cambridge, MA.

3 The draft manuscript is preserved in several versions, some in a relatively final state with all illustration drawings. See MS.BZ.019-03-01-045, MS.BZ.019-03-01-046, MS.BZ.019-03-01-050, MS.BZ.019-03-01-051, MS.BZ.019-03-01-052, MS.BZ.019-03-01-062, Underwood Papers ICFA.

4 See, for instance, Albert Friend to Paul Underwood, n.d., MS.BZ.019-03-01-053, Underwood Papers ICFA, as transcribed by Nelson, above, 40. Or see Paul Underwood to Albert Friend, n.d., MS.BZ.019-03-02-071, Underwood Papers ICFA: "Dear Bert: Here are the latest versions of two of the domes which I think have incorporated the changes we talked about when you were last here. Some of the heads in the Transfiguration came out too black but that is easily remedied. I hope you can pass on them before I draw in a decorative band at the outline of the arches. Meanwhile I have almost completed the architectural and decorative borders, ribs etc. for the central dome allowing enough space around it for the major portions of the four arch mosaics. That [?] the last will appear almost in [?]. Once I am sure of the correctness of the perspective and of the ribs-window-border arrangements I will commence studies for the figures in the arches and in the central medallion."

5 This is, for instance, the case in the following reproductions of drawings: Transfiguration: MS.BZ.019-03-01-055_016,

method there are preserved several reproductions of different versions that depict the main dome, the Anastasis dome, the Pentecost dome, and the Transfiguration dome.[6] Reproductions of architectural features do not show any additional versions different from the large format drawings here reproduced.

The architectural drawings (figs. A.1–A.9) are all part of Paul Underwood's planned publication on the architecture of the Holy Apostles. They survive in only a single version and visualize the development of the space in particular according to Constantine the Rhodian (Appendix C; see also Appendixes D and E). The ground plan (figs. A.10 and A.11) is available in two versions, of which the larger one (fig. A.10),

which was shown at the symposium and which was meant to be published seems to have been the intended final version. The drawings of the iconography of the five domes of the Holy Apostles with the exception of the Pentecost are available in two versions (figs. A.12–A.22). The Pentecost and the Ascension are available only as reproductions, whereas the other three dome drawings are originals. The Transfiguration dome is also included as a third preliminary version preserved only as a reproduction (fig. A.17), because it illustrates the subtle corrections that Friend would ask of Underwood in their continuous collaboration on the reconstruction. Friend used these drawings to visualize his conception of the iconography in his papers at the 1948 symposium (see Appendixes F and G).[7] The central dome of the Nea Ekklesia (fig. A.23) is a single final version, exhibited at the 1946 symposium. Though technically not part of the Holy Apostles project, this drawing is important owing to its early date (1946) and the methodology employed, which would later be adapted for the Holy Apostles project.

MS.BZ.019-03-02-071_010, Anastasis: MS.BZ.019-03-02-063_043, Ascension: MS.BZ.019-03-02-063_048, all part of Underwood Papers ICFA.

6 Main dome: MS.BZ.019-03-01-054_009 and _010, MS.BZ.019-03-01-055_001, _002, _003, and _007, MS.BZ.019-03-02-063_044, _050, and _055; Anastasis dome: MS.BZ.019-03-01-055_008, _010, _11, and _012, MS.BZ.019-03-01-056_001, MS.BZ.019-03-01-057_001, MS.BZ.019-03-02-063_043, _047, _049, _054, _057, and MS.BZ.019-03-02-071_011; Pentecost dome: MS.BZ.019-03-01-055_009, MS.BZ.019-03-02-063_056; Transfiguration dome: MS.BZ.019-03-01-055_013, _014, _015, _016, _017, _018, MS.BZ.019-03-01-056_002, MS.BZ.019-03-01-057_008, _009, _010, MS.BZ.019-03-02-063_041, _042, _051, _052, MS.BZ.019-03-02-071_009, _010. The negatives for some of these reproductions are also preserved with the following folder numbers: MS.BZ.019-03-01-054, MS.BZ.019-03-01-057, MS.BZ.019-03-02-071, Underwood Papers ICFA.

7 The early version (fig. A.17) is analyzed by Friend in a letter; see Nelson, above, 40. Underwood then prepared a different version (fig. A.15), to which he added a note to Friend asking whether it could serve as "the basis for a more finished drawing"; see MS.BZ.019-03-02-071_010, Underwood Papers ICFA. Fig. A.16 seems to eventually have been the once again improved finished drawing.

γραμμικὴ θεωρία κύβου· κύβος καὶ σχῆμα τοῦδε κυβικόν.

APPENDIX A.I. Unfolding of the cube, black felt-tip pen on artist board, 57.79 × 73.66 cm (22¾ × 29 in.),
MS.BZ.019-BF.F.1993.F2819, Underwood Papers ICFA

APPENDIX A.2. Unfolding of the cube overlaid with partial ground-level section, graphite on transparent paper, 47.31 × 57.94 cm (18⅝ × 22¹³⁄₁₆ in.), MS.BZ.019-BF.F.1993.F2828, Underwood Papers ICFA

γωνία κατ' ἔμβολον

APPENDIX A.3. Partial ground-level section, black felt-tip pen on artist board, 57.79 × 73.66 cm (22¾ × 29 in.), MS.BZ.019-BF.F.1993.F2818, Underwood Papers ICFA

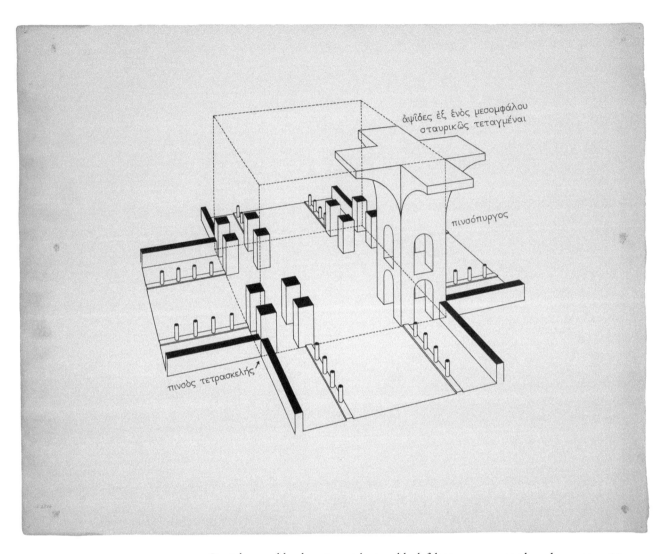

αψῖδες ἐξ ἑνὸς μεσομφάλου
σταυρικῶς τεταγμέναι

πινσόπυργος

πινσὸς τετρασκελής

APPENDIX A.4. Partial ground-level section with piers, black felt-tip pen on artist board, 57.31 × 73.66 cm (22⁹⁄₁₆ × 29 in.), MS.BZ.019-BF.F.1993.F2817, Underwood Papers ICFA

APPENDIX A.5. Partial ground plan sketch, graphite on transparent paper, 29.21 × 30.8 cm (11½ × 12⅛ in.),
MS.BZ.019-BF.F.1993.F2830, Underwood Papers ICFA

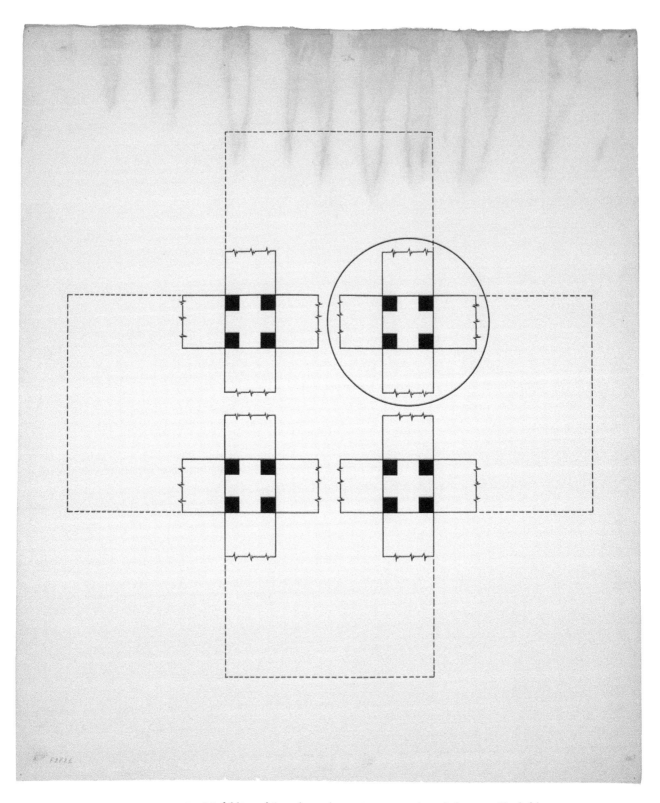

APPENDIX A.6. Unfolding of the cube with repetitive cross-shaped elements, black felt-tip pen on artist board, 57.79 × 73.66 cm (22¾ × 29 in.), MS.BZ.019-BF.F.1993.F2821, Underwood Papers ICFA

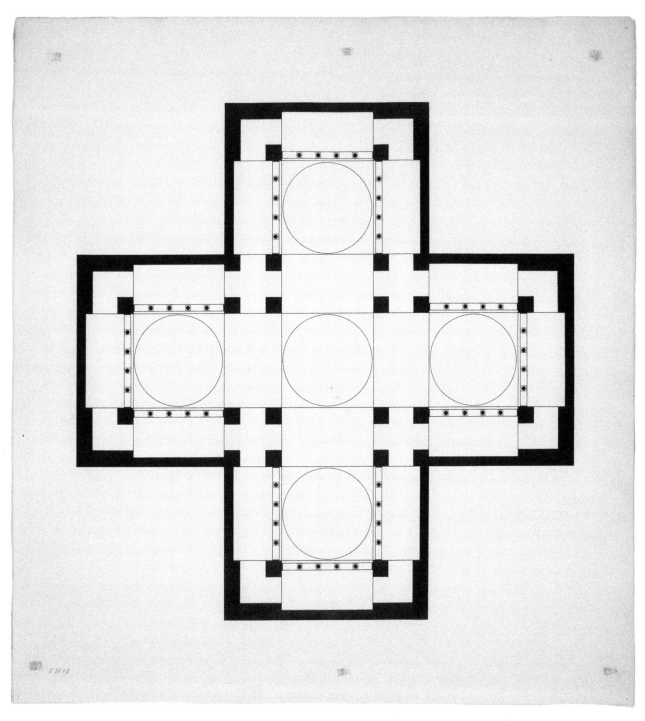

APPENDIX A.7. Ground plan of the main church, black felt-tip pen on artist board, 61.91 × 57.94 cm (24⅜ × 22¹³⁄₁₆ in.), MS.BZ.019-BF.F.1993.F2816, Underwood Papers ICFA

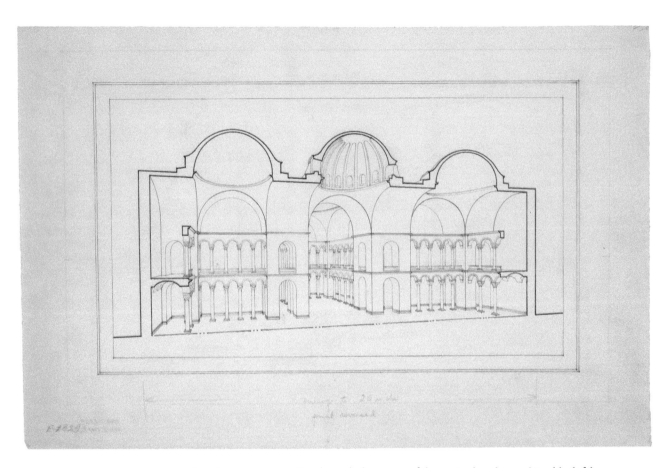

APPENDIX A.8. Axonometric section through the center of the main church, graphite, black felt-tip pen, and fine-tip black ink pen on transparent paper, 32.07 × 49.85 cm (12⅝ × 19⅝ in.), MS.BZ.019-BF.F.1993. F2829, Underwood Papers ICFA

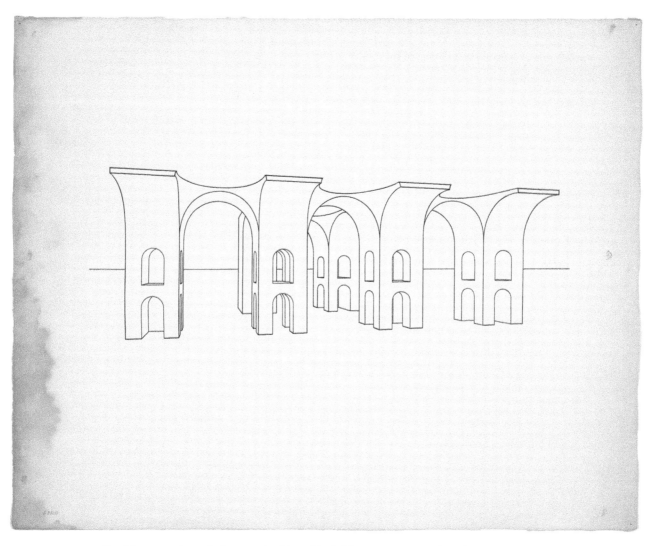

APPENDIX A.9. Partial section through the main building, black felt-tip pen on artist board, 57.79 ×
73.66 cm (22¾ × 29 in.), MS.BZ.019-BF.F.1993.F2820, Underwood Papers ICFA

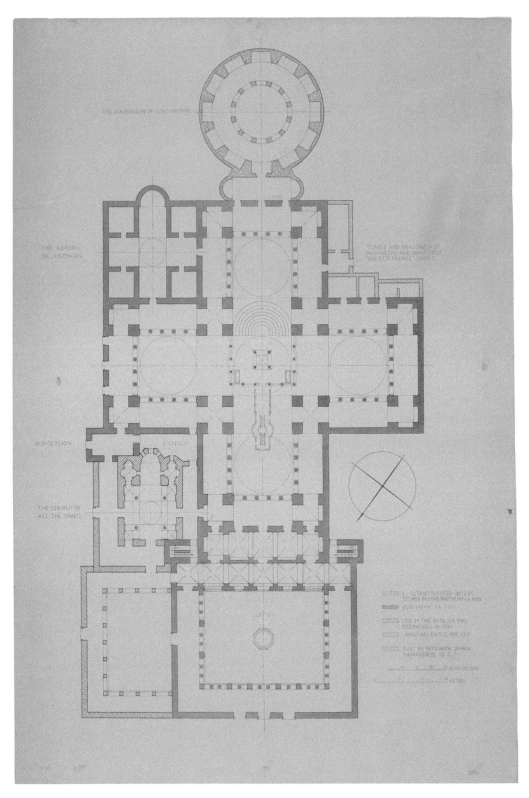

APPENDIX A.10. Large publication-quality ground plan of the complex, graphite and fine-tip black ink pen on artist board, 101.76 × 68.74 cm (40¹⁄₁₆ × 27¹⁄₁₆ in.), MS.BZ.019-BF.F.1993.F2825, Underwood Papers ICFA

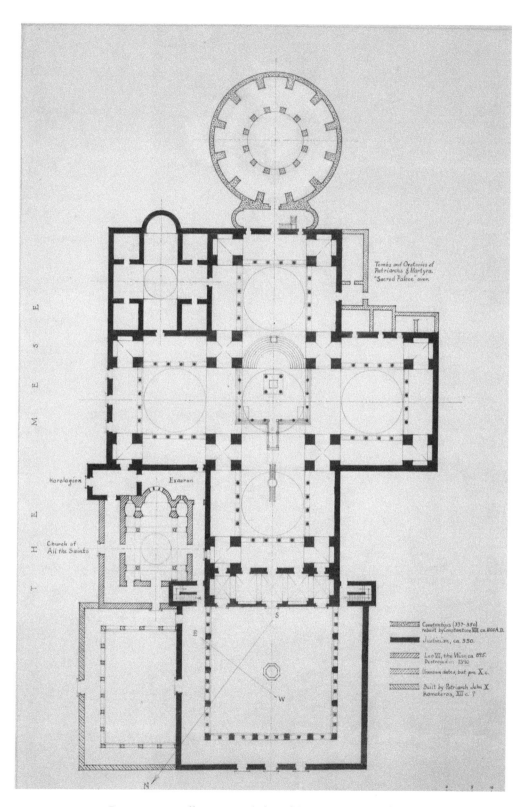

APPENDIX A.11. Preparatory small-size ground plan of the complex, black felt-tip pen and fine-tip black ink pen on transparent paper taped on artist board, 63.98 × 37.78 cm (25³⁄₁₆ × 14⅞ in.), MS.BZ.019-BF.F.1993.F2831, Underwood Papers ICFA

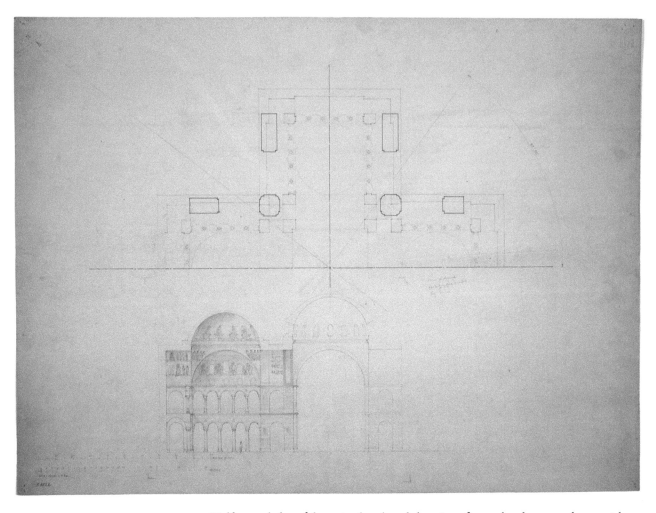

APPENDIX A.12. Half ground plan of the main church and elevation of central and western domes with representation of the Pentecost, graphite and red felt-tip pen on artist board, 55.88 × 76.2 cm (22 × 30 in.), MS.BZ.019-BF.F.1993.F2822, Underwood Papers ICFA

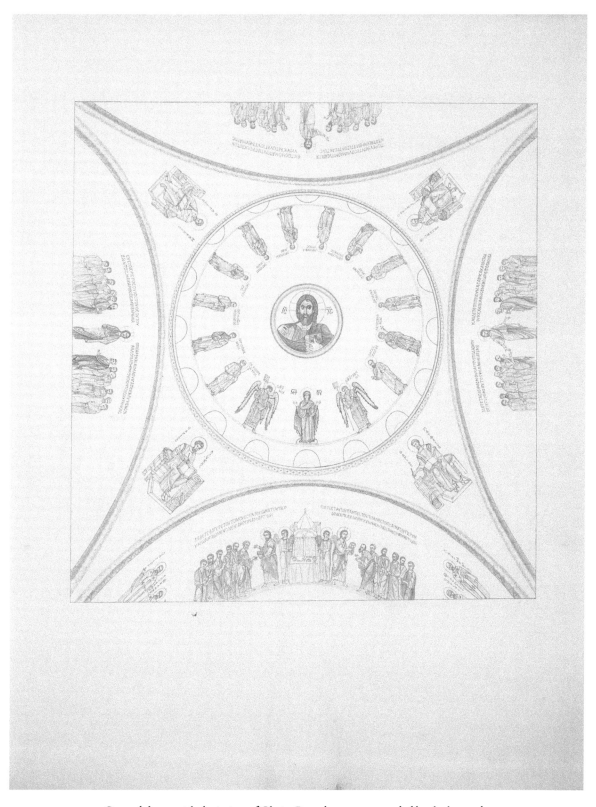

APPENDIX A.13. Central dome with depiction of Christ Pantokrator surrounded by the heavenly court, graphite on artist board, 61.91 × 57.79 cm (24⅜ × 22¾ in.), MS.BZ.019-BF.F.1993.F2815, Underwood Papers ICFA

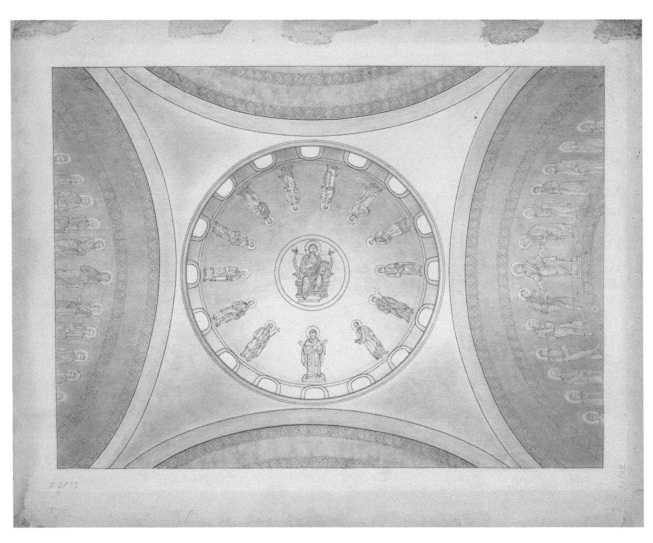

APPENDIX A.14. Central dome with depiction of enthroned Christ Pantokrator surrounded by the heavenly court, graphite on transparent paper adhered to cardboard, 35.88 × 45.72 cm (14⅛ × 18 in.), MS.BZ.019-BF.F.1993.F2832, Underwood Papers ICFA

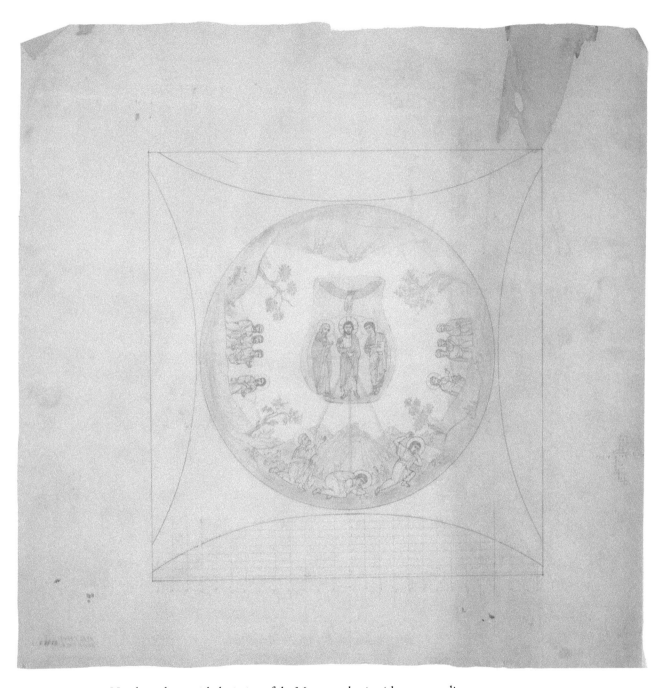

APPENDIX A.15. Northern dome with depiction of the Metamorphosis with two preceding scenes,
graphite on transparent paper, 57.47 × 57.79 cm (22⅝ × 22¾ in.), MS.BZ.019-BF.F.1993.F2813, Underwood
Papers ICFA

APPENDIX A.16. Northern dome with depiction of the Metamorphosis with two preceding scenes and one following, graphite on transparent paper, 52.23 × 50.01 cm (20⁹⁄16 × 19¹¹⁄16 in.), MS.BZ.019-BF.F.1993. F2812, Underwood Papers ICFA

APPENDIX A.17. Northern dome with depiction of the Metamorphosis with two preceding scenes, black and white reprographic print (original is not preserved), 20.30 × 26.33 cm (8 × 10⅜ in.), MS.BZ.019-03-01-057_009, Underwood Papers ICFA

APPENDIX A.18. Eastern dome with depiction of the Anastasis, graphite on transparent paper, 54.13 × 50.01 cm (21⁵⁄₁₆ × 19¹¹⁄₁₆ in.), MS.BZ.019-BF.F.1993.F2810, Underwood Papers ICFA

APPENDIX A.19. Eastern dome with depiction of the Anastasis, graphite on transparent paper, 48.26 × 57.15 cm (19 × 22½ in.), MS.BZ.019-BF.F.1993.F2811, Underwood Papers ICFA

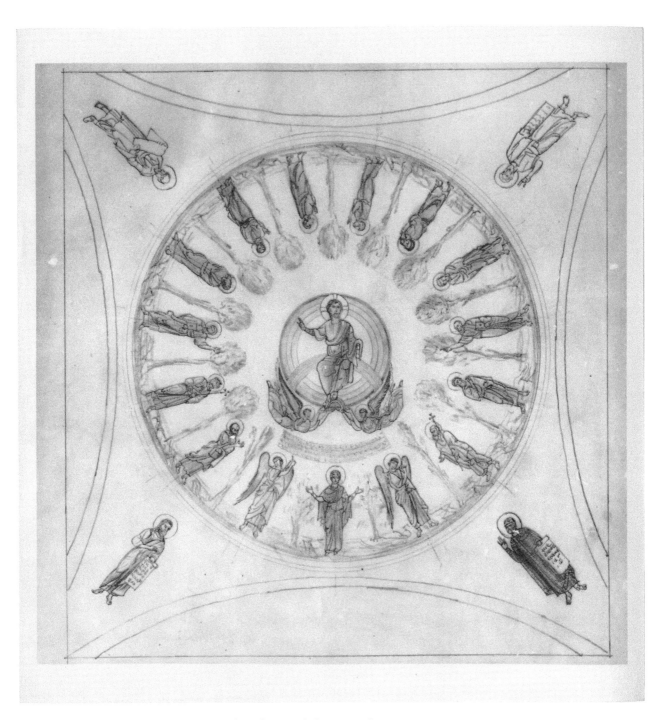

APPENDIX A.20. Southern dome with depiction of the Ascension, black and white reprographic print (original is not preserved), 20.3 × 21.15 cm (8 × 8 5/16 in.), MS.BZ.019-03-01-054_008, Underwood Papers ICFA

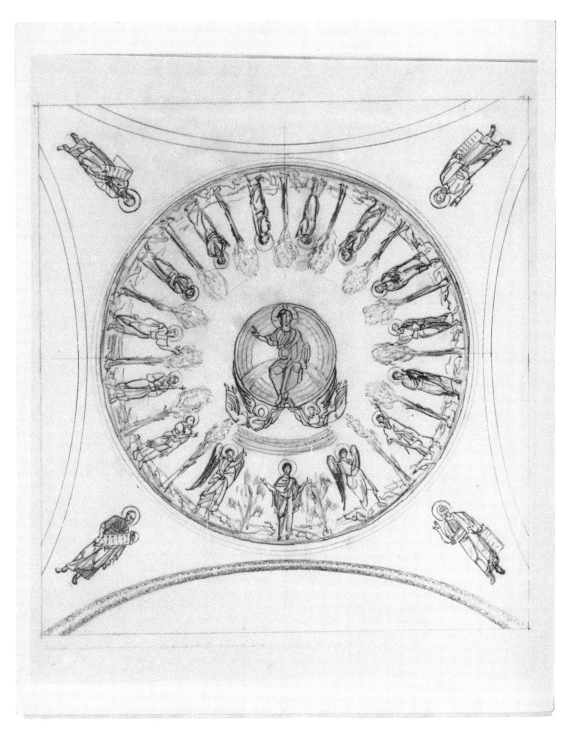

APPENDIX A.21. Southern dome with depiction of the Ascension, black and white reprographic print (original is not preserved), 20.30 × 25.40 cm (8 × 10 in.), MS.BZ.019-03-01-055_005, Underwood Papers ICFA

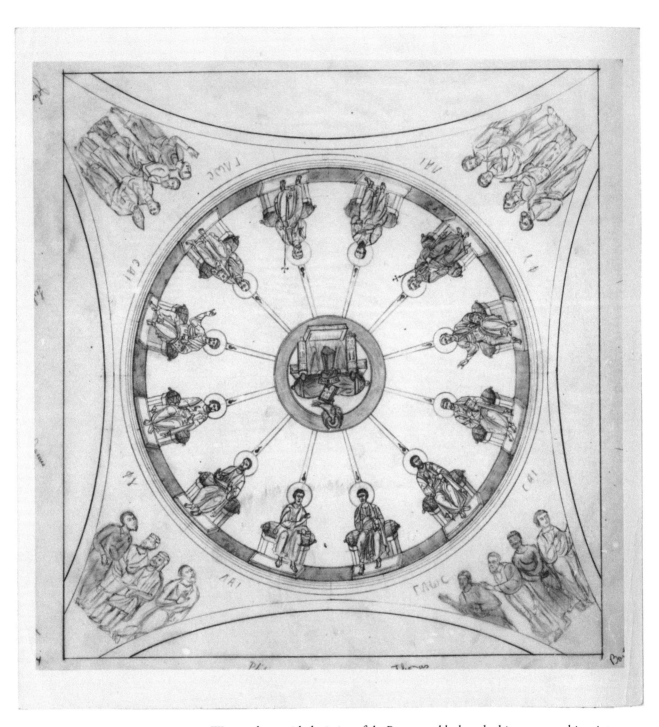

APPENDIX A.22. Western dome with depiction of the Pentecost, black-and-white reprographic print (original is not preserved), 20.20 × 21.20 cm (7¹⁵⁄₁₆ × 8⅜ in.), MS.BZ.019-03-01-055_009, Underwood Papers ICFA

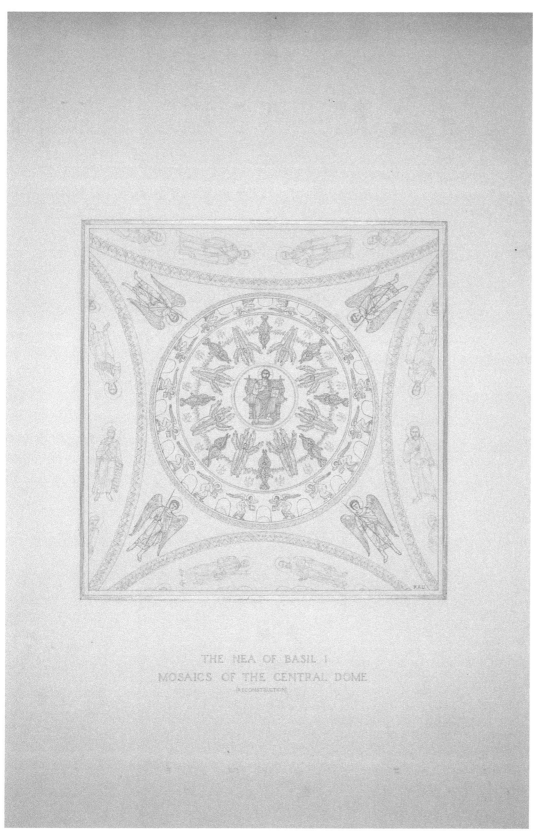

APPENDIX A.23.　Central dome of the Nea Ekklesia, graphite on artist board, 73.66 × 57.79 cm (29 × 22¾ in.), MS.BZ.019-BF.F.1993.F2814, Underwood Papers ICFA

APPENDIX B

Selected Pages from Albert Mathias Friend, Jr.'s Notebooks

Unlike Underwood and Downey, who nearly finalized their contributions to the Holy Apostles project, Friend apparently never produced any portion of his volume on the mosaic decoration. Four handwritten pages in the folder MS.BZ.019-03-02-066 in the holdings of ICFA are the only traces of his part. Those consist of the cover page; the contents page, which lists only an introduction; the introduction page, the text of which ends abruptly in the middle of the second paragraph; and a page (156) that lists nine primary texts, certainly intended to be used in this first part of his volume (figs. B.1–4).

While Friend did not produce any publishable outcome of the years-long Holy Apostles project,[1] a series of six notebooks and a few scattered pages preserved in ICFA show his thorough engagement with the topic of the mosaics in the Holy Apostles; the scheme of their iconography; their dating, iconographic features, and types; and their theological meaning.[2] The earliest notebook, MS.BZ.019-03-02-068, contains one page (089) with the date 25 July 1944, making it possible to trace his interest in the Holy Apostles back before his employment at Dumbarton Oaks.[3] Those early notes are of special interest because they clearly outline Friend's methodology and interests,

which would stay for the most part unchanged throughout the project. He engages with what he calls the type of the portraits of the apostles and traces standing and seated examples, as well as the gestures of the figures and whether their faces are portraitlike. He concludes on page 017 that "Apostle Ch. / creates iconography / for all 12 Apostles / Portrait types for all." These reflections for him are naturally based on comparisons with known monuments and miniature paintings, which according to Friend are always called "copies," thereby assuming that the Holy Apostles would be the unique source. He also draws on the "copies" in trying to reconstruct the iconographic schemes of the domes and vaults of the church, an example of which can be seen on page 009 showing the central dome, which he calls the "Dome of the Pantokrator" (fig. B.5). At this stage Friend also studied many early types and iconographies, mainly from the fourth to sixth centuries, presumably to date the mosaics and therefore distinguish them from those early models. A good example is page 059 (as well as 114) in which Friend traces the "Pentecost picture history." Other iconographic schemes include the Transfiguration dome, for which Friend concludes on page 004 that the "Metamorphosis in Sinai Mosaic is a totally different iconography," as well as the Anastasis, which he places in the eastern dome.

On three pages (006, 096, 123) Friend states his thesis that Photios laid out the mosaics for Basil I in the Holy Apostles, as well as the Nea Ekklesia and Hagia Sophia, and dates them to his second patriarchate, 878–886. Because of his attribution of the mosaics to Photios, Friend's notes reveal a preoccupation with a possible

1 See above Carder, 24, and James, 161, for Friend's reputation of being "notoriously slow in writing for publication."

2 All transcriptions from Friend's notebooks adopt his spelling, abbreviation, punctuation, and capitalization. Abbreviations are self-explanatory throughout the text. Capitalization and spelling vary occasionally.

3 This can be confirmed by Carder, above, 22. It is possible that not all pages of the notebook are from 1944 and that Friend later combined single pages that would fit certain thoughts.

theological meaning, analyzing the Hetoimasia and the filioque controversy of Photios on page 100 and following in light of what he calls the "Ecumenical Academy," or the "University of Constantinople," which he believed might have been located in the Holy Apostles church in the ninth century. In these theses, he relied greatly on publications by Father Dvornik, who was not yet involved in the project.

This notebook consists of rather loose notes, excerpts, bibliographies, and sketches. Yet it touches upon the majority of the themes that Friend presented at the Holy Apostles symposium in 1948. A single sheet from a notebook is found in MS.BZ.019-03-01-054 in between photographs of manuscripts, wall paintings, and mosaics containing a sketch of "The Nea of Basil I / Constantinople" (fig. B.6).[4] It must have served Underwood as a model for the drawing of the central dome of the Nea Ekklesia, which was exhibited during the 1946 Hagia Sophia symposium and which exemplified the methodological and collaborative approach of the Holy Apostles project. The sketch is close to Underwood's final drawing (A.23): in the layout there exist four zones with a medallion showing Christ seated on a throne in the center, surrounded by seraphim and cherubim, and in the drum, angels alternating with window openings, and a further four angels in the pendentives. The only few differences between Friend's sketch and Underwood's drawing are found in the pose of the angels and the number of windows. Friend seems to have had a very precise idea of the appearance of the dome. As with the sketch he also gave instructions on the color of the background, as well as the sources for the restoration: "f 67v of Paris 510" and "Photius Sermon on the dedication," as well as the domes of the Martorana and Palatine Chapel in Palermo, Lesnovo, Chilandar, Mistra, Daphni, and Hosios Loukas.

Notebook MS.BZ.019-03-02-070 contains notes on Hagia Sophia. It can be connected to the Dumbarton Oaks symposium on Hagia Sophia and can thus be dated around 1946. In an attempt to reconstruct the "Scheme of Mosaics" (page 022) in Hagia Sophia, Friend adapts the same methodology apparent in his research on the Holy Apostles and the Nea Ekklesia sketch, while also using the Holy Apostles mosaics as a reference point. For instance, on page 001 he compares the Hagia Sophia dome mosaic and the type of the seated Christ to the Ascension in the south dome of the Holy Apostles, which he believes was later copied in Hagia Sophia in Thessalonike: "I would take it that Photius invented the Ascension medallion and then used it with full theological meaning in dome of Hagia Sophia."

On the following pages Friend deals with the inscription in the dome and important personalities like Basil I, Photios, Gregory the Armenian, St. Athanasios, Methodios, and Ignatios the Younger. He also analyzes the specific iconographies of the prophets, as well as of the Hagia Sophia mosaics of the Apostles, which he believes were represented in the soffits of the eastern and western arches, and the Virgin in the apse among others, but he is concerned mostly with the Pantokrator of the main dome and a possible iconography of the Rex Regnantium based on comparative examples and an extensive bibliography.

Notebook MS.BZ.019-03-02-066 documents Friend's work on the Holy Apostles in 1948. It is probable that his involvement in the project was less active in the preceding years owing to his preoccupation with the Hagia Sophia symposium in 1946 and the Princeton University bicentennial celebration.[5] He seems to have taken up his research only shortly before the Holy Apostles symposium, as page 027, thus fairly early in the notebook, indicates "Spring 1948." One of the last pages, 155, is dated "September 5, 1948." Therefore, the bulk of notes covers Friend's renewed interest in the Holy Apostles project during the summer of 1948. It shows a preoccupation with iconography and the specific visual solutions within the Holy Apostles church. In the beginning he is primarily concerned with the "Icons of Christ" (page 001) and with the development of an imperial iconography, Sol Invictus, and Victoria, together with their crowns, diadems, and triumphal processions. Friend later moves to the iconographies of the empty throne or Hetoimasia, Christ in triumph, and Angel of Victory. At that point, he focuses on a lengthy

4 See also Nelson, above, 37–38.

5 See Carder, above, 23.

discussion of the central dome of the Holy Apostles church. His methodology, consistent throughout this notebook, is best exemplified on pages 017 and 018, recto and verso. The section (fig. B.7) is entitled "Central Dome of H. A." and is followed by a sketch of the dome, including the pendentives and arches. He envisions a medallion of Christ—the appearance of which occupies him repeatedly in the notebook—in the zenith of a ribbed dome, whose twelve cells are occupied by the apostles, the Virgin orant, and two archangels. The pendentives show the evangelists and the eastern arch is filled with the communion of the apostles. He refers to Constantine the Rhodian's and Mesarites' descriptions of the dome for this arrangement. The following notes are concerned with the dome being over the altar and the iconographic implications of this location. He envisions the dome, pendentives, and arches as one common iconography, whose subject is the incarnation. Christ is supposed to be "the type of Daphni" and the Virgin "the type later called Blachernitissa." The sketch and these notes closely reflect one of Underwood's drawings (fig. A.13). On the recto Friend lists four "copies" of the central dome in Cefalù, St. Sophia in Kiev, Nea Moni on Chios, and Monreale, and suggests that the central dome of the Holy Apostles influenced the east dome, that is, the one over the altar, in San Marco. On page 018 he further explains his logic: "This scheme of the H.A. has to do with the altar and the liturgy and is always placed over the altar whether in a central dome (in H.A. altar is in center of Ch) or in an east dome (as at St Marco) or in the apse of the altar (as at Kiev, Cefalu, Monreale or Nea Moni)."

On the verso Friend provides a rough sketch of the plan of the Holy Apostles with the corresponding iconographies in the domes and a numbering from 1, central dome, to 5, Pentecost dome (fig. B.8): "So a proper description of H.A. begins with central dome, i.e. the Incarnation—then Life of X to Transfiguration—then Passion to Anastasis—then appearance of X to Ascension—then Pentecost to teaching and baptising."

On page 17 verso Friend also thematizes the connection of the appearance of Christ in the central medallion to Christ on the coins of Constantine Porphyrogennetos: "The central medallion occurs for 1st time on coins of Constantine Porphyrogenitus when he governs alone—AD 945. [...] / Constantines interest in H.A. / 1. Orders C. Rhodios to write poem / 2. Puts central medallion of dome on his coins / 3. Builds little H.A. at Palace of Eria (cf. Theoph Contin. p 452 Bonn) / 4. Tells of its reconstruction under Basil in his life of his grandfather."

The following pages repeat some of these main points and deal additionally with specific comparisons at Monreale, Cefalù ("must have had copied the Mosaics of the central dome of the H.A.," p. 021), and "the Cappadocian churches." On page 026 (fig. B.9) Friend returns to the Holy Apostles central dome with a sketch of an internal view toward the northeast. This is the only page from Friend's notebooks that also gives an idea of the architecture of the church together with a rough arrangement of the mosaics. He closely follows Underwood's vision of the interior of the church as exemplified in the ground plans (figs. A.10–11), as well as the axonometric section (fig. A.8), which shows the tympana as a continuation of the vertical plane of the outer wall, as in San Marco.[6] A curious difference is that Friend does not provide windows for the main dome, an omission that does not seem to be intentional, since on the next page 027 (fig. B.10), which shows a sketch of the central dome alone, he reverts to providing indications of windows on the base of the dome. This page, dated spring 1948, is essentially a more detailed version of the drawing of page 017 (fig. B.7) specifying the appearance of the Pantokrator as a bust, holding the book in his left and blessing with his right, the Virgin orant with raised hands flanked by archangels, and the arrangement of the twelve apostles in a dome with fifteen ribs instead of an architecturally sound sixteen ribs, as he gives the Virgin double the space of the other figures. The sketch is accompanied by an excerpt from Constantine the Rhodian describing the central dome. This leads into a lengthy discussion of the eucharistic meaning for this dome, where Friend repeatedly comes back to the same point of the importance of the incarnation and therefore the inclusion of the Virgin and the apostles in the central dome, e.g., page 040:

6 Cf. below Underwood, "The Architecture of Justinian's Church of the Holy Apostles, I," p. 26.

"This means there were two infusions [. . .] of Christ himself into human nature 1. The infusion into Virgin at Incarnation / 2. The infusion into the Apostles at the Eucharist / So in dome of H.A. both Virgin and Apostles must be present since the Incarnation and the Eucharist have deified them"; page 042: "The central dome of the H.A. (with Pantokrator, Virgin orans and apostles) sets forth the Incarnation while the east arch shows the extension or continuance of the Incarnation in the Eucharist as dispensed by Christ whose εὐλογία—words of consecration—, are the inscription over the scene."; and even more extensively on page 042 verso:

> The Incarnation is instituted through the Virgin / The continuation in the Eucharist is instituted through the Apostles / Consequently in the dome both the Virgin of the Incarnation and the Apostles appear / The Incarnation is a single act in time, the Eucharist is this Incarnation in continuous time and is perpetually renewable. / In the iconography / Christ exists: / Perpetually—in the Bosom of the Father / At the Incarnation—in the womb of his mother / At the Eucharist—in the mouths of his apostles. / And so / By his human Body derived from the Virgin which is eaten in the eucharist by the Apostles he deifies the Virgin and the Apostles who then appear in dome with the Pantokrator. / The subject of the Central dome then is the apotheosis of the Holy Apostles.[7]

Further to his argument, Friend is convinced of the importance of the liturgy of Basil to the point that it is reflected in the arrangement (page 049):

> H.A. Central Dome / Sequence is that of liturgy of Basil / 1. Pantokrator—Prayer before sanctus. Seal of equal type. / 2. Archangels with Labarum—Sanctus / 3. Virgin—Incarnation—Prayer of Consecration / 4. Eucharist—Prayer of Consecration / 5. Church Fathers—commemoration—the diptychs[?] / The whole system may have its imperial and priestly connotations, since

John Chrysostom and Gregory of Nazianzus are buried under Dome—(But Gregory was brought here only under Constantine Porphyrogenetos. / Nicephoros and Methodios are also buried in H.A. showing connection with Orthodox image adorers.

At this point Friend moves on to the Pentecost dome by looking into Photios's writings, then continues with Mesarites to the northern and southern arms and specific scenes, such as the confession of Peter on the northern arch and the ascension dome, among others. He repeatedly points to the mosaics as being a "glorification of lifegiving body of Christ in history and Eucharist" (page 068) and that the "Scheme (after iconoclasm—incarnation makes physical revelation in pictures possible) [has the] Subject [of] The Human Body of Christ" (page 068 verso), as well as that it is "primarily eucharistic from Basils anaphora / But it is equal incarnational and anti-iconoclastic. / The fundamental idea is to glorify the 12 apostles who are the inheritors of the eucharist" (page 074).

This is all justified for Friend by the fact that "iconoclasm [was] not a dead issue in Constantinople till period of Leo the Wise. / It is likely that whole scheme of H.A. ch mosaics was devised by Photius as a final answer to the iconoclasts, a visual council for the images as it were. / He took the indications in the VII Ecumenical Council of his great uncle Tarasius and the Liturgy of Basil as the basis of his iconography and showed by pictures the economy of Jesus Christ both the Eucharist and the images" (page 083).

After a lengthy discussion of similar content, Friend concludes on page 098 that "The whole program is a final and visible answer to iconoclasm made by Photius after 880." Having settled these issues, Friend is again concerned with the copies of the program in San Marco, as well as in manuscripts, specifically Paris 54 and 510, Iviron 1 and 5, Berlin 66, Leningrad (St. Petersburg) 21, Dionysiou 740, Vatican 1156, and the Chludov Psalter. A further drawing of the central dome of 16 August 1948 on page 107 (fig. B.11) adds St. John the Baptist on the western side, and the evangelists in the pendentives. The subject now is defined as "The Witnesses to Jesus as the Son

7 This last passage is marked for emphasis with an arrow.

of God." Friend is convinced that the mosaics of the Holy Apostles were copied in lectionaries and provides further examples, as well as visual solutions for the transfer of the program from a three-dimensional space to a book page (page 111, fig. B.12). Those manuscripts however do not include the pendentives and arches, which are "always associated with dome above" (page 118). An example of this point is page 119 (fig. B.13), showing the east dome with the Anastasis. Here possible copies are provided not only for the main scene but also for the figures in the pendentives, all taken from manuscripts.

Friend jumps to the Pentecost dome on page 120, adding yet another example of Photios's involvement in the program and iconography:

Pentecost made like a church council with throne and Gospels of Christ which were in center of Ch. Council put in summit of dome. / This was made up for H. A. Church and put in West arm where was held 1st session of VII Oecumenical Council called by Irene in 786 (Aug 17), also 2 councils of Photius, 859 and 861. / The Pentecost was copied for catechumena of Agia Sophia where were held 2nd iconoclast council of 815, Ignatius council of 869 (sometimes called VIII Oecumenical) and Photius' council of 879, where he was rehabilitated and where II Nicaea was declared Oecumenical. It was most probably Photius who invented the dome and set it up both in H. A. and Agia Sophia. / Basil must also have had made a book on 7 councils with frontispiece for each / 2nd council was copied in Paris 510 f355 and the 7th in Menologion of Basil II pl 108. / Was copy of H.A. Pentecost dome, made up for place of council in H.A., the frontispiece of this book of Basil containing Acts of the Seven Councils?

After briefly touching on the Eulalios question,[8] Friend continues with his analysis of further scenes, such as "Christ walking on Sea. / In the program this is one of the most important

mosaics in church, and is not to be treated casually" (page 123), the Transfiguration (page 126), and Ascension (page 127), with indications of biblical passages for the pendentives, etc.

On page 137 Friend adds the Mirozhsky church in Pskov as a comparison, since he believes it has "one of the best copies of cycle of H.A. including central dome." He exemplifies it with a sketch of the ground plan with the scenes. The last pages of the notebook seem to be summarizing Friend's understanding of the scheme of the mosaics (page 153): "Iconographically / From the central dome one goes through the arches of main dome into iconography of each of the arms"; and on page 155 he gives a status of 5 September 1948 with "fairly sure copies" and a detailed list of all domes, arms, arches, and pendentives.

Separated from this notebook are five pages in MS.BZ.019-03-02-063 that seem to belong to or to have been created shortly after the last pages of the 1948 notebook. They are sketches of the four arms of the church of the Holy Apostles with detailed indications on the iconography on the walls, arches, pendentives, and domes, including the visual references that Friend used to envision those scenes and figures. These schemes present the complete visual program of the Holy Apostles as Friend believed it to have been created by Photios. While drawings by Underwood exist only for the mosaics of the domes and some preliminary drawings for a few walls, it could well have been intended by Friend that Underwood should create even more complete reconstructions of the mosaic program based on his instructions. Page 001 (fig. B.14) shows the northern arm, page 002 (fig. B.15) the eastern arm, page 003 (fig. B.16) the southern arm, and page 004 (fig. B.17) the western arm. Page 005 is a crossed-out version of the southern arm.

Notebook MS.BZ.019-03-02-067 is not dated. Based on three surviving letters in between the pages from Milton Anastos that all date to 1949 (pages 032r and v, 120, and 124 and 125r and v), as well as its content, it is likely that it represents Friend's state of research and thoughts in that same year. The Anastos letters are of special interest as they demonstrate the continuous shift in Friend's research toward a theological interpretation of the Holy Apostles mosaics, as well as his need to collaborate on this matter with Anastos

8 Cf. M. Angold, "Mesarites as a Source: Then and Now," *BMGS* 40, no. 1 (April 2016): 55–68; B. Daskas, "A Literary Self-Portrait of Nikolaos Mesarites," *BMGS* 40, no. 1 (April 2016): 151–69.

and Francis Dvornik.[9] Thus, his main concerns at this point are primary texts that could explain the appearance of specific scenes in the Holy Apostles church, as well as their particular iconography from a theological perspective and especially from an iconophile point of view. This focus also connects to the dating of the mosaics. For instance, on page 092, Friend writes:

> Portraits of Apostles / In H.A. Church / Most date after the Controversy. / Each apostle is differentiated and has an individual portrait. There are no 'types' such as several young men or several old men as in early Xian art. / Only three apostles had 'real' portraits before iconoclasm, Peter Paul & Andrew. Afterwards all had. Since then the icon was the image of a particular person (& not a type) each apostle had to have his individual (particular) portrait. This is essential in the new idea of an icon after 843. It stood for the individual prototype. This is no platonic idea (man) but an exact individual, particular person not exactly like anybody else. / (I was put onto this discovery by reading Bevan, Holy Images, pp. 171 ff who himself does not realize the importance of this for the Orthodox & say (171) that the Iconoclasts may have had a good idea when they said the Orthodox were trying to add a fourth Person to the Trinity. / All this is another proof that the mosaics of H.A. were an answer to the Iconoclasts and must date after the Controversy.

This page neatly fits into the argument in Friend's 1944 notebook and 1948 paper of the existence of individual portraits and the abandonment of figure types, but gives this visual solution a theological and political meaning. Another example, page 102, demonstrates this same logic in Friend's interpretation of the existence of specific scenes within the church: "Dogmas in H.A. Mosaics / Pantokrator—against Arians / Gethsemane—against Monothelites / Anastasis—against Appollinarians / Transfiguration [and] Ascension—against Synousiasts & Iconoclasts." Ultimately for Friend the mere existence of mosaics in the Holy Apostles church

serves the same purpose: "The mosaics in H. A. are in the nature of theophanies, appearances of God, with a sacramental value. / The question is how the incarnate Logos can be represented / 1. Before and after the Transfiguration / 2. The Bread and Wine / In Ch. two sacraments / 1. Bread and Wine—Eucharist / 2. Mosaics—Holy Images / This is answer to Iconoclasts and a full vindication of VII Council which had its 1st session in H.A. Church in 786 A.D" (page 071).

His methodology at this point is to excerpt and translate passages from primary texts for every dome and to note their appropriateness for his argument. For instance, page 005 represents Cyril of Alexandria with a note "Pantokrator text (best one)." Several pages refer to the Anastasis: Page 020 with an excerpt from John of Damascus is noted as "Text for Anastasis the best one"; page 021 with the Acts of Pilate as "Text for Anastasis Essential one"; pages 022, 023, and 024 are again by John of Damascus with notes "best text for Anastasis in H.A. Mosaics," "Important text for Anastasis in H.A. Mosaics," and "Text for Mosaics in H.A."; and 026 is a last page with a passage by Cyril of Jerusalem noting "Text for Anastasis Mosaic in H.A." Further examples are page 041: "Anastasis / 15 Anathemas against Origen and / Justinian" with a note "very important." Page 047 with the Letter of Eusebius to Constantia notes "Text for whole scheme of H.A. mosaics" and page 048 with a quote from the same source is more specific as "Transfiguration text for H.A. mosaics." The last such example, "From the Sentence of the V Oecumenical Council," is on page 111, referring to the Pentecost dome notes "H.A. Mosaics / most important."

As in earlier notebooks there are also pages concerned with comparisons and the "copies" of the Holy Apostles mosaics. The most specific one, which seems to be a definitive list, is on page 123 verso: "Central Dome—Cefalu, Moscow 13—Dionysiu 740, Kiev, Mirozski / Transfiguration. Iviron I, Paris 510, Paris 74, Chludov Ps. / Anastasis. Iviron I, Paris 550, Chludov Ps., Princeton / Ascension. St Sophia—Saloniki, St George—Saloniki / Pentecost. San Marco, St Luke in Phocis, Paris 510, Hagia Sophia, Chludov Ps / Main Arches. Dionysiu 740, Baltimore, St Sophia Kiev—San Marco / W. Arm. Paris 510—Baptisms, Chludov—Teachings, Vat 752."

9 See also Carder, above, 23.

Friend continued his work on the Holy Apostles in the same vein in the summer of 1950 and summer of 1951. Those two notebooks, which are combined as MS.BZ.019-03-02-065, are the last evidence of his research on the topic. At this point Friend's interest is centered on the three domes with representations of the Anastasis, the Transfiguration, and the Ascension, with an absolute conviction of their existence and placing, regardless of the fact that none of the written sources could confirm the existence of an Anastasis or an Ascension dome, and so this hypothesis altogether is undermined.[10]

Continuing the methodology from the 1949 notebook Friend primarily excerpts and translates passages with supposed relevance to a specific dome. Throughout the 1950 notebook he is almost exclusively concerned with the Anastasis. In this dome he sees a direct response to Iconoclasm and most specifically its purported theological source, Origen. The confirmation for Friend is found in Photios's own writings:

[page 023r] Photius says that Eusebius is tainted with error of Origen concerning the resurrection of the body. Says this is not well known. / This teaching of Origen is best seen in Eusebius in his letter to Constantia. Yet it is not alleged against him by those who dealt with letter / 1. Council of 787 / 2. Nicephorus in his 4th Antirheticus (Spicil Soles I) / Photius seems to be 1st to realize this (involved is the fact that iconoclasm has its real roots in the error of Origen concerning resurrection of the body. / In the Ch of H.A. the Anastasis of X "sarki" showing his wounds, which is in east dome, was invented (by Photius?) on basis of Old descent into Hell in order to controvert the error of [page 023v] iconoclasm which held that X's flesh/body had been swallowed up by his divinity and had become divine in its nature and so could not be depicted. / Photius knew that the Resurrection of the flesh was the answer to Iconoclasm (was it discussed in council of 861 in H.A.). He probably realized this in his reading of Methodius (Bibl. Cod. 234-237). / In any case it was Photius who could

make the best criticism of Eusebius' letter to Constantia. / Photius had no time for Origen and is a great advocate of his condemnation in 553 (see Photius letter to Boris Michael).

Consequently, one of the iconographic particularities that interested Friend since 1948 is Christ showing his wounds (e.g., page 136). The following pages analyze the theological genesis of Photios in contrast to the Iconoclasts and puts, for instance, on page 042 St. Paul, Origen, and Eusebius in one direct line when it comes to the less "fleshliness" of the Resurrection of the Body in contrast to St. John, Methodios, Epiphanios, Justinian, and Photios ("more fleshly"). The topic of the refutation of Origen can also be demonstrated in the Transfiguration (page 044), all of which leads Friend to believe that:

H.A. Church Mosaics / All based on dogma of the Resurrection of the Flesh. / Has 3 Aspects / I. Conciliar—against the Iconoclasts since VII Oecumenical Council met in church / II. Sepulchral—Ch is burial place of Emperors / III. Eucharistic—at altar under central dome the bread and wine become the Body and Blood of Christ / These 3 aspects are all unified by the Dogma of the Resurrection of Flesh. / Photius is undoubtedly responsible for the iconographic scheme which expresses all of the above (page 046).

This new dogmatic meaning later, according to Friend, develops into the "feast pictures" (page 045). Further lengthy discussions of Origen, Eusebius, Justinian, Athanasios, John of Damascus, Photios, and others are concerned primarily with the Anastasis and touch on the same theme: "The Descent into Hell was so called until time of Photius when new picture (based on old one) was called by him the Αναστασις? / Did change from Descent to Resurrection result from Photius?" (page 055). As already in 1949, Friend is aided in his analysis by Milton Anastos, as is evident in a letter dated 14 and 16 September 1950 (page 085). The last pages of 1950 bring up the new topic of the three mountains, Horeb, Thabor, and Sinai, to be represented in the Transfiguration. These last pages, as well as his discussion on Christ showing his wounds in the Anastasis and

10 See James, above, 162–63.

whether Christ is shown with open hands on a rainbow in the Ascension, neatly reflect the large number of different versions drafted for these domes by Paul Underwood[11] as well as the letters from both Friend and Underwood discussing this kind of detail.[12]

The last notebook, from summer 1951, continues with a discussion on the theology concerning Christology and the Resurrection of the Body expressed by St. Paul, John Chrysostom, Gregory of Nazianzos, Cyril of Jerusalem, and Photios in relation to his predecessors. While pages 107 and 108 are "excellent text" selections by Chrysostom for the Transfiguration dome, in this notebook Friend is again almost exclusively concerned with the Anastasis, because "If by sin came death, then in order to save sinners—i.e. the reason for the Incarnation according to XP it is necessary for Christ to destroy death. It follows then that the Anastasis dome where this triumph is depicted is the most important in the church of those which depict events in Christ's earthly life. / Transfiguration—Anastasis—Ascension" (page 131).

In search of the grand implications of the mosaic scheme for the entire church Friend posits a didactic meaning on page 110, because "The Mosaics were public and for public teaching. The theology which they seek to purvey must also be of a public nature—simple & direct— like preaching or the liturgy, or Councils. / Best places to cite for theology are in the preachers and in liturgy."

This leads him ultimately to express his final hypothesis on the mosaics of the Holy Apostles, which goes a step further in his own analysis by proposing not only that they are conceived by Photios as an answer to Iconoclasm but that they are his pictorial Summa Theologica:

[page 124r] H.A. Church / Mosaics / Expression of Complete Theology / Summa Theologica / 1. Peri Archon (Origen) / 3.Catechetical Orations (Greg. Nys.) / 4. Orthodox Faith (John Dam.) / 5. H.A. Mosaics (Photius) /

2. Catechetical Orations (Cyril of J) / The mosaics of the Holy Apostles Church give a complete picture of the 'Economy' of the Incarnation of the Word. Origen, Gregory of Nyssa and John of Damascus had attempted this before in writing. Now for the first time it is attempted in pictures. The mind behind the artists was undoubtedly Photius so this then can be called Photius' pictorial Summa Theologica (done like an exegesis of the Gospel text). / This makes the mosaics more than just an answer to letter of Eusebius to Constantia as I said in my lectures at D.O. in 1951 [page 124v] Scheme / 1. Christ is God and Man—Transfiguration—shows his God head / 2. Atonement—Anastasis brings God and Man together by the Crucifixion—i.e. the death. By death (wounds) is Death conquered. / 3. Ascension—Man's nature raised to right hand of God. / 4. Human nature in the bosom of the Father (Pantokrator) / So mosaics use the letter of Eusebius to Constantia as a mere stepping off to a much more profound scheme depicting Salvation—the freeing from Death and hence from sin with all the moral implications contained in this / Certainly the grandest religious scheme ever done in art.

In the notebook's final pages Friend discusses the "copies" of the Holy Apostles mosaics in the Serbian churches of Dečani, Staro Nagoričane, Gračanica, and Peć. There are a further three pages in Glanville Downey's handwriting, which seem to be a translation of a text by Origen (pages 174–176, "Since kneeling is necessary") an undated letter from Anastos addressing Friend with the usual "Dear Sir Boss,"[13] and several single pages from previous notebooks. They consist of thoughts from which Friend had already moved on in 1951.

11 See my introduction to the Underwood drawings, above, 299–300 and n. 6.
12 See n. 35, as well as three further examples in MS.BZ.019-03-01-055 and MS.BZ.019-03-02-063, Underwood Papers ICFA.

13 Cf. also Milton V. Anastos, "The Argument for Iconoclasm as Presented by the Iconoclastic Council of 754," in *Late Classical and Mediaeval Studies in Honor of Albert Mathias Friend, Jr.*, ed. Kurt Weitzmann (Princeton, NJ, 1955), 177, where Anastos salutes "Sir Boss." This paper must have resulted from his research together with Friend on the topic starting in 1949.

APPENDIX B.1. Cover page of handwritten draft manuscript for "The / Church of the Holy Apostles / Constantinople / Vol. II / The Mosaics / by / A. M. Friend Jr," MS.BZ.019-03-02-066_160, Underwood Papers ICFA

3

Contents

Introduction · The Imperial Church p. 7

APPENDIX B.2. Table of Contents page of handwritten draft manuscript for "The / Church of the Holy Apostles / Constantinople / Vol. II / The Mosaics / by / A. M. Friend Jr," MS.BZ.019-03-02-066_161, Underwood Papers ICFA

APPENDIX B.3. First page of the Introduction of handwritten draft manuscript for "The / Church of the Holy Apostles / Constantinople / Vol. II / The Mosaics / by / A. M. Friend Jr," MS.BZ.019-03-02-066_162, Underwood Papers ICFA

156

Texto

1. Letter of Eusebius Pamphilus to Constantia sister of Constantine the Great

2. Same quoted in Council of 754

3. Refutation of same in 6 th session of VII Oecumenical council.

4. Part of "ορος of VII th Council.

5. The IX anathema of the XV against Origen, attached to letter of Justinian sent to 5th Oecumenical Council.

6. Concerning the council of the Apostles in the XV Chapter of Acts.

7. Sacra of VII council.

8. Gospels on Throne – III Council.

9. Liturgy of St. Basil.

APPENDIX B.4. Primary sources page of handwritten draft manuscript for "The / Church of the Holy Apostles / Constantinople / Vol. II / The Mosaics / by / A. M. Friend Jr," MS.BZ.019-03-02-066_163v, Underwood Papers ICFA

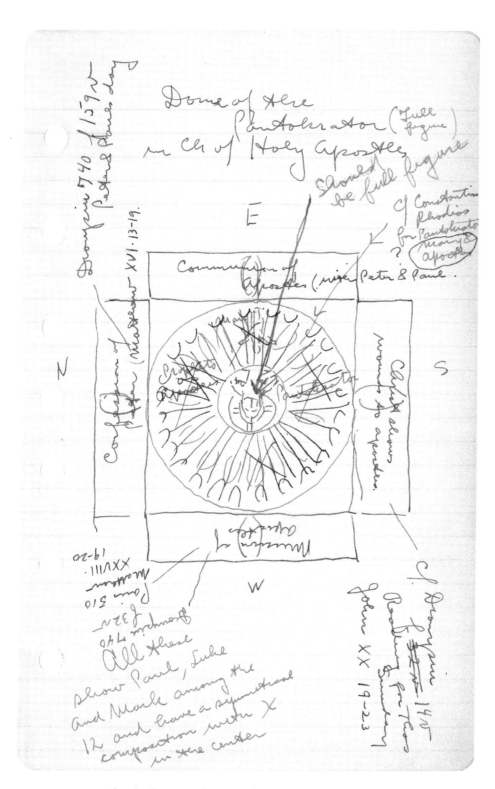

APPENDIX B.5. Sketch of "Dome of the Pantokrator" in the church of the Holy Apostles, MS.BZ.019-03-02-068_009, Underwood Papers ICFA

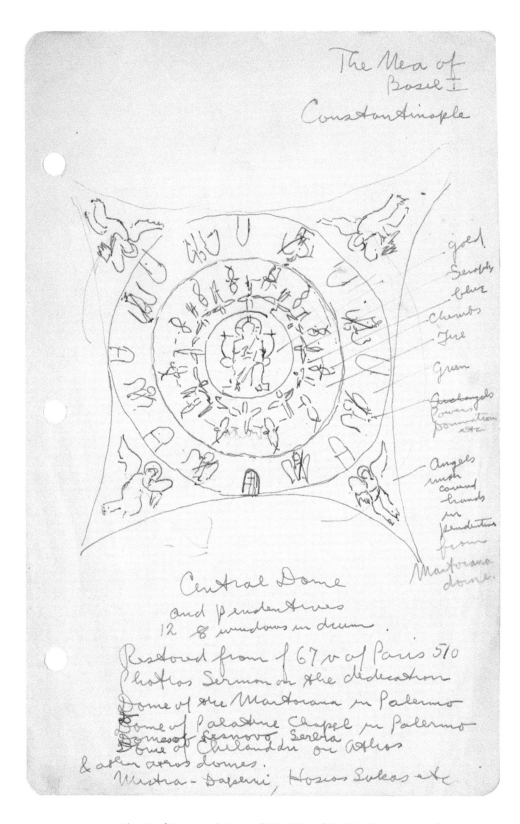

The Nea of
Basil I
Constantinople

gold
Seraphs
blue
Cherubs
fire
Green
Archangels
Powers
Dominations
etc

Angels
with
covered
hands
in
pendentives
from
Martorana
dome.

Central Dome
and pendentives
12 8 windows in drum.
Restored from f 67 v of Paris 510
Photios Sermon on the dedication
Dome of the Martorana in Palermo
Dome of Palatine Chapel in Palermo
Domes of Lesnovo Serbia
Dome of Chilandri on Athos
& other apse domes.
Mistra - Daperri, Hosios Lukas etc

APPENDIX B.6. Sketch of the central dome of "The Nea of Basil I / Constantinople,"
MS.BZ.019-03-01-054_002, Underwood Papers ICFA

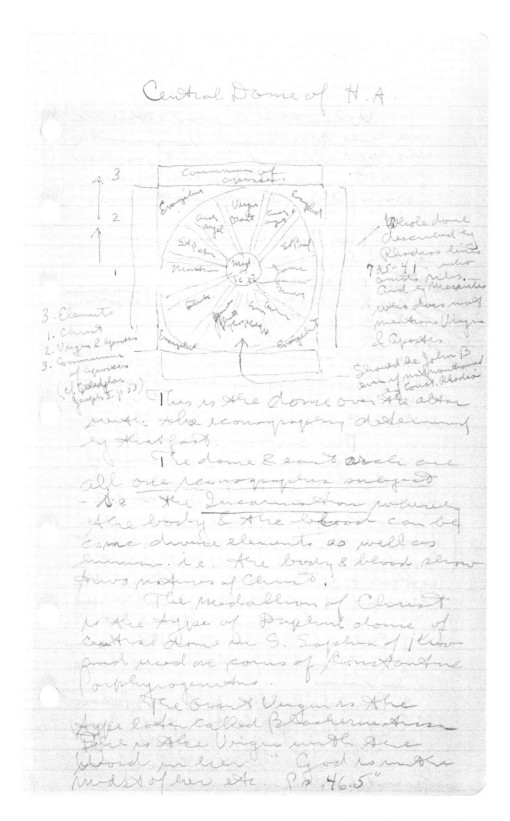

APPENDIX B.7. Rough sketch of the central dome of the church of the Holy Apostles and notes, MS.BZ.019-03-02-066_017, Underwood Papers ICFA

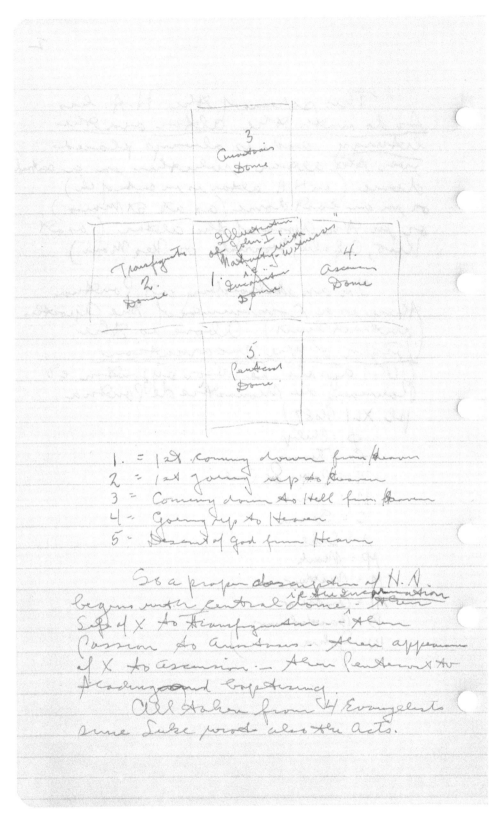

APPENDIX B.8. Schematic sketch of the plan of the church of the Holy Apostles with iconographies in the domes and notes, MS.BZ.019-03-02-066_018v, Underwood Papers ICFA

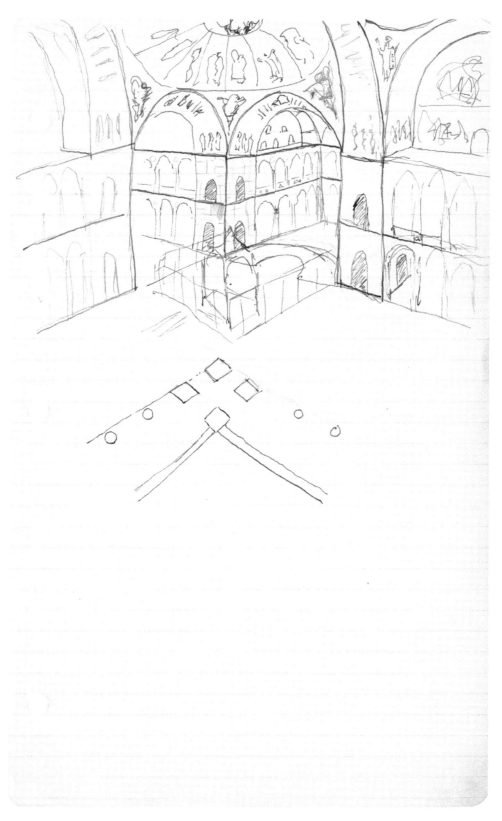

APPENDIX B.9. Sketch of a view toward northeast into the central dome of the church of the Holy Apostles, MS.BZ.019-03-02-066_026, Underwood Papers ICFA

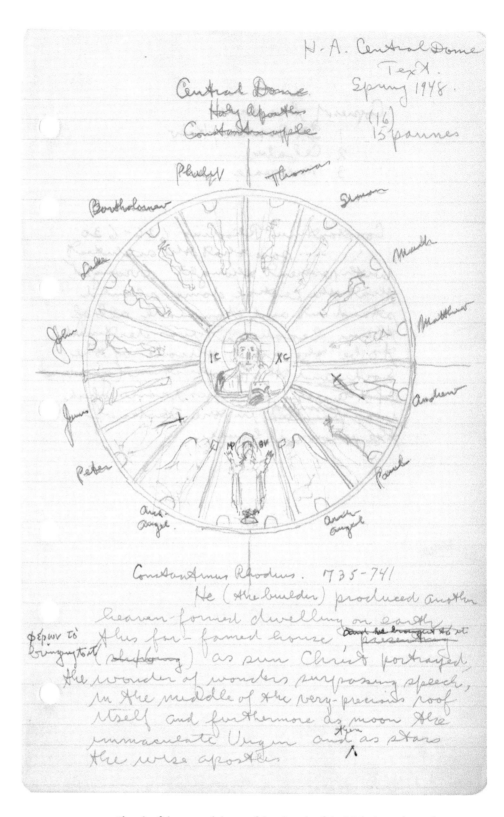

APPENDIX B.10. Sketch of the central dome of the church of the Holy Apostles and notes, Spring 1948, MS.BZ.019-03-02-066_027, Underwood Papers ICFA

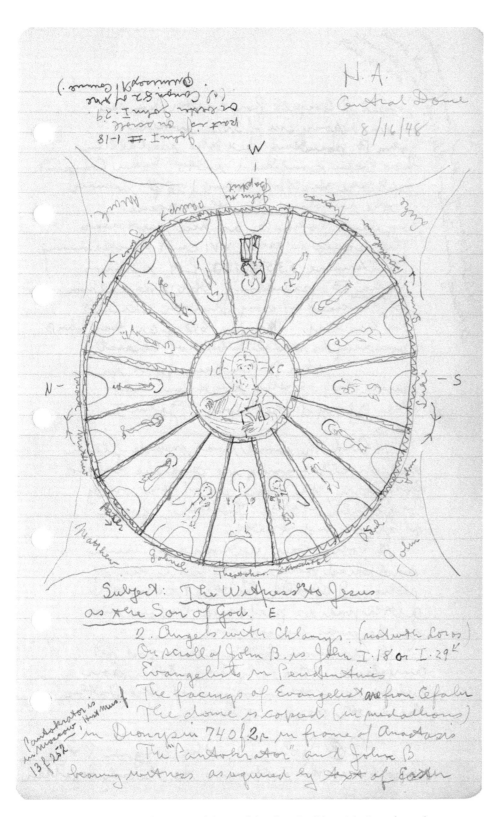

APPENDIX B.11. Sketch of the central dome of the church of the Holy Apostles and notes: "Subject: The Witnesses of Jesus as the Son of God," 16 August 1948, MS.BZ.019-03-02-066_107, Underwood Papers ICFA

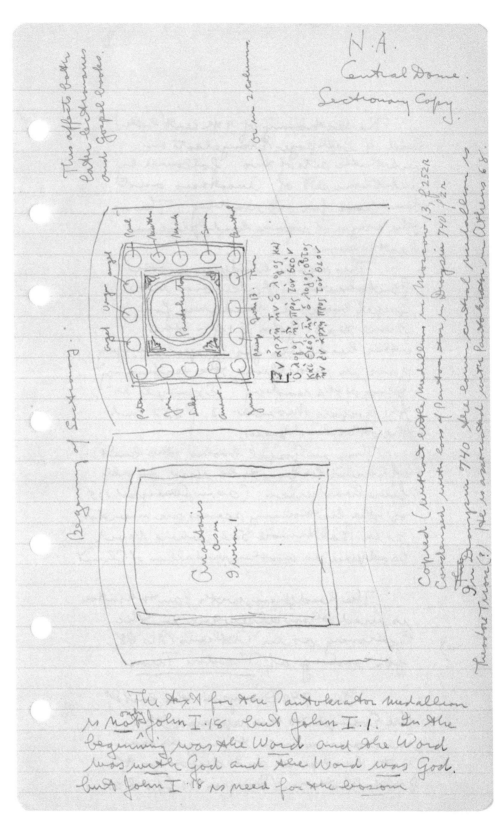

APPENDIX B.12. Transfer of the Holy Apostles central dome iconography to an imaginary
"Lectionary copy," MS.BZ.019-03-02-066_111, Underwood Papers ICFA

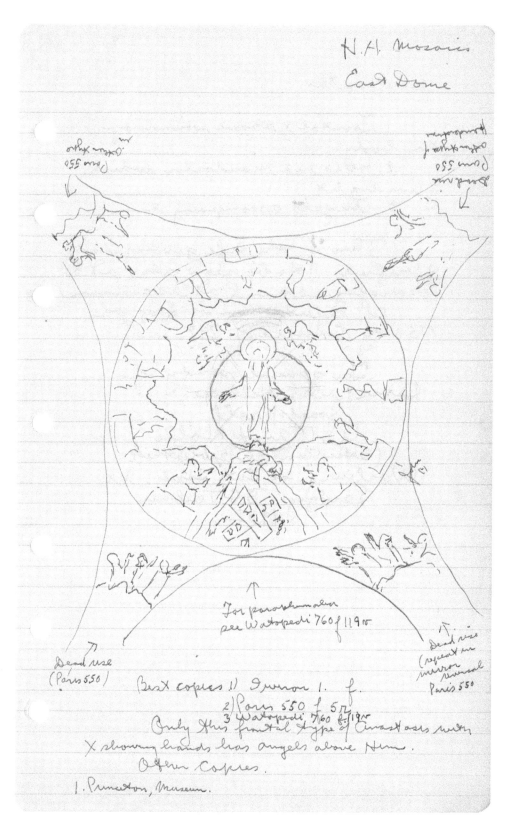

APPENDIX B.13. Sketch of the Anastasis dome of the church of the Holy Apostles, MS.BZ.019-03-02-066_119, Underwood Papers ICFA

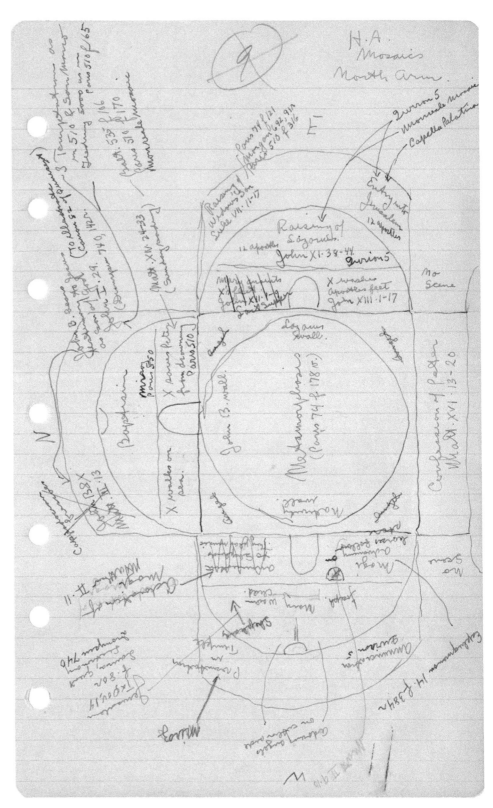

APPENDIX B.14. Schematic sketch of the northern arm of the church of the Holy Apostles, MS.BZ.019-03-02-063_001, Underwood Papers ICFA

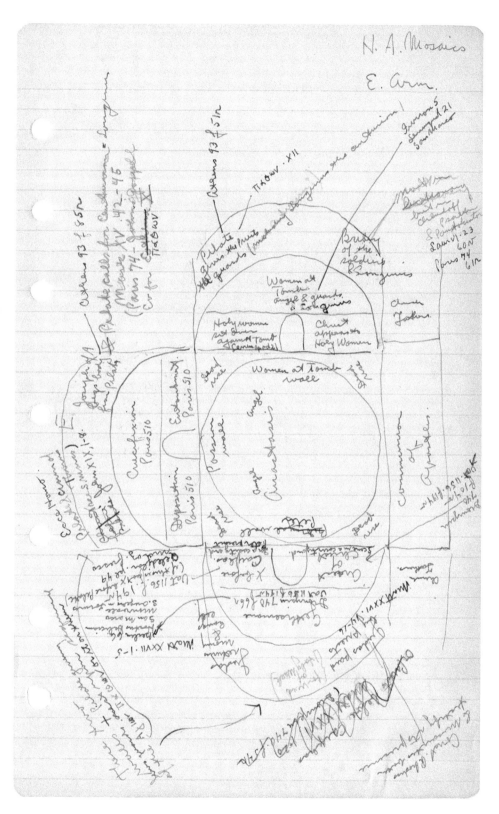

APPENDIX B.15. Schematic sketch of the eastern arm of the church of the Holy Apostles, MS.BZ.019-03-02-063_002, Underwood Papers ICFA

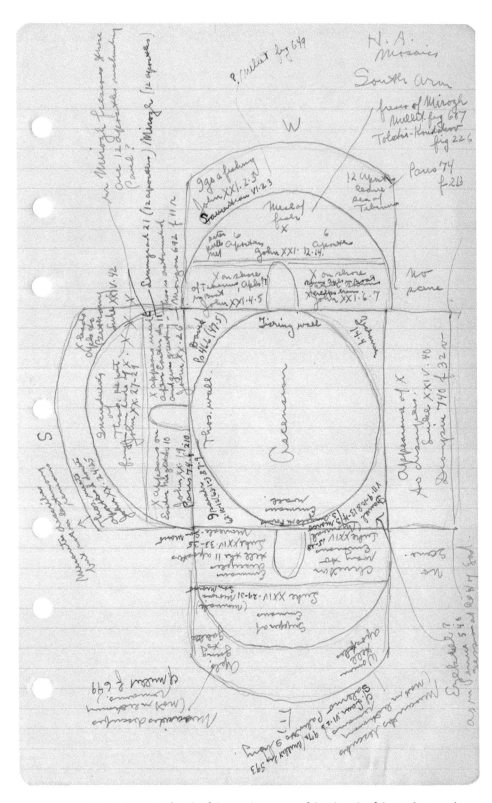

APPENDIX B.16. Schematic sketch of the southern arm of the church of the Holy Apostles, MS.BZ.019-03-02-063_003, Underwood Papers ICFA

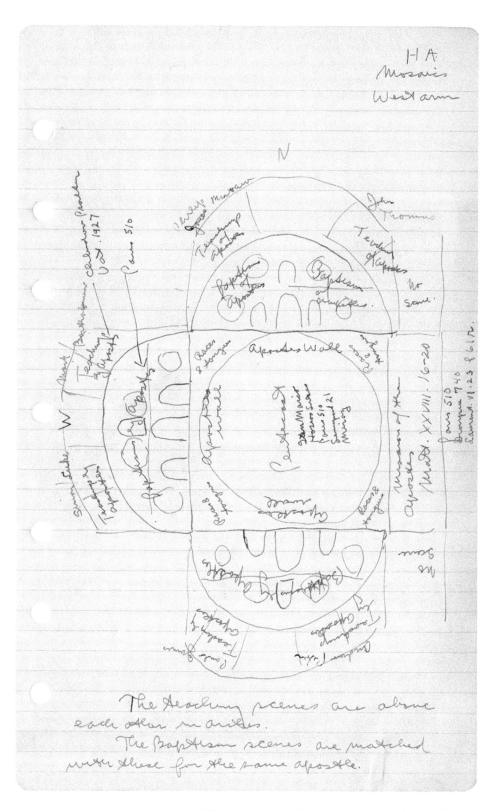

APPENDIX B.17. Schematic sketch of the western arm of the church of the Holy Apostles, MS.BZ.019-03-02-063_004, Underwood Papers ICFA

Translation of Constantine the Rhodian's Poem
by Glanville Downey

Several versions and copies of Glanville Downey's translation of Constantine the Rhodian's poem survive in Dumbarton Oaks and in Princeton. Overall, three different versions can be distinguished.

The earliest can be dated to 1945, possibly earlier, and consists of two copies of Downey's complete translation of the poem without line numbers.[1] This version contains some erroneous conceptions, for instance in the title, where Downey translates the title "a secretis" as a place name: "Verses of Constantine of Assicrecy on Rhodes."

A second version, considerably changed, is dated 3 November 1945. The first pages are not preserved, with the ICFA copy starting at line 425, at the beginning of the description of the Holy Apostles church, and the Princeton copy at line 636, when Constantine the Rhodian turns to the description of the mosaics. Both versions though are complete until the end of the poem. These two copies seem to be the ones shared with Underwood (ICFA)[2] and Friend (Princeton)[3] for comments and corrections. For instance, Friend

completely rewrote lines 735 to 741,[4] while Underwood, in his handwritten notes in the margins of the two pages, was more concerned with whether the same passage refers to the central dome.

The last complete version is preserved only in Princeton, in two halves. The first, extending up to line 633 (paginated 1–17), is a typed manuscript that dates to April 1946 with handwritten corrections that date to June 1946. It also contains Downey's endnotes up to line 498 (paginated notes 1–notes 12). The second half (paginated 18–25) resumes at line 633 and includes endnotes (paginated notes 13–notes 29) from line 501 to 961.

Although both halves are preserved in the same carton of material in the Friend papers at Princeton, the first half is preserved in a folder labeled "Constant Rhodes" whereas the folder for the second half is labeled "Mesarites."[5] The placement suggests that during this time Downey turned to the translation of Mesarites,

1 Downey, "Verses of Constantine of Assicrecy on Rhodes," n.d., Dumbarton Oaks Research Archive, ca. 1940s, MS.BZ.018, ICFA and Downey, "Verses of Constantine of Rhodes, a Secretis," April 1946, Notes, photographs, correspondence; 1915–1954, Box 6, Friend Papers.

2 Glanville Downey, "Constantine" 3 November 1945, MS.BZ.019-03-01-050, Underwood Papers ICFA.

3 Glanville Downey, "Constantine / Original Version: Not Revised," 3 November 1945, Notes, photographs, correspondence; 1915–1954, Box 6, Friend Papers.

4 Ibid., lines 735–741: "He produced another heaven-formed dwelling on the earth, this far-famed house, bearing Christ portrayed like the Sun, a wonder of wonders, surpassing speech, in the midst of its most much-prized roof, and the unblemished Virgin like the Moon, and the wise Apostles like the stars." Friend's handwritten correction at the bottom of the page reads as follows: "He produced another heaven-formed dwelling on earth, this far-famed house presenting (showing) as sun Christ portrayed, a wonder of wonders, surpassing speech, in the midst of the very precious roof itself; and furthermore the unblemished Virgin as moon as well as the wise apostles as stars."

5 Both are part of Notes, photographs, correspondence; 1915–1954, Box 6, Friend Papers.

since in September of 1946 he was pursuing the possibility of acquiring photographs of the original Mesarites manuscript, for he thought that "there is a possibility of rearranging some of the fragments of the MS to make a more logical sequence."[6]

Below is a synthesis of the two halves of the third version. The transcription has been normalized, to bring the typescript as close as possible to the published form Downey intended. Word spaces have been normalized and clear typographical errors corrected. Line numbers to the poem are by Downey, pointing to the lineation in the edition by Legrand.[7] The lineation of the typescript itself has been ignored. Superscript note callouts and accompanying footnotes are my insertions.

❧

Apr 46 / Revised June '46

Verses of Constantine of Rhodes, a secretis

O most excellent Constantine, son of the purple, as a servant of thy father from of old, I offer thee this pious friendly gift, a cheerful composition cleverly wrought in lightly running verses of iambics, (5) setting forth for thee to the best of my power the whole description of the abode and the shining temple of the Apostles, which thou didst thyself state thou was writing for us, God, perhaps, having instilled the plan in thy heart. (10) Now, having completed and carefully put together the whole task and the entire description of the temple, I come, a self-called workman, bringing to thee a rose-woven crown, all formed from the pure flowers of poetry, (15) through which crown I shall belong for life to thy renowned state, lovely and favorable; for thou art in every respect a compassionate ruler and a protector of those who toil.

Preface to the description of the Church of the Holy Apostles and a partial narration of the city's statues and of the highest and greatest columns.

Among many others the City of Constantine, (20) this famous and revered place, which now holds sway over the authority of the whole earth—and over which you now rule, as is fitting, like stars radiant with fire, giving forth four lights, (25) and equal in number to the four virtues, like four columns, or rather towers of God's kingdom, O glorious Constantine, offspring of the purple and seed of my renowned king— shines forth to the world in wondrous fashion with its marvels (30) and with the brilliance of its magnificent buildings and the splendors of its radiant shrines and with the spherical roofs of its long colonnades and with its columns raised up on high and with the Forum of Taurus and the long Xerolophos (35) which bears the most holy image of the cross and the column which is raised up far on high, made of brass and higher than the clouds, which stands by the celebrated temple of the Wisdom of God, of the first rank among structures, (40) celebrated everywhere in the whole world, which has received first place in this city. It bears on high a conspicuous rider, Justinian, that great man, wearing a golden crown and a strange[8] crest, (45) stretching out his hand into the air, so that it approaches closely to the starry vault of heaven, and seeming to grasp at the chariot of the moon. This has first place in the series of the wonders in the city which are raised up on high, (50) though it was set up somewhat later than the famous column which was first fixed in the Forum.

The second place is taken by the marvellous porphyry column, fairly erected of old in the

6 Glanville Downey to Albert Friend, 5 September 1946, Notes, photographs, correspondence; 1935–1955, Box 7, Friend Papers. See also preface in Glanville Downey, "Nikolaos Mesarites: Description of the Church of the Holy Apostles at Constantinople," *TAPS*, n.s., 47, part 6 (1957): 855–924. Greek text at 897–918; English trans. 861–897 at 855. On the codicology of the folios (reordering turns out to be a nonstarter) see above Maguire, 212.

The microfilm acquired is still preserved in the Dumbarton Oaks Library as MIL.1.1. The notes on the microfilm clarify that the manuscript photographs were taken by Mr. De Van in 1947 and that the microfilm is connected to Prof. Friend, see Manuscripts-on-Microfilm Database, http://www.doaks.org/library-archives/library/mmdb/microfilms/535.

7 E. Legrand, "Description des oeuvres d'art et de l'église des Saints-Apôtres de Constantinople: Poème en vers iambiques par Constantin le Rhodien," *REG* 9, no. 33 (1896): 32–65.

8 Typed: marvellous; crossed out by Friend and addition in handwriting: unusual (sub lineam), then crossed out, and added strange (supra lineam) with the Greek: καὶ λόφον ξένον.

Forum, (55) which the most excellent Constantine raised. For this was the first high column which was fixed in this city and on the famous hill, when this city, beloved of all the world, assumed the rule and its famous dominion and (60) took the royal power of the world and bore the sceptre and crown from Rome. This column bears on its shoulders, like Atlas the globe, the huge and wondrous statue of the nobly victorious and wise Constantine, (65) who was first to rule over the domain of Christ, and was first to build the towers of this city and first to raise this porphyry column and this great statue which with its gold lights up the whole city. (70) On it he inscribed these four lines: "Thou, Christ, king and ruler of the world, to Thee I offer this Thy servant city, and the sceptre of it and the whole power of Rome. Guard it, and save it from all harm." (75) And at the foundations of the column he placed twelve willow-woven baskets which were of old witnesses of the marvels of that wonder of those five loaves, which sated the five thousand, (80) besides the women and the fair children, so that the city should be rich in its provisions and should never lack for bread; and of this, a sight of the city is sufficient proof, and its great brilliance equal to the stars, (85) which is an adornment and a novel wonder to those within the city, and a source of gladness and glory to all the world. All this ever astonishes my heart and will not let my tongue be silent as I see these works which are greater than a miracle.

Concerning the Senate and the columns in it.

(90) The third wonder and conspicuous glory is the astonishing beauty of the Senate, and it is proper to describe its plan and situation and its whole construction. An arch rises into the air (95) and a wall, built upright and bearing the roof, supported above by beams and based on four columns which imitate the hue of the shellfish of Tyre and are stretched out to boundless height. (100) This famous building has its whole plan in a circle and is extended as far as the Forum. The wall is turned toward the north and the unsurpassed columns face toward the south and the fair breaths of the south wind. (105) In former times envy reduced these to ashes, and fire consumed their substance, when a conflagration reduced the whole city, at the

time when Leo, the former king, was ruler, that Leo who was husband of Verina, (110) whose brother was Basiliscus the fraud. Nevertheless, broken and consumed by fire they still stand there where they took their places, like well-girt and brave giants, at the crest itself of this starry Forum. (115) Mosaic adorns the wall and slabs brought from the best quarries; but time and fire have eaten all and have darkened the beauty which was formerly so great. From this point, about the porphyry pillar (120) in a circle there whirl like dancers long lines of shining white columns brought from nearby Proconnesus. Thus, thus in fact, is the Forum crowned with the columns and with buildings of the highest kind. (125) And here, there is also a bronze gate in the Senate, turned toward the north, and the wall which it bears upright; formerly this gate belonged to Artemis of the Ephesians, when the dark error of idols prevailed. (130) It bears in relief the battle of the Giants and the Gods whose cult the Hellenes of old celebrated in their delusion, and the thunderbolts of Zeus, and his boldness, and Poseidon with his strange trident, (135) and Apollo armed with his bow, and Heracles arrayed in the lion's skin, with his quiver filled with arrows and with his club breaking the heads of the Giants who like serpents (140) writhe below his feet, hurling up fragments of rocks, struggling like snakes and roaring dreadfully and bristling and shooting fire from their eyes, (145) so that onlookers are terrified and quake, and are smitten with tremendous fear in their hearts. By such impostures the foolish race of Hellenes was deceived and paid base reverence to the shamelessness of these vain and godless creatures; (150) but the most excellent and wise Constantine brought it here to be a toy for the city, a plaything for children and a laughing-stock for men. And again there is the fair maiden in bronze who stands on a tall column (155) extending her hand into the air; this is the image of Pallas which was part of the cult of the Lindians, to which belonged the people who first inhabited the land of unfortunate Rhodes, reared in impiety. It shows the crest and the gorgonian monster (160) and the snakes intertwined at the neck. Thus, thus indeed did the foolish people of olden times in vain make this idol of Pallas.

Concerning the column supporting the cross.

Then there is the far-famed object of veneration, inspired of God, the wonder and marvel of the whole earth, (165) which rightly takes fourth place; this is the Cross of the Master, with its four lights, which guards and watches over the city, raised on high on a column and extending as far as the city itself, (170) holding its fair place as though in triumph, routing all the evil boldness of the demons and setting to flight the evil swarm of barbarians, confusing and crushing all enemies and sending them to the lowest depths of Hades, (175) standing as a trophy bringing victory from all sides, from earth, sea, air, fire and sky, and gaining salvation in victory for the city.

Let fifth place among the incomparable wonders in the unfolding of my discourse, (180) among those things which are raised up to a great height, be taken by the bronze support which quickly forms the shape of a pyramid, constructed like a tower, or a well-wrought column like a Persian tiara, which Theodosius the Great erected, (185) a most surpassing work of sculpture, a four-legged construction, a surpassing sight, fitted together with four bronze sides and adorned everywhere with sculptured figures and with full blossoms of fruit and buds. (190) Naked Loves stand there, entwined in the vines, laughing gently at each other and, from their place on high, deriding those below them. Other youths, kneeling, blow the winds through their brazen horns, (195) one of them the west wind, another the south wind. High above this is a marvellous contrivance made of bronze which by means of its bronze wings is blown about in a circle and records the light breaths of the breezes which the winds blow into the city, (200) the north wind, the south wind, the fair north wind, the bold east wind and the heavy-blowing southwest wind.

Let the column of Taurus, itself brilliantly adorned, which the celebrated Arcadius set up in olden times, glorifying all the excellencies of his father (205) and his victories and incomparable battles, now take sixth place in order. It bears everywhere, in fairly carved scenes, arranged in order, all manner of slaughtering of barbarian Scythians, (210) and their cities shattered for once and all. But then what wonder does it contain hidden within itself? A stair in the hard substance of the column itself, leading up to the top

of the high pillar, so that those who wish can easily ascend (215) and can again return below. I once some time ago went up this way, wishing to see the wondrous city from on high, and how great is the length and breadth of it. And this greatest and best horseman (220) standing there, that marvellous man Theodosius, he set up there at the very tip of this road, as though alive and breathing, doing honor to his father's labors and marvellous toils, as though he were coming victorious from battle, (225) when he destroyed the rebellion of Maximus and drove all the Scythians from Thrace. And one who sees the neighing of the horse, fixed in bronze by the force of the sculptor's art, as it waves its mane and tosses its hair, (230) and bites its bridle boldly and stretches out its neck like a great tower, prancing and neighing in marvellous fashion and seeming to move its hoof, would think that the horse was really alive (235) and moving, bearing its victorious master; and the horseman has a proud eye and stretches out his right hand toward the city, pointing to the victories depicted on the great column which he himself founded, (240) the slaughters of the Scythians and the massacres of the barbarians.

Concerning the Xerolophos.

Finally let the Xerolophos take seventh and last place; for it too is the work of Arcadius, similar in all respects to the column of Taurus (245) in the scenes excellently engraved on it and in the ascent concealed within it. In general all things concerning the two columns are similar save in the contrast in their location, for one is in the middle of the city and surveys it, (250) while the other looks upon the heights of the city and the Golden Gate. They have occupied the hills, like generals, and to one of them has fallen the guarding of the central portion, while the other watches over the heights and the exits of the gates and the long towers and all the boats.

(255) So much, then, concerning the columns and the marvellous sights which the city contains; and by the skilful execution of the remainder of the statues—those in the theatre and the gilded forum, and in the Strategion and in the various quarters of the city, (260) those which are, in a word, set up there everywhere—by all these the city is adorned as though by stars, and draws the spectator's happy eye in every direction,

as is the right of a city which rules the inhab-
ited earth. By these two things indeed it speaks
aloud to all Creation (265) and brings all men
to complete astonishment and renders speech-
less the tongues of all—this City beloved by the
whole world—by the marvellous temple of God's
Wisdom, I mean, and by this greatest dwelling of
the Apostles—(270) by the former because it is
the most outstanding of all buildings and by the
latter because it surpasses all shrines in beauty.
To these my purpose and my zeal are turned, and
an anxious care which consumes me; and indeed
a kindling desire gladdens me and sets my mind
afire (275) for this work, by reason of which I have
begun to write with all reverence, at the instiga-
tion of my wise lord Constantine, the son of Leo
the Great who once ruled with all wisdom (280)
over this happy Rome, Byzantium. Wherefore
have I quickly found the path toward my goal,
relating the noblest things concerning these two
temples and the things and wonderful devices in
them, the surpassing fame of which I shall sing.
(285) Hear then my strains, inspired and pious
ruler, Constantine, as they sing a thrilling, varied
song, surpassing the melodious lyre of Orpheus
in the triple measure of the iambic which I weave
(290) and sing to your most powerful dominion.
For I do not write of the offspring of wicked dei-
ties, whose lives he celebrated, singing wicked
and foul songs, nor again the filthy obscenity of
Zeus, (295) or the rape of wandering Demeter's
daughter, or the drum-beating orgies of Cybele
who wept for Attis in the mountain-valleys; nor
do I strike my lyre like him, but I utter divinely
inspired melodies to thee, (300) to which, my
lord, thou duly bendest thine ear, making the
occasion by thine own fair commands, which
god implanted in thy heart. For of the Muses,
I believe, thou art a fruitful tree, and a shin-
ing offshoot of the Graces—(305) of the Muses,
those maidens pure with their inspired virtues,
not those which bold Homer describes, weaving
their lament at the tomb of Achilles, but those
which mighty Solomon crowns (310) with golden
crowns of precious stones, of which thou art a
most pure vessel and a gushing source, a golden
spring; it is because of this that thou wishest, O
best of men, to hear these strains. (315) Thus, hav-
ing found my desired goal, I set off rejoicing on
the rest of the road, retracing my way gladly over

the path of the iambics, to that place whence I just
now set out, namely the sights which the shining
city contains (320) and offers to strangers. What
stranger, indeed, sailing this sea and seeing all
these far-off things from afar, and approaching
this famous city, is not at once astonished by the
sight, (325) and astounded by this renowned city,
so that in his amazement he praises the celebrated
Empire, giving glory to God for the sight of such
great and so many things with which the city is
filled and is so marvellously rich? (330) Or again,
what well-girt traveller on land, making his famil-
iar way on foot across the countryside, travelling
a long and weary way, when he sees all these far-
off things from afar, the towers rising in the air,
and the highest columns, (335) striding like vigor-
ous giants, and the churches and shrines rising on
high, lifting their boundless roofs—what travel-
ler does not at once gaze upon this with happiness
and calm, (340) and quiet his soul with kindly
feelings, and take joy at once in gazing on the fair
city, the golden-formed and adorned place, which
makes strangers welcome before they have entered
it, by the brilliance of its sights? (345) And as he
reaches the wall and draws near the gates, does
he not give greeting at once and bending his head
down to the earth kiss the famous soil, and saying
"Hail, most fair-shaped city," enter filled with joy?
(350) But of all these strange marvels, though they
are of the greatest kind and beyond description,
and strike dumb every eloquent mouth, neverthe-
less it is possible to speak and write, and to point
out their craftsmanship of the cleverest kind,
(355) and whence they came and how, and who
raised them up, and how they were created and
at what time, and how they were collected in this
city. When I look at the great shrine of God, that
house of Wisdom traversing heaven, (360) spring-
ing up from the earth into the air, and reaching as
far as the dances of the stars, and at that second
one which came into existence after it, the star-
shining abode of the Apostles, and at the bronze
pillar which stands by it, (365) bearing the shin-
ing horseman, crowned with gold, that great man
Justinian, stretching out his hand into the air, and
saying "Halt, every barbarian race, Medes and
Persians and the race of Agar, (370) far from my
domain, beyond the borders, lest I drive you from
the face of the earth, bearing this honored image
of the Cross"—for this, this indeed triumphed

over all the created world, when Christ spread His hands on it; (375) alone, it has no comparison in its achievements with any other deeds, nor is it to be made equal even to the multitudes of the deeds of all the men who have been born, or the men whose incomparable achievements have been wrought in this City which rules over dominions: (380) for through it exists every marvellous success and every greatest and most extraordinary work—when I see all this I am amazed and quite without words, unable with any ease to describe these things; my mind is humble and fearful (385) and the gates of reasoning are closed because of the awkwardness which assails my mind. How indeed dost thou command me to depict in words the most honored beauty of the shrine of the Apostles, and to describe the ineffable commingling of beauty (390) in measures woven of iambics in sonorous song, a building the mere sight of which strikes one with astonishment, so that one does not even dare to speak or write concerning it, O famous Constantine, offspring of the purple, most nobly born seed of Leo, (395) whose likeness thou bearest as a mark and likewise his power in speech and strength, just as of old the race of Pelops carried on their shoulders the mark which bore witness to their origin? Nevertheless, trusting in the grace of the Holy Ghost, (400) I, the most witless of all men whom the race of mortals has brought forth—trusting in that grace which of old filled the disciples and caused their tongues to become eloquent, I set forth on the swift road of this discourse, (405) another runner like unto a new Asahel, or even brilliantly like that other disciple, running with the light feet of the iambics, even as the companion of Peter who quickly passed the old man in the course, (410) eager to be the first to see the resurrection. Even so I, running the final stage of the inspired[9] course, am the first of all to come to the description of the celebrated house of the disciples and wise teachers, that I might receive through them the fire-borne grace (415) of the Holy Ghost, by which I may write wisely and speak clearly of the most honored form of this temple of the wise Apostles to my nobly victorious and wise master

Constantine, son of the wise Leo; (420) for he loves them and yearns after them in marvellous fashion since they are his saving protectors and the steadfast leaders of all the world.

To the Wise Emperor Lord Constantine, Constantine the Offspring of the Island of Rhodes.

(425) This description of the house of the Apostles, which Constantine of Rhodes completed, he presented to the most wise ruler Constantine, as being the faithful servant of his father; for he loves the wise Apostles (430) and he honors their shining and venerable abode and yearns after it in marvellous fashion. O Disciples of the Word of God, lover of mankind, and sure guides of all the world, save him from corruption[10] and danger (435) and from the wickedness of evil enemies since you are his companions in the presence of God.

There is a long hill, like a neck, creeping across the midst of the city of Constantine, resplendent and adorned with gold, (440) a hill established by God, and marked from the beginning for a Church of the Apostles, when first the Trinity brought to light this whole system of the world, the marvellous miracle of earth, heaven, and the essence of fire (455) and the flowing substance of the waters and the ancestors of the entire race of mortals. This hill is the greatest, ruling over the seven hills; for there are seven hills which rise within the fair-shaped and wise Byzantium. (450) Of the seven, this hill is by far the most favored, standing in fourth place in the midst of the celebrated city, surpassing all in height and breadth, the first to be illuminated by the light-bringing rays of the sun and by the beams of the moon. (455) Here the most mighty House of the Apostles rises from the earth and stands forth shining like a new firmament of stars, formed of five stars, welded together with three peaks in a straight line, and two transverse which (460) seem to enclose[11] the entire city. For it is wide and exceedingly broadly made, having the inspiring and wondrous form of the Cross; for the Cross is the starting-point of the faith of those who take their name from Christ, and a cause of glory and

9 Here begins typescript p. 12, at whose head is typed "revised at this point June 46"; the first phrase has been crossed out and "not revised from this point" is written below in Downey's hand.

10 "destruction" typed above "corruption" (not crossed out).

11 "embrace" typed above "enclose" (not crossed out).

rejoicing for the Apostles. (465) It is indeed the adorned sceptre of Christ, whereby He destroyed the vast dominion of Satan, and through it all the race of mortals has been saved. Wherefore does the temple of the Apostles most excellently bear the likeness and the image of the Cross, (470) serving as a house of the Disciples of the Master, who by means of the Cross destroys the dominion of Hades.

At first, however, this was not so great in size, nor did this all-venerable and celebrated house rise to such a height, (475) this house of the Disciples, O thrice-blessed race, but it possessed a rather small form; but first by decree of Constantine did this far-famed house have its beginning, when divine faith flowed forth (480) and the light of Christ shone on all Creation. For this man (Constantine the Great) brought God-seeing Andrew from Patras in a pious manner; then from Hellas Luke, the inspired of God, and then from Ephesus Timothy, (485) finding as helper Artemius, the miracle-worker, crowned a martyr before running the unique course of martyrs. And founding this renowned building, and placing in it in golden caskets the bodies (490) of Andrew, Luke and Timothy, he gave it the name which most suitably belonged to it, that of the victorious and wise Apostles, not of these three alone, but of all of them together. Then when a long and troubled period (495) had passed by, the mighty and noble Justinian pulled it down to the ground and transformed it to its present great size and plan and projection and its marvellous elevation, the like of which the light of the sun never saw, (500) nor any mortal man, so great is the work. For another new kind of heaven has come, bringing with it this second support on earth, a five-roofed sphere-shaped covering, in appearance enclosing the whole city, and (505) adorned by new and greater stars. Concerning the sky, the myths of the[12] Hellenes say that in the stars there are men, horses, wild beasts, fierce bears and lions, bulls and serpents—what a deception! (510) But the celebrated house of the Apostles shines with other strange stars in the brightness of its pictures formed of light, which shine like the bright beams of the sun.

Not here (will you see) the wild dog of Orion, (515) nor the whirling Chariot which it pulls, nor the Bear itself, nourished by Zeus, nor the darkened circling of the Pleiades, nor the horned cruel Bull of Europa, nor the bull-eating Lion of Heracles, (520) nor the bowman Centaur, a fantastic monster, nor Pegasus himself, the swift-running steed, nor the Twins of Leda, offspring of Zeus, nor Amaltheia, reared[13] by Zeus, nor the thrice-unlucky ship of the Argonauts, (525) nor Andromeda, nor the marriages of Perseus, nor the star of Aphrodite and Kronos, nor any other of the things which the writers of fable invent; but the Word itself, the Word of God the Father, (530) Christ made Man from the Virgin maid, the unwed mother, joy of the race of mortals, and all His miracles and wonders which He wrought with glory in this life. But concerning these miracles and deeds, (535) let my discourse now be silent for the sake of its order; when the occasion[14] urges I shall speak of them again, if God wills it and inspires my discourse; but now a constraining wish impels me to speak of the varied forms of the Church and especially of its unusual construction, (541) and if I am a stranger to the affairs of architects and the highly-skilled science of geometers, nevertheless the Word which taught the Apostles and in olden times instructed them without benefit of letters, (545) will itself teach me to speak earnestly, and without the words of those who put together these complicated devices.

The man who constructed this shrine so cleverly, (550) whether it was Anthemius or Isidorus the Younger,—for that the work is theirs, all the historians have clearly stated—began the work of construction by drawing the linear view of a cube—for a cube is a figure put together of four parts (555) with dimensions which are equal from all points, whether measured in numbers or indicated by lines. The architect, inscribing this cube and its cubic form on the earth, fixes, at right angles, angles after the fashion of covered colonnades (560) down on the surface of the earth, four (angles) turned so as to face one another, all double and double-formed and

12 A typed "?" appears to the left of the line "and greater…of the."

13 "suckled" typed above "reared" (not crossed out).

14 A typed "?" appears to the left of the line "now be …occasion."

well-built. And he fixes piers, four in number, equal to the angles built in the manner of covered colonnades which I have mentioned, four-legged and four-fold in their construction, (565) which are allotted to bear the central sphere and the arches, which are thus safely established. And fitting these (arches) together, face to face with one another, with the same number of sides, from one central point, all of them double and drawn up in the form of a cross, (570) and then fastening together this remarkable form, turned toward the east, the west, the south and the north, he raised, extended and unfolded in mighty size this five-fold house bearing the honored figure of the cross, covering the roof with as many spheres (575) as he had unfolded circular hoops of stone, joining arch to arch, each to the other, and then cylinder to cylinder, and binding pier to pier, one to the other, and (580) binding one sphere, cut in two like a mountain, to another spherical form. And below he skilfully and with complete mastery marshalled the piers to stand side by side in symmetrical order, fitting secure bases to them, (585) strong and unyielding feet and foundations, lest torn apart from each other by the weight they should cause to fall the highest rings of the arches and break down the sphere to the earth. Thus fitting together the framework of the church, (590) like unto no other of the buildings which stood before it, he fixed four bases, in sets of fours, four in number equal to the towering piers, bringing the number of four everywhere, so that there were in all sixteen well-built towering piers, four-legged and four-fold in their construction—and as many arches—save for those towering piers which were allotted to the furthest points, which took the last place of all. For some of them stood on the south, (600) some on the north, others again on the west, and some had their place on the rosy-red east; it is in this fashion that a cubic shape is wont to be delineated, with four-fold composition, and to possess equal base-lines equal to the surfaces.

(605) And other piers, again made in four parts, four-legged and of four-fold composition, established from above as though from strange empty space, on those which are ranged below them, support the highest arches, (610) which receive the spherically-constructed roof. And

then they (the piers) run back toward the west, running the same road as those below. Then going back again toward the north, they stand there in the most secure array, (615) like generals and commanders of troops, drawing out their formations in the shape of the cross. Then, rising up on high like giants, and stretching out their hands into the air, each to the other, (620) their right hands toward their neighbors, and clasping their fingers with the fingers of the others, they (the piers) created arches, constructed in circular fashion, in the manner of well-turned finely-wrought cylinders, by means of which (arches), stretching out four well-built circles, which the builders call hoops, (625) they (the piers) receive the spheres, five in number, save that the architect, with reverent thought, arranged that the central dome should stand out and dominate all of them, because it was destined to be the great throne of the Lord and the protection of the very precious image (630) which was painted[15] in the center of the renowned house. You might say that they (the domes) formed a heaven, made of rolls of turned bronze, wrought in the fire; and that descending[16] thence, they fit on the shoulders of the vaults, as though they were heads (635) of the bronze-colonnaded towering piers, in magnificent and novel fashion.

With so many and such great devices of their skill, and renditions of the linear view, did (640) either Anthemius or Isidorus the Younger join together in complete fashion the whole of the star-shining abode of the Apostles, clothing it and adorning it fairly with immeasurable quantities of many-colored marbles and with the gleam of marvellous metals, like a bride with golden tassels (645) or a nuptial chamber, decked with gold, adorned with torches of precious stones and pearls from nearly the whole of the inhabited earth, such as are celebrated as far as the Indies and Libya and everywhere in Europe and Asia. (650) He gathered great pillars from Phrygia and rosy-colored columns from Dokimion,

15 "the Lord … was painted": handwriting of Friend. Typed version: "the Lord and the guardian of the image of the All-Highest (630) which was portrayed."

16 The second half of the typescript (p. 18) as contained in folder "Mesarites," n.d., Notes, photographs, correspondence; 1915–1954; Box 6, Friend Papers, begins here. See introduction, above.

white and purple slabs from Caria, and wax-colored "composers" from Galatia, from the cities of Europe and Greece (655) which Euboean Carystus feeds within its banks and the somber valley of the Laconians; and plant-shaped slabs, resembling leaves, and other imitating the emeralds of the Thessalians, and long bright columns green in color, (660) and ornamented slabs from Akytane, and from the confines of Libya, mother of wild beasts; and from Carthage, sung of old, the spotted stone which imitates the scales of fearful serpents, (665) burning everywhere with its strange beauty. The sea-nurtured Nile of Egypt sent shining slabs of porphyry and many-colored Indian sardonyx, and white-hued pearls from Erythrae. (670) The nearby Proconnesus brought slabs, which the stone-cutters spread on the pavement, and Cyzicus brought other well-cut slabs, many-colored and varied, and Paros furnished snowy-colored stone.

(675) When he had clothed the upright walls with these (marble slabs), as with tunics, he bound the whole house strongly and in orderly fashion with double girdles, inserting securely-established binders of four-cornered marble, bound to one another, (680) surrounding the house, as with a crown, with bonds stronger than adamant, so that it should stand for ages of time and should neither yield when shaken by earthquakes nor be rocked by strange tremors, (685) but should stand there of itself unshaken for all time.

Concerning the columns, however, which were novel both in their composition and in their color, I cannot say whence or in what manner or brought from what native soil they came to the home of the Apostles; (690) for a foreign origin, in another land, brought them forth from a strange and unique stone. For they are of two kinds and the marble-cutters say they bear the colors of a hundred stones. Each of them, like some marvellous meadow of flowers, (695) puts forth the hues of unnumbered plants; one might say that the beauty of all plants springs forth from them, or that it bring forth a mingled multitude of light-bringing stars round about like the Milky Way, so magnificent and marvellous in their form are they. (700) They take their stand in the light-bearing East; one on the right side, and the other has its place in the left-hand series. But when with long colonnades and magnificent

columns he fitted together the whole Church on both sides, (705) and completed it, he finished it off with another house within, running round the whole Church in a circle, like a marvellous porch. And the builder, when he fitted together the colonnade in this fashion, drew up the columns in orderly plan so that they ran in a circle about the whole Church (710) from the right side and the left side. Seeing them, like servers of the divine house and priests of the mysteries of God, one might say that they were mighty chiefs of companies (715) and commanders and spear-bearers of the Almighty Lord, so magnificently drawn up do they all stand there fulfilling the number of the wise Apostles exactly in the four parts (720) so that all the columns drawn up below, which bear the well-rounded roof of the colonnade, are forty-eight in number; and in those above you would naturally find the same number of rosy-colored columns. (725) And as he then with lattices and carved marbles, as though with the leaves of the young shoots of bending vines, and with swelling bunches of grapes, and with many other flowers rich in perfume, like roses and lilies (730) and lovely and fair-seeming fruits, all of them most excellently imitated by the stone-cutters—as he covered all the walls of the house round about, or rather clothed them as though with a tunic like those which come from Sidon and from Syria, (735) he produced another heaven-formed dwelling on the earth, this far-famed house, bearing Christ portrayed like the Sun, a wonder of wonders, surpassing speech, in the midst of its much-prized roof, (740) and the unblemished Virgin like the Moon, and the wise Apostles like the stars.

And with gold, which was mixed with glass so that it forms an integral part of it, he gilded the whole of the inner portion, both all that which rises up in the height of the sphere-shaped roof (745) and that which rises with the flanks of the arches, and as far as the many-colored marble slabs and as far as the second row of "binders," depicting the contests and venerable scenes which show the Incarnation of the Word (750) and its sojourn among us mortals.

As the first wonder (you see) Gabriel bringing tidings of the Incarnation of the Word to the Virgin maid and filling her with divine joy. The Virgin is speaking tranquilly (755) to the marshal

of the heavenly host, seeking interpretation of the unique birth, and he is instructing her in the way in which she will conceive without seed and will bear the Lord, the King of the World.

(760) In the second scene (you see) Bethlehem and the cave, the Virgin giving birth without pain, the Child wrapped in swaddling-clothes, lying in marvellous fashion in a lowly manger, the angels singing divine hymns (765) and giving glory to the Word on High, the coming of blessed peace on earth and the advent of good will to mortals from the throne of God the Father on high, and the sweet rustic harp of the shepherds, (770) singing the song of the birth of God.

Third, (you see) the Magi speeding from Persia to worship the most pure Word, whom the star of the appearing Lord led, conducting them and showing them the place (775) in which the King of Israel, the great God, was to be born of a Virgin maid, as Balaam prophesied of old, to rule over the dominion of all nations and to assume the lordship of all the earth.

(780) Fourthly, (you see) Symeon himself, the venerable, bearing Christ like a babe in his arms and speaking thus to his Virgin mother: "This Child, O Pure One, comes into existence for the fall of the wicked and for the rising again of those who live by the inspiration of God, (785) and the bitter two-edged sword of sorrow, piercing your soul, O Virgin, will disclose the deep thoughts of human hearts." And then there is the old woman Anna, the wondrous prophetess, who prophesied before the eyes of all, (790) the labors which the Child would have to perform, which would reach their end in the season of the Passion.

The Baptism is fifth, showing Him received in John's hands at the waters of Jordan, with the Father bearing witness to the Word from on high, (795) and the Spirit coming down like a bird, in the shining form of a dove, and the Voice of the Father descending from on high and bearing witness that His dearly beloved Son is the Christ and the Word of God the Father, (800) by means of which He is pleased to deliver all the race of mortals from the tyranny of Satan's rule and to snatch it from destruction and to save those who do honor to His rule.

Sixth, on thrice-happy Mount (805) Thabor you will see Christ walking with the chosen and beloved Disciples and changing His human form, and with His face gleaming more brightly than the dazzling rays of the sun (810) and with His white robe shining with light; and mighty Moses and Elias, with pious and marvellous reverence are present and stand near Him and speak of the scene of the Passion (815) which He was going to suffer upon entering the city. A bright cloud overshadowed Him and them to whom He shows the vision, with God the Father bearing witness from on high with a mighty voice and in a wondrous mortal shape, (820) that He is his dearly beloved Son, Godlike, though He bears the nature of mortals; and when this voice comes to the Disciples in the form of thunder, they fall to the ground in astonishment as they hear it, bending down and falling flat on the earth. (825) But He raised them up, casting out fear and putting courage in their hearts, charging them to tell the vision for the present to no man until He himself should be risen from the tomb.

Next you will see the widow's son, bedridden, (830) brought to the grave, covered with blisters, and again returned to the house, giving thanks and skipping and filled with joy, a son bringing life from the tomb itself.

Again, you will see Lazarus, laid in the tomb for four days, (835) decaying, ulcered, changed entirely into a corpse, eaten with scars and worms, laid out and with his hands and feet bound with the grave-clothes, (840) at the command of Christ and the life-giving Word leaping up from the tomb like a deer and returning again to the life of a mortal here on earth, having escaped corruption.

Then Christ is seen riding on a foal (845) and going toward the city of slayers of God, and with branches of trees and palm-leaves the crowds are receiving Him as Lord as he arrives at the very gates of Sion, with a crowd of children crying *Hosanna* (850) and fairly greeting the Son of David, while all the people cry out in honor of Him, so that the city of the murderers of God is agitated and is drawn together by the shouts of the children, that wretched city of Sion, the miserable place, (855) which Christ lamented, with wondrous tears, because it knew not its own proper salvation and took no heed of its own Lord.

Besides all these marvellous visions you will see, my friend, this strange, (860) fearful

wonder, the most exalted of all, the one which was depicted with the greatest care by the artist, like to none of the others which he executed in this House, moving to pity and tears the hearts of those who behold the image of the Passion; (865) for in the picture the artist has depicted this scene with deepest feeling and with utmost care, showing Judas betraying his Master and Teacher to death, that most wretched man— the other Judas, Iscariot I mean, (870) not that beloved kinsman of the Lord, but that thrice-cursed dog who in his life fell into the worst kind of fate—would that he had never come forth from his mother's womb, nor had come to birth upon the earth, (875) but would that he had died in his mother's very womb, the bane-ful disciple, the most evil man who pointed out his Master and Teacher, the seller of the Word of God the Father, for the sake of a little treach-erous profit, (880) to a wicked and hated people, the disordered crowds of the lawless Hebrews, receiving the whole cohort of the murderers of God, a numberless multitude armed with swords and clubs and cudgels and stones; (885) you will see him kissing his Master deceitfully and selling his Teacher to death, receiving his wicked payment and showing the halter as his profit. The artist showed his nature (890) and the wild form of his appearance, the pale face, the drawn cheeks, the baleful eye, filled with murder, the nostrils breathing hate like asps, the whole shameless cast of the face, (895) with the gaze of a man concentrated upon murder; his feet are extended in haste and take great strides on his wicked path and both hands are extended to seize his Master. You would say that you are not looking at a human being, (900) but at one who is falling into nether darkness from the divine, bright company of the angels—at Satan, who stretched forth his hand against God; for he, entering the depth of the heart of Judas, the wicked, the most miserable, (905) filled it com-pletely with evil and prepared the foundation of the demons, planting in it the evil disease of avarice, the wild rage of money; for such is every avaricious man in his nature, (910) and he bears a mind like that of Iscariot and betrays all for the sake of gain. But He who sacrificed Himself for mankind, may He erase the disease of ava-rice from my mind and make a beggar Lazarus

in life (915) and snatch me from the burning of the rich men.

In the seventh vision you will see the most venerable and most praised of all miracles, the Passion of Christ, portrayed with the deepest feeling, by means of which he dulled the most evil fate of mortals (920) and wholly destroyed the great power of Satan, filling all those who witnessed the acts with astonishment. Who, indeed, has such a heart of stone, when he sees the image of the Passion and such outrage on the Lord, (925) that he will not straightway feel amazement in his heart, seeing this most aston-ishing thing, the Cross bearing Christ out-stretched, naked, in the midst of condemned criminals, the Lamb, indeed, and the Word of God the Father, (930) who took away the sin of mortals, run through with nails in hands and feet, his side pierced with the prick of the lance, tasting bitter gall of vinegar, and hung up like a corpse on the wood of the Cross, (935) the one who created the whole universe and washed away the diseases of the race of mortals, defiled with blood like a criminal, by that race of hated lawless Hebrews, that race of vipers and serpents, (940) that most evil people filled with murder. These things His Mother, the pure Virgin, sees, and the Disciple who is present at the Passion and whose heart is crushed; and the Mother, suffering with Him, laments and (945) weeps and cries with-out restraint: "Alas, alas, my Child, alas for Thy Passion which Thou hast suffered from the laws which have no justice, alas, my Light, my beloved offspring, alas, solitary Child of a solitary suffer-ing Mother! (950) Where are the promises of the words of Gabriel which he spoke to me before Thy birth? Where are the sceptre of David and the exalted throne which was to remain as long as the light-bearing sun, until the end of the world and of time? (955) All is stale and is a tale told in vain. These things indeed are the words of the elder Symeon, which are now coming to pass and I see their accomplishment; these are the things that the winds and chaos of forget-fulness bring; for behold! the two-edged sword of sorrow, (960) creating a most bitter portion for my soul, as that thrice-blessed old man sang. The words of all the others have flowed away; for what is the profit of great words which never reach their fulfilment? (965) Alas for me, most

afflicted of all women; alas, unyielding agony of my heart; alas, the groans which I groan at Thy Passion! Would that I might die rather than see these things; would that I might become wholly a statue of stone sooner (970) than wait for these evils! Ah me, unfortunate woman, ah me, solitary among women! O most wretched mother! Thou hast sunk, my Light, to the abode of the setting sun! When shall I behold the gleam of Thy rising? (975) Hast Thou departed swiftly, as the sun to its setting? When shall I see the rising sun, forerunner of Thy rays? Or what star, what morning-star will come, Word of God, heralding Thy rising to me? See, the light-bearing sun itself (980) has hidden its rays, and the light-bearing moon as well, and the earth is in disorder and rent by dread."

Notes[17] on Constantine

Numbers are Downey's
line numbers of the poem

1. The initial letters of the first eighteen verses form an acrostic of the author's name.

2. On Constantine's career under Leo VI, see Introd., p. [18]

13. The statement that Constantine undertook the task at his own initiative conflicts with allusions made later in the poem; see Introd., p.

22. Constantine addresses the four co-rulers, Constantine VII, Romanus, Stephen, and Constantine.[19]

35. The emendation suggested but not adopted by Legrand is accepted here because the text in its original form yields no sense.

38. On the form of the name of St. Sophia, see Appendix X

41. I.e. the column, which was in the Augustaeum, is the first of the seven wonders which Constantine will describe.

42. The other literary sources for the statue of Justinian, which is described again below (vv. 364–372; see Introd., p.) are cited by Reinach, pp. 82–85; cf. further Wulff, *B.Z.*, 7 (1898), p. 318. See also G. Downey, "Justinian as Achilles," *T.A.P.A.*, 71 (1940), pp. 68–77, and M. P. Charlesworth, "Pietas and Victoria: The Emperor and the Citizen," *J.R.S.*, 33 (1943), p. 10. An early fifteenth century drawing of this statue is reproduced by Reinach, p. 84, by G. Rodenwaldt, *Arch. Anz.*, 1931, 331–334, and as the frontispiece to the edition of Procopius' *De aedificiis* by H. B. Dewing and G. Downey in the Loeb Classical Library (1940).

55. The column stood in the Forum of Constantine; see the other literary sources cited by Reinach, pp. 71–74.

64. The epithets applied to Constantine here and in v. 418 are those used of the Apostles below, v. 492.[20] See note on v. 413.

71. The verses are quoted also by Cedrenus, I, p. 565, 1–4 Bonn ed.; see Introd., p.

80. Cf. *Matt.*, 14, 21.

91. This was the Senate on the Forum of Constantine, not that on the Augustaeum (see Reinach, pp. 86–91). Constantine's description, though it adds details to those preserved elsewhere, does not give a complete picture of the building. He indicates that the plan of the building was circular, like that of the Pantheon in Rome with a portico supported by four porphyry columns on the southern side, towards the Forum. The ἀψίς may be either a tympanum over the portico or a tunnel vault extending back from the central intercolumniations (a similar ambiguity occurs in Procopius' description of the Senate on the Augustaeum, *De. aed.*, 1, 10, 9). Wulff (*B.Z.*, 7 1898, p. 319) takes the ἀψίς to be an arched gate. Reinach (p. 88) apparently takes it to be a dome, but the word, to the present editor's knowledge, never has this meaning:

17 The first half of the notes section as it begins here is contained in folder "Constant Rhodes," n.d., Notes, photographs, correspondence; 1915–1954; Box 6, Friend Papers. See introduction, above.

18 Typed: "'of the father' might instead be, more generally, of the house." Crossed out.

19 Handwritten note by Friend: "Christopher?"

20 Typed "The same epithets are applied to the emperor in v. 419" crossed out by Downey.

Constantine elsewhere always uses it to mean "arch" (vv. 565, 577, 587, 609, 622). In the northern wall of the building, on the side away from the Forum, was the bronze brought from the temple of Artemis at Ephesus.

92. θέσις may be used to mean plan on terrain, as distinguished from σκάριφος meaning plan on paper; see the note of H. Gregoire and M.-A. Kugener in their edition of Marcus Diaconus, *Vita Porphyrii* (Paris, 1930), pp. 130–131. Cf. also below, v. 416.

105. On the fire under Leo I (457–474), see Cedrenus, I, pp. 565, 610 Bonn ed.; Zonaras, XIV, 1; Evagrius, II, 13.

114. The emendation proposed by Legrand is accepted because the reading of the MS., which Legrand retains, yields no sense.

119. The translation represents part of the emendation suggested but not adopted by Legrand. The reading of the MS., μακροῖς—στίχοις cannot readily be construed, though the sense is clear. Legrand's suggestion that ἀφιγμένοι should be read is unnecessary, since the feminine form refers to κιόνων in v. 121. The porphyry pillar is the column of Constantine which has just been described (vv. 52–89). The "long lines of shining white columns" are the circular colonnades which surrounded the Forum of Constantine (Zosimus, II, 30; Patria, p. 174, 6 Preger; cf. Reinach, pp. 88–89).

127. This appears to be a way of saying that the gate was at the north of the Senate and also in the north wall.

129. Cf. the description in Cedrenus, I, p. 565, 7–12 Bonn (see Introd., p.).

155. Cf. v. 45.

162. The statue is described in Cedrenus, I, p. 565, 12–16 Bonn, and mentioned in the Patria, pp. 174, 2; 201, 9 Preger; cf. Reinach, pp. 89–91. Cedrenus states that there was a statue of Amphitrite facing that of Athene. Reinach (p. 90) remarks that Constantine, who was born at Lindos (cf. Introd., p.), mentioned only the statue of Athene, for patriotic reasons; he overlooks Cedrenus' statement

that the statue of Amphitrite was likewise brought from Rhodes.

165. Throughout the poem Constantine seeks to demonstrate the sovereign virtue possessed by the number four. In this scheme, fourth place among the Seven Wonders would be the place of honor (see Introd., p.). The other literary evidence for the monument is cited by Reinach, p. 74. Reinach believes that this is the column in the Philadelphion, while Wulff (*B.Z.*, VII [1898], pp. 319–320) argues that another column of Constantine, in the Artopolia, is meant.

166. τετραφεγγής: The symbolism of the number four appears here again. Perhaps Constantine conceives the cross as giving forth light from each of its four members. Or the cross may have been of the type which bore a disc at the end of the members, each of which would have been thought of as giving forth light (cf. Wulff, *loc. cit.*).

169. Compare the structure of v. 101.

178. On the Tower of the Winds, see Introd., p.

185. No parallel has been found for ἀγαλματουργός in the adjectival sense, though Constantine was capable of using the word in this way. ἀγαλματουργῶν ("a most surpassing work of the sculptors") would be more acceptable.

202. The other literary sources are cited by Reinach, pp. 74–78; cf. also Wulff, *op. cit.*, p. 320. Constantine is mistaken in stating here (v. 203) that the column was erected by Arcadius; Theophanes (A.M. 5878, I, p. 70, 20 De Boor) states that it was set up by Theodosius the Great, and Constantine himself later makes the same statement (v. 239). On the description in Cedrenus (I, p. 566, 4–9 Bonn), see Introd., p.

207. The change of the dative to the accusative in vv. 207–8 suggested by Legrand seems unnecessary; the present construction makes good sense, and Constantine's use of conjunctions is so loose that their employment in a passage of this kind is not decisive.

212. ὁδόν, lit., "road." Legrand, who corrected ἔνδον of the MS. to ὁδόν, feels that the MS. reading perhaps should be retained, but it is difficult to see how the sentence could be construed in that case.

221. I.e., just as the statue stands at the end of the stair ("road") which goes up inside the column, it also stands at the end of the road which Theodosius had travelled through the scenes depicted on the pillar.

231. Cf. *Cant.*, vii, 4.

242. The literary sources are cited by Reinach, pp. 78–82. The Xerolophos ("Bare Hill" or "Barren Hill") was the "seventh hill" of Constantinople (cf. the indexes of F. W. Unger, *Quellen der byz. Kunstgesch.* [Vienna, 1878], and J. P. Richter, *Quellen der byz. Kunstgesch.* [Vienna, 1897], s.v.). λόφος, which originally meant "the back of the neck," "the crest of a hill," or "the crest of a helmet," came to be used also to mean any massive pier or architectural support, because such a pier was "as big as a hill"; cf. Procop., *De aed.*, I, 1, 37: λόφοι χειροποίητοι... οὓς καλοῦσι πεσσούς; I. 1, 38: εἰκάσαις ἂν αὐτοὺς (sc. τοὺς λόφους) εἶναι σκοπέλους ὁρῶν ἀποτόμους Paul. Silent., *St. Sophia*, vv. 548–9: κίονας ὑψιλόφους (cf. *ibid.*, v. 577). In the present passage Constantine uses Ξηρόλοφος of the column itself instead of the hill on which it stood; evidently this confusion, arising from the two senses of λόφος, was not uncommon in popular usage. Constantine uses the word in the proper sense of the hill itself in v. 34. Elsewhere he employs λόφος to mean "hill" (vv. 57, 114, 251, 437, 440, 447, 580), "column" (v. 183) and "crest of a helmet" (v. 44).

258. The "theatre," Wulff suggests (*Izv.*, I [1896], p. 49), is the Kynegion; and the forum, according to the same scholar (*ibid.*) is in Regio V.

259. Legrand prefers τοῖς ἀμφόδοις in conformity with Byzantine usage. ἡ ἄμφοδος occurs, however in Procop., *De aed.*, II, 3, 24.

277. On the occasion of Constantine's undertaking the work, see Introd., p.

288. Although Wulff disapproves the emendation of Legrand and Begleri, it is difficult to see how the reading of the MS. can be retained.

301. On the source of Constantine's inspiration, see Introd., p.

310. Cf. *Prov.*, iv, 9.

362. The construction of the Church of the Apostles was begun four years after that of St. Sophia: Patria, p. 287, 7 Preger; cf. Reinach, pp. 93–94.

365. The statue has already been described in vv. 42–47; see note *ad. loc.*

368. The same interpretation of the cross and of the emperor's gesture appears in Procopius' description of the statue (*De aed.*, I, 2, 10–12); see also P. Friedlander, *Johannes v. Gaza u. Paulus Silentiarius* (Berlin, 1912), pp. 64–65. Epigrams on an equestrian statue of Justinian in the Hippodrome are preserved in *Anth. Plan.*, XVI, 62–63.

382. Constantine resumes the sentence begun in v. 358, and interrupted by the excursus on the cross at v. 373.

389. σύμμιξις is taken to refer to the church itself, as a compound of all kinds of beauties and excellences. The use of σύμμιξις in this sense is unusual, but it is difficult to understand the construction of the sentence in any other way. The alternative, which is much less satisfactory, is to understand that τὴν σύμμιξιν refers to the poem itself: "How doest thou command me to utter this ineffable mixture in iambic-woven measures...?"

392. Heisenberg (*Xenia*, p. 122, n. 2) considers that this line contains a hidden reference to Eulalius, who is thought by some to have been the artist of the mosaics.

398. This somewhat emphatic allusion to Constantine VII's likeness to his father was perhaps inspired by the circumstance of his birth, which occurred before Leo VI was able to marry his heir's mother.[21] It was no doubt customary at court to

21 Typed "cf. Ch. Diehl, Figures byzantines, I (Paris, 1939), pp. 200 ff." crossed out.

employ such terms when the emperor's descent had to be mentioned.

405. II *Sam.*, ii, 18–19.

408. *John*, xx, 4.

413. Constantine takes care to render due honor to the apostles; he calls them σοφοί in vv. 417, 429, 492, 718. In the *Oration of Constantine* which has been preserved in the works of Eusebius, the apostles are called οἱ σοφώτατοι τῶν ἀνδρῶν (XI, 5, p. 167, 5–6 Heikel) and τοὺς ἀρίστους τῶν τηνικαῦτα (XV, 1, p. 174, 13). George Gennadius Scholarius, in his metric prayer to the apostles, calls them σοφίης ἀμυθήτου μύστορες (*Oeuvres complètes*, ed. L. Petit, X. A. Siderides, M. Jugie, IV Paris, 1935, p. 377, 1). Constantine applies the same epithet to the city of Byzantium (v. 449), and to the Emperor, vv. 64, 418.

414. Cf. the "cloven tongues like as of fire" (*Acts*, ii, 3). This may be a hidden reference to the scene of the Pentecost which was included in the mosaics of the church; see below, vv. 543–545.

440. Constantine uses the same word in *Anth. Pal.* XV, 15, where he speaks of the σκῆπτρα θεοστήρικτα βασιλείης. W. R. Paton in his translation of the epigram in the Loeb Classical Library appropriately renders the epithet "God-supported." In the context of the present passage, the meaning seems rather to be "God-established."

451. On the symbolic significance of fourth place, see note on v. 165.

460. Cf. v. 504.

477. Constantine the Great. (Add note on other accounts of original construction)

485. St. Artemius, said to have been the assistant of Constantius in the translation of the relics, was *strategos* of Egypt and suffered martyrdom under Julian the Apostate; see *Philostorgius Kirchengeschichte*, ed. J. Bidez (Leipzig, 1913), pp. XLIV ff., esp. LVII; and A. Vogt, art. "Artème," no. 4, in Baudrillart, *Dict. d'hist. et de géogr. eccl.*, IV, 790–791.

488. On the meaning of κτίσας, see G. Downey, "Imperial Building Records in Malalas," *B.Z.*, XXXVIII (1938), pp. 1–15, 299–311.

489. Although the singular is used, the meaning probably is that each body was placed in its own casket.

498. the terms used in this line appear to be technical architectural phraseology; see G. Downey, "Byzantine Architects: Their Training and Methods," *Byz.*, XVIII (1946), pp. 99–118.

501.[22] The roofs of the temple are a new heaven, and the building itself forms a new earth under this new heaven. A somewhat similar thought appears below, v. 735.

504. Cf. v. 460.

541. Constantine's profession of ignorance of technical architectural matters, here and in the following lines, is rhetorical. Actually, as will be seen, he had considerable acquaintance with such matters. see Introd., p.

543. The context indicates that δείκνυμι is used here not in the common sense of "bring to light," but in the more unusual sense of "teach," in which it is employed in Matt. xvi, 21 and Acts x, 28, though in those passages it does not take a personal object. This passage may contain a hidden reference to the scene of the Pentecost, which was included in the mosaics of the church; see above, vv. 414–415, where the reference is more precise.

547. (attached)

548. On this sense of κτίσμα, see G. Downey, *B.Z.*, XXXVIII (1938), p. 5, n. 1.

550. The construction εἴτε … εἴτε is merely a literary locution and does not indicate uncertainty as to which man did the work. Anthemius and Isidorus seem to have worked together regularly, and the Church of the Apostles was no doubt a joint product, as was St. Sophia; the names, as used here, are almost a "firm name." Constantine employs the locution (which he may well have used *metri causa*) again in v. 640. He goes on to speak of ὁ τεχνίτης (v. 557) in the same

22 The second half of the typescript (p. Notes 13), as contained in folder "Mesarites," n.d., Notes, photographs, correspondence; 1915–1954; Box 6, Friend Papers, begins here. See introduction, above.

literary convention, much as we write of "the artist" or "the architect" when we know that several men were engaged on the work. On this terminology, and on the careers of Anthemius and Isidorus, see G. Downey, "Byzantine Architects: Their Training and Methods," *Byz.*, XVIII (1946), 101–105, 112–114.

553. χαράσσω is regularly used in this sense by Paulus Silentiarius, *St. Sophia*, 271, 651, 693, 713, 1003; cf. also the use of ἐγχαράσσω by Mesarites, ch. 29, p. 65, 6–7 H.

556. I.e. whether the dimensions are considered quantitatively, with respect to each other, or are indicated in a schematic drawing.

559. Cf. vv. 562, 589. A good example of the technical use of πῆγμα is found in an inscription of Iasos republished by L. Robert, *Etudes anatoliennes* (Paris, 1937), p. 78, n. 7.

562. πινσός and πεσσός were used of a massive, composite support, as distinguished from κίων, a more slender support or column; see below, v. 605, and Procopius, *De aed.*, I, 1, 37, 69, 71. The use of ἐξίσης governing the genitive rather than the dative is peculiar. The sense is made certain by the construction in v. 592. In two other instances Constantine uses ἐξίσης adverbially, "equally" (vv. 582, 625). Cf. P. Tannery, "Sur la locution ἐξ ἴσου," *R.E.G.*, X (1897), pp. 14–18 = *Mem. scient.*, II, pp. 540–544. In this sentence, Constantine mentions the arches briefly in order to indicate the function of the piers. In the next sentence he goes on to describe the arches in greater detail.

. [23]

637.

640. See note on v. 550.

642. The meaning "metal" seems to fit the context better, but μέταλλον may also mean "stone"; Constantine uses the word to mean "quarry," above, n. 116. Mesarites, in his description of this part of the decoration of the church, speaks only of stone

(ch. 37). Paulus Silentiarius uses the word indifferently with both meanings: *St. Sophia*, 607, 689, 749, 767; *Ambon*, 62, 122, 168, 291.

653. The meaning of συνθέτας here is not clear. Ordinarily the word means "composers," "writers," "arrangers."

657. This may refer either to slabs cut to decorative shapes, or slabs in which the veins of the marble formed designs. On the use of the latter for decorative purposes, see. E. H. Swift, *Hagia Sophia* (New York, 1940), pp. 73–75.

659. The grammatical construction here is not plain, but the meaning is clear.

672. The epithet applied to Cyzicus, βάθυγγος, which yields no meaning, may be an error for ῥάθυμος (used in the good sense), "fertile," "happy." Cyzicus was said to "rival the foremost of the cities of Asia in size, in beauty and in its excellent administration of affairs both in peace and in war" (Strabo, XII, 8, 11, pp. 575–576, transl. of H. L. Jones, Loeb Classical Library).

678. κοσμήτας Sophocles gives the meaning as "entablature"; Heisenberg (*Apostelkirche*, p. 79) leaves the word in Germanized form "Kosmeten." The literal meaning is a person or thing which marshals or sets in order. A string-course might be meant.

696. Legrand's suggested emendation is an improvement but is not received into the text here since the sense is the same in either case and the word in their present form, though not actually correct, can be construed satisfactorily. This may be a passage which had not received the author's final revision.

700–702. The meaning of this passage is not clear. It appears to mean that in the eastern part of the Church, where they made the most striking effect because of the abundant light, the columns were drawn up in equal order on the right and the left. The sentence following suggests that the reference is to the whole eastern area of the Church. The sudden introduction of the reference to the builder, who has not been mentioned for some time, suggests that the

23 Pages Notes 16–21 missing.

whole passage is incompletely preserved, or unfinished.

705. παστάδα Cf. above, v. 645. The meaning might be "inner room." (Reinach's restoration)

718–719. The same symbolism of twelve columns representing the Apostles was used in the Church of the Holy Sepulchre; cf. Eusebius, *Life of Constantine*, III, 38, p. 94, 19 Heikel.

735. Cf. vv. 501–502. Legrand suggests "tunics," which would agree better with the construction of the next line; the text can, however, be construed in its present form, and the notion of the walls of the church being covered by one garment is perhaps more striking.

739. Reinach (p. 99) took this passage to mean that the central dome contained the representation[24] of Christ surrounded by the Virgin and the Apostles. Heisenberg, however (*Die alten Mosaiken . . .*, pp. 135–136) pointed out that the allusion must be to the decoration of the whole church,[25] rather than to the portrait of Christ. Constantine evidently had in mind the commonplace comparison of the great lights and the lesser lights (Gen., i, 16–17; Psalms cxlviii, 3; Apocal., xii, 1). With much the same thought, the author of the *Life* of Athanasius, Patriarch of Constantinople 1289–1293, 1304–1310, speaks of St. Sophia as the sun, the Church of the Apostles as the Moon, and "the rest of the churches" as the stars (ed. H. Delehaye, *Mel. d'archeol. et d'hist. Ecole franc. de Rome* XVII 1897, p. 74). A similar comparison of the churches of Constantinople with the sun and the stars is made by Constantine Manasses, in which the Church of the Apostles is likened to the moon (v. 3288, p. 141 Bonn); cf. O. Wulff, "Das Raumerlebnis des Naos im Spiegel der Ekphrasis," *B.Z.*, XXX (1929/30), p. 539. Constantine of

Rhodes himself elsewhere speaks of the reigning co-emperors as "stars" (v. 23), and he several times speaks of the Church of the Apostles in terms of the stars (vv. 458, 511, 639; cf. 697–698), apparently having in mind (in addition to the appearance of the building) both the position in the hierarchy of the Apostles, as indicated in the present passage, and the position of the church, corresponding to that of the Apostles.

749. Cf. Philippians, ii, 7.

751. *Luke* i, 26–38. Constantine introduces the description of the miracles rather abruptly, in the accusative, with no verb indicated, apparently in an effort to make the narrative more vivid. Later he uses κατόψει (v. 805), εἰσορᾷς (v. 830), ὄψει (v. 859). Mesarites (ch. 32 ff.) describes these scenes in different order.

760. *Luke* ii, 1–20.

771. *Matt.* ii, 1–12.

780. *Luke* ii, 34.

785. *Luke* ii, 35; *Heb.* iv, 12.

792. *Matt.* iii, 13–17; *Mark* i, 9–11; *Luke* iii, 21–23.

793. It is to be noted that Constantine uses πρός with the dative "*at* the waters of Jordan" or "*hard by* the waters," not "*in* the waters."

804. *Matt.* xvii, 1–12; *Mark* ix, 2–13; *Luke* ix, 28–36.

814. The meaning of εἰκών here is not clear. The thought may be that Christ was giving His companions His "conception" ("image") of what the Passion would be; or possibly that Christ was actually pointing to the scene of the Passion which is described later (vv. 858 ff.). See also below, vv. 884, 923.

819. In *Luke* iii, 22, the Holy Ghost is said to have descended "in a bodily shape" (σωματικῷ εἴδει).

829. *Luke* vii, 11–17.

830. The reading of the text at this point is not clear. Heisenberg (*Apostelkirche*, pp. 239–240), finding φωηφόρον incomprehensible, writes φαιηφόρον, so that the young man is said to be clothed in dark garments for the grave. Legrand's reading,

24 Handwritten by Friend above typed "figure" (not crossed out).

25 "be . . . church," is underlined in hand, and a large question mark has been written in the left margin.

however, may represent, in incorrect form, a compound made up from φωΐς, "blister," which may make equally good sense. The description of Lazarus in the following lines may have suggested the use of the gruesome epithet here. Moreover, the use of φωηφόρον would provide a characteristic play upon words with ζωηφόρον at the end of the passage (v. 833).

834. *John* xi, 39–44.

844. *Matt.* xxi, 1–11; *Mark* xi, 1–11; *Luke* xix, 28–44; *John* xii, 12–19.

858. *Matt.* xxvi, 47–56; *Mark* xiv, 43–52; *Luke* xxii, 47–53; *John* xviii, 2–12.

864. "The image of the Passion"; see v. 814, note.

869. "The other Judas," son of Joseph; *Matt.* xiii, 55; *Mark* vi, 3.

882. The sense of λαβόντα here is not entirely clear; the meaning might be that Judas "took command of" the crowd of murderers. Begleri's correction σπεῖραν, in apposition with ὄχλον in the next line, seems necessary, for it would be impossible to construe πεῖραν.

888. Begleri's emendation (approved by Wulff), according to which Judas would "receive the halter," is possible; the reading of the MS, however, makes good sense and besides gives a more vivid picture.

916. *Matt.* xxvii, 35–61; *Mark* xv, 24–47; *Luke* xxiii, 33–56; *John* xix, 18–42. Legrand and Reinach (p. 100) consider that this scene should be numbered eleventh instead of seventh, since ten scenes have been described, although only the first six are given numbers; Reinach believes that the original text read τὸ δ'ἑνδέκατον θαῦμα. The question however, may be one of iconography rather than of the condition of

the text. The numbered scenes may have belonged to a canon in which they traditionally bore these numbers, while the intervening, unnumbered scenes were *extra ordinem*; and this tradition may have been so familiar to Constantine and his readers that[26] the insertion of unnumbered scenes and the postponement of the seventh and most important would not have been considered remarkable.

923. "The image of the Passion"; see v. 814, note.

928. There is no English term which will convey both senses of γυμνός, which could mean either "completely nude" or "clad in undergarment only" (i.e. stripped of the usual other garment). See the article "Nudité des condemnés," Cabrol-Leclercq, *Dict. d'archéol. chrét. et de liturgie*, XII, 1806–1808. Mesarites (ch. 17, p. 38, 7) states that Jesus on the cross was clad in a gray στολή (cf. Heisenberg, *Apostelkirche*, p. 191). Mesarites also says that during the Baptism Jesus was γυμνός (ch. 25).

945. On the various literary examples of the Virgin's lament, see G. Millet, *Recherches sur l'iconographie de l'Evangile* (Paris, 1916), pp. 482–491.

953. Cf. the use of σελασφόρος by Michael Psellos in his *Monody on the Collapse of St. Sophia*, p. 15, line 69 ed. Paul Würthle, *Die Monodie des Michael Psellos* (Paderborn, 1917; Rhetorische Studien, VI). Cf. also below, v. 979.

961. *Luke* ii, 35; *Heb.* iv, 12.

26 In the left margin at "may be … readers that" is a handwritten vertical line and question mark.

APPENDIX D

Paul Underwood,
"The Architecture of Justinian's Church of the Holy Apostles, 1"

Paul Underwood gave a two-part lecture at the Holy Apostles symposium on the architecture of the Justinianic building. As the scholar in the project team also responsible for creating reconstruction drawings of both the architecture and the iconography, he spends the beginning of his first talk laying out his methodology and its advantages, as well as the importance of the primary sources. The textual sources were in fact a fundamental part of Underwood's reconstruction of the building, which was heavily based on the translations prepared by Glanville Downey. Underwood was concerned with understanding, in a visual manner, the spatial concept of the authors, in particular Constantine the Rhodian (see figs. A.1.1–7). He then goes on in his lecture to name the four sources that are useful for this kind of reconstruction—Procopius, *De cerimoniis,* Constantine the Rhodian, and Mesarites—and to describe briefly the importance and merit of each. He dwells only briefly on his dating of the church by referring to Procopius as a contemporary of the construction of the Holy Apostles and argues that the evidence of the other sources shows that the building had not changed much over the centuries. The main part of his first paper is particularly technical and preoccupied with translating the architectural information found in the poem by Constantine the Rhodian into diagrams of the development of the space. He closes by comparing it to other buildings. Of particular interest in this part of the paper is his analysis of the fundamental differences that must have existed between the Holy Apostles and St. John in Ephesos (pages 25

and 26), because it contradicts Underwood's own extensive use of this church as a comparison in the second lecture. Those differences were to be found mainly in the piers, which in Ephesos were not pierced. The solution for the main supporting elements at St. John also had an important effect on the structure's vaulting of the side aisles, crossing, and transept, which consequently did not match those of the Holy Apostles. He also points out other deviations in the number of bays and the arrangement of the colonnades. For Underwood, San Marco seems to resemble the Holy Apostles more closely, with discrepancies existing only in the details.

The slides as indicated in the parentheses for this and the following Underwood lecture have not been found. Given the precise descriptions that Underwood gives of each slide, it is, however, possible to identify the architectural drawings (figs. A.1–9) as slides R-3 to R-10 and L-9 to L-11. In the transcription below, obvious typographical errors have been corrected silently. Page numbers of the typescript are set in square brackets.[1]

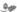

PART I

In a recent symposium at Dumbarton Oaks, many of us who are present today were impressed

1 Underwood's lecture is preserved as "Paul Underwood: The Architecture of Justinian's Church of the Holy Apostles, Part I." MS.BZ.019-03-01-050, Underwood Papers ICFA.

anew by that great architectural masterpiece of Byzantium—the Church of Hagia Sophia, still proudly standing to this day. While we did not have the actual building before our eyes, Professor Swift was able to use photography and the results of his own and others' archaeological investigations as aids in the recording and understanding of its history, forms, and details. The building exists, and the problems raised in the literary sources could frequently be resolved by a study of the monument itself. And now our subject is Hagia Sophia's great contemporary structure—the Martyrium of the Holy Apostles—and the case is quite different, for the building has not existed within modern times and can be conjured up only by means of the verbal descriptions of medieval authors and by a judicious application of those descriptions to other churches whose forms are said to have borne a peculiarly close relation to those of our lost monument. Certain aspects of the building, however, can never be known, and much can never be removed from the realm of speculation.

We who collaborated in this study have tried to bring to bear all methods at our disposal. As Mr. Downey has said, philology and archaeology have been applied. But, as part of the archaeological approach, I am convinced, it is essential to try to pin down the suggestions derived from other methods by means of reconstruction drawings at a definite scale, and in as precise a manner as possible. When this is done, the feasibility of the textual interpretations becomes a constant factor and it frequently happens that the meaning of the texts becomes clear philologically as well as architecturally.

Others have applied some of these sources of knowledge in suggesting reconstructions, but without exception, they have failed to do more than extract a passage here, and another there (frequently to [2] fit a preconception) without attempting to keep the whole of the textual evidence in mind and without permitting that evidence to indicate the limits of similarity that existed between the Holy Apostles and other related structures. Some have used these other monuments as primary sources, applicable to the Holy Apostles, whereas the primary sources are not these other buildings but the descriptions composed by eyewitnesses.

I shall not review the results of previous studies, but at certain points in the unfolding of the building, I shall refer to demonstrable errors in certain ones of the more influential reconstructions which have been rather widely accepted.

Although there is a considerable body of textual reference to the Church and its history, only four sources (Procopius, De Cerimoniis, Mesarites and Constantinus Rhodius) are of real value for purposes of a reconstruction of the building. The manner in which these texts complement one another is very interesting and fortunate. Procopius gives a very brief description which, though not as useful as some of the others for our purposes, has the merit of having been written at the time of construction in the sixth century. By comparing his summary treatment with the fuller ones of the tenth and twelfth centuries we see that in its main elements the fabric of the church itself was subjected to no material change of form during the intervening centuries. The Book of Ceremonies, although it is not a description, is peculiarly rich in information regarding the uses to which the building and various of its parts and appendages were put. Many of the component elements of the complex of buildings that together were called The Holy Apostles, are known only from this source, and the locations and interrelationships of some of them can be estab-[3]lished by inference. Mesarites is systematic in his description of only certain parts, such as the sanctuary, the mausoleum, the schools, and the mosaics; but not of the main body of the Church itself. He gives us much information about the latter in scattered parts of his work, but practically nothing that is not far better and more completely and analytically stated by the poem of Constantinus Rhodius. Constantine is about as informative concerning the architecture of the great central church as it would be possible for a medieval author to be. Indeed, it is a remarkable piece of writing from the point of view of architectural description for any period and is very revealing of an understanding of the architectural forms employed in the construction of a great vaulted Byzantine structure. In the more than 300 lines devoted to the main body of the Church itself we are provided with the ideal starting point for our investigation.

In the first of the two lectures on the architecture of Justinian's church, I will try to

demonstrate what comes out of an interpretation of this poem, by transforming the information into a series of successive diagrams which will result in the end in a general representation of the fabric of the building, but still in rather schematic form. The first lecture will close with a comparison of the general forms, derived in this way, with those of other buildings of its type. One of these has been claimed by some as the model upon which our church was patterned, while others, on the contrary, have thought it to be a copy of ours. Still another building which we will use as comparison has sometimes been acknowledged as a copy of the Holy Apostles; and again this has been denied.

After luncheon, in the second part, we will take up the question of the size and the principal proportions of the Church and introduce what we propose as the more detailed architectural plan of the building and its appendages, drawn to scale, and end with a discussion of the evidence upon which a reconstruction of the subordinate parts of Justinian's building are to be based. That evidence will bring into play texts other than the poem of Constantinus Rhodius.

[4] Constantine's description of the Church begins with a statement regarding the <u>site</u> on which it was built. The "long hill, <u>like a neck</u>, creeping across the midst of the city of Constantine" was "marked from the bringing to light of the whole system of the world" as the site of a Church of the Apostles. It was so marked, we are told, because it was the fourth of the seven hills that "rise within the fair-shaped and wise Byzantium." (SLIDE, R-1)[2] As we see upon this rather schematic contour map, the fourth hill was the one nearest the "midst of the city of Constantine" and is to be identified as the hill upon which there now stands the mosque of the conqueror of Constantinople built, in its first phase, in the year 1463.

But identifying the site of the Church still more narrowly (SLIDE, R-2), and placing it certainly quite close to the position of the mosque are Constantine's words describing the site as a "neck creeping across the city". In this more

detailed contour-map of the terrain about the fourth hill, we find that a long and rather narrow promontory or ridge projects in a south south-easterly direction from Hill IV. Near the end of the long neck, upon a narrow but level area some 535 metres from the summit of the hill is the mosque whose orientation coincides with the direction in which the ridge projects. Since this is the only level area of sufficient extent for the site of the Church, it seems quite certain that it would have been the spot selected for the Church, and that its orientation would have approximated that of the ridge upon which it was placed, perhaps even identical to that of the mosque. If that was the case, the liturgical east in the Church would have been 53 30' south of east (more nearly south than east), and not 36 30' north of east (the only other possible position if the directions of the walls of the Church coincided with those of the mosque). The latter arrangement would have been unique in Constantin-[5]ople judging from extant churches all of which are oriented south of east, most of them rather drastically so.

The fourth hill, then, was predestined for the Church. It is said also to have been "by far the most favored of the seven hills". We shall see that the poet sees in this a peculiar appropriateness because he finds that the number four is the dominant and symbolic number in the Church of the Apostles.

Still speaking in general terms about the external features of the Church, Constantine goes on to describe it as of exceeding width and as "bearing the inspiring and wondrous form of the cross". "Here (on the fourth hill) the mighty house of the Apostles rises from the earth and stands forth shining like a new vault of heaven composed . . . of five stars welded together with three peaks in a straight line and two transverse." These "peaks", of course, are the five domes, visible from the exterior. This is of some importance because there has been a tendency to think of the four surrounding domes as very flat saucers which could hardly have suggested the imagery of this passage to the poet.

Constantine next presents us with a few facts regarding the architectural history of the Church: its founding by Constantius and its dedication as a martyrium of all the Apostles even though only Andrew, Luke and Timothy

2 All indications as to whether the slide was to be projected on the right or the left side are handwritten at the left margin of the typescript as, e.g. "√√ R-1" or "√ L-1".

were placed within it, by Constantius, in a casket of beaten gold. "Then, when a long and strained period had passed by", the poet says, "the mighty and noble Justinian pulled it down to the ground and transformed it to its <u>present</u> great size and plan and projection and its marvellous elevation."

It can be safely inferred that Constantine of Rhodes recognized that the building he was about to describe was basically the one built by Justinian (who transformed it to its <u>present</u> size, plan, etc.) There were certain parts of the complex of buildings still standing in the tenth century that were [6] from both earlier and more recent periods than that of Justinian. But we are to understand that the main body of the Church, in the tenth century, was still considered to be that of the sixth.

Having named the imperial founder of the original Church and the emperor responsible for the extant building, Constantine next attempts to name the architect of the latter. "The man who brought this shrine so cleverly to completion, whether it was Anthemius or Isidorus the Younger—for that the work is theirs, all the historians have clearly stated . . ." and so forth. Later he says, "either Anthemius or Isidorus the Younger . . ." did such and such. It is apparent that he regarded as architect only one of the two men named—not both—for he says "the man who" and "whether . . . or", and in another place "either . . . or". On the other hand he says that "the work is theirs." This conflation of two names would indicate that there was disagreement among his authorities. Unfortunately we cannot determine what his authorities had said, for the poet is the only extant source to link the names of any architects at all with the building of the Church. But we can, at any rate, determine the probabilities in the case by reference to other sources.

First of all, is it likely, or even possible, that Anthemius and the younger Isidorus would have been partners in this undertaking? Anthemius is known, of course, to have collaborated with the elder Isidorus, but so far as I have been able to discover, his name is never associated in any other extant source with the younger man. Anthemius and Isidorus the Elder were the architects of Hagia Sophia, but they were not called in to rebuild the dome of that great church after it

fell on May 7, 558. Instead, Isidorus the Younger undertook the rebuilding. The reason was that Anthemius, at least, was no longer living, and indeed, according to Agathius, he had "long been dead" when the dome [7] fell, a statement which would indicate that he did not live long after the completion of his masterpiece in 537.

The Apostles' Church was dedicated (and presumably completed) thirteen years after Hagia Sophia—in the year 550. The testimony of the <u>Patria</u> that the construction of the Church of the Apostles was begun in 536 ("four years after St. Sophia began to be built"), if true, would have made it possible for Anthemius to have had a hand in its design at least. This source is, however, not to be regarded as more than legendary, and the date is not to be trusted. There is evidence that this date, for its commencement, is too early. For example, Peter Patricius, a contemporary of Justinian, says that Justinian, on entering the city through the Charisius Gate on August 12, 541, "prayed in the Church of the Apostles". Since the Church was not dedicated until 550, and prior to that would have been in course of construction for several years, it can be inferred that the Church of the Apostles in question was the earlier building, not yet torn down to make way for the new. Hence, it can be argued, the Church of Justinian was not started until after 541.

We can conclude that Constantine's tentative identification of Anthemius as architect of the Holy Apostles is rather dubious while the attribution to Isidorus the Younger is entirely possible.

The preliminaries disposed of, Constantine now begins his detailed description of the main body of the Church. The section of the poem to which we now turn is the poet's interpretation of the geometric basis of the design as he thought the architect conceived it.[3] [8] The difficulty of retaining the wording of some of the rather abstruse passages which are now to be taken up has led me to project the translations upon the screen to the left where they can be readily referred to during their explanation. The diagrams illustrating each successive stage of development will be shown on

3 At this point, an extensive passage of seven lines and one entire page of the original typed text was crossed out by Underwood.

the right-hand screen. (SLIDE, L-1) "Anthemius or Isidorus the Younger... began the work of construction by drawing the linear view of a cube (gramiké theoría kúbou); for a cube is a figure put together of four parts with dimensions which are equal from all points, whether measured in numbers or indicated by lines. The architect, inscribing this cube and the cubic pattern of it (kúbos kai schema toude kubikón) on the ground," and so forth. A little later: "it is in this fashion that a pattern of a cube is wont to be delineated, with fourfold composition, and to possess equal bases equal to the surfaces."

The architect, we are told, began by laying out the "linear view of a cube". This geometric process is expressed in different words at two other points: "inscribing this cube and the cubic pattern of it on the ground" and, "it is in this fashion that a pattern of a cube is wont to be delineated". By a gramiké theoría kúbou and a kubikón schema he does not mean anything so simple as the "plan" or "ground plan" of a cube which would merely be a square. A square would hardly produce a fourfold composition nor "possess equal bases equal to the surfaces". What he imputes to the architect is, in my opinion, the process known to modern geometers or stereometricians as "developing the surfaces of a cube", that is, unfolding the surfaces of a cube into a figure in one plane; in other [9] words, laying out the pattern of a cube. (SLIDE, R-3) In the first of our series of diagrams is presented a perspective view of the abstract cube which when unfolded in the manner indicated, produces the "fourfold... composition" and possesses "equal bases equal to the surfaces of the cube".

There is further justification for this interpretation of these passages in the emphasis the poet places upon the process of "unfolding" or "spreading out" as illustrated in such passages as: "toward the east, the west, the south and the north, [the architect] raised, extended [or spread out], and unfolded in mighty size this fivefold house bearing the honored figure of the cross." This statement is important also in that it indicates that the unfolded pattern of a cube produces a cruciform figure upon the ground. This must be grasped in order to understand what motivated the poet to speak of the goniai (angles) in direct connection with pattern of the cube in

the passage that is a continuation of the one now on the screen.

(SLIDE, L-2) "The architect, inscribing this cube and the cubic pattern of it on the ground fixes, at right angles, angles after the fashion of covered colonnades (goníai kat émbolon) down on the surface of the earth, four goníai (angles) turned so as to face one another, all double and double-formed and well-built."

(SLIDE, R-4) The poet seems unwilling to depart from his preoccupation with geometry and geometric terms, and hence tries to carry on his abstractions even when he wishes to show how the geometric "pattern of the cube" is delimited and traced out by actual structural elements. However, there can be no doubt that he uses the term goníai here as a geometric term which represents four very concrete structural forms, namely, four colonnades which take the form of right angles and which find their places in the re-entrant angles formed by the pattern of the [10] cube. These covered colonnades, we can therefore understand, form right angles, as he says; and each is double in the sense that, being bent to form an angle, it consists of two halves. They naturally "face one another", since each half of a right-angled colonnade finds its parallel counterpart in another of the four angles of the pattern of the cube. The meaning of the term "double-formed" is impossible to determine for there are two almost equally plausible possibilities. It may merely be a repetition of the idea that two colonnades form one gonía. Or, it may be that there were two elements, parallel to each other, which go to form a single colonnade, that is, the wall and the row of columns.[4]

(SLIDE, L-3) "And [the architect] fixes piers (pinsoí), four in number, equal to the angles built in the manner of covered colonnades which I have mentioned, four-legged (tetraskeleís) and four-fold in their construction, which are allotted to bear the central sphere and the arches (apsídes), which are thus safely established."

(SLIDE, R-5) Having now established the colonnades at the corners of the cube, the poet temporarily departs from his consideration of the "pattern of the cube" to indicate briefly the

4 A lengthy passage following this sentence of the original typed text of four rows was crossed out by Underwood.

structural elements which now define, or make real, the underlined three dimensional cubic form, namely, the central bay which, in its abstraction, had generated the "fourfold composition". Within the cube, therefore, he introduces the four central piers which are to support the covering of the cube, that is, the four great central arches and the central dome. The piers, naturally, must be placed at the corners of the base of this cubic figure.

We are also told that these piers are "equal to the goníai." [11] This can be taken to mean equal numerically (that is, four piers), or, equal in breadth to the goníai (that is, to the covered colonnades). Now, since the latter are obviously the side aisles of the Church and the piers are placed at the corners of the central square, it becomes evident why these piers are described as "four-legged." The "four-leggedness" consists of two arched openings penetrating through these piers at right angles thus permitting free passage through the side-aisles which ran all round the Church as is made amply clear later in the poem.[5]

(SLIDE, L-4) "And fitting these [arches] together, face to face with one another, with the same number of sides [i.e. four], from one central point, all of [the arches] double and drawn up in the form of a cross (apsídes ex henós mesomphálou staurikós tetagménai), and then fastening together this remarkable form, toward the east, the west, the south and the north, he raised, extended and unfolded in mighty size this fivefold house bearing the honored figure of the cross . . ."

The key to the interpretation of this seemingly obscure passage, whose subject is the arches, lies in Constantine's conception of the arch. The essential phrase to understand is: "all [the arches] double and drawn up in the form of a cross." His meaning can only be determined by anticipating what is said in a later passage: "Then, [the piers] [12] rising up on high like giants, and stretching out their hands into the air, each to the other, their right hands toward their neighbors, and clasping with their fingers, the fingers of the others, they [the piers] created arches . . ."

The arches are created by the piers; they are, as it were, the hands of the piers. Therefore, if the arch that springs from one pier 'fits' or 'clasps fingers' with another arch from another pier, Constantine visualizes the arch as a half-arch, and the place where they clasp fingers is the crown of the whole arch.

That is why he says in the passage now under discussion that the arches which are fitted together "face one another", and that is why they are all double. We have here the first of a series of instances in which Constantine takes a part of the whole and speaks of it as though it were the whole: a habit which we shall observe in other connections later on. The inverse of this we have already seen in the case of the gonía which is really composed of two colonnades meeting at right angles, but which he regards as one element.[6]

If we look at our slide again, we see how the half-arches form a cruciform figure as they spring from the four sides of each of the central piers, in each case as from 'central points'. This is the "remarkable form" that unfolds the "fivefold house," which also bears "the honored figure of the cross". The upper right corner of the slide now on the screen presents this form.

Just how this "remarkable form" produces the "fivefold house" is illustrated (SLIDE, R-6) in our next diagram which is a plan of the central bay and its four, four-legged, piers and the arches that they 'stretch out'. The arches are indicated as broken and separated into their two halves. [13] Obviously, other arches coming from other piers at the four cardinal points of the compass (as stated by the poet) still remain to be introduced before the four surrounding 'bases', or bays, of the Church can be realized and the "fivefold house" fill out the "pattern of the cube".

(SLIDE, L-5) "[The architect] . . . unfolded . . . this fivefold house . . . covering the roof with as many spheres as he had unfolded sphendonai in a circle, joining arch to arch, each to the other, and then cylinder to cylinder, and binding pier to pier, one to the other, and binding one sphere,

5 This passage is heavily edited by Underwood, who crossed out some ten lines and added parts of the last sentence in handwriting.

6 There is a heavily edited passage of about four lines following this one, which Underwood dismissed and crossed out altogether.

cut in two like a mountain, to another sphere-shaped construction."

Up to this point Constantine has done no more than show how it is possible for all five bays to be developed from the cube. Now, though somewhat prematurely, he indicates that the four outer bays have been "unfolded" and vaulted; prematurely, because he has not yet supplied us with more than the four central piers. In the next two sections he supplies the other piers.

(SLIDE, R-7) The process of covering the bays, each with its dome, starts with the joining together of various vaulting elements. The first of these is the "arches". Are these to be regarded again as half-arches? And is it possible that the "cylinders" that are next in his list of joined elements are really half cylinders? An affirmative answer is made possible by a later verse where the poet says that the piers "created arches, constructed in circular [that is, semi-circular] fashion in the manner of finely wrought [14] cylinders." Here he uses the term "arches" with reference to the completed, or semi-circular, whole. Obviously, a complete arch is not a cylinder but a cylinder cut in half along its longitudinal axis. In any event, the likening of the arch to the cylinder in this latter verse permits us to interpret the "cylinders" in the passage here being considered as meaning complete arches. We can thus recapitulate, and illustrate, the process of joining the parts of the building together (the function of the vaults, as the poet saw it) in the following manner. A half-arch from one pier is joined to one coming to meet it from another. Thus two arches joined together form the "cylinder". These latter join one another, not along one line of direction as do the half-arches, but at right angles to one another at their imposts on a common pier. In this way pier is bound to pier as our text says, and in the process squares are created upon which the domes are ultimately placed, after the sphendonai had been "unfolded in a circle". But since, in the case of the square formed by the central bay, each arch is at once a component of two bays, the process of "joining" is completed by the fact that dome is joined to dome. The manner in which one part of the vaults not only joins its counterpart but in so doing creates a new and larger vaulting unit, and that unit, in turn joined to another, expands

into a still larger whole, gives added support to the opinion that the poet's intention was to start with the half-arch and culminate with the juncture of dome to dome. This process of growth is a favored device of the author as we shall see in a moment.[7]

[15] But first, the sphendónai. The present passage makes it clear that their number was such as to provide five circles; that is, equal to the number of domes. But in another context, the poet says: "[the arches], stretching out four well-built circles, which the builders call sphendónai, the piers receive the spheres, five in number." Whatever a sphendóne is, one of its characteristics is that it is circular—but not necessarily a complete circle. The second of these two statements permits us to say that a sphendóne is one of a set of four vault forms by means of which the piers receive the domes. They are also "stretched out" by the arches. The only elements that fit these conditions are the pendentives which can be viewed by a spectator as individual units within a set of four, or collectively as being of such a number as to form five completed circles to receive the five domes.

(SLIDE, L-6) "Thus fitting together the framework of the Church, like to no other of the buildings which stood before it, he fixed four bases, in fours, four in number, equal to the towering piers, bringing the number four everywhere, so that there were in all sixteen well-built towering piers, four-legged and fourfold in their construction—and [16] as many arches—save for those towering piers which were allotted to the furthest points, which took the last place of all. For some of them stood on the south, some on the north, et cetera."

It is the poet's wish, in the present section, to show how a process of multiplication operates numerically in fours with reference to the piers and the bays. It is in this light, in view of his allusion to the fitting together of the vaults in the previous passage, that we should regard the present statement: [the architect] "fixed four bases, in fours, four in number, equal to the towering piers, bringing the number four everywhere . . ." That is to say: the architect had at his

7 A lengthy passage following this paragraph is crossed out by Underwood.

disposal the four bases, or bays, of his pattern of the cube which surrounded the central cube, to which he reverts in his recapitulation of the theory of the cube immediately after this statement. Each of these four bases was composed of fours; for example, each contained four 'towering piers' so that the number four appeared throughout the Church. That this is his meaning is amply proven when he proceeds to multiply the four bases by the four piers in each base in order to obtain the total number of piers and arches in the complete Church ("there were in all sixteen... piers... and as many arches").

Of course in so doing he has involved himself in a duplication, for he has viewed the outer bays (which are his 'bases') as complete entities and must therefore have overlooked the fact that each of the two innermost piers of his four 'bases' was shared, not only with the central bay, but with another bay as well.[8] Thus there were actually only twelve 'towering piers' in all, from a modern, pragmatic point-of-view, as can be seen from our diagram which shows the supporting system of the Church (the building is shown as though split down the axis).[9] [17] There is no way in which sixteen piers from our point-of-view can be arranged and still produce "as many arches" and a "five-fold house". No more than twelve piers can be used and at the same time have each of the four central piers act as supports for the side arches of the four surrounding bays—a requirement made evident in preceding parts of the poem.

His desire to extend the number four 'everywhere' has caused Constantine to refer again to the four-leggedness of some of the piers. He is however, forced to admit that the piers that were "allotted to the furthest points", that is, those that stood at the ends of the arms of the cross, were not four-legged. Thus the eight piers at the outer corners differed from the four central piers in some manner. They are not described, but since the purpose of the arches that pierced the central piers (and thus produced their four-leggedness) was to join one colonnade to its adjacent neighbor, and to produce the side-aisles which we shall see later ran "all round the whole church", the form in which they are indicated

in the drawing, at the extreme right and left, whereby there is, so to speak, only one free-standing "leg", cannot be far wrong.

Having finally expanded the superstructure of the Church from the central cube to the full pattern of the cube, we can now carry our series of diagrams one step further (SLIDE, R-8) and present a schematic plan which will include indications of the major structural elements. The goníai remain as they were in our second diagram; the four central piers and their relation to the cube and the colonnades, as they were in the third. Each of the four piers, as in the same diagram puts forth an arch (whose width is that of the pier) in each of the four directions thus beginning the process of covering the four outer and the central bays. The outermost [18] piers are now supplied, and the locations of the domes are indicated. The present diagram presents, for the first time, the structural framework of the main body of the Church.

(SLIDE, R-9) The diagrams have, I fear, anticipated what the poet says next: "And other piers, again made in four parts, four-legged and of fourfold construction, established above as though out of strange empty space, on those which are ranged below them, lift up the highest arches which receive the spherically constructed roof. And then they [the piers of the second story] run back toward the west, running the same road as those below. Then going back again toward the north, they stand there in most secure array, and so forth."

The piers in their second story were a repetition of their lower form and were thus pierced by arches through which one could pass around the galleries as one did in the side-aisles below.

With this passage Constantine has completed his description of the essential features of the skeletal structure of the Church. In the next passage he gives one bit of information regarding the domes, and, before passing on to the embellishments of the Church, has this to say about the central dome: "But the architect, with reverent thought, arranged that the central dome should stand out and dominate all of them, because it was destined to be the great throne of the Lord and the guardian of the [19] image of the All-Highest which was portrayed in the center of the renowned house."

8 This sentence has been heavily redacted by Underwood.

9 The following sentence is crossed out by Underwood.

It would seem from this that the central dome was higher than the others. This is confirmed by Mesarites when he says: "And the [Stoa] in the center stands up above [the others], and the direction of this one faces toward heaven." But Procopius is more detailed in this matter than either of the two later writers. In describing how the "central portion of the roof was constructed", he says: "That portion of the roof which is above the sanctuary, as it is called, is built to resemble the Church of Sophia (in the center, that is to say), except that it is inferior to it in size. The arches, four in number, rise aloft and are bound together in the same manner, and the circular drum which stands upon them is pierced by the windows."[10] He then makes a contrast between the central dome and the others. "And in the arms of the building, which are four . . . , the roof is constructed in the same size as the central portion, but this one feature is lacking: underneath the domes the masonry is not pierced by windows."

To the perspective section of the skeleton of the building, we can now add the domes. (SLIDE, R-10) The central dome, over the sanctuary, was raised to a greater height than the others, partly because it had a rudimentary drum like that of Hagia Sophia. Judging from domes of the period, the drum would probably not be very high, and the heads of the windows most probably reached a point a little higher than the point at which the curvature of the dome began. The presence of such a low drum, however, would not have sufficed to account for the apparently conspicuous difference in height between the domes, noted by Constantine and Mesarites. To make a really noticeable difference one would have to [20] give the lesser domes a rather flat profile in contrast to a hemi-spherical one at the center; but they could not have been the exceedingly flat vaults indicated by Gurlitt, for we have already observed that all five domes were certainly conspicuous in an exterior view.

The number of windows lighting the central dome is, of course, problematic. We can be sure that it would be an even number; (all Byzantine domes I have investigated have an even number). Most probably, it would be a number divisible by four so as to permit a window to fall at each of the cross axes. The number would of course depend to great extent upon its assumed size. For reasons which I shall take up later on, our domes were most probably 40 Byzantine feet in diameter, a size which elsewhere most frequently called for 16 windows.

There is one additional fact relating to the central dome that should be pointed out. In Mesarites' day (the beginning of the 13th century) the dome appears to have been of ribbed construction or at least its decoration, which he describes, suggests this. But, as Professor Friend will make clear, some changes occurred in the central dome between the times of Constantinus Rhodius and Mesarites, at least in the matter of the mosaics. Indeed, he will show that the mosaics of Basil necessitate a dome without ribs.[11]

With the allusion to the mosaic image in the central dome Constantine now turns to a consideration of the embellishments provided for the house of the Apostles. In the drawing now on the screen, some of these features of the interior of the Church have been indicated. Let us see now what the evidence is for them.

Constantine was much impressed by the richness and quantity of the many-colored marbles, and the gleam of the mosaics which, he says, "clothed and adorned" the interior. He makes it clear, however, that the "straight-rising walls" were "clothed as with tunics" by the many-colored marbles, while in another place he says: "And with gold, which was [21] mixed with glass . . . he gilded the whole of the interior, both all that which rises up in the height of the spherical roof and that which rises with the flanks of the arches, and as far [down] as the many-colored marble slabs, and as far [down] as the second row of string courses." The vertical surfaces of the Church, then, as far as the second string course, were reveted with marbles. Above that point, where the 'flanks of the arches' commence, the vaults as well as the tympana were covered with mosaic work in which gold predominated but in which were contained the mosaic scenes he later describes.

It is characteristic of Constantine that he follows a sequence of elements either of growth

10 The following sentence was crossed out by Underwood.

11 Handwritten note at the margin of this paragraph: "omit."

from smaller to larger units, or of direction. After developing his theory of the cubic pattern, he took up the vault forms above the "straight-rising walls", and informed us that they were covered with mosaics. Now he lowers his range of vision to recount the kinds of marbles that appear below the vaults and for what purposes some of them were used. I will not enumerate all the kinds of marbles that he identifies, but it is of some importance to note that his first reference is to the tall "rosy-colored" columns from Dokimion in Phrygia. About half way through the list he speaks of the "tall green Thessalian columns," while at the end of the list he says that from the Proconnesus slabs were brought "which the stone-cutters spread on the pavement." The slabs from Cyzicus, "many colored and varied", and the "snowy-colored stone" from Paros can also be understood to have been used for the pavement. Now in a later passage, we learn that the columns of the gallery are "rosy-colored". Therefore, since the list obviously works downward from the top of the straight-rising walls, the columns of the second story are of Dokimion marble, white with red veins. The tall green Thessalian columns must therefore have been employed in the [22]12 ground floor colonnades. Interspersed between these three items are listed many different kinds of finely veined and multi-colored marbles which must have been used to make those fine patterns of revetment comparable to those for which Hagia Sophia is so famous. The poet proceeds: "When he had clothed the straight rising walls with these [marbles] ... the architect bound the whole house ... with double zonai, inserting securely established kosmetai of four-cornered marble, bound to one another, surrounding the house as with a fillet, with bonds stronger than adamant ... " The two zonai are apparently the two horizontal bands of zones corresponding to the two storys of the piers and the colonnades, while the kosmetai are clearly the stringcourses or cornices that separate the two lower zones from one another and the straight-rising walls from the vaults covered with mosaics. Now the lower of the two kosmetai (for

we know that there were two since he uses the plural and elsewhere, as we have seen, he speaks of the upper one of the kosmetai) the lower of the two must have separated the lower from the upper colonnade, and thus ran around the nave only. The upper one therefore, must have followed the same path, and therefore stretched across the head of the upper colonnade, not against the outer walls at the back of the gallery.

Near the end of the architectural part of the poem, Constantine gives us another informative statement. (SLIDE, L-7) "So, joining together the whole Church on both sides by means of long colonnades and magnificent columns, and completing it like a marvellous nuptial chamber, he produced in finished form another house within running all round the whole Church. Thus he drew up the columns in linear arrangement, putting together its colonnade as a whole, so that [the columns] ran all round the Church everywhere, on the right side and the other side ... So magnificently drawn up do they all stand there fulfilling the number [23] of the wise Apostles exactly in the four parts, that all the columns drawn up below, which bear the well-rounded roof of the colonnade, are forty-eight in number; and in those above you would naturally find the same number of rosy-colored columns."

Heretofore we only knew that there were colonnades in the goníai. Now we know that colonnades ran across the ends of the arms to form a complete circuit of columns, just as the "other house"—the side-aisles—also ran all round the whole Church. In other words, therefore, in each of the four surrounding bays of the Church, there were three colonnades. Mesarites confirms this, and several other points made by Constantine when he says: "The Church is supported ... with columns which are both numerous and of varied appearance, which begin and, so to speak, sprout up out of the pavement and come to an end at the dressing of stone which is over the faces of the colonnades. For the colonnades ... are twelve in number."

For Mesarites, the number of the Apostles is found in the total number of colonnades in the Church. Constantine, on the other hand, finds their number in the columns of each floor level in each of the four bays. The arrangement of the columns, therefore, can only have been

12 At the left margin, a vertical line has been drawn down to the end of the paragraph, with a handwritten note midway: "omit."

in the manner indicated in our drawing now on the screen. Each individual colonnade consisted of four columns below, and four above. Moreover, Constantine implies by his statement that the columns were drawn up in a "linear arrangement", that they were not coupled, nor were two placed in the colonnade proper and two used as responds against the back wall of the side-aisles, as has been proposed by Soteriou.[13]

[24] This concludes Constantine's description of the fabric of the Church in whose vaults he found, and next describes, the scenes "which show the Incarnation of the Word and its sojourn among us mortals." Before proceeding to other aspects of the Church, I should like to make a brief comment regarding the importance to architectural history of the vault forms in which those scenes were to be found.

If we look (SLIDE, L-8) at a plan of the vaulting system of each of the five bays, it is to be observed that each is covered by a dome whose thrusts are buttressed uniformly, on four sides, by barrel vaults; for although we have referred to them as arches, they are, in reality, barrel vaults. This produces the cruciform buttressing by means of barrel vaults which later came to be so frequently employed in Byzantine architecture.

There is not sufficient time to review the history of the development of this extremely logical vaulting system. I will only say that its full development has not generally been recognized as an accomplishment of Justinian's architects. Paul Lemerle, for example, considers that if the present vaults of the Church of St. Irene in Constantinople (SLIDE, R-11) can be accepted as reflections of its original vaulting system (which has usually been denied), then, as he says, they announce the close approach of the cruciform system of vaulting. [Explain system in St. Irene] The Church of St. Irene, in its present form, is indeed the closest approach in architecture of the period of Justinian to the fully developed system of buttressing a dome to be found at the Holy Apostles. In any event the presence of these forms in Justinian's Church of the Apostles would tend to nullify the argument that St. Irene's present

vaulting system differs radically from the original because the cruciform vaulting system had a later origin.

[25] Two churches, according to certain documents that are more or less contemporary to their construction, have been said to bear a peculiarly close resemblance to the Church of the Apostles. Procopius, who undoubtedly saw the martyrium of All the Apostles and was at least in a position to know something of the forms of the martyrium of the Apostle John, at Ephesus, says of the latter that it "resembles most closely, and is in all respects a rival to the shrine which Justinian dedicated to all the Apostles in the Imperial City."

Regarding the rebuilding of the martyrium of the Apostle Mark, in Venice, by the Doge Domenico Contarini (second half of the 11th c.) an anonymous chronicler says that it was built "with artful construction similar to that Church which had been constructed in Constantinople in honor of the twelve Apostles." Later sources record the tradition that the architect employed in this rebuilding was brought from Constantinople.

But let us see to what extent these churches were similar to the Holy Apostles; (SLIDE: Diagram plan. Left 9) and let us do this on the basis of what we have learned thus far from the poem of Constantine from whose description there has emerged this diagramatic plan of the fabric of the Church itself. (SLIDE: Ephesus. Right 12)

The Church of St. John exists in its foundations only; but from its plan something of its vault forms can be deduced, for they are to some extent reflected in the plan of the piers and in their relation to the outer walls. Nowhere in the Church is there a pier that could suggest the epithet "four-legged". The piers at the outermost corners, it is true, must have been pierced by arches to provide circulation through the side-aisles as must have been the case also at the Holy Apostles. But if we look at the piers of the crossing, especially the two on its eastern side, it is readily seen that they could not have supported the great arches, or barrel vaults above the side-aisles and galleries [26] that were to be found at the Holy Apostles. This means that the individual bays, from the crossing and transepts eastward at any rate, did not have the cruciform

13 Underwood is most likely referring to G. A. Soteriou, "Ἀνασκαφαί τοῦ Βυζαντινοῦ Ναοῦ τοῦ Ἰωάννου τοῦ Θεολόγου ἐν Ἐφέσῳ," Ἀρχ.Δελτ. 7 (1921–22): 205–28.

vaulting system that was present in each bay at the Holy Apostles. And this means that the tympana of the arches that surrounded the outer bays were not continuations of the vertical plane of the outer wall, but were moved inward to a position above the gallery colonnades, thus indicating the presence of a clerestory above the gallery columns, as in the lateral tympana at Hagia Sophia. The galleries in the eastern portions of the church were therefore covered by low vaults (in contrast to the Holy Apostles) which would mean a lean-to roof as in the usual basilica. In the two western bays the plan indicates merely that the domes could have been buttressed on their north and south sides by barrel vaults the full depth of the side-aisles and galleries. The system used in the eastern parts, at least, were quite in line with those of other churches that have been termed "domed basilicas".

In these respects we have important differences between St. John's and the Holy Apostles. Other differences exist in the number of bays, and in the number and arrangement of columns in the individual colonnades. The points of resemblance therefore are more general: both were cruciform in plan, both were surrounded by side aisles—the Holy Apostles completely so, St. John's with the exception of the eastern and western extremities. There are also other points of similarity that are important. These will become apparent this afternoon.

(SLIDE: S. Marco, Plan. Right 13) A glance at the two plans now on the screen will convey better than words the essential identity that existed between the plan and vault forms of San Marco in Venice and the Holy Apostles in Constantinople. As far as the main body of the church is concerned, the differences are those of detail. The bays of the [27] transept are smaller than the others and have only two columns. The western arm has three. (SLIDE: Cross Section S. Marco. Right 14); (SLIDE: Persp. Sec. H.A. Left 10) The smaller number of columns is attributable however to the fact that the colonnades were in only one story (in contrast to the H. A.) because true galleries were dispensed with. This permitted, and in fact required the raising of the level of the lower zone at the expense of the second which is very squat. The columns thus had to be taller and therefore more widely spaced, thus reducing their number. As the two slides now on the screen indicate, the martyrium of Saint Mark much more closely approximates the Holy Apostles, in its fabric, than does that of St. John, even though the latter was built by the same emperor that constructed the Holy Apostles.

(SLIDE: Saint Front, plan. Right 15) (SLIDE: Diagr. Plan H.A. Left 11)

The Church of Saint Front de Perigueux need not detain us at all. It is merely a repetition (probably derived from St. Mark's) of the structural shell of the Holy Apostles minus the colonnades and galleries (the colonnades at St. Mark's are largely decorative), and built in the cut stone masonry of medieval French architecture.

If nothing were known of these other buildings, the poem of Constantine of Rhodes would be sufficient in itself to permit the reconstruction of its principal forms with a fair degree of certainty. Finding them echoed rather closely in one of the two monuments whose similarity to our Church was recognized at or near the times of their construction merely adds to the relative certainty we have already attained. But it is very fortunate that the other of the two buildings should be preserved, even though only in its foundations, for as we shall see this afternoon, it will be particularly useful in other ways.

Paul Underwood,
"The Architecture of Justinian's Church of the Holy Apostles, 2"

In his second lecture[1] Underwood focuses on questions of size and proportion to reconstruct a building of the "style . . . of the time of Justinian" (page 1). The definition of proportions in sixth-century buildings and the basic entity of a "foot" take up a large part of his talk, through many examples from Constantinople and the provinces. For this part he reused some material he published the same year in *Cahiers archéologiques*.[2] He proceeds to speak on St. John of Ephesos and San Marco and their similarity in terms of dimensions, and suggests that this similarity should be derived from the Holy Apostles. Underwood continues in an attempt to define the overall dimensions of the Holy Apostles based on literary sources and basic requirements for the span of an arch, as well as the size of the domes in Hagia Sophia and Hagia Eirene. After presenting the drawing of the main body of the church, Underwood continues by looking at specific spaces and their location and appearance, such as the narthex, atrium, catechumena, sanctuary, and liturgical furniture, and the *heroon* of Justinian, defined as cruciform. Finally, he touches upon the question of the tombs and thus of royal mausolea and their use and reuse.

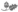

1 Underwood's lecture is preserved as "Paul Underwood: The Architecture of Justinian's Church of the Holy Apostles, Part II." MS.BZ.019-03-01-050, Underwood Papers ICFA.

2 P. A. Underwood, "Some Principles of Measure in the Architecture of the Period of Justinian," *CahArch* 3 (1948): 64–74.

PART II

Now that the general lines of the main body of the Church have emerged, in schematic form, from our primary sources, our object should be to acquire the information needed in order to produce a plan of the whole Church and especially the remaining parts of Justinian's building that have not yet been touched upon. But it is equally important that the plan reflect the style of a building of the time of Justinian. This cannot be done without adopting certain specific sizes and proportions for the parts and spaces. Let us first turn our attention to these matters before we consider the narthex and atrium, the means of access to the catechumena, the sanctuary and its furniture, and finally the heroon of Justinian.

Short of excavation, there is no method of establishing the principal dimensions and proportions of our building in a thoroughly convincing manner, for there is a total absence of specific evidence on this subject in our texts. But there are various indirect methods of approaching this problem, and since we must adopt some criteria for the building's size and proportions it is essential that they be not entirely arbitrary but based upon whatever evidence may be available. Our effort will be limited to the broadest aspects of the building's size, since only the big dimensions are of real significance. Our method will be, first, to observe the principles of measure employed by builders within the particular milieu that produced the Church of the Apostles and which, it can be assumed, would have been applied to [2] it as well. Secondly, we

shall take account of inferences regarding its size to be found in its comparison in literature to other specific buildings and an examination of those buildings with regard to their actual measurements and their conformity to the principles of measure. Third, we will advance what evidence there is, both literary and architectural, regarding the broad limits of size—maximum and minimum—within which the Church of the Apostles must fall. Finally, by comparing the results of the three types of evidence we shall be able to see whether certain fixed dimensions and proportions are indicated or at least probable.

<center>* * * *</center>

Let us first observe the principles of measure used in those churches which were products of the immediate environment in which our building was constructed, and especially those that are known to have been erected under the guidance of the same closely-knit circle of patronage, designers, and even possibly artisans that were responsible for the creation of the Church of the Holy Apostles. The architecture created by this group possessed a style, and a very definite part of that style, over and above the manner in which its forms were treated, was the use made of measure, a term I shall use to include the system of determining size and relative proportions. Elsewhere I have tried to show that Constantinopolitan builders of the time of Justinian seemed to assume, a priori, one key dimension which became the dominant measurement of the building. The dimension, which can be called the criterion of size for the building, was commonly a number of feet such as to be evenly divisible by ten, for example, 30, 40, 50, and so forth. The key dimension was that which was adopted for the dominant space of the building, that is, for the distance between the main piers in domed structures or the distance from nave arcade to nave arcade in basilical structures. [3] Because these distances represent the great spans of vaults of roof, they constituted the fundamental engineering problem to be solved, and of course, in the solution the sizes of the main supporting members were to some extent affected. The span, thus became the first and paramount concern of the designer and builder. In practice, too, the length

of the building was often in direct geometric ratio to the main span and almost invariably the width of the subordinate spacial unit of the side-aisles and sometimes that of the narthex.

Evidences of these rather simple principles of measure are so commonly found among the extant monuments with which we are now concerned that it would be safe to assume that they operated also in the Church of the Apostles. But before we can demonstrate the existence and nature of these phenomena in this group of buildings, and extract from them whatever aid they may offer in adopting a set of dimensions for the Church of the Apostles, it is first necessary to speak of the unit of measurement employed in their construction and convert their metric dimensions into the Byzantine measurements in order to see how a system of numbers operates in the dimensions of the buildings.

The poús, or foot, of Hellenistic and Roman times is known to have varied in actual length at different times and in different places, and we cannot therefore be certain how many of the ancient units were still employed in the sixth century. At any rate, there seems to have been difficulty, in our period, as we shall see, in achieving a standard foot in practice, either because their construction methods were undoubtedly far less careful than those of the ancients, or the foot was not completely [4] standardized. Of one foot, however, used by Byzantine builders we can be quite sure. (SLIDE. Left 12) We can find it by the direct measurement of a foot incised upon an inscribed stone plaque found near Bethlehem about 1924 which constitutes a memorial of an imperial edict issued at the authority of one Flavius Aeneias, Silentiarius, forbidding the cultivation of ground within a distance of fifteen feet of the aqueduct upon which the inscription is presumed to have been placed. To facilitate accurate compliance with the decree the length of one foot was carved in the form of a horizontal square bracket below the inscription which terminates with the words: "The length of the foot is indicated below by the following figure." Père Abel has measured the length of this incised foot as .3089 m. Through less direct methods of historical research Segré has calculated the Alexandrian foot at .309 m. and there can be little doubt that the Bethlehem plaque indicates

a continuance of this more ancient foot into the sixth century, for the inscription is dateable at that time.

Another method of obtaining the Byzantine unit of measure—deductions made from the measurements of buildings of our period, primarily in Constantinople—has tended to indicate that this unit, or one very close to it, while used frequently in Byzantine buildings, was not the only one. In some instances the foot used seems to have been about .315 m.

In applying one or other of these metrical equivalents ± of the foot to some of Justinian's buildings, if we repeatedly find that the result comes within half a foot, or even a foot (in rather long measurements) of a number evenly divisible by ten, we can be quite sure that it was the intention to lay out the dimensions in question to the round number and that this practice was well established. (SLIDE. Right 16) It is a well known fact that the great transverse arches of Hagia Sophia, [5] those that span the width of the nave from pier to pier, measure 31.09 m., which represents almost exactly 100 Byzantine feet at .310 m. to the foot. It is interesting to note that the soffits of these arches are 3.10 m. wide, or 10 feet. There exists no truly accurate plan of the great Church, and it is therefore impossible, at present, to go very far in determining what other dimensions may bear upon a possible system of measure. It may be significant however that the width of the side-aisles, in Professor Swift's plan, appears to be half the span of the great one-hundred foot arches if we take as the width of the side-aisles the two points on either side of their axes where complete symmetry is obtainable, that is, from the axis to the stylobate of the great colonnade, and to the small piers of the outer wall behind the small aisle columns. It would seem then that at Hagia Sophia the key dimension was 100 feet, that certain other parts used a prominent fraction of it—one tenth for the soffits of the arches, one half for the width of the aisles.

(SLIDE. Left 13) If we adopt a foot of .308 m., a little more closely comparable to that of the foot on the plaque, we find that the main span at the adjacent Church of St. Irene, also built by Justinian, measures 50 Byzantine feet (within 2 centimeters). This unit seems the correct one, moreover, because the width of the side-aisle, including the stylobate, is 6.20 m., a measurement that gives us almost exactly 20 feet. In this instance, it should be noted, the side-aisle is not exactly half the main span, or key dimension, but it again gives evidence of a preference for numbers divisible by ten in the more important dimensions.

(SLIDE. Right 17) The Church of Sts. Sergius and Bacchus, also built by Justinian, provides us with a particularly good example of the operation of the principles of measure, and another instance of a 50-foot key [6] dimension. The dominant space is octagonal in plan, yet it has an axial conception. The irregularity of the octagon is attributable to this fact. The key dimension in this instance is the width of the octagon along the major west-east axis which measures 15.75 m. or almost exactly 50 feet if we use the unit of .315 m. to the foot. The width of the eastern side of the octagon, which leads to the bema, is markedly the widest of all the sides. It measures 25 feet. The western, or entrance side of the octagon is next in descending order of size, being about a meter shorter than the eastern. The two sides flanking the entrance to the bema are next in order, while the four remaining, or typical sides, are the smallest. These measure 6.24 m. or very close to 20 feet.

We need not, however, limit ourselves to churches known to have been built by Justinian, nor to Constantinopolitan work of his life-time to see similar phenomena. (SLIDE. Left 14) At Philippi in Macedonia, for example, is the domed basilica known as Direkler, probably built in the late sixth century. In some of the carving, it is quite clear, Constantinopolitan models were followed. It should not be surprising to find there some variations on the principles of measure used in the Capital. Here, the foot was, like that at St. Irene, very close to the measurement of the Bethlehem plaque—.308 m.—for the distance between the piers, which coincides with the distance between the stylobates is 15.40 m., or 50 feet. The aisles, moreover, measured from the inner face of the wall and including the width of the stylobate come to 24.7 feet, quite probably intended to be half the width of the nave. The total width of the Church, within the outer walls in the narthex, measures almost exactly 100 feet. This figure is not necessarily significant, except as a verification of the length of the foot, because

it would result naturally from a nave width of 50 feet and two aisles [7] of 25 in a Church where the stylobate was placed (as here) flush with the inner face of the piers. This was not usually done, for almost always the colonnade was set back toward the aisle from the nave side of the pier. Hence, in most of our monuments, the total width within the outer walls does not equal a round number because it is necessary to add the amounts by which the colonnades are set back from the nave.

(SLIDE. Right 18) Another example, again outside the life-time of Justinian (this time in the fifth century) but back again in Constantinople, is that of the Church of St. John of Studios. This unvaulted basilical structure has a clear width in the nave of 12.65 m. or almost exactly 40 Byzantine feet at .315 which we found used also at Sts. Sergius and Bacchus, and will find again elsewhere. The aisles of this basilica are however not half the width of the nave but come to 15 feet if we exclude the width of the stylobate. The length of the nave, excluding the apse, is, like its width, laid out to a number evenly divisible by ten—80 feet—that is, double the width of the nave.

Let us look again at the group of Churches which, as we have seen, were remarkably like the Church of the Apostles in form. It may be that the relation between them and the Holy Apostles extends to the matter of the principles of measure, and even to an identity of important dimensions. Procopius, it will be recalled, had noted the close resemblance of the Church of St. John at Ephesus (SLIDE. Left 15) to the Holy Apostles. "This Church," he says, "which was small and in ruined condition because of its age, the Emperor Justinian tore down . . . and replaced by a church so large and beautiful that . . . it resembles most closely and is in all respects a rival to the shrine which he dedicated to all the Apostles in the imperial city." There is no reason to question Procopius' double implication that they closely resembled [8] and rivaled each other in beauty (that is, in form?) and in size. There is nothing here to indicate that St. John's martyrium was smaller than the Holy Apostles, as is almost always assumed by the restorers of the latter. On the contrary, the least that can be said is that St. John's was "so large" that "it resembles most

closely" the Holy Apostles in this respect, as it did in certain others.

Let us see what the main dimensions and proportions are at St. John's. The distances between the piers of the central bay, insofar as they have been published, are as follows: On the north, 12.58 m., or only 7 centimeters less than 40 feet if we use the foot found to operate at Sts. Sergius and Bacchus and St. John of Studios in Constantinople. On the east, the distance amounts to 40.6 feet. The distance between the piers to the north, in the northern arm, is 40.3 feet. It is quite clear therefore that the spans of the great arches were thought of and desired to be 40 Byzantine feet.

At only one point can we determine the relation of the side-aisles to this key dimension. In the northern aisle of the eastern bay the distance, from the interior face of the outer wall to and including the width of the stylobate, is 19.52 feet. We see therefore, that St. John at Ephesus, in addition to its adherence to the principle that the key dimension should be a number of feet divisible by ten, also adheres rather closely to the principle that the side-aisles should have a width half that of the nave. It should be noticed that the width of the side-aisles does not carry to the inner face of the pier.

It is very interesting, now, to find that the dimensions of St. Mark's in Venice, closely approximate those of St. John at Ephesus. (SLIDE. Right 19) The arch of the central dome, on its west, measures 12.50 m. [9] compared to 12.80 m. in the corresponding arch at Ephesus. A dimension of 27.85 m. is recorded as the total width between the outer walls of the eastern bay of San Marco thus including the nave, piers and side-aisles. We can judge that the corresponding width in the eastern bay at Ephesus was only 23 centimeters greater, or a variation of less than 10 inches in a measurement of more than 92 English feet. Moreover, the total width of the side-aisles, from the wall to and including the stylobate, is again at San Marco very close to half the width of the nave. Even Saint-Front de Perigueux, which has a width in the nave of 40 English feet, is only slightly smaller than St. Mark's and St. John's. The width of the great arches, though not the width of what should have been side-aisles, is almost exactly half the span of the nave.

This morning the documentary evidence, such as it is, was cited to indicate the probability that St Mark's was a conscious imitation of the Holy Apostles, and because of the frequent reliance of the Venetians of the period when St. Mark's was built in its cruciform shape upon Constantinopolitan artisans, we should be justified in the belief that it was the Apostles' Church and not St. John's that became the pattern for the Venetian structure. We have seen, moreover, that its vaulting system derived from our building, and it is very probable that the mosaicists were well acquainted with vault decorations of the Holy Apostles. If there is any significance at all in the extraordinarily similar dimensions at St. Mark's and St. John's, that significance would involve the Church of the Holy Apostles.

It was said at the beginning of this discussion that there are certain limits of dimension within which the Church of the Apostles must have fallen. The maximum limit is indicated by evidence of a kind of hierarchy of size among the churches of Constantinople. All authors who speak of these things award first place, of course, to the [10] matchless Hagia Sophia, the "Great Church" whose magnitude no other church of Constantinople even attempted to rival. But Procopius says of the Church of St. Irene: "the Emperor Justinian rebuilt it on a large scale, so that it was scarcely second to any of the Churches of Byzantium, save that of Sophia." This statement could hardly be true if he intended to regard its over-all length as the criterion of size, for the Church of the Apostles, with its three domes and four great arches stretched out in a row, would have had to be on a most unreasonably small scale to have failed to exceed by far the Church of St. Irene in length, for the latter consisted of only two bays, one arch and a bema. It must be that Procopius meant that it was large in some other way. His criterion might therefore be the key dimension which represents the span of the nave, and therefore affects the size of the domed area. In this sense, St. Irene may well have been unsurpassed by any Church of the Capital except that of Sophia. Sts. Sergius and Bacchus equals it as far as the diameter of the dome is concerned, but the area below the dome is smaller because of its octagonal rather than square shape, and the type as a whole is entirely central and

compact. For these reasons, our reconstruction of the Holy Apostles must not present a span greater than that of St. Irene (which is 50 feet), indeed it must be smaller. The minimum dimension for the Church cannot be fixed along these lines. We do have some help in the knowledge that there were four columns in each colonnade, and five intercolumniations. There are minimum limits for feasible intercolumniations in a church of this type. Evidence along these lines would indicate that the span of the arches should not be less than 30 feet.

To summarize our evidence thus far, it can be inferred that:

1) The Church of the Apostles would in all probability have conformed to the custom of adopting a span for the great arches of a number of feet [11] divisible by ten.

2) That the span should be less than 50 feet and certainly greater than 30 feet. In accordance with our first point, the span should be 40 feet.

3) The fact that 40 feet was the dimension adopted in the three, if not four, churches whose similarity of forms certainly reflect those of a single prototype, suggests that the import of Procopius' statement quoted above is to be taken as an indication of knowledge on his part that in size, as well as in certain other respects, St. John's and the Holy Apostles were similar.

(SLIDE: Big plan of H.A. Left 16) In our scale drawing, of the plan we have used a 40-foot key dimension, have made the side-aisles, from the inner surface of the wall to the inner face of the stylobate, 20 feet in width. Almost surely, however, the colonnades were set back from the inner faces of the piers, so we have allowed one foot for this. In establishing the over-all size of the piers one need only add the width of the aisle, the one foot "gap", and the thickness of the outer wall which, judging from other similar monuments, would be in the neighborhood of 4 feet, perhaps a trifle less. The total breadth of the piers comes to about 25 feet. This dimension is that also of the great arches. No other dimensions are required to achieve the essential features of the fabric of the Church.

So much for the main body of the Church. Let us go on now to a reconstruction of certain other parts of the building that can be ascribed to the great builder Justinian.

[12] On several occasions throughout the year, the imperial court went in procession from the great Palace to attend Divine Services at the Church of the Holy Apostles. The Book of Ceremonies of Constantine Porphyrogennitus says of the procession and services of the Monday of Easter Week, "and the emperor proceeds through the Mese as far as the Holy Apostles; and entering the narthex, he takes his seat upon a chair while awaiting the patriarch." This chair (sellíon) was apparently a kind of portable throne (for on one occasion it is borne from the Holy Apostles to the court of the nearby palace of Bonus by noblemen's sons) and thus did not require a special architectural setting as is sometimes indicated in plans of the Church. In some other passages relating the ceremonies at other Churches its location in the narthex is said to have been to the left of the central door leading into the narthex from the atrium or exonarthex. In this position the emperor faced the imperial doors, across the narthex, and observed the various orders of the clergy as they entered the Church through their assigned doorways, and received the obeisances of the bishops and metropolitans as they entered through the imperial doors. The latter, though referred to in the plural, is the central doorway leading into the Church from the narthex and the one in which the emperor and patriarch stood together during the prayer of entrance before the two proceeded to the sanctuary. A study of the references to the doors connecting the narthex and the Church has shown that there must have been five, by far the most common number in Churches of comparable size.

There is one rather deep-rooted misapprehension concerning the narthex of the Holy Apostles that must be cleared up. [13] It arises from a statement made in the chapter devoted to the Annual Commemoration of Constantine the Great. "The (co-emperors)", we read, "proceed to the Holy Apostles . . . and go in through the great gate of the atrium (louter) into the narthex. And they turn to the left toward the east of the same narthex, to the curtain which is hung there. For

there stand there the imperial chairs, and their changes of robes are prepared there . . . "

This statement is the sole basis for assuming, as has frequently been done, that the narthex of the Holy Apostles, like that of San Marco in Venice, was triple; that is, a U shaped narthex that wrapped itself around three sides of the western arm of the Church. The two lateral extensions would thus run in an easterly direction and the eastern extremity of the northern narthex would be the place indicated by the text. Of course, such triple narthexes did exist,[3] by the ninth and tenth centuries, in churches of the type of the Nea, but the references to the latter in De Cerimoniis make it plain that each of the parts is regarded as a separate entity. For example, at the Nea the narthex on the liturgical south is called "the narthex situated by the side of the sea", and another is elsewhere said to be the narthex "on the North side of the Church".

Despite the fact that the left-hand end of the western narthex at the Holy Apostles was probably more nearly east than north, the term "toward the east of the same narthex" can only mean the liturgical direction, as seems always to be the case when the cardinal points are mentioned in De Cerimoniis and other texts relating to the Church. We must assume, then, that the meaning is toward the east in the liturgical sense.

The best procedure to follow in such a case is to find another [14] passage in the same source which also refers to a left or right side, coupled with a direction toward the east, in a narthex of an extant church in Constantinople whose plan and orientation are absolutely known. Such a passage occurs in a description of the entrance of the emperor into the narthex of the Church of St. John of Studios (SLIDE, R-20). The passage reads: "And the emperors, going forward, go through the open court (diá toú exaérou); and through the passageway there they enter through the right side of the narthex, toward the east, and there they put on their golden embroidered sagia" and so forth. The procession approached the church from the south, we know, because they went to the monastery grounds by boat from the palace. The only door into the narthex at the south, other than that which made entrance

3 This passage has been heavily redacted by Underwood.

from the atrium to the west, was that which we would say was in its south end. But this door does lie "toward the east" of the only other entrance into the southern portion of the narthex. The formula here certainly does not mean that there was an extension of the narthex along the southern side of the church.

The passage relating to the Holy Apostles, on which the triple narthex is based, it seems to me, is to be interpreted as meaning that the emperors, on entering went to its northeastern corner, where, perhaps in the doorway on the extreme left that leads into the side-aisle of the church were to be found the vela and the chairs. The phrase "to the east of the narthex" is therefore not evidence, in itself, for a triple narthex; and its presence at San Marco is no more an argument in its favor than its absence at St. John Ephesus is one against its presence at the Holy Apostles. Three factors would warrant our reconstruction with a single narthex at the west. First, there is no shadow of evidence for a triple narthex in the texts; secondly, it is unknown to Constantinopolitan work of the period of Justinian, so far as our present knowledge extends; and finally there is evidence that the northwestern angle was occupied by a complete, but small, Church attached to the larger one before the time of Constantine [15] Porphyrogennitus, compiler of the Book of Ceremonies. A narthex in that quarter would have left very little space available to the Church of All Saints.

While we are still in the region of the narthex and the atrium, let us take note of another element that is associated with them before entering the Church. After the "Little Entrance" the emperor repairs to the place in the galleries (catechumena) where he is to "follow the holy liturgy". His route to this place, after leaving the patriarch near the sanctuary, is stated as follows: "The emperor goes out to the narthex, and when he has turned toward the left-hand side of the atrium [i.e. to the north], the patricii take their places outside the door of the winding staircase (kochliós) . . . and he goes up through the left-hand winding staircase to the august catechumena", and so forth.

It is clear that it was necessary to go out of the narthex, into the atrium to arrive at the entrance to the left-hand staircase. This led upward to the "august catechumena" which it has been possible to identify from other contexts as the gallery over the narthex, for what is also called the "catechumena of the narthex" also connected with the left-hand winding staircase through a doorway. It is a fair conclusion that these two are one and the same thing described in different terms, and that the left-hand winding staircase was at the northwest corner of the Church. More precisely, it ran up the northern end of the narthex to the gallery immediately above. Now, Hagia Sophia possessed four such kochlioí, (SLIDE, R-21) two in a fairly comparable position at the west and two at the eastern terminations of the side-aisles, all of them of course much more monumental than would be feasible at the Holy Apostles. St. John at Ephesus (SLIDE, R-22) possessed two at the east which [16] would doubtless be of a scale and type more appropriate to the situation at the Holy Apostles.

Since the stair-tower in question is always referred to as the "left-hand" stairs, it is a fair assumption that there was a right-hand one also. With the exception of a set of wooden stairs at the east, "opening out of St. Constantine [the mausoleum] which leads up to the catechumena of the Holy Apostles", as the Book of Ceremonies had it, no other stairs are identifiable in the texts.

But let us enter the Church and observe the elements that go to make up the sanctuary and the liturgical furniture. We have already noted that according to Procopius the sanctuary was beneath the central dome. It was still there in Mesarites' day. For a general treatment of this focal point of the Church, Mesarites is the author to consult.

"The whole floor of the Church is drawn up in four squares which are separated from one another by a curved outline . . . The curved place (kuklikós hóros) which separates the squares from each other encloses within itself . . . the sacred thysiasterion, (the curved place) being semi-circular at the east—so much of it as lies about the steps of the sacred throne—but so much of it as lies about the holy table, on the west, being quadrangular." In this indirect manner Mesarites indicates that the sanctuary occupied the central bay of the Church. It is quite clear that the kuklikós hóros was not circular throughout, but semi-circular at the east and rectangular

at the west. The semi-circular part at the east is identifiable as the steps of the sacred throne, that is to say, the <u>synthronon</u> or amphitheatre-like construction that is found in the apses of so many of the Churches of the period, such as that at the Church of St. Irene (SLIDE, R-23).

[17] The rectangular portion of the sanctuary at the west, which "lies about the holy table" was obviously the area of the sanctuary defined by some kind of chancel barrier. Unfortunately none of our sources describes this barrier and we cannot say definitely whether or not it consisted of three colonnades anchored, at the east, to the eastern piers of the crossing, or merely a low balustrade enclosing this area. But judging from ample archaeological evidence of Constantinopolitan and other sanctuaries of the period of Justinian, it would most likely have consisted originally of three colonnades with a total number of twelve columns, or other supports, six of which would have stretched across the western front of the enclosure. Our best precedent for such an arrangement of columns is to be found at Hagia Sophia and at St. John Ephesus. In the former, it is true, the text of Paulus Silentiarius, the main source of information in the matter, says that there were "six times two" silver-sheathed columns. In a recent study of some of the appointments of the sanctuary at Hagia Sophia, Stephen Xydis has very convincingly presented the evidence for an arrangement of six columns on the front and three others behind each of the corner columns making the return toward the east. At Ephesus, (SLIDE, R-24) Soteriou found a considerable number of fragments from the colonnades and cornices that once formed the enclosure around the sanctuary. He restores it, from these fragments and the foundations upon which they once stood, with twelve columns, six across the front.

Between the columns, with the probable exception of three intercolumniations, carved slabs would of course have been introduced to serve as chancel rails. The three exceptions would have been in the central intercolumniation on the front, where the holy gates were placed, and one in each of the two side colonnades, certainly in the north side at least. Our evidence for this comes from the Book of Ceremonies. [18] After the emperor and patriarch have approached the sanctuary "through the middle of the nave", and the patriarch has entered, the Book of Ceremonies says: "When the emperor has prayed . . . before the holy gates, he enters the sanctuary." After performing certain rites, the same source continues, "both the emperor and the patriarch leave by the left-hand side door of the sanctuary." Such a side door of a sanctuary of the projecting type has been found to have existed, according to Soteriou, in the right-hand barrier at St. John Ephesus. Numerous other examples could be cited from other excavations.

The barrier enclosed the altar. The altar in use in Mesarites' day is described by him in these terms. "The holy table of Christ itself conceals within itself, like an inviolate treasure, the bodies of Luke and Andrew and Timothy, who sacrificed themselves for Him; it is fashioned of pure and shining silver. The little roof which lies over the holy and sacred table, which people are accustomed to call the <u>katapetasma</u>, begins in the shape of a square supported by four columns, and ends in the shape of a pyramid made of sawn slabs of royal stone, which the craftsman made so thin that this <u>katapetasma</u>, as it is stretched out seems to be made of white linen cloth."

From many sources we learn also that besides the relics of the three apostles, within the altar, the sanctuary also enclosed the tombs of John Chrysostom and Gregory Nazianzenus. Only Mesarites however gives up precise information regarding their location. "On the north side of the quadrangular area, toward the west, John the Great . . . had his body laid to rest on the pavement." On his tomb was an image of Chrysostom, made of silver. "Toward the south", Mesarites says, "opposite John, is Gregory, called the Theologian." These two tombs, therefore were situated at or near the two front corners of the sanctuary.[4]

[19] There is one important feature in the <u>synthronon</u> that should be noted. The clue to its presence at the Holy Apostles is contained in this sentence in the chapter of the Book of Ceremonies dealing with the feast of All Saints. "Then the sovereigns proceed through the

4 A typed sentence that follows was crossed out by Underwood.

Kúklion within the sanctuary." The question is, what was the kúklion within the sanctuary?

There are, in the Book of Ceremonies, two other references to a kúklion or kuklín. Both refer to such a thing at Hagia Sophia. In the first case, immediately after the emperor has performed certain rites at the altar within the sanctuary it is said: "the sovereigns, along with the patriarch, enter the kuklín through the right-hand side of the holy bema . . ." A second passage reads: "and they go through the right-hand part of the sanctuary, and [through] the kúklion . . ."

The best indication as to the nature of the kúklion at Hagia Sophia, one might say a definition of the term, is to be obtained from an anonymous account of the construction of Hagia Sophia [Preger, Scriptores Originum Constantinopolitanarum] which contains the following description of the synthronon of that Church: "The seven seats of the priests, on which they sit, and the throne of the patriarch, and the four silver columns, [Justinian] gilded, setting the [four columns] on each side, two by two, at the entrance into the vaulted passage which is called the kúklion, which is underneath the seats; and this he called the holy of holies."

The kúklion is thus the semi-circular annular vault that runs around within the synthronon, beneath the seats, similar to that which still exists at St. Irene, (SLIDE. Right 25) and to that, of which only the plan is traceable, at St. John Ephesus (SLIDE. Right 26).

[20] It is quite apparent that in the essentials the sanctuary arrangements at the Holy Apostles were like those of St. John at Ephesus. Indeed the latter corresponds so well, in major respects, to the description of Mesarites that we could hardly do better than to follow its precedent in adapting the synthronon to our reconstruction. I have therefore placed this element on which the priests and servants of the Lord sat, under the eastern arch of the crossing which in many respects, and not solely architecturally, becomes the equivalent to an apse.

The Book of Ceremonies mentions two other elements closely associated with the liturgical functions of the sanctuary itself. At the Little Entrance, when the emperor enters the imperial doors, he is said to "pass through the middle of the nave, and through the side door of the ambo he goes into the solea, and the patriarch enters the sanctuary. When the emperor has prayed . . . before the holy gates, he enters the sanctuary." Two additional elements were therefore to be found before reaching the sanctuary, that is, between the imperial doors and the holy gates of the sanctuary. The westernmost one was the ambo, and between it and the holy gates was the solea.

Again, I must make reference to the recent study of Xydis who has cleared up many points regarding these two elements in the Church of Hagia Sophia. Judging from Paulus Silentiarius' description of the ambo in the great Church, it had a set of "eastern steps" and, therefore, doubtless, a western set in conformity to the type with two stairs on opposite sides leading up to a platform at the top, as illustrated in various miniatures of Constantinopolitan origin. Some ambos of this type still exist. The ambo proper, at Hagia Sophia, was surrounded, except at the east, by a barrier apparently curved, which left a passageway around most of the ambo itself. In this barrier, there were at least two doors which the poet locates. [21] One was toward the west in the northern side, and the other toward the east in the southern side. The latter door is probably the one meant by the compiler of the Book of Ceremonies when he says of the approach of the emperor to the sanctuary of Hagia Sophia that he "passes through the middle of the Church and through the right-side door of the ambo, he enters through the solea."

With the exception of the fact that the door is specified to be in the right side, this is the same formula used in the Book of Ceremonies for one of the means of entrance to the solea and the sanctuary at the Churches of St. Mary of Blachernae and of the Holy Apostles, as we have already seen in the latter case. On the basis of this evidence, the ambo of the Holy Apostles should be reconstructed along lines similar to that at Hagia Sophia—specifically, it should be surrounded by a barrier providing a railed passageway along the sides of the ambo and through which one could enter the solea. At the great Church this barrier contained eight columns which carried an entablature, while slabs of an unspecified height filled the intercolumniations except at the points where doors occurred. Such

an imposing monument surrounding the ambo would have been possible and appropriate in the vast spaces of Hagia Sophia, but in the relatively restricted space available in front of the sanctuary at the Holy Apostles, it is doubtful that a colonnade would have surrounded its ambo. I have therefore indicated a rather modest passageway on either side of the ambo, bounded by a screen wall or railed barrier.[5]

[22] The Silentiary describes, at Hagia Sophia, a "long defile" that begins "at the last eastern step [of the ambo]" and continues "until it reaches the silver folding doors" at the "barrier of the sacred rites". He goes on to say that it was "fenced on both sides", "as high as the belt of a man standing beside it", by slabs of Thessalian marble, and that it was raised upon a plinth. Although the Silentiary does not say what this "passage" is called, yet there can be no doubt that what the Book of Ceremonies calls the solea at the Holy Apostles and elsewhere, would seem to fulfill the requirements of the Silentiary's description. First of all the solea would seem to connect the ambo to the sanctuary, specifically to the holy gates. Secondly, it was something one entered and passed through. In one passage people are said to be standing in it, and at times candles are set upon it.

I cannot review the archaeological evidence for structures of a similar sort, which we are quite safe in saying correspond to the soleae mentioned in the Book of Ceremonies. Mr. Xydis has assembled much of this material. But just as we found the sanctuary of St. John at Ephesus (SLIDE, R-27) to have been a singularly close counterpart to that of the Holy Apostles, so too is the solea whose traces were clearly left in the ruins of that Church. The long narrow element (its width is about 9 feet), projecting toward the west from the sanctuary undoubtedly corresponds to the passageway described by the poet at Hagia Sophia; and I believe it can be definitely identified as the solea. Still further toward the west in the plan is the indication of the plinth upon which the ambo of the Church once stood. No evidence is available, however, to indicate whether or not it was surrounded by a barrier, as was the case at the [23] Holy Apostles.

I should like to point out, for future reference on the part of Professor Friend, (before moving on to another part of the building) that the foot of the western steps of the ambo in such an arrangement would project somewhat into the westernmost bay of the Church. The platform at the top of the stairs would fall within the width of the western arch of the crossing.

Among the works of Justinian at the Holy Apostles there is one structure that should finally be discussed here. That is the mausoleum which he built for himself and which, for a time, superceded the one that had generally been used as the final resting place of the Byzantine emperors beginning with Constantine the Great. Justinian did not destroy this earlier mausoleum when he built his new Church, and I regret that I cannot include a discussion of it; but, neither my subject nor time will permit.

Nevertheless it will be necessary to present the evidence regarding the situation of both mausolea with respect to the Church itself, even though I can discuss the reconstruction of only the later one. The evidence comes primarily from inferences to be drawn from the Book of Ceremonies. On the Monday of Easter Week, the emperor having placed his offering upon the altar and, with the patriarch, prayed at the tombs of St. John Chrysostom and Gregory the Theologian, they depart from the sanctuary "through the left-hand side door and go into the tomb of St. Constantine." In another chapter the direction is more explicit: "they turn to the left, toward the east of the same bema, and go out to the tombs, that is to say, to St. Constantine." These directions, paraphrased, indicate that they leave the sanctuary through the door in its northern barrier, and, proceeding through the eastern parts of the Church, they arrive at the mausoleum of Constantine. Supporting this evidence are the words of Stephen of Novgorod that from the sanctuary the mausoleum lay "straight eastward." [24] Mesarites also says that the mausoleum lay "toward the east". In view of the general import of these witnesses, and especially of Stephen of Novgorod, we should place the building in question directly to the east of the Church, and we would join it to the Church itself, because, among other bits of evidence, Mesarites calls it a "wing" of the Church.

5 A lengthy passage of at least five lines following this paragraph was crossed out by Underwood.

The situation of the heroon of Justinian can primarily be deduced from two sources. In the Book of Ceremonies we are told that "when [the emperor and patriarch] have prayed [at the tomb of Constantine] ... they go out, and go to the tombs of ... the patriarchs Nicephorus and Methodius. ... [Then] the emperor goes into the tombs of the emperors (as Justinian's heroon is sometimes called) ... and having lit candles there, he goes out. And both the emperor and the patriarch go through the left side of the Church, that is, the gynaikites, opposite the sanctuary ... and the patriarch returns [to the sanctuary], while the emperor ... goes out to the narthex" and so forth.

It is evident that on leaving the heroon the emperor is found to be in the gynaikites, which is defined as the left side of the Church opposite the sanctuary,—that is to say, the northern bay of the Church. The second source is Leo Grammaticus who says that "Justinian's body was buried in the Church of the Holy Apostles, toward the north." Since many other texts state that within the heroon Justinian's sarcophagus occupied the apse on the eastern side, Leo must mean that the heroon lay to the north of the Church. Both of these sources, therefore, demand the placing of the mausoleum on the north side. But since the evidence (which I cannot present here) is that the northwestern angle of the Church was occupied by another structure, we are left with either the northeastern angle, or the space to the north of the gynaikites. Between these two there is no means of making a choice except our judgment of the probabilities. I prefer the position in the angle because of [25] the probability that the horologion, which appears to have been placed between a narthex of the Church of All the Saints and the gynaikites, would almost certainly have been exposed to view upon a thoroughfare, possibly the Mese, which would have run past the north side of the Church.

This mausoleum seems to have been attached to the Church, not only because on leaving the heroon the emperor is found to be in the gynaikites but because of the following account of the supplication of the people of Constantinople before the battle of Versinicia (June, 813 AD), against the Bulgarian forces under Krum: "While the city was praying ... in the Church of the Apostles, certain impious people of that hateful heresy of Constantine (V), the hated of God, having bolted the door of the imperial tombs, while no one took notice because of the thickness of the crowd, suddenly contrived to open it ... with a certain noise, as though it were a kind of divine miracle; and they leaped inside and fell upon the tomb of the imposter (Constantine V), calling upon this man—and not upon God—saying, "Rise up and succor the state which is being destroyed." The sarcophagus of Constantine V Copronymus was at that time in the heroon of Justinian. Not long afterward it was broken up and the emperor's body burned publicly.

The clue to the form of the heroon of Justinian lies in a comparison of two passages in Mesarites. In beginning his description of the Church of the Apostles (the Church proper, that is), Mesarites says: "This Church ... is raised on five stoas, but not in the manner of that pool of Solomon at the Sheep-gate, because no crowd of sick lies in it, waiting for the angel to trouble the waters, but instead a crowd of those who are strong in Christ and valiant to do mighty deeds through the power of the Spirit, who wait indeed for the last trumpet call from the angel, through which they who dwell in this shrine of five stoas will rise up from their tombs as from couches."

In speaking of the heroon of Justinian, the same author says: "Let us go on [26] a little ... to another building with five stoas like that pool at the Sheep-gate of Solomon; for here too lies a great multitude of those who have lost their vigor", and so forth.

It is obvious that Mesarites strove to bring out a series of analogies and contrasts between the Church proper and the heroon. Among them was the analogy of form—five stoas. Now, for Mesarites, "five stoas" means a cruciform plan, for he repeatedly says of the Church that its five stoas have their foundations in the form of the cross. We can thus be sure that the Mausoleum of Justinian was also a cruciform structure, repeating at a smaller scale the salient characteristic of the Church, namely, a central square surrounded on four sides by other more or less square "stoas." This form was not uncommon among mausolea of antiquity and of the Early Christian period, (Galla Placidia; several at the Chersonese in Crimea; Hâss in Syria; for example), and if we

add memoriae and martyria, shown by Grabar to share their origins and forms with mausolea and heroa, the examples of the cruciform type become more extensive by far.

The Church of the Apostles itself, is of course such a building. But there is another, said by some to be a mausoleum, by others to be a martyrium, to which I would particularly invite your attention because it too was built, in all probability by Justinian at what may well have been his birthplace. (SLIDE, R-28) At Tsaritchin Grad, near the city of Nish in Serbia, not many years ago there was excavated a domed basilica to which was attached this square, domed structure, in the form of a cross inscribed within a square. Each arm of the cross terminated in a conch, and filling out the angles of the cross were four small chambers. On technical grounds these buildings have been ascribed to the period of Justinian.

Dr. Honigmann has shown that the hamlet of Taurisium, the birthplace of Justinian, must have been in the neighborhood of Nish. But Procopius recounts how [27] the emperor built a fortress called Tetrapyrgia upon the site, and nearby also built the city of Justiniana Prima, all apparently done in one great building operation. Now the basilica and the cruciform mausoleum, or martyrium, was found to be enclosed by fortress walls which contained four gate-towers, thus corresponding to the tetrapyrgia, while nearby, at the foot of this acropolis, the excavators uncovered an area of buildings and streets of what promises to be an imposing Byzantine city. This would correspond to Justiniana Prima. The excavators have noted that all the buildings seem to have been erected within one period, and that the site was abandoned before encroachments of other periods could occur.

It is this type, the inscribed cross type, now almost certainly found among the works of Justinian, that I have adopted for his "five-stoaed" mausoleum at the Holy Apostles. I would make one primary departure from the model at Tsaritchin Grad on evidence of the Book of Ceremonies which has this to say of the situation of Justinian's sarcophagus. "At the apse itself, on the east [is] the first sarcophagus in which lies the body of Justinian." This suggests only one apse and not the tetraconch form at Tsaritchin Grad.

The feature of the four small corner chambers has no textual justification, but they are taken over from the example used as model from two practical considerations. First, their presence would eliminate an otherwise isolated corner at the reentrant angle of the Church as well as the awkward reentrant angles that a free cross would provide at the points of juncture with the Church. Secondly, in contrast to the mausoleum of Constantine, Justinian's heroon seems not to have been noteworthy for its size, yet the number of tombs it contained in the 10th and 11th centuries was twenty-four; a larger number than were housed in the larger mausoleum. Some amount of free floor space was necessary because certain rites were performed there by the emperors. Therefore, unless the four chambers [28] are added it would be well nigh impossible to meet these requirements.

One very common error in regard to this mausoleum needs to be cleared up. From certain imperfect recensions of the list of imperial sarcophagi contained in the mausolea at the Holy Apostles, it has been assumed that the heroon of Justinian had two "stoas", usually interpreted as porches, one attached to its south side and the other to its north side. Obviously, our reconstruction would seemingly not take these into account. But the two lists from which this idea is derived have incomplete sets of lemmata, or subject headings, for the various sections of the list. The list contained in De Cerimoniis, on the other hand, appears to be complete and consistent. The main heading in this list reads, "Concerning the tombs of the emperors in the Church of the Holy Apostles (en tó naó tón hagíon Apostólon)" There follows the sub-heading "The heroon of the holy and great Constantine," and the list of sarcophagi it contained. Then the sub-heading, "The heroon of the great Justinian" and its sarcophagi. Then comes a sub-head: "The stoa to the south of the same Church" (toú autoú naoú) a reference to the subject of the main heading (that is, to the Church of the H. A.), and the information that it contained the sarcophagi of Arcadius (toward the south), Theodosius II (toward the north) and Eudoxia (toward the east). (These were in a relationship of father, son, and mother) The final sub-head is: "The stoa to the north of the same Church" containing the tombs of Julian the Apostate and Jovian (Julian's immediate successor).

These <u>stoas</u> (which were really additional mausolea) were, of course not associated in any way with the mausoleum of Justinian. The notion that they <u>were</u> derives from the fact that the imperfect copies of the lists give the impression that the sarcophagi in the <u>stoas</u> were continuations of the list of tombs contained in Justinian's <u>heroon</u>. Other texts make it clear that these other stoas were not even attached to the Church itself, though they <u>were</u> situated one to the south and the other to the north of the <u>Church</u>, perhaps at some distance.

[29] The presence of these additional, and separate tombs about the Holy Apostles, (hitherto unnoticed), and containing the bodies of late fourth and early 5th century personages, raises very interesting questions regarding the development of the imperial tradition of common burial in one mausoleum regardless of family or dynasty. We cannot go into that here, but it appears that the Roman imperial tradition of family burial was not as easily abandoned, nor as early, as we have been accustomed to think. But this subject touches upon matters antedating Justinian, and carries us back to questions regarding the origins of the imperial <u>mausolea</u> and their attachment to the martyrium of All the Apostles—subject on which Mr. Downey is prepared to speak.

APPENDIX F

Albert Mathias Friend, Jr.,
"The Mosaics of Basil I in the Holy Apostles, Part I"

Albert Friend's role in the Holy Apostles project was the study of the iconographic program of the mosaics in the church. He relied heavily on Downey for the translation of key texts to be able to interpret the location and iconographic scheme of the extant scenes, and on Underwood for the visualization of his findings in the form of sketches and drawings.

During the 1948 symposium Friend gave two lectures on the mosaics in the Holy Apostles. He later gave two more lectures on the topic: at Bryn Mawr College on 21 February 1950,[1] and at Dumbarton Oaks during the symposium on Iconoclasm on 28 April 1951.[2] No version of his planned volume on the mosaics of the Holy Apostles has been preserved, making it difficult to determine whether it was at all close to completion.[3]

In this lecture[4] Friend dates the mosaics on the bases of the iconographic evidence in the texts and of comparable churches and manuscripts, to the reign of Basil I, 867 to 886, and more precisely before 880, because of the supposed existence of direct "copies" of its iconography. He also believes that the decoration was conceived by the patriarch Photios, but as he himself admits, "I cannot prove it" (page 1). He follows the entire church, dome by dome, and presents the possible visual solutions of their iconographic program. Friend dwells for a significant portion of his talk on the Pentecost scene (seventeen pages), since it best proves his post-Iconoclastic dating, the significance of the iconographic program in relation to actual events taking place in the church, as well as the overall conception of the church decoration. He then moves on to the Transfiguration dome, the Crucifixion scene, and closes part 1 with the Anastasis dome.

As was the case with Underwood's lecture slides, Friend's slides have not been found. In the transcription below page numbers of the manuscript are set in square brackets.

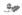

1 Albert Friend, "Holy Apostles Church. / Restoration of / the Mosaics" 21 February 1950, Notebooks and notecards, PULC; 1916-1950, Box 5, Friend Papers; Albert Friend, "Draft for a lecture: 'Holy Apostles Church: Restoration of the Mosaics,'" MS.BZ.019-03-02-072, Underwood Papers ICFA.

2 Albert Friend, "The Pictorial Answer to Iconoclasm: / The Mosaics of the Church of the Holy Apostles," 28 April 1951, Notebooks, notes, papers, course materials, photographs; 1934–1951, Box 4, Friend Papers.

3 Downey even writes in a letter to Panofsky that "Bert Friend has never begun his part," Glanville Downey to Erwin Panofsky from 13 January 1954, Series 1, Subseries 1, Panofsky Papers. See also above section "Selected Pages from Albert M. Friend's Notebooks."

4 Friend's lecture is preserved as "SYMPOSIUM ON THE CHURCH OF THE HOLY APOSTLES / IN CONSTANTINOPLE / The Mosaics of Basil I in the / Holy Apostles. / Part I. / April 23, 1948 / Lecture I.," in Notebooks and notecards, PULC; 1916–1950, Box 5, Friend Papers.

SYMPOSIUM ON THE CHURCH OF THE HOLY APOSTLES IN CONSTANTINOPLE

The Mosaics of Basil I in the Holy Apostles.

Part I.

April 23, 1948

Dumbarton Oaks

Lecture I.

Introduction

The mosaic decoration of the Church of the Holy Apostles, perhaps the richest produced for any church, was certainly the most influential scheme of iconography in the whole realm of Byzantine art. As we shall see, it has left its imprint upon the decoration of other churches in mosaic and in fresco and the copies of its famous pictures can be found in the precious illuminated manuscripts which were the glory of the imperial scriptorium. The influence of this famous church spread in the course of time to the rock-cut churches of Cappadocia as well as to the cathedrals of Russia, and to the royal foundations of Norman Sicily— nor should we forget, what first is usually mentioned, San Marco in Venice.

Thus it happens that although our church was long since totally destroyed, we possess for the restoration of its decoration such an embarrassment of riches that the art historian is excited immeasurably to make the attempt and is equally appalled by the responsibility. And I hope that with me this audience will be properly excited and appalled!

I shall be excused, I know, if today I can present only a sketch in its main outlines—if at times there is description instead of conclusive proof. But I am intent to set out before you the unified and single scheme of this great decoration which must have been the product of one extraordinary mind and have been executed—nearly all of it— at one time.

The extraordinary man who conceived the decoration is, I think, Photius, the great patriarch of Constantinople at the end of the ninth century. But I cannot prove it. [2]

The period when the mosaics were placed on the walls, vaults and domes of the church is the reign of Basil I (867–886). In this case I think the proof will emerge.

———

The learned August Heisenberg, who discovered the description of the Church by Nicolas Mesarites, wrote in 1908 the authoritative book on the Holy Apostles and based his reconstruction of the decoration on Mesarites and to a lesser extent on the poem of Constantinos Rhodios. I would like to pay tribute to this careful work which in many ways lightened the load of later scholars. The little histories of the scenes of Christ's life form a short compendium of Christian Iconography that has played a considerable part in the History of Christian art but unfortunately the assumption by Heisenberg that the mosaics of the Holy Apostles must date from the time of Justinian has bred a confusion which still persists in spite of the efforts of later scholars, who disagreed with Heisenberg, to set the famous mosaics in the proper historical milieu.

The time then has long been ripe for a new treatment of the decoration of the church based de novo not only upon the texts but also upon the many monuments of art which in one way or another reflect the iconography and style of the great masterpiece.

This has been done, in Dumbarton Oaks, the result of the pleasant and fruitful collaboration of a number of scholars, each of whom because of a peculiar competence has made himself responsible for a particular part but everyone in agreement and sharing with all the rest. So, I have been elected to report in part on the scheme of the mosaics.

It would be more scholarly to base my report on the descriptions of the eye witnesses but since the writings of both Constantine and Mesarites are fragmentary, it would also be more confusing. Besides, like eye witnesses, they don't agree. [3] Therefore it is clearer and quicker to use Mr. Underwood's ground plan as a basis and move around the Church in a systematic fashion.

<u>Slide 1*⁵</u>
Plan of the
Holy Apostles
(Explain the placing of subjects in Domes,
houses and central arches.)

1. Pentecost and apostles
2. Transfiguration and life of Christ up to
 and including entrance into Jerusalem
3. Passion scenes—dome Anastasis
4. Post-Resurrection appearances—Dome
 Ascension
5. Central dome and arches

I. Pentecost

<u>Slide 2**</u>
St. Mark's—Pentecost

The description by Mesarites of the Pentecost
mosaic is mutilated both at the beginning and
at the end so that we do not know where in the
church this mosaic was.

It begins in the middle of a sentence as follows:

"From these things which are spoken now, is
there not agreement with the things which
were prophesied by them of old, and must
we not suppose that the divine power and
grace are the same, both that which once
cast its shadow over them and that which
has lately sojourned in these men and in the
form of tongues of fire has sat upon each one
of them? Do not these men indeed open their
mouths clearly in parables and utter dark
sayings from of old such as we have heard
from our fathers the prophets and have not
understood? But now we have understood
them through the teaching of these men.
Do not these men also declare the mighty
deeds of the lord and god and saviour Christ
who is proclaimed by them? ... Their teach-
ings breathe the strength of fire which con-
sumes the adversary ... After these men we
all of us follow and we believe the word pro-
claimed by them, which they have added to
the (ancient) [4] doctrine namely that God

begat a Son before time was, without flux
and without pain, equally without a begin-
ning and co-eternal and of the same sub-
stance as the Father; and that the Father
possesses a holy spirit who appears through
the Son and comes out from Him; that he is
of a single threefold substance and consists of
three persons who are indivisibly divided and
inseparably separated, the one by reason of
their nature and the other by reason of their
persons, etc. etc."

From this we gather that the Apostles in the
mosaic were represented as teachers, that the
actual Pentecost or descent of spirit in tongues
of flame had already happened and is not repre-
sented, that the apostles were theologians teach-
ing the Nicene Creed with the full knowledge of
the Doctrine of the Trinity.

Now the dome before you is over the west-
ern arm of the Church of St. Mark's in Venice,
whose plan and structure as you have seen
copies the Holy Apostles in Constantinople.
Furthermore, the apostles in this mosaic are rep-
resented as teachers each on a separate throne.
Above in the summit of the dome against a
three colored circle is the empty throne, with
the Book and the Dove, the representation of
the Holy Trinity concerning which the apostles
are so well instructed.

We cannot be far wrong then if we take
this mosaic of St. Mark's as a copy of the West
dome of the Church of the Holy Apostles in
Constantinople.

——

As I pointed out (in this room) several years
ago the apostles in the San Marco mosaic—and
hence in the Holy Apostles—are adaptations
from the usual representations of the Evangelists
who teach in the Mss. of the Gospels.

<u>Slide 3*</u>
Rabula Gospels—
 Evangelists
VI. cent. Make comparison.

1. frontal type
2. profile type

5 Single asterisks indicate that a slide was to be projected on
the left side, double asterisks that a slide was to be projected on
the right side. In order to preserve the setting of the lectures,
slides with single asterisks are set aligning left; slides with dou-
ble asterisks are set aligning right.

Luke, Dionysiou 34

Later copies of same types can be seen in X cent Athos Ms. and in the XI century Ms. in Leningrad.

[5] Slide 5*
Mark. Leningrad 220

This last on his throne without a back is very close to apostles in San Marco Dome. For the teachers always sit on thrones, holding their books or rolls or raising their right hands in allocution. Consequently, all the apostles are now teachers in the Dome and not only those whose writings are in the New Testament.

But there is another peculiarity in the San Marco dome. The apostles are not the scriptural list of 12 with Paul in the place of Judas. There are other replacements. St. Jude and St. James the less are dispossessed by St. Luke and St. Mark thus completing the set of the four Evangelists. This list of apostles consisting of Peter and Paul, the Four Evangelists, Andrew and James, Simon and Bartholomew, Philip and Thomas—sometimes called the Byzantine list—is used in the description of the church of the Holy Apostles by Mesarites. To my knowledge this list of Apostles never occurs before the ninth century in either art or literature. The statistic for this statement is very large and I shall not inflict it upon you except to say that the one seeming exception in art—the inscriptions on the bosses on the roof of the tomb of Theodoric in Ravenna, cited by Jerphanion—can be shown to be of later date. This change in the identities of the twelve, this substitution of Luke and Mark for Jude and James the less which is characteristic for Byzantine iconography after the ninth century, cannot have been the vagary of artists or writers but must be the result of some one event or person in Constantinople.

But the uniqueness of this set of apostles can be further shown.

Slide 6*
Pentecost.
Hosios Lukas.

Here in Hosios Lukas in Greece is another copy in the XI century of the Dome of the Holy Apostles. It has all the elements as in San Marco. The Apostles are teachers. Their doctrine comes from above, where is represented the Trinity, but [6] now in the pendentives, more easily seen than in the collar of St. Mark's dome, are represented the Races and Tongues, the people of the whole world, whom the Apostles teach. (Acts II, 5–12)

Now also it is easier to see a most important point. Each apostle is an individual portrait—has his own head type. These portraits like the list of the apostles I have just discussed, become fixed in the ninth century and dominate Byzantine iconography for ever afterward.

But these types or portraits were not fixed before the ninth century. In early Christian times only three types are relatively stable. St. Peter with a white short beard, St. Andrew his brother with dishevelled white hair and beard, and St. Paul, with a long black beard and bald head. All well known.

Slide 7**
Rossano—
Communion of
Apostles

Here in the late V cent. Rossano gospels are Peter, Andrew and also John—as old man with short beard.

Slide 8**
Rossano—
Last Supper

These identifications can be made sure by reference to Last Supper miniature in same Ms. John rests on Christ's breast. Peter is opposite. Andrew with his shock of white hair—all the rest including Judas are just stock type of disciples or young followers—beardless or with short black beards, and so not portraits at all.

Same differentiation and similarity can be seen in Washing of feet to right of Last Supper.

Slide 9**
Ravenna
archiepiscopal chapel

Almost contemporary, but in the West, on the arches of the Archiepiscopal Chapel at Ravenna are represented the Twelve Apostles in medallions with inscriptions. The list, needless to say, is the scriptural one, not that of H.A.

[7] Here each apostle seems to have his proper portrait—John, contrary to Rossano, has black hair and a short black beard; Peter and Andrew are the same as Rossano and Paul is the usual fixed type.

It might seem that here we have a set of fixed portrait types for the apostles before the ninth century, but this hope is shattered even in Ravenna itself. For on the arch of the sanctuary of San Vitale is another set of medallions of the 12 apostles, only slightly later in date. Each bust seems to be a portrait. Yet these agree with the types in the Archiepiscopal Chapel only in the cases of Peter, Paul and Andrew. Again, returning to the East, we have the set of portraits of the apostles in the medallions over the Mosaic of the Transfiguration in Sinai, perhaps of the time of Justinian. And these give, except for Peter, Paul and Andrew, still another set of identifications for the sculptural list of the Apostles.

And so we must conclude that before iconoclasm there was not a fixed set of types for the apostles except for Peter, Paul and Andrew. Either the faces are the general type for a youthful disciple, as in Rossano or they are differentiated types with no specific identifications which are persistent.

———

But after iconoclasm and in Constantinople we find a very different situation. The types, already stable, of Peter, Paul and Andrew persist. A new set of portraits is invented for all the rest which now includes Luke and Mark who displace Jude and James the less. This set of twelve portraits becomes fixed and stable with the proper identifications, throughout Byzantine art which more and more derived from the capital, Constantinople.

Slide 10**

Confession of Peter.

Dionysiou 740

Perhaps the best way to get acquainted with the new and, from now on, sure portraits of the apostles is to see them in the superb XI century lectionary of the Gospels, preserved on Mt. Athos, Dionysiou, Ms. 740. The scene is the Confession of Peter that Christ is the Son of God (Matthew XVI 13–20)

Identify all the types.

[8] Now, with some difficulty to the neck we can look to the left in the Pentecost dome of Hosios Lukas and see that the portraits are the same as in the Dionysiou lectionary.

Slide 11* Slide 12**
Cefalu apostles Cefalu apostles
(left side) (right side)

The best surviving monument set of our new portraits is in the apse of the Cathedral of Cefalu, Sicily, whose mosaics were put in place by 1148 by the King Roger the second. These beautiful figures, done most probably by artists from Constantinople, will play a large part in our reconstruction of the Holy Apostles decoration but for now they may illustrate two points.

First. the portraits with inscriptions.

Identify and describe.

Second. Peter and Andrew hold Archiepiscopal or Patriarchal Cross staffs or scepters. This is of course to indicate that both these apostles, brothers as they were, founded patriarchal sees, in this case Rome for Peter and Constantinople for Andrew. But more of this later in another context. From the point of view of the existing representations, we find Peter had already his cross staff in the Rabula Gospels of the late VI century. Andrew is more interesting. There is no monument earlier than the ninth century which shows Andrew carrying the cross staff and the Andrews who have it are almost always in the set of the twelve apostles we see on the screens, i.e., the set after iconoclasm which has the closest connections with Constantinople.

Slide 13* Slide 14**
San Marco Pentecost
Pentecost —Rabula

Let us return to the Pentecost dome of San Marco (to left) and compare its peculiar rendering of the Pentecost to those on monuments before the period of Basil I.

[9] On the right is the representation in the Rabula Gospels which date 586 AD This does not depict the moment of the descent of the tongues of fire on the seated apostles but a passage in Acts very soon afterward when Peter stood up with the other eleven and addressed the mocking and astonished multitude. It has nothing to do with the iconography of the San Marco Dome. (Acts II 14–36).

Slide 15**

Drogo Sacramentary

Pentecost

Nor has the pentecost in the Sacramentary of Drogo, Bishop of Metz, which should date

before 855, any iconographic connection with the dome. Here the apostles are casually seated in the initial D. Almost like a narrative representation of the text of Acts II.2.3, "And suddenly there came a sound from Heaven as of a rushing mighty wind and it filled all the house where they were sitting; and there appeared unto them cloven tongues like as of fire and it sat upon each of them."

The rays descend from the dove who issues from the hand of God while Christ holding a cross staff assists. This representation of the Trinity is very different from the empty throne with book and dove, of the dome.

Slide 16 **
Pentecost.
Bible of St. Paul's.

The other example of the Pentecost which can predate the mosaics of the period of Basil I is that in the famous Carolingian Bible of St. Paul's in Rome. This I would date about 869 in the reign of Charles the Bald—others date it in the reign of Charles the Fat who died in 888. In any case as you see the representation of the Pentecost has nothing actually to do with the type in the San Marco Dome in spite of the superficial resemblance in that the apostles are seated around in a circle. They are represented in the upper room as in Drogo. Outside the city wall the races and tongues clamor for entrance, so the apostles do not yet think of teaching them. The apostles sit in informal poses not in those of the teachers [10] inherited from the ancient evangelist pictures. The Virgin is introduced seated in the center—and above all, there is no empty throne as the symbol of the Trinity. The Carolingian Apostles have the flame of the Spirit on their heads but they have not begun to teach nor will they ever be theologians.

Slide 17 **
Pentecost Paris 510

In fact the earliest representation of a Pentecost that bears a real relation to our dome is the Ms. of the Homily of Gregory of Nazianzus now in Paris, Ms. 510 which was made for Basil I in the imperial scriptorium between the years 880 to 886. And this we can now show to have been copied from an actual dome like San Marco or better, like the dome of Hosios Lukas, both of which reproduced the Dome of the Holy Apostles Church.

Slide 18*
Part of Pentecost
of Hosios Lukas.

Explain how 510 is copied from a dome just like Hosios Lukas.

Show the similarity in portrait set

But the most important element in the scene of the teaching Pentecost, the source of the authority and the doctrine is the great empty throne with the Book and the Dove.

Slide 19*
Pentecost Chludov
Psalter (f. 62v)

The copyist of our dome in the IX century Chludov psalter was aware of this when he so emphasized the throne in the middle with the book and the dove perched on the top of it. Indeed here all the apostles seem to turn to the Trinity which now is placed in their midst like the empty throne with the Gospels on it that was the center of a church council—as we can see in the representation of one in Paris 510.

Slide 19A*
510. Council picture

[11] The Empty Throne

The empty throne with varying symbols placed upon it has a long history in Roman Imperial art. The best resumé is by Andreas Alföldi (*Roemische Mitteilungen*, 1935).

Slide 20*
Coins of Titus
and Domitian

He illustrated his work with the coins of Titus and Domitian on the reverse, of which are the empty or vacant thrones usually without backs and with a cloth of honor leaning over the front.

One has on it thunderbolt—Jupiter
Another has helmet—Mars (Minerva)

These are the couches of the gods brought to the feasts—the so-called lectisternia concerning which Tertullian speaks. The attributes of the deity were placed on the couch to symbolize his actual presence at the feast. From this the throne came to symbolize authority when the actual person is elsewhere or invisible.

In the Vth and VIth centuries in the West the throne with the attributes took on a Christian

meaning—to represent the throne set in heaven as described in Chap. IV.2 of the Apocalypse.

Slide 21*

Sta. Maria Maggiore

—Etimasia

Throne with diadem on seat, cross rising above it and on the footstool of the throne is a scroll with the seven seals mentioned in Apocalypse (chap. 5.1).

Slide 22*

Capua. S. Presco

(Wilpert)

Another easier to see. S. Presco in Capua shows also the Apocalyptic Beasts. The scroll on the cushion has the Seven Seals so the whole conception is thoroughly Apocalyptic to adapt the Roma lectisternia to a representation of the [12] Throne in heaven and by the presence of the scroll and the Dove to give it a Trinitarian significance.

In the east there is nothing to do with the Apocalypse which was not to begin with a book in the Byzantine canon. But the Roman lectisternium was adapted in Christian iconography in a new way and for a new purpose.

Slide 23*

Nicaea. Dormition

Ch. Etimasia.

The earliest representation surviving in the east was in the arch over the altar of the Church of the Dormition in Nicaea (now recently destroyed). These mosaics of the sanctuary have been variously dated. I would place them in the ninth century before the period of Basil I.

In the representation of the throne the chief and all important difference from the examples in the west is that in place of the scroll of the Apocalypse with its seven seals, is set the jewelled Book of the Gospels, upon the cushion of the Throne. Above it is the dove with a cruciform nimbus set against a cross. Eight rays go out from the Dove and change color as they cross the triple circular mandorla which surrounds the Throne.

The whole of course symbolizes the Trinity. The Book of the Gospels is the second Person, Jesus Christ; the Dove is of course the Holy Spirit, and they rest upon the Throne which stands for the power and authority of God.

This symbol of the Trinity is placed over the Altar and on either side are orders of angels, singing the Sanctus for the Liturgy.

Slide 24**

Nicaea. Dormition.

Apse with Virgin.

Below in the apse itself is the Virgin holding the Christ child, restored as we see over the original cross. From the summit of the apse there descend three rays—from the Trinity—. In the central one is the Hand of God the Father who [13] says of Christ, as we read in the inscription,

"I have begotten thee from the womb before the Morning."

The whole composition is subtly related to the eucharist celebrated in the sanctuary underneath—revealing as it does the consubstantiality of the Father and Son and (in the original scheme with the cross) the death and sacrifice of the Son which gave to the Incarnation and to the Eucharist the tragic and life-giving meaning.

All this as we shall see was more completely and more subtly revealed in the central mosaics of the Holy Apostles Church at a later date.

So in Nicaea the Throne of the Trinity was used for Eucharist and Incarnational symbolism.

Slide 25**

Pentecost Ms. 510

(again)

But in the dome of the Church of the Holy Apostles as we see here in the almost contemporary copy, the throne has still another meaning. It is the authority which comes into and infuses the teaching of the 12 apostles. In the dome and in this its copy the apostles sit like a church council while above in the circular medallion the three in one and the one in three gives license and truth to their teaching and below the races and tongues give ear to the instruction. Indeed one might say that this is the first theological academy. We know from Mesarites' description of the Pentecost in the church that the Apostles were supposed to teach the Orthodox theology.

And this is just the point. It belongs to the Apostles and to them alone to transmit divine doctrine and only their appointed successors may decide it. This was explicitly said in the ninth century by Theodore the Studite. (Letters Bk II. CXXIX to Leo sacellarius).

"There is no question concerning secular matters. To judge of them belongs to the Emperor and to the secular tribunal. But concerning divine and heavenly dogmas, [14] these have not been entrusted to any others save to those to whom God the Word Himself has said 'Whatsoever thou shalt bind on earth, shall be bound in Heaven, and whatsoever thou shalt loose on earth, shall be loosed in Heaven.' Who are those men who are thus enjoined? They are the apostles and their successors. And who are their successors? He who holds the throne of Rome which is the first, he who holds the throne of Constantinople, the second, and he who holds that of Alexandria, Antioch and Jerusalem. This is the five-headed authority of the church and it is theirs to judge of the holy dogmas."

Now if we look closely at our miniature we see in the center of the Apostles is Paul. To the right is Peter and immediately to the left is Andrew. Both Peter and Andrew hold cross scepters because forsooth both founded Patriarchal sees; Peter, Rome and Andrew—Constantinople.

There is an interesting history which Prof. Dvornik has worked out of the growth of the legend that Andrew was the first bishop of Byzantium—a legend which grew up only when it was deemed necessary for the prestige of Constantinople to be an apostolic as well as an imperial patriarchate. By the ninth century this legend was thoroughly established as well as the need to cite apostolicity. It is at the end of this century when in art, as we see here, Andrew gets his cross scepter in the college of apostles.

So in the Dome of the Pentecost in the Holy Apostles Church Andrew was singularly honored nor should we forget that his body was under the altar of this very same church.[6]

——

To sum up:

This Pentecost picture before the IXth century would be unique in the following points:

1. The list of the Apostles, Luke and Mark in place of Jude and James the less.
[15] 2. The portrait types of the Apostles
3. The whole college sits and teaches
4. St. Andrew and St. Peter hold patriarchal crosses.
5. The Trinitarian throne in relation to the Pentecost
6. It is a composition made for a dome.

We can infer from Mesarites that such a composition was in the Holy Apostles Church and from San Marco that it was most likely in the dome of the West arm. Furthermore since it is copied in Paris 510 it must be dated before 880–886.

Such a composition must have been made up by some one at a specific time and for a specific purpose as well as, always in Byzantine art, for a general one which in the end is more important.

Slide 26*
Plan of
Holy Apostles

The dome was over the west arm of the Holy Apostles church. Under it must have been held the church councils of 858 and 861 which we know were in the Holy Apostles church. These are the councils which confirmed Photius in his Patriarchate the first time. The council of 861 was so large—318 bishops besides the Emperor and the court which must have been considerable—that it could not meet in the galleries but only in the nave of the church.

Photius was deposed by a council held by Ignatius in 869. This was held in the south gallery of Agia Sophia (called the VIII Ecumenical council).

After the death of Ignatius, Photius was restored by the large council of 879–880 and he saw to it that it was held in the same place, in the south gallery in Agia Sophia, where the previous as well as many other councils were held.

Slide 27**
Plan of Agia Sophia

Point out where the councils are held.

Under the point in the dome over this council chamber are still the fragments of a Pentecost.

6 On the back of page 14, close to this paragraph, a handwritten note by Friend reads: "1st session of 2nd Nicaea was held in H.A. on Aug 17, 786 in the nave of the Church. Irene & Constantine were in the gallery."

Slide 28**
Pentecost in
Agia Sophia

These were seen by Salzenberg in the middle of the last century and from his sketchy drawing we can see it is exactly the type of iconography that we know to have been in the Holy Apostles. In this case, in the place where it is found the subject can have no other significance than to be appropriate for a church council. We do not know the date of this mosaic and cannot know until Whittemore uncovers it. But in any case its use here confirms our theological interpretation of the unique iconography of our Pentecost dome in the Holy Apostles and raises the question whether Photius did not have something very intimate to do with the decoration of the Holy Apostles.

I have spent considerable time on the Pentecost dome because it, best of all, raises general questions about the iconography of the Apostles and because in their church it must have a paramount meaning. If indeed the Patriarchal Academy for theological training was situated in Photius' time at the Church of the Holy Apostles as Prof. Dvornik will show, then the Pentecostal Apostolic Academy in the West Dome has a further reference. Nor should we be chary in Byzantine art or literature of a multitude of reference.

But I feel it is the relation of the Pentecost dome to the scheme of the whole church which gives to the picture its chief value. So therefore let us go on with the description of the chief elements of that scheme. So I move now to the north dome of the Holy Apostles.

II. Transfiguration Dome.

It is fortunate that Mesarites' description of the dome of the North arm of the church is so complete. Here is depicted the Transfiguration a subject that one would not at first suppose to have been the decoration for such an architectural form.

[17] Slide 29 **
Sinai Transfiguration

It makes a very fine composition for an apse as can be seen here in the Monastery of St. Catherine on Sinai. The mosaic according to some dates from the time of Justinian—in any case it dates well before iconoclasm. But even in the apse the design does violence to the story in scripture since Christ, Elias and Moses should be standing on a mountain. Peter is here flattened on the ground while John, beardless, and James are in exactly similar, but reversed, balanced attitudes.

The mosaic in the church of the Holy Apostles is a very different composition as the description of Mesarites makes clear.

The best Mss. miniatures to compare with Mesarites' text are two. First, Paris 510 again, which dates 880–886.

Slide 30*
Transfiguration
Paris 510

As you see this representation is quite different from Sinai. Peter stands up at the left and does not lie prone as in Sinai. It is John in the Paris Ms. who is falling forward. James at first glance seems like the James in Sinai.

The other Ms. which must be used with Mesarites description

Slide 31**
Transfiguration—
Iwiron 1.

is a large and handsome lectionary of the XI century on Mt. Athos, Iwiron 1. This as you see is similar to the Paris Ms. and far away from the mosaic of Sinai. But there are differences between the two Mss. With these in front of us let us read—in abbreviated form—the description by Mesarites of the North dome of the Holy Apostles church.

The description is mutilated at the beginning. In the early part the positions of the Apostles are described.

[18] "Peter, the strongest, springing up from the ground, since he was able, suggested the pitching of the tents and though stricken in his mind and with his senses taken from him, seemed to speak words, while James and John, the sons of thunder, seemed rather to be stricken with thunder and not to have the strength to rise from the earth. And one of them who was the older, James, partly rising with difficulty upon his knee, and supporting his still heavy head with his left arm, still has the greater part of his body nailed to the ground, while his right hand he holds closely to his eyes like one who, waking from deep sleep, somewhere in the open air at the

hour of noon in high summer seeks immediately to look toward the sun, but is wise enough to protect his eyes with the shadow of his hand. John however does not want to look up at all, but like an undistracted man without cares and in every way maidenly . . . seems to lie there in deep sleep."

As you have looked at the two Mss. you see each has its points. Explain.

To go on—

"And in this fashion the earth holds the disciples. The space in the air supports a cloud of light and in the midst of this bears Jesus, brighter than the sun. On each side of him the space in the air bears in the midst of the cloud Moses and Elias, the branches of the prophets."

In this case Iwiron Ms. is better.
To go on.

"After this fashion is the space in the air. The space above the heads of these figures, that is in heaven, shows nothing else than the Voice, with which God the Father bore witness to the truth of his Sonhood . . . and see how this Voice coming down through from heaven, at the summit of the dome, falls like rain on the barren souls of the disciples."

Now the Paris 510 is better since it shows the voice, i.e. the hand of God in the summit of the dome.

[19] Constantinos Rhodios also has a description of the Transfiguration which is in more general terms. He says a bright cloud overshadows Christ and Moses and Elias and that God the Father bears witness from on high. At the beginning of his description Constantine says you can see Christ walking with his chosen and beloved disciples. After the vision he describes how Christ raised up the apostles and put courage into them and that he charged them to tell the vision to no man.

Putting all these evidences together we can restore the dome as here.

<div align="center">

Slide 32*
Restoration
Transfig. Dome.
Explain the parts, etc.
Why Peter kneels
Peter has † staff

</div>

<div align="center">

Slide 33**
Transfiguration.
Iwiron 5. XIII cent.
Explain going up and coming down mt.
as Constantinos Rhodios says.
Slide 34**
Transfiguration in
Laurent. XII Vi.23
The complete cycle of the dome

——

The Crucifixion
Slide 35**
Plan of the
Holy Apostles

</div>

Both Constantinos Rhodios and Mesarites basing themselves on the account of the Transfiguration in Luke (6.30–31) record the conversation of Christ with Moses and Elias concerning the Passion and the death that Christ will suffer in Jerusalem. [20] Mesarites, because of this, describes next in order the scene of the Crucifixion.

"But him whose glory the disciples saw just now as he was transfigured on Thabor, and whose end the chief of the prophets spoke of, which he was going to fulfill in Jerusalem . . . let us going along a little further in our discourse, see him hanging on the cross in the hall at the east."

Mesarites standing where he can see the dome of the Transfiguration, now, because of the association, looks to see the Crucifixion in the Hall to the East. He does not say it is in a dome. Heisenberg was ill-advised to restore the east dome with the Crucifixion which is not required by Mesarites nor Constantine and which is an impossible subject for a dome in any case.

In its full form with the crosses of the thieves, with Longinus and the sponge man it is an excellent subject for a lunette.

<div align="center">

Slide 36*
(Fresco of
Crucifixion in
S. Sophia, Kiev)

</div>

Here in the south transept of the cathedral of St. Sophia in Kiev is a fresco high up under the arch.

A composition similar to this must have been high up on the east wall of the east arm of the

Church of the Holy Apostles so that it could easily have been seen by Mesarites as he stood in the central part of the church still looking up to the dome of the Transfiguration.

Slide 37*

Crucifixion 510

For reasons I cannot go into here I think that these scenes of the Crucifixion, the descent from the cross and the entombment, which are in Paris 510, are copies with omissions of the scenes on the east wall of the H.A. church.

But if the Crucifixion was not in the dome of the east arm of the church, then what subject was?

——

[21] III. The Anastasis Dome.

The dome must have a scene which belongs to the cycle of the Passion from Gethsemane to the Appearances to the Maries, and it must be a scene of high import. There are several reasons to think that it might have been the Anastasis or the Harrowing of Hell. This evening I shall confine myself to the archaeological evidence that such a dome existed and in a context which suggests that it was in the Holy Apostles Church.

Slide 38 *	Slide 39 **
Sta. Maria	Daphni mosaic,
Antiqua, Anastasis.	Anastasis.

To exhibit this requires a little history of the scene. I forbear to show you the earliest examples wherein Christ approaches Adam in profile—such would be the lost mosaic of the oratory of John VII in the Vatican, known only by drawings of Grimaldi,—or the Anastasis on the columns of San Marco ciborium which we cannot date with assurance.

Here are two versions of the usual Byzantine type—the one to the left, the earlier one, is a drawing of the badly battered fresco from Sta. Maria Antiqua which may date from the Period of Nicolas I, 858–67—in any case probably before the Holy Apostles Church. Christ moves in profile fashion, holding the scroll and tramples upon Hades, while he pulls Adam out of the tomb.

The other to the right is the later developed Byzantine form. Christ now holds the cross instead of the scroll and the scene is enhanced by the presence of David and Solomon and the

Kings of the Old Testament. To the right is John Baptist and the just—or other prophets. All are rising from their tombs.

Back of Hades bound with chains are the broken gates of Hell with locks and keys.

Slide 40*	Slide 41**
Hercules pulling	Athos, Laura.
Cerberus out of Hell.	Lectionary, Anastasis
British Museum,	
Sarcoph.	

[22] A beautiful example of the usual variant of the developed Byzantine period, was published by K. Weitzmann after his return from Athos in 1935. This is the lectionary preserved in the Treasury of Grand Laura on Mt. Athos. The elements are the same except for the pose of Christ which Weitzmann shows to have been borrowed from a scene of—shall we say—similar content where Hercules drags out Cerberus the dog of Hell, as one of his labors. This is an excellent example of the influence of Classical remains upon the art of the Macedonian Renaissance.

——

Slide 42*	Slide 43**
Princeton Museum	Chludov
—Anastasis	Psalter—Anastasis

However at the end of the ninth century there begins another type of the Harrowing of Hell—or Anastasis—in which the Christ is frontal with Adam and Eve symmetrically flanking him.

The Ms. to the right is the Chludov Psalter, in Moscow, which dates in the late IX century. The other is a fine XI century sheet in the Princeton Museum. In the Princeton Miniature Christ does not touch Adam and Eve but stands in hieratic frontality and extends his hands which show the imprint of the nails. He saves by the simple power of his wounded body.

Slide 44**

Anastasis. Iwiron 1.

There is one very beautiful and rich example of this type in the lectionary of the XI century which is in the Athos monastery of Iwiron.

Explain parts thoroughly.

It must be the copy of a dome.

<u>Slide 45*</u>
Restoration H.A.
Anastasis Dome
Explain dome.

[23] Now this Iwiron lectionary Ms. is the same which also included the best copy of the Transfiguration dome in the Holy Apostles. The chance then is more than even that this dome which is copied in the same Iwiron Ms. is the East dome of the Church of the Holy Apostles.

(Lunch)

Albert Mathias Friend, Jr.,
"The Mosaics of Basil I in the Holy Apostles, Part II"

Friend launches his second lecture[1] in medias res with the Ascension dome, for which evidence can be found in neither Mesarites nor the Rhodian but which he deduces from significant parallels such as Hagia Sophia in Thessalonike and San Marco in Venice. He then moves on to the central dome, developing its general iconography, the appearance of the Pantokrator in its zenith, the arch to the east, which Friend believes, following Mesarites, bore the Communion of the Apostles, and finally the Virgin orans. This is followed by a lengthy analysis of the meaning of the central dome. To close he summarizes his dating and interpretation of the meaning of the scheme and brings it back together with texts written by the patriarch Photios.

❧

[1]

SYMPOSIUM ON THE CHURCH OF THE HOLY APOSTLES IN CONSTANTINOPLE

The Mosaics of Basil I in the Holy Apostles.

Part II.

April 23, 1948

Dumbarton Oaks

Lecture II.

IV Ascension

In neither the poem of Constantine nor the description of Mesarites is there any mention of a mosaic of the Ascension in the Church of the Holy Apostles. But we must remember that both these writings are fragmentary and that the portion of Mesarites which might have described the main arches and the principal domes is just the section that is missing.

Since the south arm of the church was, according to Mesarites, filled with the appearances of Christ after the resurrection the natural culmination and finality of these scenes must be the Ascension and just this subject is admirably suited to a dome. Consequently nobody has seriously questioned the conjecture of Heisenberg who placed the Ascension in the South Dome.

After the ninth century the Ascension is a frequent decoration in churches for Domes, usually the central one.

The most striking and characteristic is the dome over the main body of the Church of Sta. Sophia in Saloniki. This has all the usual elements of the Byzantine Ascension—

Virgin Orant

Angels addressing apostles

Trees

Christ seated on arc of rainbow, holding scroll, placing his feet on another arc.

This iconography is to illustrate Isaiah 66.1—"Thus sayeth the [2] Lord, 'The heaven is my throne and the earth is my footstool.'"

The earliest east Christian Ascension with the teaching angels that we have left is the page in the Syriac Rabula Gospels of AD 586.

Here we can see how conservative in forms and how progressive and creative in content Byzantine Iconography can be.

The Rabula Gospels as I have shown elsewhere copies a famous rectangular mosaic in Sion Church, Jerusalem, which was set up just before 460 AD to illustrate the theology of Chalcedon.

Now in Salonika the composition has become a dome. But the angels who address the apostles have in both cases the identical poses. The Virgin of the Incarnation is the same in both. But the upper parts are quite different. In the case of Rabula the reference is to the Vision of Ezekiel, Chap. I, with its chariot of the living Creatures. In the case of the dome the reference is to the passage in Isaiah I have quoted.

The angels and Virgin stay the same.

The inscription in the Salonika dome over the angels tells what they say. "Ye men of Galilee, why stand ye gazing up into heaven? This same Jesus which is taken up from you into heaven, shall so come in like manner as ye have seen him go into heaven."

It is the interpretation of "in like manner" that produce the changes in the Ascension scene—changes which reflect a different theological interpretation in each case.

Where the interpretation is not to be changed the forms in Byzantine art remain remarkably stable. In this Ascension in the beautiful XI century lectionary from [3] Dionysiou we can see that the Virgin and the sets of apostles are very close to the Rabula Gospels.

Paul with his book and the Evangelists John and Matthew are the only ones who point up to Christ on the rainbow. Peter stands in the same questioning attitude as in the Syriac book. However all the apostles have the portraits now of the Holy Apostles Church.

Another example of the theological change in the upper part of the Ascension is seen in the apse of Chapel XVII in Bawit Egypt, where the Christ sits on a cushioned throne and holds a book with the inscription Holy, Holy, Holy to recall the vision of Isaiah in Chapter 7.1. This is done by the Monophysite community in order to enhance the majesty of Christ's divinity at the expense—in the Ascension—of his human nature.

When we come back to the Salonika dome it is apparent that the interpretation of what the angels say gives the theological meaning to the scene and that this must be made out from the treatment of the central motif. In this case Christ ascending into heaven is represented in the guise of God whose throne is the Heaven and whose footstool is the earth—which is to say that Christ ascending with his human body can now make visible the statement of God concerning heaven and earth as recorded in the 66th chap. of Isaiah.

In the Ascension dome of S. Mark's in Venice, the starry background of the mandorla surrounding Christ emphasizes the heavenly character of the rainbow throne. The lesser arc under his feet is, of course, the earth.

[4] Both these domes most probably copy the south dome of the Holy Apostles Church:

1. Portraits of the apostles are those of H.A. set—here S. Mark's is better copy
2. In Salonika both Peter and Andrew carry the Patriarchal cross staff which is the same peculiar Constantinopolitan iconography we noticed in the Dome of the Pentecost.

If these are, then, as I confidently think, copies of the dome in the Holy Apostles church, then was it not for the first time here that the composition of Christ on the rainbow was associated with the Ascension and with a purpose which must be related to the whole scheme of decoration of the church? This then may be another of those inventions of iconography which seem to characterize the work of the whole church. (cf S Clemente in Rome)

———

V. Central Dome.

put out this lantern**

Slide 7*
Plan of Holy
Apostles

But the chief invention in the Holy Apostles Church was the decoration of the Central Dome and its supporting arches. This had the greatest influence on the mosaics of later churches and in distant lands. This central motif was the most important theme and was in itself the epitome of all the rest.

In order to understand the peculiar importance of the central dome it is necessary to look at the plan.

1. no apse.
2. altar in center
3. Synthronon is where apse would be—so Eastern arch is directly above it.
[5] 4. Domes are appropriate to their positions in H.A. Explain
5. So central dome must be related to altar

Both Constantine of Rhodes and Mesarites describe the central dome of the church and they do not exactly agree. It is best to begin with Constantine since he is the earlier author.

Constantine says concerning the Holy Apostles church "that another kind of heaven has come adorned by new and greater stars."

"Concerning the sky, the myths of the Hellenes say that in the stars there are men, horses, wild beasts, fierce bears and lions, bulls and serpents . . . what a deception! But the celebrated house of the apostles shines with other strange stars in the brightness of its pictures formed of light, which shines like the bright beams of the sun. Not here will you see the wild dog of Orion, nor the whirling chariot, which it pulls, nor the Bear itself . . . nor any other of the things which the writers of Fable invent, but you will see the Word itself, the Word of God the Father, Christ made man from the Virgin maid, the unwed mother, joy of the race of mortals, and all his miracles and wonders which he wrought with glory in this life."

And later after the major architectural section (which Prof. Underwood has so well explained), he discusses the central dome as the epitome of the whole, speaks of its mosaics and then after explaining mosaic work and where it is in the church, he starts on a description of the pictures themselves, which he calls wonders.

I quote the transitional and epitomizing passage where Constantine moves from the architecture to the mosaic pictures.

"He (the builder) produced another heaven-formed dwelling on earth, this far famed House bringing to it, as Sun, Christ portrayed, the wonder of wonders, surpassing speech, in the middle of its very precious roof; and likewise, as moon, the [6] Spotless Virgin and then, as the stars, the wise apostles."

From this we must gather that in the central dome—at the top—was an image of Christ and that below and round about were figures of the Virgin Mary and the twelve apostles. The abstract description allows us to think of no setting, no episode in Christ's life—like the Ascension.

Is there anywhere a copy of this central dome of the Holy Apostles? I think there are several.

The best and simplest is the apse of the Cathedral of Cefalu, Sicily.

Apse, Cefalu, Sicily

This church on the north shore of the island was built by Roger the second in fulfillment of a vow made in peril of shipwreck. It was dedicated to Christ and the apostles and for it Roger ordered two porphyry sarcophagi (now in Cath. of Palermo) for his own and his descendants' bodies. Thus it was to be a royal sepulchral church dedicated to Christ and the apostles. The reference to the H.A. at Constantinople is obvious. Roger brought Greek workmen, most likely from the capital to do the mosaics. The apse was finished as the inscription says in 1148 AD

There is no dome in the basilical church of Cefalu, so then, as all archaeologists who have written about it have rightly suggested, a dome composition was fitted into the apse.

The Pantokrator is normally—in the East always—a bust medallion at the top of a dome. Here he is in the conch of the apse, enormous in scale but this would be his size, were he in the summit of his dome.

Below, is the Virgin orant, the Virgin of the Incarnation, flanked by archangels in Byzantine official costume wearing the loros and holding a glove and the labarum.

Slide 9*
Apostles from
apse, Cefalu

The two zones below show the twelve apostles, whom we have seen before. They [7] are, as we said, the best monumental set to show the portrait types we have associated with the Holy Apostles church. Besides Peter and Andrew hold their cross-surmounted scepters.

It seems then sure that the apse of Cefalu is the copy of a dome with the Pantokrator, the Virgin with archangels, and the twelve apostles, and that this dome was in Constantinople. The dome in its iconography was abstract—no setting—no ascension—simply the elements enumerated by Constantine Rhodius in his astronomical way—Christ, the Virgin and the apostles—as if Sun, Moon and Stars of a heavenly dome.

So I feel we are safe to assume that this apse of Cefalu is a copy of the central dome of the H.A. and this all the more so because the iconography

is over the altar in Cefalu as it was over the altar in the H.A.

Slide 10*
Restoration
Central dome H.A.
(Masked except
for central dome)

So from this evidence we can restore, iconographically, the central dome as we see in this drawing. What is now perfectly explained is the large scale of the Pantokrator when the dome is reduced to an apse. As we see in the restoration of the Dome, the medallion of the Pantokrator would cover the orant Virgin and the two archangels in the dome exactly as it does in the Cefalu apse. This comparison of scale is the best proof that the iconography of the apse is taken from a dome.

——

The Pantokrator

According to Constantinos Rhodios the precious icon in the center of the house was the wonder of wonders, surpassing speech. From the Cefalu apse we gather that this must be the medallion of the Almighty—the Pantokrator. But the design of this mighty icon has been spoiled by making it fill the apse. Explain this showing how book is opened to fill apse.

[8] Slide 11*
Pantokrator—
Daphni

The best and best known monumental copy of the medallion is in the dome of Daphni, just outside Athens, which, as we shall see, is accurate in nearly all its details.

Nicolas Mesarites describes at length the Pantokrator which was at the summit of the Central Dome of the Holy Apostles. With this Daphni medallion in front of you I will read his description:

"This dome shows in pictured form the Godman Christ, leaning and gazing out as though from the rim of heaven, at the point where the dome begins, toward the floor of the church and everything in it, but not with his whole body or in his whole form. This I think was very wisely done by the artist as he turned the matter over

in his mind and revealed the very clever conclusion of his intelligence through his art to those who do not observe superficially, because for one thing, I believe, we now know in part and as though in a riddle, and in a glass, the things concerning Christ and belonging to Christ; and for another thing the God-man will appear to us from heaven, at the time of his second sojourn on earth, though the space of time until that coming has never yet been wholly measured,—and because he himself dwells in Heaven in the bosom of his Father and together with his own Father will return to men on earth according to that saying that "I and my Father will come and make our abode with him . . . "

His head is of the same size as the body which is depicted as far as the navel; his eyes, to those who have achieved a clear understanding, are gentle and friendly and instill joy of contrition in the souls of the pure in heart and of the poor in spirit. For the eyes of the Lord are upon the righteous as the Psalmist says, his look is gentle, and wholly mild but wholly directed toward all at once and at the same time toward each individually. Such are those eyes to those who have a clean understanding; to those, however, who are condemned by their own judgment they are scornful and hostile and boding of ill; the face is wrathful, terrifying, stern and filled with hardness, for the face of the Lord is of this fashion for evildoers.

[9] The right hand blesses those who are straight in their paths and warns those who are not straight and so to speak sends them back and turns them from their disorderly way. The left hand, spreading its fingers as far as possible from each other, supports the Gospel of Him who holds it and grasps it closely and as it were rests it on the left side of the breast and by the resting of it there procures no small relief from the burden."

Such was the medallion of the Pantokrator in the central dome of the Holy Apostles church and we see it was exactly like the mosaic medallion, on the screen, from Daphni.

Mesarites observes many things very well: namely that the figure is a bust since Christ dwells in the bosom of his Father and of course the bosom is <u>accentuated, in a bust</u>. This means again that the representation is not Christ himself at all but that of the Father—i.e. the Almighty, the Pantokrator, who however, being ineffable and invisible can be seen only in the guise of Christ his son. Then there is the left hand with its fingers widely spread hugging the book of the Gospels to the bosom as if it were infinitely precious, as if it were a child.

Thus we must see in this remarkable icon a representation of God, the Father Almighty, who clutches the Word, the Gospel book, the only begotten Son to His bosom where indeed he dwells. Yet the Almighty can be depicted to our eyes only in the form of the Word incarnate, who as Athanasius said is a seal of an equal type with the Father. Truly a remarkable image and we are tempted to ask as the pagan asks the Christian in the work of Photius, "Why should the Word contain the Word?"

(οὐ γὰρ ἔχει Λόγον ὁ Λόγος)

Yet the whole conception can become as simple and clear as the image itself by the quotation of the text on which it must rest—a text from the Gospel of St. John 1:18. "No man hath seen God at any time—the only begotten Son which is in the bosom of the Father, he hath declared him."

——

[10] It is a matter of caution in connection with Mesarites' description of the Pantokrator in the Holy Apostles church to realise that this image was only a restoration set up in the dome by the mosaicist Eulalios in the 12th century. The whole dome must have suffered damage after the days of Constantine's description since Mesarites describes no Virgin or apostles in the central dome but speaks only of decorated rays or spokes which come down from the medallion of the Pantokrator to the lower lip of the dome. Were it not for the apse of Cefalu we might question the accuracy of Constantine's report, or ask whether the Pantokrator was there before the restoration by Eulalios.

There are several reasons which can show that Eulalios merely restored the Pantokrator which was in the central dome, at least in the X century.

The famous mosaic icon was copied on the coinage of the Byzantine Emperors.

Slide 12**
Coin of Constantine
Porphyry.
alone 945.

This coin of Constantine Porphyrogenitos which can be dated 945 is the first which shows on the reverse the icon of the Pantokrator—the drapery, the gestures of the hands, one blessing, one clutching, the book are the same.

Slide 13**
my coin of
C. Porphy. 945–59

The head type is better seen on another coin of Constantine of slightly later date. (Here are all the features—explain—

hand, drapery, severe expression.)

So it is absolutely clear that the coin copies a mosaic and not the mosaic a coin. Such a mosaic then must have existed in a famous dome in Constantinople before 945 and since it is on the imperial coinage the original must have something to do with the Emperors. From this we conclude again that the dome is the central one in the Burial church of the Emperors, the Church of the Holy Apostles.

But we have further evidence.

——

[11] After Mesarites finishes his description of the central dome he begins with the four arches which hold it up.

"There support and hold up this hall which can really be called the dome of Heaven since the Sun of righteousness shines in it . . . four arches which are so to speak Atlas-like pillars and arms, taking their intervals from one another in the form of a four-sided figure with equal sides.

The Arch to the east shows us the actual distribution with his own hands of the very body and blood of our Lord and Saviour Jesus Christ, which the Saviour made as he was going out to His willing and glorious and life-giving death, to those blessed table-companions and disciples."

There is depicted an upper chamber of blue and purple . . . Christ himself the sacrificer and the sacrifice stands at the table as though at an altar. For an altar indeed is this mystic and holy table. . . . He sheds his blood into the cup which he holds in front of him with both hands, etc. (until description breaks off in the Ms.)

On the eastern arch then is depicted the Communion of the Apostles or as it is called in orthodox countries the Divine Liturgy.

Slide 14**
Kiev. St. Sophia—
Communion

The best representation of this scene is in the apse of the Church of St. Sophia in Kiev.

Describe—altar
2 Christs
hold cup with both hands
Apostles are Holy apostles portraits

Above are the words of the Liturgy which end prayer of consecration.

"Take eat this is my body which is broken for you for the remission of sins."

"Drink ye all of this for this is my blood of the New Testament which is shed for you and for many; for the remission of sins."

This formula is not the words of the Gospels or of 1st Corinthians but is the exact formula from the liturgy of St. Basil or St. Chrysostom.

[12] Slide 15*
Restoration drawing
of central apse.

So now we can restore further and show the Communion of the Apostles on the East arch below the central dome.

The elements are:
1. Pantokrator
2. Apostles and archangels
3. Virgin
4. Communion of apostles

——

With these determined we must now be immediately struck by the similarity of this iconography to the whole central portion of the Cathedral of St. Sophia at Kiev—the part done in mosaics which are the closest in style to Byzantium of any work in Russia.

St. Sophia—Kiev

Slide 16**
Plan of S. Sophia
—Kiev.

Jaroslav, the son of Vladimir, built the church of Saint Sophia as part of the attempt to make Kiev a rival or an imitation of Constantinople. The church with its decoration was finished in

1037 AD As you can see from the plan, the Kiev church did not at all resemble Agia Sophia in Constantinople nor does it, the Holy Apostles either. The church is a small cross form with a high and single central dome and a very deep bema and apse.

Slide 17**
Section of S. Sophia—
Kiev

Section, looking east, shows the surfaces on which the mosaic decoration is placed,—the dome with its twelve windows, and the high apse and bema.

[13] Slide 18**
View into dome.
S. Sophia Kiev

Describe:
 Pantokrator
 archangels
 apostles
 evangelists

Slide 19**
Pantokrator in Kiev

very coarse
drapery
left hand—holds or clutches book of Gospels

Slide 20**
Apostle Paul. Kiev.
Sta. Sophia

Between windows of dome were 12 apostles only Paul is left with his inscription ꟼπαυλοσ and parts of inscription of Peter.

Slide 21**
Kiev. Sophia. General
view of apse

Explain and enumerate iconography
 Beginning with evangelists
 Virgin
 Communion of apostles
 Church Fathers
 Bishops of Kiev, Alexius and Peter (of the
 XIV cent.)

Just exactly the scheme of the Holy Apostles church as we already have it in our restoration on left screen.

The Virgin of the Incarnation

In Kiev the Orant Virgin in the center of the apse is singularly important and the great inscription over the apse on the arch refers to her. It is a quotation from Psalm 46:5 which reads,

"God is in the midst of her and she shall not be shaken, God shall help her, ever and always."

From this inscription the apse is popularly called the "indestructible wall" taking the Virgin to personify the church.

[14] Slide 22*
Virgin of Kiev apse

But actually the inscription must be taken literally to refer to the Virgin herself who at the time has the Christ child in her womb. It is the Virgin after the Annunciation, and when she has this orant gesture she should be called the Virgin of the Incarnation for truly God is in the midst of her.

Slide 23**
Nereditsa. Virgin of
the apse

And this can be seen in the fresco of the Virgin in the church of the Saviour at Nereditsa which dates at the end of the 12th cent. Here the Virgin is in the apse over the communion of the apostles—that is in exactly the same iconographic context as in Kiev. On her breast is the medallion of the youthful Christ Emmanuel. So, God is in the midst of her.

Slide 24**
Virgin of apse of
Cefalu

Coming back to the apse of Cefalu which we saw some time ago, again we can recognize in the Orant Virgin the Mother in whom Christ is already incarnate.

Slide 25**
Communion of
Apostles—Kiev.

Below the Virgin of the incarnation in Kiev is the distribution of the body and blood by Christ himself, the Communion of the Apostles.

The portrait types are those of the church of the Holy Apostles.

Slide 26*
Detail of Holy
Apostles in
communion. Kiev.

Here we see in detail Paul and Matthew with their proper portraits.

The style is a hardening of a good IX century Constantinople model of the period of Basil I. This can be seen in draperies and in face of Matthew with his drooping beard and mustaches.

[15] The angel by the side of the altar is clad as a deacon and wears the orarium or deacon's stole over his left shoulder. Therefore he is officiating at the Divine Liturgy. (He wears sticharion or alb-camice).

Slide 27**
Ch. Fathers at Kiev.
right side

Below the Communion scene are the Church Fathers in full vestments as bishops.

(left—Epiphanios, (2) Clement, (3) Gregory
Naz., (4) Nicholas, (5) Stephen
Set of five on each side
In center—left: Gregory of Nazianzus
right: John Chrysostom—both patriarchs
of Constantinople
(right—(1) Gregory Thau., (2) Gregory
Nyssa, (3) John Chrysostom, (4), Basil,
(5) Lawrence)

At the end of the file nearest and directly under the altar of the scene of the Communion above, are the deacons St. Stephen and St. Lawrence. They are properly clad for their office of the Divine Liturgy and wear the orarium or stole just as the angels did above. This introduction of the deacons among the Church Father-bishops was of course done to relate the bishops as successors of the apostles to the scene of the Communion above.

Slide 28*
Sts. in 510 (Basil,
Nyssa, Naz.)

The style of these Church fathers rests on that of the figures of the Church Fathers in Paris 510 which dates from 880–886. Ainalov is very insistent upon this comparison, which is to say that the mosaics of Kiev have late IX century Constantinopolitan mosaics at their immediate prototypes.

Slide 29*
Heads of John
Chrysos. & Basil,
Kiev

The heads of St. John Chrysostom and St. Basil in Kiev show a basis in the ninth century style with their large eyes and broad features, hardened up as they are.

[16] Slide 30**
St. Ignatius of
Antioch—St. Sophia
cycle

A comparison with an actual IX century Constantinopolitan mosaic—head of St. Ignatius from Agia Sophia at Constantinople will show the differences and similarities in the way the hair of Basil and Ignatius is done with short, straight white lines.

It is, I think with Ainalov, quite plausible to assume a ninth century Constantinopolitan model as the immediate prototype of the Kiev mosaics.

Slide 31* Slide 32**
General view. Restoration of H.A.
Sophia. Kiev. Central dome.

There is no question about the iconography since Kiev copied the whole scheme of the central dome of the Holy Apostles with its east arch. On this evidence we now can add the Church Fathers under the Communion of the Apostles on the east arch in our restoration.

So Kiev and Cefalu—as far apart as Russia and Sicily—copied the central part of the Church of the Holy Apostles and, by a comparison of these copies which have no relation with each other, we can with confidence restore the central mosaic scheme of the burial church of the Emperors.

——

VI. The Meaning of the Central Dome

The central dome in the Holy Apostles was directly over the altar, and the east arch is over the synthronon or seats of the clergy which is placed where an apse would be in another church. Therefore the meaning of the mosaic decoration should be sought for in the Eucharist which is represented with Christ as officiant, on the very same east arch. The situation in connection with

the altar is virtually the same, in St. Sophia in Kiev save that there being an apse, the Virgin, the Communion and the church fathers are on the conch and the apse wall itself. In the [17] two churches the placing of everything in regard to the actual altar is the same, as indeed the iconography would require.

The only differences of note are, 1) in Kiev the Virgin in the apse is far separated from the Pantokrator in his small high dome while in the Holy Apostles, where the Virgin is in the dome with the Pantokrator, she is not so close to the communion of the apostles on the east arch.

It is however easy to show that she must be thought of in close connection with the Divine Liturgy.

<u>Slide 33</u>*
Putna embroidery
1481 AD

In this XV century embroidery from the Roumanian treasure of Putna, the Divine Liturgy is celebrated after the departure of Christ, with the groups of apostles, each distinguished by a monogram, on either side. Above, in a triple mandorla, is the Orant Virgin of the Incarnation who as the Mother of God is the necessary presence to represent the source of Christ's human body, which alone can give meaning to the Body and Blood of the Eucharist celebrated below.

So now to read the central iconography of the Holy Apostles church in our restoration:

1. Before all ages Christ is in the bosom of the Father—as we see in the Pantokrator

2. At the Incarnation, he is in the womb of his Mother—the Orant Virgin

3. At the Eucharist his Body and Blood is the Bread and Wine that by his words Christ has consecrated and now distributes to his apostles.

4. Below the successors of the apostles and the ministering angels, i.e. the bishops and the deacons, are present around

5. the Liturgy as it would be actually celebrated in the church at the altar over which this whole decoration is placed.

[18] The eucharist is then an extension of the Incarnation, and of course meaningless without it. All this is clearly stated already in the 4th century by St. Gregory of Nyssa in his famous

Catechetical Oration. He has this to say in the classical passage concerning the Eucharist:

"<u>Since</u> the god who was made visible mingled himself with our perishable nature for this purpose, to wit, that by communion with the divine nature mankind might at the same time be deified; <u>so</u> for sake of this it is that, by dispensation of his grace he disseminates himself in every believer by means of that flesh whose substance is from both bread and wine, blending himself with the bodies of believers so that by this union with that which is immortal, man also might be a partaker in incorruption. And he gives these gifts by virtue of the words of consecration transforming the nature of the visible elements into that (which is immortal)."

So the Incarnation and its extension in the Eucharist are parts of the dispensation or the economy of God for the salvation or deification of men. <u>As the Virgin</u> is the necessary instrument for the Incarnation, <u>so the apostles</u> and their successors, the Bishops and Church Fathers, are the necessary instruments for the Eucharist. And the result of the whole economy is the glorification of the Virgin and the twelve apostles in the central dome of the Holy Apostles church.

But, it is all even more detailed and explicit than this. The structure and the words of the Holy Liturgy itself give the clue to the decoration of the whole church. The passages are in the very heart of the service. I shall quote—quite at length—from the Liturgy of St. Basil, where phrase after phrase comes from his own writings or from St. Athanasius.

It begins after the Anaphora. "Lift up your hearts," in the prayer before the Sanctus of which I give excerpts:

"O thou who in verity existeth, Master, Lord God, Father Pantokrator, adorable; meet it is, in truth, and just, and befitting the majesty of thy holiness, that we should magnify thee and glorify thee the only God which verily existeth. . . . O Sovereign Master of all things . . . who art from everlasting, invisible, inscrutable, ineffable, immutable, the Father of our Lord Jesus Christ, our great God and Saviour, [19] our hope, who is the image of thy goodness, the seal of equal type, in himself showing forth thee, the Father."

There follows the Sanctus, Holy, Holy, Holy, in which the whole economy of salvation

is described in St. Basil's liturgy. Again I give excerpts:

"With these blessed Powers (the Angels) O Master who lovest mankind, we sinners do cry aloud and say: Holy art Thou."

Then after the account of creation and the prophets:

"And when the fullness of time was come, thou didst speak unto us by thy son himself, by whom also thou madest the ages; who being the brightness of thy glory and the express image of thy person, and upholding all things by the word of his power, thought it no robbery to be equal to thee, the God and Father. But albeit he was God before all ages, yet he appeared upon earth and dwelt among men; and was incarnate of a Holy Virgin and did empty himself, taking on the form of a servant and becoming conformed to the fashion of our lowliness that he might make us conformable to the image of his glory.

For as by man sin entered into the world, and by sin death, so it seemed good unto thine only begotten Son, who is in thy bosom, our God and Father, to be born of a woman, the Holy birth-giver of God and ever virgin Mary; to be born under the law that he might condemn sin in his flesh; that they who were dead in Adam might be made alive in thy Christ.

1. And becoming a dweller in this world, and giving commandments of salvation . . . he gave himself a ransom to Death whereby we were held . . . And having descended into
2. Hell through the cross that he might fill all things with himself he loosed the pains of death, . . . making a way for all flesh through the Resurrection from the dead. And ascending into heaven he sat down at the right hand of thy majesty on
3. high . . . and he shall come again to render unto every man according to his works.

And finally the consecration:

And he hath left with us as memorials of his saving passion, these things which we have spread forth according to his commandment. [20] For when he was about to go forth to his voluntary and ever memorable and life-creating death, in the night in which he gave himself for the life of the world, he took bread in his holy and stainless hands, and when he had shown it unto thee, his God and Father, he gave thanks, blessing it, sanctifying it, and breaking it, he gave it to his holy disciples and apostles saying;

And the very words of consecration at the end of this long prayer are the inscriptions over the scene of the Divine Liturgy on the eastern arch.

In these prayers of the Liturgy of St. Basil there are stressed by the nature of our religion

1. the Pantokrator—with his only begotten in his bosom
2. the Virgin of the Incarnation
3. the life of Christ culminating in his death, his descent into Hell and his ascension
4. ending finally in the eucharist itself on the eastern arch.

The eucharist—the Divine Liturgy—is indeed very important in the church and for the twelve apostles it is the most important scene; for here Christ their master gave himself to them. For the apostles the Liturgy is the epitome of the whole church decoration—the church which was specially dedicated to them.

Theodore the Studite in his writings against the iconoclasts says in one place (Antirhet adv. economachos P.G. 99, col. 340 c):

"For the Divine Liturgy is a summation of the whole economy of salvation, signifying by synécdoché the whole by the principal part."

——

Thus the east arch over the synthronon is the most important of the four which sustain the central dome and as we have seen is a part of the dome composition.

The other three arches show also architectonic balanced compositions with two groups of six apostles flanking a larger isolated and majestic figure of Christ.

[21] These compositions unique in themselves are found copied in the beautiful XI century lectionary from Mt. Athos, Dionysiou 740, of which we have seen other pictures.

Slide 34*
Dionysiou 740.
Confession of Peter

On the North arch was the Confession of St. Peter. "Thou art the Christ the Son of the

living God," with Christ's reply: "Blessed art thou Simon Barjona, for flesh and blood have not revealed it unto thee but my father which is in heaven."

What would normally be a casual representation is here given a monumental symmetry reflecting the design on the top of the soffit of the north arch.

In the Ms. the text of Matthew's Gospel below identifies the picture.

This arch then leads to dome of the Transfiguration.

Slide 35*

Dionysiou 740—

Christ appears

Easter night

On the opposite arch to the south was the scene of the appearance of Christ behind closed doors on Easter night.

"Peace be unto you, as my father hath sent me even so send I you."

Christ stands hieratically and displays his wounded hands to two groups of six apostles. The text of the lectionary below identifies the exact scene in John's Gospel.

This arch is in front of tympanum with the Doubting of Thomas—a week later.

Slide 36*

Dionysiou 740—

Sending out

of the apostles

On the remaining arch to the west was represented the sending out of the apostles. The correct text is from Matthew's Gospel.

"Go ye therefore and teach all nations, baptizing them in the name of the Father and of the Son and of the Holy Ghost."

This arch leads then to the Dome of the Pentecost.

As you have seen these three scenes in the Athos lectionary are identical in composition. The best explanation for this identity is that the scenes are from [22] architectural mosaics where the three scenes must have been designed for each other. The subjects glorify Christ and his apostles and the portraits and identities are those of the Holy Apostles Church as we have seen.

Slide 37**

Ground plan

restoration of H.A.

So now we have seen nearly all the copies of the mosaics of the Holy Apostles Church, which we can identify (use plan). So frequently it has been necessary for one reason or another to come to a ninth century date for the originals that I think it useless to refute Heisenberg once again. If the decoration is all of a piece, to begin with, then it must, as a scheme be dated before 880–886—the date of the Paris Ms. of Gregory's sermons which was made for Basil I, and where so many of the Holy Apostles mosaics are copied.

From the life of Basil written by his grandson Constantine Porphyrogenitus we know that Basil restored the church of the Holy Apostles. Here is the text.

After telling of Basil's restorations in Agia Sophia, Constantine says:

"Also the famous and great church of the Holy Apostles which had fallen off from its former beauty and strength, he made firm, placing props about it and rebuilding the rent parts; and erasing the signs of age which came from the passage of time and removing the wrinkles, he made it again fair and fresh."

This fairness and freshness was probably enhanced by the magnificent mosaics. However the subtle theological and eucharistic scheme of the whole decoration was not invented by Basil but by a theologian of great power at his court.

This surely must have been Photius, now in his second Patriarchate.

The whole scheme has to do with the incarnation and the epitome of this is the Eucharist.

From the bosom of his ineffable Father, Christ descends to take our flesh in the womb of his spotless Mother. This flesh is glorified at the Transfiguration, broken [23] for us at the Eucharist, raises the dead in the Harrowing of Hell, ascends to make possible that the ineffable God may be revealed again to our understanding.

Photius himself has written a commentary on the text of John 1:18 on the incomprehensibility of God. This writing (to Amphilochius) must date only a little before the mosaics of the Holy Apostles.

After citing Moses, and the prophets as well as St. Athanasius, St. Basil, St. Gregory and St. John Chrysostom on this invisibility, Photius says:

"But now the voice of those who are bodiless is enough for me; if, when the chorus of the apostles looking at the ascension of our Lord and God with that which he assumed (i.e. our human nature) were struck dumb and were amazed—the angels clearly said to them: 'Why stand ye gazing up into Heaven, this same Jesus which is taken up from you into heaven shall so come <u>in like manner</u> as ye have seen him go into heaven.'

For he thus departed to take his place in the bosom of his Father with what he had assumed, bearing our flesh and outwardly clothed with human form as before on earth he had been seen. Indeed the divine oracle has confirmed it that our Lord should again be revealed in form and in nature so as to reach our knowledge and understanding."

<u>Slide 38**</u>
Color of Pantokrator,
Daphni

"No man hath seen God at any time. The only begotten Son which is in the bosom of the Father, he hath revealed him."

———

Letter from Sirarpie Der Nersessian to Albert Mathias Friend, Jr., 20 May 1947

As members of the Board of Scholars at Dumbarton Oaks during 1947 Albert Mathias Friend, Jr., and Sirarpie Der Nersessian shaped the research focus at Dumbarton Oaks by suggesting scholars to be invited, as well as the topics of the annual symposium. The letter below, preserved in the Friend Papers of the Princeton University Archives (20 May 1947, Notes, photographs, correspondence; 1935–1955, Box 7, Friend Papers), demonstrates their collaboration in those matters. In the letter, Der Nersessian discusses the need to change the 1948 symposium subject, originally planned to be on Thessalonike in the fourteenth century, because the invited specialist, Andreas Xyngopoulos, would be unable to be at Dumbarton Oaks. She suggests the theme of the Holy Apostles in Constantinople instead, which she and Friend had previously discussed. In order to avoid any objections that the topic was too similar to that of the 1946 Hagia Sophia Symposium, Der Nersessian suggests widening the scope to include the periods of the sixth and the ninth centuries, "when the church was built" and "when, in all probability, the greater part of the mosaic decoration was done." On the following page Der Nersessian lays out the entire program of the symposium, which is understood to include all members of the group and especially the younger ones in order to "give an idea of the work which is done at D.O. Vasiliev is the only one who is left out of this program." Underwood, Anastos, Friend, and Der Nersessian would certainly speak, while Der Nersessian leaves the question with Friend whether "Downey is able,

or willing." Further in the letter Der Nersessian suggests scholars who could be invited to Dumbarton Oaks for a semester, arguing that as a "trained architect, as well as an art-historian, [Ejnar Dyggve] would be able to give good advice to Underwood." Eventually, Francis Dvornik was invited instead, presumably at Friend's request, in order to aid him in the theological questions that occupied him in the aim of reconstructing the mosaic decoration.

❧

May 20th 1947

Dear Bert

I am sorry that I shall not see you again before sailing next week as there are a number of questions I should have liked to talk over with you. The first of these concerns next year's Symposium. Since Xyngopoulos is unable to come, there does not seem much point in taking Salonica in the XIVth century as a subject, for his discussion of the mosaics of the Holy Apostles would have formed the focal point. The other subject we had tentatively discussed was the Holy Apostles in Constantinople which has a great deal in its favor; the only objection that might be made would be that it is a little too much like last year's Symposium on Hagia Sophia. However I think that this might be avoided if we do not insist too much on the Ceremonies and widen the subject a little to include two periods: The VIth century when the church was built; the IXth century where,

in all probability, the greater part of the mosaic decoration was done.

I feel very strongly that the younger members of our group should be given a chance to speak, and if you agree, in principle, to the subject, the following might be a general outline of the talks.

Underwood would present the main argument for his [2] reconstruction of the Church. Since this would be dealing with the art of the VIth century and Justinian, in particular, I wonder if it would be possible to bring in another aspect of Justinian's activity and have Anastos give a paper on the theological ideas of Justinian.

You would naturally speak of the mosaic decoration. I do not know whether Downey is able, or willing, to read a paper and whether you would want him to discuss separately the texts of Constantine the Rhodian and Mesarites, or would prefer to include his work in your talk or talks. In connection with the mosaic decoration, I should like to discuss the more general problems of the art of the IXth century and in particular the Byzantine conception of art and representations of sacred subject, as it grew out of the discussions of the iconoclastic period.

This is just a rough outline of the program as I have thought of it so far—it would have to be considered in greater detail—modified or amplified—but I wanted to know, first of all, if you agreed to it in principle. The main point would be to give an idea of the work which is being done at D.O. Vasiliev is the only one who is left out of this program and if you feel that we should include him I assume we can find a historical subject, dealing either with Justinian or Basil I, which could be fitted in with the other papers.

The second question I should have liked to discuss with you is that of having someone else next year, in place of Xyngopoulos. I realize that this is the responsibility of the administrative [3] Board, but we who are here on the spot, like you and myself, cannot help but give some thought to it. It seems a pity not to utilize any of the funds which will be made available when Kraeling and Grabar leave and moreover you know, even better than I do, that a very small group, as we shall be next year, is not altogether desirable.

I am sure you have been thinking a great deal about all this and you may have some definite plans. However, since we have always discussed these problems quite freely, I venture to make some suggestions—which are absolutely tentative.

I wonder what you would think of asking Lassus to come for one semester. From conversations I had with Grabar, I gathered that he (Lassus) was anxious to spend a few weeks in this country to finish up writing on the work he did in Antioch. If he came for a semester, he would also have time to begin the preparation of the "Book of Kings" which you want him to do for the Octateuchs series. From all that I have heard—I know him only slightly personally—he would fit in to the group, especially as he speaks English quite fluently, I am told.

The other suggestion would be Dyggve. His work at Salona and Salonica has been extremely interesting, he is a well known scholar whose presence would add to the prestige of D.O. As a trained [4] architect, as well as an art-historian, he would be able to give good advice to Underwood, and also as a person who has worked as much in the Balkans and with monuments of the Early Christian period, he would be able to help Kitzinger. I don't know him personally. I asked Grabar who had met him and who says he is a very distinguished gentleman—(I looked up his L.C. card and he is 60 years old).

I should think that in either case it would be preferable to invite them for one semester. I think they could get away more easily for a shorter period, and also, on this end, if there were by any chance difficulties in adjusting themselves to the kind of rather 'close' life we lead, a semester would be better than a year.

If you have a moment before the end of the week—either to write or to telephone—I should be very much interested to know what you think of all this. I am leaving on the evening of the 28th—that is a week from to-morrow—for Wellesley, and I sail from New York on the morning of the 31st.

Cordially yours
Sirarpie

APPENDIX I

Attendance at the 1948 Symposium

The invitation list of the 1948 Holy Apostles Symposium is preserved in one copy with handwritten notes on planned attendance in the Dumbarton Oaks Archives.[1] It gives a total of 208 names most of which were closely connected to Dumbarton Oaks as scholars, colleagues from Byzantine and medieval studies, classics, art history, or theology interested in the topic from throughout the United States and abroad. Also invited were a good number of non-academic Dumbarton Oaks benefactors or Harvard University administrators. The list reflects the number of people that accepted the invitation to the symposium according to date, as well as, in some instances, morning or afternoon sessions.

The handwritten notes on the last page reveal that a consistent number of over 66 people were expected to participate in the symposium. The higher number of people that had planned to attend on April 24 is due to the Trustees' two-day meeting at Dumbarton Oaks that immediately followed the Symposium that same afternoon.[2] It is unclear whether all confirmed guests indeed attended.[3] Interesting, however, are notable absentees of scholars who later shaped the debate on the Holy Apostles church, such as Richard Krautheimer, or of long-time Dumbarton Oaks associates, such as Royall Tyler, Barbara Sessions, or Robert Van Nice.

THE INVITATION LIST OF THE 1948 SYMPOSIUM, DOA, BYZANTINE STUDIES, SYMPOSIUM 1948

	APRIL 22ND	APRIL 23RD	APRIL 24TH
Alexander, Mr. & Mrs. Paul J.			
Alexander, Mr. & Mrs. Robert Lester	x	x	x
Anastos, Dr. Milton V.	√	√	√
Arbez, Rev. Edward P.	√ p.m.	√ p.m.	√ a.m.
Averill, Miss Louise			
Avery, Miss Myrtilla	√	√	√
Bailey, Mr. David Washburn	x	x	√
Bellinger, Professor Alfred R.			
Berger, Prof. Adolf	√	√ a.m.	x
Berry, Mrs James	√	√	√
Biebel, Mr. Franklin	x	x	x
Blake, Miss Marion	x	x	x
Blake, Professor Robert P.	√√	√√	√√
Bliss, Honorable & Mrs. Robert Woods	√√	√√	√√

2 See "Program: April 24th and April 25th, 1948," MS.BZ.019-03-01-050_010, Underwood Papers ICFA. See also Nelson above, 27, for Thomas Whittemore's pragmatic reasons for being interested in attending. According to the attendance list, it is unclear whether he was actually present.

3 For instance, the late Elizabeth Ettinghausen is marked as confirmed guest alongside her husband Richard Ettinghausen (first page), but when asked about it on the occasion of the 2015 Holy Apostles symposium, she had no recollection of attending the 1948 Symposium. See above Mullett, 7n15.

1 Symposium 1948, Byzantine Studies, DOA. A copy of these original pages also exists as MS.BZ.019-03-01-050_005 to _008, Underwood Papers ICFA.

	APRIL 22ND	APRIL 23RD	APRIL 24TH
Bloch, Dr. Herbert	x	x	x
Breeskin, Mrs. Adelyn D.			
Brown, Mr. & Mrs. John Nicholas			
Buck, Dean Herman	√	√	√
Burke, Mr. & Mrs. William	xx	xx	xx
Cairns, Mr. Huntington	√	√	√
Callahan, Mr. & Mrs. John E.	√√	√√	√√
Campbell, The Very Rev. James Marshall	x	x	x
Capps, Edward, Jr.	√	√	√
Charanis, Mr. Peter	√	√	√
Chase, Dr. George H.	x	x	x
Claflin, William H.			√ ?
Clark, Mr. Grenville	x	x	√ ?
Cook, Professor Walter W. S.	x	x	x
Coolidge, Mr. Charles Allerton	x	x	x √ ?
Conant, President James B.	x	x	√
Conant, Professor Kenneth J.	x	x	x
Crosby, Mr. Sumner McK.			
Day, Miss Florence	x	p.m.?	√
Deferrari, Dr. Roy J.			
De Jerphanion, Father Guillaume	x	x	x
Deknatel, Mr. Frederick B.	x	√	√
Der Nersessian, Miss Sirarpie	√	√	√
DeWald, Professor Ernest T.			
Downey, Mr. and Mrs Glanville	√√	√√	√√
Dun, The Right Reverend Angus	x	x	x
Dvornik, Prof. Francis	√	√	√
Egbert, Professor Donald Drew	x	x	x
Elder, Prof. J. Peter	x	x	x
Emerson, Mr. William	x	x	x
Erck, Prof. Theodore H.	x	x	x
Ettinghausen, Dr. & Mrs. Richard	√√	√√	√√
Evans, Dr. Luther H.	x	x	x
Finley, David E.	x	x	x
Finley, Professor John Huston, Jr.	x	x	x
Focillon, Madame Henri	x	x	x
Forbes, Edward W., Esq.	x ?	√	√
Forsyth, Prof. George H. Jr.,	x	x	x
Forsyth, Mr. William			
Frantz, Miss Alison	x	x	x
Franc, Miss Helen	x	√	√
Friend, Prof. Albert Mathias, Jr.	√	√	√
Gorman, Father, Rector			
Grabar, Professor Andre	x	x	x
Graves, Dr. Mortimer	?	?	?
Green, Miss Rosalie B.	√	√	√
Greene, Miss Belle da Costa	x	x	x
Gregoire, Professor Henri	x	x	x
Guest, Miss Grace Dunham	√	√	√
Guthrie, Dean Hunter	x	x	x

	APRIL 22ND	APRIL 23RD	APRIL 24TH
Harris, Miss Josephine	x	√	√
Harrsen, Miss Meta	x	x	x
Herter, The Honorable Christian A.			
Higgins, The Rev. Martin J.	√	√	√
Hill, Miss Dorothy	√	√	√
Honigmann, Professor Ernst & daughter (former student of Brussels Academy of Science)	√√	√√	√√
Houck, Dr. Lester	x	x	x
Howland, Prof. Richard	x	√	√
Jaeger, Professor Werner Wilhelm	x	x	x
Janosi, Father Frederick Engel	√	√	√
Jones, Professor Howard Mumford	x	x	x
Keck, Mr. & Mrs. Andrew S.	√	√	√
Keenan, Sister Mary Emily	x	x	x
Kennedy, Miss Winifred, Registrar	x	x	x
King, Mr. Edward S.	x	√	x
Kitzinger, Dr. & Mrs. Ernst	√	√	√
Koehler, Professor Wilhelm R. W.	x	x	x
Kraeling, Professor Carl Hermann	√√	√√	√√
Krautheimer, Dr. & Mrs. Richard	x	x	x
Kubler, Prof. George	x	x	x
Kuttner, Professor Stephan	a.m.	a.m.	√
Ladner, Professor Gerhard			
La Monte, Professor John	x	x	x
Lane, Mr. James W.	x	√	x
La Piana, Professor George	√	√	√
Lawrence, Dr. Marion	x	x	x
Lee, Professor Rensselaer	x	x	x
Lee, Dr. Roger Irving	x	x	√
Leger, M. Alexis			
Lehmann, Prof. Karl	x	x	x
Lopez, Professor Robert S.	x	x	x
McGuire, Dean Martin R. P.	√	√	√
MacLeish, The Honorable Archibald	x	x	x
Marbury, Wm. Luke, Jr., Esq	x	x	√
Metcalf, Mr. Keyes De Witt	x	x	x
Michels, The Very Rev. Father P. T.			
Middeldorf, Dr. Ulrich A.	x	x	x
Miller, Mr. Charles R. D., Exec. Sec.	√	√	√
Miner, Miss Dorothy	√	√	√√
Mommsen, Professor Theodor	x	x	x
Mongan, Miss Elizabeth	x	x	x
Morey, Professor Charles Rufus	x	x	x
Myers, Mr. George Howitt	xx	xx	xx
Niver, Mr. Charles			
Nock, Prof. Arthur Darby	x	x	x
Panofsky, Dr. Erwin			
Peterson, The Reverend Theodore C.	√	√	√ am
Phillips, The Rev. Edward C., S. J.			
Phillips, Mr. & Mrs. Duncan	xx	xx	xx

	APRIL 22ND	APRIL 23RD	APRIL 24TH
Peirce, Mrs. Hayford	x	x	x
Pope, Professor Arthur	x	x	x
Pope, Mr. John A.	xx	xx	√√
Porter, Mr. James A. & Ruth Burde ?	√√	√√	√√
Meyer[4], Mrs. Eugene			
Niederer, Miss Frances J.	√	√	√
Quasten, The Rev. John	√	√	√ am
Rapp, Prof. Franz	x	x	x
Richter, Miss Gisela Marie Augusta	x	x	x
Robb, Professor David M	x	√	√
Robinson, Professor & Mrs. David M.	xx	xx	xx
Rorimer, Mr. James J.	x	x	x
Ross, Mr. Marvin C.	√	√	√
Rostovtzeff, Professor Michael I.	x	x	x
Sachs, Prof. Paul J.	√	√	√
Saltonstall, The Hon. and Mrs Leverett			
Schapiro, Prof. Meyer	x	x	x
Segall, Miss Berta	x	x	x
Seyrig, Dr. Henri			
Sessions, Mrs. Barbara	x	x	x
Seymour, Mr. Charles, Jr.	√	√	√
Seznec, Professor J. J.	√	√	x
Shattuck, Henry Lee	x	x	√
Shaw, The Hon. Gardiner Howland	x	x	x
Sherbowitz-Wetzor, Prof. Olgerd			
Sloane, Professor Joseph	x	x	x
Smith, Professor Baldwin	x	x	x
Snowden, Prof. Frank M., Jr.	x	x	x
Stanley, Reverend Victor	√	√	√
Spencer, Miss Eleanor P.	√ pm	√ pm	x
Spinka, Prof. Matthew	x	x	x
Stergiou, Miss Nafsika	x	x	x
Strittmatter, Dom Anselm, O.S.B.	√	x	am
Stohlmann, Professor Frederick	x	x	x
Stone, Mrs. Harlan F.			
Swarsenski, Dr. Georg	x	x	x
Swarzenski, Dr. Hanns			
Swift, Professor Emerson	√	√	√
Taylor, Professor Charles H.	x	x	x
Taylor, Mr. Francis Henry	x	x	x
Tisserant, His Eminence Eugene Cardinal	x	x	x
Toll, Professor Nicholas	√	√	√
Toumanoff, Prince Cyril			
Townsend, Miss Gertrude	x	x	x
Toynbee, Professor Arnold	?	?	?
Tselos, Prof. Dimitris T.	x	x	x
Tyler, Mr. Royall	x	x	x

4 A handwritten arrow by this name indicates that it should have been placed between Metcalf and Michels to appear in an alphabetical order. Similar arrows were added by Niederer to be placed between Myers and Niver, and by Valyah to be placed between Van Nice and Vasiliev.

	APRIL 22ND	APRIL 23RD	APRIL 24TH
Tyler, Mr. William R.			
Underwood, Mr. and Mrs. Paul A.	√√	√√	√√
Van Nice, Mr. Robert W.	x	x	x
Vasiliev, Professor A. A.	√	√	√
Vernadsky, Prof. George	x	x	x
von Simson, Professor Otto	x	x	x
Wagner, Sister Monica	√ pm	√ pm	√
Walker, Mr. John III	x	x	√
Walker, Mr. Robert	x	x	x
Walsh, The Rev. Edmund A., S. J.			
Wedel, The Rev. Theo. O.	x	√	√
Weitzmann, Prof. Kurt	√	√	√
Wenley, Mr. Archibald G.	?	?	?
White, Mr. Lynn, President	x	x	x
Van Valyah, Mrs Aglan	√	x	√
Whittemore, Mr. Thomas	√ ?	√ ?	√ ?
Williams, Rev. Ernest H.	√	√	√
Williams, Mr. Herman	x	x	x
Willoughby, Prof. Harold R.	x	x	x
Wolff, Prof. Robert	√	√	√
Woodruff, Miss Helen	x	x	x
Woods, Mrs. Arthur	x	x	x
Wright, Prof. Leon			
Xydis, Mr. Stephen G.	√	√	√
Yakobson, Mr. Sergius			
Zabriskie, Dean Alexander Clinton	x	x	x
Ziegler, The Rev. Aloysius K.			
	Yes 66[+11] No 100	Yes 69[+11] No 94	Yes 79[+11] No 88
Joshua Starr	x	x	x
P.A. Michelis	√	√	√
Moses Hadas	x	x	x
Floyd W. Tomkins	√	√	√
Alexander Page	x	x	x

APPENDIX J

Letter from Paul A. Underwood to Father John T. Tavlarides of St. Sophia Cathedral, Washington, DC, 17 June 1963

The four-page letter transcribed below was provided by the staff of the St. Sophia Greek Orthodox Cathedral of Washington, DC, where it is preserved. It contains a detailed suggestion for a possible iconographic program for the new church building, which would be based on iconographic programs in Constantinople from the period after the iconoclastic controversies. Underwood cites in this letter visual parallels and the Bible passages on which certain images would be based. The overall aim would be to have "a scheme of iconography that would be at once unique among modern churches and yet within the finest traditions of decoration in Byzantine art" and on a practical level that fits the available surfaces in the vaults of the building. Underwood encloses a drawing that he had "made some years ago" to illustrate his ideas. The drawing that he refers to can be undoubtedly identified as the drawing of the dome of the Nea Ekklesia, which Underwood had prepared in 1946 (fig. A.23). Underwood also suggests that each competing artist should be sent a copy of this letter and his drawing, among other items, and even though he explicitly states that "I do not mean to suggest that he should slavishly copy the examples provided for his guidance," the selected iconographer, Demetrios Dukas, closely followed both the guide and the solution presented in the drawing.[1] It could also be argued that Underwood's continuing involvement in the project had a great impact on how literally

the suggestion was followed. Underwood never saw the completed mosaic decoration, which Dukas finalized only in the late 1980s.

<center>⁑</center>

<div align="right">Dumbarton Oaks,
June 17, 1963.</div>

The Reverend Father John T. Tavlarides,
Saint Sophia Cathedral,
Washington, DC

Dear Father John:

Since meeting with you and the Committee in charge of the decoration of the Cathedral of Saint Sophia I have given considerable thought to the problems that confront you and would like to make certain recommendations which, if properly carried out, would provide your church with a scheme of iconography that would be at once unique among modern churches and yet within the finest traditions of decoration in Byzantine art. Briefly, I would recommend that you adapt the iconographic program that was used in the churches of Constantinople immediately after the Iconoclastic Controversies were brought to an end in 843 AD when it again became possible to depict the holy persons. The program I have in mind was introduced during the reigns of the emperors Michael III and Basil I and remained in vogue for a considerable period of time before it was gradually replaced by other programs. It is a program that may well have been conceived by the great theologian of that period, the Patriarch Photius, probably during his first patriarchal

1 See also Nelson, above, 45–48.

term. We know from textual sources that one of the very first churches to be decorated after Iconoclasm was the Palace church dedicated, in 864 AD, to the Theotokos of the Pharos. On the occasion of its dedication Photius delivered a homily that tells a good deal about the subjects that were represented in its vaults. It is from this and other texts, as well as from some surviving mosaics and paintings, that the program in question can be reconstructed. Much the same scheme of iconography was used also in the great church of Hagia Sophia, in the Chrysotriclinos (the throne room of the Great Palace of the Emperors), and in the church of Kauleas decorated by Leo the Wise towards the end of the 9th century.

The scheme consists entirely of individual figures arranged in the vaults of the naos and excludes all scenes from these areas although scenes may well have been introduced in areas of lesser prominence. The main idea of the decoration of the vaults was to depict, by means of a hierarchical arrangement and order, the principal Beings that together comprise the Christian cosmos. In the diagrammatic layout and the typed "Key to the Layout of the Paintings," which are enclosed herewith, one can easily follow the arrangement of the figures which are described below.

The dome is devoted entirely to an arrangement of the celestial hierarchy as revealed to Isaiah (6: 1–4) when, in his vision he saw "the Lord sitting upon a throne, high and lifted up, and his train filled the temple. And above it stood seraphim: . . . and one cried unto another and said, Holy, holy, holy is the Lord of Hosts: the whole earth is full of his glory." An excellent painting of this subject, of about the year 880, is among the miniatures of a manuscript in the National Library of Paris (ms. 510) a photograph of which I enclose herewith. I would suggest that this painting be used as the basis for the design of the dome of your church. This can be worked out along the lines of the drawing which I made some years ago to illustrate how the painting may well have been based on a great dome decoration in one of the churches of Constantinople. By comparing my drawing with the miniature you will see how well it fits a dome. I can supply later some color notes giving the colors used in the miniature. [2]

According to this plan a great medallion, about 14 feet in diameter, in the top of the dome (Key No. 1) would be filled by a majestic figure of Christ seated on a lyre-back throne; He blesses with his right hand and holds the book of the Gospels on his knee. An enthroned Christ of this type exists in one of the mosaics in Hagia Sophia, Constantinople. Arranged in the zone around the medallion (Key No. 2) there would be eight large figures of seraphim, each with six wings: two raised above their heads, two covering the feet, and two spread out at the sides in flight. Between these, and placed a little lower in the dome, would be eight cherubim which would be smaller in size but large enough to fill comfortably the spaces between the seraphim. Both seraphim and cherubim stand in a zone of fire. The sixteen fiery wheels which appear on my drawing of the dome in the spaces between the lower parts of the seraphim and cherubim should probably be omitted.

In the apse and bema vaults I have suggested an adaptation of the pre-Iconoclastic mosaics in the sanctuary of the Koimesis Church at Nicaea. Accordingly, I suggest a large figure of the interceding Mother of God standing on a footstool (Key No. 3). There are various types of the Virgin and Christ Child that could be considered for the apse painting. In the soffit of the arch immediately in front of the conch I have indicated a series of nine medallions of angels, the Virgin's heavenly attendants (Key No. 4). In the top of the main eastern arch, over the solea, there should be the representation of the Etimasia (Key No. 5), that is, the throne prepared in the heavens, a motif that derives from Psalm 102 (103): 19, "The Lord hath prepared his throne in the heavens and his kingdom ruleth over all." In the Church of the Koimesis at Nicaea there was a splendid pre-Iconoclastic representation of the Etimasia which is known from photographs (unfortunately the mosaic and the church were destroyed in the Greco-Turkish war of 1921). It was placed in the arch of the bema and consisted of a circular "glory" in three concentric zones. In the glory is a jewelled throne (with footstool) on which is a bolster-like cushion. On the cushion is laid an imperial chlamys and on this a jewelled closed book and above it the dove of the Holy Spirit bearing a cross-inscribed nimbus. From

the Dove rays of light radiate in all directions. At each side of the Etimasia, in the lower slopes of the same arch, there should be two great archangels, about 13 feet high including the halos, facing one another on opposite sides. The finest examples of such angels, in this position in the church, are those at Hagia Sophia in Constantinople which could be used as the basis for your design. These beautiful figures wear the imperial chlamys, hold a scepter in the right hands, and a crystal orb, or globe in the left hands signifying world dominion. The archangels are indicated by the Key Nos. 6 and 7.

The dome, the conch of the apse, and the arch of the bema thus are devoted to the celestial hierarchy. According to the iconographic program which I suggest you should adopt, the remaining spaces in the vaults (i.e. the arches to north, south, and west, and the four pendentives) would be assigned to a hierarchy of God's chief witnesses on earth. These are: the prophets who received divine inspiration and foretold the advent of Christ; the four Evangelists who were inspired to write the basic scriptures of the Christian faith; the Apostles who were sent out to the four corners of the earth to teach of Christ and establish his Church among all men; and the great saints and martyrs who were Christ's witnesses since they saw Christ at their martyrdoms. These parts of the hierarchy should be laid out as follows. The four Evangelists (Key nos. 8–11) in the four pendentives. A row of four prophets, one above the other, in the north and south arches, placed nearest the central dome (8 prophets as per Key Nos. 12–19), and a row of four apostles in each arch parallel to the prophets but [3] further away from the dome (8 apostles as per Key Nos. 19a–26). In the wide western arch a series of comparable figures, also in rows above one another, should portray the principal saints and martyrs of the church whose feasts are commemorated in the church calendar. I have found that sixteen figures would fit the arch and leave about the same spatial relationship between them that would exist in the two side arches. Among the martyrs I have suggested the eight most prominent soldier saints (Key Nos. 27, 28; 31, 32; 35, 36; and 39, 40). The others are taken from a list of the most frequently portrayed martyrs in Byzantine art. The military saints were very often given the most prominent positions among the saints in Byzantine churches and they were very frequently represented in the ancient military costumes which are most decorative and colorful. They need not, however, be depicted in military garb and in that case they should wear the usual garb of the martyr, that is, long undertunics, a chlamys or cape open down the front and richly ornamented, and in their hands the small crosses that represent the trophy of their victory over death.

I have thought that this iconographic program would be most suitable for your church not only because of its unique historic interest which would associate your church with one of the glorious periods of ecclesiastical art in Byzantium and some of the great churches of Constantinople but because it would give a unity of theme that would encompass all the major areas of the vaults that are in need of decoration. But perhaps of even greater importance are the practical considerations. First is the fact that the existing surfaces of the vaults are subdivided in such a way that it would be nearly impossible without expensive structural alterations to introduce scenes which require much greater widths of uninterrupted surface than are available in the eastern, northern and southern arms. The existing surfaces, on the other hand, fit the scheme suggested here very neatly. The areas that are not filled with figures would require the design of ornamental motifs.

Among the finest monuments of Byzantine art (mosaics or frescoes) that exist today there are a number that contain splendid examples of figures of Christ, the Mother of God, angels, prophets, apostles, and martyrs. The best of each category could be selected to serve as models for the painter whom you appoint to carry out the decoration. I do not mean to suggest that he should slavishly copy the examples provided for his guidance but these could be adapted and used as a basis for the types of figures and the general style in which he might work.

I recommend that each competing artist should be sent the following material:

1. a copy of this letter
2. the architect's sections of the church
3. the diagrammatic layout of the iconographic scheme

4. a photograph of the miniature of the Vision of Isaiah

5. my drawing which adapts that miniature to a dome composition.

Each artist should be asked to submit two things: a color-sketch of the dome as a whole; and a larger color-drawing or painting (preferably a painting)

of the central medallion of the enthroned Christ. I could also provide a photograph of the enthroned Christ in Hagia Sophia, Istanbul, as a guide to the general type of Christ and the type of throne on which he sits.

Sincerely yours,
Paul A. Underwood

[4]

KEY TO THE LAYOUT OF PAINTINGS IN THE VAULTS

The Dome: The Vision of Isaiah (Cherubic Hymn)
 1. Enthroned Christ
 2. Seraphim and Cherubim in Tongues of Flames

The Apse:
 3. Standing Figure of the Mother of God
 4. A Series of 9 Medallions of Angels

The Bema:
 5. The Etimasia
 6. Archangel Michael
 7. Archangel Gabriel

The Pendentives: The Four Evangelists

8. St. John	10. St. Luke
9. St. Matthew	11. St. Mark

The Vaults of the Transepts: Prophets and Apostles

Prophets	Apostles
12. Isaiah	19. St. Peter
13. Jeremiah	20. St. Paul
14. David	21. St. Bartholomew
15. Solomon	22. St. Philip
16. Ezekiel	23. St. Andrew
17. Daniel	24. St. James
18. Jonas	25. St. Simon
19. Habbakuk	26. St. Thomas

The Vaults of the Western Arm: Martyrs and Saints

27. St. George	31. St. Theodore Tiro	35. St. Mercurios	39. St. Nestor
28. St. Demetrius	32. St. Theod. Strat.	36. St. Procopios	40. St. Artemios
29. St. Gourias	33. St. Sergios	37. St. Floros	41. St. Tarachos
30. St. Samonas	34. St. Bacchos	38. St. Lauros	42. St. Andronikos

ABBREVIATIONS

AB	*Analecta Bollandiana*		ByzAus	Byzantina Australiensia
ActaIRNorv	*Acta ad archaeologiam et artium historiam pertinentia, Institutum Romanum Norvegiae*		*ByzF*	*Byzantinische Forschungen*
			BZ	*Byzantinische Zeitschrift*
			CahArch	*Cahiers archéologiques*
AH	*Art History*		CC, ContMed	Corpus Christianorum, Continuatio Mediaevalis
AI	*Ars Islamica*		CFHB	Corpus fontium historiae byzantinae
AJA	*American Journal of Archaeology*			
AnatSt	*Anatolian Studies*		CSHB	Corpus scriptorum historiae byzantinae
AntTard	*Antiquité tardive*			
APf	*Archiv für Papyrusforschung und verwandte Gebiete*		*Δελτ.Χριστ. Ἀρχ.Ἑτ.*	*Δελτίον τῆς Χριστιανικῆς ἀρχαιολογικῆς ἑταιρείας*
Ἀρχ.Δελτ.	*Ἀρχαιολογικὸν δελτίον*		DOA	Dumbarton Oaks Archives. Courtesy of Dumbarton Oaks Research Library and Collection, Washington, DC.
ArtB	*Art Bulletin*			
ArtV	*Arte veneta*			
BAR	British Archaeological Reports			
BMFD	*Byzantine Monastic Foundation Documents: A Complete Translation of the Surviving Founders' "Typika" and Testaments,* ed. J. Thomas and A. C. Hero, 5 vols. (Washington, DC, 2000)		DOML	Dumbarton Oaks Medieval Library
			DOP	*Dumbarton Oaks Papers*
			DOS	Dumbarton Oaks Studies
			FHG	*Fragmenta historicorum graecorum,* ed. C. Müller (Paris, 1841–70)
BMGS	*Byzantine and Modern Greek Studies*		Friend Papers	Albert Mathias Friend Papers, 1913–1955, Manuscripts Division, Department of Rare Books and Special Collections, Princeton University Library.
BollClass	*Bollettino dei classici*			
BollGrott	*Bollettino della Badia greca di Grottaferrata*			
BSCAbstr	*Byzantine Studies Conference, Abstracts of Papers*		Garden Archives	Dumbarton Oaks Garden Archives, Dumbarton Oaks Research Library, Rare Book Collection. Dumbarton Oaks, Trustees for Harvard University, Washington, DC.
BSl	*Byzantinoslavica*			
Byzantine Institute Records ICFA	The Byzantine Institute and Dumbarton Oaks Fieldwork Records and Papers, ca. late 1920s–2000s, MS.BZ.004, Image Collections and Fieldwork Archives, Dumbarton Oaks, Trustees for Harvard University, Washington, DC.			
			GCS	Die griechischen christlichen Schriftsteller der ersten [drei] Jahrhunderte
			GRBS	*Greek, Roman, and Byzantine Studies*
ByzArch	Byzantinisches Archiv		*HJ*	*Historisches Jahrbuch*

HTR	*Harvard Theological Review*	PL	Patrologiae cursus completus, Series latina, ed. J.-P. Migne (Paris, 1844–80)
HUA	Harvard University Archives, Harvard University, Cambridge, MA.	*REB*	*Revue des études byzantines*
ICFA	Image Collections and Fieldwork Archives, Dumbarton Oaks, Trustees for Harvard University, Washington, DC.	*REG*	*Revue des études grecques*
		RESEE	*Revue des études sud-est européennes*
ICS	*Illinois Classical Studies*	*RSBN*	*Rivista di studi bizantini e neoellenici*
IstMitt	*Istanbuler Mitteilungen, Deutsches Archäologisches Institut, Abteilung Istanbul*	*SBN*	*Studi bizantini e neoellenici*
		SC	Sources chrétiennes
JDAI	*Jahrbuch des Deutschen Archäologisches Instituts*	SPBS	Society for the Promotion of Byzantine Studies
JEChrSt	*Journal of Early Christian Studies*	ST	Studi e testi
JEH	*Journal of Ecclesiastical History*	SubsHag	Subsidia hagiographica
JHS	*Journal of Hellenic Studies*	*Synaxarium CP*	*Synaxarium ecclesiae Constantinopolitanae: Propylaeum ad Acta sanctorum Novembris*, ed. H. Delehaye (Brussels, 1902)
JNES	*Journal of Near Eastern Studies*		
JÖB	*Jahrbuch der Österreichischen Byzantinistik*		
JRA	*Journal of Roman Archaeology*	*TAPA*	*Transactions [and Proceedings] of the American Philological Association*
JRAS	*Journal of the Royal Asiatic Society*		
JSAH	*Journal of the Society of Architectural Historians*	*TAPS*	*Transactions of the American Philosophical Society*
JTS	*Journal of Theological Studies*	*TheolSt*	*Theological Studies*
JWarb	*Journal of the Warburg and Courtauld Institutes*	*TM*	*Travaux et mémoires*
		TTB	Translated Texts for Byzantinists
Loeb	Loeb Classical Library	TTH	Translated Texts for Historians
MGH AuctAnt	Monumenta Germaniae historica, Auctores antiquissimi	Underwood Papers ICFA	Paul Underwood Research Papers and Project Materials on the Reconstruction of the Church of the Holy Apostles in Constantinople, ca. 1936–1950s, MS.BZ.019, Image Collections and Fieldwork Archives, Dumbarton Oaks, Trustees for Harvard University, Washington, DC.
NT	*Novum Testamentum*		
OCA	*Orientalia christiana analecta*		
ODB	*The Oxford Dictionary of Byzantium*, ed. A. Kazhdan et al. (New York and Oxford, 1991)		
ÖJh	*Jahreshefte des Österreichischen Archäologischen Instituts in Wien*		
		VizVrem	*Vizantiiskii vremennik*
		YCS	*Yale Classical Studies*
Panofsky Papers	Erwin Panofsky Papers, 1904–1990 (bulk dates 1920–1968), Archives of American Art, Smithsonian Institution.	*ZRVI*	*Zbornik radova Vizantološkog instituta, Srpska akademija nauka*
		ZSavRom	*Zeitschrift der Savigny-Stiftung für Rechtsgeschichte, Romanistische Abteilung*
PG	Patrologiae cursus completus, Series graeca, ed. J.-P. Migne (Paris, 1857–66)		

FLORIS BERNARD is Assistant Professor of Ancient and Medieval Greek Literature at Ghent University, Belgium. He previously taught at the Central European University. His research focuses on Byzantine poetry and epistolography (tenth to twelfth centuries), with an interest in themes such as education, competition, social networks, reading habits, and humor. His book *Writing and Reading Byzantine Secular Poetry (1025–1081)* was published in 2014 by Oxford University Press. He has also initiated a database of Byzantine book epigrams (www.dbbe.ugent.be).

JAMES N. CARDER holds a doctorate in art history and was a former junior fellow in the Byzantine Studies program at Dumbarton Oaks, where he also served as Archivist and Manager of the House Collection for twenty-six years until his retirement in 2018. He is the author of *American Art at Dumbarton Oaks* (2010) and was the editor of and contributor to *A Home of the Humanities: The Collecting and Patronage of Mildred and Robert Woods Bliss* (2010). In collaboration with Robert S. Nelson, he prepared the online publication of the annotated correspondence between Mildred and Robert Woods Bliss and Elisina and Royall Tyler. He also authored the online publication "Philip Johnson at Dumbarton Oaks."

GEORGE E. DEMACOPOULOS holds the Fr. John Meyendorff & Patterson Family Chair of Orthodox Christian Studies and is the Co-Director of the Orthodox Christian Studies Center at Fordham University. His research focuses on contact and discord between Christian East and Christian West in the premodern era. He serves as coeditor for the *Journal of Orthodox Christian Studies* and his most recent monograph is *Colonizing Christianity: Greek and Latin Religious Identity in the Era of the Fourth Crusade* (2019).

FANI GARGOVA received her doctorate in art history from the University of Vienna in 2019. Previously she was Byzantine Research Associate at the Image Collections and Fieldwork Archives of Dumbarton Oaks, project coordinator for the Digitales Forschungsarchiv Byzanz (DiFaB) at the University of Vienna, and junior fellow at the Internationales Forschungszentrum Kulturwissenschaften in Vienna and at the Université Bordeaux Montaigne. Her research is on architectural Byzantinisms, medievalisms, and orientalisms with a special focus on Jewish architecture and the Balkans, as well as the historiography of Byzantine art history.

LIZ JAMES is Professor of Art History at the University of Sussex. From 2000 to 2005, she was Associate Director of the AHRC Centre for Byzantine Cultural History and is now Director of the Sussex Centre for Byzantine Cultural History. From 2007 to 2011 she organized a Leverhulme-sponsored international network on the composition of Byzantine glass mosaic tesserae. She held a Leverhulme major fellowship from 2014 to 2017. She has worked on color and light, the senses, and Byzantine mosaics, and published *Constantine of Rhodes, On Constantinople and the Church of the Holy Apostles* in 2012.

SCOTT FITZGERALD JOHNSON is Associate Professor of Classics and Letters and Joseph F. Paxton Presidential Professor at the University of Oklahoma. He has published numerous books and articles on the literary history of late antiquity and Byzantium, such as *Literary Territories: Cartographical Thinking in Late Antiquity* (2016). He has held fellowships at Harvard, Dumbarton Oaks, and the Library of Congress, and was awarded a Guggenheim Fellowship in 2018.

MARK J. JOHNSON earned his PhD from Princeton University in 1986. He is currently Professor of Art History at Brigham Young University in Provo, Utah, where he has taught since 1987 and where he was University Professor of Ancient Studies from 2014 to 2018. His research focuses on the art and architecture of late antiquity and his publications include *The Roman Imperial Mausoleum in Late Antiquity* (2009), *The Byzantine Churches of Sardinia* (2013), and *San Vitale in Ravenna and Octagonal Churches in Late Antiquity* (2018).

NIKOLAOS KARYDIS is a Senior Lecturer in Architecture at the University of Kent specializing in architectural history, urban design, and conservation. He studied architecture at the National Technical University of Athens and building conservation at the University of Bath. His doctoral thesis earned the 2010 R.I.B.A. President's Commendation and resulted in his book *Early Byzantine Vaulted Construction in Churches of the Western Coastal Plains and River Valleys of Asia Minor* (2011). From 2010 to 2012, Karydis was Assistant Professor of Architecture in the Rome Studies Program of the University of Notre Dame. In 2012, he moved to the University of Kent where he founded and directs the MSc Programme in Architectural Conservation.

RUTH MACRIDES was Reader in Byzantine Studies at the Centre for Byzantine, Ottoman and Modern Greek Studies at Birmingham with special responsibility for graduate students. She was coeditor of *Byzantine and Modern Greek Studies* and symposiarch (and subsequent volume editor) of SPBS meetings on Byzantine travel and on Byzantine history as literature. Her major works were on George Akropolites (2007) and on Pseudo-Kodinos (2013), but she published on a wide range of Byzantine literature, history, and anthropology. She was a Senior Fellow of Dumbarton Oaks from 2014 to 2019. She was looking forward to taking up a membership of the Institute for Advanced Study at Princeton when she died suddenly in April 2019.

PAUL MAGDALINO is Emeritus Professor of Byzantine History at the University of St Andrews, where he taught from 1977 to 2009. He has also taught at Koç University, Istanbul, and held visiting appointments in Paris and at Harvard, in addition to research fellowships in the United States, Germany, and Australia. His Oxford DPhil thesis was on Thessaly in the later Middle Ages; since then he has worked on many aspects of Byzantine history, with a special emphasis on twelfth-century literary culture, the built environment of Constantinople, and astrology, prophecy, and divination. He was a Senior Fellow in Byzantine Studies at Dumbarton Oaks from 2001 to 2007, and has been a Fellow of the British Academy since 2002.

HENRY MAGUIRE is Emeritus Professor of the History of Art at Johns Hopkins University. He has also taught at Harvard and at the University of Illinois, Urbana-Champaign. From 1991 to 1996, he served as Director of Byzantine Studies at Dumbarton Oaks. He has authored six books on Byzantine art, and coauthored three more with Eunice Dauterman Maguire. Together with Ann Terry he carried out a survey and publication of the wall mosaics in the Cathedral of Eufrasius at Poreč, which was published in 2007. Throughout his career he has been interested in the relationships between art and literature in Byzantium, although he has also written on other topics, including ivories, Byzantine secular art, magic, and attitudes toward nature in Byzantium.

MARGARET MULLETT is Professor Emerita of Byzantine Studies at Queen's University Belfast, where she taught from 1974 to 2009. From 2009 until 2015, she was Director of Byzantine Studies at Dumbarton Oaks and editor of *Dumbarton Oaks Papers*; since then she has held visiting professorships at Vienna and Uppsala. She is general editor of the new Routledge series Studies in Byzantine Cultural History. She has worked on epistolography, rhetoric, literacy, monasticism, gender, friendship, networks, performance, and narratology; her current research is on tents, emotion, and the *Christos Paschon*.

NEVRA NECIPOĞLU is Professor of History at Boğaziçi University in Istanbul and the founding director of Boğaziçi University's Byzantine Studies Research Center, established in 2015. She has served as the founding member and general secretary of the Turkish National Committee for Byzantine Studies since 2001. Her monograph *Byzantium between the Ottomans and the Latins: Politics and Society in the Late Empire* was published by Cambridge University Press in 2009. She has also edited and coedited several books, including *Byzantine Constantinople: Monuments, Topography and Everyday Life* (Brill, 2001), and published numerous articles on late Byzantine social and economic history, Byzantine-Seljuk and Byzantine-Ottoman relations, and the urban history of Constantinople and Thessalonike during the Palaiologan period.

ROBERT S. NELSON teaches at Yale University and lately has looked again at the connection of Byzantine architecture to the modern world in an article about American synagogues. Otherwise, he continues thinking about Byzantine art and the Italian Renaissance.

ROBERT G. OUSTERHOUT is Professor Emeritus in the History of Art at the University of Pennsylvania, where he taught from 2007 to 2017. He taught previously at the University of Illinois, where he received his PhD in 1982. Since 2011 he has codirected the "Cappadocia in Context" graduate seminar, an international summer field school for Koç University. His most recent books are *Visualizing Community: Art, Material Culture, and Settlement in Byzantine Cappadocia* (2017) and *Eastern Medieval Architecture: The Building Traditions of Byzantium and Neighboring Lands* (2019).

JULIAN RABY is Director Emeritus of the Freer Gallery of Art and the Arthur M. Sackler Gallery of the Smithsonian Institution in Washington, DC. He served as director there from 2002 to 2017, having previously been Lecturer in Islamic Art and Architecture at the University of Oxford for more than twenty years. He wrote his doctoral thesis on Mehmed the Conqueror as a patron of the arts, but his interests range widely. Recently he has published on Mosul metalwork of the thirteenth century, Syriac painting in the eleventh century, and, still in the eleventh century, Andalusian metalwork, notably the Pisa Griffin. He is grateful to have been invited to think again about Mehmed the Conqueror and the Holy Apostles.

Flavian of Constantinople, 66n62

Florence-Ferrara, Council of (1438–1445), 237, 254

"Fontes" and "Research Archives" project, Dumbarton Oaks, 4n10, 18, 20–21

Fontevrault, Cathedral, 222

foot, Byzantine, 382–83

Forlati, Ferdinando, 215, 276n99

Forum of Constantine, 132

Foskolou, Vicky, 6

Foucault, Michel, 74

Friedländer, Max, 8

Friend, Albert Mathias, Jr.: collaboration with Underwood, 37, 38, 40–41, *42*, 44, 299–300, 326, 332; Der Nersessian, letter from (1947), 419–20; at Dumbarton Oaks, 3, 4n10, 10, 20–23, 27, 36–43; final illness and death of, 11, 31, 36n32, 42; Greek, knowledge of, 43; Karydis's methodology compared, 288; likely view of new symposium and exhibition, 14; Mango on, 43–44; mosaics, study of, 23–24 (*See also* Friend on mosaics of Holy Apostles); organization of original Holy Apostles project and, 1, 6, 7, 9, 9n30, 17, 22, 30, 36, 419–20; papers and notebooks of, 293, 295–96, 325–32, *333–49*; photos, *2, x*; Princeton Manuscript Room, creation of, 35–36; Princeton University Chapel, design of iconographic program for, 31–35, *32–35*, 37, 43–45; scholarly work for Holy Apostles project, 40–42, *42*, 325–32, *333–49*; scholarship of, 23, 29, 30–31, 36–43, *38, 42*; slowness to publish, and nonpublication of original Holy Apostles project, 10–11, 24–25, 30, 36, 161, 325, 395; subsequent projects under, 25; vision of the past, 43–44, 50

Friend on mosaics of Holy Apostles, 395–418; Anastasis dome, 325, 327, 329, 330, 331, *345*, 395, 405–6; Ascension dome, 326, 327, 329, 330, 331, 332, 407–9; Crucifixion scene, 395, 404–5; dating of, 395, 396; Demus's conceptual ideas and, 157; Hetoimasia (empty throne), 326, 400–401; Karydis on, 109; methodological issues, 161–73; Pantokrator (central) dome, 325, 327–28, 330, *337, 339,* 341–44, 407, 409–18; Pentecost dome, 325, 327, 328, 329, 395, 397–403; theological significance of, 325–32, 401, 411, 414–18; Transfiguration dome, 325, 327, 329, 330, 331, 395, 403–5; Virgin orans, 327, 328, 407, 408, 410, 413–15

Gadara, martyrium church, *92,* 93

Galerius (emperor), 84, 85, 133

Gallienus (emperor), 84

Gamzigrad (Romuliano), Galerius's complex at, 133

Garden of the Mosques (Ayvansarâyî), 277, 282

Gargova, Fani, 1n4, 6, 12, 45, 288, 293

Gelasian Decree, 55

Gelasius (patriarch), 75

Gennadios II Scholarios (patriarch), 14, 237–46; apostolic patterns of thought in, 364n413; biographical information, 237–39; first Ottoman survey of city (1455) and, 244–45; "Lament," 246; "Pastoral Letter on the Fall of Constantinople," 242, 243, 246; patriarchate, Ottoman restoration at Holy Apostles/removal to Pammakaristos Monastery, 237–42, 245, 254–57, 279; preservation of Orthodoxy as Ottoman subject and, 245, 254; as "reluctant patriarch," 245–46; responsibilities prior to appointment to patriarchate, 243–44; self-association with apostle Paul, 8n23; Theodore Agallianos and, 241n19, 245; writings of, 238, 242–44

geographic distribution of apostles, 58–61

Geometres, John, ekphraseis on monastery churches, 197–98

George Scholarios. *See* Gennadios II Scholarios

Gerasa, church of the Prophets, Apostles, and Martyrs, 114

Géraud III de Cardaillac, 222

Giese, Friedrich, 253n16

Gilles, Pierre (Gyllius), 100n6, 260n55

Glabas, Isidore, 245

Gombrich, Ernst, 163–64

Göreme, Elmalı Kilise, 228

Grabar, André, 25, 37n45, 392, 420

Gračanica, church of, 332

Gratian (emperor), 95

Great Palace, 28, 36, 37, 50, 141, 142, 177, 179, 263, 427, 428; Chrysotriklinos, 36, 179, 428; Mouchroutas, 181, 190, 191; Nea Ekklesia, 37, *38,* 43, 44, *47,* 48, 158, 170, 226, 277, 293, 296, 300, *323,* 326, *338,* 386, 427; Pharos Chapel, 37, 170, 172, 180–81, 191, 427

Greece: Daphni Monastery, 162, 164, 166, 167, 326, 327, 410, 418; Hosios Loukas Monastery, 39, 162, 326, 398, 399, 400; Mistra, domes of, 326

Green, Rosalie, 9n30, 22, 36, 38–39

Gregoras, Nikephoros, *The Life of Saint Theophano,* 259

Gregory I the Great (pope), 68, 142

Gregory III Mammas (patriarch), 238

Gregory the Armenian, 326

Gregory of Nazianzos (Gregory the Theologian): apostolic succession, concept of, 68, 69, 72; cited in Mesarites' *Ekphrasis,* 196; on Constantine's Apostoleion, 81, 82, 83, 94, 109; Friend on, 332, 401, 414, 417, 418; homilies in Paris BnF gr. 510, 37, 45, 159, 162, 164, 401; in Michael Psellos's "Encomium for his mother," 188; *Poemata de se ipso,* 81; tomb of, in Holy Apostles, 135, 188, 289, 328, 388, 390, 417; Underwood on, 388, 390

Gregory of Nyssa, 414, 415

Gregory Thaumaturgus, 414

Grierson, Philip, 11, 109–11

Griffin, Gail, 1n4

Grimaldi, Giacomo, 405

Grottaferrata, Abbey of Sta. Maria, 162

ground plan drawings, 1–2, *4,* 300, *301–3, 305–7, 310–12,* 340

Gülbahar Hatun (wife of Mehmed II), 126

Gurlitt, Cornelius, 105–6, 109, 112, 124n88, 276, 377

Gyllius (Pierre Gilles), 100n6, 260n55

gynaikites (women's section), Holy Apostles, 135, 136, 137, 391

Hadrian (emperor), 58, 84, 96

Hagia Eirene (St. Irene), 28–29, 96, 106, 109, 117, 119, *120,* 213, 379, 381, 383, 385

Hagia Sophia: apostolic churches in neighborhood of, 140; body of John Chrysostom moved to, 281n116; Constantine the Rhodian and, 367n739; Constantine's Apostoleion and, 89; Fatih Camii and, 100, 253–54, 257; Friend on, 163, 326, 329, 330, 402, 410, 417; Holy Apostles compared, 124, 126, 137, 212, 241, 251, 287, 288, 289; Imperial Door Mosaic, 27, *28,* 36; Justinian's Holy Apostles, reconstruction of, 106, 117, 120, 124–26, 130; Mesarites and, 177, 182; mosaics of, 171–72; original Holy Apostles project and, 25, 43, 45, 49, 296; Ottoman conversion to royal mosque, 237, 255, 256, 281; Paul the Silentiary on, 13, 155–56, 197, 289, 388, 389, 390; Photios's homily on image of Mother of God, 171, 172; St. Peter, chapel of, 140; siting and neighborhood of, 289; St. Sophia, Washington, DC, and, 428, 429; Underwood on, 370, 372, 377, 378, 380, 381, 383, 385, 387–90, 428, 429

Hagia Sophia symposium (1946), 27, *28,* 36–38, *38,* 296, 326, 419

Hall, Stuart, 88

Hallaç, near Ortahisar, rock-cut chapel, 226–28, *228*

Hatch, W., 59n25

Hawkins, Ernest, 36

head of St. Paul, 141–42, 289

Heisenberg, August, 105–6, *107,* 111, 119, 123, 141, 158–59, 168, 175, 191, 194, 276, 277, 396, 404, 407

Heraclius (emperor), 66

heroon: of Justinian, 116, 129, 140, 226, 241, 381, 390–93; at Pantokrator Monastery, 140, 229–31, 235, 236, 288; as term, 229–31, 235, 236, 288

Hesiod, 194, 195n13

Hetoimasia (empty throne), 326, 400–401

Hierapolis (Pammukkale), churches at, 217

Hiereia, Iconoclast Council of (754), 163

Hilsdale, Cecily, 290

Hippodrome, 28, 29n6, 132, 140, 263, 280, *282,* 283, 365n368

Hippolytus of Rome, 61, 68–69n11

Historia Patriarcha, 260

history, apostolic organization of, 57–58

Holy Apostles, 1–14, 287–90; abandonment and demolition of, 237, 239, 242, 281–82; apostles in Byzantine culture and, 7, 12 (*See also* apostolic patterns of thought; apostolic succession); changes in study of, from 1948 to 2015, 8–9, 14; Constantinopolitan context of, 289–90 (*See also* neighborhood of Holy Apostles, Mesarites on; neighborhood of Holy Apostles, structures of); dilapidation of, around time of Ottoman conquest, 237, 240, 241–42, 255–56; ekphraseis on, 8–9, 13, 287–88 (*See also* Constantine the Rhodian; Mesarites, Nicholas); Fatih Camii and, 8, 13–14, 247–83, 288 (*See also* Mehmed the Conqueror, Fatih Camii, and Holy Apostles); Gennadios Scholarios (patriarch) and, 14, 237–46 (*See also* Gennadios Scholarios); imperial authority, as symbol of, 65, 211, 212, 233, 236, 241, 277, 281–83, 289, 290; interdisciplinary nature of, 1–7; intertextuality versus intermonumentality, 8–10; murdered man found in courtyard of, 240–41, 255; new symposium and exhibition (2015), 2, 6–8, 14, 294; orientation and alignment of, 269–70n88; original project and symposium (from 1948), 1–12 (*See also* original Holy Apostles

project and symposium); past and present, interaction of, 7, 10, 50, 290; patriarchate, Ottoman restoration at Holy Apostles/removal to Pammakaristos Monastery, 237–42, 245, 254–57, 279; possible surviving fragments at Fatih Camii, 111, 126, 197–98, *198,* 260–69, *261, 262, 265, 267, 268,* 288, 299n1; post-Justinianic changes to, 211–13, *272, 273,* 274–77; reconstruction of church, 12–13 (*See also* Constantine's Apostoleion; Justinian's Holy Apostles; mosaics of Holy Apostles); significance and importance of, 7–8, 13–14, 287–90 (*See also* architectural legacy of Holy Apostles). *See also specific parts, e.g.* narthex

Homer, 194, 195, 203

Homilies of Photius (Mango), 8, 37, 43, 48

homoousios doctrine, 70

Honigmann, Dr., 392

Horologion, 136, 137

Hosios Loukas Monastery, Greece, 39, 162, 326, 398, 399, 400

Hübsch, Heinrich, 12, 105, *106,* 111, 276

Hunt, Richard Morris, 31

Hypatios (emperor), 134

Ibrahim Pasha, 283

ICFA (Image Collections and Fieldwork Archives), 294, 295, 351

iconoclastic controversy: apostolic authority and, 12, 65, 71, 75; apostolic portraits following, 399; Hiereia, Iconoclast Council of (754), 163; Holy Apostles mosaic program as response to, 163, 168, 172, 328, 330–32; post-Iconoclastic decorative programs and, 37n38, 46, 48, 169–70, 427–28

The Idea of Apostolicity in Byzantium and the Legend of the Apostle Andrew (Dvornik), 64–65

Ignatios the Younger, 326

Ignatius of Antioch, 55, 414

Image Collections and Fieldwork Archives (ICFA), 294, 295, 351

imperial authority: apostles linked with, 65, 96–97, 133; Holy Apostles as symbol of, 65, 211, 212, 233, 236, 241, 277, 281–83, 289, 290; of Macedonian emperors, 136–37, 211, 212, 233; Mehmed II the Conqueror, Fatih Camii, and, 65, 236, 277, 281–83

Imperial Door Mosaic, Hagia Sophia, 27, *28,* 36

imperial mausolea: architectural legacy of Holy Apostles and, 213, 228–33, *230–32;*

Bohemond of Antioch, mausoleum of, and, 218; Constantine's Apostoleion as, 79, 84–90, 109–11, 129, 133, 211, 226, 251; Fatih Camii, tomb of Mehmed II, 126, 252, 279; *heroon,* as term, 229–31, 235, 236, 288; Justinian, *heroon* of, 116, 129, 140, 226, 229, 241, 251, 281, 381, 390–93; Justinian's Holy Apostles as, 115–16, 140, 241, 381, 387, 390–93; "Mausoleum of Constantine" in later sources, Constantine's Apostoleion as, 83–84, 95, 99n2; Mesarites on Holy Apostles as, 254–55; in neighborhood of Holy Apostles, 140; other imperial mausolea, Constantine's Apostoleion compared to, *82,* 84–90, *85, 87–90,* 133; Pantokrator Monastery, 140, 213, 228–36, *230–32,* 280, 288; Philanthropos Monastery, 140; Rome, Mausoleum of Augustus, 79, 84, 96, 132, 229; St. Constantine, church of (Mausoleum of Constantine), 135, 136, 140, 233; Şeyh Süleyman Mescidi, *232,* 233; siting of Holy Apostles and partial urbanization of, 140; spolia, sarcophagi as, under Mehmed II, 279–81, *280;* Theotokos Kecharitomene, 140; Theotokos *tou Libos* Monastery, *235*

Imperial Palace. *See* Great Palace

inductive versus deductive approach, 30–31

Irenaeus of Lyon, 67–68, 69, 71, 74

Isidore of Seville, 53–55, 58, 61, 62

Isidoros, Nicholas, 243

Isidorus the Elder, 372

Isidorus the Younger, as architect of Holy Apostles, 170, 357, 358, 365–66n550, 372, 373

Italikos, Michael, 189n117, 190

Jacob of Serugh, 59

James (apostle), 196

James, Liz, 2, 8, 13, 102n11, 109n31, 112n40, 113n45, 115n52, 118n74, 125n93, 145, 151, 154, 155, 157, 211, 226, 287–88

Janin, Raymond, 258, 260, 277

Jenkins, Romilly J. H., 43

Jerome, *De viris illustribus,* 62

Jerusalem: Anastasis Rotunda, Church of the Holy Sepulchre, 86, *87,* 90, 93, 96; Dome of the Rock, 172; Holy Sion Church, 9n30, 22, 36, 38–39, 408

John (apostle), 56, 60, 398

John (evangelist), 331

John I Tzimiskes (emperor), 169

John II Komnenos (emperor), 140, 172, 181n55, 229–31

John III Vatatzes (emperor), 242

John VIII (emperor), 237

John X Kamateros (patriarch), 194

John Chrysostom: apostolic succession, concept of, 65–66, 69, 71, 72–73; cited in Mesarites' *Ekphrasis*, 196; on Constantine's Apostoleion, 81; Friend on, 332, 414, 418; Hagia Sophia, American copy of tmpanum mosaic of John Chrysostom from, 49, 63; Leo VI's homily on translation of relics of, 13, 152, 200; in Michael Psellos's "Encomium for his mother," 188; relics, as spolia at Topkapı Sarayı, 281; tomb of, in Holy Apostles, 66, 135, 289, 328, 388, 390; Underwood on, 388, 390

John of Damascus, 281, 330, 331

John of Gaza, ekphrasis of bathhouse painting, *199*

John Komnenos the Fat, attempted coup of, 13, 175, 177, 179–83, 184, 185, 190

Johnson, Mark J., 12, 79, 111, 287, 288

Johnson, Scott Fitzgerald, 12, 53, 289

Joseph II (patriarch), 242

Jovian (emperor), 81, 95, 392

Julian (emperor), 81, 94, 95, 229n62, 392

Justin II (emperor), 158, 211

Justinian (emperor): *Codex,* 70n22; Friend on, 331; *heroon* at Holy Apostles, 116, 129, 140, 226, 229, 241, 251, 281, 381, 390–93; military campaigns of, 229; *Novellae,* 70–71; statue of, Constantinople, 229, 352, 355, 362n42; theological writings of, 23

Justiniana Prima, 392

Justinian's Holy Apostles, 12–13, 99–130, 288; arcades and clerestory walls, 118–24, *120–23*; architectural legacy of, 99; bays and piers, 116–18; Constantine's Apostoleion and, 83–84, 95, 99, 109–11, 116, *127*, 129; crossing plan and section, *123, 129*; effects of construction on neighborhood, 134; Fatih Camii and reconstruction of, 109, 111; as imperial mausoleum, 115–16, 241, 381, 387, 390–93; literature review, 105–11, *106–8, 110*; narthex, 113, 116n61; new interpretation of evidence, 111–13; as rebuilding of Constantine's Apostoleion, 99; reconstruction of, *127–29,* 127–30; sanctuary, 115, *123*; scale and size, 126–27; shape and general layout, 113–16, *114*; texts and affiliated monuments, evidence from, *100, 101,* 101–5, *103, 104*; vaults, 102n14, 124–26. *See also* Underwood on architecture of Justinian's Holy Apostles

Kallistos, Nikephoros, 171

Kariye Camii, 25

Karydis, Nikolaos, 6, 12, 99, 104, 213, 215, 217, 274, 276, 277, 288

Kastoria, Hagioi Anargyroi, *205*

Kauleas, Church of, 428

Kauleas Monastery, 172

Kazhdan, Alexander, 176n8, 180n43, 190, 194

Kecharitomene Monastery, 13, 236

Kedrenos, 229

Kephalas, Constantine, 146

Khludov (Chludov) Psalter (Moscow, Hist. Mus. MS. D.129), 162, 166, 328, 330, 400, 405

Kiev, St. Sophia (Hagia Sophia), 162, 327, 330, 404, 412–15

Kiti, Cyprus, church of, 170n69

Kitzinger, Ernst, 8n25, 11, 20, 25, 31, 45, 157, 169–70, 173, 212

Kleinbauer, E., 94

Koehler, Wilhelm, 4n10, 17–20

Kokkinobaphos, James, 9, 103n15, 159, 173n82, 198

Kometas, 147–48, 149

Kontakia (Romanos the Melodist), 75–76

Koutsandrea, Peter, 296

Kraeling, Carl, 36

Krahmer, Gerhard, *199*

Krautheimer, Richard, 8n25, *82,* 88, 94, 102–3nn14–15, 103, 111, 117, 165, 169, 170, 173, 212, 213, 217, 275, 287, 421

Kritoboulos of Imbros, 239, 241n19, 242, 244–45, 256n34

Kumrulu mescid, 270n88

Kurbinovo, church of St. George, 203–5, *204*

Kyros Monastery, 197

La Piana, George, 20

Lambros, Spyridon, 258n39

Larnaka, Cyprus, Hagios Lazaros, 218

Lassus, Jean, 420

Lauxtermann, Marc, 146, 154

Lawrence (saint), 414

Leeb, Rudolph, 82, 88

Leo I (pope), 74, 75

Leo VI the Wise (emperor): All Saints, church of, 212, 258; architectural ekphrasis and legitimization of dynasty of, 289; Constantine the Rhodian and, 146, 151–53, 353, 355, 356, 364n398; Friend on, 328; homilies on Kauleas Monastery and Zaoutzas Church, 39, 172; homily with

description of Holy Apostles, 13, 152, 158, 168, 170, 200; Miraculous Toad of, 281n114; mosaics of Holy Apostles and, 158; neighorhood of Holy Apostles and, 135, 136; tetragamy (fourth marriage) of, 152; Underwood on, 428

Leo Choirosphaktes, 147, 148–49, 150, 153–54

Leo Grammaticus, 391

Lesnovo, domes of, 326

Leunclavius, Johannes, 258n39

Libanius, 194–95, 200

Liber insularum archipelagi (Cristoforo Buondelmonti), 242, 255, 290

Liber Pontificalis, 93

Licinius (emperor), 61, 131

Life and Miracles of Thecla, 56

Life of Basil (Vita Basilii), 112n40, 158, 168–69, 211, 226, 277n108

Life of Constantine (Vita Constantini; Eusebius), 57, 80–81, 96n74, 97, 99, 109, 116, 133, 139

Life of St. Theodora, 259

liturgy: mosaics of Holy Apostles and, 328, 412, 415–16; three-dome repetitions and, 218

Liudprand of Cremona, 137, 141

Loerke, William, 11, 294

Lorenzetti, Ambrogio, 205

Lorichs, Melchior, *248*

Lowden, J., 164n43

Luke (evangelist), 64–66, 96n74, 399. *See also* relics (of Andrew, Luke, and Timothy) interred in Holy Apostles

Lythrankomi, Cyprus, church of, 170n69

Macedonian emperors, 136–37, 211, 212, 226, 233

Macrides, Ruth, 8, 13, 155, 175, 289

Magdalino, Paul, 8, 13, 131, 153, 155, 187n100, 195, 231, 233, 236, 276–77n104, 288, 289

Maguire, Henry, 8, 13, 171, 192, 287

Mainstone, Rowland, 112, 120n82

Majeska, George, 259

Makedonios (patriarch), 81, 82

Malalas, John, 58

Malickij, N., 159, 162

Mamaloukos, Stavros, 296

Manasses, Constantine, 367n739

Mangana, church and monastery, 8, 245

Manganeios Prodromos, 171n74

neighborhood of Holy Apostles, Mesarites on); Underwood's use of, 160, 369, 370, 377, 378, 387–91; Zarras on, 164n43

Messis, Charis, 149

Methodios (patriarch), 135, 326, 331, 391

Metrophanes II (patriarch), 242

Michael III (emperor), 137, 427

Michael VIII Palaiologos (emperor), 235, 242, 290

Michael the Syrian, 58

Milan: Basilica Apostolorum, *82, 95*; Holy Apostles, 114; Ospedale Maggiore, 252

Millet, Gabriel, 29

Miraculous Toad of Leo VI the Wise, 281n114

Mistra, Greece, domes of, 326

Moffat, Ann, 276–77n104

Monody on the Collapse of St. Sophia (Michael Psellos), 368n953

Monothelites, 330

Monreale, dome, 169, 170, 327

Montinaro, F., 101n9

Morelli, Giovanni, 159n16

Morey, Charles Rufus, 10, 14, 31, 50

mosaics of Holy Apostles, 13, 157–73; coordination and coherence of iconography, 172–73; dating of, 158–59, 168–72, 190–91; differences between sources, significance of, 158–59, 168, 191; legacy of, 172–73; literary sources, issues with use of, 165–68, 171–72; liturgy and, 328, 412, 415–16; locations of, 159; original Holy Apostles project and symposium (1948) and, 157, 159, 160–68 (*See also* Friend on mosaics of Holy Apostles); problems with reconstruction of, 163–68; restoration and repair, 172; sources of information about, 157–59; Underwood on, 377–79

Mouchroutas, Great Palace, 181, 190, 191

Moutsopoulos, N. K., 226

Müller-Wiener, Wolfgang, 258, 259

Mullett, Margaret, 1, 2–5, 290, 294

Murad II (sultan), 274

Myrelaion, 8

narthex of Holy Apostles: in *De ceremoniis*, 276; of Justinian's Holy Apostles, 113, 116n61; post-Justinianic, 276–77; Underwood on, 276, 381, 386–87

Nasuh, Matrakçi, 264, *265*

Nea Ekklesia, Great Palace, 37, *38*, 43, 44, *47*, 48, 158, 170, 226, 277, 293, 296, 300, *323*, 326, *338*, 386, 427

Necipoğlu, Gülru, 270

Necipoğlu, Nevra, 8n23, 14, 237, 288

neighborhood of Holy Apostles, Mesarites on, 13, 138–40, 193–207, 289; characteristics of descriptions of, 194–95; gardens, agricultural lands, and Philopation (open lands), 195, 201; *realia,* interest of twelfth century Byzantine art in, 203–7, *204–6*; school at Holy Apostles, 139, 188–90, 195–96, 201, 202, 252; transitions between description of church itself and, 196–203; views from upper galleries and roof, 13, 195, 200–201, *200–202*

neighborhood of Holy Apostles, structures of, 13, 131–42, 289; apostolic patterns of thought and, 140–42; atrium, 135, 137, 139; *De Ceremoniis* on, 134–38, 139; Eusebius, *Vita Constantini* on, 133, 139; founding of Constantinople, intentions of Constantine regarding, 131–32; *gynaikites* (women's section), 135, 136, 137; hypothetical plans of Holy Apostles with related structures, *138*; imperial maosolea, 140; Justinian's Holy Apostles, construction of, 134; Mesarites on, 138–40; purpose of Constantine's Apostoleion and, 133; schools/learning spaces, 139, 188–90, 195–96, 201, 202, 252; siting of Holy Apostles within city, 132–34, 139–40; uncluttered view of church, lack of, 233–34, *234*; washing facilities and water supply, 134, 139. *See also specific buildings*

Nelson, Robert S., 1n4, 6, 10, 12, 27, 45, 288

Nerezi, St. Panteleimon, 203, *223*

New Mosque (Cami-i Cedid). *See* Mehmed II the Conqueror, Fatih Camii, and Holy Apostles

Nicaea: Dormition Church, 401; Koimesis Church, 428

Nicaea, 1st Council of (325), 57

Nicaea, 7th Ecumenical Council at (787), 23, 163, 328–31, 402

Nicene-Constantinopolitan Creed, 70

Nicholas I (pope), 405

Nika Riot, 134

Nikephoros (patriarch), 135, 391

Nikephoros II Pohkas (emperor), 141, 169

Nomikopoulos, John, 187, 189n116

Norton, Charles Eliot, 50n75

Notaras, Loukas, 13–14, 255

Notitia Urbis Constantinopolitanae, 134

Odyssey (Homer), 195

Öner, Tayfur, 9

Origen of Alexandria, 60, 72, 331

original Holy Apostles project and symposium (1948), 1–12, 17–25, 288; already-published texts from, 7n15, 293n1; attendance at symposium, 7n15, 421–25; collaboration of Friend and Underwood, 37, 38, 40–41, *42*, 44, 299–300, 326, 332; collaborative research methodology at Dumbarton Oaks and, 1, 3–6, 17–23, 25, 43, 326; differences compared to 2015 symposium, 8–9, 14; intertextuality versus intermonumentality, 8–10; legacy of, 172–73; as medieval revival project, 49–50; methodology of, 293; mosaics of Holy Apostles and, 157, 159, 160–68; nonpublication of, 6, 10–12, 24–25, 30; organization of, 17, 22, 30, 36, 419–20; papers and materials of, 293–97; place in scholarship of, 29–30, 50; program for symposium, *5*, 7n15, 419–20; proposal of project and gathering of scholars, 22–24; St. Sophia, Washington, DC, design of, 10, 30, *44, 45–50, 46–49*, 288, 293, 296–97, 427–30; speakers' photo, *x*; surviving texts from, 7n15, 40, 293–97. *See also specific speakers at symposium by name*

Ourbanos (disciple), 64

Ousterhout, Robert, 6, 10, 13, 97, 112n40, 211, 287

Oxford Dictionary of Byzantium, 173

Özgümüş, Feredun, 111, 126, 259n51, 260–69, 279, 288

Palaiologos, Constantine Doukas, 177n22

Palau, Cataldi, 176n12

Palermo, Sicily: Cappella Palatina, 162, 170, 181n52, 181n57, 326; Martorana, 170, 326

Pammakaristos Monastery (church of St. Mary Pammakaristos), 14, 28, 29, 237, 239–42, 244, 255–56

Pammukkale (Hierapolis), churches at, 217

Panofsky, Erwin, 10, 24, 295, 395n3

Pantokrator Church, 281

Pantokrator (central) dome, Holy Apostles, 162–64, 167–68; Friend on, 325, 327–28, 330, *337, 339, 341–44,* 407, 409–18; Mesarites' description of, 190, 194; Underwood drawings, *313, 314*

Pantokrator Monastery, 8, 13, 140, 189, 213, 228–36, *230–32*, 238n4, 245, 280, 288

Papacostas, Tassos, 213, 217

papal claims to apostolic priority, 71, 72, 74, 75

Parani, Maria, 190, 203

Paros, *Katapoliani,* 114

Passion relics, Pharos Chapel, Mesarites' description of, 180–81, 191

St. Mary of Blachernae (Blachernae Church), 233, 389

St. Mary Pammakaristos (Pammakaristos Monastery), 14, 28, 29, 237, 239–42, 244, 255–56

St. Mokios, church of, 96

St. Paul at the Orphanage, 140, 142

St. Peter, chapel of, 140

Sts. Sergius and Bacchus, church of, 27, 28, 383, 384, 385

St. Theophano, identity with All Saints, 258–59

St. Thomas, church of, 140

Salač, A., 159

Salamis, Hagios Epiphanios and Hagios Barnabas, 218, *219*

Saloniki, St. George and St. Sophia, 330, 408

Salzenberg, Wilhelm, 403

Samonas (courtier of Leo VI), 146, 148

sanctuary, Holy Apostles, 115, *123*, 381, 387–89

Sardis, Building D, 117n70, *217*

Scarella, Francesco, *250*, 263, 264

Schermann, T., 61n35

Schnorrenberg, John Martin ("Schwarzenberg"), 6

schools: at Fatih Camii, 252; at Holy Apostles, 139, 188–90, 195–96, 201, 202, 252

Segré, Angelo, 382

Şehzade Mehmed Camii, 266n76

Selim I, mosque of, 266n76

senate (Constantinople), 353, 362–63n91

Serpent Column, 283

Sessions, Barbara, 421

Ševčenko, Ihor, 50, 65

Şeyh Süleyman Mescidi, *232*, 233

Shelov-Kovediaev, Fedor, 88

Shepard, John, 216

Sicily: Cefalù, Cathedral, 162, 170, 327, 330, 399, 409–10, 411, 413, 414; Palermo, Cappella Palatina, 162, 170, 181n52, 181n57, 326; Palermo, Martorana, 170, 326

Simon Magus, 58

sin, forgiveness of, and apostolic authority, 72–73

Sinai, Monastery of St. Catherine, 166, 168, 170n69, 403

Sinan, Atik (Sinan al-Din Yusuf bin 'Abdullah; Christodoulos), 14, 253, 270n88

Sokollu Mehmed Paşa, 263

Sokrates Scholastikos, 81

Sol Invictus, 133, 326

Sophianos, Maximos, 245

Sophianos, Theodore, 238

sortes apostolorum, 61, 66

Soteriou, George A., 106–9, *108*, 118n74, 119, 122, 275n93, 276, 379, 388

Spandugino, Teodoro, 258n39

Speck, Paul, 88, 146

Speculum, 19

Sphrantzes (historian), 239, 255n28

Split, Diocletian's complex at, 133

spolia, imperial sarcophagi as, under Mehmed II, 279–81, *280*

Stachys (disciple), 64, 74

Stang, Charlie, 70n20

Staro Nagoričane, church of, 332

Stathes, S. Thomas, 296n23

statues and columns in Constantinople, 149, 229, 242n24, *282*, 283, 290, 352–55, 363n162

Stephen of Novgorod, 116, 281n116, 390

Stephen protomartyr, 56, 414

Stewart, Charles A., 213, 217

Stilbes, Constantine, 186, 188

Stone of the Deposition, 281

Stoudios, monastery church, 197–98

Strygowski, Josef, 31

Süleyman the Magnificent (sultan), 283

Süleymaniye Mosque, 249n4, 266n76

Sultan Ahmed Camii (Blue Mosque), 263, 266n76

Swift, E. H., 370, 383

Symeon the Logothete, 229

Symeon the New Theologian, 68, 73

synaxis, 238

Synkellos, George, 58

Synopsis Chronike, 229n62

Synousiasts, 330

Talbot, Alice-Mary, 290

Tarasius (uncle of Photios), 328

Taurisium (birthplace of Justinian), basilica and other structures in vicinity of, 392

Tavlarides, Harriett, 296

Tavlarides, John T., 45, 46, 48, 293, 296, 427–30

Tertullian, 56, 68, 72n35, 73, 400

Teteriatnikov, Natalia B., 37n38

Tetrapyrgia, 392

Thacher, John, 45–46

Thasos, cruciform basilica, 114

Thecla, 56–57

Themistius, 23, 194, 195n13, 196

Theodora (empress), 269, 270n88

Theodora (wife of Michael VIII), 235–36

Theodore I Laskaris (emperor), 177n22

Theodore Paphlagon, 149–50, 154

Theodore Prodromos, 171

Theodore Stoudites, 71–72, 75, 401, 416

Theodosius I (emperor), 95, 134, 354

Theodosius II (emperor), 12, 66, 87, 95, 134, 140, 392

Theophanes, 158, 211

Theophano (wife of Leo VI), 135, 136, 212, 233, 258–59, 275n93

Theotokos Kecharitomene, 140

Theotokos of the Forum, 226

Theotokos *tou Libos* Monastery, 223, *235*

Thessalonike: Hagia Sophia, 162, 326, 407; Hosios David, *206*; St. George, 85

Thiel, Andreas, 213

Thomas (apostle), 53–54, 59–60, 75–76, 202–3

Thomas Aquinas, 237

Thousand-Line Elegy (Leo Choirosphaktes), 153

Timothy (disciple), 64–66. *See also* relics (of Andrew, Luke, and Timothy) interred in Holy Apostles

Titus (disciple), 64

Titus (emperor), 96, 400

Topkapı Sarayı, 256, 280–81

Tornikes, Euthymios, 179n34

Transactions of the American Philosophical Society, 11

Transfiguration dome, Holy Apostles, 162, 163, 165–67, *168, 169,* 171, *172*; Friend on, 325, 327, 329, 330, 331, 395, 403–5; Underwood on, 300, *315–17*

Trebizond, Ottoman capture of, 256

Trinity, doctrine of, 70, 401

Tursun Beg, 239, 241n19, 244, 254

Tyler, Royall, 18, 421

Typikon of the Great Church, 13, 76, 140–41, 142

typikon of Kecharitomene Monastery, 236

typikon of Pantokrator Monastery, 189, 228–30, 233

Underwood, Irene, 293n3

Underwood, Paul: on All Saints, 212, 289; Byzantine garden plan for M. Bliss, 1, 2n5, *4*; collaboration with Friend, 37, 38, 40–41, *42,* 44, 299–300, 332; death of, 11; drawings and plans of, *110,* 163, 276, 287, 299–300, *301–23,* 332; field-work in Constantinople, 2n5, 10, 24–25,